THE PAINTINGS
OF
DOMENICO VENEZIANO

ca. 1410–1461

A STUDY IN FLORENTINE ART
OF
THE EARLY RENAISSANCE

by

HELLMUT WOHL

NEW YORK UNIVERSITY PRESS

New York *and* London

Library of Congress Cataloging in Publication Data

Wohl, Hellmut.
 The paintings of Domenico Veneziano, ca. 1410–1461.

 Bibliography: p.
 Includes index.
 1. Veneziano, Domenico di Bartolomeo, d. 1461.
2. Painting, Renaissance—Italy—Florence.
I. Veneziano, Domenico di Bartolomeo, d. 1461.
II. Title.
ND623.V382W63 1980 759.5 78-68140
ISBN 0-8147-9185-9

Manufactured in the United States of America

To my three children,
ANN, MAIKA, MATTHEW

PREFACE

My study of Domenico Veneziano began in a seminar on problems in Italian art conducted by Craig H. Smyth at the Institute of Fine Arts of New York University in the autumn of 1952. It was subsequently guided by the late Richard Offner, who put at my disposal his files and his incomparable knowledge of Italian quattrocento painting. From the time I met Charles Seymour, Jr., in Florence in the autumn of 1954 until his death in 1976 he was my indispensable counselor. The example of these three teachers and friends stands behind every page of this book, and my gratitude to them is immeasurable.

My other greatest indebtedness is to Gino Corti, who checked and transcribed all Domenico Veneziano documents for me; to H. W. Janson, who recommended the manuscript to the New York University Press; and to Sir John Pope-Hennessy, who at crucial stages during the course of my work provided generous and stanch support. Among those who helped me in various ways I should also like to single out especially the late Bernard Berenson, Eve Borsook, David A. Brown, the late Horace Buttery, Ellen Callman, Dario Covi, the late Martin Davies, Samuel Y. Edgerton, Jr., Creighton Gilbert, Marcia Hall, Frederick Hartt, William S. Heckscher, the late Ernst Holzinger, the late Wilhelm Köhler, Richard Krautheimer, Marilyn Aronberg Lavin, Bates Lowry, the late Millard Meiss, Ulrich Middeldorf, Michelangelo Muraro, the late Erwin Panofsky, Howard Saalman, John Shearman, the late Curtis Shell, and the late Evelyn Sandberg Vavalà.

My work in Italy was facilitated by a Fulbright research grant (1953–54) and a Morse Fellowship from Yale University (1959–60). Two former students at Boston University, Laura Camins and Jane McCall, supplied me with bibliographical information during periods when I was out of reach of libraries. I should further like to express my gratitude to the staffs of museums and libraries, especially of the Frick Art Reference Library and the Kunsthistorisches Institut Florenz, for their courtesy and patience in responding to my requests for information and photographs, and to Robert Bull and Despina Papazoglou for their skill and good humor in seeing the manuscript through the press.

Hellmut Wohl
Stockbridge, Massachusetts

CONTENTS

LIST OF ILLUSTRATIONS

Frontispiece. Letter from Domenico Veneziano to Piero de' Medici, Florence, Archivio di Stato (courtesy Gino Corti).

FIGURES (Pages 87–112)

[xi]

LIST OF ILLUSTRATIONS

LIST OF ILLUSTRATIONS

LIST OF ILLUSTRATIONS

LIST OF ILLUSTRATIONS

LIST OF ILLUSTRATIONS

LIST OF ILLUSTRATIONS

INTRODUCTION

Domenico Veneziano is the most elusive artist of what Hartt (1969) has called the Second Renaissance Style. Acclaimed by Vasari for having brought oil painting from Venice to Florence, which he could hardly have done, he is also the least studied of the great painters of his time, partly because of a tendency to think of him chiefly as an innovator in pictorial technique, less concerned with the fundamentals of form and expression than his Florentine contemporaries. Even so astute a critic as Roger Fry (1930) felt that "though he always has a certain charm, Domenico seems to lack intensity of feeling as compared with the other members of his group." Kennedy (1938, p. 20), who wrote about Domenico with great sensitivity, nevertheless believed that his principal achievement was his "impressionism." And Pudelko (1934) concluded his illuminating study of Domenico with the judgment that "in contrast to the Florentine system builders [*Systematikern*] Domenico appears like an ingenious dilettante whose only real domain was color" and that only Vasari "seems to have suspected something of his significance."

Yet Domenico was far more than a brilliant colorist. The elegance and subtlety of his pictorial style are the expressions of one of the most versatile and lucid minds among the great realists of the early Renaissance. As Berenson (1896) perceived, it was Domenico who first succeeded "in giving to the figure movement and expression, and to the face individuality." One of the pervasive traits of quattrocento realism, from Brunelleschi's rediscovery of linear perspective in the century's second decade to Giovanni Bellini and Leonardo da Vinci, is the counterpoint between abstraction and naturalism—a counterpoint inherent in the very system of fifteenth-century perspective, with its dual objective of illusion and intellectual coherence (see Mesnil, 1926), or as Francastel (1967) has put it, "le principe du champ figuratif considéré comme le lieu d'integration d'une double image illusionniste et mentale" (p. 264). Although a synthesis—as opposed to a counterpoint—between abstraction and naturalism was achieved by Masaccio and envisioned in Alberti's *De pictura*, it did not become a principle of style until the High Renaissance.[1] During the fifteenth century, abstract and naturalistic aspects of pictorial art retained a crisply articulated distinctness, and their relationship displayed restraint and tension. Each artist interpreted and orchestrated the counterpoint between them—between decoration and imitation, scheme and observation, geometry and the pulse of life—according to his temperament, the taste and intellectual climate of the time, and the preferences of his religious or secular patrons. Few painters of the early Renaissance were as sensitive, intellectually as well as pictorially, as Domenico Veneziano to the modalities and potentialities of the contrapuntal character of quattrocento realism.

Domenico Veneziano is best known by the *sacra conversazione* of the St. Lucy altarpiece in

the Uffizi (Pls. 60–74), painted during the fifth decade of the quattrocento and his supreme extant achievement. Beside it only eleven other works incontrovertibly by his hand have survived: the five predella panels from the altarpiece in Berlin, Cambridge, and Washington (Pls. 88–89, 105–107, 110–113, 116–119, 123–128); the *Madonnas* at Bucharest, Settignano, and Washington (Pls. 24–27, 31–34, 132–136); the *Adoration of the Magi* in Berlin (Pls. 38–45); the damaged fragments of the Carnesecchi Tabernacle in London (Pls. 1–7); and the recently cleaned fresco of *Sts. John the Baptist and Francis* in the Museo di S. Croce in Florence (Pls. 138–148). None of these pictures is documented. None can be dated on grounds other than the context of style. We do, however, have dates and documentation for three sets of important and influential lost works: frescoes in the Baglioni Palace in Perugia cited by Vasari and datable to the years 1437–38 through the letter written by Domenico Veneziano from Perugia to Piero de' Medici on April 1, 1438 (see frontispiece); frescoes in S. Egidio in Florence, described by Vasari and certified by the records of payments from 1439 to 1445; and two *cassoni* for the Florentine patrician Marco Parenti for which Domenico received payments during 1447–48. Beyond this the only documentation of the painter's life consists of notices testifying to his presence in Florence, Perugia, and Pistoia in the 1450s, and the record of his burial in 1461.

Since his own day Domenico has been looked upon as one of the major artists of the fifteenth century. Yet almost all fundamental questions concerning his art can be but imperfectly answered: the nature of his achievement and his contribution to the process of quattrocento painting; his artistic origins and development; the chronology of his works; and the distinction between his own production and that of his workshop, his pupils and followers, and of artists influenced by him. Only two studies have attempted to deal comprehensively with some of these issues: Pudelko's admirable essay of 1934, which in spite of its improbable chronology, spurious views of Domenico's stylistic sources, and insufficient attention to iconography, remains the most perceptive discussion of the artist's style; and the short section in Salmi's *Paolo Uccello, Andrea del Castagno, Domenico Veneziano* of 1936 and 1938, which reliably assembles the available data, but suffers from excessive brevity and the inclusion in Domenico's oeuvre of unacceptable attributions. There are illuminating pages on Domenico's paintings in a number of studies devoted to other artists, notably Longhi's essay on the Master of Pratovecchio (1952), Kennedy's *Alesso Baldovinetti* (1938), and Zeri's book on the Master of the Barberini Panels (1961); as well as in articles proposing new attributions, among which Gioseffi's on the Masaccesque panel of *Sts. Jerome and John the Baptist* from the S. Maria Maggiore altarpiece (catalogue no. 31) is particularly rewarding. An excellent summary of the state of Domenico Veneziano scholarship through the 1950s is provided in the article by Berti in *The Encyclopedia of World Art* (1961).

The present study offers no discoveries of previously unknown documents or of new works. Rather, I have attempted to present a coherent exposition of Domenico Veneziano as an artist through a reexamination of the known paintings, documents, and sources, and by taking advantage of new possibilities for interpretation suggested by Renaissance studies, especially those centering in various ways on Alberti, since the publication of Pudelko's and Salmi's work four decades ago. Their view of Domenico Veneziano, as well as that of Kennedy and of most other writers on Domenico, reflects the formalist approach that has dominated the reevaluation of Italian Primitives since their rediscovery about a century ago, and the neo-Fiedlerian, neo-Crocean position of Berenson, Longhi, and Offner. Only a handful of scholars

have commented on the intellectual content and structure of Domenico's art: Spencer (1955) and Edgerton (1978) in their studies of the spatial imagery and symbolism of *The Annunciation,* Lavin (1961) in her work on the iconographic source of *The Vocation of St. John the Baptist,* Hatfield (1966) in his comments on the *Adoration of the Magi,* and Welliver (1973) in his interpretation of the *sacra conversazione* and the *Annunciation* of the St. Lucy Altar.

But even with the available evidence, a more rounded picture of Domenico Veneziano can be constructed, one that shows him, rather than if he had been a forerunner of the Macchiaioli, as centrally involved in the artistic process of his time and place. In order to portray him as such, I have at the outset attempted to establish his artistic biography and have begun my discussion of the paintings, not with his early production, but with the St. Lucy altarpiece, the work that stands chronologically as well as conceptually at the center of his extant oeuvre, and whose *sacra conversazione* and predella provide the richest, most complex, and most revealing testimony of the anatomy of his art.

In the Catalogue Raisonné I have included all of the sixty-two works I regard as apocryphal attributions to Domenico, his workshop and his immediate followers. A number of these are the subject of ongoing debate, while many are by general consent looked upon as by known or unknown masters other than Domenico or his followers. Because of the uncertainty of Domenico Veneziano scholarship and the difficulty of forming criteria for including some attributions and excluding others, I have listed them all and have stated, however briefly, my view of their authorship.

The only attributions that I have discussed neither in the text nor in the Catalogue Raisonné are of drawings. We have no assurance that any of Domenico's drawings has survived. None was given to him in Berenson's *Drawings of the Florentine Painters* (1938) or by Salmi (1936 and 1938). The ascription of a group of drawings to Domenico by Degenhart and Schmitt (1969) lacks credibility,[2] and scattered earlier attributions by Wickhoff (1899), Böck (1934), Geiger (1948), and Grassi (1961) seem equally implausible. The absence of drawings—Domenico Veneziano must have been a tireless as well as brilliant draftsman—is the oddest of the many gaps in our knowledge of this great artist.

Throughout the text and Catalogue Raisonné I have kept bibliographical references to the shortest possible form, providing page, illustration, and catalogue numbers only when I felt them to be essential for locating the item referred to. The only abbreviations I have used which may not be self-evident are "Cavalcaselle" for Cavalcaselle and Crowe (1892) as well as for Crowe and Cavalcaselle (1864, 1870, 1871, 1909, and 1911) and "Van Marle" for Van Marle (1923 ff.).

NOTES

1. Clark (1944) holds the view that Alberti's ideal of painting was realized only partially during the quattrocento, but was brought to fulfillment in works of the classic style of the early sixteenth century such as Raphael's *School of Athens.*
2. The same attributions were published earlier by Degenhart (1959) alone. The reviewer of the Degenhart-Schmitt *corpus* in the *Times Literary Supplement* (1969) wrote—justly, in my opinion—of the group of drawings assembled there under Domenico's name that "why the hand should be that of the elusive Domenico Veneziano is not demonstrated in any persuasive way."

THE PAINTINGS
OF
DOMENICO VENEZIANO
ca. 1410–1461

CHAPTER I

THE *VITA* OF
DOMENICO VENEZIANO

I

By the time Vasari composed the first edition of his *Lives of the Artists* nearly a century after Domenico Veneziano's death, the great quattrocento master had become a very shadowy figure and the subject of a legend that he had brought the secret of oil painting from Venice to Florence. The praises bestowed on him by the Florentines for his mastery of oil painting, the legend continued, so aroused the envy of Andrea del Castagno that Andrea murdered him (source 11D). The story of the murder was disproved more than a century ago when Milanesi (1862) discovered that Castagno died four years earlier than his alleged victim. Not as easily resolved is the question of Domenico's knowledge of oil painting. By "the secret of oil painting" Vasari meant the Flemish oil technique. It seems certain, contrary to Vasari, that Domenico did not use this method in his lost frescoes at S. Egidio (see catalogue no. 86). And even though the Medici Inventory listed a canvas "cholorita a olio" by him (see catalogue no. 84), oil as it is used in Netherlandish painting appears in none of his surviving works. In any event, whether Domenico knew its secret or not, he could not have learned it in Venice.

In the course of the *Vite* Vasari mentioned Domenico Veneziano on five occasions: in the Introduction to the edition of 1568 (source 11A), in the Lives of Piero della Francesca (source 11B) and Antonello da Messina (source 11C), and in the joint Lives of Domenico Veneziano and Andrea del Castagno (source 11D) and of the Bellini (source 11E). The picture that emerges from these passages, which partly repeat each other, is a curious mixture of fact and fiction: Domenico was brought to Florence from Venice, where he had learned the Flemish oil technique from Antonello da Messina and had been the rival of Jacopo Bellini, in order to decorate in oil the choir of the chapel of S. Maria Nuova (S. Egidio) according to the 1550 edition of the *Vite,* by the Portinari (source 11D), who were the patrons of S. Egidio, or by their agents in Venice—"da quegli che facevano in Venezia le facende mercantili de' Portinari" (source 11C). Before coming to Florence he had worked in Perugia and, together with Piero della Francesca, in Loreto. His first work in Florence was the Carnesecchi Tabernacle.

He failed to complete his wall at S. Egidio because he was murdered by Castagno out of envy for the acclaim he received from the Florentines for his mastery of oil painting. Before he died he painted the St. Lucy altarpiece.

For Vasari to have assigned Domenico so important a role in the progress of the arts as the dissemination among Florentine painters of the Flemish oil technique, he must have considered him a very great master. Indeed, he referred to him as the "then very celebrated painter," claiming in the *Vita* of the Bellini that no matter how Jacopo Bellini applied himself in order to excel in the art of painting, he was not held in esteem in Venice until after the departure of Domenico;[1] and in the *Vita* of Antonello da Messina that when Antonello arrived in Venice, Domenico was one of the best painters in that city. According to Vasari, Antonello had acquired the secret of oil painting from Jan van Eyck in Bruges. Although it has been recently suggested (Frew, 1977) that Antonello might have traveled to the north and there learned the Eyckian technique of oil glazing, he could hardly have done so before 1450–55; and we know that he did not come to Venice until 1475, fourteen years after Domenico Veneziano's death. For Vasari the Jan van Eyck, Antonello da Messina, Domenico Veneziano connection must have appeared to have the advantage of certifying the identity of the secret Domenico allegedly learned from Antonello as the Flemish oil technique, as distinct from various methods of oil painting practiced in Italy since the fourteenth century and described by Cennino Cennini (see p. 202).

Evidence for the fact that Domenico had indeed been a "very celebrated painter" in his day is provided by a number of well-known lists of artists' names of the second half of the fifteenth century and the beginning of the sixteenth century. Domenico's name was not included in the important list in Cristoforo Landino's Commentary on Dante of 1481, which among painters includes Masaccio, Fra Filippo Lippi, Andrea del Castagno, Paolo Uccello, Fra Angelico, and Pesellino (see Morisani, 1953; Baxandall, 1972). But it does appear on five other lists. In fact, Domenico is the only painter who is mentioned in all five. The earliest, in Giovanni Rucellai's *Zibaldone,* is a roster of names of artists by whom there were works in the Rucellai Palace (see source 1). The four others are eulogistic recitals. The first of them, roughly contemporary with the *Zibaldone* of Giovanni Rucellai, is in Filarete's *Treatise on Architecture* (source 2). The occasion for it is a dialogue between an architect and a young prince concerning the pictorial decoration of a palace. In the course of it the architect names Domenico Veneziano as one of the painters whom, were he still living, he would recommend to his patron for the commission of frescoes "of things pertaining to both vice and virtue" in the loggia of the gate below the palace portico. But this project, the architect continues, "will have to wait, because there is a shortage of masters who would be good enough to make these things turn out well." All those who might have succeeded, he informs the prince, had died: not only Domenico, but also Masaccio, Masolino, Fra Angelico, Pesellino, Andrea del Castagno, and a mysterious "Berto who died at Lyon on the Rhone." Paolo Uccello, Fra Filippo Lippi, and Piero della Francesca are not included, perhaps because they were still alive. It seems to have been the custom to restrict eulogistic lists such as Filarete's to artists who were no longer living (see Gombrich, 1966, p. 140, n. 4).

More rewarding than Filarete's reference to Domenico is the appearance of his name in the dedicatory epistle of 1473 addressed to Federigo da Montefeltro by Alamanno Rinuccini in his translation into Latin of Philostratus' *Life of Apollonius* (source 3). In a vein reminiscent of both Alberti and Ghiberti, Rinuccini declared that

the arts of sculpture and painting, graced in earlier times by the genius of Cimabue, Giotto and Taddeo Gaddi, have been carried to such greatness and excellence by painters who flourished in our own age, that they may well deserve to be mentioned beside the ancients.

As foremost among these, by dint of his naturalism, Rinuccini cited Masaccio. He then asked:

What could be more accomplished than the paintings by Domenico Veneziano? What more admirable than the pictures of Fra Filippo Lippi? What more ornate than the images of Fra Angelico? All these differ from each other in their various manners and are yet considered quite alike in excellence and quality.[2]

As criticism this is no more enlightening than most humanist commentary on visual art. It is, however, an important testimony of Domenico's fame.

In the 1480s Domenico was included in the eulogistic list of artists in the *Cronaca* by Giovanni Santi, the rhymed chronicle which the father of Raphael began after the death of Federigo da Montefeltro in commemoration of his great patron's achievements (source 4). It is the longest list of quattrocento painters compiled in the fifteenth century, naming, in addition to the four masters cited by Rinuccini, the Florentines Francesco Pesellino, Andrea del Castagno, Paolo Uccello, and Antonio and Piero Pollaiuolo, as well as Gentile da Fabriano, Pisanello, and Federigo's own preferred artist, Piero della Francesca. Finally, Domenico Veneziano is mentioned as one of the *nobili e valenti uomini* in Florence at the time of the *catasto* of 1458 (actually 1457–58) in the diary of the Florentine drugs and spices dealer Luca Landucci (1436–1516), probably composed sometime during the last two decades of Landucci's life (source 7).[3]

In order to understand Vasari's allegations that Domenico brought oil painting from Venice to Florence and that he was murdered out of envy by Castagno, they must be seen in the context of the thematic structure and the sources of the *Vite*. Andrea, according to Vasari, did not envy Domenico for his knowledge of oil painting as much as for the fame it brought him. It was the praise bestowed by the Florentines on the Carnesecchi Tabernacle that made Andrea resolve to wrest from Domenico the secret of oil painting. Having succeeded in this, he applied it in his mural of the *Death of the Virgin* at S. Egidio, and there showed "that he knew how to paint in oil as well as Domenico Veneziano his rival." Yet although he completed this work "to perfection," he was still "blinded by envy of the praises he heard of the excellence of Domenico, and wishing to do away with him at all costs, devised a number of ways of murdering him," one of which he carried out—as Vasari went on to describe. Inherent in this account by Vasari are three characteristic Renaissance themes: rivalry or envy, one of the commonplaces in the repertory of artists' biographies that the Renaissance inherited from antiquity (see Kris and Kurz, 1934, pp. 118ff.); the pursuit of personal fame; and the striving for progress. For Vasari one of the most notable examples of artistic progress—the major theme of the *Vite*—was the adoption by Italian artists of Flemish oil painting, the medium which as a painter he himself preferred to all others. So profoundly did Vasari believe in progress in the arts that he assumed, as Gombrich (1967) has put it, "that any improvement must have been striven for and that those who still lacked it felt the absence as a mark of inferiority" (p. 14). It is in the light of this assumption that we should interpret Vasari's characterization of the relationship between Castagno and Domenico Veneziano.

Another, equally relevant context for the legend of Domenico Veneziano is the frescoes at S. Egidio, the only works Vasari explicitly stated he painted in oil (no matter how clearly, Vasari only implied this about the Carnesecchi Tabernacle). A connection between these murals and Castagno's murder of Domenico had already been made in the *Libro di Antonio Billi* (source 9) and the *Codex Magliabecchiano* (source 10). According to the latter, Domenico was murdered while he was working on his wall at S. Egidio "by Andrea del Castagno out of envy, because they were painting in competition in that place . . . in order that he [Domenico] might not be able to finish [aciò finire non potessi]" the decoration of that wall. With a difference in inflection, the second part of this passage is based on the report of the *Libro di Antonio Billi* that Domenico "was murdered by Andrea out of envy . . . and was therefore not able to finish [et però non potette finire]" his wall. The two chronicles transmitted to Vasari three important components of the Domenico Veneziano legend: that he and Castagno were rivals at S. Egidio, that Castagno murdered Domenico out of envy, and that for this reason Domenico did not complete his part of the decoration of the S. Egidio choir. In the first edition of the *Vite* Vasari wrote that whereas Castagno completed his work at S. Egidio, "that of his dead friend, which was praised by craftsmen everywhere and by all citizens, remained unfinished." In the second edition Vasari established the connection that had already been made in his two sources: the *Marriage of the Virgin*, the third of Domenico's murals at S. Egidio, "remained incomplete for the reasons," that is to say, his murder, "which will be mentioned below."

The most intriguing aspect of this part of the legend of Domenico is that even though the S. Egidio *Marriage of the Virgin* had been completed by Alesso Baldovinetti (document 7), the chroniclers of the sixteenth century knew that Domenico had in fact left it unfinished. The connection between Domenico's failure to complete his work at S. Egidio and his murder by Castagno was evidently transmitted to them from the quattrocento. It is likely, as Berenson (1901, p. 8) suggested, that "the story-spinning Florentines cooked up" the murder in order to explain the fact that Domenico's wall at S. Egidio remained unfinished for sixteen years—from 1445, when Domenico abandoned it, until Baldovinetti began to complete it in 1461. Since Andrea painted the wall at S. Egidio opposite to Domenico's, even if only in 1451–53, it was easy to make him first Domenico's rival and then his assassin. References to Andrea's malevolence—the earliest is the notice in the *Codex Magliabecchiano* that in the predella by Pesellino of Fra Filippo Lippi's S. Croce altarpiece there were "several errors marked by Andreino da Castagno" (Frey, 1892, p. 120), which Vasari adapted in the second edition of the *Vite* to read that Andrea "had dared secretly to mark with scratchings of his nails the works of other artists, such as Domenico, in which he recognized errors"—are found only after the legend of the murder was established. Vasari's judgment that the sin of wrath and envy "totally buried and hid every ray of light" of Andrea's artistic greatness, rather than reflecting a recorded or transmitted trait of Castagno's character, would seem to have followed the legend of his murder of Domenico Veneziano.[4]

The indebtedness to Domenico Veneziano of Castagno's works, from the S. Tarasio *St. John* (see catalogue no. 46) to the *sinopia* of the *Vision of St. Jerome* (see catalogue no. 25) and the landscape background of the SS. Annunziata *St. Julian* (see Hartt, 1969), would suggest a master-pupil relationship, rather than one of rivalry and antagonism as described by Vasari. Indeed, corroboration for this hypothesis, first broached by Kennedy (1938, pp. 14ff.), is offered by Vasari himself. Andrea's fresco at S. Egidio of the *Presentation of the Virgin in the Temple* contained, according to Vasari, an octagonal temple in the middle of a square,

and surrounding the square there is a variety of most handsome buildings, which the shadow of the temple strikes from one side, showing the effect of sunlight with great beauty, intricacy and skill.

From Vasari's description alone one might well deduce that he was referring to a work by Domenico Veneziano or Piero della Francesca. In view of the revision of Castagno's birth date to ca. 1417–19 (see Hartt and Corti, 1966; Hartt, 1969), it would have been entirely feasible for Domenico, who was probably in Florence as a master from 1432 to 1437, to have had Andrea as an apprentice. The teachers who have been proposed for Castagno include Paolo Uccello, Fra Filippo Lippi, Lorenzo di Bicci, and Paolo Schiavo (see Fortuna, 1957), while Hartt (1959) has suggested Giovanni dal Ponte. But with the works of none of these do Castagno's productions have as much in common as with Domenico Veneziano's.

A possible source for Vasari's allegation that Domenico brought oil painting to Florence could have been the entry in the Medici Inventory according to which an *Allegorical Figure* by Domenico Veneziano was "cholorita a olio" (see catalogue no. 84). But surely Vasari's main reason for crediting Domenico with the knowledge of oil painting was his wish thus to designate him as a representative of Venetian *colore,* as opposed to Castagno's mastery of Florentine *disegno,* and thereby to lend credibility to the story of the murder that had been transmitted to him. It was an ingenious invention, so *ben trovato* that even though it flies in the face of the evidence of Domenico's surviving works, scholars are still tempted to wonder whether there might not be some truth in it. But there is very little likelihood of this. The antithesis of *colore* and *disegno* as characteristics of Venetian and Florentine painting was first formulated in Paolo Pini's *Dialogo di pittura* of 1548 (Barocchi, 1960, p. 127). In the quattrocento Alberti used *colori* (see Galantic, 1969, pp. 149ff.) and Landino *disegno* (see Baxandall, 1972) in a purely technical, descriptive way. Vasari, however, saw Castagno in cinquecento terms, contrasting his mastery of *disegno* with his deficiency in *colore* on the grounds that his color lacked grace and charm—Vasari's crucial criteria of aesthetic merit. When Andrea was apprenticed in Florence, Vasari wrote, he

> showed very great intelligence in the difficulties of the art of painting, most of all in *disegno.* It was not quite the same with the coloring of his works, which was somewhat crude and harsh, and deprived them of much of their quality and grace, most of all of a certain charm, which was not to be found in his color.[5]

The first part of this characterization originated in Landino's Dante Commentary ("Andreino fu gran disegnatore et di gran relievo: amatore delle difficultà dell'arte et di scorci") and was repeated, except for the reference to foreshortening, in the *Libro di Antonio Billi* and the *Codex Magliabecchiano.* None of Vasari's sources, however, mentions Andrea's weakness as a colorist, a criticism Vasari apparently invented in order to play Castagno off against Domenico Veneziano. In another passage Vasari wrote that

> if nature had given him [Castagno] gentleness in coloring as she gave him invention and *disegno* and knowledge for expressing passion, he would truly have been considered both perfect and marvelous,

applying to the quattrocento the dictum of Paolo Pini that the master who would have "the *colore* of Titian added to the *disegno* of Michelangelo" would be "the God of painting."

THE *VITA* OF DOMENICO VENEZIANO

The thesis that Vasari associated the rivalry between Domenico Veneziano and Andrea del Castagno with the stylistic antinomy of *colore* and *disegno* finds support in two differences between the first and second editions of the *Vite*. In the first edition Vasari wrote that Domenico "excelled in perspective and was very meritorious in many things pertaining to the art of painting." He omitted this passage from the second edition, perhaps because there was a certain inconsistency in praising an artist whom he wished to portray as a master of *colore* for his prowess in perspective, a branch of *disegno*. The other point of difference between the two editions is that according to the first Andrea knew that he was "more excellent" than Domenico; according to the second, he knew that he was "more excellent in *disegno*."

II

The legendary and the real biographies of Domenico Veneziano—Vasari's and that based on the painter's works and documentation—have essentially different structures. Vasari's is a literary creation, based on what earlier sources transmitted to him, embellishing them in order to make the story they told more convincing, and composed according to thematic patterns characteristic of Vasari's epoch and of the *Vite* in general.[6] The shape of the real biography reflects the forces and trends of a century earlier than Vasari, prior to the formulation of the categories and theories by which Vasari interpreted the history of Italian art. Fragmentary as it is, Domenico's real biography provides us with an image of the artist in the context of his own time, rather than in the light of the attitudes and biases of a later age.

Though his early life is undocumented, there can be little doubt that Domenico was born in Venice and that he received his artistic education in Florence and Rome. Beginning with Cavalcaselle a number of scholars have formed the conviction that the origins of Domenico's art are to be found, not in Venice or northern Italy, but in central Italy (see note 28). Indeed, neither sources nor traces of Domenico's style are discernible in Venetian painting. Such similarities as his art has to Jacopo Bellini's are due to the fact both were pupils of Gentile da Fabriano and to the strong influence on Jacopo of Florentine quattrocento art (see Joost-Gaugier, 1974). Yet there is incontrovertible proof in the spelling of Domenico's letter to Piero de' Medici (document 1) that he learned to write and was thus surely born in Venice.[7] Only a Venetian would have written *Domenico da Vinesia* with an *s* in *Vinesia*. The text of the letter also contains twenty-five other examples of Venetian spelling, in which an *s* or a *c* have been replaced by a *z,* or a double consonant has been changed to a single one. There are, however, nine examples in the letter of the Florentine habit of prefixing vowels, especially the letter *o* with an *h,* suggesting that Domenico came to Florence at a sufficiently early age to have assimilated this custom of Florentine usage—a trait he adopted again in the first word of the invocation following the signature in the St. Lucy altarpiece: HO [instead of O] MATER DEI MISERERE MEI.[8]

Domenico apparently retained Venetian citizenship all his life. The majority of fifteenth- and sixteenth-century citations of his name refer to him as "Domenico da Vinegia";[9] the two records of his burial identify him as "Dominicho Vineziano" and "Domenicho Veniziano" (documents 8A and 8B); and the St. Lucy altarpiece and the Carnesecchi Tabernacle are signed OPUS DOMINICI DE VENETIIS (Pls. 68–69) and DOMI[NI]CUS D[E] VENECIIS P[INXIT] (Pls. 4–5). Both signatures conform to a practice of Italian painters of adding their nationalities to their names when working away from home. Benozzo Gozzoli added FLORENTINUS or DE

FLORENTIA to his signature in San Gimignano, Montefalco, and Perugia, but signed his frescoes in the Medici Palace in Florence with his name only. The fact that the form DE VENETIIS denotes Venetian nationality and not merely that Domenico "was of a Venetian family" (Cavalcaselle, 1911, p. 139) is proven by its occurrence in the signatures of other Venetian painters. Nicolò di Pietro, for example, signed his *Madonna* of 1394 in the Accademia in Venice NICHOLA FILIUS M[AEST]RI PETRI PICTORIS DE VENETIIS PINXIT HOC OPUS; and a lost panel of *St. Michael* painted by Jacopo Bellini in 1430 for the Paduan church of S. Michele Arcangelo had the inscription JACOPUS DE VENETIIS DISCEPULUS GENTILI FABRIANI PINXIT (Rigoni, 1929, p. 263).

Domenico Veneziano's status in Florence as a foreigner is attested by his designation in the S. Egidio, Parenti, and other documents as *maestro*,[10] a title usually not used for painters of Florentine nationality but commonly applied to non-Florentines, normally in the Latin form *magister:* to Stefano da Verona in 1425 and 1434 (see Degenhart, 1937); to Gentile da Fabriano in Brescia, Florence, Orvieto, and Rome (see Venturi, 1896); to Benedetto Bonfigli in the Cappella de' Priori contract (see document 4); and to Pisanello in the S. Giovanni in Laterano documents (see Venturi, 1896). The paradox of Domenico's Venetian origin and Florentine style can be accounted for by the capacity of Florentine art for redirecting the vision of artists from elsewhere, "by the power it had," as Offner (1927) put it, "of very nearly effacing the national characteristics in foreign artists" (p. 21).

The date of Domenico's birth is not known. His burial, however, is recorded in 1461. If Vasari is to be believed that he died at fifty-six, he would therefore have been born in 1405. In the majority of verifiable cases Vasari's birth dates are correct within five years (see Kallab, 1908, pp. 233ff.), and he probably overestimated Domenico's life span by at least that much. Domenico Veneziano appears to have received his earliest artistic training as an apprentice to Gentile da Fabriano in Florence in 1422–23,[11] and to have produced his first works as an independent master, of which only the Carnesecchi Tabernacle and the *Madonna* at I Tatti survive, in the period 1432–37. Since quattrocento artists generally seem to have begun their apprenticeship between the ages of ten and fifteen, the date of Domenico's birth is probably closer to 1410 than to 1405—not quite ten years later than Masaccio's (1401) and Fra Angelico's (ca. 1400–1402),[12] about half a decade after Fra Filippo Lippi's (ca. 1406), and roughly a decade before Piero della Francesca's (ca. 1420) and Andrea del Castagno's (ca. 1417–19).

The career of Gentile da Fabriano prior to his inscription in the Florentine Guild of *Medici e Speziali* in 1422 is far from certain (see Grassi, 1953; Micheletti, 1976). It has been argued by Carl Huter that Gentile was in Venice from before 1400 until he is documented in Brescia in 1414; that his Venetian works include the *Madonna with Saints and Donor* in Berlin (Pl. 29), the *Madonnas* in Perugia and the Metropolitan Museum of Art in New York, and the Valle Romita altarpiece; that he painted the *Stigmatization of St. Francis* at Crenna di Gallarete (Pl. 108) while he was in Fabriano in 1420; that his Florentine works of the mid-1420s comprise, besides the Strozzi and Quaratesi altarpieces, the *Madonnas* in Pisa, Washington, Yale (Pl. 30) and the Frick Collection in New York; and that the formative influences on his art were Milanese, Paduan, and French manuscript illuminations and Bohemian painting.[13] In 1423 Gentile signed the great *Adoration of the Magi* for the Strozzi Chapel in S. Trinita (Pl. 51), one of the works that made him known as the most illustrious painter in Italy of his time (see Degenhart and Schmitt, 1960). The altarpiece reveals how much Gentile transmitted to

Domenico Veneziano and how fundamental his teaching was for the formation of Domenico's art: in the realism and eloquence of its figures (Pl. 152); its naturalistic representation of animals; its experimentation with light, especially, as Hartt (1969) has pointed out, in the predella panel of the *Nativity;* the pictorial mobility of its description of the terrain and vegetation of landscape; and in its rendering of flowers and foliage in the strips of the frame (Pl. 35). But the link between Gentile and Domenico is evident not only in the works which Gentile produced in Florence. An unmistakable thread of kinship connects the heads of Gentile's *Madonna* in Berlin, probably painted ca. 1400 and generally considered his earliest surviving work (Pl. 28), and of Domenico Veneziano's *Madonna* at I Tatti (Pl. 27)—a connection so striking that one might well look upon the latter as a sequel in terms of Florentine possibilities in the mid-1430s to a type established in northern Italy, probably in Venice, over three decades earlier and transmitted to Domenico through the example and training of his master.

Domenico Veneziano was not the only major Florentine artist indebted to Gentile da Fabriano. The image of Gentile as the representative of an ornamental late medieval style which was superseded by the sober realism of Masaccio (see Dvorak, 1927; Antal, 1947) does justice neither to Gentile nor to Masaccio—nor, indeed, as has been recognized by Shell (1958) and as I shall endeavor to show in a study of Masaccio's older contemporary, Giovanni Toscani, to the currents in Florentine art during the decade of the 1420s. Gentile's art not only participated in the realistic and classicizing trends of Florentine painting and sculpture of the mid-1420s (see Longhi, 1940; Grassi, 1951; Krautheimer, 1956; Sterling, 1958; Hartt, 1969)—works like his *Madonna and Child* at Yale (Pl. 30) and in the cathedral of Orvieto suggest that he looked particularly closely at Florentine sculpture of the decades since 1400—but in certain respects seems also to have played an innovative role in their evolution. Whether or not Ghiberti designed the portal of the sacristy of S. Trinita, the site of Gentile's *Adoration* (see the recent study by Davisson, 1975), the floral borders in the North Doors of the Baptistry, as Krautheimer (1956) has observed, owe their naturalism at least in part to the flowers with which Gentile decorated his altarpiece's frame (Pl. 35). But Gentile may have been an even more important source for Masaccio. The cast shadows in the *Nativity* of the Strozzi Altar and *St. Francis Receiving the Stigmata* at Crenna di Gallarete (Pl. 108)—where the shadow of the friar measures both the direction and the intensity of the light emanating from the apparition of the Crucifix—show that Gentile, like Masaccio, thought of light as an active force (see Gilbert, 1966). In his conception of light Masaccio would thus seem to have been influenced not only by Roman painting and mosaic (see Offner, 1959) but also by the prior example of Gentile.

With the exception of commissions in Siena and Orvieto in the summer and fall of 1425, Gentile stayed in Florence until 1426. In that year he went to Rome to begin the fresco decoration of S. Giovanni in Laterano, one of the programs through which Martin V sought to restore to the Eternal City the eminence it had lost as a result of the residence of the popes in Avignon during most of the previous century (see Pastor, 1901, pp. 205ff. Golzio and Zander, 1968, pp. 201ff.; Holmes, 1969, pp. 68ff.). Gentile is documented at the Lateran from January to August 1427 (see Venturi, 1896). He died sometime before October 14 of that year and in his will left his painting materials to Pisanello (see Degenhart and Schmitt, 1960). Among his three great pupils—Pisanello, Jacopo Bellini, and Domenico Veneziano—the first was the one with whom Gentile had the closest and longest contact. Paccagnini (1973) has convincingly argued that Pisanello not only completed Gentile's lost frescoes in the Venetian Doge's Palace, proba-

bly by 1415, but also collaborated on them; that his earliest artistic training was not, as has always been supposed, under Stefano da Zevio in Verona, but under Gentile in Venice; and that between 1415 and 1422, before he is documented at Mantua, Pisanello was in Verona and painted the Stefanesque *Madonna della quaglia* now in the Museo del Castelvecchio. It is not implausible that after leaving Mantua in 1422 he joined Gentile in Florence and took part in the painting of the Strozzi altarpiece, whose style is even more fundamental for Pisanello, especially in its studies of animals (see Degenhart, 1945; Coletti, 1953; Scheller, 1963, p. 200), than it is for Domenico Veneziano. Although between 1424 and 1426 Pisanello was once more in Mantua and Verona, the fact that Gentile left him the tools of his atelier suggests that he was in Rome at the time of his master's death. As he had done at the Palazzo Ducale, Pisanello completed Gentile's murals at S. Giovanni in Laterano. Bartolomeo Fazio, who knew Pisanello, wrote that Gentile's paintings at the Lateran consisted of "a scene from the story of St. John" and that "he left certain things in his work only in outline and incomplete" (trans. Baxandall, 1971). Pisanello is documented at the Lateran from April 1431 until February 1432. But if Gentile did only one composition, and if at the time of his death part of it, as Fazio suggests, had not progressed beyond the *sinopia,* Pisanello must have been at the Lateran much longer than for the ten months certified by the documents. He probably took over the work upon Gentile's death in 1427 (see Hill, 1905). In July 1432 Pisanello obtained a passport to leave Rome and soon went to Verona. What remained of the materials left him by Gentile was sold by the Chapter of S. Giovanni in Laterano in May 1433 (see Degenhart and Schmitt, 1960, p. 71).

The close relationship between Gentile and Pisanello has recently been underlined by the attribution to Gentile of part of a series of drawings from the antique previously given to Pisanello or his atelier, drawings which originally were part of a sketchbook that seems to have been begun by Gentile and continued by Pisanello and his assistants (Pls. 96–97).[14] The assignment of these drawings to Gentile augments the progressive aspect of his art with a humanist dimension. What he transmitted to Pisanello and Domenico Veneziano, therefore, also included the habit of studying and copying Graeco-Roman sarcophagi. Domenico Veneziano probably remained with Gentile in Florence until 1426 and then accompanied him to Rome to continue his apprenticeship at the Lateran. Too young to be an independent master at Gentile's death in 1427, he most likely stayed on at the Lateran as an assistant to Pisanello. Indeed, the importance of Pisanello in the formation of Domenico's style is second only to that of Gentile. To Gentile, Domenico owed his artistic direction and outlook. In his careful description of observed reality, his fluid brushwork, and in the receptivity of his forms to light, however, Domenico was also indebted to Pisanello. So clear are the links between the two artists that the Berlin *Adoration of the Magi* has often been thought to be Pisanello's. It was from Pisanello that Domenico learned his distinctive way of drawing ears (Pls. 45 and 48). But the strongest evidence for the relationship between the two artists is the predela panel from the St. Lucy Altar depicting the *Young St. John the Baptist in the Desert* (Pl. 88), which, because of the episode in the legend of the Baptist that it represents (see p. 43), may more appropriately be referred to as the *Vocation of St. John the Baptist.*

Some years ago I identified a virtually effaced mural in the Baptistry at Castiglione d'Olona (Pls. 90–91) as a depiction of the same subject as the panel by Domenico Veneziano, and went so far as to suggest that Domenico had painted it (Wohl, 1958; Lavin, 1961; Shapley, 1966). I am now quite certain that the author of the fresco was Masolino—it is extremely unlikely that

Domenico Veneziano could have been in Lombardy in 1435, the date inscribed in the Baptistry—and that both Masolino's and Domenico's compositions derive independently of each other from a lost fresco by Pisanello at S. Giovanni in Laterano. Masolino and Masaccio both came to Rome from Florence in 1428. Masaccio died in that year or in 1429 (see the *catasto* document in Somaré, 1924), but Masolino remained in Rome until 1432. From the end of 1429 until early 1431 Masolino painted the murals in the chapel of the Cardinal Branda at S. Clemente (see Vayer, 1965; Genthon, 1965), and in 1432 he completed a fresco cycle of *uomini famosi* in the Palazzo Orsini, on which Paolo Uccello also worked in 1430 and 1431 (Scheller, 1963, p. 204; Vayer, 1965; Mode, 1972). Until Masaccio's death Masolino's style had been to a large extent shaped by the art of his younger compatriot. But then he began to change, and the first signs of this change are those passages in the murals at S. Clemente that are influenced by Pisanello: the foreshortened horses, the armor of the soldier seen from the back, the multi-storied hats of two of the riders seen from the back in the middle distance of the *Crucifixion* (Pl. 208), and the ivory landscape in the *Martyrdom of St. Catherine*.[15]

Masolino's debt to Pisanello is understandably even greater—in respect to figural motifs, costumes (especially headgear), and landscape—in his fresco cycle in the Baptistry at Castiglione d'Olona, whose subject, the *Life of St. John the Baptist,* was also that of the lost frescoes by Gentile and Pisanello at the Lateran. The background of Masolino's *The Vocation of St. John* (Pl. 90), with a swiftly descending mountain at the right and smaller ridges in the distance, repeats the landscape of his *Martyrdom of St. Catherine.* The same landscape appears with right and left reversed in Domenico Veneziano's predella panel, suggesting that both Domenico and Masolino had seen it in the Lateran frescoes. More specific links between Castiglione d'Olona and the Lateran murals can be made on the basis of two drawings from the atelier of Pisanello probably connected with the lost frescoes: a group of figures from a drawing of *The Baptism of Christ* in the Louvre is related to Masolino's *Baptism* in the delicate, swaying figure of Christ, the angels in profile holding curling towels, and in the motif of the neophyte—his posture in the drawing is copied from a figure on a Dionysus sarcophagus—pulling his shirt over his head;[16] and a drawing of the *Arrest of St. John the Baptist* in the British Museum has in common with Masolino's composition of this episode the seated figures and the armor of the soldiers.[17]

Although no drawings can be associated with a Lateran *Vocation of St. John,* there are reasons for presuming that it was one of the lost frescoes. The anonymous fourteenth-century *Vita di San Giovanni Battista* on which the scene is based (see Lavin, 1955 and 1961) is also the source for a rapid sketch by Pisanello of the youthful St. John in the wilderness surrounded by animals ("quelle bestiuole piccole, che stanno per il bosco, . . . venivano a lui, e stavansi con lui, come fanno a noi le domestiche").[18] Moreover, the only extant depictions prior to Masolino's mural at Castiglione d'Olona of the nude figure of the Baptist with the camel's skin sent him by God are frescoes in the cathedral of Pordenone (Pl. 92) and in the Baptistry at Treviso of the first half of the 1420s which reflect the Venetian style of Gentile da Fabriano and Pisanello (see Coletti, 1947 and 1953; Wohl, 1958, pp. 337f.; Lavin, 1961, p. 322, n. 5; Fossi-Todorow, 1966, p. 4, n. 1; Paccagnini, 1973). Indeed, the image of the youthful nude penitent in a rocky desert landscape may well have been established in the Veneto by Pisanello's early *St. Benedict on Mount Subiaco* in the Poldi-Pezzoli Museum in Milan (Pl. 93).[19] It is plausible to assume that Pisanello used it once more for the *Vocation of St. John* at the Lateran.

The derivation of the predella panel of the St. Lucy altarpiece from S. Giovanni in Laterano is the most concrete evidence we have for the presence of Domenico Veneziano in Rome as an

assistant of Gentile da Fabriano and Pisanello.[20] Further testimony is provided by the classically inspired nude in Domenico's predella panel and by his dependence in the Berlin *Adoration of the Magi* on Masolino's *Crucifixion* at S. Clemente. The source of the posture of Domenico's St. John is a figure of Hercules in combat with Diomedes, an example of which is on a sarcophagus in the Museo Torlonia in Rome mentioned by Albertini (1510a) and copied in both the *Codex Coburghensis* and the *Codex Pighianus* (Pl. 94).[21] The posture in reverse occurs in the figure of Orestes at the far right of a sarcophagus in the Museo Chiaramonti at the Vatican which during the Renaissance was installed in the wall of S. Giovanni in Laterano, (Pl. 95) and from which the Orestes in the center (*Codex Vallardi* 2397v; Fossi-Todorow, 1966, no. 195) as well as the sleeping Clytemnestra (Biblioteca Ambrosiana F 214, fol. 13r; Fossi-Todorow, 1966, no. 185) were copied in the Gentile-Pisanello sketchbook (Pls. 96–97).[22] We can be certain, therefore, that the Hercules-Orestes posture was known to the artists at S. Giovanni in Laterano, and that, like Gentile and Pisanello, Domenico Veneziano copied antique sarcophagi.[23]

It is natural that while Domenico was working at the Lateran he would have studied the work of the Florentine painters—Masaccio, Masolino, and Paolo Uccello—who were in Rome during those years. It has been argued that he collaborated with Masolino at S. Clemente,[24] and that he is the author of the panel of *Sts. Jerome and John the Baptist* in London from an altarpiece painted for the Roman church of S. Maria Maggiore by Masaccio and Masolino (Pl. 192; see catalogue no. 31). Though neither suggestion is convincing, Masolino's S. Clemente *Crucifixion* (Pl. 52) made a lasting impression on Domenico, for he adopted its plateau composition—an originally Eyckian scheme of locating the foreground figures on a plateau high above a distant landscape—in the Berlin *Adoration*, and probably also in his lost frescoes in Perugia (catalogue no. 88), through which the plateau composition was transmitted to the Umbrian painter Giovanni Boccati.[25]

The most influential of Jan van Eyck's plateau compositions seems to have been a lost *Crucifixion*, several reflections of which—a miniature by Hand H in the Milan Hours (ca. 1422–24), the *Crucifixion* in the Eyckian diptych in the Metropolitan Museum (ca. 1426–30), and a panel by a follower of Jan van Eyck in the Ca' d'Oro (Pl. 53)—were available before the early 1430s.[26] A version of the composition, most likely in the form of a manuscript illumination, must have been in Rome at the time Masolino was working on the *Crucifixion* at S. Clemente. Domenico Veneziano's acquaintance with Netherlandish painting and illumination, from which he derived greater profit than any other Italian painters of his time except his pupil Piero della Francesca, would therefore seem to date from the formative years of his career as an assistant of Pisanello in Rome.[27]

Although the view that Domenico was trained in central Italy rather than in the Veneto is not new and has recently been gaining support,[28] most scholars have assumed that he owed his artistic education to northern Italy.[29] This thesis has two major disadvantages, however. First, it is difficult to imagine where in northern Italy in the decade 1422–32, the years in which Domenico came of age as a painter, he could have acquired the artistic foundations—a Florentine grasp of design and form, a Netherlandish feeling for light, and a north Italian sensitivity for ornament and naturalistic rendering—that are evident in his works from the Carnesecchi Tabernacle on. Second, in that same decade Gentile da Fabriano and Pisanello, whom most scholars, irrespective of their positions on where Domenico received his artistic education, regard as his masters, were not in northern Italy (except for Pisanello's stay in Mantua from 1424 to 1426) but in Florence and Rome. It was only there that during his formative years

Domenico had available to him the essential prerequisites for the development of his art.

With the death of Martin V in 1431 and the departure from Rome of Masolino and Pisanello in 1432, the artistic revival that had begun with the pope's invitation to Gentile da Fabriano to decorate the walls of S. Giovanni in Laterano lost its momentum. Leon Battista Alberti came to the papal chancery in 1432 but went to Florence with Eugene IV in 1434. Donatello and Michelozzo worked on the tabernacle of the Sacrament for St. Peter's in 1432–33, and in 1433 Brunelleschi seems to have been in Rome to study the remains of ancient architecture. But Rome was not an artistic center in these years and did not become one again until the ascension to the papacy of Nicholas V in 1447. Like Masolino and Pisanello, Domenico Veneziano probably left the Eternal City in 1432. Unlike them, however, he would seem to have returned to Florence; and it was in the city of Brunelleschi, Donatello, Ghiberti, Luca della Robbia and Masaccio—artists of "genius for every laudable enterprise in no way inferior to any of the ancients who gained fame in these arts"—that Domenico, then in his early twenties, began his career as an independent master.[30]

III

The decade since Domenico's arrival in Florence as an apprentice of Gentile da Fabriano had seen the application in Masaccio's *Trinity* (Pl. 9), and in the frescoes of the Brancacci Chapel of Brunelleschi's reinvention of linear perspective (see Edgerton, 1975). The *operai* of the Baptistry had installed Ghiberti's first set of Bronze Doors. Donatello had made the tomb effigy of Baldassare Cossa, and the bronze relief of *The Feast of Herod* for the Baptismal Font in Siena; at Or San Michele his marble *St. George* had been joined by the bronze *St. Louis of Toulouse* in his Renaissance niche; and the *Zuccone* had been installed on the campanile of S. Maria del Fiore. A team of painters, including Paolo Uccello, recently returned from Venice and Rome, had begun a mural cycle of scenes from Genesis on the east wall of the *chiostro verde* at S. Maria Novella. With the exception of Masaccio, however, the advanced art of the decade 1422–32 was dominated by sculpture; and even though the 1430s saw the ascent of Fra Angelico, Fra Filippo Lippi, Paolo Uccello, and Domenico himself, this situation continued until Donatello's departure for Padua in 1443. In 1432, the year of Domenico's return to Florence, Donatello was completing the tabernacle of the *Annunciation* in the Cavalcanti Chapel in S. Croce, beside which some twenty years later Domenico was to paint the mural of *Sts. John the Baptist and Francis* (Pl. 150); the *operai* of the Duomo had awarded Ghiberti the commission for the shrine of St. Zenobius, whose principal composition was to serve as the inspiration for one of the predella panels of the St. Lucy Altar (Pls. 115 and 110), and Ghiberti had agreed to supply the frame for a tabernacle with paintings by Fra Angelico commissioned by the guild of linen makers (Pls. 18–19);[31] Luca della Robbia began work on his marble *cantoria;* the young Fra Filippo Lippi painted the fresco of the *Reform of the Carmelite Rule* at the Carmine;[32] and the Florentine orator in Venice was asked by the *operai* of S. Maria del Fiore to inquire about the reputation and fees of Paolo Uccello, who had done a figure in mosaic on the façade of St. Mark's.

By 1437, when Domenico left Florence for Perugia, the balance had started to shift toward painting. Donatello was completing the stucco reliefs in the *sagrestia vecchia* of S. Lorenzo (Pl. 50), and was working on his pendant to Luca's *cantoria* for the sacristy of the Duomo; the reliefs for Ghiberti's Gates of Paradise had been modeled and cast; Alberti had published *De pictura,* in Latin and in Italian; Fra Filippo Lippi had been in Padua and perhaps in Flanders

(Ames-Lewis, 1977), and in 1437 delivered to Cardinal Vitelleschi the *Madonna and Child* which the cardinal took to Corneto Tarquinia (Pl. 76); Paolo Uccello had painted the mural of *Sir John Hawkwood;* the Portuguese painter Giovanni di Gonçalvo and his atelier were at work on the fresco cycle in the *chiostro degli aranci* at the Badia; and Fra Angelico and his shop were producing a series of glowing altarpieces for churches in Florence, Fiesole, Cortona, and Perugia. In addition, a steady volume of religious painting in which the advanced art of the period was beginning to be reflected was issuing from the workshops of minor masters such as Francesco d'Antonio, Andrea di Giusto, Bicci di Lorenzo, and Giovanni dal Ponte.[33]

Domenico Veneziano's apprenticeship in Florence and Rome during the decade 1422–32 had provided him with the most varied and advanced training available to a young artist of his time: the tutelage of Gentile da Fabriano and Pisanello; the experience of working from Graeco-Roman sculpture; exposure to the works of Masaccio, Masolino, and Paolo Uccello, and to Netherlandish painting; and the lessons of the sculpture of Donatello and Ghiberti, which were to be continuing and ever more deeply assimilated influences on his art. If one were to try to predict Domenico's style in the years after 1432 on the basis of his training, one might expect a manner somewhere between his own *Adoration of the Magi*—Fiocco (1927 and 1941), Pudelko (1934), and Hartt (1959) have in fact argued that the tondo is Domenico's first extant work— and Paolo Uccello's Genesis frescoes in the *chiostro verde.* Yet Domenico did not paint the *Adoration* until a decade later, and as far as we know he did nothing that resembles Uccello's murals in more than certain traits common to the progressive, realistic art of the time. As decisive in determining Domenico's earliest style as what he absorbed during his formation as an artist were the taste and stylistic norms of painting that he found on his return to Florence, his ability to adapt his own vision and what had been transmitted to him to these norms and to the commissions he received, and his capacity for redefining the aims of painting in his time in terms that were his.

The dominant influence on the mode of Florentine painting in the years 1432–37 was the art of Fra Angelico, with its roots in the late Giottesque tradition of the trecento, and its judicious revision of this tradition through Fra Angelico's ability to profit from the achievements of Masaccio and Ghiberti (see Longhi, 1940; Argan, 1955; Middeldorf, 1955; Shell, 1958). Most representative of this mode—of setting the tone of what was expected and valued by patrons and audiences alike—were the minor masters, who produced the majority of commissions for the city, its environs, and its neighboring towns. Their importance in the process of Florentine art after Masaccio was first demonstrated to the extent it deserves by Shell (1958 and 1965),[34] who detected in their works of the mid-1430s a number of common denominators: linear construction of form; harmony of pattern; what he called "problemless" space—the conflict-less integration of flat pattern with the illusion of depth and relief; balanced articulation and symmetrical disposition of the picture plane; emphasis on the confining role of the frame; dark color; a renewed interest in the decorative, courtly style of Gentile da Fabriano; and the minor masters' "first encounter with the rising star of Fra Angelico." It is this stylistic milieu that provides the context for Domenico's *Carnesecchi Madonna* (Pl. 1), designed on a monumental scale and with plunging perspective so as to make it three-dimensionally effective when seen from a distance, and the exquisite *Madonna* at I Tatti (Pl. 24). The order in which they were painted is difficult to determine, especially in view of the damaged state of the fragments of the Carnesecchi Tabernacle (see catalogue no. 1). I have formed the conviction that the Carnesecchi Tabernacle, which according to Vasari was Domenico's first work in Florence and was "greatly praised by the citizens and craftsmen of the time," and which is less finely wrought in

design than the Berenson *Madonna,* is the earlier of the two. Be that as it may, I feel certain that Domenico painted both works between his return to Florence in 1432 and his departure for Perugia in 1437.

Vasari, who believed that Domenico had come from Venice to Florence as an established master, tells us that before his arrival in Florence he had been in Perugia to paint ''a room for the Baglioni,'' which was later destroyed. The Baglioni Palace was in fact razed in 1540 in order to make room for the fortification known as the Rocca Paolina, and no traces of Domenico's frescoes in the palace have survived (see catalogue no. 88). Begun in 1437, they were probably finished by April 1, 1438, when Domenico wrote to Piero de' Medici in Ferrara in search of employment (document 1). The letter (Frontispiece) says:

I have heard, that Cosimo has decided to have an altarpiece painted and that he wants a magnificent work, a thing which pleases me very much, and would please me even more were it possible through your mediation that I should paint it.

Domenico addressed himself to Piero rather than to Cosimo himself because in matters of artistic patronage it was Piero and his brother Giovanni who usually dealt with painters and sculptors. The fact that Domenico realized this, and the familiar tone in which he addressed Piero, show that he was no stranger to the Medici:

Time and time again I have inquired about you without learning anything, but then I asked Manni Donato, who told me that you were in Ferrara and in the best of health.

Domenico went on to say that he had been greatly comforted to have had news of Piero and that he would have written sooner, for the sake of his own ''consolation and obligation,'' had he known where Piero was.

Piero de' Medici had probably gone to Ferrara in order to attend the church council convened by Eugene IV, whose official opening session was held in the church of S. Giorgio on January 8, 1438. It is possible, therefore, that Domenico had been trying to get in touch with Piero for as long as three months; that he may have completed or been close to completing the Baglioni frescoes by the end of 1437 (the bitter Perugian winter would in any case have prevented him from working in fresco later than December); and that Cosimo, as part of his modernization of the convent and church of S. Marco, had already by that time—two years before the interior of the church was restored—decided to replace the polyptych over its high altar by Lorenzo di Niccolò with a new altarpiece. The commission for this work, however, was to go not to Domenico but to Fra Angelico (Pl. 81), whose gift for combining the piety and shining color of late medieval painting with the innovations of Masaccio and Ghiberti made him a logical choice for the ''magnificent work'' on the high altar of the most important of Cosimo's religious foundations.[35]

In composing his letter Domenico, as the Wittkowers (1963) put it, ''took his cue from the morals of a commercial clientele and left no stone unturned to beat his colleagues at the competitive game'' (p. 34). He acknowledged that Fra Angelico and Fra Filippo were ''good masters'' but stressed the fact that they had a great deal of work, especially Fra Filippo, with a ''panel destined for S. Spirito which is so large a project that working day and night he will not finish it in five years.'' Whatever this might imply about Fra Filippo's—or his own—pace of

work, Domenico's estimate of the time it would take Fra Filippo to complete the S. Spirito "panel"—the Barbadori altarpiece, now divided between the Louvre and the Uffizi—could suggest that he was familiar with the patron's requirements for the painting, possibly because he had sought the commission for himself. In any event, his knowledge of the altarpiece presumes that he did not leave Florence until after the contract for it was awarded to Fra Filippo by the Captains of Or San Michele on March 8, 1437 (the document is published in Mendelsohn, 1909, pp. 226ff.). But if, as Kennedy (1938, n. 27) has proposed, Domenico was asked to decorate the "room for the Baglioni" on the occasion of the wedding of Braccio Baglioni in April 1437 (see de Baglion, 1909, pp. 59f.), he very likely left soon thereafter. Domenico did not mention the altarpiece commissioned from Fra Angelico in 1437 by the Perugian church of S. Domenico, although he surely must have known of it.[36] The fact that he did not refer to it strengthens my suspicion that he had a personal interest in the commission of the Barbadori altarpiece.

Domenico's arguments to Piero de' Medici why the altarpiece for Cosimo should be painted by him imply that although he seems to have known Piero in Florence he had not yet worked for the Medici. If given the commission, he wrote, he hoped to show Piero "marvelous things," and declared that

the great and good will that I have to serve you makes me so bold as to offer that if I were to do less well than anyone else, I wish to be subject to every deserved correction, and to undergo whatever trial may be required, honoring everyone concerned.

Were the altarpiece to be so large as to be given to several masters, he would still entreat Piero to use whatever influence he could so that he might at least receive some small part ("qualche particela"). Toward the end of the letter Domenico once more pressed his request:

If you only knew the desire I have to execute some famous work, and especially for you, you would be favorable to me in this matter.

It seems unlikely that Domenico would have written to Piero in this vein if he had already had a commission from him; and on the basis of this evidence alone we may safely conclude that the Berlin *Adoration of the Magi,* which is almost certainly a Medici picture, was probably not painted until after Domenico returned from Perugia to Florence.

Among Domenico's surviving works the only one that appears to have been done in Perugia is the *Madonna* in Bucharest (Pl. 31). In design and color it clearly belongs to the 1430s. But its departures from the style of the Carnesecchi Tabernacle and the Berenson *Madonna*—in the action and three-dimensional thrust of the figures, the strong dependence on Masaccio, the recollection in the striding Christ of the sprinting *putti* of Donatello's marble *cantoria,* and in the adjustment of the figural block to the spatially complex forms of the floral hedge rather than to a brocade or inlaid marble pattern—suggest a different, later stylistic context. The floral hedge is a motif of the northern Italian International Style, and its appearance in the earlier quattrocento invariably documents that style's influence on artistic taste. The arched pattern of roses on the gilt background of Domenico di Bartolo's *Madonna and Child* of 1437 in the Johnson Collection, for example, reflects his indebtedness to Pisanello, an obligation which he also incurred, no doubt encouraged by the example of Domenico Veneziano, in the altarpiece

he painted for the Perugian church of S. Giuliana in 1438.[37] Following Gentile da Fabriano's *Madonna and Child* at Yale (Pl. 30), the floral hedge is virtually absent from painting in Florence until the middle of the century, and after that it is found mainly in the backgrounds of half-length Madonnas inspired in large measure by the Kress *Madonna* of Domenico Veneziano. Among the few parallels in mid-fifteenth-century Florence to Domenico's full-length Virgin seated before a rose hedge at Bucharest are a *Madonna* in the Accademia in Florence (Salmi et al., 1955, Pl. CXIII) and a *sacra conversazione* in the museum at Chartres (*De Giotto à Bellini*, Pl. XXXIX), both given by Longhi (in Suida, 1955) to a follower of Fra Angelico whom he called the Master of the Buckingham Madonna, and Luca della Robbia's beautiful *Madonna of the Rose Garden* in the Bargello. But in Umbrian painting, which at the time when Domenico arrived in Perugia was a blend of trecento Florentine and Sienese influences emanating from S. Francesco at Assisi, a habitual dependence on Sienese painting, and an International Style tradition originating in northern Italy which Umbria shared with the Romagna, the Marche, and the Abbruzzi (see Bombe, 1917; Gnoli, 1923; Van Marle, VIII; Gamba, 1949), the Madonna in front of a rose hedge was a standard motif.

The Umbrian origin of the Bucharest *Madonna* is further borne out by the fact that among all of Domenico's extant works it is the only one which left no mark on the development of painting in Florence. In Perugia—aside from its influence on the formation of a realistic style of Umbrian painting—Domenico di Bartolo took from it the motif of the Madonna's outstretched arm (Pl. 34) for his S. Giuliano altarpiece of 1438 (Pl. 36), and Giovanni Boccati owes to it the three-dimensionally conceived floral hedge in the background of his *Madonna del pergolato* of 1446–47. As the first major Florentine master of his time actually to work in Umbria—Fra Angelico's altarpiece of 1437 for S. Domenico was produced in Florence—Domenico entered on a new phase of his art, one in which he infused the repertory of the International Style with the principles and potentialities of quattrocento Florentine realism. Not constrained by the norms of Florentine taste, Domenico showed even more forcefully than in the Carnesecchi Tabernacle and the Berenson *Madonna* his capacity for investing traditional themes with new life.

The earliest surviving work of this phase of his art is the *Madonna* in Bucharest; the latest, which even though it was painted after Domenico's return to Florence still reflects the character of his lost murals in the Baglioni Palace, is the *Adoration of the Magi* in Berlin (Pl. 38). In view of the analogies—the plateau composition, the panoramic landscape, the chivalric trappings, the pictorial touch and the brilliance of light and color—between the Berlin tondo and a number of small panels painted by Giovanni Boccati after he arrived in Perugia from Camerino in 1445 and studied Domenico's frescoes (see n. 25), as well as on the basis of the relationships in costumes, poses and the grouping of figures in space between the tondo and the frescoes of 1440–44 in the Pellegrinaio of the Spedale della Scala in Siena by Domenico di Bartolo, Priamo della Quercia and Vecchietta (Pl. 56), begun two years after the first two of these painters had been in Perugia to paint the S. Giuliana polyptych (see Meiss, 1964), it may be presumed that what Domenico's *Adoration* has in common with the compositions by Boccati and in the Pellegrinaio, it also shared with his own Baglioni murals. These, incidentally, and not Domenico's lost frescoes at S. Egidio in Florence, as has been argued by Pudelko (1934), Pope-Hennessy (1939 and 1975a), and Meiss (1964), were probably the inspiration for the design and the system of spatial projection of the painted architecture in the frescoes at the Spedale della Scala.[38]

Considering the influence of the Baglioni frescoes, it seems unlikely that they depicted a series of *uomini illustri*, as was proposed by Milanesi (in Vasari-Milanesi, II, p. 674, n. 1) but was rightly contested by Bombe (1909). For this reason alone the recent attribution by Santi (1970) of a damaged figure of a *Man in Armor* from the Baglioni Palace is unpersuasive (see catalogue no. 88). Much more plausible is Kennedy's (1938, n. 27) suggestion that the room Domenico painted for the Baglioni was a *camera degli sposi,* which it might well have been if it had been commissioned for the wedding of Braccio Baglioni. The pictures of such a cycle would have been secular and chivalric, resembling the taste Warburg called *antico alla francese,* staged in both landscape and architectural settings, and consistent with the impact of Domenico's frescoes on the works I have already cited as well as on Umbrian painting in general, notably the works of Bonfigli and Caporali.[39]

IV

A little more than a year after Domenico wrote to Piero de' Medici—on May 11, 1439—he was at work in the choir of S. Egidio (document 2A). His first fresco was by then well under way, and he must have begun the decoration of the choir at least several months earlier. The church of S. Egidio, founded in the late thirteenth century, is the chapel of the hospital of S. Maria Nuova, and until 1450 it was also the chapel of the Florentine Company of St. Luke. Its founders and patrons were the Portinari, and according to Vasari they commissioned Domenico Veneziano's frescoes. It is perhaps not fortuitous that the decision to decorate the choir of S. Egidio coincided with the move from Ferrara to Florence of the church council attended by Emperor Palaeologus. Eugene IV proposed the move on January 6, 1439, and arrived in Florence on January 25. The Byzantine emperor entered the city early in February, and the first full session of the council was held on March 2 (see Gill, 1959, pp. 178ff.). A slip in Albertini's description of the S. Egidio frescoes (source 6A) just may point to a connection between the council and the inception of the fresco cycle. The church of S. Egidio was rebuilt between 1418 and 1420 by Bicci di Lorenzo and was consecrated in 1420 by Martin V. Albertini, however, wrote that it was "consecrated by Pope Eugene IV in the year that the council at which the most devout Greek emperor was present was held in Florence." The only noteworthy development at S. Egidio in the late winter or early spring of 1439 was the beginning of the fresco cycle in its choir. The Portinari were closely connected with the Medici and were their agents in many parts of Europe. With Cosimo's reconstruction and redecoration of S. Marco in full swing, the Portinari may well have felt that the advent of the church council was a fit occasion for a pious foundation in the form of the mural decoration of the still empty walls of the choir of their newly rebuilt chapel at S. Maria Nuova.

The theme of the frescoes on the lateral walls of the choir was the *Life of the Virgin.* The scenes assigned to Domenico—the *Meeting at the Golden Gate,* the *Birth of the Virgin,* and the *Marriage of the Virgin*—were on the west wall, behind the altar on the left, next to the late medieval cloister of the women's hospital of S. Maria Nuova, known as the *chiostro delle ossa.*[40] Between 1451 and 1453 Andrea del Castagno painted the *Annunciation,* the *Presentation of the Virgin in the Temple,* and the *Death of the Virgin* on the east wall; and in 1460 Alesso Baldovinetti added a scene (or scenes) on the north wall. Payments to Domenico Veneziano of a total of just over 116 florins for two frescoes completed and one begun are recorded from 1439 to 1445 (document 2). Domenico's fees for his two completed frescoes—44

florins for the *Meeting at the Golden Gate* in the lunette zone and 60 florins for the *Birth of the Virgin* in the central zone—show that he must have been held in very high esteem. In 1451, by comparison, Andrea del Castagno agreed to paint his three murals on the east wall of the S. Egidio choir for but 100 florins (see Fortuna, 1957), and in 1462 Alesso Baldovinetti received only 20 florins for his *Nativity* in the forecourt of the SS. Annunziata (see Kennedy, 1938).

The *Meeting at the Golden Gate* was carried out between early spring and September 1439. Though it was substantially finished by the fourth week of August, a final sum of two florins and three lire was consigned three weeks later to Piero della Francesca, who in the entry recording the payment is identified as Domenico's assistant.[41] Zampetti (1969, I, p. 47) has made the intriguing and in my view extremely plausible suggestion that Piero was first apprenticed to Domenico in Perugia and then accompanied him to Florence. By the time Domenico began the *Birth of the Virgin* in the spring of 1441 Piero was probably back in Borgo San Sepolcro, since in the following year he was enrolled as a member of its town council. One would like to believe that Piero was still in Domenico's atelier when his master painted the *Adoration of the Magi* (Pl. 38), for it was Piero who derived the greatest profit from the lessons that it had to offer: its geometric layout (Fig. 9), measured construction of masses and volumes, pictorially loose distant landscape, and clear, atmospheric light.

The tondo was probably commissioned by Piero de' Medici—at the end of the fifteenth century it was in the Medici Collection—and fully lives up to Domenico's promise in his letter to Piero that he would show him "marvelous things."[42] The most brilliant of Domenico's surviving paintings, it shows him bringing into play all the resources that had become available to him and that he had himself developed since his apprenticeship to Gentile da Fabriano. The picture is an astonishing synthesis of northern Italian, Florentine, and Netherlandish achievements in the formulation of early quattrocento realism. In its discernment of the potentialities of the quattrocento style for integrating a figural composition with a deep landscape, the tondo remains unsurpassed until the last quarter of the century. Because it presupposes renewed contact between Domenico and Pisanello, who was in Florence in 1439 (see Fasanelli, 1965), and because two of the hats at the rear of the cortege (Pl. 39) were inspired by the headgear of the Byzantine delegation at the Council of Florence (see Hatfield, 1966, I, n. 27), it is unlikely that the *Adoration* was begun before the end of that year. It was probably painted during the roughly eighteen-month interval from September 1439 to the spring of 1441 between the first two murals at S. Egidio. And it is not impossible that the tondo and the S. Egidio *Meeting at the Golden Gate* had similar landscape backgrounds.

The encounter of Joachim and St. Anne is not a frequent subject in quattrocento Florence. Yet within less than a decade of Domenico's mural—the first large-scale depiction of the episode in terms of fifteenth-century realism—Fra Filippo Lippi represented it again in a predella panel in the Ashmolean Museum in Oxford (see Lloyd, 1977). Lippi's panel is reminiscent in its landscape setting of both the Berlin tondo (the animals and the landscape at the right) and the landscape panels from the predella of the St. Lucy Altar (the mountains at the left), and also has something of Domenico's pictorial touch (Pl. 57). We know from the color of Fra Filippo's *Annunciation* in the Metropolitan Museum of Art and the pictorial looseness of his *Miraculous Rescue of St. Placidius* in Washington (see Shapley, 1966; Zeri, 1971), products, like the *Meeting,* of the mid-1440s, that he was at this time susceptible to the influence of Domenico Veneziano. The extent to which the Ashmolean panel reflects Domenico's *Meeting at the Golden Gate* is of course conjectural. The formation, placement, and posing of its figures

are so typically in the canon of Fra Filippo that it is difficult to imagine them as not wholly his invention. But if its background was inspired by that in Domenico's monumental composition of the same subject, the lost mural would have contained essentially the same kind of landscape as we admire in the Berlin tondo and as made such an impression on Giovanni Boccati in Domenico's lost frescoes in the Baglioni Palace in Perugia.

The *Birth of the Virgin,* the second of Domenico's frescoes at S. Egidio, begun in the spring of 1441 and completed by the end of May of the following year, was staged, according to Vasari, in "a most sumptuous room [una camera molto ornata]" and was enlivened by a figure of a *putto* striking the door of the room with a hammer. Meiss (1964) has detected a derivation of this figure in one of the mid-fifteenth-century illustrations, which he attributed to Priamo della Quercia, of the Yates-Thompson Dante manuscript; but no one has so far succeeded in reconstructing larger sections of the lost mural. Our most reliable clue for visualizing the ladies attending St. Anne may be provided by the elegantly attired figures in the main group of the Berlin tondo; and as in the case of the landscape background of the *Meeting at the Golden Gate,* similar figures may have graced Domenico's frescoes at Perugia.

Indeed, there are other grounds as well for supposing that the fresco cycles in the Baglioni Palace and at S. Egidio may have been alike, not only in these two particulars, but also in general character. If, as may have been the case, the occasion for the pictorial embellishment of the choir of S. Egidio was the Council of Florence, the chapel's patrons may well have wanted mural decorations appropriate to that gathering's theatrical glitter and ceremony. The Berlin tondo as well as pictures by Boccati and others influenced by Domenico's frescoes in Perugia suggest that at the Baglioni Palace Domenico had produced the kind of brilliant courtly display as the Portinari may have had in mind for their chapel at S. Maria Nuova. Perhaps the reason the award of the S. Egidio commission went to Domenico Veneziano rather than to Paolo Uccello, Fra Filippo Lippi, or one of the minor masters—it is unlikely that Fra Angelico would have been available because all his efforts were at that time concentrated on work at S. Marco—was that at Perugia Domenico had demonstrated a gift for decorative splendor on a grand scale of which none of his contemporaries had yet given proof, and which as far as we know was not equaled in Florence until Benozzo Gozzoli painted the chapel of the Medici Palace some two decades later (see Hatfield, 1970).

No payments to Domenico Veneziano are recorded at S. Egidio between May 1442 and the beginning of June 1445. All we know of him during these years is that in 1444 he obtained a loan from Marco Parenti, for whom he later designed and decorated two wedding chests. Then on June 1, 1445, Domenico received a final payment at S. Egidio, an advance of 10 florins for his third fresco, which was to depict the *Marriage of the Virgin* and for which he did the *sinopia* (Pl. 58). He did not, however, carry the mural beyond that stage, for at his death in 1461 he still had not done the work for which he had received the advance of 10 florins in 1445; and about a month before he died—after the composition had remained as he had left it for sixteen years—Alesso Baldovinetti made an agreement with the governor of the hospital to paint it (document 7). A careful reading of the agreement leaves no doubt that the mural described by Vasari—with its portraits of Bernardetto de' Medici, Bernardo Guadagni, Folco Portinari, and others; its lively figure of a dwarf breaking a staff; and its fashionably dressed ladies ("alcune femine con habiti in dosso vaghi, e graziosi fuor di modo, secondo, che si usavano in que' tempi")—was entirely the work of Baldovinetti. Proposals by Gioseffi (1962) and Meiss (1964) that the S. Egidio *Marriage of the Virgin* influenced figural, spatial, and architectural schemes

in the frescoes of 1440–44 at the Spedale della Scala in Siena, as well as other suggestions of reflections of the *Marriage* in works before the mid-1460s, can consequently not be sustained.

The sketch of the torso of the Virgin in the *sinopia* (Pl. 58) is the only surviving example of Domenico's drawing style—elegant, economical, and assured.[43] Enough of the *sinopia* is left so as to provide clues to the perspective system as well as to the architectural and figural scheme that Domenico had in mind. Among the ruled lines surrounding the Virgin's torso, four belong to a bifocal perspective system like that in the *sinopia* of Paolo Uccello's *Nativity* from S. Martino della Scala (Fig. 11 and Pl. 87). The indications of a series of steps at the right of Domenico's *sinopia* suggests that he may have envisioned a setting and possibly also an arrangement of figures not unlike the design of the *Marriage of the Virgin* from the predella of Fra Angelico's *Coronation of the Virgin* in the Uffizi (Pl. 59), which was installed on the choir screen of S. Egidio at the time Domenico drew his *sinopia*. The painted remains of draperies and ground at the bottom of the fresco, found at the same time as the *sinopia,* are too skimpy and damaged to allow us to visualize the figures to which they belonged. Other remnants of the fifteenth-century fresco decoration of the choir include strips of draperies, feet and ground on the east and north walls, and bits of decorated borders in the vault (Pls. 161–168).

V

On September 11, 1447, two years and three months after Domenico had abandoned his wall at S. Egidio, he received the first payment for a pair of lost *cassoni* which he designed and decorated for the Florentine patrician Marco Parenti (document 3). The interval between the two commissions was probably taken up with the execution of the St. Lucy Altar (Pl. 60), and perhaps by a second collaboration with Piero della Francesca. The altarpiece shows major stylistic changes since Domenico painted the *Adoration of the Magi* half a decade earlier, most conspicuously a shift in palette from the rich, dark colors and glittering ornamentation of Gentile, Pisanello, and the northern Italian International Style, to the brighter colors of Florentine late Gothic painting (see Cowardin, 1963) and an interest in the interaction of color and light first explored in what Meiss (1967) has called the "new color" of Burgundian illumination. As the taste of Florentine painting of the mid- and later 1430s, partly in the wake of the color of Masaccio, was dominated by deep colors and by contrasts of tone, often based on the counterpoint of blue and red, so that of a decade later—the period of Fra Angelico's Annalena Altar (see Pope-Hennessy, 1974), Fra Filippo's Munich *Annunciation* and Castagno's Passion scenes in the upper register at S. Apollonia—favored harmonies of light tonalities and subtle chromatic patterns, more along the lines of Alberti's color preferences in *De pictura*. In his earlier works, from the Carnesecchi Tabernacle to the *Adoration of the Magi,* Domenico was a master of the first mode. In the St. Lucy altarpiece, the Kress *Madonna* (Pl. 132) and the *Sts. John the Baptist and Francis* at S. Croce (Pl. 138)—examples of what Antal (1925) called the Gothic Quattrocento Style—he was a virtuoso of the second. Within the wide range of conceptual and stylistic differences between Domenico's earlier and later production, the change in color is the most apparent and provides the surest criterion for the chronological structure of his oeuvre.

In the summer of 1447, with the St. Lucy Altar completed, Domenico may have worked a second time with Piero della Francesca. The two artists, according to Vasari's 1568 *Vita* of

Piero (source 11B), began the fresco decoration of the vault of S. Maria at Loreto, but left it unfinished because they were afraid of the plague. The plague struck in the Marches between 1447 and 1452, and if Vasari is to be believed, Domenico and Piero would presumably have been working at Loreto in the first of these years. The collaboration of the two masters at this time, when Piero had probably finished the polyptych with the *Madonna della Misericordia* for his native city, would have the great advantage of providing an explanation for Domenico's influence on Piero beyond what he would have transmitted to him at S. Egidio in 1439, when he had not yet developed the luminous palette of his later works. Domenico's production from the Carnesecchi Tabernacle to the Berlin tondo was fundamental to Piero's vision in the Misericordia altarpiece, begun in 1445. But only an encounter with Domenico after the mid-1440s can account for the affinity in light and color between Piero's works of the 1450s and 1460s and the St. Lucy Altar.

The two *cassoni* for which Domenico began receiving payments in September 1447 were commissioned by Marco Parenti for his wedding on January 13, 1448, to Caterina Strozzi. In the Parenti Palace on the Via del Cocomero the two chests, "gilded and painted by Domenico Veneziano," were in Caterina's bedroom, flanking "a large tabernacle carved in the classical manner [*all'antica*] by Giuliano da Maiano and painted by the brother of Masaccio,[44] which contains a Virgin in relief colored by Stefano di Francesco Magnolini" (Strozzi, 1877, p. 21). The marriage between Marco Parenti and Caterina Strozzi had been negotiated by Caterina's mother Alessandra Macinghi negli Strozzi in an attempt to stabilize the declining fortunes of the Strozzi family, whose power and wealth had fallen sharply since the beginning of the fifteenth century, and some of whose male members—those of the family of Palla di Nofrio Strozzi—had been exiled after the Medici assumed control over the Florentine government in 1434. The Parenti were silk manufacturers, and like other families in the silk business were on their way up (see Brucker, 1969, pp. 85ff.). Marco Parenti's grandfather had been an artisan. But Marco listed among his assets in 1458 a town house on the Via del Cocomero, three estates (*poderi*) in the Mugello with an annual income of more than 700 florins, and investments in the *monte*, the Florentine public debt, of nearly 9,000 florins.[45] Among his humanist acquaintances were Alamanno Rinuccini and Leon Battista Alberti, and he was at one time Alberti's business agent. He played an active part in Florentine political life, although he held no important political offices.[46]

Marco and Caterina were betrothed and her dowry of 1,000 florins was ratified on August 13, 1447 (see Strozzi, 1877, pp. 3ff.). The *cassoni* which Marco ordered for the wedding—they were usually supplied by the family of the bride, but Alessandra Strozzi was evidently too poor to do so—were begun four weeks later and were completed on June 20, 1448, five months after Domenico had originally agreed to deliver them. Domenico's budget for the design, construction, furnishing, and painted decoration of the *cassoni* was 50 florins.[47] About 16½ florins of this went to various craftsmen. The roughly 33½ florins that Domenico kept for himself compares favorably with fees for tempera painting at the time. Fra Filippo Lippi received 40 florins for the Barbadori altarpiece, and in 1449 Andrea del Castagno agreed to paint the *Assumption of the Virgin* for the church of S. Miniato fra le Torri for as little as 104 lire, at that time the equivalent of 25 florins (see Fortuna, 1957; Lerner-Lehmkühl, 1936). Seven of the eighteen payments listed in the Parenti account were delivered to Domenico's assistant Antonio di Giovanni.

Two of the payments to Domenico listed in the Parenti account were for the settlement of debts. Some time between July 2 and 19, 1448, his budget was charged approximately 3⅓ florins for the repayment of a loan which he had had from Marco Parenti in five installments beginning in 1444 ("i quali gli prestai più tempo fa in V partite inchominciati insino nel 1444, per più suoi bisogni"). We therefore know that in 1444, a year in which Domenico is not otherwise documented, he was in Florence, and that Marco Parenti seems already at that time to have been his patron.

Domenico's other debt was to his landlord Baldassare di Falcho, whom he owed roughly 2½ florins for six months' back rent. In *catasto* declarations of 1451 and 1457–58 Baldassare unfortunately did not mention Domenico Veneziano as his tenant.[48] But in his declaration of 1451 he listed among his assets two houses, one in the Via de' Pilastri in the S. Ambrogio parish with an annual rent of 12 florins, and another with a workshop under it on the Ponte Rubaconte (the present Ponte alle Grazie) with an annual rent of 7 florins.[49] At the time of the 1457–58 *catasto* Baldassare declared that he himself was living in the house on the Ponte Rubaconte, and that he was getting 7 florins in rent for the workshop under it alone.[50] If rents had risen by as much as these figures suggest between 1451 and 1457, the house on the Ponte Rubaconte together with its workshop may have rented for even less than 7 florins in 1448. In that year Domenico was paying Baldassare an annual rent of approximately 5 florins—about what the house on the Ponte Rubaconte may then have been worth. It is not impossible, consequently, that Domenico lived there, at least from December 1447 to June 1448.

After the last entry in the Parenti account on July 19, 1448, the documents of the time are silent about Domenico Veneziano for nearly six and one-half years. During this period, however, he seems to have produced the last two of his surviving works, the elegiac *Madonna* in the Kress Collection and the fresco of *Sts. John the Baptist and Francis* for the Cavalcanti Chapel in S. Croce. In their pale colors, shallow space, compression of volume, and mobility of line they show the development of Domenico's style beyond the St. Lucy Altar. The *Madonna* (Pl. 132), probably painted at the very end of the 1440s, is compositionally related to reliefs of the middle of the century by Desiderio da Settignano (Pl. 137), and set a fashion in Florence during the following two decades in its posing of the Virgin and Child and its floral background. The figures in the Cavalcanti fresco (Pl. 138) are sequels to the Baptist and St. Francis in the St. Lucy Altar (Pl. 60), but show clearly the evolution of Domenico's style toward an ever greater reliance on the descriptive and expressive potentialities of contours. Compositionally the Baptist has analogies to the figure of *Eve* from Castagno's murals in the Villa Pandolfini at Legnaia (Pl. 157), as well as to the central figure in the *sinopia* for Andrea's *Vision of St. Jerome* at the SS. Annunziata (Pl. 159), probably drawn before Donatello's return in 1453 from Padua and Venice, while Castagno was working on the wall opposite Domenico's at S. Egidio. The gaunt figure of St. Jerome in the SS. Annunziata fresco (Pl. 158) is surely inspired by the late sculptures of Donatello. The saint in the *sinopia*, however, does not yet show this contact, but would rather seem to look to the Cavalcanti Baptist by Domenico Veneziano. Domenico's mural can therefore be placed with some confidence between the Villa Pandolfini frescoes, executed between 1448 and 1450 (Fortuna, 1957; Berti, 1966; Hartt, 1969), and the SS. Annunziata *sinopia*. The Cavalcanti fresco was also a source of inspiration for other Florentine artists of the 1450s and 1460s, and the rhythmically charged contours of its figures point the way to the linear styles of Antonio Pollaiuolo, Verrocchio, and Botticelli (see Offner, 1927; White, 1967).

THE *VITA* OF DOMENICO VENEZIANO

On December 2, 1454, after Domenico had completed the fresco for the Cavalcanti, his name appeared in a contract between the chaplains of the Palazzo de' Priori in Perugia and the painter Benedetto Bonfigli for decorating with murals half of their chapel, the Cappella de' Priori (document 4). The contract named Fra Angelico, Fra Filippo Lippi, and Domenico Veneziano as alternate judges for estimating the frescoes upon their completion.[51] It is the second of three occasions at intervals of about two decades—the first being Domenico's letter to Piero de' Medici and the third the dedication by Alamanno Rinuccini in 1473 of his translation of Philostratus' *Life of Apollonius* (source 3)—on which the three artists were singled out as the most eminent Florentine painters of their time. Indeed, it is to Fra Angelico and Fra Filippo among painters, rather than to Paolo Uccello and Andrea del Castagno, as Salmi implied in the scheme of his books of 1936 and 1938, that the evolution of Domenico Veneziano's style is most closely related. Perugia possessed works by all three: altarpieces in S. Domenico by Fra Angelico and Fra Filippo (see note 36), and the frescoes in the Baglioni Palace and probably the *Madonna* now in Bucharest by Domenico. The influence and example of the three great Florentines were the principal foundation of the Umbrian school of realistic painting in the third quarter of the fifteenth century. It was natural, therefore, that the *priori* of Perugia should have wished the murals in their chapel—the largest contract for wall painting they had ever awarded—judged by one of these masters.[52] Bonfigli finished his work in the late summer of 1461, when neither Fra Angelico nor Domenico Veneziano was still living. It was consequently Fra Filippo Lippi who on September 4, 1461, went to Perugia to evaluate what Bonfigli had done.[53]

Domenico's residence in Florence is not documented from July 19, 1448, the date of the last entry in the Parenti account, until May 14, 1455, when he is recorded as renting a house in the S. Paolo parish of the S. Maria Novella quarter (document 5). The church of S. Paolo, known today as S. Paolino, faces the Piazza S. Paolino to the south of S. Maria Novella. Domenico's lease stipulated a year's rent of 6 florins payable semiannually, and a fine of 100 florins should the terms of the lease—care of the property and its restitution in good condition after a year's time—fail to be observed. Domenico was apparently already living in the S. Paolo parish at the time the lease was drawn up, since it refers to him as "pictore populi Sancti Pauli de Florentia." It may have been at this time that Domenico worked for Giovanni Rucellai, who not long before had commissioned Leon Battista Alberti to renovate the façade of S. Maria Novella, and whose new palace on the Via della Vigna Nuova was also in the S. Maria Novella quarter. Sometime between 1460 and 1470 Giovanni listed in his *Zibaldone*—a journal of recollections set down "per dare notitia et amaestramento a Pandolfo et a Bernardo miei figliuoli di più chose" (Perosa, 1960, p. 2)—the names of eleven masters whose works—sculptures, paintings, *intarsie,* marble inlays, and mosaics—were to be seen in the Rucellai Palace (source 1). At the head of the list is Domenico Veneziano. The other painters included in it are Fra Filippo Lippi, Andrea del Castagno, Paolo Uccello, and Antonio Pollaiuolo.[54] The importance of the entry beyond what it tells us about Giovanni Rucellai as a collector is that it certifies that he too—in addition to Piero de' Medici, Marco Parenti, the Portinari, and the Cavalcanti—was Domenico's patron.

More than two and one-half years after the date of the Bonfigli contract, in the summer of 1457, Domenico was named in an account book of the Company of the Trinity in Pistoia, which had employed Francesco Pesellino to paint the altarpiece of the *Trinity* now in the National Gallery in London. Pesellino died on July 29, 1457. Several weeks earlier, when it may have

[23]

become clear that he would not live to finish the work, the company's treasurer had evidently asked Domenico Veneziano and Fra Filippo Lippi to evaluate it. Accordingly, on July 10 a payment of 15 soldi was entered in one of the company's ledgers for the fee of the notary who had registered the two painters' estimate, and for the transport of the altarpiece from a joiner's (document 6; see Davies, 1961). The year 1457 also saw the death of Domenico's alleged assassin, Andrea del Castagno. Domenico himself did not die until four years later. His burial in the church of S. Piero Gattolino, near the Porta Romana in the S. Spirito quarter, was recorded in the death books of the *Medici e Speziali* guild and of the Florentine *grascia* office, the agency in charge of regulating prices and the activities of artisans, on May 15, 1461 (document 8). The deaths of all painters were as a matter of routine entered in the death books of both organizations, and the fact that they listed Domenico's burial does not necessarily mean that he belonged to either. He does, however, seem to have been a member of the Florentine Company of St. Luke (document 9), which until 1450 used as its chapel the church of S. Egidio.

From a marginal note next to Domenico's advance of 1445 at S. Egidio we know that he died bankrupt ("non lasciò nulla"). The fact that we have no surviving works from the last decade of his life may indicate that his activity as a painter fell off during this period; and this would explain why he died destitute. On the other hand, it is unlikely that the Pistoian Company of the Trinity would have called on him to evaluate Pesellino's *Trinity* if he had ceased to function in his profession. As perplexing as the absence of paintings from Domenico's last decade is why he did not complete the *Marriage of the Virgin* at S. Egidio and why the mural remained as he had left it in 1445 until the time of his death. Whether or not, four weeks before the date of Domenico's burial, the governor of the hospital of S. Maria Nuova asked Baldovinetti to finish the fresco "by way of a sort of filial piety" to his master, as Kennedy (1938) suggested (Baldovinetti donated his services for finishing it to the hospital "for the love of God"), it may be presumed that Domenico, who still owed the hospital the work for which he had received the advance of 10 florins on June 1, 1445, wanted to clear both his accounts and his conscience, and that he saw to it that before he should die an arrangement was made for painting the composition he had abandoned sixteen years earlier.

Evidence of Domenico's continued productivity during the last decade of his life is perhaps provided by the attribution to him of two paintings in the Medici Inventory (source 5): a *Portrait of a Lady,* which may have been the prototype for the profile protraits in the Gardner and Bache Collections (see catalogue nos. 51 and 60), and is unlikely to have been painted before the fashion of this type of stylized, elegant portrait, reflected on a small scale in Pesellino's *cassoni* of the *Story of David,* the *cassone* of the *Adimari Wedding,* and the *Judgment of Solomon* at Richmond (catalogue no. 71), caught on in the 1450s; and an *Allegorical Figure,* described as a canvas painted in oil with a tabernacle containing a simulated statue of a half-nude figure holding a skull, which could hardly have been painted until shortly before Domenico's death (see catalogue no. 84).

The data of Domenico Veneziano's artistic biography can be summarized as follows (documented dates are marked with an asterisk):

ca. 1410 Born in Venice.
ca. 1422–26 Apprenticed to Gentile da Fabriano in Florence.
ca. 1426–32 In Rome with Gentile and Pisanello at S. Giovanni in Laterano.

ca. 1432–37	In Florence. Paints Carnesecchi Tabernacle and Berenson *Madonna*.
1437–38*	In Perugia. Paints frescoes in Baglioni Palace and Bucharest *Madonna*.
1439*	Paints the *Meeting at the Golden Gate* at S. Egidio.
ca. 1439–41	Paints the *Adoration of the Magi* for Piero de' Medici.
1441–42*	Paints the *Birth of the Virgin* at S. Egidio.
1444*	In Florence.
1445*	Makes *sinopia* for the *Marriage of the Virgin* at S. Egidio.
ca. 1445–47	Paints St. Lucy altarpiece.
ca. 1447	Begins frescoes in sacristy of S. Maria at Loreto with Piero della Francesca.
1447–48*	Designs and decorates two *cassoni* for Marco Parenti. Lives in house on Ponte Alle Grazie (?).
ca. 1449–50	Paints Kress *Madonna*.
ca. 1450–53	Paints *Sts. John the Baptist and Francis* in Cavalcanti Chapel at S. Croce.
1454*	Named to evaluate frescoes by Benedetto Bonfigli in Perugia.
1455*	Lives in S. Paolo parish of S. Maria Novella quarter. Makes painting for Giovanni Rucellai (?).
ca. 1453–61	Paints *Portrait of a Lady* and *Allegorical Figure* listed in Medici Inventory.
1457*	In Pistoia to evaluate Pesellino's *Trinity*.
1461*	Arranges for Baldovinetti to paint the *Marriage of the Virgin* at S. Egidio. Dies destitute. Is buried at S. Piero Gattolino.

NOTES

1. Jacopo Bellini and Domenico Veneziano must have known each other when they were both apprentices of Gentile da Fabriano in Florence in the mid-1420s (see Kennedy, 1938; Paccagnini, 1952; Gioseffi, 1962). But Vasari was better informed about Jacopo's training than he was about Domenico's. In the second edition of the *Vite* he inserted into his account of the rivalry between the two that Jacopo had been a pupil of Gentile da Fabriano.

2. Gombrich (1966) has translated Rinuccini's epithet for Domenico "artificiosius"—as "more cunning" (p. 2). I believe that "more accomplished" is perhaps closer to what Rinuccini had in mind, as it would seem to be the sense in which "artificiosus" was used by Cicero ("rhetores elegantissimi atque artificiosissimi") in his *De inventione rhetorica* (I, 35), which was probably Rinuccini's source for the term. Moreover, it was surely in the sense of "accomplished" or "skilled" that Landino, in his Dante Commentary of 1481 (see Morisani, 1953; Baxandall, 1972), applied "artificioso" to Fra Filippo Lippi ("gratioso et ornato et artificioso") and to Paolo Uccello ("artificioso negli scorci").

3. Landucci's recollections of the year 1458 are extremely imprecise. At that time, he wrote, were begun S. Lorenzo (begun four decades earlier), S. Spirito and the lantern of the Duomo (begun about fifteen years before), the Medici Palace (finished or nearly completed by 1457), and the Badia Fiesolana (in fact begun in 1456).

4. Milanesi (Vasari-Milanesi, II) sought to explain Vasari's account of the murder as a case of mistaken identity, born "of the altered tradition concerning an event which actually happened at the time of the two artists," namely the murder in November 1448 of a Florentine painter called Domenico di Matteo by an assassin who, Milanesi supposed, might have been called Andrea. The names Domenico and Andrea, he suggested, were later transferred to Domenico Veneziano and Andrea del Castagno. But this thesis is highly improbable. Equally implausible are two recent proposals that Castagno may actually have been a murderer. According to Fortuna (1958), the Andrea who killed the painter Domenico di Matteo may in fact have been Andrea del Castagno, and the figure of St.

Julian in Castagno's mural in the SS. Annunziata may be the tortured artist's "confessional" self-portrait. An autobiographical significance has also been imputed to the fresco of *St. Julian* by von Einem (1962), who has argued that Andrea may have been guilty of a murder that was hushed up at the time he committed it but to which he "confessed" in this painting.

5. For a discussion of Vasari's use of the term *disegno,* see Alpers (1960). The importance of Vasari's theory of art of grace and charm is emphasized in Blunt (1940).

6. The legendary biography was repeated by Borghini (source 12), Baldinucci (III, p. 95) and Lanzi (1789, p. 65). During the eighteenth century Domenico Veneziano—like the masters of the quattrocento in general—was such a remote figure that Richa (VIII, pp. 202f.) was capable of attributing to him the Portinari altarpiece by Hugo van der Goes, which was then installed in the choir of S. Egidio.

7. Domenico's Venetian origin has been doubted by Cavalcaselle (1911, pp. 138f.), Berti (in Salmi et al., 1954), Sindona (1960), and Wundram (1970, p. 135). On the other hand, Kennedy (1938) rightly observed in support of her belief that Domenico came from Venice that "even his speech retained a Venetian flavor" (p. 4).

8. The orthographic relationship between Domenico's letter and the inscription on the St. Lucy Altar was pointed out to me by Dario Covi.

9. Documents 2, 3, 4, 6, 7; sources 1, 2, 5, 7, 8, 9, 10, 11, 12.

10. Documents 2, 3, 4, 6, 7; sources 1, 5, 7, 8, 10, 11C.

11. The dependence of Domenico on Gentile was first recognized by Kennedy (1938).

12. Although Orlandi (1954) has in the eyes of most scholars shown conclusively that Fra Angelico was born in the first years of the quattrocento, Centi (1963–64) has defended his birth date of 1387 given in the first edition of Vasari. Much is to be said for Gilbert's view (1965) that Fra Angelico's birth date should not be advanced beyond 1400.

13. Professor Huter will present his case for this reconstruction of Gentile's career in his forthcoming monograph on the artist. In the meantime, see Huter (1970).

14. The sketchbook reconstructed by Degenhart and Schmitt (1960 and 1969, II, pp. 639ff.) has also been assembled by Bean (1960, pp. 185ff.). The Degenhart-Schmitt case for the authorship of its drawings has been summarized and endorsed by Scheller, (1963, pp. 171ff.), who has made useful distinctions between the approaches of Gentile and Pisanello to their antique models. The traditional attribution of the drawings in the putative sketchbook to the atelier of Pisanello has been defended by Fossi-Todorow (1962 and 1966, pp. 47f.) and Keller (1967, pp. 68ff.).

15. The landscape scheme of the S. Clemente *Martyrdom of St. Catherine* originated in northern Italy toward the end of the fourteenth century (see the *Beheading of St. George* in the Oratory of St. George at Padua). Multistoried soft hats are a common International Style motif which apparently originated in Burgundian portraiture and manuscript illumination of the late fourteenth and early fifteenth centuries. The earliest appearance of these hats in central Italy is in Gentile da Fabriano's Strozzi altarpiece and, by way of Gentile and Pisanello, in the S. Clemente *Crucifixion.* Later they were used with greatest effectiveness in the medals of Pisanello and in the Berlin *Adoration of the Magi* and the *Martyrdom of St. Lucy* by Domenico Veneziano. In the second half of the quattrocento they became a standard motif of Florentine *cassone* painters, especially in the shop of Apollonio di Giovanni (see chap. II, n. 46).

16. Louvre 420r; see Fossi-Todorow (1966, no. 191). The antique derivation of the figure of the neophyte was discovered by Degenhart and Schmitt (1960), who believe that the drawing is a copy by Pisanello of a lost fresco by Gentile da Fabriano.

17. Fossi-Todorow (1966, no. 179). According to Longhi (1940), the only reflection of Gentile's Lateran frescoes is a drawing in the Albertina with the *Imprisonment of a Saint* on one side and two studies of rams on the other (Stix and Fröhlich-Blum, 1932, no. 6, pl. 2). It is extremely unlikely, however, that this drawing has any connection either with Gentile or with the lost composition (see Fossi-Todorow, 1966, no. 207, and Dell'Acqua and Chiarelli, 1972, where all the drawings that have been associated with Gentile's and Pisanello's Lateran murals are conveniently assembled). As further testimony of the activity of Gentile de Fabriano and Pisanello at S. Giovanni in Laterano, Gollob (1927 and 1965) has cited the seventeenth-century drawings of episodes from the lives of Job and

Tobias in *Codex Barb. lat.* 4408 in the Biblioteca Vaticana, which she believes may be copies of murals that the two artists did at the Lateran hospital. But neither the documentation of the putative frescoes nor the visual evidence of the seventeenth-century drawings makes a convincing case (see Wätzold, 1964, pp. 142f.).

18. *Codex Vallardi* 2594v (see Fossi-Todorow, 1966, no. 66; and Keller, 1967, p. 67). The derivation of the subject of the drawing from the anonymous fourteenth-century life corrects Kaftal's observation (cited in Fossi-Todorow, 1966, p. 85) that "non si conosce . . . l'iconografia del Santo circondato da tanti animali."

19. See Russoli (1955). For the most searching and persuasive discussion of the attribution of this much-debated picture, including a summary of earlier views, see Paccagnini (1973). Paccagnini concludes that together with three other scenes from the life of St. Benedict in the storerooms of the Uffizi the panel was painted by Pisanello between 1415 and 1422, but at a time during these years when he was still working in the style of Gentile da Fabriano and had not yet been influenced by Stefano da Verona.

20. Parts of the Lateran frescoes were apparently not visible for very long. According to Bartolomeo Fazio's *De viris illustribus,* composed between 1453 and 1457, Pisanello told Fazio that after he had completed the fresco cycle it was "almost obliterated by the moisture in the wall" (trans. Baxandall, 1971).

21. See Robert (1890ff., III, no. 126C); Matz (1871, no. 196); Jahn (1868, no. 201). The sarcophagus was almost certainly known to artists working in Rome in the early fifteenth century, for it was at that time in the Palazzo Savelli, which also contained lost paintings by Masolino.

22. See Jahn (1868, no. 204); Degenhart and Schmitt (1960, p. 96). The version of this sarcophagus in the *Codex Pighianus* comes from the Palazzo Giustiniani and so is now in Weimar.

23. Domenico's Giovannino has previously been related to studies in the Gentile-Pisanello sketchbook by Degenhart (1959).

24. See Kennedy (1938, pp. 4ff.), Brandi (1957), Gioseffi (1962), Battisti (1971, I, p. 461, n. 36), and Paccagnini (1973, p. 152).

25. See Meiss (1956 and 1961) and Zeri (1961, pp. 54ff.), who believe that the pictures in which Boccati used the plateau composition—the three predella panels of his *Madonna del pergolato* of 1446–47 (Pl. 55) and small compositions of the *Crucifixion* in Esztergom and in the Ca d'Oro and the Cini Collection in Venice—depend from Domenico's Berlin tondo.

26. See Panofsky (1953), Wohl (1958), Meiss (1961), and Zeri (1961). For the dates of the Milan Hours and the Metropolitan Museum diptych, see Sterling (1971).

27. Scholars who have emphasized Domenico's affinities with Flemish painting (Longhi, 1925 and 1952; Pudelko, 1934; Meiss, 1956 and 1962; Zeri, 1961) have tended to assume that he studied Netherlandish pictures in the Veneto (see especially Meiss, 1961). But there is no evidence of the influence of Flemish painting in the Veneto until the Mantegnesque *Crucifixion* in the Accademia in Venice in which Panofsky (1953) saw a reflection, by way of Mantegna's own similarly staged *Crucifixion* in the predella of the S. Zeno altarpiece, of a *Crucifixion* by Jan van Eyck. This relationship led Meiss (1956) to the conclusion that "an early copy of Jan's *Crucifixion,* or the original itself, was in Padua or Venice by about 1455." For the presence of paintings by Jan van Eyck in Italy, see Weiss (1956 and 1957). Sterling (1976) has recently proposed that Jan van Eyck may have been in Italy during the voyage he was sent on by Philip the Good in 1426, and has argued that he was influenced by Masaccio and Gentile da Fabriano. Such influences as Sterling cites could just as well have come from Burgundian sculpture and northern International Style painting. He therefore does not seem to me to make a convincing case for Jan van Eyck's presence in Florence in 1426.

28. In his pioneering pages on Domenico Veneziano, Cavalcaselle (1864, pp. 315ff.) wrote that "even now, with the materials at hand, one may assume that Domenico learned design and painting in Tuscany," a view which before me has been shared only by Gronau (1913), Kennedy, Paccagnini, and Gioseffi. According to Kennedy (1938), Domenico came to Florence about 1425 as an apprentice to Gentile da Fabriano, and about 1428 went to Rome as an assistant to Masolino at S. Clemente. Paccagnini (1951 and 1973, p. 152) believes that Domenico's teachers were Gentile and Pisanello, that he first came to Florence in 1422, that he then assisted Masolino at S. Clemente, and

that this explains why his career moved in a different direction from Pisanello's after 1432. Domenico's arrival in Florence is also placed in 1422 by Gioseffi (1962), who has further argued that in Florence Domenico was associated not only with Gentile but also with Masaccio—to the extent of working on the lost *sagra* at the Carmine and on the Pisa altarpiece—and Masolino; that he went to Rome in 1427, and in 1431–32 was an advisor to Masolino at S. Clemente; and that in 1432 he painted the panel of *Sts. Jerome and John the Baptist* in London (catalogue 31).

29. According to Fiocco (1927), Domenico was taught by Pisanello and influenced by Uccello in Venice, and then followed Uccello to Florence in 1432 or 1433. Pudelko (1934) has argued that Domenico arrived in Florence from northern Italy in the mid-1430s and that before going to Perugia in 1438 he went to Siena, where he came under the influence of Domenico di Bartolo. Salmi (1936 and 1938) has placed Domenico's arrival in Florence from Venice in the early 1430s and believes that in Venice he was influenced by the color of Venetian Gothic painting and by Masolino, while in Florence the major influence on him was that of Uccello. Longhi (1952) saw Domenico as coming to Florence about 1430, after having absorbed in Venice the lessons of the International Style and of Flemish painting. The most ambitious attempt to reconstruct Domenico's career in northern Italy has been Coletti's (1953a). Coletti argued that Domenico worked in Venice until 1437, first as a pupil of Pisanello and then under the influence of Fra Filippo Lippi, and that either his hand or his direct influence can be seen in a number of works in and near Venice (see catalogue nos. 15, 16, and 45). Carli (1954) also believes that Domenico remained in Venice until he worked in Perugia, but that on his way to Umbria he stopped in Prato, where, according to Carli, Uccello was completing the frescoes in the Cappella dell' Assunta (catalogue no. 43). Semenzato (1954) has attributed to an alleged early, northern Italian phase of Domenico's career a small panel of *Christ in the Tomb* now in the Museo di Castelvecchio at Verona (catalogue no. 48).

30. The translation of this and all subsequent passages from Alberti's *De pictura,* as well as from his *De statua,* are Grayson's (in Alberti, 1972). Among those who believe that Domenico spent his formative years in Rome, Kennedy (1938) and Gioseffi (1963) have placed his return to Florence in 1432. Brandi (1957) believes that he did not get back until after the accord of May 1433 ending the Lucchese war.

31. Fra Angelico's paintings for the Linaiuoli altarpiece are usually dated 1433. He received the commission on July 11, 1433 (Orlandi, 1964). On November 25, 1435, provisions were made for payments for the colors and gold used in painting the decoration "intorno al tabernacolo;" and payments for the installation of the panels and for painting the exterior wings were not made until August 6, 1436 (see Glasser, 1965). This suggests that the angels on the inside of the frame were painted by the fall of 1435 and that all the other paintings could have been done anytime between the summer of 1433 and the summer of 1436; though the last were probably the full-length standing figures on the two sides of the wings.

32. In spite of recent arguments to the contrary, I continue to find the documentary and visual evidence for Fra Filippo's authorship of this work convincing (see catalogue no. 26).

33. In spite of many studies on individual major and minor Florentine masters, there is, with the exception of Antal (1947), none that deals with the artistic milieu of early quattrocento Florence as a whole. For the fluctuation in the rate of sculptural commissions awarded in Florence in the first half of the fifteenth century, see Gilbert (1959).

34. For earlier attempts to assess the significance of the production of the minor masters in the context of the evolution of Florentine painting, see Offner (1927 and 1933), Pudelko (1953a and 1938), and Longhi (1940).

35. For the commission, execution, and installation of Fra Angelico's S. Marco altarpiece, see Pope-Hennessy (1952 and 1974) and Orlandi (1964). Salmi (1954) has argued unpersuasively that the commission to which Domenico referred in his letter to Piero de' Medici was the altarpiece for the Medici Chapel in the novitiate of S. Croce, now in the Uffizi, begun by Fra Filippo Lippi probably not until 1440 and, it would seem, not finished until after 1445, when Cosimo dedicated a bell in the chapel for which is was painted (see Moisé, 1845, p. 162).

36. Orlandi (1964) has convincingly stated the case for acceptance of the date 1437 assigned to this altarpiece by Padre Timoteo Bottonio, the late-sixteenth-century chronicler of the Perugian convent

of S. Domenico, and against the later date proposed by Middeldorf (1955). Bottonio also attributed to Fra Angelico the painting on the high altar of the church. Orlandi has argued that in this case, however, Bottonio was in error, and has identified the work in question with a lost altarpiece by Fra Filippo Lippi recorded in S. Domenico by Vasari, as well as with the commission that Fra Filippo is documented as having executed for Antonio del Branca in 1451.

37. Brandi (1949) has argued that the S. Giuliana altarpiece was painted not in Perugia but in Siena. Because it was decided in 1438 that Domenico di Bartolo should continue to decorate the sacristy of the cathedral of Siena, where he had already been employed, with two frescoes of scenes from the lives of Sts. Crescentius and Savinus (see Milanesi, 1877, II, p. 167), Brandi has assumed that in that year Domenico di Bartolo must have been in Siena. But the two murals commissioned in 1438 were completed only by March 10, 1440. Domenico di Bartolo probably left the employ of the cathedral in 1436, after he had been paid on October 25 for scenes from the lives of Sts. Ansanus and Victorinus, and was rehired sometime after the deliberations of 1438. The St. Savinus mural was completed on September 7, 1439, and the St. Crescentius scene was finished by the spring of 1440. Since the second mural took only six months, there is no reason why the first should have taken any longer, and why Domenico di Bartolo should have begun it before the spring of 1439. For the presence of Domenico di Bartolo in Perugia in 1438, see also Zeri (1961) and Meiss (1964).

38. Pudelko (1934), Pope-Hennessy (1939 and 1975a), and Meiss (1964) have argued that the Pellegrinaio frescoes show the influence of Domenico Veneziano's lost murals at S. Egidio. To this it may be objected, however, that when the Pellegrinaio cycle (consisting entirely of architectural compositions) was commissioned in 1440 the only fresco at S. Egidio that had been completed was the *Meeting at the Golden Gate,* which almost certainly had not an architectural but a landscape background (see p. 19); that the second S. Egidio mural, the *Birth of the Virgin,* the architecture of which (the interior of the bedchamber of St. Anne) would have been in no way comparable to the complex architectural settings of the Pellegrinaio frescoes, was not finished until the end of May 1442, when the latter were well under way; and that Domenico Veneziano did not begin even the *sinopia* of the S. Egidio *Marriage of the Virgin* until the year after the Sienese hospital cycle was finished.

39. For Domenico's importance for the development of painting in Umbria, see Cavalcaselle (1911), Schmarsow (1912), Colasanti (1904), Venturi (1911), Kennedy (1938), and Zeri (1961).

40. For a discussion of the evidence for this and other matters in regard to the S. Egidio frescoes, see catalogue no. 86.

41. Although Domenico must have had more than one assistant at S. Egidio, Piero is the only one mentioned in the documents. Kennedy (1938) suggested that Andrea del Castagno's "first employment as a painter was under Domenico Veneziano at S. Egidio." But in view of the recent revision of the date of Castagno's birth (see Hartt, 1969; Hartt and Corti, 1966) Andrea would have been at least twenty when Domenico began to work at S. Egidio. Indeed, he was at the time probably painting a mural of his own—his early *Crucifixion*—for the hospital of S. Maria Nuova.

42. Pope-Hennessy suggested at one time (1951) that in reply to Domenico's letter Piero de' Medici commissioned him to complete Fra Angelico's *Coronation of the Virgin* for S. Domenico at Fiesole, and that Domenico painted the seven panels of its predella as well as the floor and the foreground figures of the main panel. In the second edition of his monograph on Fra Angelico (1974) Pope-Hennessy has withdrawn his attribution of parts of the *Coronation* to Domenico and has assigned the work a date after 1450 (see catalogue no. 39).

43. For the problem of Domenico as a draftsman, see p. xxv.

44. Bellosi (in *Mostra d'arte sacra della diocesi di San Miniato,* 1969) discovered that Masaccio's brother, Giovanni di Ser Giovanni, known as Scheggia (or Scheggione), is the painter designated by Berenson (1930) as Francesco d'Antonio Banchi, and referred to as the Master of Fucecchio or the Master of the Adimari *cassone* by Longhi (1927 and 1940) and Pudelko (1934).

45. See Florence, Archivio di Stato, *Catasto,* 825 (S. Giovanni, Drago, 1457–58), cc. 492r–494r.

46. For a profile of Marco Parenti, see Martines (1963, p. 346). In the *scrutinio* of June 21, 1455 Marco was disqualified from being a candidate for the *signoria* from the S. Giovanni quarter (see Rubinstein, 1966, p. 45, n. 1).

47. Fifty florins was not an extravagant price for a pair of wedding chests. The dowry which Constanza Guicciardini brought to Francesco de' Medici in 1433 included two *cassoni* valued at 62 florins (see Watson, 1969, p. 20).

48. Florence was divided administratively into quarters (*quartieri*), districts (*gonfaloni*), and parishes (*populi*). *Catasto* declarations were filed according to quarter and district. However, in legal documents such as leases the customary demographic unit was the parish (see document 5).

49. See Florence, Archivio di Stato, *Catasto*, 717 (S. Giovanni, Chiavi, 1451), cc. 533–34. The declaration is dated August 14, 1451, and lists the following holdings in real estate:

> Una chasa in sul ponte Rubachonte in sula
> pila delo Scharpione, chon una boteghata
> sotto; one l'anno di pigione fiorini sete l'anno per anno.

> Una chasa chon orto, posta nel popolo di
> Santo Ambruogio di Firenze, nella Via de'
> Pilastri, chon dua avilari, la quale era per
> mio abitare, ogi l'o apigionato e sto a pigione . . . Rendemi in tuto . . . f. 12.

For comparable rents, see Wackernagel (1938).

50. See Florence, Archivio di Stato, *Catasto,* 829 (S. Giovanni, Chiavi, 1457–58), cc. 111–12. Baldassare gave his age as eighty, and listed the following real estate assets:

> Una chase chon una bottega posta 'n sul
> ponte Rubachonte 'n su la pila delo
> Scharpione, la quale e per mio uso; per
> fiorini 7 l'anno la bottegha . . . f. 100.

> E più ò di pigione e d'avilare da Checho
> di Jacopo, del popolo di San Piero Maggiore,
> gonfalone Chiavi, lire 9 l'anno.

> E più ò di pigione e d'avilare da
> Giovanni di Francescho fornaciaio di deto
> popolo 'n deto gonfalone, lire 5 l'anno . . .

Among his debtors Baldassare listed:

> Domenico di Bartolommeo e figlioli da
> Palazuolofiorini 6.

This was also the name of Domenico Veneziano. But he could hardly have been the man named by Baldassare di Falco, since Palazzuolo is halfway between Siena and Arezzo, not far from Monte San Savino, and it is hardly possible that Domenico could at any time have lived there.

51. According to Gombrich (1966, p. 140, n. 4), the contract named the three painters "as arbiters in case of disagreement." However, the document merely states that one of them is to estimate (*stimare*) the work.

52. The former Cappella de' Priori is now Sala II of the Galleria Nazionale dell' Umbria. Only about half of the frescoes mentioned in the contract—scenes from the legend of St. Louis of Toulouse, one of the patrons of Perugia—are visible today. Bonfigli's *Crucifixion* in the chapel was covered in 1565 by another by the Mannerist Arrigo van den Broeck (Arrigo Fiammingo), roughly following Bonfigli's design (see Cecchini, 1932, pp. 33f.).

53. Fra Filippo declared the workmanship of the murals sound and the figures well done. He proposed that the fee for painting the whole chapel—twice again as much as had been done by 1461—be 400

florins, and recommended that Bonfigli be asked to continue. On the same day the *priori,* according to their promise in the contract of 1454, commissioned Bonfigli to paint scenes from the legend of St. Herculanus, the other principal patron of Perugia, in the remaining half of the chapel. With this second set of frescoes, however, Bonfigli made very little progress, and before his death in 1496 he set aside a sum of money in his will to pay for their completion. They were subsequently finished by several unknown painters (see Mariotti, 1788, pp. 133ff.). Vasari wrongly attributed the completion of Bonfigli's second set of murals to Perugino.

54. The *Zibaldone* fails to mention the architectural fresco which Neri di Bicci was commissioned to paint in the Rucellai Palace on June 26, 1455 (see Poggi, 1930, pp. 137f.). Perhaps he did not complete it. Giovanni Rucellai's artistic interests and activities are discussed in Wackernagel (1938, pp. 234ff.).

CHAPTER II

THE ST. LUCY ALTARPIECE

I

The main panel of the St. Lucy Altar (Pl. 60) presents the theme of the *sacra conversazione*—the grouping of the Madonna and saints in a continuous spatial setting introduced into Italian painting in Masaccio's Pisa altarpiece (see p. 55)—in terms of what Alberti called an *istoria:* of figures in a geometrically and proportionally coherent perspective system who through their bearing and gestures provide models of Christian *virtù*. In the luminous stillness of a summer day the Virgin and Child and four saints—Francis, John the Baptist, Zenobius, and Lucy—are held together as if in a shared segment of time, their bearing informed by a common spirit, aristocratic, meditative, and elegiac; though in each figure that spirit is reflected in a different key. Yet the St. Lucy altarpiece is also a complex system, "full of thought," as Dürer said of the Ghent altarpiece. Formally as well as thematically the main panel is closely connected with the panels of the predella, and it is only by following the links between them that the meaning of the work can be discerned.

In its original state the *sacra conversazione,* which was drastically overcleaned at the end of the nineteenth century (see catalogue no. 5), must have been one of the most luxurious examples of tempera painting in its time. Even in its present condition we can follow the shaping of its forms in untold layers of brushstrokes, responsive to the subtlest directional nuances, and weaving a pattern within which each form emerges as spatially alive and as a bearer of light. The nature of Domenico's modeling is such that light seems to be embedded in the fabric of each colored surface—a method which is one of the unmistakable indications of Domenico Veneziano's hand, and one that contributed much to that "change of vision" by which "the figure was no longer seen in isolation, but as part of a given visual field," which Offner (1924) recognized in Piero della Francesca.[1] The theoretical counterparts of this method are Alberti's designation of the "colours of surfaces" as "the reception of light," and his advice to painters "to devote particular study to those surfaces that are clothed in light and shade." Indeed, in our mind's eye we can see Domenico at work when we read Alberti's description of how painters should proceed in rendering changes of color in "spherical and concave surfaces" according to light and dark:

He will first begin to modify the colour of the surface with white or black, as necessary, applying it like a gentle dew up to the borderline. Then he will go on adding another sprinkling, as it were, on this side of the line, and after this another on this side of it, and then another on this side of this one, so that not only is the part receiving more light tinged with a clearer colour, but colour also dissolves progressively like smoke into the areas next to each other.[2]

Equally indicative of Domenico's style are contours which, rather than drawing attention to themselves, modulate the three-dimensional inflections of solids in space. Their distinctive character is apparent at once when one compares them, for example, with the drawing style of Andrea del Castagno's *Assumption of the Virgin* (Pl. 75), where contours define form with implacable hardness, or with Fra Filippo Lippi's *Corneto Tarquinia Madonna* (Pl. 76), in which outlines are like tautly charged, gleaming loops of wire moving around and cutting into the bulk of the figures (see Pudelko, 1936a). Domenico was no less a master of line than Lippi or Castagno, as may be seen, for example, in the miter of his St. Zenobius (Pl. 61), which he has not only set firmly on the saint's skull but whose horizontal band he has curled around the forehead so that its form is a clear volume turning in space. Domenico's contours are supple, undulating ribbons, searching out the modalities of relief in their passage through space. As his modeling corresponds to the description in *De pictura* of the "reception of light," so does his draftsmanship to Alberti's assertion that

circumscription is simply the recording of the outlines, and if it is done with very visible lines, they will look in the painting, not like the edges of surfaces, but like cracks. I want only the outlines to be sketched in circumscription. . . .

In the contour of the profile of St. Lucy, for example (Pl. 62), while it emphasizes the cylindrical form of the neck and the ovoid of the head, in contrast to the elliptical wreath described by the upswept coiffure, lineality is felt not as a "crack" but as the articulation of the "edge of the surface"—of the contiguity of the solid of the head and the space around it.[3]

The quality that distinguishes Domenico's contours most sharply from those of his contemporaries is not their command of three-dimensional form but their naturalism—the heritage of Gentile da Fabriano and Pisanello. In his faces, for example (Pl. 63), they follow the adherence of skin to bone, suggesting the looseness and softness of flesh and the hardness of the skull beneath. Physiognomic expression thus assumes immediacy and eloquence, and thought becomes empathically graspable (Pl. 64). It is through the slowly bending contours of St. Francis's habit that Domenico has expressed its weight and stiffness, while the broken contour of the gown of St. Lucy conveys the lightness and delicacy of silk. By means of contours, finally, Domenico is able to integrate the postures of his figures with the expression of inner vitality, as in the interplay between the swift bounding outline of the rounded belly of the Christ child (Pl. 65)—his posture, with its sharp break and concentration of energy at the waist, and its swing of the head away from the thrust of the body, learned from Donatello (Pl. 77)—and the grappling contours of his back and legs. The lines defining his outstretched arm adapt themselves to the fall of light, becoming darker in the shadows, and running lightly over the upper, more brightly lit edge. Contours such as these, which assume the functions of modeling agents—sensitive to the qualities of mass, texture and light in modulating between solids and space—are one of the

trademarks and innovations of Domenico's style. He was the first in a series of Florentine draftsmen who conceived of drawing as the most concentrated means of expressing the tension of natural form.

In the fundamentals of his craft Domenico, like his contemporaries, adhered to the tradition described in Cennino Cennini's *Libro dell' arte*—a tradition whose practices were first modified, as Kennedy (1938) has pointed out, by Domenico's pupil Alesso Baldovinetti. In paintings by Domenico Veneziano draperies were first applied in dark tones and then modeled up to higher values. In all but the Bucharest *Madonna* and the Berlin *Adoration of the Magi* he used *verdaccio* for the ground coat of the flesh tones—sparingly, like Masolino and Fra Angelico, and modeled up with ivory and pink. (In the Bucharest *Madonna* and the Berlin tondo the base color of the flesh tones is gray-green.) The polished finish of the *sacra conversazione* of the St. Lucy Altar reflects Cennini's delight in technical mastery of the painter's craft and his conception of the painting as a precious object. The smoothness of the inlaid marble pavement, the chiseled precision of the arched moldings, the luster of the jewels and of the brocade in the costume of St. Zenobius: all have been rendered with the devotion and, as Cowardin (1963) wrote of Domenico's control of tonality, with "the sensitivity of a fine Gothic craftsman." Domenico's interest in light, too, was well served in the altarpiece by his return to the bright tones and high values of late Gothic painting, in contrast to the darker colors of his own earlier works.

The special quality of Domenico's modeling resides in his sensitivity to the spatial implications in shifts of tone, the result of an acuteness of observation for which his training with Gentile da Fabriano and Pisanello once more gave him an edge over his Florentine colleagues. A flickering patchwork of light, like a translucent film, spreads almost imperceptibly from one value gradation to another. Only in the most regularly rounded forms, such as the columns, is there an even transition from higher to lower values. In draperies and figures the ridges, projections and hollows of form are staked out by light and shadow with the same probing that characterizes the painter's contours. Modeling, however, is tempered by decorative balance. The passage from light to shadow is carried only as far as is essential for the development of relief as defined by contour.

As is generally true of advanced Florentine painting of the 1440s, draperies express the postures and movements of figures more successfully than they reveal anatomical structure, a trait which Pudelko (1934) somewhat unjustly cited as evidence for Domenico's "unfamiliarity with plastic form." The weighted fall of the habit of St. Francis, for example, eloquently conveys the forward motion implied in his stance, while the horizontal loop of his cowl graphically expresses tension across the span of his chest, accentuating the forward thrust of the head in relation to the shoulders. How the body of St. Francis works anatomically is far from clear. The patterning of light on the pliable ridges of the vertical folds that are suspended from the horizontal loop gripping the shoulders of the figure recurs like a signature throughout Domenico's work (Pl. 66): bands which broaden into long, elliptical lozenges become thinner, so that the outer edges come close to converging in a single strand and then, as in a vibrating string, fan out again. (Pls. 42, 65, 107, 124, 136). In order to allow light to spread, the wider sections are flattened out, while the narrow, converging segments are carefully rounded threads of light accelerating the bands' rhythmic motion. Other recurrent patterns in Domenico's style are the butterfly-shaped highlighted folds near the inner bend of the saint's elbow and the shallow, crescent-shaped arcs on his sleeve.

If the patterning of highlights I have described can yet again be traced to the continuing influence on Domenico of his northern Italian masters, the juxtaposition of the vertically falling folds of the habit of St. Francis and the horizontal brace of the cowl from which they are suspended strongly suggests a sculptor's attitude toward form, as we find it, for example, in the figure of Herod in Donatello's *Feast of Herod* and Ghiberti's tomb figure of Leonardo Dati (Pl. 78), both completed in 1427. Domenico also seems to have drawn on Donatello for the drapery of the Baptist (and perhaps also for his stance, which recalls, especially in the placement of the feet, the Baptist on the Bronze Doors of the Old Sacristy in S. Lorenzo). The spatial foil of the mantle over his left arm, forming a pocket of space around the lower arm, is again a sculptor's way of thinking, as witness Donatello's *St. George, St. Louis of Toulouse,* or *Habbakuk.* Such a pocket of space is produced too by the mantle enveloping the body of the Virgin (see Pudelko, 1934) and by the brocaded cope of St. Zenobius, whose fall produces a stable shell from which the thin, crushable linen surplice, ruffled by the bishop's forward movement, emerges into the light. The extent to which Domenico profited from the example of Florentine sculpture in designing his draperies—complex formations of spatial pockets, projecting wedges, and contracting and expanding ridges—is suggested particularly well by a comparison between the mantles of his St. Lucy (Pl. 67) and of Michelozzo's caryatid at the left of the Brancacci Tomb in S. Angelo a Nilo at Naples (Pl. 79). But as in the drapery studies of Leonardo three decades later, the realistic effect of St. Lucy's robe, lightly plummeting from her shoulder and arm, and settling noiselessly on the smooth, hard marble pavement, is the result of the subtlety of its *chiaroscuro* passage work.

The symmetrically designed Virgin, crowned as the Queen of Heaven (Pl. 73), has a more iconic presence as well as a less palpably definable position in space than the saints, and her stylized drapery—Pudelko (1934) rightly compared its formation with the drapery schemes in the contemporary *Apostles* by Luca della Robbia in the Pazzi Chapel—subtly relates the figure, by means of an ascending, crescent-shaped pattern beginning at the lower left (to which a counter-movement is described by the S-curved ridge descending from the outer contour of Christ), to the niche behind her (Pl. 65). About halfway up to her knee two of the ascending highlighted folds, in a formation that is a further recurrent characteristic of Domenico Veneziano's hand, converge, fan out, and part again, as they merge into the highlight on the knee itself. Above the Virgin's waist the naturalistic looseness of the outer mantle, with its fluctuating highlights, is sharply differentiated from the tightly pulled, straight creases of her dress, gathered at the waist by the oval band encircling the abstract shape of her torso.

The relationship between the two drapery passages offers an instructive example of Domenico's interpretation of the quattrocento counterpoint between abstraction and naturalism, a *Zweistimmigkeit* at work not only in his contours and modeling but also in his adjustment of naturalistically descriptive to decorative demands of color, and in the balance he achieves between the dual requirements of spaciousness and decorative order in the painted architecture (see White, 1957). In the Carnesecchi Tabernacle and the Berenson *Madonna* this counterpoint is weighted more toward abstraction. In the Kress *Madonna* and the Cavalcanti fresco the emphasis is clearly on naturalism, not only in relation to Domenico's early works, but also in comparison with the St. Lucy Altar.

What I have referred to as the counterpoint in quattrocento realism is at play as well in Domenico's handling of light. The *sacra conversazione* is lit as if by several lamps.[4] The mainstream of projected light enters the composition from the upper right; another source is

implied between the right edge of the picture and the column hidden by the mantle of St. Lucy; and additional lights play on the composition from in front. This threefold projected illumination, however, is neutralized—rendered "indifferent" (see Schöne, 1954)—by its intersection with the light which, as in late Gothic painting, shines in the colors themselves. The effect of real light in the altarpiece is produced, not through the naturalistic consistency of its illumination, but, as Cowardin (1963, pp. 158ff.) has observed, by a number of devices in the handling of tonal relationships. First, by the harmonious maintenance of high values, which suggests the luminosity of colored marble and stonework. Second, by the depiction of reflected light in the folds of the drapery and in the vaulted surfaces of the architecture—the accompanying color reflections in these passages show, incidentally, that Domenico understood that "reflected rays," as Alberti put it, "assume the colour they find on the surface from which they are reflected." Third, by the maintenance of a proportional relationship between hue, value, and intensity in both light and shadow zones. And last, by the credibility of shadows cast by a raking light that floods both the foreground and the polygonal exedra.

Domenico's cast shadows, unlike the dense, black projected shadows of Masaccio and in the early work of Fra Filippo Lippi, are delicate and transparent. The wispy shadows cast by the bishop Zenobius and by St. Lucy, for example, function mainly as horizontal accents along the gliding extension of the marble pavement, and hardly at all as projection of the figures' masses. Light and shadow in the paintings of Masaccio act as elementally opposed forces (see Gilbert, 1966). Domenico Veneziano's overall tonality of subdued brightness revives a trecento mode of maintaining a decorative balance between lighted and shaded areas, but is consistent as well with Alberti's advice to painters to balance and to use "restraint" in the depiction of light and shade.

"The significance of his work rests on a new conception of color," Pudelko wrote of Domenico Veneziano in 1934; "for the first time color and light are treated for themselves, and the construction of the picture is realized with purely pictorial means." Although I do not share Pudelko's proto-Impressionist interpretation, and believe that Domenico's importance far exceeds his innovations as a colorist, it is true that even in its reduced state the *sacra conversazione* of the St. Lucy altarpiece evokes the experience of light and color in nature as no earlier Italian painting does. At the same time, however, color produces a carefully organized decorative surface. The color patterns of the saints have been woven into the scheme—originally less pale than now—of pink, green, blue, and white of the architecture and the Madonna, reminiscent of Alberti's reference to "a kind of sympathy among colours, whereby their grace and beauty are increased when they are placed side by side. If red stands between blue and green, it somehow enhances their beauty as well as its own." [5] Accents of color are provided through the distribution of crimson and vermilion. The crimson of the book held by St. Francis is picked up in the miter and in the bands crossing the breast of St. Zenobius (and reinforced by the violet collar under his cope). The coloristic brilliance of the figure of the bishop, rendered especially vivid by what Cowardin (1963) has aptly called "the flash of gold" in his mantle (rendered not with gold leaf, which Domenico used in earlier works and at S. Egidio, but, as Alberti recommends, "with colours rather than with gold"), balances the vermilion triangle pinned to the shoulder of the Baptist, the dominant color accent in the painting and a masterful example of the affective use of color, focusing attention on the head, and embodying in terms of color of the intensity of his expression. The echo of the Baptist's vermilion drapery patch is taken up in the left edge of St. Zenobius' cope, in the

shoes of St. Lucy, and in the shoes of the Madonna in the predella panel of the *Annunciation*.

Chromatically—from the point of view of what Siebenhüner (1935) called "Farbschönheit"—Domenico's color resembles the late Gothic Tuscan tradition more closely than the palette of any of the painters whom he most influenced—Baldovinetti, Castagno, Piero della Francesca; and in relation to his other contemporaries it is most like Fra Angelico's (see Cowardin, 1963, pp. 152ff.). Particularly close in color to Domenico's *sacra conversazione* is Fra Angelico's Annalena alterpiece, begun, according to Pope-Hennessy (1974), in 1443–44, a year or two before the St. Lucy Altar. One of the advantages of the bright, decoratively balanced colors of Gothic altarpieces was their visibility, and one explanation for the shift in Domenico's work from darker to lighter color, a shift which as far as we know sets in with the St. Lucy Altar, may be that the patrons of the main chapel of S. Lucia de' Magnoli, presumably the Uzzano, wanted the new altarpiece, like the work by Pietro Lorenzetti which it replaced (see catalogue no. 5), to be as distinctly visible as possible on the high altar of the small, poorly lit interior of the church.

Like Fra Filippo Lippi in the *Corneto Tarquinia Madonna* and the S. Lorenzo *Annunciation,* and like Fra Angelico in his Perugia and S. Marco altarpieces, Domenico knew and was influenced by Netherlandish painting (see Meiss, 1956), probably from the time of his stay in Rome (see p. 11); not by its color, which his own does not resemble at all, but by the naturalism, opulence, and luminosity of its pictorial style. Nowhere, as Pudelko (1934) perceived, is this more apparent than in Domenico's treatment of jewels, which he renders, like Jan van Eyck, so that light reveals their opalescence, glint, and pebblelike three-dimensional form, arranged in rows of small pearls along brocade borders, or in settings of white pearls surrounding either a colored one or an oval or cut gem (Pls. 61 and 80). But Domenico also drew on Burgundian illumination, perhaps by way of Gentile da Fabriano, for whom it had been a major source. Those qualities of Domenico's palette in the St. Lucy Altar that do not easily fall into the domain of late Gothic Tuscan color, especially in the predella panel of the *St. Francis Receiving the Stigmata,* continue the research into the interaction of color and light that characterizes what Meiss has called the "new color" of André Beauneveu's Psalter of Jean de Berry and Giovannino de' Grassi's Book of Hours of Gian Galeazzo Visconti: a "basic counterpoint of shining white and radiant yellow (gold), the intermittent *basso* of deep blue, red, or even black, and the chord of sharps and flats—blueish rose, yellow—or grey-green, violet," augmented by "dun-browns and dusty greys" (Meiss, 1967, p. 146).

II

In his design of the architectural setting of the *sacra conversazione,* an example of the mid-fifteenth-century revival of what Offner (1939) called a fundamentally "Gothic mode of maintaining a decorative unity in the altarpiece by imposing upon the composition a visible means of organization," Domenico is entirely on Tuscan ground. His triple arcade not only introduces into the unified space of the *sacra conversazione* the vestigial form of the triptych but also conforms to the trecento habit of spanning the full width of a composition with three pointed arches, as, for example, in *St. Francis Preaching Before Honorius III* in the Upper Church at Assisi (a mural which Domenico could have seen while he was in nearby Perugia). The use of pointed arches in the context of a classically inspired architectural setting with

round arches is rare but not unique in advanced quattrocento art, as witness the *Solomon and Sheba* panel from the Gates of Paradise and a number of pages in drawing the books of Jacopo Bellini. In the St. Lucy Altar, beyond their bow to the tradition of the triptych and their possible allusion to the Temple of the Old Covenant (see Panofsky, 1935), the Gothic arches also have the advantages of articulating the verticality and separateness of the three bays of the loggia, as well as marking the vertical axes between the two lateral figures of saints and the two lateral predella panels (see Fig. 16). The Gothic arches, finally, enhance the allusion of the architectural setting of the *sacra conversazione* to a hall church, with the loggia representing one tripartite bay across, and the exedra the apse.

Unlike the Giottesque fresco at Assisi, but like other mid-quattrocento perspective compositions, notably Fra Angelico's *St. Lawrence Distributing Alms* of 1448 in the Vatican (for the date, see Gilbert, 1975), the St. Lucy Altar is spatially ambiguous: while the columns of the loggia rest on the platform well back in space, the tops of its arches are flush with the picture plane. As White (1957, p. 188, n. 16) has put it, "the arched upper area is so cut as to appear to lie on the surface, whilst its supports prove it to be deep in space, and the niche-shaped back of the Virgin's throne is actually part of a wall lying many feet beyond it" (see also Shell, 1961 and 1968). In spite of Domenico's strict adherence to a one-point perspective construction (Fig. 15), the depicted space of the painting is perceived differently when read from the bottom than when read from the top of the composition. Proceeding from the bottom, we apprehend a single zone of space, defined by the pavement and the steps leading up to the Madonna and closely surrounded by the arches and niches of the exedra. If we begin from the top, we encounter two zones: the vaults of the loggia, and beyond them the space staked out by the five sides of the exedra. Domenico Veneziano has thus secured a singular advantage: the figures of the saints can be seen as both in front of, and under, the loggia. They stand between the congregation and the Queen of Heaven, with Christ looking out across space toward the Baptist. But at the same time they are also gathered into the zone of space that is the domain of the Virgin and Child.[6]

In its unification of the Madonna and saints in "a common space and light" (Shearman, 1966), the St. Lucy Altar, like the *sacre conversazioni* by Fra Angelico, was surely dependent not on Masaccio's lost *sagra,* as Pudelko (1934) argued, but on the main panel of the Pisa altarpiece, as has been shown by Shearman (1966) on the basis of his reconstruction of this dismembered work.[7] But through the introduction of the tripartite loggia and the polygonal exedra (the shape of the three missing sides of its octagonal form are assumed by the steps that lead up to the Madonna), with their polyphonic deployment of arches, Domenico has taken a significant further step toward the solution of three problems: "creation of a spatial unity that transcends the architectural subdivisions, creation of sufficient depth to accommodate an imposing and seemingly three-dimensionally disposed group of figures," and "pictorial compression, but not destruction, of this deep space in order to allow its incorporation within a satisfactory pictorial design" (White, 1969). The crucial factor in meeting these three conditions is Domenico's handling of the exedra. Its three niches inscribe and thus draw together the Baptist and the bishop Zenobius with the Madonna and Child, while the foreshortened arches of its two open, lateral wings, through their perspective thrust, generate the effect of spaciousness behind the loggia. (They also effectively separate the outer saints, who are posed in profile or near-profile, from the inner ones, who are seen frontally or in three-quarters view.) Yet Domenico's success in creating the illusion of a unified, deep space depends not only on the

ingenuity of his design but even more on the credibility of the light in which the architecture and the figures are seen.

But is the depicted space of the altarpiece measurable—can we determine the distance between the throne of the Madonna and the wall of the exedra? Ground plans of the *sacra conversazione* by Uban (in Battisti, 1971, I, pp. 35ff. and 1971a) and Welliver (1973) notwithstanding, we cannot, anymore than it is possible to measure the distances in space—in spite of attempts by Sanpaolesi (1962) and Janson (1967) to do so—in Masaccio's *Trinity*. Domenico Veneziano, like Masaccio in his fresco at S. Maria Novella (see Polzer, 1971), constructed the perspective system of his composition by means of surface geometry rather than by the measurement of distances in depth (Figs. 2, 3, 4 and 12). Indeed, the only quattrocento picture which has been convincingly shown as having been designed with the aid of a ground plan is Piero della Francesca's *Flagellation* (see Wittkower and Carter, 1953; Casalini, 1968).

The key to the perspective system of Domenico's *sacra conversazione* is the pattern of its cool, gleaming, effortlessly receding marble floor. Composed of six-sided stars inscribed by hexagons, with the forward apexes of the first row of stars (*C, D,* and *E* in Fig. 15) dividing the front edge of the pavement, that is, the baseline of the perspective construction, into six equal units, it has been so carefully worked out that Verga (1977a), finding the only parallel for what he calls its "laboriosità preparatoria" in the Urbino *Flagellation* by Piero della Francesca, has suggested that in its design Piero collaborated with Domenico Veneziano. Not only, however, was Piero in Borgo San Sepolcro in 1445, the year in which the St. Lucy Altar would seem to have been begun, but we have by that time no proof of his ability in perspective. Indeed, his earliest-known perspective design—the mural of 1451 in Rimini—postdates his reported partnership with Domenico at Loreto (see p. 21). I therefore regard it extremely unlikely, if not impossible, that Piero had a hand in the St. Lucy Altar's pavement pattern.

From the forward apexes of the stars on the front edge of the pavement lines drawn inward and outward (as from *D* in Fig. 14) reveal a lozenge pattern (compare Figs. 14 and 15) and, when continued in both directions, meet in two lateral vanishing points at either side of the composition; while lines drawn through the forward and backward apexes of the pavement's star formations meet in a central vanishing point (Fig. 12). Like Uccello in the *sinopia* of the *Nativity* for S. Maria della Scala (Pl. 87),[8] Fra Angelico in the S. Marco Altar (Fig. 17), Ghiberti in the *Jacob and Esau* panel on the Gates of Paradise (Fig. 7),[9] and Leonardo da Vinci in the Uffizi *Annunciation*,[10] Domenico used not the *costruzione legittima* of Alberti but the so-called bifocal method, known as a device for perspective foreshortening since the fourteenth century, brought into line with the Brunelleschian innovations of the central vanishing point and the horizon line.[11] This reformed bifocal method, as I shall refer to it, was very likely the most common practice for making perspective pictures in quattrocento Florence.[12] Domenico's *sacra conversazione* is the only example, however, in which the pattern of a receding floor is formed by the intersections of the bundles of lines connecting the equal divisions of the baseline with the lateral vanishing points.

Yet Domenico has used the equal divisions of his baseline for more than his perspective construction. They also provide the module for a grid of thirty-six squares—the reticulated veil Alberti recommends in *De pictura* as a technical aid in the making of perspective pictures—whose vertical axes regulate the placement of the figures and the architecture (Fig. 12) and the spacing of the predella panels (Fig. 16), and which, when bisected horizontally, provides a

six-part canon of proportions for the figure of St. John the Baptist (Fig. 13). The lowest horizontal axis of this grid is not the baseline of the perspective construction at the front edge of the painted pavement (*HI* in Figs. 12, 14, and 15), but the lower edge of the gray strip underneath it (*AG* in Figs. 12, 14 and 15), the height of which is determined by the next points of intersection beyond the edge of the pavement of the bundles of lines radiating downward from the lateral vanishing points. The dimensions of the *sacra conversazione* with the inclusion of the gray strip at the bottom, but not of the similar strips at the sides and top, are 206 × 207 cm, less than half of 1 percent short of a square on the vertical side. Imperfections such as this are not uncommon at the time. They do not, as Polzer (1971) has shown, invalidate or jeopardize the geometric coherence of Masaccio's *Trinity*. The same is true of the St. Lucy altarpiece.

Domenico's use of the same module of measurement for the divisions of the baseline of a reformed bifocal perspective construction and for the units of a squared grid controlling the composition whose lowest horizontal axis is under the base of the perspective system was anticipated in the *Jacob and Esau* panel by Ghiberti. In Ghiberti's *istoria* the baseline of the perspective construction, as in the St. Lucy Altar, is at the forward edge of the receding floor (*AB* in Fig. 7), while the lowest horizontal axis of the grid is at the bottom edge of the section of floor projecting forward of the frame (*FG* in Figs. 6 and 7). In both works—by virtue of the projecting ledge in Ghiberti and of the gray strip below the pavement in Domenico Veneziano—the floor is read as a thick slab. In both, the horizon of the perspective construction is identical with one of the horizontal axes of the grid (*PQ* in Fig. 12 and *CE* in Figs. 6 and 7). And in both compositions the module common to the reticulated grid and the perspective construction is also the unit of measurement for a three-part canon of figural proportions (Fig. 6). As Krautheimer (1956) pointed out in his analysis of the *Jacob and Esau* panel, this is an exact application of the method for laying out a perspective composition described by Alberti in *De pictura*: after deciding on the size of the figures in a painting, Alberti writes, "I divide the height of this man into three parts, which will be proportional to the measure commonly called a *braccio*," and "with this measure I divide the bottom line of my rectangle into as many parts as it will hold. . . ."

Alberti claims that he "was the first to discover" the use of the reticulated veil for controlling a perspective picture. Yet the principle of the squared grid surely goes back to Masaccio, the upper part of whose *Trinity* is divisible into ninety-six squares, eight across and twelve high (Fig. 2). As in Ghiberti's *Jacob and Esau* panel and in the St. Lucy altar, the grid's vertical divisions coincide with the divisions of the baseline of the perspective construction (Fig. 3).[13] Masaccio does not, however, derive the module for these geometric systems from the proportions of the height of a man. In the *istoria* by Ghiberti the canonical figure of Esau just to the left of center is situated slightly below the grid's horizontal axes (Fig. 6). Domenico Veneziano's canonical figure of St. John the Baptist reaches from the bisection of the lowest horizontal zone of the quadratic grid (Fig. 13) to the line marking the tops of the heads of the figures of the saints, which bisects the grid's fourth horizontal zone. The Baptist is thus seen to be proportioned according to both the three-part canon of *De pictura* and, if bisecting lines are drawn through the second and third horizontal zones of the quadratic grid, the six-part *exempedum* system of *De statua*. "Whatever the size of the chosen figure," Alberti writes in his treatise on sculpture, "we divide it into six equal parts which we call feet. . . ." The modular unit for this canon is prominently displayed by the Baptist's left profile foot (Pl.

69 and Fig. 13), while both of the other measurements which Alberti lists in whole feet—the distance from the ground "to the bone which hangs below the penis" (three feet) and "to the fork of the throat" (five feet)—are also observed in the figure of St. John (*PQ* and *TU* in Fig. 13).[14] By demonstrating the congruence of the canons of *De pictura* and *De statua*, Domenico Veneziano visually affirms that painting and sculpture employ the same principles learned from nature. And as if to prove that proportions in height and width are measured by the same module as proportions in depth (i.e., in perspective), Domenico has juxtaposed the Baptist's left profile foot with his frontally foreshortened right foot (Pl. 68).

It has often been remarked that in his *sacra conversazione* Domenico violates one of the most commonly observed rules of linear perspective pictures, what Edgerton (1975) has called "horizon line isocephaly," and Alberti referred to in saying that the "centric line"—that is to say, the horizon line—of a perspective construction should determine the level of the heads of all depicted figures. Domenico has placed his horizon three *exempedum* units below that level, on the second horizontal axis of his quadratic grid (*PQ* in Figs. 12 and 13). Thus his figures have a powerful, commanding presence—because of their closeness to the picture plane and the shallowness of the arc they describe in space (see Meiss, 1963), the swift recession of the floor, and because the viewer is made to look up at the composition rather than down on it, as, for example, in Fra Angelico's S. Marco Altar (Pl. 81). At the same time, by virtue of the steep descent of the architectural forms in the upper part of the picture, the artist has been able to (1) create the effect of sufficient distance between the loggia and the exedra so as to render convincing their allusion to one bay and an apse of a hall church; (2) inscribe the heads of the Madonna, the Baptist, and Zenobius, as Edgerton (1975) has pointed out, in the niches of the exedra, so that the arches of the niches draw the Virgin and the two patron saints of Florence together into a triptych in the center of the composition, and the niches appear to be not deep in space but immediately behind the three figures;[15] and (3) make a caesura between this group, which is turned toward the viewer, and the outer saints, who establish an internal axis within the painting, parallel to the picture plane and crossing at 90 degrees the axis of the Virgin's and the Baptist's glances. The low horizon of the painting, finally, contributes to a twofold ambiguity in the role played by the Virgin, appropriate to her dual nature as both celestial and human: (1) she appears as an icon, set apart in the central zone of the architecture from the saints attending her (see Fig. 16), as well as a dramatis persona in the *sacra conversazione*, seen in the same light as the saints, occupying the same space, and looking out at the congregation, as Christ also looks toward the Baptist, with the same humanity as St. John; (2) because the distance between her and the front of the pavement cannot be measured, as it can in the S. Marco altarpiece, and because the central niche of the exedra contains her at the same time as it is far behind her, Domenico's Madonna, like the figure of God in Masaccio's *Trinity*, cannot be located in space, but is both near and far.

The architectural setting of Domenico Veneziano's *sacra conversazione* reflects a mid-fifteenth-century taste also represented by Alberti's Holy Sepulcher in S. Pancrazio and his façade of S. Maria Novella for combining the polychromatic decorative patterns of the proto-Renaissance with the classicizing forms, themselves in part influenced by the proto-Renaissance classical revival, of Brunelleschian and post-Brunelleschian architecture.[16] Domenico's choice of architectural repertory, like his low placement of the horizon, involves questions of meaning as well as of aesthetics. The architectural setting as a whole would seem to be an allusion to a church interior (see p. 38)—a symbolic form, as Meiss (1945) has shown

in another connection, of the Virgin. Within this ecclesiastical context the orange trees behind the exedra—oranges and other fruit stand for the Fall and Redemption of man (Sill, pp. 55f.)—are an evocation of the Garden of Paradise. The shell framing the head of the Madonna signifies Resurrection. The stylized pear sprig on St. Zenobius' cope symbolizes Redemption (Pl. 71). And the wreaths of pointed palm leaves which form the abaci of the loggia's capitals are references to Christ's Passion and to Christian martyrdom (Pl. 70), the one prophesied by St. John, the other exemplified by St. Lucy.

Yet the saint who commands the stage of the *sacra conversazione* is not Lucy but John. Having prepared himself in the solitude of the desert for his mission as the precursor and baptist of Christ (Pl. 64), he is depicted as exemplary not only in his proportions but also ethically and devotionally, as a model of Christian *virtù*. His physiognomic type—the broad, bony head with furrowed brow, soulful eyes, parted lips, and a scanty beard—was anticipated forty years before in Taddeo di Bartolo's elongated, late Gothic *Baptist* of 1407 in the Palazzo Pubblico at Siena (Pl. 84). Domenico's St. John, however, looks directly at the congregation (as before him only the Baptist in Gentile da Fabriano's Quaratesi Altar), his eloquent, harrowed face accented by the vermilion triangle beneath it and his right hand pointing to the Redeemer (Pl. 72), who in turn looks toward him (Pl. 73). In explicitly foretelling Christ's Passion, implicitly prophesied by the gazes of the Virgin and the Infant, he plays the part, as Alberti puts it in *De pictura,* of "someone in the historia who tells the spectator what is going on, and beckons them with his hand to look. . . ."

The Baptist also provides the key to the vocabulary of the *sacra conversazione*'s painted architecture. St. John is the patron of Florence and titular saint of the proto-Renaissance Baptistry of S. Giovanni Battista, the most revered religious building in Florence, for which Ghiberti and his shop were completing the installation of the Gates of Paradise while Domenico Veneziano was at work on the St. Lucy Altar, and to which the architecture of Domenico's *sacra conversazione* refers in various ways: by alluding to the Baptistry's octagonal plan in the shape of the exedra (five sides of an octagon, with the three missing sides filled in, as it were, by the steps leading up to the Virgin); through the exedra's proto-Renaissance entablature; by the painted architecture's white, pink, and green polychromy; but above all in the dark blue-green, pink-and-white pattern in the spandrels of the loggia and the exedra, which is identical with the spandrel pattern on the Baptistry's exterior (Pl. 85). Through its allusions to the Florentine Baptistry Domenico's painted architecture reinforces the leading role in its *sacra conversazione* of St. John the Baptist and, by adducing the sacrament of Baptism, underlines the Resurrection motif in the shell framing the heads of the Virgin and Child. The painting's religious message is thus transmitted to the congregation not only through its sacred figures but also through the symbolism of its architectural setting.

III

The full orchestration of the altarpiece's meaning, however, also comprises the predella. We have seen that the original arrangement of its panels, like the disposition of the figures in the *sacra conversazione,* was aligned with the vertical axes of the quadratic grid governing the composition of the main panel, so that the width of each predella panel corresponded to the zone occupied by the figure to which its *istoria* refers (Fig. 16). However, the relationship between the predella and the *sacra conversazione* goes far deeper. Each predella panel not

only illustrates an episode from the life of the figure above it but also elucidates that figure's significance in the altarpiece's thematic fabric.

I have suggested that the canonical figure of the Baptist is exemplary both in his ideal proportions and as a model of Christian *virtù*. As if the predella panel of the saint's *Vocation* (Pl. 88) were a commentary on the figure in the *sacra conversazione*, it confirms and augments, ethically as well as aesthetically, this conception of St. John. The textual source for the image of the youthful saint entering the life of penitence by exchanging his clothes for the shirt of camel's skin sent him by God has been identified by Lavin (1955 and 1961) in an anonymous fourteenth-century life of St. John. "And when the time came," the anonymous *Vita* states:

> that his clothes were so worn out that they fell to the ground . . . as God wishes, one day [St. John] found a camel's skin; and I cannot imagine how this could have happened if it were not that God had it prepared for him by His angels. . . . John, seeing this skin, immediately thought about putting it on . . . and began to thank God who had it prepared for him; and he clothed himself in the hair garment.[17]

In the fresco of the same subject by Masolino in the Baptistry at Castiglione d'Olona (Pl. 90), like Domenico Veneziano's panel probably derived from a lost fresco by Pisanello at S. Giovanni in Laterano (see p. 10), there are two angels—no doubt the "angels" mentioned in the fourteenth-century text—assisting the young saint: one on the left bringing the camel's skin to him, and another behind him to the right helping him put it on.[18] By sticking closer than Masolino to the wording of the text, which says that John "clothed *himself* in the hair garment" and omitting the angels, Domenico, in Lavin's words, has "removed the emphasis from the miraculous circumstances of the narrative and laid full stress on the significance of John's action, namely the conscious assumption of the penitential life." It was probably the artist's—or the patron's—wish to present this exemplary image of St. John that led to the choice of the rare *Vocation* as the subject for the predella panel rather than the more conventional *Baptism*.

While the sources for both Masolino's and Domenico's nude figures are antique, their specific prototypes are different. Masolino's Giovannino is in the classic pose of Graeco-Roman statues, with his full weight on his right leg and his left leg extended so that only the ball of the foot touches the ground. The saint on Domenico Veneziano's panel, on the other hand, is derived from a figure shown in the context of action (Pl. 89). As in the Hercules subduing Diomedes from which the St. John takes his posture (Pl. 94; see p. 11), his weight is distributed evenly between his two legs, with the right foot posed frontally and the left in profile and pointing downward. In antiquity this posture was used for figures engaged in physical combat, and with the exception of Domenico's Giovannino it was in the same context that it was revived in the late Middle Ages and the Renaissance.[19] One late medieval example would seem to have been the image of Hercules which the Florentine *signoria* adopted in 1281 as the emblem of its official seal. No example of the seal has survived. However, Weiss (1969) has inferred that the seal's inscription—HERCULEA CLAVA DOMAT FLORENCIA PRAVA—"suggests an antique model, if not actually an ancient engraved gem with a medieval inscription," and Passerini (1868) interpreted the evidence for reconstructing the figure of Hercules as indicating that "he was turned to the left, that his head was in profile and looking at an object in front of him, that his feet were pointed forward, the left arm raised, perhaps in the act of

striking with the club, and with the lion's skin suspended from it, and that with the right arm extended, he grasped with his hand one of the necks of the hydra''—virtually the exact posture, though in reverse, of the figure by Domenico Veneziano, with a lion's skin instead of a camel's hanging over the raised arm.[20]

Domenico has used the posture, however, to represent not combat but moral choice: the youthful Baptist's rejection of the world and assumption of the Christian life of penitence dedicated to prayer and meditation. By expressing not physical but ethical heroism, the classically inspired nude in the desert has become an example of what Eisler (1961), who did not refer to this little figure, has called ''the athlete of Christ,'' and thus a model of the Christian virtue of Fortitude, which by the fifteenth century, as in the classically conceived figure on one of the jambs of the Porta della Mandorla (Pl. 101),[21] had come to be personified by the figure of Hercules. The sources for Domenico's *Vocation* would seem to have been a lost composition by Pisanello at S. Giovanni in Laterano and the young artist's own study of Graeco-Roman sarcophagi when he was Pisanello's assistant in Rome (see pp. 9–11). But it is not unlikely that he was encouraged to use the posture which has its origins in an antique figure of Hercules by its recurrence on the seal of the Florentine *signoria*. To his contemporaries his conception of St. John as a representative of *Fortitudo* would have been instantly recognizable through the reference to this familiar Hercules image.

Like a number of small-scale sculptures of the later 1430s—the Samson on the Gates of Paradise or the *putti* by Maso di Bartolommeo on the capital of the outdoor pulpit of the cathedral of Prato (Pl. 102; see Marchini, 1952)—Domenico's Giovannino belongs to what Kauffmann (1935) called a Hellenic phase in the quattrocento image of the classical nude, gentler and more radiant than the tough, muscular Hercules, inspired by Roman sculpture (see Kurth, 1912), on the Porta della Mandorla, and related to small Greek bronzes such as the *Orpheus* in the Städtische Galerie at Frankfurt-am-Main (Pl. 103).[22] He is aesthetically exemplary, not only in his measurements, as is the Baptist in the *sacra conversazione*, but also in the formation of his body. His ideal beauty complements the ideal proportions of the figure above him. However, just as the posture of the young saint in the desert denotes moral resolution rather than physical prowess, so his suave and unblemished beauty is a vessel and metaphor for spiritual perfection. Far from being pagan and irreligious, as Pudelko (1934) saw him, Domenico's Giovannino transmits religious messages on at least three levels: as illustrating an episode from the fourteenth-century *Vita* of John the Baptist, as a personification of Christian *virtù*, and as an early example of the Neoplatonic belief that physical beauty reflects and leads the mind to the contemplation of that spiritual beauty which is the vestige of man's origin in God.

The bleached terrain with its flickering, jagged shapes in which the saint is standing—''a landscape of the spirit,'' as Seymour (1961) has called it—is alive with movement, as if urging St. John on his way along the broad, winding, pebbly path to his right; while his measured, resolute presence brings stability into the midst of its restless forms. As in the originally adjacent *St. Francis Receiving the Stigmata* (Pl. 105), the figure is inseparable from its surrounding space. In both Domenico has aligned the contours and patterns of the landscape background with the figures' poses—the slope behind St. Francis, for example, carries his glance toward the apparition in the upper right corner, and the mountain to the left of St. John follows the direction of his look as well as of the arm with which he is dropping his crimson

cloak on the ground—and, as in the *sacra conversazione,* maintained consistent value relations in a pattern of rapidly alternating lights and shadows in the figures as well as the background.[23] In the realm of pictorial relief a similar integration of figures and landscape was accomplished on the Gates of Paradise, with the difference that for Ghiberti (Pl. 104) the consistency in tonal relations was provided by the light of nature as it was received by the modeled forms of the relief, whereas Domenico created an illusion or imitation of this process by means of color.[24] Yet in the paintings too the quality of modeling plays a crucial role, for their unprecedentedly naturalistic, palpable evocation of light, air, and a feeling of place—of a spring morning in the *Stigmatization* and, in Yeats's words, of "shadowless noon" in the *Vocation*—is also the result of the consistency of Domenico's grainy, porous, in certain respects impressionistic modeling by means of crescent-shaped brushstrokes or flecks of color—recurrent characteristics of his hand which he owed to his training by Gentile da Fabriano and Pisanello—in both figures and landscape.[25]

The forms and the scale of landscape in the St. Francis and St. John panels belong in a general way to the common repertory of mid-fifteenth-century painting. However, the tonalities of the *Stigmatization* also show Domenico's debt to the "new color" of Burgundian painting (see Meiss, 1967, and p. 37); and the *Vocation*'s ivory cliffs interspersed with dark green vegetation reflect a north Italian formula derived from Altichiero and Avanzo (see the *Beheading of St. George* in the Oratory of St. George at Padua) by Gentile da Fabriano and Pisanello (see Pl. 93). The landscape of Pisanello's putative *Vocation of St. John* at S. Giovanni in Laterano very likely had in common with Domenico's predella panel the latter's bare, faceted mountains, patches of shrubs and trees—allusions to the glade (*bosco*) in which, according to the fourteenth-century *Vita* of the Baptist, the infant St. John and Christ met—and the stream at the right, a reference to the river Jordan where, according to the same text, Christ told St. John he would come to him to be baptized (see Lavin, 1955).[26]

Because the mountainous terrain in both the St. Francis and St. John panels drops off sharply at the lower right it is clear that the meadow at La Verna where Francis receives the stigmata as well as the desert plateau on which John assumes his shirt of penitence are high places, closer to God than the ground on which mortals ordinarily stand. But the two landscapes are related also in another way, for their background mountains describe a continuous arc in space, which moves forward from the peaks behind Francis, across the borders of the panels with the help of the slope containing the figure of Friar Leo and the cliff descending toward St. John, and back into the distance along the ridges to the Baptist's right. At the same time the mountains' jagged faces, which point in the opposite direction, provide a gentle but constant contrapuntal movement to the eye's journey from left to right. The two panels have the same cloud-streaked sky; and the light in both, as in all panels of the altarpiece, including the *sacra conversazione,* comes from the right, a fact of great importance for our understanding of the work as a whole.

IV

The St. Lucy Altar has been so lavishly admired for the naturalism and beauty of its light and color that the symbolic meaning of its light has been virtually overlooked. The only reference to it I have found is the observation of Wittgens (1930) that in the *Stigmatization*

Domenico "makes his color irradiate his light and uses it according to the teachings of the mystics, as an ethereal element which spiritualizes matter, an artistic means of expressing ecstasy." Indeed, the St. Lucy Altar is a subtle, elaborate, and ingenious demonstration of the late medieval doctrine that there is a divinely ordained harmony between optical and mystical vision, and that the laws of the former, as Edgerton (1975) has put it, reflect "God's manner of spreading His grace throughout the universe." That vision should be the theme of the altarpiece follows from the identity of the titular saint of the church for whose high altar the work was made. St. Lucy's attributes are her eyes. According to her legend, she plucked them out and sent them to a Roman suitor because he had fallen in love with their great beauty; whereupon new eyes, even more beautiful than those she had had, were miraculously restored to her. She thus became the saint of sight—the patron of those afflicted with diseases of the eye—as well as of light and spiritual illumination. Her feast day is the shortest day of the year. And in the *Purgatorio* (IX, 52–63) she shows Dante and Virgil the gate to Purgatory—"and first her fair eyes," Virgil says to Dante, "did show me that open entrance." In Domenico Veneziano's *sacra conversazione* she looks with the unclouded gaze of the elect in the direction of St. Francis, who points to the mark of the stigmata on his breast and meditates on a text which his pointing gesture and the *istoria* below him identify as the Passion of Christ. St. Lucy stands on the side from which light enters the altarpiece, as the agent, so to speak, of that spiritual illumination which, in a more intense form, leaves its marks on his body in the vision of the stigmatization. But St. Lucy's gesture too is significant. As Welliver (1973) has observed, she holds her palm leaf, the emblem of her martyrdom, like a pen. By pointing with it to her plucked-out eyes as if she were writing on the tablet on which they lie (Pl. 71),[27] she affirms the power of sight to perceive not only what is optically visible but also what is revealed through the written word of sacred scripture.

The message conveyed by the attitudes and the attributes of Francis and Lucy is confirmed by two phrases of the inscription on the lower step of the Madonna's throne: MISERERE MEI on the right side of its central section (Pl. 74) and ET DATUM EST on its right face. Welliver (1973) has shown that the first is an entreaty by which, in several passages in the Gospels, the blind appeal to Christ for the restoration of sight (Matt. 9:27–31 and 20:29–34, Mark 10:46–52, Luke 18:35–43); and that the second occurs in Christ's declaration to the apostles (Matt. 13:11, Mark 4:11–12, Luke 8:10), "Unto you it is given to know the mysteries of the kingdom of God; but to others in parables, that seeing they may not see" (Luke 8:10). The coupling of these two references to the Gospels in the altarpiece's inscription suggests a supplication for the granting of the gifts that are under the special protection of St. Lucy: optical sight and spiritual illumination—that faculty of sight by which we may in the life to come, like the apostles, perceive what is divinely revealed "face to face" rather than, as now, in parables "as through a glass darkly."

The most explicit illustration in the altarpiece of the harmonious relationship between optical and mystical vision is the panel of *St. Francis Receiving the Stigmata* (Pl. 105). The seraphic apparition in the painting does not contain the image of the crucifix or of the figure of Christ with arms extended or raised, as it otherwise does invariably in fourteenth- and fifteenth-century Italian painting; but, like the earliest thirteenth-century depictions of the miracle, consists only of the wings and head of the seraphim itself.[28] According to St. Bonaventura's description of St. Francis's vision (see Thode, 1909),

while he was praying in a hollow of the mountain, he saw a seraphim which had six flaming and radiant wings, and which descended toward him from high in the sky. And when after a flight of marvelous swiftness through the air the seraphim had arrived close to the man of God, he discovered between the wings the image of a crucified man, who had his hands and feet attached to a cross (p. 159).

Domenico Veneziano was the first artist, as Meiss (1964a) pointed out, who located the vision deep in space. By depicting it in accordance with the principles of perspective he has not, as Pudelko (1934) implied, neutralized its religious or mystic significance, but has, on the contrary, produced the first accurate illustration of Bonaventura's text. Recording the moment when the vision appeared "high in the sky," he has, following Bonaventura, shown only the seraphim and not the "image" which the saint discovered between the wings after its "flight of marvelous swiftness through the air." Yet because the seraphim already emits the golden rays by which the stigmata are imprinted on Francis's body (Pl. 106), it is evident that with the faculty of mystic sight possessed by those to whom "it is given to know the mysteries of the kingdom of God" he also perceives the fullness of the vision. As its divine radiance is expressed by the natural light that washes clean the mountain landscape, so the laws of optics by which the vision is depicted affirm both its mystic nature and the saint's mystic experience.

But the vision is experienced not only by St. Francis. Its flash has startled Friar Leo (Pl. 107), the saint's traditional companion in pictures of the *Stigmatization*. Steadying himself with one hand and shielding his eyes with the other, the friar—like the luminous landscape and the depiction of the seraphim deep in space—conveys the message that the vision is real: that God is immanent in nature and that His grace illuminates all of creation.[29] He is the indispensable witness, the link between the miracle and the congregation, who through his dramatically lucid pantomime once more recalls Alberti's member of "the historia who tells the spectators what is going on, and beckons them with his hand to look. . . ."[30]

The connections we have observed between the figures of Francis and Lucy through the axis they establish across the front of the painting, and between John and Zenobius by being united as a triptych with the Madonna (see p. 41), are of course but a *sotto voce* counterpoint to the principal relationship of the saints as pairs. The latter is expressed in various ways: by grouping the pairs under the lateral arches of the loggia; by leading the hand gestures in each pair toward the Virgin and Child; through costume (on the left the monk's habit and the garb of penitence, on the right the bishop's robes and the silken mantle of St. Lucy); and finally in the backgrounds of the predella: high mountain landscapes—the world of the spirit—on one side, and architecture—the world of man—on the other. The two architectural panels have almost identical perspective systems. Apparently worked out on cartoons which exceeded the width of the painted compositions, they consist of baselines divided into equal units and vanishing points located two units up and two units in from the bottom and left edges of quadratic grids, which, as in the *sacra conversazione*, are constructed on the module of the baseline's equal divisions (Figs. 19–20). Since the two paintings contain no checkerboard floors or other elements requiring the establishment of a rate of recession for transverse distances, their perspective schemes conform neither to the reformed bifocal construction with its lateral vanishing points, nor—contrary to the assertion of Pope-Hennessy (1950) in regard to the St. Zenobius panel—to the *costruzione legittima* of Alberti.[31]

THE ST. LUCY ALTARPIECE

V

While St. Lucy embodies spiritual illumination, St. Francis mystic identification with the Redeemer, and St. John Christian fortitude, Zenobius, like John a patron saint of Florence, his worn, intellectual, ascetic face set off by the opulence of his vestments (Pl. 61),[32] personifies the sacraments of the church. The subject of the predella panel beneath him is his power to raise the dead—the most conclusive proof of his sainthood (Pl. 110). According to his legend, St. Zenobius (337–417), while he was bishop of Florence, on three occasions brought to life a dead boy. The miracle depicted in Domenico's predella panel would seem to be the resurrection of the son of a Frankish pilgrim. As told by Giambullari (1863, p. 19), a rich woman from Gaul, accompanied by friends, servants, and her son, passed through Florence on her way to visit the tombs of Sts. Peter and Paul in Rome. Her son being too weak with fever to continue to Rome, she left him in the care of St. Zenobius. During her absence the boy became gravely ill and died on the second morning of Easter, while St. Zenobius was taking part in a procession at the church of S. Pier Maggiore. On the same morning the mother returned and found her son dead. Lamenting and accompanied by a multitude of onlookers, she took the dead boy and went in search of St. Zenobius. They met on the Borgo degli Albizzi as the saint was on his way from S. Pier Maggiore. Greatly moved by the death of the boy, he knelt down and began fervently to pray, whereupon the boy came to life. The miracle is commemorated by a plaque on the façade of the Palazzo Altoviti on the Borgo degli Albizzi, not far from the Piazza S. Pier Maggiore.[33]

In his staging of the miracle Domenico had as a precedent, as Pudelko (1934) was the first to point out, the composition by Ghiberti on the front of the St. Zenobius shrine (Pl. 115);[34] while in the arrangement of the spectators at either side he was indebted as well to Fra Angelico, specifically to the *Sermon of St. Peter* in the predella of the Linaiuoli altarpiece and, as Pudelko also observed, the *Deposition* from the Strozzi Chapel at S. Trinita. Ghiberti's conception of the scene, however, is very different from Domenico's. The *istoria* in the relief is ceremonious and grandiloquent. By showing the resurrected as well as the dead child, and by subordinating the action of the mother to the sweeping movement of the saint's arms raised in prayer, Ghiberti has stressed the miraculous nature of the event. His crowds of spectators recede far into the distance, and his background architecture, pure and classically inspired like the architectural settings of the Gates of Paradise (see Krautheimer, 1956), is an ideal city.

In the predella panel the *istoria* is harsh and realistic. Domenico has restricted the onlookers to the foreground (Pls. 111–112), and has knit them together with the protagonists in a chain of interlocking planes.[35] He has shown only the dead boy, his blood spilled on the irregular pavement of the street. The miracle has not yet been accomplished; and the focus of the composition is the bereaved mother. Domenico's setting is the site where the incident actually occurred, confined by medieval houses which rise beyond the picture's frame and plunge steeply into depth toward the church of S. Pier Maggiore. Whether, as Pudelko (1934) has claimed, the stonescape is an accurate portrayal of the site is, however, open to question. Contrary to their appearance in the painting, the Piazza S. Pier Maggiore is minuscule, and the Borgo degli Albizzi extremely narrow. Looking from the street toward the church one cannot, as one can in Domenico's panel, see mountains in the distance. The structures flanking the street are not specifically identifiable buildings but, like those in Masolino's *Raising of Tabitha* in the Brancacci Chapel and in the *Burial of Sts. Cosmas and Damian* in the Museo di S.

Marco and their *Attempted Martyrdom by Fire* in Dublin from Fra Angelico's S. Marco Altar, typical medieval houses (see Paatz, 1939). "Quattrocento art," as Gombrich (1966) has said, "offers no reportage of the places and personages of its time, for it operates with types and patterns, not with individualistic portrayals. The stereotypes and formulae used in architectural backgrounds are no exception" (p. 14). Not until the work of Domenico Ghirlandaio and his pupils—Domenico's own frescoes in the Sassetti Chapel at S. Trinita, his son Ridolfo's depiction of the *Resuscitation of a Youth by St. Zenobius* in the Accademia in Florence, or Francesco Granacci's *Entry of Charles VIII into Florence* in the Museo Mediceo—are Florentine buildings accurately and identifiably portrayed.[36]

Domenico has integrated his cityscape and his foreground figures through a spirited pattern of shapes, accents, and colors. On the left the predominant color is black,[37] interspersed with crimson and white; on the right it is crimson set off by cobalt blue. The brownish-gray windows of the buildings, dispersed over the background as if echoing the cry of the wailing mother, relate the sharply foreshortened house fronts to the picture plane. On either side of the street the planes are relatively simple and clear; but in the distance they are denser and more complex. Accented by the radiant blue arch over the balcony of the church, the juxtaposition of the mother's fluttering veil and the closely spaced verticals behind her give the eye no rest at the picture's dramatic focus. The mountains extend our vision beyond the confines of the city, soften and bind together its silhouette of towers and spires, and are a reminder of the mountain landscapes in the two *istorie* on the left side of the predella.

The posture of the dead boy's mother, her head thrust forward and her arms thrown back, had been used to express grief in antiquity, as in a mourning figure on a Meleager sarcophagus in the Louvre (Pls. 113–114). Like the posture of his Giovannino, it is likely to have been among the repertory of motifs of which Domenico made drawings while he was studying Graeco-Roman sculpture in Rome. First revived by Nicola Pisano in the *Massacre of the Innocents* on the pulpit of the cathedral of Siena and then adopted by Giotto for the unforgettable figure of St. John lamenting over the dead body of Christ in the Arena Chapel,[38] it has been charged by Domenico with a vehemence that anticipates the wailing women mad with grief in the Lamentation groups of Niccolò dell'Arca. The mother's lunge across the perspective shaft of the architecture, her veil fluttering behind her,[39] is crossed by the flight of two incised orthogonals (*QI* and *QM* in Fig. 19) toward the vanishing point, but is accompanied by the edge of the street above her, which leads to the geometric center of the composition (*BR*). She is thus placed between two opposing forces, one impelling her forward, the other pulling her back. Her head is poised directly over her dead son's raised leg, and the painting's central axis (the vertical at *H*) intersects both her open mouth and the boy's knee.[40]

If the St. Zenobius panel is the most dramatic of Domenico Veneziano's paintings—Fry (1930) felt that "its marked difference in scale, its greater complexity and its broken surfaces" were discordant with the rest of the predella, the *Martyrdom of St. Lucy* is the most lucid, the one in which the design of the narrative and its setting are most perfectly integrated, and the counterpoint between naturalism and abstraction most effectively tuned (Pl. 116). According to her legend, St. Lucy, a third-century resident of Syracuse, was put to death for refusing to abandon the Christian faith at the order of the Sicilian governor, Pascasius, by being stabbed in the neck. In depicting her execution Domenico has followed a scheme used in the fourteenth century for the martyrdom of St. Matthew, as in Jacopo di Cione's Arte del Cambio altarpiece in the Uffizi (Pl. 120).[41] A comparison of the two pictures is revealing in two respects: it shows

that Domenico's application of linear perspective produces not only coherence and regularity in the depiction of space but also clarity and force in the rendering of action; and it is an illuminating visual demonstration of Alberti's argument in *De pictura* that observance of the rules of perspective is the precondition for an *istoria* which will convince—or, as Alberti says, "move"—the spectator.

The vanishing point of Domenico's perspective system is at the focal point of the action, in the hand with which the executioner plunges the dagger into the saint's neck (Fig. 20). But the figures' pantomime is aligned with the geometric scheme of the composition in other ways as well. As in the *istoria* of St. Zenobius, the vanishing point is also at the intersection of two axes of a quadratic grid.[42] Its horizontal axis along the rear edge of the bench that projects from the rear wall (*BN*) passes through the executioner's bent knees. At the forward knee it is intersected by the panel's central axis (the vertical at *G*), which also crosses the outstretched hand that steadies and tempers the impetuousness of the executioner's forward movement.[43] Among the orthogonals of the architecture, all of which point to the dagger in the executioner's raised hand, the one coming from the upper right (*SP*) does so particularly emphatically. Beginning in the pink molding to the right of the miniature governor, it is continued by the cornice of the balcony, accompanied by the governor's pointing staff (Pl. 117), accelerated by the forward movement and the glance of the executioner, and reaches its goal in the dagger at the neck of the saint. Her glance in turn is carried upward by the orthogonal descending from the upper left (*TP*). Her upper arms are aligned with the direction of the foreshortened base of the arch (*DP*). The orthogonals at *I*, *J*, *K*, and *L* move with and advance the executioner's gait.[44]

The cadence of his step and the finality expressed in his posture show how deeply Domenico must have studied and understood the art of Masaccio, for the executioner of St. Lucy shares these qualities with the soldier holding down the head of the Baptist in the predella panel of the *Beheading of St. John* from Masaccio's Pisa altarpiece.[45] Yet Domenico's figure is shown at the climax of a swift movement, his loosely painted jerkin—akin in its expressive function to the mother's agitated veil in the Zenobius panel—fluttering behind him, and his silhouette against the pink wall behind him unbroken except for the horizontal of the bench that intersects his knees (Pl. 118). The saint too is posed in profile—as she is in the *sacra conversazione*—and her steadfast posture is inscribed on the wall at the back with the same graphic clarity as the movement of the executioner. Among Domenico's contemporaries only Fra Angelico—most memorably in the *Attempted Martyrdom of Sts. Cosmas and Damian by Fire* at Dublin, but also in the background of the *Burial of Sts. Cosmas and Damian* in the Museo di S. Marco—similarly projected figures on an unbroken surface parallel to the picture plane. However, St. Lucy's cast shadow, which points toward the center of the foreshortened arch, and the overlapping of the further column of the portico by the executioner's heel and jerkin, clearly situate the figures in the middle of the courtyard in which the action unfolds. The stark, concentrated depiction of the *istoria* is reinforced by the character of the architectural setting. With the exception of the moldings that direct the eye to the vanishing point, and the entablature of the portico, which stabilizes the position in space of the executioner's black hat,[46] it is devoid of ornament—even of bases and capitals on the portico's columns. Yet the severity and stillness of its abstract geometric forms find release in the swaying tops of the cypress trees behind its crenellated wall (Pl. 119). Inherited by the quattrocento from antiquity by way of Byzantium (see Kennedy, 1938, n. 192), they are rendered by Domenico not like

conical spires, as they are by Fra Angelico, but with the same impressionistic freedom of the brush and openness of form as the vegetation in the *Annunciation* (Pl. 128) and in the Francis and Baptist panels.

Domenico's courtyard is also a model of functional stage design. Its constituent parts—a foreshortened archway, a crenellated wall parallel to the picture plane, and a balcony supported by columns projecting from a plain wall—are similarly assembled in the *Attempted Martyrdom of St. Catherine* of Andrea di Giusto's polyptych of 1437 in the Florentine Accademia (Pl. 122), a composition Salmi (1948) has identified as a reflection of a lost predella panel of the same subject from the altarpiece formerly in the Florentine church of S. Maria Maggiore attributed by Vasari to Masaccio (see p. 151).[47] In both the balcony is needed for the depiction of the functionary ordering the execution, whose small scale in relation to the principal figures is one of the many medieval formulas retained in quattrocento art. The crenellated wall, besides serving as a screen against which the action is projected, identifies the site as a courtyard in a castle or fortified palace. And the foreshortened arch, as also in a *Martyrdom of St. John the Baptist* given to Giovanni del Biondo in the Johnson Collection in Philadelphia, may allude to the entrance to Paradise, through which the saint is about to be admitted, and which is in fact depicted in the form of a round arch in Andrea da Firenze's *Church Militant* in the Spanish Chapel at S. Maria Novella.

VI

But the predella panel most charged with symbolic meaning is the *Annunciation* (Pl. 123), originally located under the Virgin and Child and nearly twice as wide as the panels to either side of it. Like these, it elucidates the role of the sacred figures above it. But to a greater extent than the other *istorie* it also illuminates the significance of the altarpiece as a whole. The Virgin in the *sacra conversazione* is both human and celestial—icon as well as dramatis persona, both near and far in space. Her bared head and her crown are references to her intercessionary, compassionate capability as the Madonna of Humility.[48] Yet by virtue of the transparent halo which floats over her head, as it does over the heads of the Christ child and the four saints, she and the other figures as well acquire, in the words of Braunfels (1950), "eine neue Weihe, den Charakter wundersamer Unberührlichkeit."[49] The *sacra conversazione*'s inscription hails her as the mother of Christ—AVE MARIA / HO MATER DIE—and it is in that role—as the vessel through which the prophecy of Redemption was fulfilled—rather than in her own right that the supplicant before the altarpiece looked to her for the restoration or cure of eyesight in this life and for the sight of Paradise in the life to come. This is also how she is shown in the *Annunciation*. Rather than sharing the center of the stage with the angel, as she does in Fra Angelico's similarly composed *Annunciation* from the silver cupboard originally in the SS. Annunziata, she is off to the right, protected by the colonnade of the projecting pavilion (Pl. 124). The space between the pavilions is occupied only by the angelic messenger (Pl. 125), the transmitter to Mary, according to St. Antoninus, of the light of the Holy Spirit (see Edgerton, 1978). However, the Virgin in the *sacra conversazione* and the *Annunciation* are connected not only thematically but also formally. Both she and the *istoria* below her are symmetrically bisected by the altarpiece's central axis, which is also the central ray—the *axis visualis,* as Alberti called it—of the perspective constructions of both panels in which Mary is depicted (the vertical at *D* in Figs. 12 and 21).[50]

[51]

The symmetrical design of the *Annunciation*'s painted architecture was an innovation of the fifteenth century probably first formulated in Masaccio's lost *Annunciation* at S. Niccolò Oltrarno (see Spencer, 1955).[51] The setting of Domenico's *istoria,* with its two projecting wings on either side of an open court, also resembles Renaissance representations of stage sets, and depictions of prosceniums in antiquity (see Battisti, 1960). Indeed, the conception of the painting is theatrical throughout. Among the examples of what Spencer has called the new "spatial imagery" of the Annunciation, Domenico's is the only one in which the figures have been arranged asymmetrically and far apart. By placing the Virgin off to one side and the angel close to the composition's center, the artist has made it clear that it is the latter, the index finger of his right hand pointing upward in a gesture assumed by celestial messengers to signify mediation between heaven and earth (see Tikkanen, 1913),[52] who is the protagonist of the *istoria.* Clearly the angel's pose also exhibits the "rhetorical nature of gestures" (Spencer, 1955) advocated by Alberti in *De pictura.*[53] By virtue of its contrapuntal relationship to the symmetry of the architecture, the asymmetrical disposition of the figures adds a temporal dimension to the painting's spatial regularity and endows the action with dramatic urgency. It also leaves the two bays in the central block of the pavilion between the figures empty. Through one we see the symbolic images of the garden—"the first passage of *plein air* painting in post-classical art" (Clark, 1944)—and the closed door (Pl. 128). The other is bare except for the bench and the square black window, which by repeating the identical window over the head of the angel conducts his message across the courtyard toward the Virgin.[54]

As Saxl (1957) pointed out in a memorable lecture, the geometric harmony of the panel's architecture is a metaphor of divine perfection, and its ground plan is so clear that it "could be used as an actual building plan without any alteration." Indeed, Domenico's painted pavilion is characterized by that "homogeneity of wall, space, light and articulation" which Wittkower (1953) recognized in the interiors of the buildings of Brunelleschi, and which produces, in Wittkower's words, "a psychological situation in which proportions and perspective are felt as compatible or even identical realizations of a metrical and harmonic concept of space" (see also Kauffmann, 1941; Heydenreich, 1963). Yet it would be erroneous to assume, as Welliver (1973) and Verga (1977) have done, that Domenico worked his architectural setting out in ground plan and then projected it onto the surface of his panel. As was the custom in his time, and as he did in all of his perspective pictures, he used a system of surface geometry (Fig. 21). It consists of orthogonals drawn from five equal divisions of the painting's baseline (at *C, E, F, G, H,* and *I*) to the vanishing point at *P. FP* and *GP*, as well as the central ray *DP*, are incised into the panel's surface. As in the *Martyrdom of St. Lucy,* the points of intersection of the orthogonals which define the horizontal plane of the bench at the right (*JP* and *KP*)—and, because of the perfect symmetry in the design of the *Annunciation*'s setting, presumably also on the left (*AP* and *BP*)—are within the module of the divisions of the baseline. *IJ* and *BC* are equal in length to each of its five units, and *AB* and *JK* are half as long and thus equal to *FD* and *DG.* The verticals at *E* and *H* mark the front corners of the pavilion's projecting wings, and the vertical axis at *F* passes through the upward pointing finger of the angel. In height the picture is divided into eight equal zones, four above and four below the horizon (the axis through *P*). The perspective scheme of the *Annunciation,* like those of the Zenobius and Lucy panels, has neither a distance point nor lateral vanishing points. Transversal distances are put in by eye between the horizontal axes below the horizon. The first above the baseline marks the top edge of the step that supports the columns flanking the arch; the second runs along the top of the

bench; and the third is close to the upper edge of the boards nailed to the bottom of the wooden door at the back of the garden. Above the horizon the first axis defines the tops of the square black windows; the second lies on the bottom edge of the architrave; and the third marks the top of the cornice of the recessed central block and is near the top of the architrave of the projecting wings.

While the vanishing point in the Zenobius and Lucy panels is located at the dramatic focus of action, in the *Annunciation* it is in the picture's—and the altarpiece's—theological center, the door at the back of the garden. Bolted in exactly the same way as the door of the house of the three unmarried daughters whom St. Nicholas is providing with dowries in the predella of Gentile da Fabriano's Quaratesi Altar (Pl. 129), it is a simple, sturdy gate such as any Florentine carpenter would make. The picture's vanishing point is marked by a pin hole at the intersection of the lower edge of the boards nailed to the top of the door and the vertical division between its two wings, and it is surely not accidental that these two lines form a cross (Pl. 128). The door, as Edgerton (1978) has shown, is an allusion to the *porta clausa* on the east side of the mystical temple in the Vision of Ezekiel, through which came "the Glory of the Lord which filled the house" (Ezek. 43:4–5). For Gregory and St. Antoninus the *porta clausa* signified faith, while the latter interpreted Ezekiel's "Glory of the Lord" as "the light of the Holy Spirit conveyed by the Angel to Mary" and believed that it was through the *porta clausa* that the angel came to the Virgin at the Annunciation. According to the Gospel of St. John (10:9), Jesus said, "I am the door. By me if any man enter in, he shall be saved. . . ."[55] But the door also seals the garden with its rose bushes, its trellis over the path leading to the gate, and its wall surmounted with identical crenellations as the wall in the *Martyrdom of St. Lucy*. The garden, as Edgerton has also pointed out, is an image of the *hortus conclusus*—"a garden enclosed is my sister, my spouse"—of the Song of Solomon (4:12), symbolizing the Immaculate Conception and, like the lily held by the angel, the Virgin's purity. But the rosebushes and foliated trellis are also the attributes of the Garden of Paradise, traditionally the setting of the *Virgo inter virgines* (see Molsdorf, 1926, pp. 137ff.; Degenhart, 1952).

Domenico has emphasized the symbolic door not only by his location of the vanishing point but also through other formal devices. The most important of these are the archway and the trellis. Foreshortened at the same rate as the floor, they establish successive stages in depth above the horizon line, and thus push the door back into space. On the ground the intervention of the arch is marked by a diagonal shadow (which moves up the left inner face of the arch until, just below the horizon line, it meets the shadow of the entablature). The arch is also flanked by two columns, tall and slender like those in the pavilion's projecting wings but surmounted by composite rather than by ionic capitals. The two columns are significant iconographically as well as formally. They establish a plane of reference in space for judging the arch's thrust into depth. And together with the entablature they support, they surround the arch with a system of classical forms, which, as in the arches leading to the sanctuaries in the *sagrestia vecchia* and the Pazzi Chapel, impose on it an allusion to the triumphal arches of Roman antiquity.

The two black square windows on either side of the columns that flank the arch, besides advancing the flow of the action from left to right, counteract the perspective thrust into depth of the path and the successive arcs of the arch and trellis, and pull the rectangle of the door—the widths of the two windows and of the door are the same—forward from its position deep in space. They thus bring not only the image of the door toward the foreground of the

painting, but to the forefront of our minds that the perspective construction focused on the *porta clausa* is a metaphoric depiction of God's infinite perfection, and that the painting's *axis visualis,* which is continuous with the central ray of the perspective system of the *sacra conversazione,* is also the *axis spiritualis* by which we may apprehend God's Will.[56] As Nicholas of Cusa wrote to Cardinal Nicholas Albergati in 1463,

> keep in mind that in this world we walk in the way of metaphors and enigmatic images, because the spirit of truth is not of this world and can be grasped by us only in so far as metaphors and symbols which we recognize as such carry us onward to that which is not known. (Jaspers, 1974, p. 47)

God's infinite being, according to Nicholas of Cusa, is graspable most fully, clearly, and incorruptibly in mathematical signs (see Cassirer, 1963), preeminent among which is the *recta linea,* in linear perspective the central ray—"the prince of rays," as Alberti also referred to it—which connects the eye with infinity as symbolized by the vanishing point.

In the *Annunciation,* then, the two principal messages of the complex thematic fabric of the St. Lucy Altar—the prophecy of Redemption and the promise of spiritual illumination—are joined in a mutually reinforcing bond. The altarpiece occupies a space between Leon Battista Alberti, who formulated rules of optical vision in order to facilitate the aim of painting "to represent things seen," as he says in *De pictura,* and Nicholas of Cusa or St. Antoninus, for whom the laws of optics were a vehicle for mystic vision and an expression of the immanence of God. Stylistically the work combines a profound understanding of the most advanced art of the second quarter of the quattrocento with the Gothic, trecento tradition of religious painting. Like the culture of mid-fifteenth-century Florence by which it was sustained, the altarpiece embraces Renaissance humanism as well as medieval piety, asceticism, and mysticism.

NOTES

1. This distinction was first formulated by Longhi (1914) and was subsequently developed by Hetzer (1948).
2. White and black, according to Alberti's *De pictura,* are "not true colours but, one might say, moderators of colours." On the other hand, he designated white as a color which gains by being combined with others when writing that it "lends gaiety, not only when placed between grey and yellow, but almost to any colour." Both Cowardin (1963) and Edgerton (1969 and 1975) have commented on the impreciseness of Alberti's terminology of color and the difficulty of understanding exactly what he thought of the nature and function of black and white.
3. For the development in the fifteenth century of the habit of reading the contours of objects as descriptions of the movements of their edges through space, see Argan (1946) and Baxandall (1972).
4. Multiple light sources are also clearly discernible in Gentile da Fabriano's *Nativity* in the Strozzi altarpiece and in Fra Angelico's *Miracle of the Deacon Justinian* from the S. Marco Altar (see Hartt, 1969) and his *Obsequies of St. Nicholas* in the Perugia altarpiece (Pl. 193).
5. In spite of such analogies between theory and practice, it is unlikely, as Edgerton (1969 and 1975) has pointed out, that Alberti's inconclusive and inconsistent color theory could have been of much use to painters. One reason for this may be that unlike Cennino Cennini, whose artistic theory is a descriptive account of the craft of painting, Alberti's theory of art has less to do with painting as craft than as rhetoric (see Cameron, 1975). I suspect that much of what is inconsistent in Alberti is the result of this shift in the focus and context of his ideas about painting in relation to Cennini, whom no painter would have had the slightest difficulty in understanding.

6. Ambiguities in the relationship of foreground figures to their architectural settings—in the zone above the figures the architecture adheres to the picture plane, but on the ground, in order not to block figures from view or interfere with the flow of the narrative, it is tucked behind them— characterize medieval art from early Christian times on. Yet these spatial ambiguities were not recognized as an issue until the development of pictorial space in the trecento, when painters had to find solutions for reconciling the new demands for spatial consistency with the traditional demand for clarity in the representation of narrative and of sacred figures. The formulation of linear perspective by Brunelleschi, though it provided painters with powerful new tools for manipulating and regulating the creation of pictorial space, did not fundamentally change this situation (see Edgerton, 1975).

7. Both Gardner von Teuffel (1977) and John Ward (in a forthcoming paper) present evidence and arguments contesting Shearman's scheme for the main story of the altarpiece as a continuous space with pendant arches, proposing instead—and more convincingly—that the Madonna was divided from the two saints at either side of her by pilasters. Ward has gone further than Gardner von Teuffel in showing that this would not be incompatible with Shearman's view that the Madonna and saints were placed in a continuous perspective space. Ward has also improved Shearman's reconstruction by placing the four saints on one and the same rather than on two levels.

8. The perspective construction of Uccello's *sinopia,* rather than being "unlike anything else that we know," as Procacci (in *The Great Age of Fresco,* 1968) has put it, would, on the contrary, seem to be typical of its time.

9. For previous reconstructions of the perspective of this relief, see Krautheimer (1956), Parronchi (1964), and Seymour (1966). Parronchi has argued that Ghiberti planned this perspective system according to a viewing position of a spectator standing on the ground in the center of the Bronze Doors—below and to the right of the relief. Be that as it may, Ghiberti does seem to have made his perspective scheme as if seen slightly from the right. Its left lateral vanishing point (C) is on the inside of the plain strip surrounding the relief, while the right one (E) is on the outside of this strip. The orthogonals running from the baseline AB to the central vanishing point (D) and the transversals drawn through the intersections of the bundles of lines that connect the lateral vanishing points with the nine equal divisions Ghiberti marked off at the edge of the pavement follow the foreshortened checkerboard pattern incised on the pavement's surface.

10. Sanpaolesi (1954) appears to assume that the perspective construction discovered under the paint layer of this picture was made by Leonardo himself. It could just as well be the work of another member of the Verrocchio shop, however.

11. For the crucial importance of the vanishing point and the horizon in Brunelleschi's perspective system, see Edgerton (1975).

12. Once the utility of the vanishing point and the horizon had been demonstrated by Brunelleschi, three new capabilities were recognized in the bifocal construction: (1) the transversals of a foreshortened checkerboard floor (or ceiling) could be obtained by the intersections between the bundle of lines from a single lateral vanishing point and the orthogonals drawn from the baseline to the central vanishing point (Fig. 5), so that for the purposes of establishing transversals a second lateral vanishing point was not necessary. (2) The same foreshortened checkerboard pattern could be obtained if the distance of the lateral from the central vanishing point was doubled. In the *Disputation of St. Catherine* at S. Clemente, for example (Fig. 18), the lateral vanishing point (R) is placed on the horizon line at the right edge of the composition. A second lateral vanishing point (N) is located farther to the right at the same distance from R as R is from $L,$ and, as Örtel (1933) has shown, in the same place as the central vanishing point of the *Attempted Martyrdom of St. Catherine,* adjacent to the *Disputation* (Fig. 18A). Contrary to Örtel, Krautheimer (1956), and Klein (1961), N is not a distance point but a demonstration of the geometric and proportional properties of the reformed bifocal construction. The concept of the distance point was formulated by Alberti in *De pictura,* perhaps as a result of his realization that in the reformed bifocal construction the transversals of the foreshortened checkerboard pattern could be obtained by the intersections of the lines from a lateral vanishing point with but a single orthogonal, that drawn vertically from the baseline to the central vanishing point (FE in Fig. 3). Alberti's "distance point" construc-

tion is a method for establishing this "perpendicular," as he calls it in *De pictura,* wherever the painter chooses, thus enabling him to determine for himself the distance from which he wishes to make his perspective scheme, rather than having to make it from the same fixed distance close to the picture plane. (3) The lateral vanishing point or points did not have to be at the edges of the composition, even though for the sake of convenience they often continued to be placed there (Figs. 1, 5, 11; Pl. 87), but could be located wherever the artist wanted along the line of the horizon (Figs. 12 and 17). This secured for him the same freedom for deciding the distance from which to make his perspective construction as the *costruzione legittima* of Alberti, and may well explain why during the fifteenth century the reformed bifocal system was in far greater use than the method described by Alberti in *De pictura.* For recent discussion of the bifocal construction, Alberti's perspective method, and the relationship between them, see Klein (1961), Grayson (1964), Parronchi (1964 and 1964a), Edgerton (1966), and the summaries of their as well as others' views by Dalai (1968) and Battisti (1971b).

13. The establishment of this grid, and of a perspective system with a baseline (*BC*) at the beginning of the vault behind the triumphal arch, a central and a lateral vanishing point (*E* and *O*), and the placement of the transverse ribs of the vault along the central axis (*FE*) at the points of its intersection with lines drawn to the baseline from the lateral vanishing point, probably preceded the location of the hemicycles of the vault as reconstructed by Polzer (Fig. 4). The square into which the vault is set in Fig. 4 is formed by the intersections of the axes *HG* and *JI* with *KL* in Fig. 2. *MN* in Fig. 2 is the axis which bisects this square horizontally, from which lines drawn to *P* in Fig. 4, where they intersect the central axis *FE,* mark the centers of the hemicycles of the arches. One of the major differences between the perspective systems of Masaccio and Masolino (see Mesnil, 1927; Francastel, 1967) is that Masolino, although he places his horizon line so that it bisects the composition in equal halves, and is clearly conscious of the importance of surface organization (see the vertical and horizontal axes in Figs. 5 and 18, and especially the placement of the group seen through the window in Fig. 18 between the line of the horizon and the axis *OP*), does not coordinate the construction of perspective with the distribution of forms on the surface with the same rigorous and coherent understanding of their interdependence as the author of the *Trinity*—or as Ghiberti and Domenico Veneziano. Alberti describes his perspective method in Book I, and his reticulated veil in Book II of *De pictura,* without connecting one with the other.

14. For the application of this canon by Donatello, Michelozzo and Ghiberti, see Kauffmann (1935), Parronchi (1964), and Seymour (1966 and 1968). To what extent the proportions of works cited by these authors may be related to Alberti's treatise is a moot point. Much can be said for Grayson's recommendation (in Alberti, 1972) to study how *De statua* "reflects already existing practice and gives it form"—as the formulation of the perspective method in *De pictura* may be the result of Alberti's analysis of the reformed bifocal construction—rather than to speculate on its influence on practice. Nevertheless, I cannot agree with Grayson and Flaccavento (1965) that *De statua* was composed about 1450, but concur with the arguments of Krautheimer (1956), Janson (1961), Parronchi (1964), and Seymour (1966 and 1968) that it precedes *De pictura* and was written in the early 1430s. As for the influence of the treatise on painting, Baxandall (1971 and 1972) has concluded that it was written more for humanist patrons than for painters and has sensibly pointed out that "there was not much reason why the general run of Quattrocento painters should be directly influenced by any text; they learned from visual things, from models, tricks, formulas, groupings." Only Piero della Francesca and Mantegna, in Baxandall's view, could be described "as more than occasionally Albertian." For the influence of Alberti on the latter, see Muraro (1965).

15. Edgerton's "alternate perspective construction" of the *sacra conversazione* (see his Illustration IV-6) falls short of being a true alternative because he has failed to show that raising the horizon would raise not only the height of the arches of the exedra but also the slope of the floor and the placement of the figures and of the columns of the loggia. His reconstruction shows the painting as it would look not, as he claims in a somewhat unclear passage, "if the artist had followed Alberti's rules to the letter, that is, if he had raised the vanishing point to the center and on the same level as the heads of the four saints standing on the ground plain," but if it had two vanishing points—its present one for the floor, and another, higher one for the ceiling.

16. Photographs published by Luporini (1964, Figs, 192, 194, and 204–214) show the identity of the pattern in the spandrels of Domenico's painted architecture and of the Florentine Baptistry (see below), and the similarity of the exedra's entablature with those of the Baptistry, the Palazzo di Parte Guelfa and the Spedale degli Innocenti. The moldings on the arches of the Spedale degli Innocenti's loggia are identical with those on the arches of the loggia in the *sacra conversazione*. The continuous moldings on the exedra's arches resemble those on the arches framing the windows of the Palazzo di Parte Guelfa, the side chapels at S. Lorenzo and the Badia Fiesolana, and the niches on the tomb of John XXIII. The spatially active, scalloped shell behind the Virgin, like the shells in Fra Angelico's Annalena Altar and in Fra Filippo Lippi's *Madonna and Child* in the National Gallery of Art in Washington and *sacra conversazione* from S. Croce in the Uffizi, is most probably derived from the niche of Donatello's *St. Louis of Toulouse*. The exedra's niches, with their smooth surfaces decorated with flat vertical bands, resemble the niches in the Gates of Paradise. The capitals of Domenico's loggia reflect the taste of Michelozzo's architectural decoration (see Heydenreich, 1938), particularly of the tabernacle he began for Piero de' Medici in 1447 at S. Miniato al Monte (see Morisani, 1951), whose column capitals share with Domenico the volutes and the fluted bell, and whose pilaster capitals have Domenico's cabbage leaves growing upward from the astragal (Pls. 70 and 82). For the influence of Brunelleschi's architectural vocabulary on painting, see Fasolo (1938).

17. Before the discovery of this text the panel's subject was thought to have no religious significance at all (Pudelko, 1934), to belong simply to a type of the Baptist as a youth (Berenson, 1926), to allude to the statement in Matt. 3:4 that John "had his raiment of camel's hair" (Kaftal, 1952), or to relate to an emphasis on ascetic subjects reflecting a mid-quattrocento pietistic trend in the wake of St. Bernardino and other preachers of the Observant reform movement (Kauffmann, 1935).

18. Two angels also appear in a small panel of the *Vocation of St. John* in the Kunstmuseum in Bern (see Lavin, 1961), which together with its companion, *St. John the Baptist Preaching,* also in Bern, is attributed by Örtel (1950) to the school of the Romagna of the third quarter of the fourteenth century. The two pictures are by the same hand—surely Florentine and related to Spinello Aretino—as a *Noli Me Tangere* in the Lee of Fareham Collection at the Birmingham Museum and Art Gallery (see Royal Academy, 1931, no. 17; City of Birmingham, 1955, no. 54).

19. For example, an advancing soldier in the *Massacre of the Innocents* on the Siena pulpit by Nicola Pisano; Christ in the *Expulsion of the Money Lenders from the Temple* in the Arena Chapel; Lamech killing Cain in one of the early-fifteenth-century frescoes at the *chiostro verde* in Florence; and executioners in the *Martyrdom of St. Isidore* (ca. 1350–60) on the tomb of that saint in S. Marco in Venice (Saxl, 1957, Pl. 86-b), the *Martyrdom of St. Peter Martyr* in the Spanish Chapel, Masolino's *Execution of the Wife of the Emperor Maximin II* at S. Clemente, or Fra Filippo Lippi's *Lapidation of St. Stephen* in the choir of Prato cathedral. The most durable Christian heir to the posture was St. Michael, who assumes it on the façade of the cathedral of Orvieto (Toesca, 1951, Fig. 784), in a fourteenth-century panel in the Walters Art Gallery (Pl. 98), Bicci di Lorenzo's polyptych in S. Maria Assunta at Loro Ciufanna (Sinibaldi, 1950, Fig. 2), the *Belles Heures du Duc de Berry* (Porcher, 1953, Pl. LXXXVII), and Jacobello del Fiore's *Justice with Sts. Michael and Gabriel* of 1421 in the Accademia at Venice (Pl. 99)—and retains it until as late as the eighteenth century in a gilded wooden statue in a village church in Portugal (Pl. 100). In the celebrated engraving after Baccio Bandinelli of the *Combat of Reason and Love* the posture is reintegrated with a pagan figure, though with Apollo rather than Hercules (Panofsky, 1962, Pl. LVIII).

20. For a different reconstruction of the Florentine Hercules seal, see Ettlinger (1972), who has argued that it is reflected in the *intaglio* seal of Duke Cosimo I de' Medici and in the woodcut on the title page of *Osservazioni istoriche sopra i sigilli antichi* of 1739 by D. M. Manni, which shows a striding figure with a club over his shoulder.

21. For a discussion of the significance and attribution of this figure, see Panofsky (1960), Krautheimer (1956), and Seymour (1966).

22. This 41 cm high statuette (inv. 194) is as far as I know unpublished. The Greek look of Domenico's Giovannino has been noted by Pudelko (1934), Kennedy (1938), Salmi (1936 and 1938), and Seymour (1961).

23. The integration of figures and landscape so that the forms of the landscape follow and amplify the action of the figures was, according to Meiss (1960), one of Giotto's major contributions to Western painting, though it is rooted in the Byzantine concept of landscape, as Demus (1970) has put it, "not only as scenery but as an orchestral accompaniment to the melody of figure composition."

24. The reason why, with the exception of Masaccio, early quattrocento pictorial relief succeeded before painting in producing convincing and coherent perspective pictures is partly that sculptors work with real light, and in pictorial relief manipulate it so that it "paints" their carved or modeled forms. To match the effects of pictorial relief in painting, which, in the words of Leonardo, "carries its own light and shadow everywhere with it," demanded a mastery that painters did not gain until Leonardo himself.

25. For illuminating analyses of the landscape of the St. Francis panel, see Longhi (1925) and Pudelko (1934).

26. One of the examples which Pudelko (1934) cites to show the north Italian affinities of Domenico's landscape style, a *Rape of Deianeira* formerly in the Courtauld Collection in London (see Royal Academy, 1931, no. 41), is surely not north Italian but Florentine and painted about 1450–60 under the influence of Pesellino.

27. If the tablet were foreshortened in accordance with the location of the vanishing point (Fig. 12), we would see it not from the top but from the bottom, and it may have been in order to minimize this inconsistency that Domenico has made the foreshortening of the tablet so extremely shallow.

28. For the development of the iconography of the *Stigmatization,* see Meiss (1951).

29. The motif of the figure looking upward and shielding his eyes was used in the fourteenth century for Joachim visited by the angel (as in frescoes by Giovanni da Milano in the Rinuccini Chapel at S. Croce or by Nardo di Cione in the *chiostro de' morti* at S. Maria Novella) or for one of the shepherds in the *Nativity* (see the panel from Jacopo di Cione's S. Pier Maggiore altarpiece in the National Gallery in London or the *Nativity* by a follower of Taddeo Gaddi in the Musée des Beaux Arts at Dijon [*De Giotto à Bellini,* 1956, no. 9]). It seems to have been first adapted for the *Stigmatization,* as Pudelko (1934) observed, in Gentile da Fabriano's panel in the Carminati Collection at Crenna di Gallerete (Pl. 108), which in its representation of the vision (with the image of Christ holding his arms aloft as if himself in flight) as a supernatural light source illuminating the dark landscape provides a stunning contrast to the *istoria* by Domenico Veneziano. The friar shielding his eyes was then rephrased in one of the pen drawings of 1427 of the Life and Fioretti of St. Francis in the Biblioteca Laurenziana (Degenhart-Schmitt, 1969, no. 199); in a panel by Giovanni dal Ponte in the Musée d'Art Ancien at Brussels (no. 631a); Sassetta's version of the scene from the Borgo San Sepolcro Altar in the National Gallery in London; the predella of Andrea di Giusto's *Assumption of the Virgin* of 1437 in the Accademia in Florence; a badly damaged fresco of about 1440 in S. Maria della Croce al Tempio (see Pudelko, 1934; Paatz, 1940ff., III); an unrecognized panel in the Cleveland Museum of Art (no. 16.787) by the Signa Master (see Zeri, 1963); a compartment in the predella by Fra Angelico in the Pinacoteca Vaticana; and, as Pudelko (1934) also noted, the predella panel by Pesellino in the Louvre from Fra Filippo Lippi's S. Croce altarpiece. Following Domenico Veneziano's picture the posture of his friar continues in the repertory of Florentine art, as in a woven *paliotto* in the Confraternity of the Vanchetoni (*Catalogo,* 1933, p. 27), a damaged fresco in the lunette over the first altar in the left aisle of S. Martino a Mensola, and a miniature in a Choral in the Museo di S. Marco (Alinari 31052). The most impressive example of the posture by a major artist after Domenico is on Benedetto da Maiano's pulpit in S. Croce, and a distant reflection of Domenico's composition can perhaps still be recognized in the fresco by Bronzino on the ceiling of the chapel of Eleanor of Toledo in the Palazzo Vecchio (see Smyth, 1963, n. 114).

30. The friar has an explicitly didactic role in an unpublished predella panel by a provincial mid-fifteenth-century painter in the sacristy of the Florentine church of S. Margherita de' Ricci, where he points the vision out to the congregation (Pl. 109), and in the predella by Domenico di Michelino in the Galleria Communale at Prato, where he imitates St. Francis' gesture.

31. They are related, however, to the perspective construction of Donatello's Lille relief (Fig. 8).

Janson (1957) has pointed out that its baseline is divided into nine equal units and that its vanishing point is three units above the baseline. Its horizon is also the median horizontal axis of a quadratic grid which Donatello, like Domenico Veneziano in his two predella panels, has constructed on the baseline's equal divisions. Like Domenico too he has moved the vanishing point from the center of the composition to where it emphasizes the dramatic action of the *istoria*—in the relief it is over the pivotal foreground figure who recoils at the sight of the presentation of the Baptist's head to Herodias, in the *Martyrdom of St. Lucy* it is where the executioner's dagger enters the saint's neck, and in the St. Zenobius panel it is just to the left of the head of the wailing mother. Moreover, the vanishing point in all three works is equidistant—two units in Domenico Veneziano and three in Donatello—from the quadratic grid's left and bottom edges. Still, while the two artists are clearly thinking along similar lines, the predella panels are no match for the relief's magisterial geometric regularity and coherence. Not only does Donatello's quadratic grid coincide with the dimensions of his composition horizontally as well as vertically, but since the level of the horizon (AB), as well as the segments CD, DE, and EF, correspond to the height of a man standing on the baseline, the module for that line's equal divisions, as in the perspective method described in *De pictura*, is one-third of a man's height, or one *braccio*. Although the Lille relief has an incised checkerboard pavement, the transverse distances of the floor are located neither by the reformed bifocal nor by Alberti's method but in accordance with the horizontal axes of the quadratic grid. Two incised transversals are aligned with the axes GH and JK, and the rest are placed between them by eye. Pope-Hennessy (1974b) disagrees with the date of ca. 1435 Janson has assigned the relief, on the ground that its modular system belongs to a class of composition that is found in painting only about 1450. In pictorial relief, however, it occurs as early as the Gates of Paradise (see Fig. 6), and like Ghiberti's *Isaac and Esau* panel the Lille relief may well reflect the first impact of ideas expressed in *De pictura*. For further discussion of the perspective systems of Domenico Veneziano's St. Zenobius and St. Lucy panels, see pp. 49 and 50.

32. St. Zenobius is usually bearded. The only precedent for his shaved face is in one of the predella panels in the National Gallery in London from Fra Angelico's Fiesole altarpiece.

33. B. ZENOBIUS PUERUM SIBI A MATRE GALLICA ROMAE CREDITUM ATQUE INTEREA MORTUUM DUM SIBI URBEM LUSTRANTI EADEM REVERSA HOC LOCO CONQUERENS OCCURRIT SIGNO CRUCIS AD VITAM REVOCAT/AN(NO) SAL(UTIS) CCCC. For the story, see also Razzi (1627, pp. 78f), who erroneously states that the miracle took place near the church of SS. Apostoli, and Kaftal (1952, col. 1040). St. Zenobius' other two resurrection miracles, as recorded by both Razzi and Giambullari, were the bringing to life of a boy who had been run over by an oxcart, and raising from the dead the son of a noble Florentine family as his body was being taken to be buried. Goodison and Robertson refer to the subject of Domenico's predella panel as the restoration to life of "a widow's son killed by an ox-cart." But according to Giambullari (p. 21), this accident occurred near the cathedral, and neither he nor Razzi (pp. 82f.) place the miracle in the Borgo degli Albizzi. Both, moreover, declare that the boy was brought to life by the prayers, not of St. Zenobius alone, but by the joint prayers of the saint and his "ministers, Eugenio and Crescenzio" (Razzi, p. 83). However, Domenico Veneziano himself seems to have confused the story of the resurrection of the son of the Frankish pilgrim with the miracle of the oxcart, for by showing the boy's spilled blood on the pavement he suggests that he has met a violent death, as by being run over.

34. The competition for the shrine was announced in 1432. Its reliefs were designed perhaps prior to 1437 and certainly by March 1439. Payments to Ghiberti continued until the end of August 1442, the year in which the shrine was installed under the altar of the Duomo's apse (see Krautheimer, 1956). Krautheimer (pp. 154f.) identifies the story on the front of the St. Zenobius shrine as the "Miracle of the Strozzi Boy," perhaps in reference to the legend of the resurrection of the son of a noble Florentine family (see n. 33).

35. This arrangement, which here seems to have its origin, was later used for the same type of composition in Fra Filippo Lippi's *Burial of St. Stephen* in the choir of the cathedral of Prato and other large-scale Florentine frescoes.

36. A painting of the same subject as Domenico's panel and illustrated in Magherini-Graziani (1904)

which, according to Pudelko (1934), shows the Borgo degli Albizzi even more accurately than the *istoria* from the St. Lucy Altar, is surely a forgery, its figures adapted from the repertory of the quattrocento and its setting copied from the picture by Domenico Veneziano. Predella panels of St. Zenobius resuscitating a boy by Benozzo Gozzoli in Berlin-Dahlem and in the Metropolitan Museum of Art in New York follow Ghiberti's relief in their perspective rows of spectators and their depictions of the resurrected as well as the dead child; but their backgrounds—cityscapes with townhouses on either side and a church in the center—show the influence of the panel by Domenico Veneziano. Goodison and Robertson believe the New York panel, part of a predella originally in the Alessandri Chapel at S. Pier Maggiore, to be a "modified repetition" of the picture in Berlin, which comes from an altarpiece painted in 1461–62 for the *confraternità della purificazione* at S. Marco (see Königliche Museen zu Berlin, 1931). Zeri (1971), on the other hand, feels that the Metropolitan Museum version is the earlier of the two. Indeed, in the composition from S. Pier Maggiore, as in that by Domenico Veneziano, the mother is looking at her child, and the ground is spattered with the boy's blood; while in the Berlin panel there is no trace of blood on the ground, and the mother looks not at the child but upward. Because in these respects Gozzoli followed Domenico Veneziano in the painting in New York and not in the one in Berlin, I agree with Zeri that the Metropolitan Museum picture is probably also closer to Domenico's predella panel in date.

37. Domenico's black corner figure seen from the back was repeated, as Meiss (1961a) pointed out, in the *Marriage of the Virgin* at I Tatti. Its painter, probably the young Botticini (see catalogue no. 86, n. 20), must have studied Domenico's panel closely, for, as Meiss also observed, he has imitated the fall of the mantle of St. Zenobius in one of the donors who originally belonged to the same predella as the painting at I Tatti.

38. See Bush-Brown (1952). A variant of the posture, with the hands thrown up rather than back, occurs in a number of quattrocento Entombments of Christ (Donatello's reliefs on the St. Peter's Tabernacle, the Santo Altar and one of the pulpits at S. Lorenzo; the predella of Piero della Francesca's Misericordia altarpiece, the engraving by Mantegna, the small relief by Bertoldo in the Bargello [inv. 267]). It is assumed by Hecuba in the picture of *Pyrrhus Killing Priam* in the Virgil Codex by Apollonio di Giovanni and by the figure in the center of the *Death of Adam* in S. Francesco at Arezzo. It was known to Cosimo Tura (as witness his Louvre *Pietà*) and to Francesco di Giorgio, who used it with great effectiveness in his splendid relief of the *Bewailing of Christ* in S. Maria del Carmine in Venice. Giuliano da Sangallo adopted the posture with arms thrown back, probably derived directly from a Roman sarcophagus, in a relief on the tomb of Francesco Sassetti in S. Trinita (see Bush-Brown, 1952; Seymour, 1966). For the posture in antiquity and the Middle Ages, see Panofsky (1953, n. 24-1).

39. The mother's veil is a particularly good example of what Warburg referred to as the "pathos formula"—the expression of aroused feeling by means of agitated drapery which the Renaissance took over from Hellenistic antiquity (see Warburg, 1932; Paatz, 1941).

40. The vanishing point is also located at the intersection of two axes of a quadratic grid of twenty squares. The horizon line is at the horizontal center of the panel (*AP*), allowing an equally and maximally steep foreshortening for both the street and the tops of the houses. The grid can be reconstructed as follows: the orthogonals incised in the pavement cross a line drawn along the top edge of the painted frame at the bottom of the composition at *I* and *M*. The distance from *I* to the intersection of the vertical drawn through the vanishing point with the baseline (*G*) is one-half the distance from *I* to the inside edge of the painted frame at the right (*K*), and one-fourth of the distance from *I* to *M*. By bisecting *IK* and *KM*, the span between *G* and *M* is divided into five equal units. Four of these units are equal to the height of the panel between the inside edges of its lower and upper painted frames, and two mark the height of the horizon line. The implied ground line for the figures (*DN*) bisects the horizontal zone defined by the baseline and the horizontal *CO*.

41. Niccolò di Pietro Gerini followed roughly the same scheme in his fresco of the *Martyrdom of St. Matthew* in the chapter house of S. Francesco at Prato, and this mural was the model for the panel in the predella of Pietro da Miniato's altarpiece of 1412 in the Galleria Communale there (see Freemantle, 1977). The motif of the executioner advancing on his victim from behind was also

employed in the *Martyrdom of St. Peter Martyr* of Gentile da Fabriano's Valle Romita altarpiece.

42. Fig. 20 shows the panel's original dimensions, which have been cut by about 3.5 cm in height and 4 cm in width (*Q* and *R* mark the painted frame at the right). Its grid of thirty squares, which as in the Zenobius panels overlaps the painting's frame at one side, is constructed on equal divisions of the baseline produced by its intersection with the orthogonals of the foreshortened bench (*JP, KP,* and *LP*) and of the columns of the balcony (*IP*). Each of these divisions is half the distance from *I* to the vertical that runs through the vanishing point (*FP*), and from *F* to the left inside edge of the painted frame (*D*). Five units of the baseline span the height between the inside edges of the painted frames at the top and bottom. The horizontal axis (*UV*), three units up from the baseline, runs along the top of the entablature under the balcony. (Were the executioner standing up straight, it would also mark the top of his hat.) The horizon line (*AO*) is two units from the bottom. One unit defines the rear edge of the bench projecting from the wall behind the figures (*BN*). The horizontal *CM*, which is not a subdivision of the quadratic grid, is aligned with both the top front edge of the foreshortened bench at the right and the bottom edge of the bench running parallel to the picture plane in the back.

43. The gesture of the outstretched hand appears to have been invented by Giotto for one of the tormentors in the *Mocking of Christ* in the Arena Chapel. In the quattrocento it was employed by Masolino for one of the onlookers at the *Raising of Tabitha* in the Brancacci Chapel and for the executioner of St. Catherine at S. Clemente; by Ghiberti for the figure of Christ in the *Baptism* on the Siena font; by Piero della Francesca in the St. John of his *Baptism of Christ* in the National Gallery in London; and in the *sinopia* of Castagno's *Vision of St. Jerome* (see catalogue no. 25). After the middle of the century it became a staple in the repertory of Tuscan painting, as for example in the *Rape of Helen* in the National Gallery in London (catalogue no. 32), Apollonio di Giovanni's *Murder of Julius Caesar* in the Ashmolean Museum, the *Entombment of Christ* in the predella of Piero della Francesca's Misericordia altarpiece, the Opper *Diana and Acteon* (catalogue no. 29), or Vecchietta's *Flagellation* in the vault of the Sienese Baptistry.

44. A comparable alignment of forms in foreshortening with forms parallel to the picture plane at various levels of depth occurs in Piero della Francesca's *Flagellation*. There the orthogonal of the dark beam in the ceiling is continued in the profile of the molding over the door behind Christ and is reiterated in the diagonals of the railing behind the figure of Pilate, in the arms of the flagellator on Christ's left, and in Pilate's posture. There is little doubt that this method of design was transmitted to Piero by Domenico.

45. As Berenson (1898) observed, the striding posture of Domenico's executioner was repeated in the servant pouring wine in Baldovinetti's *Marriage at Cana* of 1448 from the cupboard in the SS. Annunziata, and this relationship has been cited by Salmi (1938) as evidence that the St. Lucy altarpiece must have been completed before the date of the panel by Baldovinetti.

46. One of the stock items in the wardrobe of the International Style, multistoried soft hats like that worn by Domenico's executioner, were probably introduced to central Italy by Gentile da Fabriano and Pisanello. Masolino appropriated them for the *Crucifixion* in S. Clemente and the frescoes in the Baptistry at Castiglione d'Olona. Domenico too came to know and obviously admire them in Rome. He used them in his *Adoration of the Magi* (Pl. 45), and it was probably through him that they were transmitted to the repertory of Apollonio di Giovanni and other Florentine *cassone* painters (for the influence of Domenico on this tradition of painting, see Longhi, 1952). They must also have been worn by figures in his lost frescoes in the Baglioni Palace, since Giovanni Boccati, who made a careful study of Domenico's work at Perugia, employed them in the predella of his *Madonna del pergolato*. Even more striking and surely also derived from Domenico's Baglioni frescoes is the vermilion multistoried hat worn by the executioner at the right of Domenico di Bartolo's *St. John the Baptist Before Herod* from his S. Giuliana altarpiece of 1438 (Pl. 121). In several respects Domenico di Bartolo's painting is indebted to Ghiberti's relief of the same subject on the font in the Sienese Baptistry (see Ash, 1968); but it can also be connected to the Pisanello atelier at S. Giovanni in Laterano. The guard seen from the back has the same posture as Domenico Veneziano's Giovannino, a posture Domenico probably drew from the front after a figure on a Graeco-Roman sarcophagus while he was in Rome. And a drawing of the *Arrest of St. John* in the British Museum

thought to be a copy of one of the Lateran frescoes (Fossi-Todorow, 1966, no. 179) shares with the *istoria* by Domenico di Bartolo the arrangement of the narrative in two blocks, Herod's pointing arm, and the armor of the guards who are bringing the Baptist before the king.

47. Basically the same stage set was employed by Masolino for the *Attempted Martyrdom of St. Catherine* at S. Clemente.

48. The relationship which Pudelko (1934) suggested between the form of the Virgin's head and the heads of the Madonnas in Domenico di Bartolo's panel in the Rifugio at Siena, Paolo Schiavo's tabernacle at S. Piero a Sieve, and Francesco d'Antonio's fresco at Montemarciano (see Shell, 1965) and tabernacle in the Piazza S. Maria Novella (a group to which should be added the *Madonna of Humility* from the Osservanza Master's *Birth of the Virgin* at Asciano) fails to carry conviction. For the general stylistic connection between Francesco d'Antonio and Domenico's Carnesecchi Tabernacle and I Tatti *Madonna,* see p. 13.

49. The transparent halos also have the advantage of not obscuring the architectural forms behind the figures. In his other works, in which this is not an issue, Domenico's halos themselves—in the form of solid discs seen in perspective—have an architectural, space-defining function.

50. It is characteristic of Domenico's geometrically conscious mode of thought that the central axis should pass through both the right hand of the Christ child and the left hand of the Virgin (and that the vertical axes at *C, E,* and *F* should intersect the right hands of John and Zenobius and the left hand of Lucy).

51. Spencer's list of works in which the new scheme was adopted omits the *Annunciation* by Masolino on the outside wall of the chapel of St. Catherine at S. Clemente, whose architectural setting composed of a pavilion with projecting wings at either side seen from below anticipates the predella panel by Domenico Veneziano, as well as a number of later examples: the centerpiece of the predella of Domenico di Michelino's *Trinity* in the Accademia in Florence; Neri di Bicci's *Annunciation* from S. Andrea at Mosciano (also in the Accademia); the predella panel by Fra Filippo Lippi in the Griggs Collection at the Metropolitan Museum of Art (see Zeri, 1971); two *Annunciations* by Vecchietta (the *cimasa* of the Spedaletto altarpiece in the museum at Pienza and a fresco in the sacristy of the Spedale della Scala at Siena); and a lunette by Bartolomeo della Gatta in the Musée de Perigueux (see *De Giotto ò Bellini,* 1956).

52. The gesture was used for the angel of the Annunciation by Jan van Eyck (in the Ghent altarpiece, the triptych at Dresden, and the panel in the National Gallery of Art in Washington); Fra Angelico (the panel from the silver cupboard from the SS. Annunziata); and in the *Annunciation* in the Isabella Stewart Gardner Museum in Boston (see Zeri, 1953). The upward-pointing index finger is also frequent in Renaissance images of St. John the Baptist, as in the predella panel by Rossello di Jacopo Franchi in the Galleria Nazionale dell' Umbria at Perugia, Ghiberti's *St. John Before Herod* in the Baptistry at Siena, two of the predella panels of Domenico di Bartolo's S. Giuliana polyptych of 1438, a panel at Indiana University (see catalogue no. 21), and a small picture of *St. John the Baptist* in the Musée Condé at Chantilly (Pl. 130) by the assistant of Fra Filippo Lippi who painted the compartment of *St. Nicholas Saving Innocent Victims from Execution* in the predella of the S. Lorenzo *Annunciation* (Pls. 130–131).

53. For the relationship of the gestures of the angel and the Virgin to the characterization of the Annunciation in contemporary sermons, see Baxandall (1972).

54. Pudelko (1934) correctly observed that Domenico's use of black—in the windows here, the figures of the St. Zenobius panel, and the hat of the executioner of St. Lucy—is contrary to Alberti's notion that black and white are not true colors. However, the blacks in Domenico's paintings revive not only, as Pudelko claimed, the palette of Duccio and the Lorenzetti, but like the triple arcade in the *sacra conversazione,* the compositional scheme of the *Martyrdom of St. Lucy,* and the St. Lucy Altar's luminous tonality, Domenico's blacks revert to a tradition of Florentine trecento painting. Cennino Cennini listed black as one of the seven natural colors; and the masters of what Offner called the "miniaturist" and "decorative" trends in Florentine painting—especially Bernardo Daddi, Nardo di Cione, the Master of the Bambino Vispo, and in the quattrocento Fra Angelico— employed it to great advantage in their coloristic designs.

55. Edgerton has made a connection between the light that enters the *Annunciation* from the right and the fact that the clerestory windows through which light enters the church from the right look toward the east. According to St. Antoninus, the Annunciation took place in the east at dawn, and Edgerton has argued that Domenico planned the altarpiece to be "lit" by the eastern clerestory of the church of S. Lucia as if by way of illustrating St. Antoninus' belief. Hartt (1969) has specifically interpreted the door in Domenico's painting as an allusion to Salvation and to the Cross.

56. St. Antoninus devoted a chapter of his *Summa Theologica,* entitled "Concerning Those Things Which Are Required for Good Seeing Both Corporeally and Spiritually" (Tomus I, Titulus III, Caput III, col. 118), to the correlation of optical and mystical vision. See Edgerton (1978).

CHAPTER III

DOMENICO VENEZIANO'S ARTISTIC DEVELOPMENT

I

Domenico's surviving works may be arranged in four chronological groups, each marking a phase of his own development and of the evolution of Florentine art. (1) The Carnesecchi Tabernacle and the *Madonna* at I Tatti, painted between his arrival in Florence from Rome, probably in 1432, and his departure for Perugia in 1437, and related to a period style in which Fra Angelico and the Florentine minor masters assimilated the principles and implications of linear perspective and of the art of Masaccio and Masolino. (2) The *Madonna* at Bucharest and the *Adoration of the Magi* at Berlin, in which Domenico reanimates the northern Italian International Style with the vigor of Florentine realism (ca. 1437–41). (3) The St. Lucy Altar (ca. 1445–47), with its revival of trecento traditions in color and design, and its realistic, plastically inflected contours. And (4) the Kress *Madonna* and the mural of *Sts. John the Baptist and Francis* at S. Croce (ca. 1448–53), done in a new linear style at the beginning of a pietistic phase in Florentine art which also found expression in the works of Fra Filippo Lippi, Andrea del Castagno, Desiderio da Settignano, and Donatello.

"His great but sadly damaged Madonna," Holmes (1923) wrote of the Virgin of Domenico's Carnesecchi Tabernacle (Pl. 1),

proves him a fine colourist, and in its geometrical planning we may discern a scientific bent of mind akin to his contemporary Uccello and his pupil Piero della Francesca. Like Piero, and like Masaccio too, is the monumental dignity of the Virgin, while his noble portrait heads [Pls. 2 and 3] show with what refinement of tonality and contour Domenico painted. By this refinement on contour the artist gains a certain advantage over the ruder methods of Graeco-Roman work. His line may not have the same appearance of vigour,

[64]

but it is capable of far more subtle variation, and so conveys, in the case of the human face, a far more delicate indication of the sitter's physical and spiritual temper. Also from its tender quality it suggests an atmosphere of remoteness, whereby an impression of grandeur of scale is conveyed to the spectator. (p. 19)

It would be difficult to improve on this characterization of the solemn and impressive work— and of the essentials of Domenico's style. The relationship between the Carnesecchi Tabernacle and Paolo Uccello has also been stressed by Pudelko (1934) and Salmi (1936 and 1938). However, we may surely dismiss Salmi's thesis, founded on the assumption that Domenico began his artistic career in northern Italy, that the fresco's stereometrically clear forms show his "Florentinization" under Uccello's influence, and that Uccello collaborated with him in its execution. Indeed, the system of surface geometry which underlies the work's perspective construction and compositional arrangement is wholly within the canon of Domenico Veneziano (Fig. 1).

Undoubtedly worked out on a cartoon and then transferred to the wall of the tabernacle, it probably corresponds to the fresco's original dimensions (see catalogue no. 1). Like the geometric scheme of the *sacra conversazione* of the St. Lucy Altar, it is a reformed bifocal construction with a baseline divided into six equal units. On these Domenico has built a quadratic grid of fifty-four squares, in which the horizon line (HL), not as low as in the St. Lucy altarpiece, is four units high. The grid's first horizontal axis above the baseline marks the placement on the meadow of the section of the platform that bears Domenico's signature (Pls. 4–5), while the second lies on the intersection of the platform with the base of the throne. The third horizontal above the horizon defines the height of the throne's sides and passes through the hands of God, and is there crossed by the verticals at C and E, which establish the corners of the throne behind the figures. The fourth horizontal axis above the horizon (OQ) is at the level of God's lips (P). Diagonals drawn from this point to the horizon (PI and PK) inscribe the Holy Dove and the Virgin and Child in a triangle, and bisect the orthogonals which define the rate of foreshortening of the cornices surmounting the sides of the throne (OJ and QJ). Another triangle (MRN), its sides establishing the slope of God's extended arms and passing through the points of intersection of the vertical and horizontal axes in his hands, inscribes his image as well. The fresco's central vertical axis (DR) comprises both the central ray of the perspective construction and the vertical ray issuing from God's lips, visually demonstrating that the *axis visualis* of linear perspective is identical with the *recta linea* by which God makes his will known (see p. 54).[1]

Domenico's habit of integrating perspective with surface design, and architecture with the placement and the gestures of figures, is seen to particular advantage in the posing of the Christ child. His fingers raised in blessing are placed on the vertical axis at C, which also passes through the right hand of God and defines the corner behind the Child of the throne's superstructure. The arm with which he steadies himself by holding on to his mother's wrist is aligned with the orthogonal of the upper edge of the throne's left side; and his blessing arm runs parallel to the diagonal that meets the central axis in the mouth of God. How did Domenico Veneziano come by such geometric coherence and control, which are the principal sources of the lucidity of his works and the most fundamental traits he transmitted to Piero della Francesca? Their appearance in the Carnesecchi Madonna should be seen in the context of four phenomena of the time. (1) The fact that between Brunelleschi's demonstration of

linear perspective in the century's second decade and the mid-1430s at least four artists—Masaccio (Figs. 2–4), Masolino (Fig. 5), Donatello (Fig. 8), and Ghiberti (Figs. 6–7)—had in various ways thought out compositions along similar lines (see pp. 40 and 59). (2) The taste for regularity, harmony, and balance in design that dominated Florentine painting, whether in the works of Fra Angelico and his atelier or in the productions of his lesser contemporaries, during the years in which Domenico received his first commissions as an independent master (see p. 13). (3) The emphasis on geometrical principles, methods, and devices in Alberti's *De statua* and *De pictura*.[2] (4) The period belief that symmetry and regularity were metaphors for divine perfection and expressions of God's immanence in the world.

Which of these ideas or examples specifically guided Domenico Veneziano is impossible to say. There can be little question, however, that he was a close student of Masaccio's *Trinity* (Pl. 9), for the Carnesecchi Tabernacle is indebted to it for much besides the Virgin's "monumental dignity:" the steeply foreshortened rectangular space containing figures conceived as rounded, sculptural masses; the alignment of architectural forms and figures with the axes of a quadratic grid built on the equal divisions of the baseline of the picture's perspective construction (Figs. 1–3); the dominant color chord of blue and red; and the incorporation in the spatial and surface design of the imposing image, his arms outstretched, of God the Father.

While in its principles of design the Carnesecchi Tabernacle is related to the Florentine avant-garde of its day, it also relies on earlier tradition. In accordance with the mural's function as an outdoor tabernacle in the medieval streets of Florence, the Virgin's throne—the harshness of its foreshortening probably motivated by Domenico's wish to compensate for the fact that as originally located the work was seen from below (see catalogue no. 1 and Pl. 8)—has its source in a type developed in Tuscany in the fourteenth century, when the throne was first employed as a spatial enclosure.[3] In this respect, therefore, though perhaps also in its uniformly bright illumination and in the solemn, hieratic character of its figures, the painting belongs to the early quattrocento Giottesque revival which, as Boskovits (1966) has shown, ran parallel to the Florentine revival of classical antiquity. At the same time, Domenico's throne shows that he was the first major quattrocento artist who perceived the beauty of the colored geometric marble inlays of the proto-Renaissance. The oval inlays of the throne's sides and the circular and rectangular colored marbles of its platform and base set a fashion which was taken up, as Pudelko (1934) pointed out, by Alberti, Botticelli, and the Pollaiuoli, and which, like the pose and the "carriage of the head" of the Virgin, anticipates the mature paintings of Piero della Francesca (see Clark, 1951).

In the contrasting postures of their heads—one looking up, the other looking down—the two saints on either side of the Madonna's throne—the bearded one probably on the left—anticipate a similar rhythmic alternation between an introspective, relaxed figure and a tense, alert one in the Sts. Francis and John of the St. Lucy Altar and the mural from the Cavalcanti Chapel in S. Croce. From the similarity of the heads of the *Bearded Saint* and of the *St. John the Evangelist* on the vault of S. Tarasio (see catalogue no. 46; Pls. 2 and 13) Berti (1963) has concluded that the two figures probably had the same posture and gait. Be that as it may, the saint's inclined head emphasizes the weight and pressure of his body on the ground; while the glance and the turn of the head of his beardless companion invest the body's gravitational mass with the expression of physical and psychic energy. The articulation of mass and energy as opposing forces in the human figure would seem to have been one of the major innovations of Donatello. The *Beardless Saint*, who in the turn of his head away from the axis of his body

resembles the contemporary *St. Lawrence* in one of Donatello's lunettes in the *sagrestia vecchia* (Pl. 17), as well as the Carnesecchi Tabernacle's Christ child (Pl. 6), are the earliest adaptations by Domenico of this innovation to painting (see also Pls. 31, 60, 65, 132 and 138).

A similar contrapuntal relationship as that between Domenico's two saints is expressed by the contrast of the postures of the reading figure of St. Mark and the heavenward-looking St. Peter on the exterior wings, paid for on August 6, 1436 (see chap. I, n. 25), of the Linaiuoli Tabernacle (Pl. 18). The interior of Fra Angelico's altarpiece too (Pl. 18)—in its balanced design, stereometrically lucid Virgin, and monumental figures of John the Baptist and John the Evangelist in the wings on either side of her—has analogies of style and organization to Domenico's tabernacle which clearly show that the two works belong to the same phase of the evolution of Florentine art.[4]

A good example of the blending of advanced and conservative ideas that characterizes this phase is the Carnesecchi Tabernacle's Christ child (Pl. 6), defined by his mother's hands as a rounded, sculptural solid and stepping into the light that enters the composition from the left at the head of a movement which begins in the outstretched arms of God and finishes in the enclosing arms of the Virgin. The type of the standing, blessing Child was established in the trecento (see Shorr, 1954, p. 29)[5] and includes at least one notable example—Nardo di Cione's large panel in the New York Historical Society—in which, as in Domenico's fresco, the little figure is nude. In the specific posture of his blessing Infant Domenico followed the clothed figure in Lorenzo Monaco's Monte Oliveto altarpiece in the Uffizi, which was also the model for the Child—clothed as in the painting by Lorenzo Monaco—in the Cortona altarpiece of about 1435–46 by Fra Angelico. (Alone among the works which have the same thronal platform as the Carnesecchi Tabernacle, the Cortona Altar also shares with Domenico's mural the platform's pointed tip.) In depicting the Infant nude rather than clothed Domenico may have looked back to Gentile da Fabriano, who had painted images of the nude standing Christ child in his early *Madonna with Saints and Donor* in Berlin and, in the mid-1420s, in his *Madonna and Child* at Yale (Pl. 30).[6] But the rounded, naturalistic modeling of the figure's planes and muscles, the distribution of his weight, the forward slope of his belly, the slight twist of his torso in accordance with the actions of his arms, and the turn of his head in the opposite direction—in all these structural aspects Domenico shows that already by the mid-1430s he had learned the lessons of quattrocento sculpture.

Domenico's Child was appropriated practically verbatim in a *Madonna and Child with Two Angels* by Andrea di Giusto in the Florentine Accademia (Pl. 20), a fact which has some bearing on the fresco's date. Andrea di Giusto's panel repeats the composition of the central compartment of his polyptych of 1435 in the Galleria Communale at Prato, whose Virgin and Child are copied from the Monte Oliveto altarpiece of Lorenzo Monaco, but with two revisions: the figures are less elongated, so as to have a more modern, less International Style look, and the Christ child, following Domenico Veneziano, is nude. Though we cannot be sure of the exact date of Andrea's Accademia picture, it is typical of the style of the Florentine minor masters of the mid-1430s. One would like to think that after he painted the Prato polyptych Andrea was commissioned to produce a smaller version of its central compartment, brought up to date by de-Gothicizing the figures and by substituting Domenico Veneziano's Infant for Lorenzo Monaco's.[7] In any event, the Accademia panel would seem to confirm that shortly after 1435 Domenico's tabernacle could have been admired above the Canto de' Carnesecchi.

In these years Domenico probably also painted one of the most beautiful devotional pictures of the quattrocento, the *Madonna and Child* at I Tatti (Pls. 24–27). In its brocade background and in the contrast between its cool, dark colors and the burnished gold leaf of the Virgin's dress it shows to an even greater degree than the Carnesecchi Madonna the "renewed concern with the courtly style of Gentile da Fabriano" which Shell (1965) recognized in Florentine painting of the mid-1430s. The Berenson *Madonna* being an easel painting in tempera rather than a monumental public mural, Domenico has adjusted the arrangement of the figures and of their gestures to the picture's format and geometric design more subtly than in the tabernacle. And since the figures in the panel are seen against a flat ground rather than within a foreshortened box, ornamental pattern and three-dimensional form too are closely interwoven. The head of the Infant, for example, takes the place of the pomegranate pattern at the lower right of the brocade background (the pomegranate at the lower left is just visible behind the Virgin's shoulder); and the middle finger of the Virgin's raised hand merges with the punched border of her gilt dress.[8] The composition's system of stable, frontal, symmetrical forms is animated, as a column is by its entasis, by the hushed pantomime, focused on the pear sprig in the Virgin's hand to the right of center, between the Mother and Child (Pl. 25);[9] and its geometric rigor and clarity endow the Berenson *Madonna* with qualities of measure, lucidity, and restraint in expression which we later encounter in the works of Piero della Francesca, and which Clark (1951) has related to the sculptures of the Temple of Zeus at Olympia. At the same time, Domenico's panel shares with other Florentine paintings of the mid-1430s—Fra Angelico's *Madonna of Humility* in the Galleria Sabauda at Turin (a copy of which by Andrea di Giusto at I Tatti bears the date 1435), Bicci di Lorenzo's *Madonna* of 1433 at Parma, or Francesco d'Antonio's *Madonna and Child with Five Angels* in the collection of the Earl of Haddington (Shell, 1965, Fig. 13)—not only its ornamental luster and dark color, but also the regularity, harmony, and balance of its compositional organization. Indeed, one would like to think that upon his probable arrival from Rome in 1432 Domenico played a decisive role in the articulation of the style which found its loftiest and noblest expression in his *Madonna* at I Tatti.

Although the background of the painting contains no indications of a spatial setting, the figures nevertheless occupy a light-filled zone of space between the picture plane and the brocade cloth. That they do so is due to: (1) their foreshortened halos, with the Infant's cut by the right edge of the panel so as to insure the illusion that its exists within the pictorial space; (2) the effect of relief produced by the modeling of the Child's body and the head and hand of the Virgin; and (3) the placement of the Christ child's feet and of the cushion on which he is seated—perhaps inspired by the position of the *putti* in the *Players on Psaltery* of Luca della Robbia's marble *cantoria* (Pl. 29)—on the picture's bottom edge (Pl. 26) so that the volume between his legs and arms (the latter clarified by the insertion of the foreshortened hand of Mary) push the torso of the Virgin back into space.[10] Yet the posing of the Infant is motivated not only by aesthetic objectives but also, like the pillow on which he sits, the pear sprig for which he reaches, and the brocade backdrop with its figures of pomegranates, by the painting's function as a vehicle for transmitting theological meaning. The bottom edge of the panel, as in Giovanni Bellini's *Madonna and Child with Two Female Saints* in the Accademia in Venice, implies the parapet that runs along the lower border of the great majority of Giovanni Bellini's half-length Madonnas as an allusion to both Christ's tomb and the Christian altar; the pillow refers to the Christ child asleep in simulation of his death; and the brocade is the "cloth of honor" which invests the devotional image of the Virgin and Child with ceremonious presence

(see Goffen, 1976).[11] The pear sprig in Mary's hand, as on the cope of St. Zenobius in the St. Lucy Altar (see p. 42), is a symbol of Redemption (see Friedmann, 1947), and the pomegranates in the "cloth of honor" signify Resurrection (see Ringbom, 1965, p. 304, n. 10).

II

When he went to Perugia in 1437 Domenico Veneziano had as far as we know resided only in the most advanced artistic centers of central Italy: Florence (ca. 1422–26), Rome (ca. 1426–32), and again Florence (ca. 1432–37). In the two surviving works which follow his return to Florence from Rome he had shown a superb mastery of the Florentine idiom of his time, and had elevated that idiom to heights of form and expression in which may be recognized the premises of the art of Piero della Francesca. The contrast which he now encountered between the artistic cultures of Florence and Perugia could not but have deeply impressed and affected him. The style of Perugian painting at the time of Domenico's arrival was by and large a product of three traditions: the fresco decoration of the Upper and Lower Churches of S. Francesco at nearby Assisi, Sienese painting, and the northern Italian International Style which reached down the east coast of Italy from the Veneto to the Abruzzi. It was probably not by coincidence, but as a result of an effort to reform and invigorate this repertory with new ideas that an altarpiece by Fra Angelico, who had already painted two major works for Cortona, was installed in 1437 in the Perugian convent of S. Domenico, and that in the same year Domenico Veneziano was summoned to Perugia to decorate a room in the Baglioni Palace. Notwithstanding the influences on Perugian painting of Fra Angelico, and later of Fra Filippo Lippi and Piero della Francesca, it was the art of Domenico Veneziano, as has been masterfully shown by Zeri (1961), by which the painters of Perugia set their sights until the advent in the last quarter of the century of the young Perugino.

The principal agents through which Domenico left his mark on Umbrian painting were his lost frescoes in the Baglioni Palace (see pp. 16–17). But during his stay in Perugia he also seems to have produced the *Madonna* now in Bucharest (Pls. 31–34). Iconographically the picture belongs—whether by personal choice or in accordance with the terms of the commission—to the only ingredient of Perugian painting, the northern Italian International Style, that was congenial to him. However, he transformed the theme of the Madonna seated before a rose hedge, familiar in the art of Lombardy, Verona, and Venice,[12] into a vehicle of unprecedented vitality. Not before the paintings of Dürer or the young Cranach are the forms of plants again endowed with such plastic energy as Domenico's rose leaves. The posture of the striding Child too has been charged with extraordinary movement and vigor. Employed in painting and sculpture since the early fourteenth century, it occurs again in Domenico's later *Madonna* in the Kress Collection (Pl. 132).[13] But its appearance in the Bucharest *Madonna* is one of the two occasions I know—the other being Gentile da Fabriano's *Madonna* at Yale (Pl. 30)—in which the forward stride of the Christ child endows his gesture of blessing with life and immediacy. His posture does not merely suggest the affectionate relationship between Mother and Child or the Child's liveliness, but expresses an action appropriate to its prophetic implications: under the watchful eye of Mary, the Infant, his outstretched arm guiding the direction of his stride, hurtles toward the red rose of martyrdom which she is holding away from his reach (Pl. 34). The symbolic meaning of the Virgin's and the Child's gestures, depicted with solemn poise and grace in the *Madonna* at I Tatti, is here enacted as realistic physical and psychologi-

cal drama—so much so that the Christ child has been deprived of his halo, and the foreshortened, space-defining disc over the head of Mary serves as the halo for both figures. While maintaining his earlier Florentine paintings' dark color and frontal, symmetrical, balanced mode of design—observe the alignment of the tassels of the throne with the vertical branches of the rose hedge on either side of the Virgin—Domenico has invested the Bucharest *Madonna* with a dynamism of action hardly predictable in the restraint and formality of the Berenson *Madonna* and the Carnesecchi Tabernacle.

The sources for Domenico's realistic conception of the subject were of course embedded in the whole of his artistic education. From Gentile da Fabriano he learned to paint leaves and flowers (Pl. 35). He was indebted to Masaccio for the declaration of mass and weight in the block of the Virgin and Child. And Donatello, who since 1435 (see Janson, 1957) had been working on the sprinting *putti* for his marble *cantoria*, provided the precedent for the charging, twisting figure of the Infant. However, the Florentine artistic milieu of the mid-1430s was unfavorable not only to showing the Virgin and Child in front of the complex spatial pattern of a floral hedge, but also to the Bucharest *Madonna*'s direct and forceful borrowings from the innovations of Masaccio and Donatello. In 1437, with Fra Filippo Lippi's explosive *Madonna and Child* in the Palazzo Barberini (Pl. 76), commissioned not by a Florentine patron but by Cardinal Vitelleschi and upon completion taken by the cardinal to his native city of Corneto Tarquinia, though Domenico could have seen it in Fra Filippo's studio before he left Florence for Perugia, this situation began to change. For Domenico it seems to have been the cultural climate of Perugia, backward and provincial but anxious to keep abreast with the innovations of Florence, which encouraged him to explore formal and dramatic aspects of quattrocento realism largely incompatible with the taste and style of Florentine painting during the five years following his return to Florence from Rome.

We know neither whether Domenico painted the Bucharest *Madonna* before or after the murals in the Baglioni Palace, nor how soon after having written to Piero de' Medici he left Perugia. All we can be sure of is that by the early spring of 1439 he was working at S. Egidio (see p. 202). Upon his return to Florence, perhaps accompanied by Piero della Francesca, to whom a payment is recorded at S. Egidio on September 12, 1439, but whose indebtedness to the early style of Domenico Veneziano would tend to bear out Zampetti's (1969, I, p. 47) hunch that he had already been Domenico's apprentice at the Baglioni Palace, he found the ranks of painters augmented by Fra Filippo Lippi, now permanently established after his sojourn during the mid-1430s in Padua, and by Andrea del Castagno, perhaps trained in Domenico's atelier during the mid-1430s, and about to deliver the first proof of his precocious, formidable talent in the *Crucifixion* for S. Maria Nuova (see Hartt, 1959). That the vigor with which these artists infused Florentine painting through their dramatic, sharply focused lighting, luminescent metallic colors, and plastically charged contours may have been reflected in Domenico's *Meeting at the Golden Gate* and *Birth of the Virgin* is suggested by his *Adoration of the Magi* in Berlin (Pls. 38–45), the most sumptuous, vividly realized of Domenico's surviving works, probably painted during the interval (from September 1439 to the spring of 1441) between his two murals at S. Egidio.

From the inventory of the Medici Collection made after the death of Lorenzo the Magnificent we know that in the fifteenth century Domenico's tondo was in the Medici Palace. Hendy (1968), following Pudelko (1934), has called the panel "a wonder picture produced by Domenico for Cosimo de' Medici or his son Piero as proof of his virtuosity" in response to the

artist's letter to Piero from Perugia. It seems unlikely, however, that the commission would have been awarded him on the basis of just his letter. Indeed, he probably received it only after he had completed the first of his murals at S. Egidio. In its inscriptions and its visual pageantry the tondo appears to allude both to the Medici family and, as the lost frescoes also may have done, to the Council of Florence.

The tondo's inscribed mottoes—the Italian *tenpo,* the Latin HONIA BOA IN TENPOR, and the French *ainsi va le monde* and *grace fai die(u)*—are as far as I know unique in a religious painting of the quattrocento. In Italian art French mottoes are found on astrological pictures, such as an engraving of the *Planet Venus* of about 1460–70, which Warburg (1932, I, Fig. 22) traced to a Burgundian variant of a German original, or in the context of chivalric pictorial cycles like the murals of the *Seven Ages of Man* of ca. 1424 in the Palazzo Trinci at Foligno (see Salmi, 1919). Beyond scattered instances in quattrocento art of dicta referring to time,[14] devices invoking temporality are especially associated with the Medici. The motto of both Piero de' Medici and his son Lorenzo was the word SEMPER (it is inscribed on the harness of the horse ridden by Piero at the head of the cortège of the magi in Benozzo Gozzoli's frescoes in the chapel of the Medici Palace), and at the *giostra* in the Piazza S. Croce of 1469 Lorenzo wore a scarf on which was written in pearls the motto *le temps revient.*

The introduction of inscriptions from the late medivial milieu of chivalry in a Medici picture of the *Adoration of the Magi* of about 1440 is consistent with the family's interest at that time in the Florentine Company of the Magi (see Hatfield, 1966 and 1970a). From 1436 on the Medici were the principal patrons of this confraternity, which had its headquarters at S. Marco, and which beginning in 1428 staged annual *feste* dedicated to the three magi, celebrations which gave expression to the desire of the Florentine aristocracy to preserve the courtly pageantry and chivalric code they could no longer maintain in their daily lives as citizens, and whose visual opulence is reflected in the splendor of the tondo's costumes. The three kings, as Hatfield has noted, became the "heraldic representatives" of the Medici; and pictures of the *Adoration of the Magi* commissioned by them, like the frescoes by Benozzo Gozzoli in the Medici Palace or the painting by Botticelli in the Uffizi, began to display their portraits. A tradition of inserting portraits of contemporaries in depictions of the *Adoration of the Magi* goes back at least as far as Altichiero's mural in the Oratorio di S. Michele at Padua. It includes the Emperor Sigismund in Gentile da Fabriano's Strozzi altarpiece (see Scaglia, 1968) and the notary Giuliano degli Scarsi and his son in the predella from the Pisa altarpiece by Masaccio. In the figure looking out at the spectator to the right of the two young kings Domenico Veneziano's tondo too appears to contain a portrait (Pl. 44). He has a prognathous jaw and a sharp, prominent nose. Though apparently young, he seems old beyond his years and physically infirm. There can be little doubt that he is Piero de' Medici.[15] His features match those in the bust of 1453 by Mino da Fiesole (Pl. 46) and of his portrait in Benozzo Gozzoli's frescoes in the Medici Palace (Pl. 47).[16] But unlike these later likenesses, Domenico's portrait of him in his mid-twenties—Piero was born in 1416—expresses something of what we know of his life history: that he was sickly from childhood on and at an early age began to suffer from gout. He is dressed in the same black-and-white costume as the man on horseback wearing a red hat at the far left. According to Smith (1974), this is the huntsman, who with his outstretched arm has released the two peregrine falcons—not, as Smith would have it, hawks—in order to attack a heron.[17] The falconer's gesture also points toward the Christ child and the figure of Piero de' Medici, who, like the man behind the youngest king in the *Adoration* by Gentile da Fabriano

(Pl. 51), is holding a falcon, a symbol of the faithful (see Davisson, 1975, n. 76) and Piero's personal emblem (see Hatfield, 1966, II, n. 97). In contrast to the huntsman on horseback—and as is underlined by the huntsman's gesture—Piero has his falcon with him. In terms of the metaphor of falconry, therefore, he is depicted as the custodian of the faithful, a role the Medici might well have wished to assert as the ruling family of Florence at the time of the Council of Florence. Indeed, it is from this context that Piero's outward glance toward the spectator would seem to derive its purpose and meaning.

But beyond their references to the Medici family and the chivalric taste of the Company of the Magi, the tondo's inscriptions also have a collective significance. It is the way of the world, they appear to say, that through the grace of God all goodness will in time come to pass; perhaps in reference to the birth of the Saviour, and perhaps also—especially because two of the four mottoes invoke time—as an allusion to the union of Christendom which was unsuccessfully sought at the Council of Florence, but which will in time surely come about.[18] Thus the pomp of the magi and their cortège may be not only a pictorial reenactment of the festivals mounted by the Florentine Company of the Magi, but also a citation of the council which was attended by Emperor Palaeologus and his retinue from Constantinople. The fashions of the Greek contingent had a profound influence on Florentine artists, visually because of their exotic splendor and iconographically because the Florentines believed, as Vespasiano di Bisticci (1938) put it, that "the Greeks in fifteen hundred or more years never changed their costume." Indeed, the hats worn by two riders at the rear of the cortège (Pl. 39)—one a folded cone set into a turban, and the other an upward-flaring cylinder (also worn by Lysias in Fra Angelico's *Sts. Cosmas and Damian Before Lysias* from the predella of the S. Marco Altar)—do not appear in Florentine painting, as Hatfield (1966, I, n. 27) has observed, prior to the council, and were undoubtedly inspired by the headgear of the Greeks who accompanied the Byzantine emperor.

Though the style and genre of the Berlin tondo had probably been anticipated in Domenico's fresco cycle at Perugia (see p. 16), they also belong to a tradition of exotic, orientalizing depictions of the Adoration of the Magi which originated in the International Style of the late fourteenth century and found its most magnificent expression in the Strozzi altarpiece by Gentile da Fabriano (Pl. 51).[19] What divides Gentile's and Domenico's pictures most sharply is of course the intervention of linear perspective; and Domenico's revision of Gentile's composition, aside from its indebtedness to Pisanello and Netherlandish painting, relies most heavily on Donatello and Masaccio. Like Donatello in his circular reliefs of 1436–37 (see Janson, 1957) in the pendentives of the *sagrestia vecchia* at S. Lorenzo (Pl. 50), Domenico interpreted the tondo form as an oculus—"an open window," as Alberti wrote in *De pictura*, "through which the subject to be painted is seen"—and even seems to have applied to it Alberti's reticulated veil (Fig. 9).[20] Although the picture contains only a single orthogonal (NG), the fact that this intersects the vertical diameter (LD) at the point where the latter is crossed by the horizontal diameter (FH) makes it evident that G is the vanishing point and FH the horizon line of the foreground composition. The distance between the nearer post of the shed (marked by JNE) and the vertical diameter is one-third the length of FH, which can consequently be divided into six equal units (along the slightly longer vertical diameter six such units reach from L to M). The resulting quadratic grid reveals that among Domenico's surviving works the tondo, aside from the *sinopia* for the S. Egidio *Marriage of the Virgin* (Fig. 11), is the only one in which the foreground figures are subject to the principle of horizon line isocephaly advocated by Alberti

and observed in the majority of Florentine perspective pictures following Masaccio's *Tribute Money* and Masolino's *Raising of Tabitha* in the Brancacci Chapel (see Edgerton, 1975). The painting's quadratic grid also shows that the horizon of the landscape on which we look down from the foreground plateau coincides with the axis immediately above the horizontal diameter; and that, as in the Masacciesque *desco da parto* in Berlin (see catalogue no. 18; Fig. 26), two of the grid's units determine the height of the foreground figures.

Domenico's debt to Masaccio is most apparent in the lighting of the heads of the riders at the rear of the procession (Pl. 39) and, as Pudelko (1934) first pointed out, in the arrangement of the foreground figures, following the *Tribute Money,* in an S-shaped arc in space; though in generating space by the overlapping and diminution of figures as the arc curls back into space Domenico's composition, as Meiss (1963) has noted, also resembles the Joseph panel on the Gates of Paradise. To Masolino's *Crucifixion* (Pl. 52) at S. Clemente Domenico owes the introduction to Italian painting of the plateau composition, which he apparently also employed in his frescoes at Perugia, and may have adopted as well in the *Meeting at the Golden Gate* at S. Egidio (see p. 11). The strong relationships of the tondo to Pisanello, which have led several scholars to attribute it to the Veronese artist, suggest a renewed contact between Domenico and his former master at S. Giovanni in Laterano and lend credence to the assertion of Paolo Giovio in a letter to Duke Cosimo I de' Medici that Pisanello was in Florence in 1439 to make the medal of Emperor John VIII Palaeologus (see Fasanelli, 1965), as against Weiss' argument (1966) that the medal was made in Ferrara in 1438. The reverse of the medal (Pl. 49) contains the model for the motif of the boy on horseback seen from the rear who in the painting wears a brocade shirt and exchanges glances with the black boy dressed in white astride the camel at the right. The juxtaposition of this horse with the frontally foreshortened horse of the huntsman—a motif anticipated in the foreground of Gentile da Fabriano's Strozzi altarpiece (Pl. 51)—has parallels in both Pisanello's *St. George and the Princess* of 1433–38 at S. Anastasia and in a drawing in the *Codex Vallardi* (no. 2468; Fossi-Todorow, 1966, no. 33). To Pisanello as well Domenico owes the beautiful costume of the man seen from the back at the left of the main group, and the multistoried hats worn by the members of the cortège.[21] But it is above all in the factualness, precision, and sensitivity of his rendering of animals that Domenico is the master of a tradition which, like the depiction of the Adoration of the Magi as an exotic pageant, originated in late-fourteenth-century Lombardy and which Pisanello, its other supreme practitioner, transmitted to him.[22] A number of scholars have sought to explain the tondo's affinities with Pisanello by connecting the work with a presumed early phase of Domenico's career in northern Italy. A simpler explanation would be that these affinities corresponded to the wishes of the patron, that the picture looks like Pisanello because it was meant to. It is entirely possible that the commission was originally offered to Pisanello, and that when he declined it Domenico Veneziano was asked to execute the painting in Pisanello's style.

The term "factualness" has also been applied by Clark (1969) to the tondo's landscape; and it is no doubt this quality that led Fiocco (1927) to identify the lake in the distance as the Lago di Garda. It is of course possible that Domenico Veneziano remembered that part of the Veneto from his boyhood. But even if this memory had been an inspiration to him, as the region of the Lago di Trasimeno seems to have inspired Fra Angelico in the predella panel of the *Visitation* of his Cortona *Annunciation* (see Salmi, 1947), it is unlikely, given the tendency of quattrocento art to function with "types and patterns," as Gombrich (1966) has put it, rather

than with "individualistic portrayals," that the landscape in the *Adoration* records a specific place.[23] Indeed, its spaciousness and topographical descriptiveness build on pictorial accomplishments of Florentine, northern Italian, and Netherlandish art—integrated so masterfully that in the tondo, as Berti (1961) has remarked, "all landscape problems were solved for the fifteenth century."

Domenico's projection of a deep landscape by means of a receding terrain ringed by distant mountains whose inclination toward the center of the composition, like perspective orthogonals, advance the landscape's thrust into depth—see the alignment of the mountains' slopes with the diagonals *IG* and *JG* in Fig. 9—was, like his conception of the tondo as an oculus, anticipated in Donatello's *St. John on Patmos* (Pl. 50).[24] The use of the conifer tree as a screen in relation to which the forms of the landscape appear in deep space appropriates a device from the repertory of Fra Angelico (see the *Deposition* from S. Trinita in the Museo di S. Marco, or the *Decapitation of Sts. Cosmas and Damian* from the predella of the S. Marco altarpiece). In his rendering of the terrain and vegetation of landscape, as in the depiction of animals, Domenico is heir to a tradition which first crystallized in International Style Lombardy (see Pächt, 1950), but whose principal transmitter to him—judging by the landscapes of Gentile da Fabriano's Strozzi altarpiece (Pl. 51)—was Gentile rather than Pisanello.

Beyond Domenico's familiarity with the plateau composition through Masolino, he must also have had firsthand knowledge of Netherlandish painting or illumination. Behind the sharply focused lighting of the tondo's figures and Courbet-green hills streaked with white roads, tilled fields, houses, and flocks of sheep, the farther mountain at the left is painted more thinly in a brownish tone, and the mountains behind the castle are hazy and blueish. This gradation of the landscape by means of light zones in accordance with the effects of atmospheric perspective, attributed by Sienbenhüner (1935) to the influence of Alberti's *De pictura*, has a precise parallel in the background of the *Crucifixion* in the Ca' d'Oro (Pl. 53), which may have been the example of the plateau composition that Masolino drew on in his *Crucifixion* at S. Clemente, and which would probably have been available to Domenico Veneziano as well.[25] Moreover, the bend in the road and the lake with sailboats in the tondo's landscape (Pl. 39) are so remarkably similar to the background of the *Nativity* by the Master of Flémalle at Dijon (Pl. 39A; see Sindona, 1960) that Domenico, like Antonello da Messina when about three decades later he painted his *Crucifixion* at Bucharest (formerly in Sibiu), must have known a Flemish picture with a similar landscape (Pl. 54).[26]

In the *Adoration of the Magi* the early style of Domenico Veneziano, with its dark tonalities and decorative brilliance, comes to an end. Within the half decade that separates the tondo from the St. Lucy Altar, its resonant, glowing colors, dominated by violets, blues, vermilion, yellow, and white against a background of deep green gave way to the leaner textures and paler tonal range of the late trecento, Lorenzo Monaco and Fra Angelico;[27] and its pictorial and plastic opulence was replaced by a more linear style that stressed the articulation of movement and tension, and the expression of individual, religious emotion. Among the crosscurrents of Florentine painting of the 1440s a similar shift is evident in a comparison of Fra Filippo Lippi's *Annunciation* in S. Lorenzo or his Barbadori altarpiece, painted between 1437 and 1440, and his *Annunciation* of a decade later at Munich. And Andrea del Castagno too worked in a more linear mode in his *Assumption of the Virgin* of 1449 in Berlin and his *David* of about the same time in Washington than he did earlier in the decade at S. Tarasio and S. Apollonia. "Gotik im

Quattrocento,'' Antal (1925) called this collective development. Appropriate as this characterization may be, we should keep in mind that, as Berenson wrote in 1896,

> the history of art in Florence can never be, as that of Venice, the study of a placid development. Each man of genius brought to bear upon his art a great intellect, which, never condescending merely to please, was tirelessly striving to reincarnate what it comprehended of life in forms that would fitly convey it to others; and in this endeavour each man of genius was necessarily compelled to create forms essentially his own.

III

As Domenico Veneziano approached the age of forty the individuality of his style, as we have seen in the St. Lucy Altar, emerged ever more clearly. This was no doubt evident as well in the wedding chests he designed and decorated for Marco Parenti, the influence of which on Florentine *cassone* painting, as Longhi (1952) stressed, must have been prodigious. Probably our most reliable clue to their appearance are the chivalric fashions of the Berlin *Adoration of the Magi* (rendered in the paler colors and more linear style of the executioner of the *Martyrdom of St. Lucy*), which came into vogue among the masters of *cassoni,* especially in the atelier of Apollonio di Giovanni and Marco del Buono (see Gombrich, 1966), after the middle of the century. Between the time Domenico completed his *cassoni* for Marco Parenti in the summer of 1448 and his fortieth year he probably painted the most explicitly and emotionally expressive of his five surviving images of the Virgin and Child, the delicate *Madonna* in the Samuel H. Kress Collection at the National Gallery of Art in Washington (Pls. 132–136).

Although the Kress *Madonna*'s pale violets, blue-greens, pinks, and ochers—and her jewels as well—are familiar from the Virgin of the St. Lucy Altar, the panel shows a new phase of Domenico's style in respect to what Alberti called ''circumscription'' and ''composition.'' Like Desiderio da Settignano in his early shallow marble reliefs of the Virgin and Child, the earliest of which is in the Galleria Sabauda at Turin (Pl. 137) and is roughly contemporary with the Kress *Madonna* (Pope-Hennessy, 1958, p. 303, dates it 1450–53; but Cardellini, 1962, p. 144, regards it as ''prima delle 1450''), Domenico has emphasized the flow of forms across the surface rather than their three-dimensional construction. Avoiding symmetry and frontality, he has arranged them obliquely to the picture plane, but not allowed them to move into depth. Through the avoidance of overlappings and by stressing the confluence of contours—as in the common outlines of the Child's raised thigh and the Virgin's wrist, the Virgin's shoulder and the Child's arm reaching across it, and Mary's cheek and the top of the Infant's head; or in the continuous contour of the Virgin's hand and the rising yellow fold of her mantle—he has linked his forms as a flattened pattern close to the picture plane. The Virgin and Child are thus more intimately and affectionately related than they are in any of Domenico's other Madonnas. Beyond placing the Child's head next to Mary's, he has drawn the two figures together by the rhythmic movement and countermovement of the Virgin's arm and the Infant's stance, accompanied by the curve of his lavender loincloth and of the sinking and rising movement of the oval which the opening of the Virgin's blue-and-yellow mantle describes around her torso.

Pudelko (1934) derived the Kress *Madonna*'s composition and the posture of its Infant from the relief by Michelozzo in the Bargello, carved, according to Janson (1941, pp. 205f.) about

1431–32. But although the panel has an indubitable relationship to relief sculpture, its affinities, formally as well as expressively, are with reliefs of its own time like the Turin and Foulc *Madonnas* by Desiderio da Settignano (see Cardellini, 1962), in which the figures are similarly drawn together (Pl. 137). Domenico's four earlier Madonnas are translations by means of lines and colors of sculpture in the round. In the volumetrically compressed linear style of the *Madonna* in Washington, following upon the plastically inflected contours of the St. Lucy Altar, his mode of declaring form is that of pictorial relief; the inflections of contours are emotionally expressive rather than spatially constructive; the mood is informal, gentle, and intimate; and it transmits its religious message with immediacy and warmth of feeling. Among Domenico's figures of the Christ child the flesh of the Kress *Madonna*'s is the most yielding, and his hair is the softest and most pliant (Pl. 134). The Virgin is the least austere and most tender of his depictions of Mary (Pl. 133). The Child's head, turned toward us as if in prophetic speech, is the focus of the composition's internal rhythms, and is appropriately larger in proportion to his body than it is in the Infants of Domenico's earlier pictures. His striding posture does not launch him forward into space, as it does in the *Madonna* at Bucharest, but, as in trecento art, expresses his affectionate relationship to the Virgin—even though the two pictures have in common the foreshortened foot which anchors the Child's posture in pictorial space (Pls. 33 and 135).

With the Kress *Madonna* the floral hedge returns to Florence as the background of a half-length Madonna two and one-half decades after Gentile da Fabriano had depicted it in his *Madonna* at Yale (Pl. 30). The reason it disappeared during the second quarter of the century may well be that its irregular, intertwined forms were ill-suited to a preference for architectural or regularly structured backgrounds (see p. 13). Its complex patterns, however, are entirely congenial to the informal composition and swaying cross-rhythms of Domenico's Washington *Madonna*. In keeping with the painting's tranquil mood, the patterns of the hedge's leaves—in contrast to the thick growth in the background of the Bucharest *Madonna*—are so clearly and evenly spaced that they resemble the designs of groups of five rose leaves on the glazed terra-cotta borders of the Federighi Tomb by Luca della Robbia (Kennedy, 1938, Fig. 76).[28]

The rose hedge's symbolism as well serves the purposes of Domenico's painting, for it reinforces the religious message transmitted by the picture's figures. The Christ child's look and his lips parted as if in speech—like the Baptist's in the St. Lucy altarpiece—prophesy his Passion, while the lavender bands around his body—the lower band, perhaps as a concession to St. Antoninus' disapproval of unseemly nudity in sacred figures (see Gilbert, 1959), has slipped down and become his loincloth—is a reference to his shroud. The Virgin too foresees Christ's Passion. Bareheaded as the Madonna of Humility, she displays her humanity and mildness as the intercessor for mankind by her attitude of protection and affection with which she holds her son. The rose hedge, originally an attribute of the Madonna of Humility, alludes to the *hortus conclusus* of the Song of Solomon and to the Garden of Paradise of the *Virgo inter virgines*, both metaphors, like the hedge's white roses, of the Virgin's purity (see p. 53). The hedge's red roses symbolize martyrdom. The directness with which Christ announces his Passion, tempered by the emphasis on the merciful, human, intercessionary capacity of the Virgin, is no doubt a reflection of the pietistic attitude toward religious images in the sermons of St. Antoninus (see Kauffmann, 1935; Gilbert, 1959; Hartt, 1969; Edgerton, 1978) and St. Bernardino. On entering a church, the latter counsels, "above all pay dutiful homage to the

Body of Christ; only then go to the paintings which represent the Saints and the Blessed, and venerate them. First always God, and then them out of love for God'' (Hefele, 1912, p. 258).[29]

The accent of pietism is felt even more strongly in Domenico's last surviving work, the mural of *Sts. John the Baptist and Francis* painted for the Cavalcanti Chapel in S. Croce (Pls. 138–148). In its original position on the wall of the church's rood screen, which projected from the wall of the south aisle not far to the right of the great *Annunciation* by Donatello, it was closely related to Donatello's tabernacle (Fig. 22). Both saints are motioning in the direction of the relief: St. John in the attitude and garb of the ascete indicating with the gesture of his right hand the Incarnation of the Redeemer for whose coming he has prepared himself through the life of penitence in the desert,[30] and St. Francis, the signs of the stigmata upon him, with his hands before him in adoration. Their movements are accompanied by the foreshortened arch above them. The ascending diagonal of John's left forearm (Pl. 143) is continued by the molding behind him, and because of this the perspective slant of the arch, while it plunges into depth and establishes the pictorial space in which the figures are standing, also urges them onward in their forward motion to the left. The geometric as well as the thematic focus of the mural is not within the composition but beyond it: its vanishing point is below and to the right (Fig. 23), and the object of the saints' devotion, as if the Cavalcanti Chapel were the stage of a *sacra conversazione*, is Donatello's *Annunciation*.[31] A connection between the painting's devotional and perspectival centers which would have been evident before the mural was removed from its original location in 1566 was that both its vanishing point and the lower edge of the tabernacle's frame were at eye level, about 1.62 m from the floor.[32] The fact that the fresco was to be seen from the right, presumably from in front of the *Annunciation* to which it addresses itself, is also indicated by the alignment of the Baptist's torso not parallel to the picture plane, but obliquely, in the direction of the position of the vanishing point.[33] His right foot (Pl. 144) overlaps the base of the archway and breaks through the picture plane, as if he were stepping into the space of the chapel itself in the *Annunciation*'s direction. Yet he is firmly bound to the pictorial space in which he stands by the alignment of his left forearm with the molding of the archway and of two fingers of his right hand with the archway's left corner.

As he did in the Carnesecchi Tabernacle and the *sacra conversazione* of the St. Lucy Altar, Domenico laid out and controlled the composition of the Cavalcanti fresco with the help of a quadratic grid compatible with his system of perspective (Fig. 23). The vertical distance from the vanishing point (*H*) to the ledge on which the figures are standing (*IJ*) is one-third of the height of the archway from this ledge to the moldings supporting the wreath of palm leaves that adorns the front of the arch (*MP*); and the horizontal distance from the vanishing point to the right edge of the archway (*RE*) is three-quarters of the archway's width (from *RE* to *QA*). From these relationships results a quadratic grid of fifty-six squares (*AMPH*), eight units high and seven wide. Its vertical at *B* runs through the heel of the foot bearing the weight of St. John; the vertical at *C* bisects the arch, allotting two of the arch's four vertical zones to each of the figures; and the vertical at *D* passes through the ankle of the foot that bears the weight of St. Francis. The six horizontal zones between *IJ* and *MP* establish the same six-part *exempedum* canon of proportions for the figures by which Domenico constructed the figure of the Baptist in the *sacra conversazione* of the St. Lucy Altar (Fig. 13). Two further horizontal zones reach up to the intrados of the arch (*QS*).

In its ever greater reliance on the descriptive and expressive potentialities of contours, the

Cavalcanti fresco is the culminating expression of Domenico's mastery of line (Pl. 145). It was Domenico, Offner (1927) wrote,

> who seems to have drawn face and body to a single expression . . . and first reduced the body to its motor essentials. See e.g. his Baptist in S. Croce. Here the tight-clutching line rhythmically unites the muscle and the bone, rendering the form at once as function and as solid, which it contains and defines at every point. (p. 33)

It is evident from the figure of Hercules in Antonio Pollaiuolo's *Rape of Deianeira* at Yale, or from the legs of his *David* in Berlin (Pl. 156), that "this type of drawing," as Offner continued, "becomes Antonio's inheritance."[34] The Cavalcanti saints are also among the quattrocento's crowning achievements in depicting the counterpoint—incomparably more articulated and concentrated than in the same figures in the St. Lucy Altar—between the upward accent of a tense, alert figure and the downward cadence of a relaxed, introspective one. Yet both figures stand lightly and buoyantly in space, indissolubly part of the pictorial field in which they are seen, and drawn together by their slightly swaying postures and by the movement of light across their delicately modeled surfaces. The postures of both convey forces of will and intellect, of which line is the expressive agent, and by which flesh—the gravity of the body—is infused with spirit. The mobility of Domenico's line is especially apparent in comparison with the sculpturally hard contours of Castagno's figures from the Villa Pandolfini at Legnaia, which antedate the Cavalcanti fresco by at most a few years (ca. 1448–50). Among them the youthful, athletic *Eve* (Pl. 157) is so strikingly similar to Domenico's Baptist—in posture, costume, the view from below, and the definition of the oval cylinder of the torso by a belt tightly drawn around the waist—that she, and not, as Pudelko (1934) supposed, Castagno's St. Jerome in the SS. Annunziata (Pl. 158), would seem to be the source for the Cavalcanti St. John. The latter in turn appears to have inspired the St. Jerome in Castagno's SS. Annunziata *sinopia* (Pl. 159).

The two figures by Castagno—the *sinopia* for the Corboli Chapel was probably drawn by 1453 (see catalogue no. 25)—thus establish the limits for the date of the mural by Domenico Veneziano. That it was painted before 1453 is suggested as well by the dependence of the St. Lawrence in Baldovinetti's *sacra conversazione* from Cafaggiolo in the Uffizi (Pl. 160), which Kennedy (1938) has placed in that year or soon after, on Domenico's St. Francis. Among the many similarities between the two figures—the inclination and turn of the head, the praying hands, the fall of the full sleeves, the implied forward motion—one in particular shows that Baldovinetti derived his figure from Domenico Veneziano's: in both figures, at a place corresponding to the left knee, there is a bulge in one of the folds that falls from the waist to the ground. In Domenico's figure the existence of the knee and the action of the left leg are clearly felt behind St. Francis's thin habit. But neither a knee nor a leg is sensed under the heavy garment worn by Baldovinetti's St. Lawrence. In taking over Domenico's drapery pattern Alesso characteristically did not make visible the bodily action in accordance with which it takes its form, and which gives it meaning.[35]

In the St. Lucy altarpiece, painted within less than a decade before the Cavalcanti fresco, two religious messages—the prophecy of Redemption and the promise of spiritual illumination—and two strains of mid-quattrocento Florentine culture—Renaissance humanism and medieval piety, asceticism, and mysticism—were harmoniously held in balance.

Domenico's mural at S. Croce, through its relationship to Donatello's *Annunciation,* transmits the first of the St. Lucy Altar's themes—the prophecy of Redemption—but not the second; and by depicting its two sacred protagonists as penitents with spare, skeletal, lined faces (Pls. 147–148), humanism has been subordinated to the expression of religious emotion. The fresco's Baptist and Francis are clearly the descendants of their predecessors in the altarpiece for S. Lucia (Pls. 63–64). But in their harsher, more ascetic reincarnation—Francis in adoration with the stigmata upon him and John as if addressing not the congregation but God—they not only prophesy but have become mystically identified with the Passion of Christ. A wreath, not of oak leaves, as in the classically inspired tomb of Leonardo Bruni (see p. 205), but, as in the capitals of the loggia of the St. Lucy Altar (Pl. 70), of palm leaves (Pl. 146)—an allusion to Christ's Passion and to martyrdom—adorns the arch above them. And the light that floods the archway, transforming the brownish-gray habit of St. Francis from orange-yellow in the highlights to a dark blueish tone in the shadows, is not the light of nature but of divine revelation. The cast shadow on the archway's vault indicates that the light comes from above and to the right, as if through the church's northern clerestory windows. Since when standing in front of the fresco in its original location one would have faced west, the light which illuminates the saints is not that of the sun, which would come from the south at the mural's left, but, as Meiss (1945) pointed out in a similar situation in Jan van Eyck's *Madonna in the Church* in Berlin, the light of God and of the Holy Spirit—the *lux gratiae,* as St. Antoninus called it—which was transmitted by the angel to Mary at the Annunciation (see p. 53).

IV

Domenico Veneziano's works span a period of two decades, from the formation of what Hartt (1969) has called the Second Renaissance Style in the early 1430s to a period at mid-century when the classically inspired realism of that style and of the century's first three decades was being reexamined in the light of the exigencies of piety and religious orthodoxy. As an outsider in Florence, born in Venice and trained, partly in Rome, by Gentile da Fabriano and Pisanello, Domenico gave expression to the crosscurrents that animated Florentine art in his time with a diversity and richness matched by none of his contemporaries with the exception of Donatello. An inventive, intellectually subtle thinker as well as a virtuoso painter, he profited from and in his art reconciled the achievements of the three major strands of early quattrocento realism: the northern Italian, Florentine art and artistic theory, and Netherlandish painting and illumination. His supreme gift for lucidity enabled him to anticipate the noble forms and luminous colors of Piero della Francesca, as well as the exalted linear rhythms of Antonio Pollaiuolo, and to be a conductor between these and the traditions of art to which he himself was heir. To make the point visually, it is sufficient once more to compare the heads of Domenico's own early *Madonna* at I Tatti and of his master Gentile da Fabriano's altar panel of about 1400 in Berlin (Pls. 27 and 28),[36] and then to consider the relationship between the heads of the Baptist at S. Croce and of Bartolomeo della Gatta's *St. Roch* from Cortona of about 1475 (Pls. 148 and 149). And yet, although the profile of Domenico Veneziano's achievement and of the position of his surviving works in the artistic process of his time can be relatively clearly drawn, he remains elusive and mysterious, an artist whose identity is virtually unknown except through his paintings.

NOTES

1. Battisti (1971, I, p. 461, n. 35) has supposed, without going into detail, that Domenico applied to the design of the Carnesecchi *Madonna* a "reticolo grafico assai elaborato." The mural's forms, especially in the platform of the throne, were pulled to the left in the course of its transfer from plaster to canvas, so that they are no longer uniformly centered or symmetrical (see catalogue no. 1).

2. In no sense, however, can I agree with the assertion of Berti (1961) that the Carnesecchi Tabernacle is "the first Renaissance painting to put into practice the principles enumerated by Alberti in *De pictura*."

3. Schmarsow (1912) called the throne "a detailed imitation of a Venetian bishop's or Doge's throne," and Shell (1968) believed that the picture's "thronal architecture, particularly the base, certainly points to Venice." Gioseffi (1962), according to whom Domenico Veneziano was an advisor to Masolino in the chapel of St. Catherine at Rome, has attributed to the throne a "Roman Cosmatesque character" inspired by the ambos in S. Clemente. However, its marble inlays, decorative bands, and marble spheres were as common in proto-Renaissance Florence as they were in Rome. Fourteenth-century Tuscan examples of thronal superstructures in the form of open boxes with three sides of equal height are in miniatures of *Prudence Enthroned* and *Providence Enthroned* by the Biadaiolo Illuminator (Biblioteca Laurenziana, *Codex Plut.* 42, 19; fols. 52v and 53r); in the episode of *St. Dominic Carried to Heaven by Angels* of Francesco Traini's St. Dominic altarpiece of 1345 from S. Caterina at Pisa (Pl. 10); and in an illumination in a manuscript of the Visions of St. Bridget of Sweden in the Morgan Library (Ms. 498, fol. 343v), which Harrsen and Boyce (1953) call Neapolitan, though it is more likely, as Salmi (1952a) thinks, Florentine. Coletti (1953a) has related the superstructure of Domenico's throne to the spatial enclosures of groups of figures in a triptych by Cecchino da Verona in the cathedral of Trent; but the latter are connected, rather, with the box-like constructions in the paintings of Konrad Witz. The box top of Domenico's throne was copied in one wing of a diptych bearing the arms of the Peruzzi and Pazzi families formerly owned by Böhler of Munich and was the model for the thrones in the *sacra conversazione* by Francesco Botticini in the Galleria Communale at Prato (no. 22) and in a *Madonna and Child* by Zanobi Machiavelli in the Musée Calvet at Avignon (no. 413). The latter two, like the throne in the Carnesecchi Tabernacle, are also surmounted by marble spheres. These occur earlier in Francesco d'Antonio's Rinieri altarpiece of the early 1430s in the museum at Grenoble, and following Domenico Veneziano in a tabernacle by Cosimo Rosselli, and in his *Madonna and Child* in the McLaren Collection in London (Musatti, 1950, Figs. 6 and 11). The shape of the foreshortened platform in front of the Carnesecchi Tabernacle's throne—though with a rounded rather than pointed semicircular section in front—also goes back to the Tuscan trecento, as in a panel by the Master of the Horne Triptych at Pian di Mugnone (Offner, 1930ff., III, 1, Pl. XIX) or in the *Apotheosis of St. Thomas Aquinas* in the Spanish Chapel at S. Maria Novella. It became particularly popular, however, in the early fifteenth century. A few among many works in which it occurs are panels by Lorenzo Monaco in the Fitzwilliam Museum at Cambridge (Pl. 11), by the Master of the Bambino Vispo at Würzburg (Örtel, 1950, Pl. 4), by Arcangelo di Cola in the collection of Helen Frick, or by Bicci di Lorenzo in the Collegiata at Empoli. After its appearance in the Carnesecchi Tabernacle it was used—always with a rounded rather than pointed tip—in the small *sacra conversazione* by Pesellino in the Metropolitan Museum of Art (whose St. Zenobius is derived from the St. Lucy Altar), in a depiction of the same subject by Domenico di Michelino in the Musée de Dijon, and in Botticini's *sacra conversazione* with the box-like thronal superstructure at Prato.

4. Even more closely related to the vertically aligned stereometric forms of Domenico's Virgin and standing Infant than the Linaiuoli Madonna are Fra Angelico's *Madonna of the Trinity* of the early 1430s in the Museo di S. Marco (Salmi et al., 1955, no. 2) and the *Madonna* from S. Maria Nuova for which, according to Collobi-Ragghianti, a payment to Zanobi Strozzi is recorded in 1436 (Salmi et al., 1955, no. 86).

5. To the examples of the type cited by Shorr should be added the *Madonna and Child with Angels* by Antonio Veneziano at Hannover (Örtel, 1950, Pl. 13).

6. According to Horster (1953), Domenico derived the nude standing Christ child, his right hand raised in blessing, from Jacopo Bellini. But both Jacopo (in his *Madonna* at Lovere and the *Madonna of Humility with Leonello d'Este* in the Louvre) and Domenico had the motif from their common master Gentile. Pudelko (1934) made the suggestion that the Infant in the Carnesecchi Tabernacle was taken from the *sacra conversazione* from the Castello di Trebbio formerly in the Contini-Bonacossi Collection at Florence (Pl. 21). However, the relationship between the figures in this Castagnesque work of the middle of the century (see catalogue no. 3, n. 2) and in Domenico's mural is probably the reverse.

7. Of all the Florentine minor masters of his time Andea di Giusto was the most tireless and prolific in copying the works of his greater contemporaries, not only Lorenzo Monaco and Domenico Veneziano, but also Masolino and Fra Angelico (see Boskovits, 1970).

8. The borders of the Virgin's dress and veil, and the borders of the dress of the Bucharest *Madonna and Child* as well (Pl. 32), are punched with a rosette stamp described by Cennino Cennini which was common throughout the fourteenth century and until after the middle of the fifteenth century. (See the Cimabuesque *Madonna* in the Galleria Sabauda in Turin; the *Pietà* ascribed to Giottino in the Uffizi; Luca di Tomè's *Assumption of the Virgin* at Yale; *St. Jerome* and the *Bearded Carmelite Saint* from Masaccio's Pisa Altar; Fra Angelico's *Annunciations* at Cortona, Montecarlo, and in the Prado, and his Perugia altarpiece of 1437; a *Madonna and Saints* by Neri di Bicci in the Accademia in Florence [Van Marle, X, Fig. 318]; or the small *St. Dorothy* by Francesco di Giorgio in the National Gallery in London.) Domenico Veneziano used the same motif as a painted pattern on the front edge of the platform in the Carnesecchi Tabernacle (Pl. 5), in the decorative borders and next to the Gothic inscriptions of his *Adoration of the Magi* (Pls. 40 and 42), in the volutes of the capitals of the loggia in the *sacra conversazione* of the St. Lucy Altar (Pl. 70), on the miter of the St. Lucy Altar's St. Zenobius (Pl. 61), and in the borders of the dress of the *Madonna* in Washington (Pl. 132). The rosette pattern in the form of simulated pearls in the halo of Domenico di Bartolo's *Madonna* of 1437 in the Johnson Collection in Philadelphia imitates rosette clusters containing actual fillings of glass paste, as in the *Madonna and Saints* by Giovanni del Biondo in the Pinacoteca Vaticana (Meiss, 1951, Fig. 52), or set with jewels, as depicted in an early-fifteenth-century northern Italian illumination of a *Madonna of Humility* in the Biblioteca Vaticana (Degenhart, 1945, Fig. 8-a).

9. The Virgin's hand gesture appears to have originated in French Gothic sculpture (see Kennedy, 1938, n. 14) and occurs occasionally in German and Netherlandish painting, as in a *Madonna and Child* of ca. 1400 in the Wallraf-Richartz Museum in Cologne (Wallraf-Richartz Museum, 1955, no. 20) or Petrus Christus' *Madonna and Child with Saints* in the Städel Institut at Frankfurt-am-Main. In fourteenth-century Italy it is rare except in Venice, where it was employed by Paolo Veneziano (Palluchini, 1964, Fig. 35) and Lorenzo Veneziano (Shapley, 1966, Fig. 20). Perhaps by way of Gentile da Fabriano (see the *Madonna* from his early, Venetian period at Perugia) it gained wide popularity among painters in the Marche (Lorenzo Salimbeni, Ottaviano Nelli, Pietro di Domenico da Montepulciano, Giacomo di Niccolò da Recanati, Gerolamo di Giovanni da Camerino) and Umbria (Giovanni Boccati, Bartolomeo Caporali); and to a certain extent as well in Venice (see the *Madonna of Humility* related to Jacopo Bellini in the Metropolitan Museum of Art) and Florence (see *Madonnas* by Bicci di Lorenzo at Fabriano, Marseilles, Ristonchi, and Cologne). The most notable precedent in Florence for the interplay between the gesture and the outstretched arms of the Christ child is in Fra Angelico's painting for the high altar of S. Domenico in Fiesole, in which Mary is holding the red rose of martyrdom, and which, according to Salmi (1938), was the source for the exchange of gestures in the Berenson *Madonna* by Domenico Veneziano.

10. Pudelko (1934) suggested that Domenico owed the compositional scheme of the Berenson *Madonna* to the marble relief by Agostino di Duccio in the Museo dell'Opera del Duomo in Florence, probably carved between 1435 and 1440 under the influence of Michelozzo and Luca della Robbia (see Janson, 1942). But the affinities between the two works are the result of a common stylistic milieu rather than of a specific relationship. Agostino di Duccio's relief does seem to have been the source for a painting of the *Madonna and Child* reminiscent of the style of Botticini in the Galleria Communale at Prato (photo Soprintendenza alle Gallerie di Firenze no. 96937). The leg posture of the Christ child in Domenico's picture, though it appears in Gentile da Fabriano's early *Madonna* in

Perugia and in a *Madonna and Child* which Berti (1968, p. 6) believes Fra Angelico painted about 1430, was probably inspired by figures of *putti* sitting on ledges with their legs apart in relief sculpture, as on the sarcophagus of Giovanni di Bicci de' Medici in the *sagrestia vecchia* of S. Lorenzo by Buggiano of about 1433 (see Seymour, 1963) or, more likely, in the *Players on Psaltery* relief by Luca della Robbia, which seems to have been carved by the late summer of 1434 (see Pope-Hennessy, 1958).

11. In Florentine painting subsequent to the Berenson *Madonna* the parapet with a seated Infant was depicted in Fra Filippo Lippi's *Madonna and Child* of ca. 1445 in the National Gallery of Art in Washington (in which the Madonna's head is framed by the shell of Resurrection), and in the *Madonna* of ca. 1465 by Alesso Baldovinetti in the Louvre (see Wohl, 1976). The so-called pomegranate pattern of the I Tatti *Madonna*'s background was developed in Italy during the fifteenth century, replacing the animal designs of medieval brocades with an architecturally organized plant ornament (see von Falke, 1936). The type of brocade imitated by Domenico Veneziano, with the design incised into velvet, seems to have originated in Venice and was manufactured and exported by all weaving centers in Italy by the middle of the fifteenth century (see Podreider, 1928 pp. 114ff.). The specific pattern in the picture closely resembles the design of a Tuscan velvet of about 1440 formerly in the Figdor Collection (see von Falke, 1929, Pl. 3). In painting it occurs in works as diverse as the *Madonna della quaglia* by Pisanello in the Museo di Castelvecchio at Verona, the central compartment of Andrea di Giusto's polyptych of 1436 in S. Andrea a Ripalta (Salmi, 1948, Pl. 218), and the altar frontal of 1453 by Giovanni di Francesco at S. Biagio in Petriolo (Offner, 1933, p. 177). The use of a brocade pattern as the background for half-length Madonnas is rare. Exceptions are Giambono's panel in the Palazzo Barberini in Rome, and a polychromed stucco relief from the atelier of Antonio Rossellino in the Spedale degli Innocenti (Cherici, 1926, no. 96). For the relationship between textiles and their representation in painting and relief, see Weinberger (1941).

12. See *Madonnas* by Cristofero Moretti and Antonio Vivarini in the Poldi-Pezzoli Museum in Milan, Stefano da Verona in the Galleria Colonna in Rome, or Giambono in the Museum of Fine Arts in Budapest (no. 103). The image of the Madonna seated out-of-doors in front of a floral hedge was originally one of the forms of the Madonna of Humility that evolved in Italy in the second half of the fourteenth century and spread from there to the rest of Europe (see Meiss, 1951). In the repertory of the International Style the most popular version of the Virgin before the floral hedge remained the Madonna of Humility, as in Pisanello's *Madonna della quaglia*.

13. For examples of the posture in trecento painting, see Shorr (1954, type 16). In sculpture it occurs in the Madonna on the tomb of Antonio degli Orsi by Tino da Camaino, in Jacopo della Quercia's relief in the Ojetti Collection in Florence and *Madonna* at S. Petronio, and, as Pudelko (1934) pointed out, in a relief by Michelozzo in the Bargello. Like the painters of the fourteenth century, Masolino used it in his lost Novoli *Madonna* with the Christ child wearing a long robe. Following Domenico Veneziano the striding Child appears in a *Madonna* at Yale and a *sacra conversazione* at Dublin by the eclectic Zanobi Machiavelli, as well as in Siena (Neroccio's *Madonna* at Cracow), Umbria (a *Madonna and Child with Saints* in the Fogg Art Museum given to Niccolò da Foligno), and the Marche (a *Madonna* in the Royal Museum of Fine Arts in Copenhagen; see Zahle, 1934, p. 8).

14. A costume study in the Louvre attributed by Degenhart and Schmitt (1960) to Gentile da Fabriano bears the inscription *ven got vil*. The legend ELFIN FATUTTO is written in the manner of Roman engraved inscriptions on the ledge at the bottom of the male profile portrait given to Uccello in the museum at Chambéry (see catalogue no. 15). The word *tenpo* appears on an illumination by Apollonio di Giovanni of Petrarch's *Triumph of Time* (Salmi, 1954a, Pl. XLI-B). And a monumental medal of Bona Sforza struck in 1470 by Zanetto Bugetto and melted down twenty-five years later at the Genoese mint carried the motto MIT ZAIT (Hill, 1930, no. 634).

15. Pudelko (1934) proposed unpersuasively that Domenico portrayed Piero de' Medici in the profile of the middle-aged man to the right of the figure seen from the back. Earlier (Christie, Manson, and Woods, 1879, no. 489) it had been claimed that the three magi were portraits of the members of the Acciaiuoli family, perhaps on the basis of the notice in the second edition of Vasari that an *Adoration of the Magi* by Pesello in the Palazzo Vecchio contained a number of portraits, among them that of Donato Acciaiuoli.

16. Domenico's Piero de' Medici has the upswept hairstyle fashionable in the two decades before the middle of the century (see Brandi, 1934) worn by Pisanello's *Leonello d'Este* of 1441 in Bergamo and by the male figures in the Masacciesque *desco da parto* in Berlin (see catalogue no. 18). A fourth known portrait of Piero de' Medici is on a medal in the Taverna Collection in Milan (Hill, 1930, no. 908).

17. To the right, flying into the conifer tree, is a magpie (Pl. 43). Three other herons—one of them also being attacked by a peregrine falcon—are on the meadow in the foreground.

18. According to Krautheimer (1956), Ghiberti fashioned an explicit, carefully worked out allusion to the Council of Florence in the *Meeting of Solomon and Sheba* on the Gates of Paradise.

19. Apparently first given pictorial form by Michelino da Besozzo (see Pächt, 1950, Pls. 4c and 4d), it was transmitted from Lombardy to the Limbourg brothers and to Gentile (for the importance of Lombardy in disseminating new ideas around the turn of the century, see Salmi, 1955). Later northern Italian examples are the small panel of 1435 in the Museo di Castelvecchio at Verona by Stefano da Zevio, who seems to have introduced the peacock also used by Domenico Veneziano and in the Kress *Adoration* by Fra Filippo Lippi and Fra Angelico, and the large composition by Giovanni d'Allemagna in Berlin, which Böck (1931–32) considered a source for, but Coletti (1953) thought dependent from, the tondo by Domenico Veneziano. For the iconography of the Adoration of the Magi, see Kehrer (1908f.).

20. In this respect Domenico's painting is a far more advanced example of quattrocento realism than the slightly later Kress tondo by Fra Filippo Lippi and Fra Angelico, in which the composition is adapted to the picture's circular shape. For a different estimate of the relationship of the two panels in dealing with the problem of the tondo shape, see Hauptmann (1936).

21. For the ornate, flaring costume, see studies by Pisanello in the *Codex Vallardi* (nos. 2275r, 2277, and 2278; Fossi-Todorow, 1966, nos. 71, 70, and 69). Pisanello was no doubt also the source for the same costume on the title page of the Book of Ecclesiastics in the Bible of Borso d'Este (Salmi et al., 1953, Pl. LXX). The tondo's multistoried hats are of two kinds: (1) soft felt hats (*a tocco*) such as those in the medals of Pisanello, worn in Domenico's painting by the bearded man in the main group, the falconer, and a rider at the rear of the procession; and (2) hats *a mazzocchio*, whose lowest story has a tubular frame as an armature, worn by the man in profile who closes the main group at the left, by the two men in conversation to the right of the figure seen from the back, and by two of the riders farther back. Pisanello used them in a drawing of *Riders in a Mountain Landscape* (*Codex Vallardi* 2595r; Fossi-Todorow, 1966, no. 65). They are the type worn by the executioners in Domenico di Bartolo's *St. John Before Herod* (Pl. 121) and in the *Martyrdom of St. Lucy* from the St. Lucy Altar, by Michelotto da Cotignola in Uccello's *Battle of San Romano* in the Louvre, and by Castagno's *Farinata degli Uberti* from the Villa Pandolfini at Legnaia and *Niccolò da Tolentino* in the Duomo. As in the tondo by Domenico Veneziano, both kinds of hats occur in the *Crucifixion* at S. Clemente by Masolino.

22. See the animal heads by Michelino da Besozzo in a Book of Hours in the Bodmer Library at Zurich (Pächt, 1950, Pl. 4d), and Pisanello's drawings in the *Codex Vallardi* of a donkey (no. 2458; Fossi-Todorow, 1966, no. 6), a horse's head (no. 2360; Fossi-Todorow, 1966, no. 41), a dog (no. 2434; Fossi-Todorow, 1966, no. 12), a cow (no. 2410; Fossi-Todorow, 1966, no. 51), or herons (no. 2469; Fossi-Todorow, 1966, no. 9).

23. An exception to this would seem to be representations of cities, such as the towers of Borgo San Sepolcro in Piero della Francesca's *St. Jerome with a Donor* in the Accademia in Venice and *Baptism* in London, or the distant view of Florence in Antonio Pollaiuolo's *Rape of Deianeira* at Yale.

24. According to Pope-Hennessy (1969a), Donatello's method of space projection is a "highly personalized derivative from a constructional technique that originated . . . in painting" and is "identical" (Pope-Hennessy, 1975a) with the perspective system in Domenico's picture. However, the truth of the matter is that during the 1420s and 1430s pictorial relief was more advanced than painting in creating the illusion of three-dimensional space and that Domenico probably derived the perspective scheme of his landscape from Donatello.

25. As we know from Fra Angelico's *Visitation* in the predella of his Cortona *Annunciation*, unpersua-

sively attributed by Salmi (1947) to Piero della Francesca, effects of atmospheric perspective were depicted in Italian art prior to Domenico's *Adoration*. More convincing than Sienbenhüner's thesis that *De pictura* influenced the aerial perspective of the tondo by Domenico Veneziano is his argument that Piero della Francesca followed Alberti in the background of his *St. Jerome with a Donor* in Venice. The pictorial freedom and spontaneity in the landscapes of this picture and of Piero's *Baptism* in London suggest that Piero was still in Domenico Veneziano's atelier when the latter evoked the fields and hills behind his cortège of the magi with similarly sure, rapid touches of his brush.

26. The bend in the road in the plateau compositions of Domenico's tondo and Antonello da Messina's Bucharest *Crucifixion*—as well as of the *St. Jerome with a Donor* in the Accademia in Venice by Piero della Francesca—also appears in the background of an Eyckian *Crucifixion* of 1433–35 formerly in Dessau (see Sterling, 1971, Fig. 19). The lake with sailboats was first introduced to Florence in the frescoes at the *chiostro degli aranci* (1436–39) by the Portuguese Giovanni di Gonçalvo, whose knowledge of the behavior of light and shadow suggests that his training had been at least in part Netherlandish, and whose loose brushwork in the rendering of vegetation is comparable to Domenico Veneziano's (see *The Great Age of Fresco*, 1968, no. 37). Meiss (1961a) has argued that Giovanni di Gonçalvo was in these respects indebted to Domenico Veneziano; but the relationship between the two artists was more likely the reverse. As Offner (1939) pointed out, the lake with sailboats was later taken over from Domenico in the *Birth of the Virgin* at the Metropolitan Museum of Art by the Master of the Barberini Panels (Giovanni Angelo di Antonio da Camerino). Paatz (1934) has traced the motif of the gallows at the edge of the lake in Domenico's tondo (Pl. 39) to Pisanello's fresco of *St. George and the Princess* at S. Anastasia in Verona.

27. For a useful distinction between the dark color of the northern Italian International Style and the light tonalities of the International Style of Florence with its roots in the chromatic tradition of the trecento, see Keller (1967, pp. 9f. and 75).

28. Half-length Madonnas with floral backgrounds become extremely common in Florence in a series of works dependent on Fra Filippo Lippi and Pesellino and usually given to Pier Francesco Fiorentino or the Pseudo-Pier Francesco Fiorentino. Examples are in the Walters Gallery, the Johnson Collection, the Toledo Museum of Art, the Huntington Library, the National Gallery of Art in Washington, the Metropolitan Museum of Art, the Uffizi (no. 486), and the Städel Institut in Frankfurt-am-Main.

29. Kennedy (1938) related the expression of the Christ child to the smile of the blessing Infant in Gentile da Fabriano's *Madonna* at Orvieto. But a quarter of a century of the study of the human physiognomy and of the forms by which to depict it lies between the two works.

30. Offner (1920a) showed that what he called the Baptist's "posture of exaltation" was anticipated in the *St. Jerome* in the Art Museum of Princeton University (Pl. 151) attributed by Eisenberg (1976) to Giovanni Toscani (formerly known as the Master of the Griggs *Crucifixion*). The saint's upturned head reverts to a Hellenistic prototype such as the *Laocoön,* revived in Italian art by Giovanni Pisano (see Pudelko, 1934; Weise, 1939; Paatz, 1941). It was used by Gentile da Fabriano for the beggar in the Strozzi altarpiece's predella panel of the *Presentation of Christ in the Temple* (Pl. 152), and by Pisanello in one of the riders at S. Anastasia in Verona (see Richter, 1929, Pl. II-C). The expression of spiritual exaltation conveyed by the pantomime of the Baptist's head and arm postures was anticipated in the ascetic figure of Christ in Vitale da Bologna's *Baptism* from S. Apollonio a Mezzaratta now in the Pinacoteca at Bologna (Pl. 153), and later in Pisanello's *St. Benedict on Mount Subiaco* in the Poldi-Pezzoli Museum in Milan (Pl. 93; see chap. I, n. 13). Following Domenico Veneziano we find it in Antonio Pollaiuolo's drawing of the Baptist in the Uffizi (Gab. Dis. 699E) and in the St. James of Antonio and Piero Pollaiuolo's altarpiece in the Chapel of the Cardinal of Portugal at S. Miniato al Monte. Pudelko (1934) has seen reflections of the head of Domenico Veneziano's St. John in the heads of St. Jerome in the *Crucifixion* at Argiano and the fresco fragment in the Palazzo Pitti (see catalogue no. 24). It is extremely unlikely that the heads of the Cavalcanti fresco's two figures were inspired by the foreshortened view of the heads of Donatello's statues on the campanile of the Florentine Duomo, as has been suggested by Nicholson (1942).

31. A painted *sacra conversazione* in which the central image of the Virgin and Child has been replaced

by the Annunciation was in fact produced in 1473 by Cosimo Roselli, and is today in the Louvre (Alinari 23279).

32. Earlier Florentine frescoes composed as if seen from below include Masaccio's *Trinity* and, according to Vasari's descriptions, *St. Ivo* in the Badia and *St. Paul* in the Carmine; Uccello's *Hawkwood*, which was originally higher on the north wall of the Duomo than it is now and whose vanishing point, like the Cavalcanti fresco's, was originally at eye level (see Mittig, 1969; Meiss, 1970a); and Castagno's *Huomini Famosi* from the Villa Pandolfini at Legnaia. Though these feats of illusionism were greatly admired by Vasari, neither Alberti nor later Florentine Renaissance artists, as Meiss has noted, were enthusiastic about them. In the second half of the quattrocento the view from below (*di sotto in su*) is frequently encountered in northern Italian painting. Figures towering above distant, small-scaled landscapes, as in Domenico Veneziano's fresco, occur in Mantegna's *St. George* in the Accademia in Venice and in the beautiful personification of *Autumn* from the studio of Belfiore in Berlin; while arches foreshortened from below like the Cavalcanti mural's were adopted in Mantegna's *St. James Going to his Martyrdom* in the Ovetari Chapel, in the left wing of Gentile Bellini's organ shutters at S. Marco in Venice, and in the *Martyrdom of St. Sebastian* by Vincenzo Foppa in the Brera which was so extravagantly praised by Lomazzo (1590, pp. 108f.). The only Florentine examples after Domenico Veneziano of *di sotto in su* arches seen from the side and containing monumental figures are the *intarsia* panels with the prophets *Amos* and *Isaiah* on either side of the *Annunciation* in the *sagrestia delle messe* of the Duomo (Pls. 154–155). Probably directly inspired, as Pudelko (1934) suggested, by the Cavalcanti fresco, they were, like the other *intarsia* panels in the *sagrestia delle messe,* executed by Giuliano da Maiano between 1463 and 1468 (see the documents in Fabriczy, 1903; Kennedy, 1938). The cartoons for the two figures would seem to be due to different hands. The drawing for *Amos* is in the style of Finiguerra, who is known by document to have finished the design of the *Annunciation* by February 21, 1464, the year of his death. No documents refer to the two prophets flanking the *Annunciation*. It is possible, however, that Finiguerra died before he had been able to make the cartoon for the figure of *Isaiah*. Be that as it may, its vigorous, realistic, and spatially active style appears to me to show, as Ortolani (1948) and Busignani (1970) have also thought, that it was designed by Antonio Pollaiuolo.

33. Hall (1970) has observed that Domenico

> has employed another device in addition to the perspective to enhance the impression that the figures are seen from the right. When one looks at their feet the saints appear to be placed symmetrically, both turned slightly inward, their outer feet placed closer to the picture plane than their inner feet. Yet St. John's rear shoulder, accentuated by the strong light that shines on him, overlaps St. Francis' so that his body rotates into frontal view and he appears to be facing us directly, as he would if we were standing to the right.

34. Whether Domenico's style of drawing was based on a scientific knowledge of the human body derived from dissection, as White (1967, pp. 102ff.) has claimed for Antonio Pollaiuolo from about 1460 on, is a moot point. It seems to me that Domenico's rendering of the figure may be the result of remarkable powers of sight and hand, disciplined by the knowledge that, as Alberti wrote in *De pictura*, "in painting a nude the bones and muscles must be arranged first, and then covered with appropriate flesh and skin in such a way that it is not difficult to perceive the positions of the muscles." Be that as it may, Domenico's influence on Antonio Pollaiuolo's draftsmanship is such that it is tempting to think that the Antonio who received several payments for Domenico Veneziano in the course of work on the *cassoni* for Marco Parenti within half a decade prior to the Cavalcanti fresco could have been Antonio Pollaiuolo. Antonio's debt to Domenico has been stressed by Sabatini (1944), Ortolani (1948), and Busignani (1970).

[85]

35. The posture of Domenico's St. Francis is also reflected in the figures of Sts. Eugene and Crescentius in an *intarsia* panel in which they flank St. Zenobius, designed by Finiguerra in 1463–64 for the *sagrestia delle messe* in the Duomo.
36. The facial type of the I Tatti Virgin provided the model not only for the Madonnas of Piero della Francesca, but also, as Schulz (1977, p. 47) has pointed out, for the head of Mary in the lunette, which she ascribes to Desiderio da Settignano, in the tomb of Leonardo Bruni.

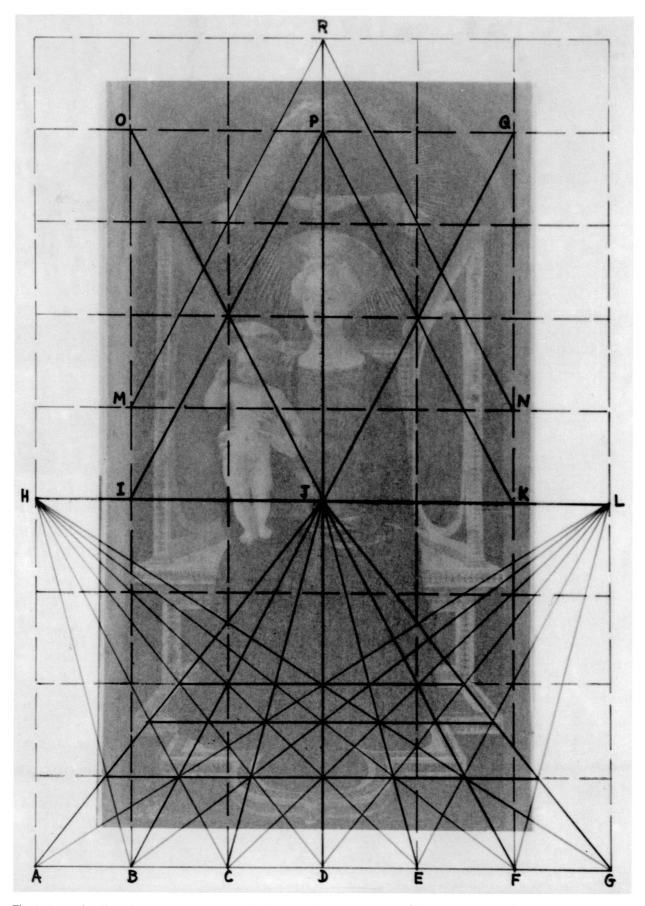

Fig. 1. Domenico Veneziano, *Madonna and Child,* Carnesecchi Tabernacle, geometric scheme.

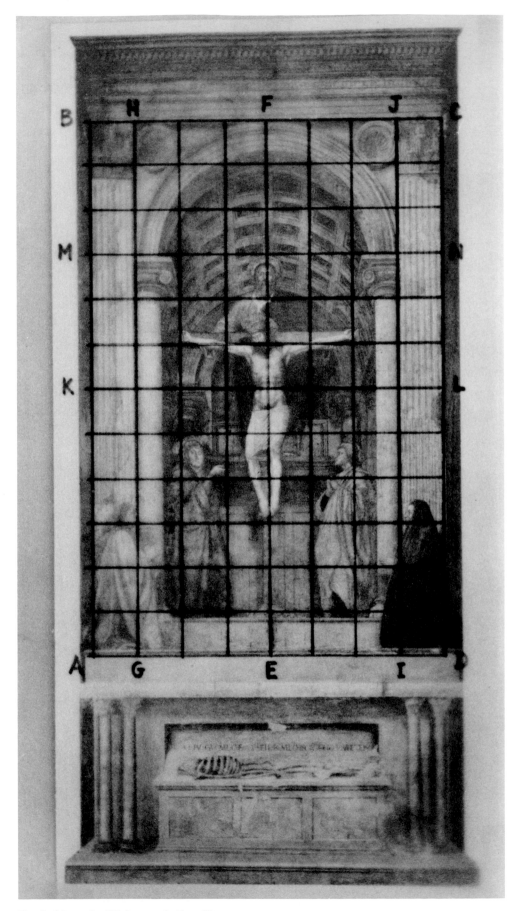

Fig. 2. Masaccio, *Trinity,* quadratic grid.

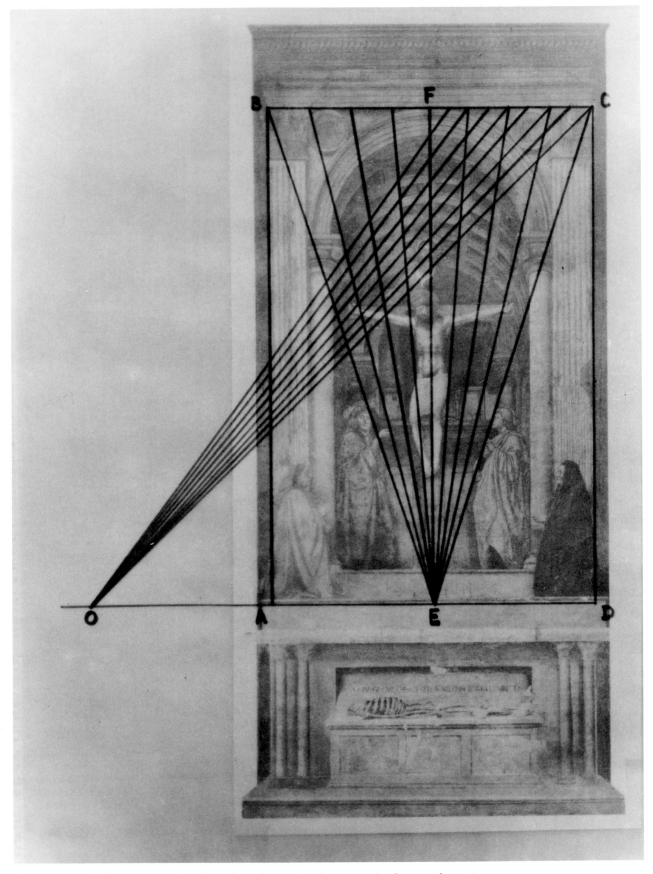

Fig. 3. Masaccio, *Trinity*, geometric scheme for orthogonals and transversals of perspective system.

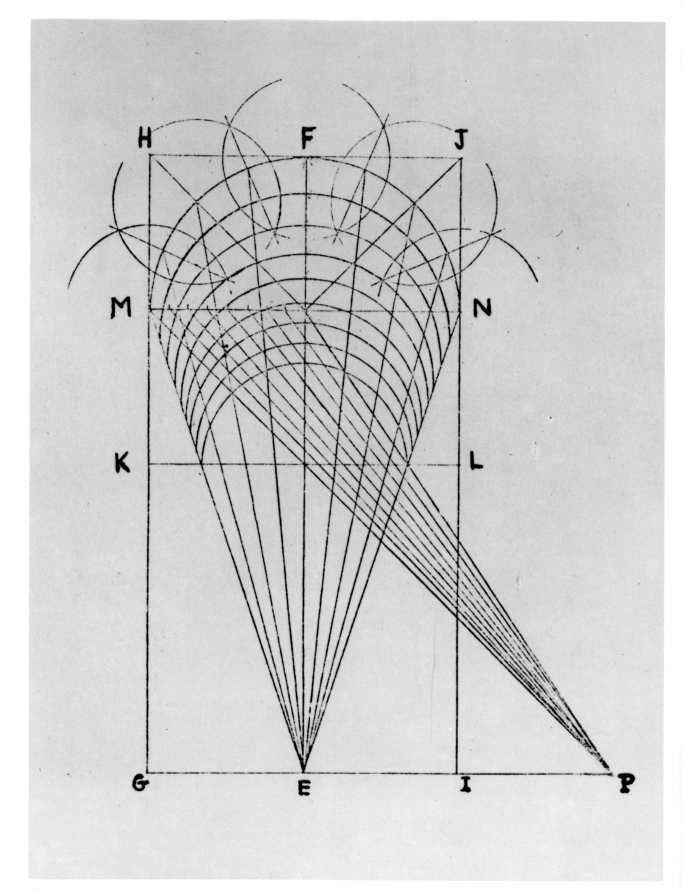

Fig. 4. Masaccio, *Trinity*, geometric scheme for perspective constuction of vault (after Polzer).

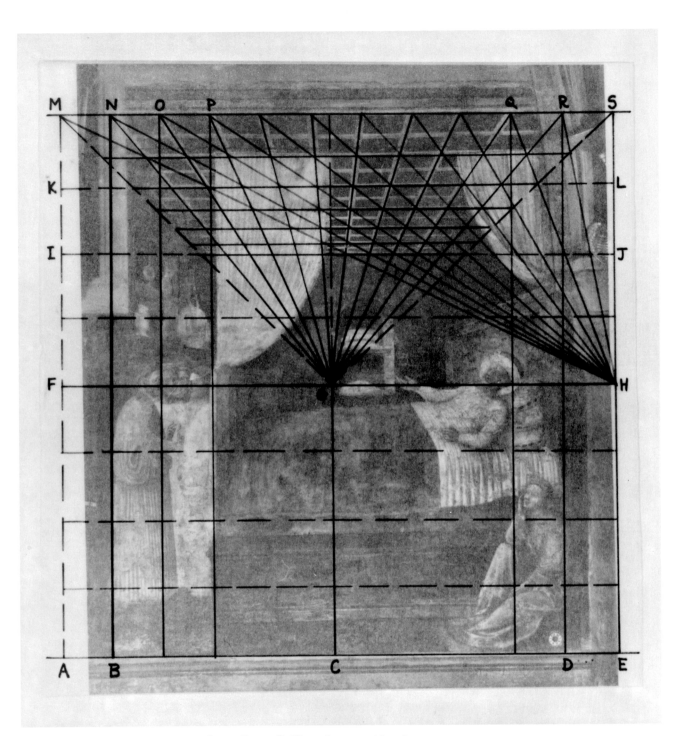

Fig. 5. Masolino, *The Death of St. Ambrose,* Rome, S. Clemente, geometric scheme.

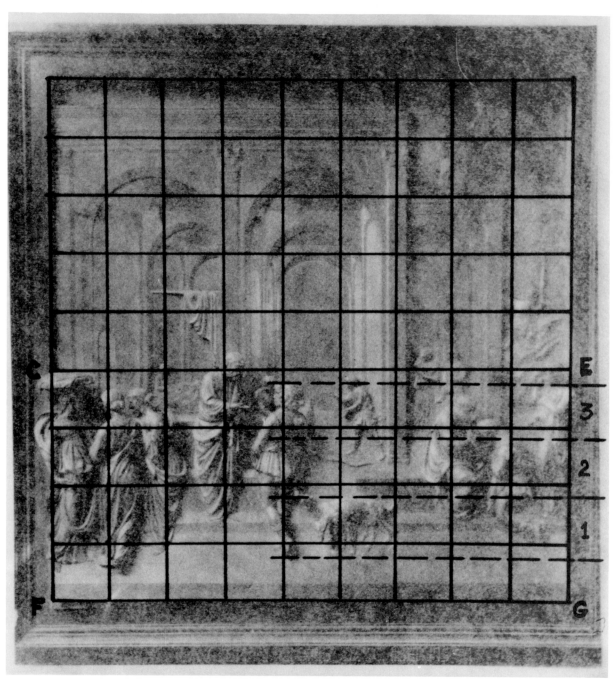

Fig. 6. Lorenzo Ghiberti, *Jacob and Esau*, Gates of Paradise, quadratic grid.

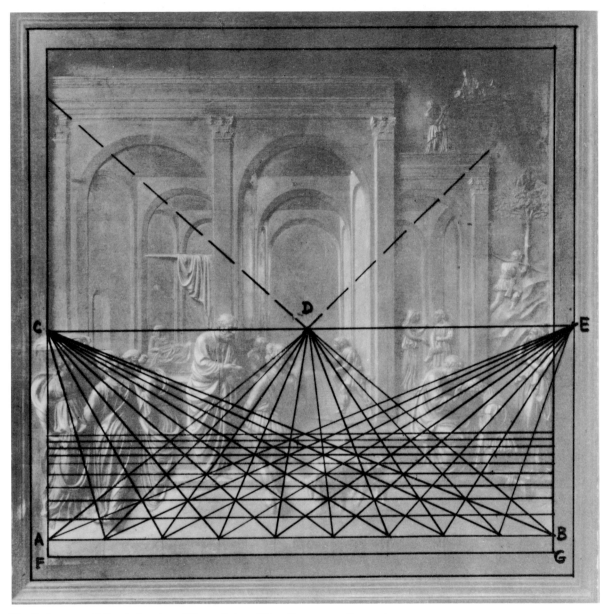

Fig. 7. Lorenzo Ghiberti, *Jacob and Esau,* Gates of Paradise, perspective system.

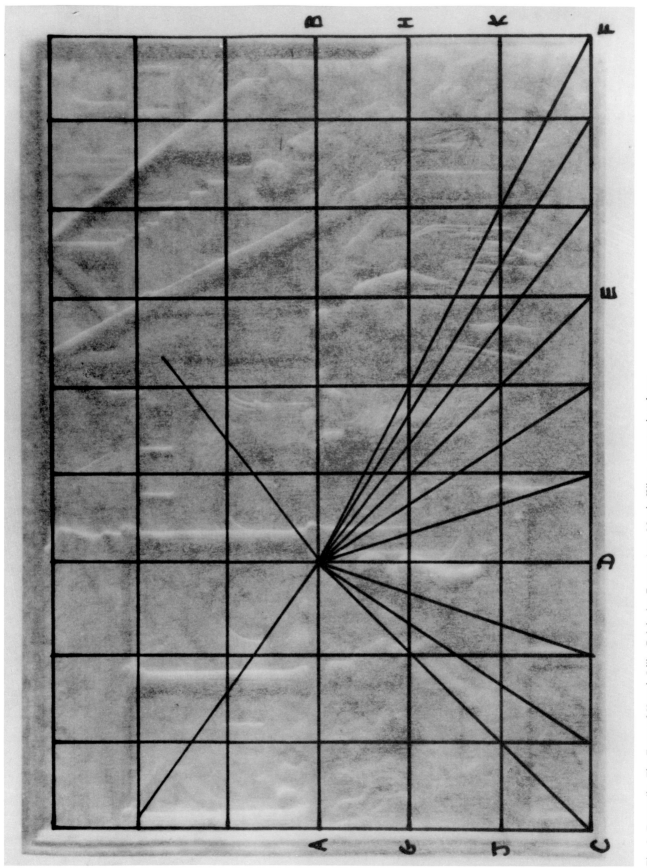

Fig. 8. Donatello, *The Feast of Herod*, Lille, Palais des Beaux-Arts, Musée Wicar, geometric scheme.

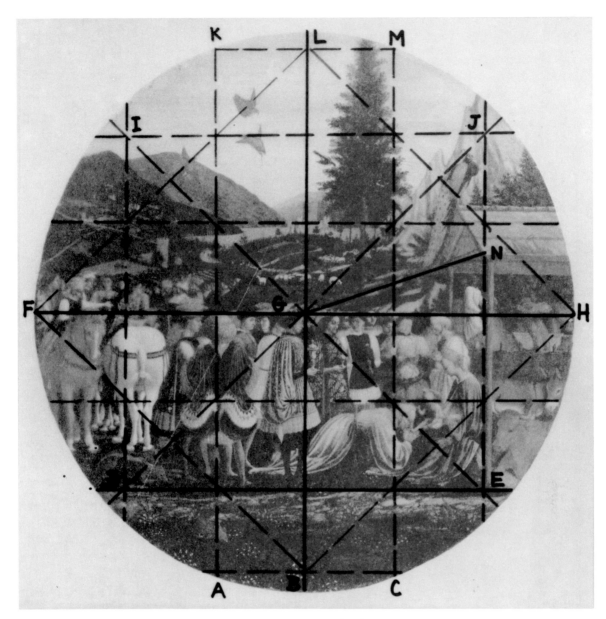

Fig. 9. Domenico Veneziano, *The Adoration of the Magi,* geometric scheme.

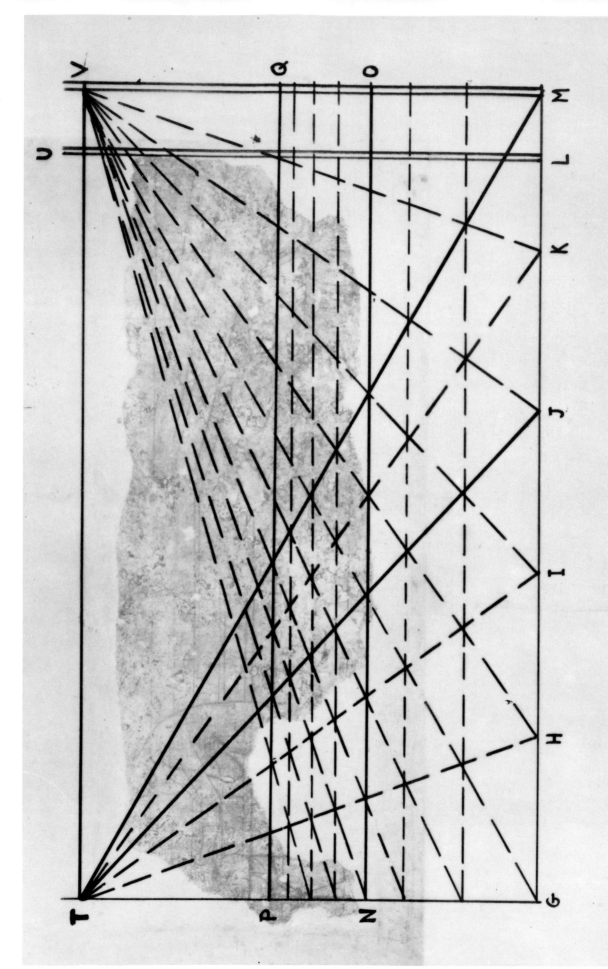

Fig. 10. Domenico Veneziano, *sinopia* for the *Marriage of the Virgin*, perspective system.

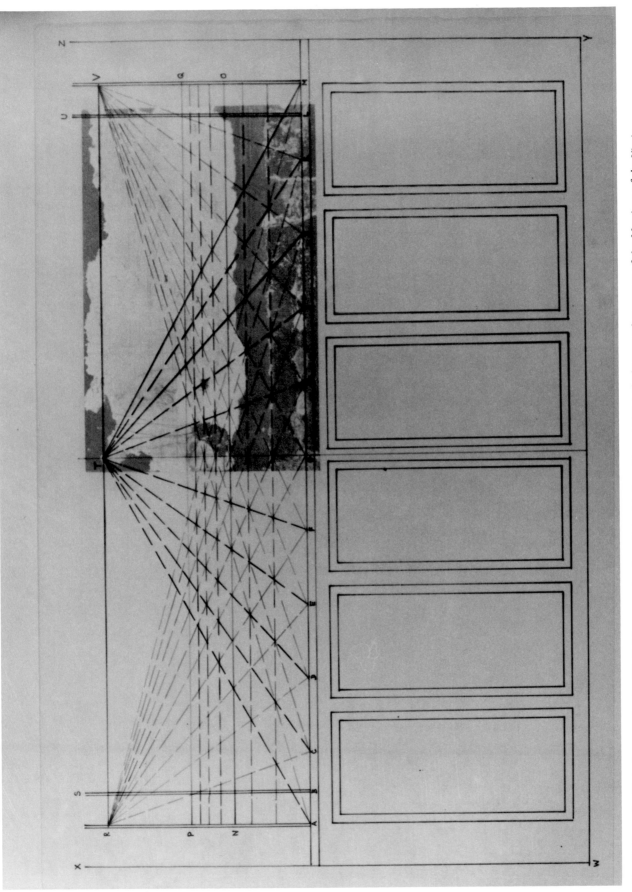

Fig. 11. Domenico Veneziano, west wall of S. Egidio, reconstruction of simulated marble paneling and of perspective system of the *Marriage of the Virgin*.

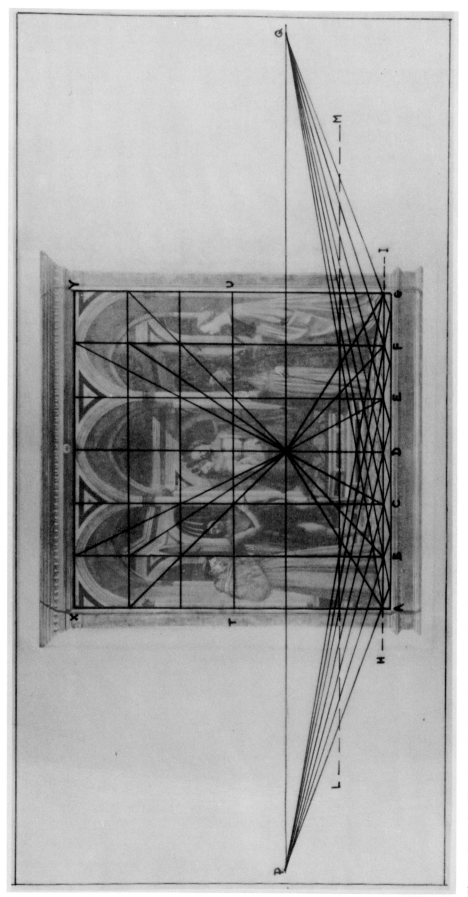

Fig. 12. Domenico Veneziano, St. Lucy Altar, geometric scheme.

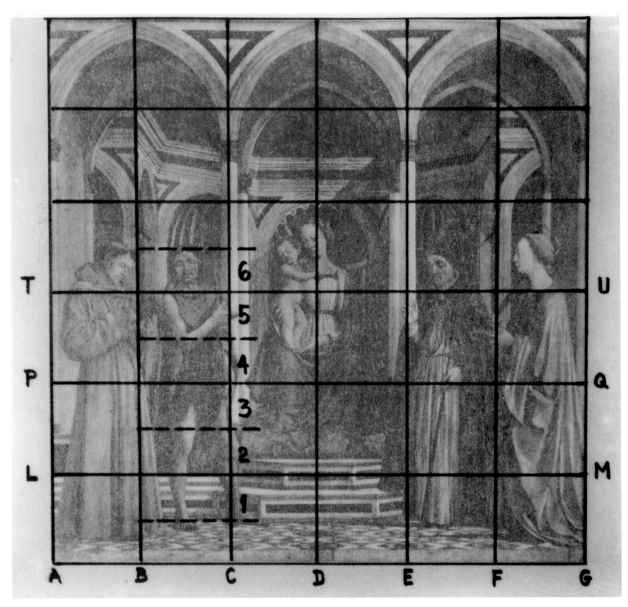

Fig. 13. Domenico Veneziano, St. Lucy Altar, quadratic grid.

Fig. 14. Domenico Veneziano, St. Lucy Altar, orthogonals of pavement.

Fig. 15. Domenico Veneziano, St. Lucy Altar, ground plan of pavement.

Fig. 16. Domenico Veneziano, St. Lucy Altar, reconstruction of frame.

Fig. 17. Fra Angelico, S. Marco Altar, perspective system.

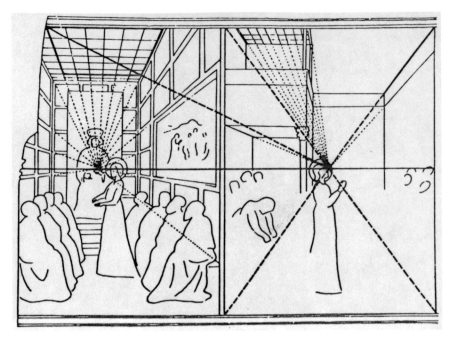

Fig. 18A. Masolino, *The Disputation* and *The Attempted Martyrdom of St. Catherine,* Rome, S. Clemente, geometric scheme (after Ortel).

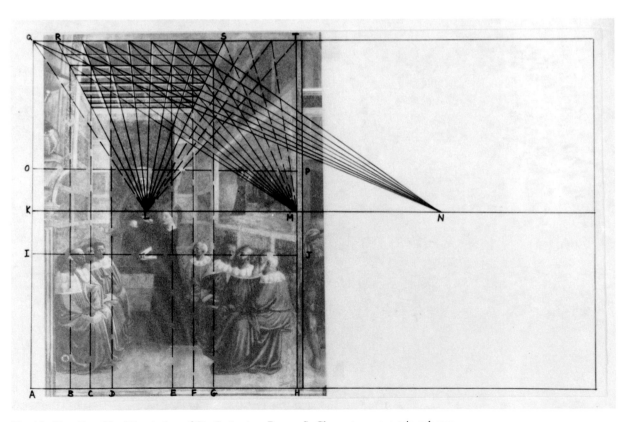

Fig. 18. Masolino, *The Disputation of St. Catherine,* Rome, S. Clemente, geometric scheme.

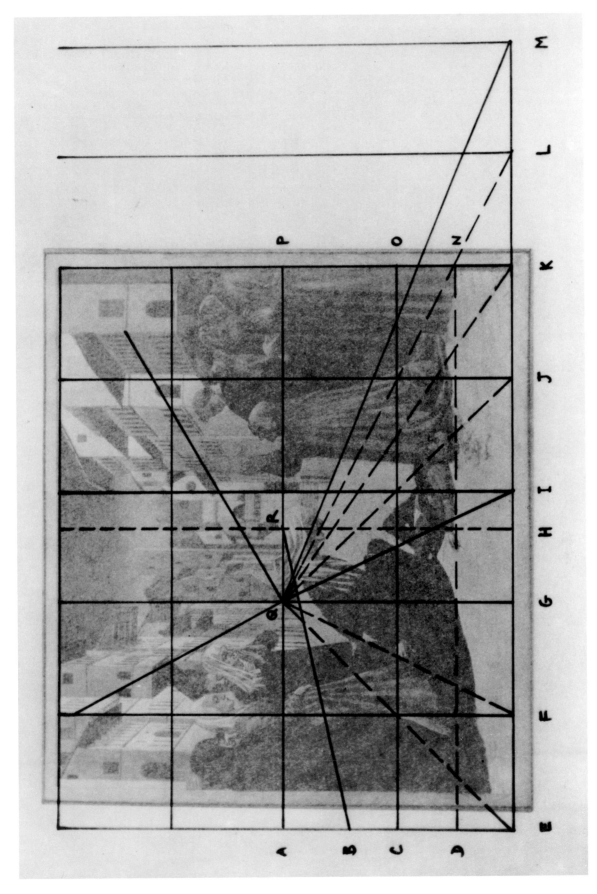

Fig. 19. Domenico Veneziano, *A Miracle of St. Zenobius*, geometric scheme.

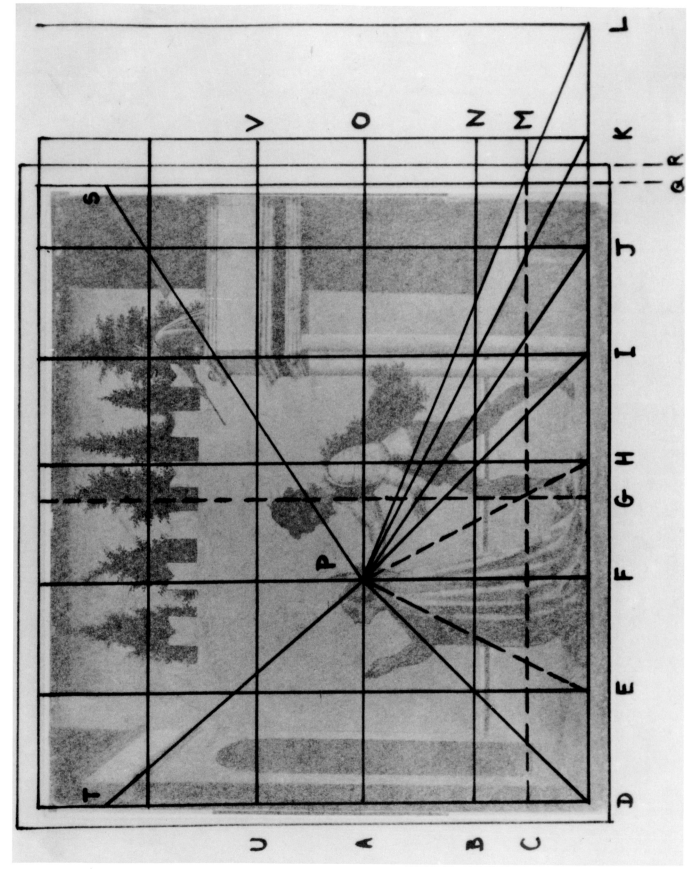

Fig. 20. Domenico Veneziano, *The Martyrdom of St. Lucy*, geometric scheme.

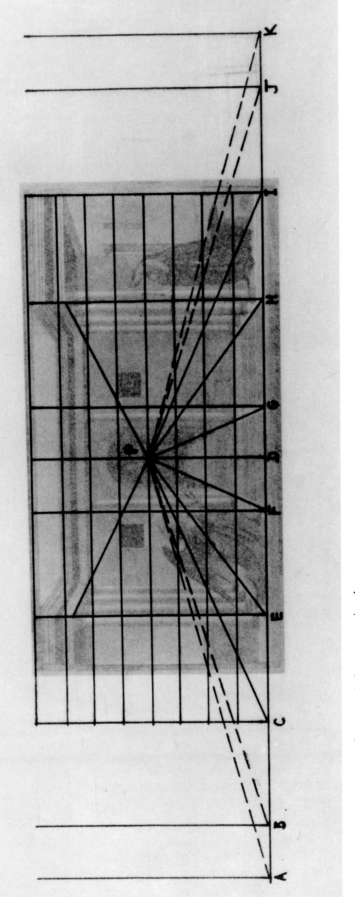

Fig. 21. Domenico Veneziano, *The Annunciation*, geometric scheme.

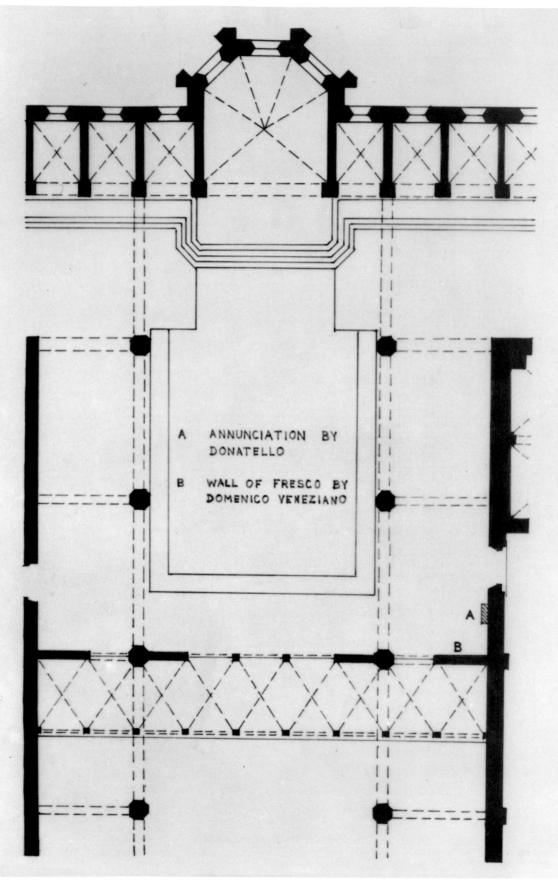

A ANNUNCIATION BY
 DONATELLO

B WALL OF FRESCO BY
 DOMENICO VENEZIANO

A

B

Fig. 22. S. Croce, Florence, plan of rood screen and original location of fresco by Domenico Veneziano (after Hall)

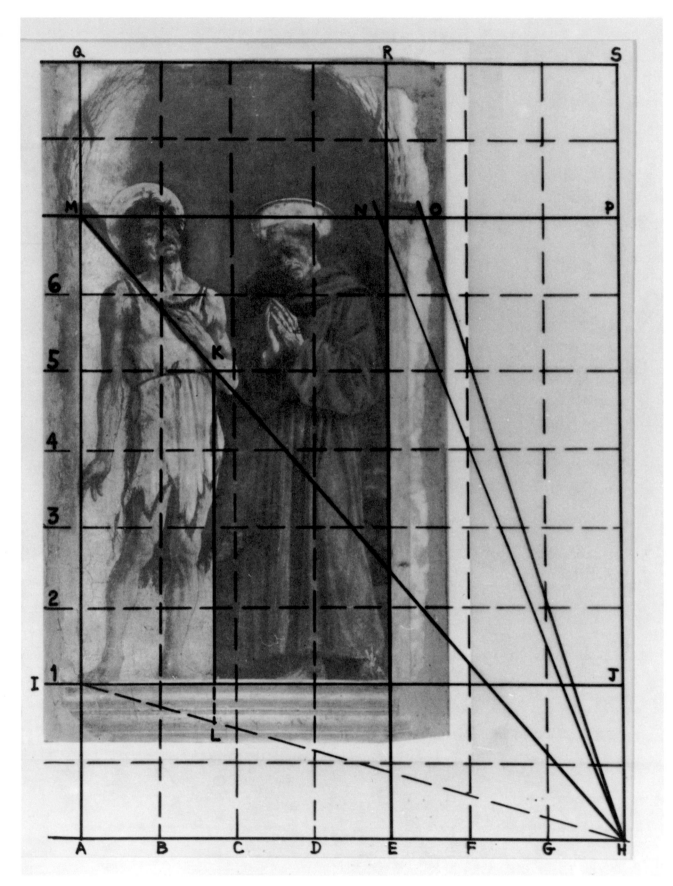

Fig. 23. Domenico Veneziano, *Sts. John the Baptist and Francis*, geometric scheme.

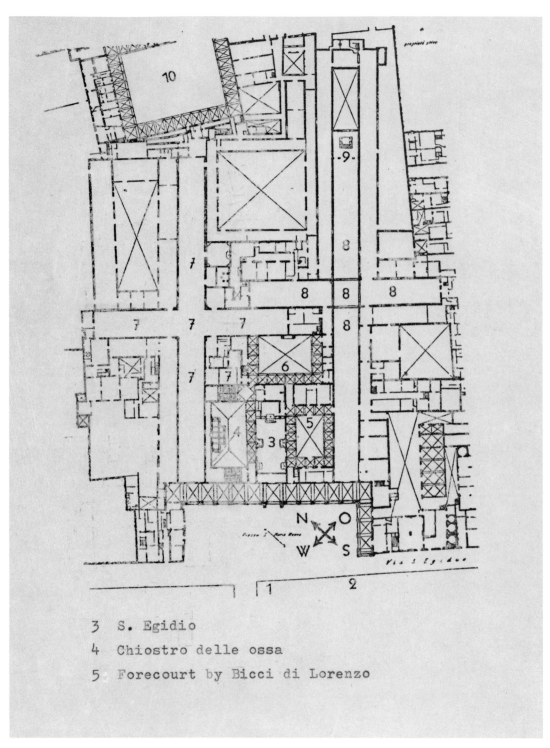

3 S. Egidio
4 Chiostro delle ossa
5 Forecourt by Bicci di Lorenzo

Fig. 24. S. Maria Nuova, Florence, plan (after Paatz, *Die Kirchen von Florenz*).

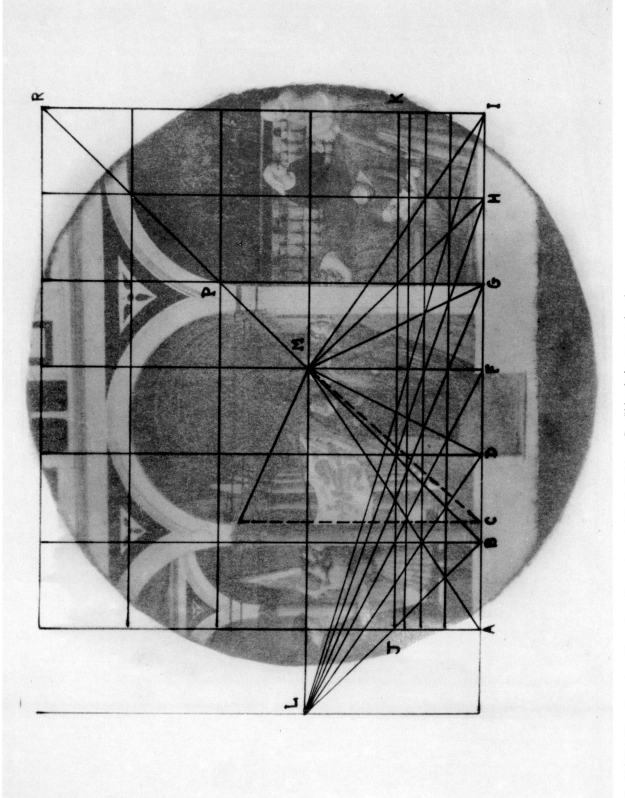

Fig. 25. Mid-fifteenth-century Florentine, *Desco da parto*, Berlin-Dahlem, Gemäldegalerie, geometric scheme.

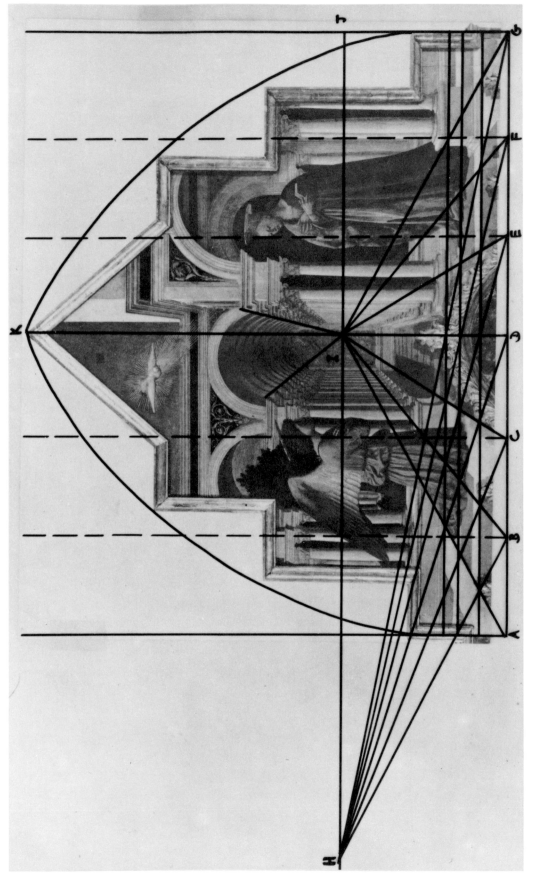

Fig. 26. Piero della Francesca, *The Annunciation*, Perugia, Galleria Nazionale dell' Umbria, geometric scheme.

CATALOGUE RAISONNÉ

INTRODUCTORY NOTE

The present catalogue raisonné is divided in nine parts:

Autograph Works (nos. 1–12)
Workshop Productions (nos. 13–14)
Apocryphal Works (nos. 15–49)
Apocryphal Works: Portraits (nos. 50–64)
Attributions to Domenico's Workshop or Followers (nos. 65–76)
Erroneously Identified Attribution (no. 77)
Unidentifiable Attributions (nos. 78-79)
Copies (nos. 80–82)
Lost Works (nos. 83–88)

The purpose of the entries for autograph works is to unburden the text of the data pertaining to each picture's documentation, provenance, physical state, and original appearance, and of the opinions regarding its attribution and date in the literature of art. The entries for workshop productions through copies enumerate these data as well but also include my own arguments for each object's date and authorship. The entries for lost works discuss their documentation and the evidence for their reconstruction.

A number of apocryphal attributions reflect topics that have been of special interest in Domenico Veneziano criticism and research: his early career (the *Head of a Saint* at Asolo; the four martyrdom panels at Bassano, Bergamo, and Washington; the Verona *Christ in the Tomb;* the *Madonna* at Pisa; the predella of Fra Angelico's Louvre *Coronation of the Virgin;* and the riders in the *Crucifixion* at S. Clemente); his painterly style (the Franciscan diptych at Munich and the *St. John the Evangelist* at S. Tarasio); his realism (the *Kneeling Monk* at Lugano, the Berlin *Sts. Cosmas and Damian,* the *St. Francis* in the Brivio Collection in Milan, the Pitti *St. Jerome,* and the fresco with St. Jerome from S. Domenico in Pistoia); his activity as a *cassone* painter (the Glasgow *Judgment of Paris,* the *Meeting of Solomon and the Queen of Sheba* at Houston, the Opper *Diana and Acteon,* the *Rape of Helen* in the National Gallery in London,

[113]

and the Bryan *Triumph of Fame* in the New York Historical Society); and his activity as a portraitist (nos. 50–64).

AUTOGRAPH WORKS

1. Fragments of a Tabernacle from the Canto de' Carnesecchi in Florence, ca. 1432–37 (Pls. 1–7).

Madonna and Child Enthroned, 241 × 120.5 cm.
Head of a Beardless Saint, 45 × 35.5 cm.
Head of a Bearded Saint, 45 × 35.5 cm.

Fresco transferred to canvas.

London, National Gallery, nos. 1215, 766, 767.

The platform of the throne bears the inscription DOMI[NI]CUS D[E] VENECIIS P[INXIT]. In his *Memoriale* of 1513 Francesco Baldovinetti (source 8) attributed the Carnesecchi Tabernacle to his father Alesso, who was Domenico Veneziano's pupil. According to Vasari, Domenico painted the work "in the first days" (1550) and "before he did anything else" (1568) after his arrival in Florence (source 11D). Vasari also described the location of the tabernacle—"at the angle of the two streets that go to S. Maria Novella"—and claimed that because it was "greatly praised by the citizens and craftsmen of the time" it inflamed Andrea del Castagno with envy and rage against Domenico.

Nothing is known about the commissioning of the mural. The Carnesecchi family had a chapel in the church of S. Maria Maggiore, diagonally across the street from the site of the tabernacle, which contained an altarpiece said by Vasari to be by Masaccio (see catalogue no. 23). There is no evidence for the suggestion made by Gioseffi (1962) that the Carnesecchi family also commissioned Domenico's tabernacle.

The property to which the tabernacle belonged was sold in 1851 by the Marchesa Marianna Venturi Vedova Ginori Lisci to Don Ercole dei Principi Pio di Savoia, and in the same year or early in 1852 the *Madonna* and the heads of the two *Saints* were detached and transferred to canvas by the Milanese restorer Giovanni Rizzoli.[1] They were then restored by Antonio Marini and shown in Prince Pio's house, where they were seen by Cavalcaselle (1864, p. 317), Eastlake (1869, II, p. ix), and Milanesi (Vasari-Milanesi, II, p. 675, n. 1). The two heads were bought by Eastlake in 1862 and were purchased from his collection by the National Gallery in 1867. The *Madonna* was sold by Prince Pio on February 16, 1859 to the dealer Luigi Hombert,[2] who in turn sold it in 1865 to Lord Lindsay (later earl of Crawford and Balcarres) for 8,000 francs. The *Madonna* entered the National Gallery with the bequest of Lord Lindsay in 1886.

The instrument of 1851 recording the sale of the house to which the tabernacle belonged states that of the saints "only the two heads were visible, the rest of the figures having been almost destroyed by time and weather." The heads, however, are in very poor condition, and have been almost entirely repainted and redrawn (Pls. 2–3).

In 1864, after the *Madonna* had been detached and restored, Cavalcaselle described it as "damaged chiefly in the draperies and in parts of the heads" (p. 318, n. 1). Lord Lindsay must have had the work treated a second time, for when it entered the National Gallery it was described as "most gravely disfigured by oil varnishes" (Phillips, 1886; see also Fabriczy, 1887); and in the Italian edition of his *History of Painting in Italy* (1892) Cavalcaselle wrote that "the figures stand out from a ground of thick, dark paint, so reduced are they by restoration" (p. 129, n. 1). However, twenty years later Schmarsow (1912) declared that "cleaned of all former additions, [the work] now presents itself to the eye of the student in a state of authenticity" (see also Testi, 1916, pp. 425f.). Schmarsow's description records the state in which the *Madonna* is still today, far though it may be from what we would call "authentic":

Losses appear in many parts: the whole nose, for example, down to the lower contour, is recognizable only by the line of its profile; the lips are only partly preserved; losses can also be observed in the chin and the neck, from the throat down to the edge of the gown. . . . Similar gaps are visible in the head and body of the Child, which was originally nude as in the St. Lucy Altar, but was later covered with a veil crossing the hips. (p. 14)[3]

Even with the help of infrared photographs it is extremely difficult to distinguish between remnants of original paint and later additions. According to Vasari, Domenico's fame rested on his mastery of oil painting. In saying that the Carnesecchi Tabernacle was greatly praised and that its acclaim aroused the envy of Castagno, he implied that it too, and not only Domenico's frescoes at S. Egidio, was painted in oil. Although this is clearly not the case, there are many *a secco* passages in the Carnesecchi *Madonna,* and in some of these, such as the crown and the brocade dress of the Virgin (Pls. 6–7), Domenico may have used oil glazes, as he apparently did in the *Birth of the Virgin* at S. Egidio (see catalogue no. 86).[4]

The composition has evidently been cut down on all sides. The arch by which it is now framed, and which confines the throne and the foreshortened figure of God much too closely, producing disturbing and surely unintended spatial ambiguities between them, must have been added after the work was transferred to canvas.[5] The original dimensions of the mural probably corresponded to the size of the squared cartoon on which Domenico seems to have laid out its proportions and perspective construction (Fig. 1). In the course of the transfer to canvas the forms of the platform in front of the throne, and to some extent perhaps also its left side, were shifted to the left and then partly repainted. The vertical axis of the composition now passes well to the right of the center of the platform, whereas originally it surely divided it symmetrically.

The original site of the Carnesecchi Tabernacle at the intersection of the Via de' Banchi and the Via de' Panzani is recorded in the engraving showing the Canto de' Carnesecchi by Giuseppe Zocchi (1754). The tabernacle, according to Cinelli's edition of Bocchi's guide to Florence (1677, p. 212), was located "above [*sopra*]" this intersection.[6] Probably it was in the arch framed by columns, protected by a railing and a glass front, on the level of the *piano nobile* at the end of the row of buildings on the right side of Zocchi's engraving (Pl. 8). The fact that the proportions of this arch are considerably wider than those of the *Madonna* in the National Gallery would support the thesis that the dimensions of the mural originally extended farther beyond the sides of the Virgin's throne than they do now.

According to the bill of sale of the house, the two *Saints* were originally "in the two

thicknesses of the wall, or wings of the tabernacle.'' In view of the position of the tabernacle well above eye level, the *Beardless Saint,* rather than looking out at the spectator, probably turned toward the Virgin and thus stood on her right. Parronchi (1964) has taken Vasari's description of the Virgin as having ''alcuni santi da lato'' (1550) and of being ''in mezzo d'alcuni santi'' (1568) to mean that there might have been more than two saints. But the 1851 bill of sale specifically lists two saints only.

Like other works by Domenico Veneziano, the Carnesecchi Tabernacle has been dated within a range of two decades. Shell (1968) considered it Domenico's first extant work. Other datings are as follows: ca. 1433–34 (Gioseffi, 1962); ca. 1435 (Salmi, 1936 and 1938; Longhi, 1952); 1437–39 (Berti, 1961: ''the first Renaissance painting to put into practice the principles enumerated by Alberti in *De pictura''); the* late 1430s (Paccagnini, 1952); after 1438 (Murray, 1963); after 1440 (Clark, 1951); 1440–45 (Hartt, 1959: painted during the phase of Domenico's ''assimilation of Florentine style''); ca. 1442 (Muraro, 1959); 1443 (Mallé, 1965); the 1440s after the St. Lucy Altar (Testi, 1916; Toesca, 1932); ca. 1450 (Parronchi, 1964); and after 1454–55 (Pudelko, 1934; Wackernagel, 1938, p. 194).

Only three of these proposed datings are based on specific visual comparisons and call for brief comments. Muraro's date of ca. 1442 rests on his view that there is so close a similarity between the head of the *Bearded Saint* and the head of the *St. John the Evangelist* at S. Tarasio in Venice (Pls. 2 and 13), which he has attributed to Domenico Veneziano, that the two must have been painted in the same year. Muraro's attribution, however, is far from conclusive. Castagno may well have used Domenico's figure as his source. Moreover, both bearded heads adhere to a type in the repertory of Florentine painting of the time (see catalogue no. 46).

Parronchi has argued for a date of ca. 1450 on the strength of his comparison of the head of the Virgin to the style of Baldovinetti. The descendants of Domenico's stately figure, however, are not the maidenly Madonnas of Baldovinetti, but, as Holmes (1934) and Clark (1951) have emphasized, the monumental, austere Virgins of Piero della Francesca. Pudelko based his date of after 1454–55 on his belief that the figure of God presupposed the foreshortened representation of God the Father in Castagno's *Vision of St. Jerome* (Pl. 158), which was painted in those years. But the head of God in Castagno's picture is foreshortened at an angle and projects forward as a sculptural mass in space, whereas the head of Domenico's figure is frontal, symmetrical, restrained in its spatial thrust, and integrated with the two-dimensional design of the arms and mantle, somewhat as in the roughly contemporary Rinieri altarpiece at Grenoble by Francesco d'Antonio.[7]

NOTES

1. See Davies (1961) and documents recording the sale of the property, as well as of February 4, 1852 in the files of the National Gallery in London.
2. See a letter by Hombert of February 6, 1852 in the files of the National Gallery.
3. No evidence of a veil covering the nudity of Christ is visible today.
4. I am most grateful to the late Martin Davies for giving me a set of infrared photographs of the *Madonna* taken on August 2, 1952.
5. Nevertheless, Schmarsow (1912) and Parronchi (1964) have accepted the arch as authentic.
6. The Carnesecchi Tabernacle was not mentioned in the first edition of Bocchi. Cinelli may have included it in his 1677 edition because of the fame of Giovanni Bologna's *Hercules and the Centaur,* which was set up at the Canto de' Carnesecchi in December 1599 and is shown in Zocchi's engraving.
7. The differences between Domenico's and Castagno's foreshortened figures have been

pointed out previously by Böck (1934. For further references to the Carnesecchi Tabernacle, see A. W. (1868), Cavalcaselle (1870, p. 51, and 1911, p. 143), Bode (1883 and 1897), Schmarsow (1893), Berenson (1902, 1932, and 1963), Kugler (1902, I, p. 139), Brown and Rankin (1914, p. 113), Escher (1922, p. 77), Van Marle (X), Böck (1934a), Ragghianti (1935), Busuioceanu (1937), Kennedy (1938), Pope-Hennessy (1947 and 1975a), Robertson (1954), and Salmi (1954).

2. *Madonna and Child,* ca. 1432–37 (Pls. 24–27).

Tempera on poplar panel, 86 × 61.5 cm.

Settignano, Villa I Tatti (The Harvard University Center for Italian Renaissance Studies).

The panel is neither signed nor documented. It was first mentioned in the later nineteenth century when it was in the Panciatichi Collection in Florence (Cavalcaselle, 1870, p. 51). In 1900 it was exhibited in Florence at the Cantigalli Gallery on the Via del Campidoglio, and on April 16 of that year it was bought from the Marchesa Marianna Panciatichi Ximenes Paulucci by Bernard Berenson as a work of Alesso Baldovinetti.

In spite of a certain amount of restoration in the mantle of the Virgin and the background, the picture is in very good condition. The judgment in the Italian edition of Cavalcaselle (1892, p. 134) that "the blue mantle is greatly altered by retouches" and that "the background is all newly gilt" seems exaggerated. The reverse of the mantle, however, has turned from olive to black. A crack, clearly visible near the Virgin's face, runs vertically through the entire panel. The gilt parts—the Virgin's dress, the border of her mantle, the halo and the background—are incised and stamped with decorative patterns according to methods described by Cennino Cennini. The flesh passages in both figures are in mint condition. In 1954 Mr. Berenson told me that the painting had not been touched since he had acquired it in 1900.

Jordan (in Cavalcaselle, 1870) thought it might be an early work of Piero della Francesca influenced by Domenico Veneziano, or even by Domenico himself. The editor of the Italian edition of Cavalcaselle (1892) inclined toward Baldovinetti's pupil Graffione.[1] Other early attributions were to Giovanni di Francesco, known as the Master of the Carrand Triptych (Bode, 1897) before Longhi (1928) discovered his identity, and Baldovinetti (Berenson, 1898, 1900, and 1902, pp. 32ff.; Pietri, 1909; Venturi, 1911, p. 550). Douglas (in Cavalcaselle, 1911, p. 143, note) thought the panel "in a style which wavers between that of Baldovinetti and Domenico Veneziano." Domenico's certain authorship was first recognized by Supino (1900), Weisbach (1901a), Gronau (1913) and, with some qualifications, by Testi (1916, p. 431). It was firmly established by the time of the Exhibition of Italian Art of 1930 at Burlington House (Royal Academy, 1931; Constable, 1930a), and the panel was given to Domenico Veneziano in the first edition of Berenson's lists of Italian pictures (1932).

According to Fiocco (1927 and 1941), the Berenson *Madonna* was painted soon after 1431, the year in which he places Domenico's arrival in Florence from northern Italy. Berti (1961) has dated it 1436. Clark (1930) considers it an early work, "between the Kress and St. Lucy [*Madonnas*]." For Russoli (1962) it belongs to the years 1436–48. Salmi (1936 and 1938) has

CATALOGUE RAISONNÉ

proposed 1440–41, Hartt (1959) 1440–45, Shell (1968) a date in the 1450s, and Pudelko (1934) 1455. Paccagnini (1952) believes that the panel is Domenico's next to last work (the last, in his view, being the St. Lucy Altar).[2]

NOTES

1. For Graffione, see Horne (1905a) and Kennedy (1938).
2. For further references to the Berenson *Madonna,* see Van Marle (X), Toesca (1932), Böck (1934), Kennedy (1938), Salmi (1938a),

Offner (1939), and Berenson (1963). An excellent reproduction of a color photograph of the painting in its very good imitation Renaissance frame was published in the October 1954 issue of *Du.*

3. *Madonna and Child,* ca. 1437–38 (Pls. 31–34).

Tempera on poplar panel, 83.2 × 53.2 cm.

Bucharest, Art Museum of the Romanian People's Republic (Muzeul de Artă al Republicii Socialiste România), no. 4.

Neither signed nor documented, the picture can be traced back as far as 1877, when it was in the collection of Felix Bamberg in Brussels, already with an attribution to Domenico Veneziano.[1] In 1879 it entered the collection of King Carol I of Romania at Peleş Castle, where it remained until World War II (see Bachelin, 1898, no. 7). After the war, together with the other paintings from the royal collection, it was moved to Bucharest.

The panel is today in uneven condition. Virtually unknown until it was published by Busuioceanu (1936), it had, according to Busuioceanu (1937), never been restored, and would, in his opinion, "appear lighter in color and closer to Domenico's other works once it is cleaned and restored." As late as 1968 Hendy published a description of it as being "much darkened by dirt and old varnish, so that the color has to be guessed at." However, when I saw the picture in Bucharest in 1960 it had been partly cleaned and restored (see the color reproductions in Oprescu, 1960 and 1961). A vertical split running through the entire height of the composition had been mended, and the panel had been cradled. A pentimento was revealed along the contour of the Virgin's waist, which the painter made narrower than he seems originally to have intended. A loincloth that had at one time been added to the Child (see Busuioceanu, 1937) had been removed. The paint surface is still partly covered with cracks, dirt, and old varnish. There are serious losses in the middle and on the shadow side of the Virgin's face (Pl. 32) and in the face of Christ. The Child's legs and feet (Pl. 33) and the right hand of the Virgin are in good condition and show to advantage Domenico's carefully constructed modeling. The foliage and the roses of the hedge are darkened by old varnish but otherwise appear to be intact. The most disturbing loss is the virtual disappearance of the crimson of the Virgin's dress.

Since the work is not easy of access, it may be helpful briefly to describe its color and physical appearance. The panel has not been cut and extends about 2 cm beyond the gesso

[118]

ground on all sides. The outlines of the folds in the lower part of the Virgin's mantle are incised, in accordance with the method recorded by Cennino Cennini for blue draperies in fresco, by which you "first scratch in the plan of the folds with some little pointed iron, or with a needle." The tonality of the picture is clear and metallic, like that of the Berlin *Adoration of the Magi*. The sky is prussian blue, darker at the top and progressively lighter as it approaches the rose hedge. The hedge itself is dark olive; the flowers are either light gray with white rims, dark yellow centers, and touches of blue, or dark crimson with lighter red rims and dark red spots in the center. The mantle of the Virgin is dark green-blue on the outside, and dark violet-blue on the inside. Her dress was once crimson. Her belt is black. The sides of her chair are gilt, the cushion on which she sits is reddish purple, and the tassels below its gilded bosses are striped in white, pink, and black. The tip of the Virgin's shoe, like the shoes of St. Lucy in the *sacra conversazione* and of the Virgin in the *Annunciation* of the St. Lucy altarpiece (and also like the shoe of the princess in Paolo Uccello's *St. George and the Dragon* in the National Gallery in London), is vermilion. The Virgin's hair is ash blond; the Child's is near black streaked with gold. The flesh color is yellowish-gray with a slight greenish tinge, and the underpainting of the flesh tones is gray-green, as it is in the *Adoration of the Magi*. As in the Berenson *Madonna*, the gilded borders of the Virgin's dress are punched with rows of points and rosette stamps.

From the time the rediscovery of the picture was reported by Busuioceanu in 1936, its attribution to Domenico Veneziano has never been questioned. It has been dated within a narrower range than any of Domenico's other works except the S. Croce fresco. Busuioceanu (1937) placed it among the painter's first productions after his arrival in Florence from Venice. Zeri (1961) too considers it to be one of his earliest works. Shell (1968) believed it was Domenico's second extant painting, following the Carnesecchi Tabernacle. Longhi (1952) dated it 1430–35, Hartt (1959) 1435–40, Berti (1961) 1442–45, and Salmi (1938 and 1958) and Kennedy (1938) 1444. Paccagnini (1952) places it between the Carnesecchi Tabernacle, which he dates in the late 1430s, and the Kress *Madonna*.

The only dating which is supported by a specific argument is Salmi's, who believes that in the middle of the 1440s Domenico Veneziano was in Venice, and that the source for the Child in the Bucharest *Madonna* is the *putto* holding up the wreath that contains the bust of St. Benedict on the intrados of the triumphal arch at S. Tarasio (inscribed 1442).[2] But the posture of the S. Tarasio *putto* (Pl. 37) is only superficially like that of Domenico's Christ child: the *putto*'s feet are on a level rather than as if climbing, and its stationary foot is on tiptoe and seen from behind instead of standing flat and being frontally foreshortened. The reverse of its posture is assumed by the *putti* holding the wreaths with the prophets Daniel and Isaiah. The common source for the *sottarco*'s and Domenico's *putti* was probably Donatello.[3]

NOTES

1. See *Catalogue de la collection . . . Bamberg* (1877, no. 12). It is not impossible that the Bucharest *Madonna* is the picture mentioned in Cavalcaselle (1870, p. 51, and 1892, p. 134) as being in the Mündler Collection in Paris, tentatively attributed in the edition of 1870 to Domenico Veneziano, and in that of 1892 to Domenico or to Alesso Baldovinetti, and described in the former as depicting a Madonna, "auf deren Knie das Kind aufrecht steht, während sie eine Rose pflückt."

2. The frieze on the *sottarco* of S. Tarasio is usually given to Castagno. However, Fiocco (1957) has given both the *sottarco* frescoes

and the *Madonna and Child with Saints* from the Castello del Trebbio formerly in the Contini-Bonacossi Collection (Pl. 21) to an assistant of Andrea's whom he has identified as the mosaicist Silvestro di Pietro. Though Fiocco's identification of the assistant and his view that the Trebbio fresco precedes the *sottarco* frieze are not persuasive, the two works are undeniably connected. There can be little doubt, for example, that the bust of Daniel on the *sottarco* and the angel at the right of the Virgin in the Trebbio fresco were painted by the same hand (Pls. 22–23). Yet the latter could hardly date from before the middle of the century (see Keller, 1954; Hartt, 1959). In the pink, light green and white color chord of its foreground carpet and in the ribbonlike shadows cast by the legs of St. Jerome it is clearly dependent on the pavement of the St. Lucy Altar, while in the angels flanking the Madonna it follows Castagno's *Assumption of the Virgin* of 1449.

3. For further references to the Bucharest *Madonna*, see Kennedy (1938), Busuioceanu (1939), and Berenson (1963).

4. *The Adoration of the Magi,* ca. 1439–41 (Pls. 38–45).

Tempera on poplar panel, 84 cm in diameter.

Berlin-Dahlem, Gemäldegalerie, no. 95-A.

The picture is neither signed nor documented. It contains four inscriptions:

1. *tenpo* in lower case Gothic letters on the hat of one of the riders in the background (Pl. 39).
2. HONIA BOA IN TENPOR in capital Roman letters on the strap around the rump of the white horse (Pl. 40).
3. *ainsi va le monde* in lower case Gothic letters placed vertically along the edge of the figure to the right of the white horse, with the word *monde* symbolized by the emblem of the *orbis terrarum, globis crucifer* (Pl. 41).
4. *grace fai die* [*u*] in lower case Gothic letters along the lower border of the tunic of the figure between the man with the falcon and the attendant holding the crown of the kneeling magus (Pl. 42).

In the second inscription, a contraction of the Latin OMNIA BONA IN TEMPORE, the first word (HONIA) conforms to the Tuscan habit of prefixing the letter *o* with an *h*, a practice Domenico also adopted in his letter to Piero de' Medici and in the inscription of the St. Lucy altarpiece. Although the evidence provided by this detail is slight, it would lend support—were support needed—for the attribution of the tondo to Domenico Veneziano.

Pudelko (1934) has convincingly identified the tondo with an *Adoration of the Magi* listed in the Medici Inventory:

Uno tondo alto braccia 2 entrovi la storia di Magi di mano di Pesello.........f.20
(Müntz, 1888, p. 64)

It might be objected to this identification that the Berlin tondo is neither by Pesello (actually Francesco Pesellino, who in the later fifteenth and sixteenth centuries was confused with his

grandfather and probable teacher Giuliano Pesello) nor two *braccia* (about 120 cm), but rather less than one and one-half *braccia* in diameter. However, the entry in the Medici Inventory would not be the only instance in which a painting by Domenico Veneziano was attributed to Pesellino: in the first edition of the *Vite*, for example, Vasari designated Pesellino as the author of the St. Lucy Altar (see catalogue no. 5). As for the discrepancy in size, the measurement in the Medici Inventory may have included not only the diameter of the panel itself but also the width of its frame.

Pudelko and subsequent scholars have written that after the dispersal of the Medici Collection the tondo was in the Palazzo Guicciardini (Pudelko, 1934; Salmi, 1938; Pittaluga, 1949). However, this is very unlikely and, although a minor point, is perhaps worth clearing up. An inventory of the Palazzo Guicciardini of 1807 listed two tondi of the *Adoration of the Magi* by Botticelli, which appeared as lot 34 and lot 38 at the sale of the William Coningham Collection in London in 1849. Lot 38 was the painting by Botticelli now in the National Gallery in London. It was bought at the Coningham Sale by W. Fuller Maitland, was then attributed by Waagen (1854, III, p. 3) to Filippo Lippi, and was sold to the National Gallery in 1878 (see Davies, 1961). Lot 34 at the Coningham Sale was the tondo by Fra Angelico and Fra Filippo Lippi now in the Kress Collection at the National Gallery of Art in Washington. It was bought in 1849 by Alexander Barker, went to the Cook Collection at the Barker Sale at Christie's in 1874, and was acquired by Rush Kress in 1947 (see Shapley, 1966; Walker, 1974). As it happens, the tondo by Domenico Veneziano was in the middle of the nineteenth century also in the possession of Alexander Barker, with an attribution to Fra Filippo Lippi before Waagen (1854, II, p. 125) gave it to Benozzo Gozzoli, and was also included in the 1874 sale of the Barker Collection. Pudelko's assumption that it had come from the Palazzo Guicciardini was based on the confusions, first, of Cavalcaselle (1864, p. 350), who mistook Domenico's *Adoration* for the painting in the Maitland Collection attributed by Waagen to Fra Filippo Lippi, and second of Borenius (1913, I, p. 22), who mixed it up with both of the *Adorations* at the Coningham Sale of 1849.

The Berlin tondo found no buyers at the sale of the Barker Collection in 1874. At the second Barker Sale in 1879 it was bought by Colnaghi, and in 1910 was acquired for the Kaiser Friedrich Museum in Berlin. Following World War II the painting was in the care of the Hessische Treuhandverwaltung des früheren preussischen Kunstgutes at the Neues Museum in Wiesbaden. In 1956 it was installed in the Gemäldegalerie at Berlin-Dahlem.

The panel is in exceptionally good condition. When I saw it in Wiesbaden in 1952 it was split by a crack running through the entire surface from the upper right to the lower left, and its paint layer was flaking badly. In 1958, however, it was cleaned, with virtually no losses, and repaired. Cleaning revealed a previously unsuspected strength and luminosity of color, as well as the figure of a standing shepherd, who had been covered by a clump of shrubbery, to the right of the tree (Pl. 43). There are varying degrees of finish in the execution of the heads. That of the groom holding the crown of the kneeling magus is hardly modeled at all, while in certain heads light and shade are contrasted with a thick, painterly impasto. Other heads yet are modeled with Domenico's characteristic crescent-shaped hatchings. The head of the Child has been slightly damaged and is retouched on the shadow side. There is also some retouching along the contour of the back of his head, as well as along the profile of the Virgin. A number of holes in the left side of the sky have been filled in. The ground under the foliage of the tree and the four birds in the sky is slightly raised above the level of the gesso in the rest of the panel.

Domenico Veneziano's authorship of the panel was apparently first recognized by Berenson in 1898, an attribution which went unnoticed because it appeared in an obscure publication with a small edition.[1] Thereafter the picture was connected with Domenico by Rankin (1907 and 1907a) and was given to a follower, perhaps Baldovinetti, by Mather (1923, p. 182). The firm attribution to Domenico is due to Longhi (1925), and has been questioned only by Mesnil (1927, pp. 109f., n. 1), Sindona (1960 and 1962, pp. 102ff.), Francastel (1967), Redslob (1967), and Wundram (1970). The tondo has a varied history of earlier designations, however: Benozzo Gozzoli (Waagen, 1854, II, p. 125); "the Peselli School" (Cavalcaselle, 1864, p. 350, and 1911, p. 124); Fra Filippo Lippi (Christie, Manson, and Woods, 1874, no. 44, and 1879, no. 489); Dello Delli (Hamilton, 1901, pp. 39f.); a follower of Pesellino (Weisbach, 1901, pp. 25f.); a follower of Uccello (Venturi, 1911, p. 340); Florentine school (Venturi, 1906; Offner, 1920); a Veronese follower of Stefano da Zevio imitating Pisanello and influenced by Florentine painting (Morelli, 1880, p. 103); Veronese school (Colasanti, 1909); a follower of Pisanello (Zöge von Manteuffel, 1909); and Pisanello (Königliche Museen zu Berlin, 1883, 1904, 1912, and 1931; Bode and Tschudi, 1885; Weizsäcker, 1886; Bode, 1889; Burckhardt, 1898, p. 304; Hill, 1905, pp. 215ff.). After having been listed in the catalogues of the Kaiser Friedrich Museum for five decades as a work of Pisanello, the tondo has been given to Domenico Veneziano in the catalogue of the Gemäldegalerie at Berlin-Dahlem (Stiftung preussischer Kulturbesitz, 1963).

The dates proposed for the *Adoration of the Magi* span three decades—from the late 1420s to the late 1450s. Van Marle (VIII), Böck (1931–32 and 1934), Toesca (1932), Sandberg Vavalà (1948, p. 137) and Paccagnini (1952), without specifying a date, have thought it Domenico's earliest extant work. Örtel (1942, pp. 29 and 70), Meiss (1961), and Zeri (1961) have judged it early, but have also failed to provide a date. Murray (1963, p. 104) has placed it in the late 1420s or early 1430s, Hauptmann (1936, pp. 175ff.) in 1430, Fiocco (1927, pp. 43f., and 1941) in 1431 or shortly thereafter, Longhi (1952) in the period 1430–35, Coletti (1953a) and Volpe (1956) in 1435, Longhi on an earlier occasion (1940) and Hartt (1959) in 1435–40, Hendy (1968) after Domenico's return to Florence from Perugia, Gioseffi (1962) in 1438–39, Pudelko (1934 and 1936) and Pope-Hennessy (1969a) in 1440, Berti (1961) in 1442–45, Salmi (1938, 1954, and 1958) in 1445–46, Hatfield (1966) in 1445–50, Pope-Hennessy (1951) in 1448, Berenson (1932a) in 1450, and Shell (1968) in the late 1450s.

Only two of these datings are based on grounds other than their authors' reading of Domenico's stylistic development. Hatfield (1966), whose dates of 1445–50 seem to me to put the tondo later than it can be, has nevertheless pointed out correctly that "two of the figures in the background have the Greek type of headwear found in Florentine paintings only after [the church council of] 1439" (I, no. 27). Salmi has tried to find support for his date of 1445–46, following an alleged journey by Domenico to northern Italy, in the resemblance of the hat with the inscription *tenpo* to the headpiece in a drawing by Bonifazio Bembo in a codex in the Biblioteca Nazionale in Florence datable in the second half of the 1440s (see Degenhart, 1949, no. 13). However, the same type of hat was used by the Lombard painter Leonardo da Besozzo shortly after 1433 in the frescoes in the choir of S. Giovanni Carbonara at Naples.[2]

NOTES

1. The publication, which is neither in the library at I Tatti nor listed in W. Mostyn-Owen's *Bibliografia di Bernard Berenson* (Milan, 1955) is *The Golden Urn*, III, 1898.

2. See Urbani (1955). For further references to the Berlin tondo, see Miller (1926), Longhi (1927, p. 117), Scharf (1930), Gamba (1931), Berenson (1932 and 1963), Salmi (1936 and 1938a), Kennedy (1938), Offner (1939 and 1945), Pope-Hennessy (1944 and 1969), Beccherucci (1950), Covi (1958), and Meiss (1963 and 1964a).

5. *Madonna and Child with Sts. Francis, John the Baptist, Zenobius and Lucy,* ca. 1445–47 (Pls. 60–74).

Tempera on panel. Overall dimensions 209 × 216 cm. Area covered by painted architecture 198 × 207 cm. Gray strips surrounding painted architecture 3 cm at the top, 8 cm at the bottom, and 4.5 cm at either side.

Florence, Galleria degli Uffizi, no. 1305.

The work is the main panel from the altarpiece painted by Domenico Veneziano for the high altar of the Florentine church of S. Lucia de' Magnoli. The steps leading up to the Madonna bear two simulated engraved inscriptions in capital Roman letters, first noticed by Rumohr (1920, p. 387) in 1827: AVE MARIA on the central section of the upper step, and OPUS DOMINICI DE VENETIIS / HO MATER DEI / MISERERE MEI / (ET) DATUM EST on the three faces of the lower step.

The altarpiece was first mentioned in the *Vita* of the Peselli in the 1550 edition of Vasari (Vasari-Ricci, II, p. 129) with an attribution to Francesco di Pesello, who according to Vasari was the father of Francesco Pesellino, and whose alleged works Vasari confused with those of his putative son:

Fece Francesco Pesello nella via de' Bardi la tavola della cappella di Santa Lucia, la quale gli arrecò tanta lode che per la Signoria di Fiorenza gli fu fatto dipinger una tavola a tempera, quando i Magi offeriscono a CHRISTO.[1]

In the second edition, however, Vasari referred to the St. Lucy Altar in the *Vita* of Domenico Veneziano and Andrea del Castagno and correctly gave it to Domenico, though he named the saints in the wrong order and mistook the St. Zenobius for St. Nicholas (source 11D).[2]

The church of S. Lucia de' Magnoli in the Via de' Bardi was founded in 1078. In 1373 it was given by Pope Gregory XI to the monks of the Olivetan reform branch of the Benedictine order. At the same time the Uzzano family assumed patronage of the church and of the main chapel, for which in 1332 Pietro Lorenzetti painted an altarpiece representing St. Lucy. In the early fifteenth century the building was remodeled, and the painting by Lorenzetti was moved to the sacristy. It is now installed on the first altar on the left. In 1421 Arcangelo di Cola executed an altarpiece, now lost, for the church's Bardi Chapel, and a few years later Niccolò da Uzzano commissioned Bicci di Lorenzo to decorate the main chapel with frescoes, which are also lost, of scenes from the life of St. Lucy. According to Vasari, they included a portrait of Niccolò "from life, together with those of some other citizens."[3]

[123]

Nothing is known of the commission for the altarpiece. There is no evidence to suggest, as Gioseffi (1962) has proposed, that Domenico received it through the intervention of Cosimo de' Medici.[4] Domenico's altarpiece was reported as being on the main altar of the church until the late seventeenth century (see Bocchi-Cinelli, 1677, p. 280). In the course of repairs during the first half of the eighteenth century it was moved to the altar of the Bigallo Office, and it remained there until it was taken to the Uffizi in 1862. The decree authorizing its transfer (*Memoria della traslocazione del quadro di Domenico Veneziano dall' altare a lato di quello del Santissimo, alla Regia Galleria per il restauro*) is dated August 28, 1861, and is preserved in the archive of the church. It contains nothing of note except the information that the church and Domenico's painting were at that time under the protection of the De Barberino and Martelli families, and that the altarpiece was to be moved to the Uffizi "for the purpose of being restored there under the direction and surveillance of the director." All the predella panels had by that time been removed and thus escaped the drastic cleaning which befell the *sacra conversazione*.

While it was still in the church of S. Lucia, we read in the 1892 edition of Cavalcaselle, the altarpiece was "in abbastanza buono stato." But after it was taken to the Uffizi it was, according to Cavalcaselle, subjected to

so disgraceful a cleaning and to so many retouchings as to lose much of its original quality, and thus to produce a disagreeable impression, having been left with a cold tonality, with its paint surface laid bare ("posto allo scoperto") unevenly in several places, and gone over. (p. 123)

Close examination of the surface confirms Cavalcaselle's comments. For the condition of the work prior to its transfer to the Uffizi we have the testimony of Eastlake (1869, II, p. x), who noted that "from the effects of modern varnishing the picture has a warm tone which gives the resemblance (but it is only a resemblance) to a work in oil." Eastlake insisted correctly that the altarpiece was painted in tempera, as had also been recognized by Rumohr (1920, p. 387) and Milanesi (1862). Cavalcaselle (1864, p. 316), however, perhaps under the influence of Vasari's portrayal of Domenico, judged the *sacra conversazione* "clearly painted in tempera composed of vehicles differing from the old ones," which Douglas interpreted to mean "a medium tempered to a certain extent with oil" (Cavalcaselle, 1911, p. 133). This view, which is patently contradicted by the painting itself, has continued to find support up to the present (see Wackernagel, 1938, p. 329; Wundram, 1970, p. 136).

The present condition of the work must be kept in mind as a corrective in estimating its style. The blue mantle covering the knees of the Virgin has been reduced to a state of semi-transparency, its barest patches having been filled in with a flat tone that roughly matches the remaining original blue (Pl. 65). The Virgin's dress and part of the mantle around her left arm are similarly worn. The extent of the damage to the faces of the Virgin and the Child (Pl. 73) can be gauged from the relative rigidity and opaqueness of their expressions as compared with the mobility and subtlety of expression in the head of the *Madonna* at I Tatti (Pl. 27). The transparent veil which originally covered the hair and forehead of the Virgin has disappeared except for a remnant of its fringed border on her shoulder. The niche behind the Virgin, especially its shell, is so heavily repainted that it no longer functions properly as a hollow in the pictorial space. The figures of the saints have suffered somewhat less, the Baptist very little.

The habit of St. Francis is worn in the shadows, and there are repairs above his tonsure and around his ear and lower lip. There is damage along the left edge of the face of St. Zenobius (Pl. 61). The contour of his skullcap has been redrawn. The dress and the mantle covering the shoulder of St. Lucy are very threadbare. The contour of her profile has been reinforced, and her face retouched, especially to the left of her eye (Pl. 62). The background above and to the right of her head is also extremely thin. The effects of the "disgraceful" nineteenth-century cleaning and retouching of the *sacra conversazione* are not, however, confined to these areas, where they are particularly conspicuous, but show throughout the panel.

The original frame of the altarpiece has been lost, but we may perhaps visualize it as resembling a number of original frames that have survived on altarpieces by Neri di Bicci. Neri relied so heavily on the figures and painted architecture of Domenico's *sacra conversazione* that we might expect some resemblance as well between its frame and those of the minor master. Domenico's St. Lucy, for example, is herself in Neri di Bicci's *Coronation of the Virgin* in the Spedale degli Innocenti, and St. Catherine in his altarpiece of *Sts. Catherine, Anthony and John the Baptist* in Grenoble. The St. Anthony in the latter work is Domenico's St. Francis. Moreover, the painted architecture of the *sacra conversazione* is reflected in the *Annunciation* which Neri painted in 1461 for S. Giorgio alla Costa (now in the Accademia), and in his masterpiece, the mural of *St. John Gualberto and Other Saints* of 1454–55 from the cloister of S. Pancrazio (see Pudelko, 1934). At least three altarpieces by Neri di Bicci have frames whose proportions and architectural ornament would be compatible with the St. Lucy Altar: a *sacra conversazione* of 1452 in the Pieve of Cameto near S. Miniato al Tedesco, another in the church of S. Martino a Mensola near Settignano, and the *Madonna and Child with Sts. Michael and Blaise* in the Montreal Museum of Fine Arts (Pl. 86), whose frame would appear to suit Domenico's composition particularly well.

The main difference between the frames of the Montreal altarpiece and the St. Lucy Altar would have been in the organization of their predellas, which in Neri di Bicci's work is a continuous strip, whereas Domenico's predella was divided into framed compartments (Fig. 16). We first hear about it, though without reference to its individual panels, in Baldinucci (III, p. 95). When it was mentioned in Rannalli's edition of Baldinucci (1845, I, p. 500, n. 1), only the St. Francis and St. John panels were still in place, and these had also been removed by the time the altarpiece was taken to the Uffizi in 1862. The original positions of the four lateral predella panels under their respective saints are indicated by painted frames with perspective ledges, rendered as if seen from the left or the right, which have survived intact only in the St. John panel and in the *Miracle of St. Zenobius*. The *Annunciation*, originally located under the Virgin and Child, probably did not have and did not need such a frame (though Goodison and Robertson, 1967, argue that it had one). All five panels had been recovered by 1925 (Berenson, 1925; Bode, 1925) and were shown at the Exhibition of Italian Art in London in 1930 (Royal Academy, 1931). The correctly reconstructed predella has been reproduced by Miller (1926), Fry (1930), Bodkin (1945), and Salvini and Traverso (1959). Its original total width was about 189 cm, 18 cm less than the width of the painted area of the main panel. Each of the six vertical framing strips of the predella (four between the panels and two at either end) would have been 3 cm wide.[5] The four strips between the panels were aligned with the four lateral vertical axes governing the composition of the *sacra conversazione,* whose central axis continued downward through the center of the *Annunciation.*

Since Rumohr published the signature of the St. Lucy Altar in 1827 the painting has been the

cornerstone of Domenico's oeuvre. The great majority of scholars who have written about it have rightly placed its execution in the 1440s, though it has been dated as early as 1430 (Frankfurter, 1952) and as late as 1450 (Clark, 1944; Battisti, 1971, I, p. 461, n. 36). Three scholars have thought it Domenico's last work (Testi, 1916, pp. 423ff.; Van Marle, X; Paccagnini, 1952). The date that has found the greatest agreement is ca. 1445 (Longhi, 1925; Pudelko, 1934; Stiftung preussischer Kulturbesitz, 1963; Meiss, 1964; Chastel, 1966, p. 247; Shapley, 1966; Hartt, 1969). Longhi at one time (1928) considered ca. 1440. Pope-Hennessy has suggested both 1440–41 (1939) and 1442 (1951), Gioseffi (1962) 1440–42, and Shell (1968) the early 1440s. Janson (1957) has argued that the *sacra conversazione* was completed or near completion by 1443. Shearman (1966) has proposed the period 1440–45, Goodison and Robertson (1967) 1442–48, Salmi (1938) 1444–45, Degenhart (1959) and Berti (1961) 1445–48, and Hartt (1959) 1445–50. Offner (1939) and Zeri (1961) have dated the altarpiece ca. 1448.

Only Janson's and Salmi's views rest on alleged relationships of the St. Lucy Altar to works with known dates. According to Janson, Domenico's arrangement of figures under a tripartite canopy was the model for Donatello's altar in the Santo at Padua, and would therefore have had to be available to Donatello before he left for Padua in 1443. But as White (1969) has rightly pointed out, the question whether Donatello knew Domenico's composition is less important than the recognition of those elements which the Santo Altar and the St. Lucy altarpiece have in common with other contemporary and later *sacre conversazioni*. "In devising a three-dimensional canopy for his freestanding saints," White has pointed out, "Donatello was carrying sculpture into a realm which had hitherto been occupied exclusively by the painted *sacra conversazione*." Donatello's solution is surely indebted to the development of a unified architectural space for the Madonna and saints that led from Masaccio to Fra Angelico, Fra Filippo Lippi, and Domenico Veneziano. But in order to account for the composition of the Santo Altar it is not necessary to assume that Donatello specifically knew the system of the St. Lucy altarpiece. Moreover, White has shown that the scheme of the Santo Altar was not as similar to that of Domenico's painting as Janson had supposed. In Janson's reconstruction the two central columns of Donatello's canopy are placed at either side of the Madonna, as they are in the St. Lucy Altar. According to White's calculations, the columns in the center of the Santo Altar enclosed not only the Virgin but also the figures of Sts. Francis and Anthony.[6]

Salmi's date of 1444–45 rests on his argument that in the capitals of the loggia of the *sacra conversazione* Domenico imitated the capitals on the windows of the Medici Palace, which Salmi presumes to have been begun in 1444. Beyond their fluted bells, however, the two sets of capitals have no specific features in common. In Domenico's capitals cabbage leaves grow upward from the astragal, whereas at the Palazzo Medici the cabbage leaves are cupped over the volutes at the top of the capitals and curl downward (Pls. 70 and 83). According to Hyman, moreover, the capitals were probably not carved before 1448–51, years in which Pagno di Lapo Portigiani is recorded as receiving payments for work on the palace's architectural decoration (Hyman, 1968, I, p. 140).[7]

NOTES

1. It is conceivable that this *Adoration of the Magi* is the tondo by Domenico Veneziano, which was attributed to Pesello in the Medici Inventory, and which like other works from the Medici Collection may have been taken to the Palazzo della Signoria after the Medici Palace was occupied by French troops in 1494.

2. Because of the ambiguity of the sentence in which Vasari refers to the altarpiece (see Berti in Salmi et al., 1954), Bocchi-Cinelli (p. 280), Baldinucci (III, p. 95), Richa (X, p. 294), Cambiagi (1765, p. 275), Baldinucci-Piacenza (I, p. 464) and Lanzi (1789, p. 65), writing prior to Rumohr's discovery in 1827 of Domenico's signature, gave the work to Castagno. Rosini (III, p. 95) was the first scholar after Rumohr who published it as by Domenico Veneziano.

3. Niccolò da Uzzano died in 1433. Bicci di Lorenzo's murals were painted before 1427, probably about 1425 (see Wackernagel, 1938, p. 227). For the history of the church of S. Lucia, see Paatz (II, 1940ff.).

4. Information about church commissions is occasionally found in the records of pastoral visits. But during the fifteenth century the Florentine Archivio Vescovile lists such a visit only for the year 1422. The archive of S. Lucia de' Magnoli contains a *Libro di ricordi A, cominciato il 23 di gennaio 1370*, which, however, has no entries prior to 1487.

5. The present measurements of the predella panels are as follows:

St. Francis	26.7 × 30.5 cm
St. John	28.3 × 32.4 cm
Annunciation	27.3 × 54.0 cm
St. Zenobius	28.6 × 32.5 cm
St. Lucy	25.0 × 28.5 cm

All except the St. John and St. Zenobius panels show evidence of having been cut down. The four lateral panels must originally have had the same dimensions. The widths of the Francis and Lucy panels would therefore have been trimmed by about 2 cm and about 4 cm, and their heights by a little less than 2 cm and about 3.5 cm. The *Annunciation* has been cut by about 6.3 cm in width and between 1 and 1.5 cm in height. The total of the original widths of the five panels is about 189 cm. Pudelko (1934), who calculated that the *Annunciation* had been cut by only 3 cm in width and did not take into account the reductions in the widths of the Francis and Lucy panels, estimated the original width of the five panels as 176 cm and the widths of the framing strips between them as 6 cm.

6. The available evidence for the reconstruction of the Santo Altar allows sufficiently differing interpretations as to make it unlikely that a definitive solution can be formulated. For two attempts which White was not able to take into consideration but which seem to me less satisfactory than his, see Schröteler (1969), and Herzner (1970).

7. It would be both futile and impossible to list all the references in the literature of art to the St. Lucy Altar. Few works that deal on any level with Italian quattrocento art fail to mention it. By far the best and most detailed analysis of its style is Pudelko's (1934); but see also Cavalcaselle (1864, pp. 316f., and 1911, pp. 141f.), Schmarsow (1893 and 1912), Venturi (1911, pp. 356ff.), Antal (1925), Van Marle (X), Salmi (1936 and 1938), Kennedy (1938), Offner (1969), Sandberg Vavalà (1948), Salmi et al. (1954), and Hartt (1969). The spatial organization of the *sacra conversazione* has been studied by Wilde (1929), White (1957), Shearman (1966), Battisti (1971), and Welliver (1973). For the architectural background, see Clark (1946 and 1947), and for the relationship of the altarpiece to Alberti, see Spencer (in Alberti, 1956) and Edgerton (1975). Domenico's handling of light and color has been the subject of valuable comments by Siebenhüner (1935), Schöne (1954), and Cowardin (1963).

6. *St. Francis Receiving the Stigmata*, ca. 1445–47 (Pls. 105–107).

Tempera on poplar panel, 26.7 × 30.5 cm.

Washington, National Gallery of Art, Samuel H. Kress Collection, K 278.

The panel was originally at the far left of the predella of the St. Lucy altarpiece, under the figure of St. Francis. It must have been removed from the altarpiece sometime before 1862, when the *sacra conversazione* without any of the predella panels was moved from the church of S. Lucia de' Magnoli to the Uffizi in order to be restored (see p. 124). In the mid-1920s it was bought from Julius Böhler of Munich by Count Contini-Bonacossi, who in 1933 sold it to Samuel H. Kress. It was shown at the Exhibition of Italian Art in London in 1930, the Exhibition of Italian Paintings of the Renaissance at the Century Club in New York in 1935, and the Great Lakes Exposition at the Cleveland Museum of Art in 1936, and has been on display at the National Gallery of Art since 1941.

The work is in relatively good condition. In a photograph taken in 1930 (Anderson 30039) it was covered with a film of dirt and varnish, and a fair amount of retouching. In 1934 Pudelko reported that the panel had been cleaned, that it had "gained extraordinarily in delicacy of color," and that "to the left of the seraphim there appeared the shape of a mountain, and in the sky several silver-grey clouds." In the present state of the picture losses and retouchings can be observed throughout the sky, in the lower part of St. Francis's habit, and around his ear. The painted frame which still surrounds the St. John and St. Zenobius panels has survived only along the left edge but is covered by modern wooden framing strips.[1] In height as well as in width the panel has been cut by about 2 cm. The picture was first discussed in an admirable article by Longhi (1925), though it was referred to a year earlier by Chiapelli (1924), and according to Shapley (1966) was connected with the St. Lucy altarpiece by Hans Gronau as early as 1921.[2]

NOTES

1. According to Shapley (1966), "modern framing strips are now attached to the top and bottom of the panel." When I last saw the picture in October 1972 such strips were attached all around.
2. For further references to the St. Francis panel, see Royal Academy (1931), the Century Association (1935), *The Twentieth Century Anniversary Exhibition* (1936), National Gallery of Art (1941), Bode (1925), Berenson (1925, 1932 and 1963), Venturi (1927, p. 18, n. 1), Deusch (1928, p. 38), Van Marle (X), Borenius (1930), Venturi (1930), Wittgens (1930), Gamba (1931), Böck (1934), Salmi (1936 and 1938), Degenhart (1959), Seymour (1961), Smyth (1963, n. 114), and Meiss (1964a).

7. *The Vocation of St. John the Baptist,* ca. 1445–47 (Pls. 88–89).

Tempera on poplar panel, 28.3 × 32.4 cm.

Washington, National Gallery of Art, Samuel H. Kress Collection, K 1331.

The panel was originally to the left of center in the predella of the St. Lucy altarpiece, under the figure of St. John the Baptist. It was probably removed from the altarpiece at the same time as the St. Francis panel (see catalogue no. 6), for in photographs taken after the two pictures were first identified (Anderson 30039 of the St. Francis panel, and a photograph by Murray

Kendall Keyes of New York of the *Vocation*), they appear to be in very nearly identical condition, as if they had been treated by the same restorer—either before or after their removal from the altarpiece.

The first published references to the St. John panel date from 1925, when it was shown in the exhibition of the Carl W. Hamilton Collection at the Montclair Art Museum and was cited in articles by Berenson and Bode. David A. Brown has recently discovered that Hamilton acquired the picture in 1919, with an attribution to Pesellino, as a present from Bernard and Mary Berenson. Its authorship and provenance were first recognized by Richard Offner.[1] The panel was bought for the Samuel H. Kress Collection in 1942 and has been on exhibition at the National Gallery of Art since 1945. It has been shown at the Exhibition of Italian Art in London in 1930 and at the Exhibition of Italian Paintings of the Renaissance at the Century Club in New York in 1935.

In a photograph dated December 1927 by Gabriel Moulin of San Francisco the panel appears to have been partly cleaned, in comparison with its state in the earlier photograph of Murray Kendall Keyes. Nevertheless, Roger Fry commented in 1930 that it was "hard to speak of the [panel's] colour, as it is so obscured by dirty brown varnish." And in 1935 Alfred Frankfurter too found the picture still covered with "thick, dirty yellow varnish." After the panel was acquired by the Kress Collection it was, like the St. Francis panel from the St. Lucy Altar and Domenico's Kress *Madonna*, cleaned and restored in the New York atelier of Stephen Pichetto, whose methods and philosophy of treating pictures are described with remarkable candor by Walker (1974). Sizable losses have been filled in. The vermilion contour and the golden surface of the halo, which were barely visible in the photograph of 1927, have been partly redrawn and repainted. In the head of the saint a loss has been restored extending from the hair to the chin, the cheekbone and the left edge of the eye. Others have been filled in around the mouth, nose, and eyes. The shapes of the mountains above and to the right of the saint's head have been partly repainted and redrawn, most noticeably in the contour common to the edge of the figure's hair and one of the peaks in the background. The present contours and interior shapes of the hair, and much of the modeling of the face are also due to restoration. The nude body is relatively free of damage and shows only minor repairs. But there is much retouching in the area surrounding the figure, from the stony path up to the sky, in the upper part of the sky, in the clouds, and in the upper ledge of the painted frame. Although the panel is 3 mm less high than the *istoria* of St. Zenobius, it does not seem to have been cut down. The ledges of its painted frame are depicted as seen from the right, in accordance with a point of view at the center of the altarpiece.[2]

NOTES

1. According to Miller (1926), "the discovery by Mr. Berenson and Mr. Offner independently of this little John the Baptist was a momentous event of last year." The discovery was in fact made by Offner when he saw the panel in Hamilton's New York apartment after its arrival from Florence. He immediately cabled his attribution to Berenson who, contrary to Walker (1974), had until then not realized that

his former picture belonged to the predella of the St. Lucy altarpiece.
2. For further references to the St. John panel, see Shapley (1966), Montclair Art Museum (1925), Royal Academy (1931), Suida (1930 and 1945), Deusch (1928), Van Marle (X), Vaughan (1929), Venturi (1930), Berenson (1932 and 1963), Böck (1934), Pudelko (1934), Kauffmann (1935), Salmi (1936 and 1938),

Kennedy (1938), *The Art Quarterly* (1944), Borenius (1945), Kaftal (1952), Lavin (1955 and 1961), Degenhart (1959), Seymour (1961), and Hartt (1969).

8. *The Annunciation,* ca. 1445–47 (Pls. 123–128).

Tempera on poplar panel, 27.3 × 54 cm (painted architecture 26.5 cm high, with 0.8 cm neutral strip at bottom).

Cambridge, Fitzwilliam Museum, no. 1106.

The *Annunciation* was originally in the center of the predella of the St. Lucy altarpiece. It was bought in Florence, together with the St. Zenobius panel, by Joseph Fuller of Chelsea in 1815. Both pictures were bequeathed to the Fitzwilliam Museum by Professor Frederick Fuller in 1909 but were not put on exhibition until 1923 (see Fitzwilliam Museum, 1924). When it was acquired by Joseph Fuller the *Annunciation* was attributed to Domenico Ghirlandaio, a fact which suggests that it had been removed from the altarpiece sometime before 1815, and that the seller either did not know its provenance, or thought that an attribution to Domenico Ghirlandaio was more attractive. The panel was first published as a work by Domenico Veneziano by Chiapelli in 1924, and as the centerpiece of the St. Lucy predella by Yashiro in 1925. It has been shown at the Exhibition of Italian Art in London in 1930, at Goldsmith's Hall in London in 1959, at the Exhibition *Italian Art and Britain* at Burlington House in 1960, and at Wildenstein's in London in 1965.

The work is in exceptionally good condition. It was cleaned once by Horace Buttery, and again in 1966. A number of holes have been filled in, most noticeably in the door at the back of the garden. The surface is marked with numerous incised lines for the painted architecture, the control of the composition, and the perspective construction. It is not always clear to which of these categories the incised markings belong. Domenico seems to have changed his mind and made adjustments as he went along. A good example of this is the archway, which the artist drew both higher and wider before he settled on its final shape. A careful examination of the picture shows that it was executed in the following order: (1) the floor and the walls; (2) the columns, the entablature, the garden, and the furniture; and (3) the figures. Some of the lines seem to have been incised after the application of colors had begun. The head of the angel is one of the most perfectly preserved passages in the entire canon of Domenico's work (Pl. 126).

The entablature of the projecting left wing of the courtyard is about 6.3 cm shorter than that of the wing at the right, and Goodison and Robertson (1967) have rightly concluded that the left side of the panel has been cut by that much. The centric point of the perspective construction now lies 3.15 cm (rather than 6.3 cm, as Goodison and Robertson would have it) to the left of the original center of the composition. The top of the panel has been trimmed by between 1 and 1.5 cm. Goodison and Robertson have assumed that the *Annunciation*, like the panels to either side, had a painted frame with perspective ledges. But there are no signs of one either at the bottom or at the right, where the panel has not been cut. Moreover, a painted frame

would have been superfluous. The architectural setting itself fulfills the purposes that the painted frames serve in the side panels: to enclose and unify each composition; to produce the illusionistic effect of a window; and to define the place of each panel in the predella with reference to a viewing position at the center of the altarpiece.[1]

NOTE

1. For further references to the *Annunciation,* see Berenson (1925, 1932, and 1963), Bode (1925), Longhi (1925), Venturi (1925, 1927, and 1930), Van Marle (X), *Principal Pictures* (1929), Borenius (1930), Constable (1930), Fry (1930), Mackowsky (1930), Suida (1930), Gamba (1931), Royal Academy (1931 and 1960), Toesca (1932), Böck (1934), Pudelko (1934), Salmi (1936, 1938, and 1943), Offner (1939), Pope-Hennessy (1939, p. 110), Spencer (1955), Saxl (1957), *Treasures of Cambridge* (1959), Battisti (1960 and 1971), *The Art of Painting* (1965), Sutton (1965), *The Times Literary Supplement* (1968), Hartt (1969), Welliver (1973), and Edgerton (1978).

9. *A Miracle of St. Zenobius,* ca. 1445–47 (Pls. 110–113).

Tempera on poplar panel, 28.6 × 32.5 cm.

Cambridge, Fitzwilliam Museum, no. 1107.

The panel was originally to the right of center in the predella of the St. Lucy Altar, under the figure of St. Zenobius. Its history is identical with that of the *Annunciation* (catalogue no. 8). When it was first exhibited at the Fitzwilliam Museum in 1923 it was attributed to a master influenced by Benozzo Gozzoli. Its provenance from the St. Lucy altarpiece was first recognized by Yashiro in 1925. It has been exhibited at Burlington House in 1930 and 1960 and at Wildenstein's in London in 1965.

The work is in the same condition and has the same cleaning history as the *Annunciation*. Its most noticeable repaired loss is at the tip of the saint's nose. Much of the gold on the border of his mantle and on the back of his stole has come off. The rim of his foreshortened halo has been reduced to a very thin, incomplete contour. The painted frame surrounding the composition, with its perspective ledges rendered as if seen from the left, is intact. The panel does not appear to have been cut. Sir John Pope-Hennessy has reminded me that before Horace Buttery cleaned it, the roughly cut pavement (which was anticipated in the *Crucifixion of St. Peter* in Masaccio's Pisa altarpiece, and repeated in the tondo with the *Civettino Game* in the Museo Horne) and the pink frame had been overpainted.[1]

NOTE

1. For further references to the St. Zenobius panel, see Berenson (1925, 1932, and 1963), Bode (1925), Royal Academy (1931 and 1960), Venturi (1927 and 1930), Van Marle (X), *Principal Pictures* (1929), Borenius (1930), Fry (1930), Mackowsky (1930), Suida (1930),

Gamba (1931), Böck (1934), Pudelko (1934), Salmi (1936 and 1938), Offner (1939), Paatz (1939), Pope-Hennessy (1939, 1950, and 1969), Murray (1963), *The Art of Painting* (1965), Goodison and Robertson (1967), and *The Times Literary Supplement* (1968).

10. *The Martyrdom of St. Lucy,* ca. 1445–47 (Pls. 116–119).

Tempera on poplar panel, 25 × 28.5 cm.

Berlin-Dahlem, Gemäldegalerie, no. 64.

The panel was originally at the far right of the predella of the St. Lucy Altar, under the figure of St. Lucy. It was bought for the Kaiser Friedrich Museum in Italy in 1841–42 with an attribution to Pesellino,[1] and was first given to Domenico Veneziano by Bode in 1883. It has been shown at the Exhibition of Italian Art in London in 1930, at the Metropolitan Museum of Art and the National Gallery of Art in Washington in 1948, at the Neues Museum in Wiesbaden from 1952 until 1956, and at the exhibition *Quattro maestri del primo rinascimento* in Florence in 1954. In 1956 it was permanently installed in the Gemäldegalerie at Dahlem.

The work is in uneven condition, having been considerably damaged and restored. The faces of both the saint and the executioner have been redrawn and retouched. Other damaged and restored areas are the right half of the hand, the forearm and the shoulder of St. Lucy; the left leg from above the knee to just below the waist, the left forearm down to the fingers, the right thumb, the collar and the top section of the hat of the executioner; parts of the dark gray wall and of the pink molding at the right; and other areas throughout the painted architecture. The saint's mantle has lost much of its original color and has been retouched. The best preserved passage in the panel is at the upper right, around the figure of the governor Pascasius. Fragments of the painted frame which originally surrounded the composition are visible along the left edge. The panel has been cut by slightly more than 3.5 cm in height and by nearly 4 cm in width. A reconstruction of its perspective system shows that the composition has lost more at the top and the right than at the left and along the bottom (see chap. II, n. 42).[2]

NOTES

1. See Königliche Museen zu Berlin (1883), where the panel is designated as Florentine school, ca. 1450. Berti (in Salmi et al., 1954) has argued that the early attribution of the picture to Pesellino implies that its provenance was at that time unknown and that it was therefore probably acquired elsewhere than in Florence.
2. For further references to the St. Lucy panel, see Bode (1888, 1897, and 1925), Schmarsow (1893 and 1912), Berenson (1896, 1898, 1902, 1925, 1932, and 1963), Königliche Museen zu Berlin (1904, 1912, and 1932), Cavalcaselle (1911, p. 141, n. 1), Venturi (1911, p. 359), Gronau (1913), Brown and Rankin (1914, p. 113), Testi (1916, p. 424), Chiapelli (1924), Venturi (1927 and 1930), Van Marle (X), Borenius (1930), Fry (1930), Gamba (1931), Royal Academy (1931), Böck (1934), Pudelko (1934, Salmi (1936 and 1938), Pope-Hennessy (1939), *Paintings from the Berlin Museums* (1948), Beihn (1953), Lassaigne and Argan (1955), and Stiftung Preussischer Kulturbesitz (1963).

11. *Madonna and Child*, ca. 1448–50 (Pls. 132–136).

Tempera on poplar panel, 82.6 × 56.6 cm.

Washington, National Gallery of Art, Samuel H. Kress Collection, K 410.

The painting is neither signed nor documented. It first became known when it was shown at the Exhibition of Italian Art in London in 1930 and belonged to Julius Böhler of Munich. Böhler had acquired it from Professor Francis Y. Edgeworth of Edgeworthtown, Longford, Ireland, in whose family it had been for several generations. In the early 1930s it was bought by Sir Joseph Duveen, who sold it to Samuel H. Kress in 1936. It has been on exhibition at the National Gallery of Art since 1941. In 1935 it was included in the Exhibition of Italian Art at the Petit Palais in Paris, and in 1941 it was lent to the show of Duveen Pictures in Public Collections of America at the Duveen Brothers Gallery in New York.

The work has been cleaned—it gives the appearance of having been somewhat overcleaned—and restored. Retouched areas include the upper part of the rose hedge; a number of passages in the face of the Virgin (below the right side of the right eyebrow, the tip and right wing of the nose, the shadows around the nose and the right side of the mouth, areas throughout the right cheek and the chin, and the chin's contour); an irregular strip above the Virgin's dress; the border of her dress (its upper contour, patches in its left corner and around the brooch); extensive areas in the dress itself and in the sleeve; the upper contour of the Virgin's arm and hand; a sizable area between the Child's ear and left cheekbone; the shadows under his chin and to either side of the third and fourth fingers of the Virgin's hand; numerous places in the Child's belly and forearm; the greater part of the back side of his left leg; and passages of drapery at either side of it.

The eyelids and the upper contour of the lips of both heads are visibly outlined with *spolveri* (Pl. 134), the dust marks by which the pricked lines of a cartoon were transferred to the panel (see Tintori and Meiss, 1967, Fig. 6). This method of transferring cartoons came into use in Florentine ateliers in the mid-1440s (see Örtel, 1940), and its adoption in the Kress *Madonna* virtually precludes the possibility that the picture could have been painted before then.[1]

The attribution of the Kress *Madonna* to Domenico Veneziano has not been questioned since it was first proposed at the Exhibition of Italian Art in 1930. Among the scholars who have commented on the picture's date, Clark (1930) has designated it Domenico's first extant work. Semenzato (1954) and Shell (1968) have placed it in his early period. Hartt (1959) has given it to the years 1440–45, Shapley (1966) to 1442–45. Pudelko (1934) and Salmi (1938) have dated it 1444. For Böck it belongs to Domenico's "late maturity." Seymour (1961) and Zeri (1961) have proposed a date of ca. 1450.[2]

NOTES

1. The *spolvero* method was used mainly for murals and was never widely adopted in panel painting. A later example is a *Madonna and Child* of about 1470 in the Samuel H. Kress Collection at the Brooks Memorial Art Gal-

 lery in Memphis, Tennessee (see Shapley, 1966).
2. For further references to the Kress *Madonna*, see Constable (1930), Mackowsky (1930a), Gamba (1931), Royal Academy (1931), Beren-

son (1932 and 1963), Venturi (1933), Petit Palais (1935), Serra (1936), Salmi (1936), Busuioceanu (1937), Kennedy (1938, pp. 5ff.), *Duveen Pictures* (1941), Pope-Hennessy (1944), Clark (1951, p. 3), and Paccagnini (1952).

12. *Sts. John the Baptist and Francis,* ca. 1450–53 (Pls. 138–148).

Fresco (detached), 200 × 80 cm.

Florence, Museo di S. Croce.

The mural is neither signed nor documented. It was first mentioned by Albertini (1510) as a "tavola di Pietro P[ollaiuolo]" near ("appresso") the *Annunciation* tabernacle by Donatello in S. Croce (source 6B), and was again given to "Pollaiuolo"—without specifying Antonio or Pietro—in an anonymous manuscript of the early sixteenth century:

S. Giovanni B.ta con S. Franc.o in fresco nel muro a man destra della cappella de' Cavalcanti del Pollaiuolo, eccelente maestro, maniera del S. Bastiano de' Pucci nella Nuntiata.[1]

The *Libro di Antonio Billi* and the *Codex Magliabecchiano* (sources 9B and 10B) gave the fresco to Castagno and identified the Baptist as St. Jerome.[2] The attribution to Andrea, though with the Baptist identified correctly, was repeated by Vasari (source 11D), Borghini (source 12), and Bocchi (source 13).

The work has been moved twice. Once, as we know from Bocchi, in 1566, when it was taken from its original location and installed on the south wall of the church to the right of the *Annunciation* tabernacle by Donatello (Pl. 150); and again in 1954, when it was detached on the occasion of the *Mostra di quattro maestri del primo rinascimento.* In 1959 it was permanently installed in the Museo di S. Croce. The floodwaters of 1966 left a deposit of oil and dirt on the lower third of the composition (see Kuh, 1967); but this film has been removed and caused no significant damage.

The sixteenth-century relocation of the work was, according to Borsook (1960), "the earliest recorded instance of transferring a mural from one place to another." In 1566 Duke Cosimo I de' Medici granted a request by the overseers of S. Croce to have the church modernized. It was Cosimo's wish that "in the same way as has been ordered in S. Maria Novella, fourteen chapels should be made along the wall, at greater cost and with more decoration, because this church is much larger than that one."[3] The renovation of S. Croce was entrusted to Giorgio Vasari, who on August 18, 1566 wrote to his friend Vincenzo Borghini that "in S. Croce everything is clear and about to be beautiful. It will be redone considerably more than S. Maria Novella, and the Duke favors it"—no doubt because of the many tombs and commemorative monuments in S. Croce of great Florentines.[4] It has been shown by Hall (1970) that Vasari razed two sets of walls in the interior of the basilica. One set belonged to the screen that surrounded the monks' choir, which Bocchi (1591) called the *coro di legno,* and which was located within the space of the nave between the middle of the sixth bay and the beginning of

the transept. The other set of walls that Vasari dismantled belonged to the rood screen, to which Baldinucci (III, p. 93) referred as the *tramezzo,* and which consisted of short sections of wall (remains of which are still visible) projecting into the nave and aisles from the fifth pair of piers, and into the aisles from the north and south walls, from which were hung iron grills.

The original site of Domenico's fresco was the wall of the rood screen projecting from the south wall of the church into the right aisle next to the *Annunciation* by Donatello (Fig. 22), as is indicated in the pre-1566 sources: the anonymous sixteenth-century manuscript locates the mural "on the right-hand wall," and the *Codex Magliabecchiano* "in the corner at the side" of the Cavalcanti Chapel, while Albertini places it next to Donatello's *Annunciation.* The editor of the 1730 edition of Borghini's *Riposo* correctly described Domenico's two saints as having been "on the wall of the *tramezzo;* but this *tramezzo* having been removed in 1566, they were transported to the side [*allato*] to the chapel of the Cavalcanti, which is next to the door of the cloister, where there is the *Annunciation* by Donatello" (p. 269).[5] The only inaccuracy here is the implication that the original wall of the mural was not part of the Cavalcanti Chapel, which, according to the earlier sixteenth-century sources, it clearly was.[6]

When the mural was moved next to Donatello's *Annunciation* in 1566 it was installed at a height of about 2.30 m, about 68 cm higher from the floor than the tabernacle by Donatello, above an inscription commemorating Benedetto Cavalcanti, a monk of S. Croce who was buried there in 1374 (Pl. 150). The height of the composition in its original location on the wall of the *tramezzo* was probably about 42 cm lower. The vanishing point of its perspective system, which lies roughly 26 cm below and 55 cm to the right of the painted archway (Fig. 23), was very likely at the eye level of the spectator (see Borsook, 1960; Hall, 1970), roughly 1.62 m from the floor. Thus the original height of the painting from the floor was probably about 1.88 m.

Following its transfer to the south wall of the church, the mural was surrounded by a new painted frame in the form of a tabernacle surmounted by two winged *putti,* and with a base bearing the inscription S IOHES B S FRANCS.[7] Remnants of this inscription are still visible on the cleaned architectural molding at the bottom of the composition. Originally the base seems to have had no inscription. If it had had one it is unlikely that the *Libro di Antonio Billi* and the *Codex Magliabecchiano* would have identified the Baptist as St. Jerome.

After the painting had been detached in 1954 it was decided not to transfer it to canvas, but to leave it on the section of wall on which it was painted. With the exception of losses at the edges of the archway and in the upper part of the wreath, the work is in excellent condition. The wreath, white and tied with light green ribbon, as well as the dark pink molding strips on which is rests, came to light during cleaning in 1954. There are minor damages on the left side of the shirt of the Baptist, in the left sleeve of the habit of St. Francis, and in the upper part of the sky, especially between the two figures. The technical execution of the mural has been lucidly described by Borsook (1960):

The mural is one of the earliest examples which shows that the figures were transferred to the freshly plastered wall by dusting chalk through holes pricked into the main lines of drawings prepared to size (Pl. 142). . . . With the exception of the gold stigmata and details of the landscape, the painting was carried out in true fresco. Once the various parts of the figures were transferred on to the wet plaster via the *spolveri,* the armature of dots describing the contours were drawn together by a delicate boundary line. Then a pale

wash of ungraded color was brushed in. On top of this were laid the fine strokes by which Domenico explained each tissue and wisp of hair. (p. 153) [8]

Nine *giornate,* or days of work, can be distinguished: (1) the wreath and the vault of the archway, leaving room for the heads of the figures; (2) the head and neck of the Baptist (Pl. 139); (3) the head and shoulders of St. Francis, down to his hands (Pl. 140); (4) the left arm of St. John and the left side of his body as far as the middle of the thigh; (5) the right half of St. John's torso down to his hips, and part of the left sleeve of St. Francis; (6) the torso and hands of St. Francis; (7) the legs of St. John, the wall behind them, and the landscape as far as St. Francis's habit; (8) the lower part of the habit of St. Francis, the landscape and the wall up to the right edge of the painting (Pl. 141); and (9) the molding at the base.

All scholars until the later nineteenth century, and some until as late as 1929, followed Vasari in giving the fresco to Andrea del Castagno.[9] At the end of the nineteenth century it was once ascribed, following Albertini, to Piero Pollaiuolo (Rossi, 1890), and Longhi at one time (1925) gave it to Antonio Pollaiuolo. All other scholars since the late nineteenth century have endorsed the attribution to Domenico Veneziano first proposed by Bode in 1873, and all but three have thought the painting to be Domenico's last work.[10] Pudelko (1934), followed by Salmi (1936 and 1938), Wackernagel (1938, p. 124), Berti (in Salmi et al., 1954), and Hartt (1959), argued that the Cavalcanti fresco presupposes Castagno's *Vision of St. Jerome* (ca. 1454–55) in the SS. Annunziata, and should therefore be dated in the second half of the 1450s. To this it may be objected that Domenico's Baptist and Francis evolve from their counterparts in the St. Lucy Altar, while Castagno's Jerome is inspired by the late works of Donatello. And Pudelko's thesis is contradicted by Castagno's reliance in the central figure of his *sinopia* for the SS. Annunziata mural, which was probably drawn before Donatello's return to Florence from Padua and Venice in 1453, on the Cavalcanti Baptist by Domenico Veneziano (see catalogue no. 25).

NOTES

1. This passage was published by Rossi (1890) as a text of the early sixteenth century, a date which has been accepted by Berti (in Salmi et al., 1954) and Micheletti (in *Primo rinascimento in S. Croce,* 1968). Pudelko (1934) and Salmi (1938) have attributed the manuscript to the seventeenth century, while Ulmann (1894) believed it to be a "traveller's notebook of the eighteenth century." Its description of the location of Domenico's fresco is proof, however, that it must have been written before the painting was moved in 1566. The phrase *S. Bastiano de' Pucci nella Nuntiata* refers to the large painting of the *Martyrdom of St. Sebastian* by Antonio and Piero Pollaiuolo in the National Gallery in London, which was originally in the Oratory of St. Sebastian, under the patronage of the Pucci family, in the SS. Annunziata.

2. The erroneous identification of the Baptist as Jerome may rest on the similarity in type between Domenico's figure and Castagno's St. Jerome at the Annunziata. Indeed, with the exception of the drawing by Antonio Pollaiuolo in the Uffizi (*Gab. Dis.* 699E), the gaunt penitent depicted by Domenico Veneziano represents St. Jerome, as in the *Crucifixion* from the shop of Verrocchio at Argiano (see p. 152), rather than St. John the Baptist. Moreover, it was not uncommon in Florentine painting of the third quarter of the fifteenth century to represent St. Francis and St. Jerome as a pair or in paired predella panels (see the *Crucifixion* attributed to Pesellino in the National Gallery of Art in Washington, the *Pietà with Sts. Francis and Jerome* in the Arcivescovado at Florence thought to be by Fra Filippo Lippi's pupil Fra Diamante, the painting by Fra Filippo Lippi from the Medici Collection at Altenburg, the

diptych by Giusto d'Andrea in the Museum of Fine Arts at Dallas, Domenico di Michelino's predella in the Galleria Communale at Prato, or an unpublished predella in the sacristy of S. Margherita de' Ricci in Florence).

3. Vasari, 1568, III, p. 1010. For the Medici-sponsored modernization of S. Croce, S. Maria Novella, and the Pieve at Arezzo, see Isermeyer (1950).

4. See Frey (1930, II, p. 272). For Vasari's work at S. Croce, see del Vita (1929) and Hall (1970, 1973, 1974, and 1974a).

5. It was this text and not, contrary to Borsook (1960), Bocchi's late-sixteenth-century guidebook to Florence (source 13), that specifically designated the original location of Domenico's fresco as the *tramezzo*.

6. Moisé (1845, p. 110, n. 13), who believed that Domenico's mural had always been on the south wall of the church, used the term *tramezzo* to designate not the rood screen but the monks' choir, or *coro di legno*. On the basis of Bocchi's report that Vasari removed "the monks' choir and several chapels in the middle [of the nave]" ("il coro di legno, ed alcune cappelle del mezzo"), Moisé concluded that along the outside walls of the monks' choir there had been

> altars and chapels closed by gates and grills, each of which was under the patronage of various Florentine families who had ordered them built. There one could admire paintings in fresco and on panel, representing the principal mysteries of the Passion of Christ and other stories of the saints, works of the most renowned artists of the time. (p. 109)

Following Moisé, Wackernagel (1938, pp. 124f.) located Domenico's fresco on the outside wall of the monks' choir over the altar of the Cavalcanti Chapel; Janson (1957, pp. 103ff.) and Beccherucci (in *Primo rinascimento in S. Croce,* 1968) placed it at the corner of the monks' choir in the sixth bay of the church, opposite Donatello's *Annunciation;* and Berti (1959) and Micheletti (in *Primo rinascimento in S. Croce,* 1968) thought it might have been "on the pier" ("sul pilastro") of the chapel abutting the monks' choir. The correct position of the mural on the wall

of the rood screen was confirmed by the discovery of particles of *intonaco* protruding at right angles along the left edge of the detached section of wall on which it was painted, showing that this wall had originally been joined at 90 degrees to another wall, made, not of wood, but of masonry covered with plaster.

7. Borghini (1584, p. 635) reported that Alessandro Fei, known as Alessandro del Barbiere (1543–92), painted a pair of *putti,* which were removed in the nineteenth century, above Donatello's *Annunciation,* and Paatz (1940ff., I) assumed that Barbiere also did the *putti* that were on the pediment of the sixteenth-century frame around the fresco by Domenico Veneziano. Because the inscription below the relocated position of the mural records a reconsecration of the tomb of Benedetto Cavalcanti in 1570, Salmi (1938) has concluded that the new surround of the painting dated from that year.

8. At a time when the fresco was nearly obscured by dirt and varnish Schmarsow (1912) thought that Domenico had used linseed oil in its execution.

9. Baldinucci (III, p. 93), Richa (I, p. 99), Cambiagi (1765, p. 124), Baldinucci-Piacenza (I, p. 497), Fantozzi (1842, p. 200), Baldinucci-Rannalli (I, p. 497), Moisé (1845, pp. 106ff.), Kugler (1847, I, p. 417), Ricci (1848, p. 166), Formigli (1852, p. 149), Burckhardt (1860, p. 763), Cavalcaselle (1864, p. 309; 1870, p. 42; 1892, pp. 104ff.; 1911, pp. 133f.), Müntz (1889, p. 624), Schmarsow (1893), Chiapelli (1924), and Mencherini (1929, pp. 28 and 42).

10. Morelli (1880, p. 239, n. 1), Ulmann (1894), Berenson (1896, 1932, and 1963), Burckhardt (1910, p. 692), Venturi (1911, p. 359), Schmarsow (1912), Gronau (1913), Testi (1916, pp. 429f.), Offner (1920a, 1927, and 1939), Escher (1922, p. 78), Van Marle (X), Toesca (1932), Pudelko (1934 and 1936), Salmi (1936 and 1938), Kennedy (1938, p. 200), Wackernagel (1938, p. 124), Paatz (1940ff., I), Nicholson (1942), Sabatini (1944), Ortolani (1948), Caviggioli (1954), Salmi et al. (1954), Janson (1957), Fortuna (1957), Hartt (1959), Borsook (1960), White (1967), and Meiss (1970 and in *The Great Age of Fresco,* 1968). Van Marle (X) placed the Cavalcanti fresco in the 1440s. According to Testi (1916) and Paccagnini (1952), Domenico's last work was the St. Lucy altarpiece.

CATALOGUE RAISONNÉ

WORKSHOP PRODUCTIONS

13. *Portrait of Matteo Olivieri,* ca. 1440–1455 (Pl. 171).

Tempera on panel transferred to canvas, 48 × 34 cm.[1]

Washington, National Gallery of Art, Mellon Collection.

The inscription MATHEUS OLIVIERI IOANNI FILI runs along a painted ledge at the bottom of the picture.[2]

Prior to its acquisition by Andrew Mellon the panel was in the collections of Stefano Bardini in Florence and of Sir Joseph Duveen. It has been on exhibition at the National Gallery of Art since 1941.

The work is in poor condition, having been extensively cleaned and restored. Hatfield (1965) has noted that it has been cut down at the sides by at few centimeters, and that the final letters US are missing from the last word of the inscription.[3]

NOTES

1. The measurements of the portraits of Matteo as well as of Michele Olivieri (catalogue no. 14) are given as 48 × 33 cm in Flaiano and Tomasi (1971).
2. For comments on the inscriptions, and on other aspects of this work see catalogue no. 14.
3. For references to the picture, see catalogue no. 14.

14. *Portrait of Michele Olivieri,* ca. 1440–55 (Pl. 172).

Tempera on panel, 48 × 34 cm.

Norfolk, Chrysler Museum.

The inscription MICHAEL OLIVIERI MATHEI FILIUS runs along a painted ledge at the bottom of the picture. Hatfield (1965) appears to be correct in noting that the inscriptions in the portraits of both Matteo and Michele Olivieri are later additions, that they were probably put in before the middle of the sixteenth century, and that they seem to have been gone over since then. The letters in the inscription of Matteo are slightly smaller than in Michele's and appear to have been redone more extensively and more recently. Different too are the placement of the inscriptions on the ledges and the design of the ledges themselves. In Michele the inscription is on a dark, narrow strip. Matteo's ledge is about twice as high, and the strip containing the inscription is framed by two lighter ones. It is fairly certain, however, that the ledges were part of the original paintings, for they also occur in two of three other mid-quattrocento male profile portraits that belong to the same group (see Hatfield, 1965). In the portrait at Chambéry given

to Paolo Uccello, the ledge with the simulated engraved inscription ELFIN FATUTTO is certainly original (see Pope-Hennessy, 1969). The ledge in the portrait in the Mellon Collection at the National Gallery in Washington attributed to but surely not by Masaccio, which bears no inscription and seems either unfinished or hastily painted over, also appears to be part of the original design of the picture.

The portrait of Michele was formerly in the collection of John D. Rockefeller, Jr. It was subsequently owned by Laurance Rockefeller and by his daughter Laura (Mrs. Richard) Chasen, and was acquired by Walter Chrysler in 1975.

Contrary to Hatfield's claim (1965) that the portrait of Michele is in better condition than its companion in the Mellon Collection, the Chrysler panel has been restored at least as drastically, though perhaps not cleaned as energetically, as the portrait of Matteo. Hatfield feels that the latter "looks stiffer and less finely executed," suggesting that these discrepancies "are the result of restorations, deliberate variations introduced by the artist, and possible differences in date." To me they seem to be due entirely to restoration. There are also further particulars in which the portrait of Matteo differs not only from that of Michele but also from the three related profile portraits at Chambéry, in the Mellon Collection in Washington, and at the Isabella Stewart Gardner Museum in Boston. The first is a question of scale. Matteo's bust is cut lower, and the size of his bust, head and turban is smaller in relation to the size of the field on which he is painted than is the case in any of the other four portraits. The second point concerns costume. All five figures wear a coat, a vest with a fur collar, a second vest with a dark cloth collar, and a shirt with a white collar showing at the neck. In all but Matteo these four items are clearly distinguished. In Matteo the shirt and the dark collar of the second vest, as well as the fur collar and the collar of the coat, where they come forward from behind the neck under the chin, are joined, so that instead of four only two collars are delineated. The matter of scale may have been a "deliberate" variation by the artist. The detail of costume may well be the result of restoration.

Pope-Hennessy (1966) has observed that both images "have the character of posthumous rather than life portraits." Indeed, Hatfield has shown that Matteo was in fact, and Michele very probably, painted posthumously. Matteo Olivieri, the son of Ser Giovanni, left a will in 1365. Michele, Matteo's youngest son, gave his age as fifty-two and fifty-nine in *catasto* declarations of 1427 and 1433, may have died by 1439 or by 1442, and is known to have been dead by 1446. Hatfield believes, as I do, that the two portraits were painted when Michele was no longer living. But Gilbert (1968) considers this "no more than an even possibility" and thinks that they were done when Michele was about sixty-five. Be that as it may, the fact is that Michele, like his father Matteo and the individuals in the portraits in Boston, Chambéry, and Washington, is shown as a youth. Moreover, the five portraits are not realistic, but schematic, idealized, and emblematic. Hatfield has sought to account for this by the improbable suggestion that they are images of *virtù* as described in Alberti's *Della famiglia*. Equally unpersuasive is Hatfield's proposal that the Olivieri portraits "appear to be pieces from the family portrait gallery, a sort of family tree in pictures," whose purpose it was "to establish a pedigree."

Berti (in Volponi and Berti, 1968) has proposed that all five portraits may have been derived from Masaccio's lost *sagra*, an argument of some force in the light of Vasari's report that portraits by Masaccio of persons also represented in the *sagra* were in the house of Simone Corsi in Florence. However, the differences in costume between the five portrait panels and

the figures in the *sagra* as shown in a drawing after the lost composition, in which they are wearing loose mantles gathered at the neck (see Gilbert, 1969), suggest that such a connection could at best have been an extremely general one. A more likely precedent for the five portraits might have been the pictures mentioned by Vasari in the house of Simone Corsi.

The Olivieri as well as the other three portraits are clearly related to both contemporary medals and sculpted portrait busts. Their similarities to the latter are particularly suggestive. Painted and sculpted portraits are cut at roughly the same level below the shoulders, and have similar costumes. The portraits in the five paintings are modeled so as to feign the three-dimensionality of sculpture, and are conceived as complete objects, as if they were or could be standing on a horizontal surface. In these respects they are like sculptures seen from the side—one of the ways, as Lavin (1970) has shown, in which quattrocento sculpted portrait busts were installed and meant to be viewed. Although the earliest unequivocally identifiable documented sculpted bust of the period is Mino da Fiesole's *Piero de' Medici* of 1453 (Pl. 46), the genre goes back at least to Donatello's *Portrait of a Youth* of ca. 1440 in the Bargello, and perhaps to the bust of *John VIII Palaeologus* in the Vatican which Schuyler (1972, pp. 75ff.) believes to have been made by Donatello in 1429.[1] If the Olivieri portraits and the three others in their group presuppose, as I believe they do, the development of the sculpted portrait bust, in the light of our present evidence on sculpted busts they should not be placed earlier than ca. 1440. I would not hesitate, however, to date them as late as the mid-1450s, when figures in profile with similar costumes and headgear frequently appear in Florentine *cassone* painting.

Attributions of the Olivieri portraits have been evenly divided between Paolo Uccello and Domenico Veneziano.[2] Carli (1954) and Hatfield (1965) have given them to Domenico with reservations, while Longhi (1952) thought them copies of Domenico. The portrait of Matteo poses so many questions of condition, design and execution that a meaningful attribution is hardly possible. That of Michele is another matter. Comparison with the profiles of Domenico Veneziano's St. Lucy (Pl. 62) and of the figure at the far left of the main group in the Berlin *Adoration of the Magi* (Pl. 45) reveals that in spite of basic affinities in shape and composition, Domenico's heads are anatomically and structurally more clearly articulated, and are modeled so as to suggest much more palpably their existence in pictorial space and light. Michele lacks the grasp of character of Domenico's heads. His bearing, his look, and the shaping of his features, especially his mouth, are not integrated as they are in heads by Domenico, and his expression is ambiguous and unresolved. Nevertheless, the portrait of Michele shows sufficient analogies to the profile of St. Lucy to justify an attribution to Domenico Veneziano's workshop.

NOTES

1. Schuyler also rehabilitates the much-discussed bust of *Niccolò da Uzzano* in the Bargello, arguing that it is a work by Donatello of ca. 1433. Schuyler's arguments do not persuade me to abandon my agreement with Janson (1957) in questioning both the identification and Donatello's authorship of the bust, and in dating it ca. 1460–80.
2. For attributions to Uccello, see Venturi (1930a, 1931, and 1933), Böck (1933 and 1939), Pudelko (1934, 1934a, and 1935), Lipman (1936), Kennedy (1938), and Sindona (1957). The portraits are given to Domenico Veneziano in Berenson (1932 and 1963), Salmi (1936 and 1938), *Art News* (1937), National Gallery of Art (1941), Antal (1947), Pope-Hennessy (1950, 1966, and, with reservations, 1969), Mallé (1965), and Gilbert (1968).

CATALOGUE RAISONNÉ

APOCRYPHAL WORKS

15. *Head of a Saint,* ca. 1450 (Pl. 173).

Fresco fragment, the head roughly life-sized.

Asolo, S. Gottardo.

The head has often been referred to as female, perhaps because of a certain resemblance to the female saints of Antonio Vivarini. But its tonsure clearly indicates that the saint is a man. The fragment is in relatively good condition. Nothing is known and nothing has survived of the original context of the work.

Since its publication by Fiocco (1923), the head has been cited as an example of the influence of Florentine art on Venetian painting in the second quarter of the fifteenth century. Fiocco (1923 and 1927, pp. 35ff.) and Volpe (1956) have given it to Paolo Uccello, who was in Venice from 1425 until 1430. On another occasion (1937) Fiocco revised his attribution to "the manner of Paolo Uccello." Van Marle (X), Procacci (1935), and Böck (1939, p. 119) have suggested a Venetian imitator of Uccello, while Pope-Hennessy (1950 and 1969) and Carli (1954) have called it simply "Venetian school."

The work was tentatively attributed to Domenico Veneziano by Coletti (1953), who believed that together with the *Visitation* in the Mascoli Chapel at S. Marco in Venice (see catalogue no. 45), and the four martyrdom panels in Bassano del Grappa, Bergamo, and Washington (see catalogue no. 16), it shows the influence of Domenico on Venetian painting during the 1440s. There is not the slightest evidence for this thesis, however, beyond the implausible statement by Vasari that Domenico was active in Venice before coming to Florence (source 11E; see p. 6.) The most serious attribution of the Asolo head to Domenico Veneziano is Salmi's (1958), who had earlier assigned it to a Venetian painter influenced by Fra Filippo Lippi and Uccello (1936 and 1938). Salmi's revised view is that Domenico painted the Asolo figures at the same time (1442) as the upper part of the St. John the Evangelist on the vault of S. Tarasio in Venice (see catalogue no. 46), and that the former shows analogies to "the head"—presumably of the *Beardless Saint*—from the Carnesecchi Tabernacle. This attribution has been rightly rejected without comment by Hartt (1959) and Zeri (1961).

The style of the fragment seems to me to have been best defined by Longhi (1926), who gave it tentatively to Antonio Vivarini and argued that its Florentine qualities—the foreshortened halo and the three-dimensionality of the head—depend not from Uccello but from Masolino. The similarities between the fragment and the works of Antonio Vivarini are fairly general, however. Its frontality and stylized, rounded contours are rooted in a Venetian stylistic tradition going back at least to Nicolò di Pietro. The Asolo mural was most probably painted about the middle of the century—the foreshortened halo would be unlikely before Jacopo Bellini had made perspective a standard practice in Venetian painting—by an artist associated with or influenced by Antonio Vivarini.

16. Four Panels from an Altarpiece, ca. 1450 (Pls. 174–175).

(A) *The Martyrdom of a Female Saint.*
Tempera on panel, 58 × 33 cm.
Bassano del Grappa, Museo Civico.

(B) *The Martyrdom of St. Apollonia.*
Tempera on panel, 52 × 29 cm.
Bergamo, Accademia Carrara, no. 179.

(C) *The Martyrdom of St. Lucy.*
Tempera on panel, 54 × 32 cm.
Bergamo, Accademia Carrara, no. 180.

(D) *St. Catherine Casting Down a Pagan Idol.*
Tempera on panel, 60 × 34 cm.
Washington, National Gallery of Art, Samuel H. Kress Collection, K 7.

Though the four panels clearly come from the same altarpiece, the pair in Bergamo differs from the panels at Bassano del Grappa and Washington in several respects. The Bergamo panels are rectangular and measure 52 and 54 cm in height. Those in Bassano and Washington are 58 and 60 cm high and are in the form of an arch. The edges of the arch in the Washington panel look as if they had been filled in, and as if the arch had originally had the same shape as it does in the Bassano panel. Furthermore, the architecture at Bassano and Washington is more delicate and more classical, and the scale of the figures in relation to the architecture is smaller than at Bergamo. The two pairs would seem to have been painted by two members of the same workshop, and to have been installed on different levels of the altarpiece to which they belonged—perhaps on either side of a central image, with the Bergamo panels below the other two.

The altarpiece from which the panels came must have been broken up by the third quarter of the nineteenth century, for the Bassano picture entered the Museo Civico there as the legacy of Count Giuseppe Riva in 1876.[1] The Washington panel was acquired by Samuel H. Kress from Count Contini-Bonacossi in Rome in 1927. All panels are in relatively good condition, though they have suffered losses and restoration.

The attribution of the panels to Domenico Veneziano by Brandi (recorded in Palluchini, 1946, p. 73) has been rightly rejected without comment by Zeri (1961). Coletti (1953) gave them to Domenico's workshop, with the possible collaboration of Antonio Vivarini, and cited them, along with the fragment at Asolo (catalogue no. 15) and the *Visitation* in the Mascoli Chapel (catalogue no. 45), as examples of the influence of Domenico Veneziano on Venetian painting during the 1440s (see p. 141). The panels show not the slightest trace of Domenico's style, but are related to both Antonio Vivarini and Jacopo Bellini. Their attribution to the former by Longhi (1926 and 1946, pp. 50f.) has been widely accepted.[2] Fiocco (1927, pp. 57f.) gave them to Dello Delli, an attribution rejected by Post (1930, p. 260, n. 1), and later (1948, 1959, pp. 36f., and 1966) ascribed them to an anonymous Master of the Martyrdoms. Other attributions

have been to Francesco de' Franceschi (Van Marle, VII and IX) and Jacopo Bellini (reported in Van Marle, XVII, p. 125, n. 4).

It would seem, as I have argued, that the panels fall into two pairs and were painted not by one but by two artists, both probably members of the workshop of Antonio Vivarini. The abundant borrowings from Jacopo Bellini in the architecture, the architectural decoration, the representation of sculpture, and the perspective in all four panels—a practice not generally characteristic of Antonio Vivarini himself—would suggest that he had little if any share in their execution. These borrowings are most pronounced in the panel in Washington (Pl. 175), where Jacopo Bellini's drawings are the source for the arch at the right, the brackets under the balcony, the classical inscription on the balcony railing, the base of the statue, and the statue itself. There are two northern Italian precedents, both at Castiglione d'Olona, for the frieze of *putti* in the Bassano panel (Pl. 174): Masolino's *Banquet of Herod* in the Baptistry,[3] and the frieze, apparently carved after 1444, over the entrance of the portal of the Brunelleschian parish church in the center of the village.[4] Since the drawings by Jacopo Bellini on which the martyrdom panels depend so heavily were probably not made until 1448–50 at the earliest,[5] it is unlikely that the panels were painted before the middle of the century.

NOTES

1. For this information I am indebted to Bruno Passamani, Director of the Museo Biblioteca e Archivio di Bassano del Grappa.
2. See Suida (1940), National Gallery of Art (1941), della Chiesa (1955), Berenson (1957), Martini (1957), Palluchini (1962), and Shapley (1966).
3. The influence of Masolino on Antonio Vivarini has been rightly stressed by Longhi (1926). Berenson (1932) attributed the martyrdom panels to an unknown Venetian painter influenced by Masolino and Antonio Vivarini.

4. Construction of the church was completed by 1444, the year in which Baldassare Castiglione, the nephew of Cardinal Branda Castiglione, left a provision in his will for its decoration (see Cazzani, 1967, p. 550). The painted *putti* holding wreaths on the frieze under the exterior cornice of the church are probably a later addition.
5. See Canova (1972), who has convincingly shifted the date for the Louvre sketchbook by Jacopo Bellini to these years from the date of ca. 1455 proposed by Röthlisberger (1956).

17. *Bust of Christ,* late fifteenth century.

Tempera on panel, 53 × 36.5 cm.

Bayonne, Musée Bonnat, no. 882.

The picture is known to me only from photographs, in which it is evident that it is badly disfigured by restoration (see del Buono and de' Vecchi, 1967: "L'opera risulta depressa da estesi guasti e da vecchi restauri"). The work was first published Gruyer (1903 and 1908) as by Piero della Francesca. Adolfo Venturi, according to Gruyer, attributed it to Domenico Veneziano. Longhi (1927, p. 171) thought it Venetian and later (1938, p. 87) gave it to Lazzaro Bastiani, an attribution endorsed by Collobi (1939). Berenson (1932) assigned the panel tenta-

tively to Giovanni Battista Utili da Faenza, and Van Marle (XV) ascribed it to Gerolamo di Giovanni da Camerino. In the catalogues of the Musée Bonnat (1930 and 1952) the picture has continued to be listed as by Piero della Francesca. Although its damaged condition makes any attribution chancy, that to Lazzaro Bastiani seems more convincing than the others.

18. *Desco da parto,* ca. 1435–40 (Pls. 176–177).

Tempera on poplar panel, 56 cm in diameter.

Berlin-Dahlem, Gemäldegalerie, no. 58C.

The panel is painted on both sides. The front shows a cutaway view of the interior of a quattrocento palace. At the right is a bedroom with a nurse holding a swaddled infant, surrounded by the reclining mother and three attendant women. In the courtyard two groups of visitors—women and nuns in the center, and heralds followed by men bearing gifts at the left—are approaching the bedchamber. The back of the panel shows the nude figure of an infant gently instructing a sharp-toothed dog, and a meadow with flowers.

When the work was first mentioned (Gherardi-Dragomanni, 1834, p. 45, n. 2) it was in the collection of Professor Sebastiano Ciampi in San Giovanni Valdarno. It was acquired by the Kaiser Friedrich Museum from the Palazzo Capponi in Florence in 1883 and has been in the Gemäldegalerie in Dahlem since 1956.[1]

According to Watson (1969, n. 79), the Florentine banners on the trumpets of the two heralds are an allusion to the expulsion of the Duke of Athens on July 26, 1343; and Berti (1964) has referred to a nineteenth-century interpretation of the *desco* as a political allegory. Be that as it may, the heralds with trumpets and banners of the Florentine republic, and the staging of the visitation in a Brunelleschian courtyard, suggest that the family of the newly born child was an eminent one.

Both sides of the *desco* are in relatively good condition. A number of cracks in the lower part of the front side have been filled in. There are retouchings throughout the front, especially in the bedcover and the draperies of the two women in front of the bed. The herald holding his trumpet upright has no legs—a detail that was repeated in a twelve-sided copy of the Berlin *desco* in the Musée Jacquemart-André.[2] The infant with the dog was copied on the back of a twelve-sided salver formerly in the Landau Finaly Collection in Florence (see catalogue no. 82).

The traditional attribution of the *desco* to Masaccio continues to find the support of the majority of scholars.[3] But almost from the time the picture became known there have been justified doubts about Masaccio's authorship. Morelli (1893, p. 17) thought it inferior in quality and gave it to Andrea di Giusto. Brandi at one time (1934) attributed it to Domenico di Bartolo and was supported in this by Mather (1944). Brandi later (1949, pp. 106ff.) judged the *desco* to be a mediocre approximation of the style of Masaccio by a Sienese painter between 1430 and 1440; and, according to Berti (1964, n. 283), subsequently formed the opinion that it is by "un

pittore non intimamente legato all'istituzione rinascimentale." The work has also been ascribed to a follower or pupil of Masaccio,[4] and by Ragghianti (1938 and 1952), Shell (1968), and tentatively by Pope-Hennessy (1944) to Domenico Veneziano. The copy of the *desco* in the Musée Jacquemart-André was connected with Domenico Veneziano by Schmarsow (1898), who remarked that

la conception et le mouvement des figures se rapprochent de l'art du groupe de Dello depuis Starnina, et l'ensemble nous donne un avant-goût des artistes plus modérés qui suivrent, tel que sera Domenico Veneziano.

Meiss (1964b) expressed interest in the attribution to Domenico Veneziano—he cited the architecture, the figures at the right, the intense blue of the vault, and the green instead of yellow underpainting of the flesh tones as uncharacteristic of Masaccio—but did not fully endorse it. Zeri (1961) has rejected it without comment.

The explanation for a work so strongly and obviously Masaccesque in some respects and so unlike him in others may be that it was made as a pastiche of his style, perhaps the earliest Renaissance example of a genre known to us later from pastiches of Donatello such as Michelangelo's *Madonna of the Steps* (see Eisler, 1967), the early-sixteenth-century *St. Jerome* at Faenza (see Janson, 1957), or reliefs of the *Virgin and Child,* when they are not nineteenth-century forgeries (see Pope-Hennessy, 1974a), given to Donatello by Bode (1902).

If the *desco* was meant to look like a work by Masaccio, how long after Masaccio's death was it painted? Pittaluga (1935) dated it ca. 1430; Brandi (1934 and 1949), Procacci (1951), and Watson (1969, p. 383, n. 76) in the 1430s; Pope-Hennessy (1944) in the mid-1430s; and Meiss (1964) and Shell (1968) in the early 1440s. But the fact that its author adopted a modular system—a compositional method integrating the perspective construction, the squared grid controlling the surface design, and both the placement and size of figures by the same unit of measurement (Fig. 25)—reminiscent of Donatello's Lille relief (Fig. 8), Ghiberti's *Esau* panel (Figs. 6 and 7) and Domenico Veneziano's *Adoration of the Magi* (Fig. 9) would favor a date in the late 1430s (between the two reliefs and Domenico's tondo, though perhaps closer to the latter than to the former). The *desco* has also been connected in a general way by Salmi (1938), and in some detail by Shell (1968), with the St. Lucy Altar. The *sacra conversazione* and the *desco* have in common, Shell pointed out, proto-Renaissance marble-encrusted spandrels over quattrocento columns, the positioning of the architecture so that it is back in space at the bottom of the composition and flush with the picture plane at the top, and the handling of light. The *desco* also shares with the predella panels of the *Annunciation,* of St. Zenobius and of St. Lucy the use of black as a means of stabilizing and accenting the decorative arrangement of the composition, and with the St. Zenobius panel the placement of a strong accent (in the *desco* the head of the older nun, in the predella panel the head of the mother) near the vanishing point in order to neutralize the perspective thrust into depth (Figs. 19 and 25).

But the most revealing link between the *desco* and the St. Lucy Altar is the geometric system that underlies and integrates its perspective construction and surface composition (Fig. 25). Like the geometric schemes of the altarpiece (Figs. 12, 19, 20, 21), it was worked out not on the panel itself but transferred to the painting from a cartoon. For the painter of the *desco* this meant adapting a rectangular scheme to a circular field. Although his construction lacks

Domenico Veneziano's elegance, he solved the problem with considerable ingenuity. The baseline of his perspective system, and also the ground line for the nearest figures, runs along the front top edge of the low wall near the bottom of the composition. The horizon, located slightly above the tondo's horizontal diameter, coincides with the tops of the heads of the figures standing on the baseline—as, according to Alberti's *De pictura*, it should. The centric point lies just to the right of the vertical diameter. (In order to give sufficient visibility to the bed and the two women behind it the artist has projected the space of the bedchamber, not according to the perspective of the courtyard, but with an upward-slanting floor, as in trecento paintings or, closer in date to the salver, the predella panels of the Linaiuoli altarpiece by Fra Angelico.) The baseline is divided into six equal units, two of which mark the height of the figures standing on it and of the horizon, and five the distance from the baseline to the top of the panel. The geometric scheme of the painting consequently consists of thirty squares, several of whose vertical and horizontal axes, such as the verticals at *B, D, F,* and *G,* are aligned with the design of the architecture, a control over the composition that is also provided by some of the axes which bisect the zones of the basic thirty-square grid, like the vertical at *E* and the horizontal axes above the horizon line. The axis bisecting the horizontal zone immediately above the horizon line also has the additional function of marking the tops of the heads of the two women behind the bed, so that their distance above the horizon line is regulated by the proportions of the squared grid.

The perspective system of the tondo is what I have called the reformed bifocal construction (see p. 39). The transversals along the ground are obtained by the intersection of the central axis *FM* with the lines *LG, LH* and *LI* drawn from the lateral vanishing point *L* to the baseline. The first two transversals coincide with the bases of the second and fourth columns of the courtyard. The third one runs along the upper edge of the bench projecting from the rear wall. Mesnil (1927, pp. 96f.) claimed that the viewing distance of the perspective construction is six-sevenths of the tondo's diameter. But the point *L* is not a true distance point, and its distance from the central axis, which in the reformed bifocal construction serves as the intersection for determining the rate of recession of the transversals, is not six-sevenths but four-sevenths of the diameter of the *desco*. Because the designer felt cramped at the left side of the composition (see the unequal sizes of the spandrels), he has moved the visible edge of the wall supporting the perspective row of columns (*CM*) to the right of the constructional orthogonal *BM* and has placed his columns between the two. Once it becomes apparent that the constructional orthogonal is not *CM*, as one would expect, but *BM*, the geometric system of the picture emerges as a model of regularity, closely related in its integration of proportions in perspective with proportions on the surface to Domenico Veneziano. The horizontal *JK,* for example, is both one of the horizontal axes of the thirty-square grid that controls the composition and the fourth transversal of the perspective construction. The orthogonal *PM* along the tops of the wall capitals is also part of the diagonal *MR,* which bisects the square formed by the horizon, the central axis, and the upper and right edges of the total grid.

It is hardly possible, however, that the painter of the Berlin *desco* could have been Domenico himself. Shell's comparisons of its heads, faces, hair, and drapery with the *Annunciation* and the St. Zenobius panel from the St. Lucy Altar simply do not stand up. In the St. Lucy predella these and other forms are defined by means of delicate contours and meticulously rounded, structurally articulate hatchings. In the *desco* modeling is clumpy and patchy. Ears are defined by highlights which summarily trace the path of their outer rims. The looks in

shallow-set eyes with black pupils and black eyelids do not match the figures' bearing and gestures. In the panels of the St. Lucy predella or in the Berlin *Adoration of the Magi*, even when Domenico is working rapidly, he defines the structure of eyes and ears in carefully differentiated crescent-shaped strokes. His eyes are set well within the head, and their look contributes to each figure's explicitness of expression. The tondo's eyes and ears resemble those of the *Saints* from the frame of Masaccio's Pisa polyptych; the profile of the man at the far left is like that of Mary in the Naples *Crucifixion;* and the composite capitals of the columns in the courtyard match those on the throne of the Pisa Altar's *Madonna and Child* in London. Also in favor of the thesis that the work is a pastiche of Masaccio is the fact that the neckline of the woman in black behind the bed is identical with that of the angel at the upper right in the Uffizi *Virgin and Child with St. Anne*. However, the best example of the *desco*'s emulation of Masaccio's style is the *putto* on the back (Pl. 177).

I should like to return to the blue of the vault, which Meiss (1964) found uncharacteristic of Masaccio. Among extant works of the second quarter of the quattrocento blue vaults occur occasionally in the production of Fra Angelico, including the *Annunciation* from S. Domenico in Fiesole now in the Prado (in which the vault is embellished with gilt stars). The remarkable architectural setting of this picture, with its vanishing point at the center of the bay containing the angel, near the center of the composition, and its lucid perspectival definition of interior space, is perhaps not entirely the invention of Fra Angelico, but may derive from the architecture of Masaccio's lost *Annunciation* in S. Niccolò Oltrarno, which Vasari described as "a large house filled with columns beautifully drawn in perspective," and which may also have been the source for the interior, including the blue vault, of the Berlin *desco*.[5]

The architectural vocabulary and proportions in the *desco* have been related to both the portico of the Spedale degli Innocenti (see Mesnil, 1927, pp. 94f.) and to the Brunelleschian cloister at S. Croce (see Clark, 1946). But the only Brunelleschian building with which the architecture of the *desco* has a specific similarity is the interior S. Spirito: the unit for the proportions of the foreground arch in the *desco* is measured across the bay from the centers of the supports, as in the arcades at S. Spirito, rather than from their inside edges, as at the Innocenti portico. If, as Clark has suggested, the design of the *desco* was inspired by drawings of Brunelleschi, they are likely to have belonged to his late period (see Heydenreich, 1931).

NOTES

1. It has been suggested (see Königliche Museen zu Berlin, 1931) that the *desco* may be the work described in Bocchi-Cinelli (1677, p. 366) and Baldinucci (II, p. 296) in the house of Baccio Valori in Florence. According to the description in Bocchi-Cinelli, however, the two paintings have nothing in common except the depiction of a birth:

 Quadretto dipinto a tempera, un parto di una Santa di mano di Masaccio di gran bellezza di vero: dovè oltra la donna di parto, che è fatta con somma diligenza, è bellissima una figura, che picchia un us-

 cio, e dentro ad una paneretta, che ha in capo, porta un cappone, la quale e panneggiata con tanta grazia, che del tutto par vera.

2. See Müntz (1894), Schmarsow (1898), Schubring (1915, no. 87), Van Marle (X), Pittaluga (1935, p. 150), Salmi (1948), Brandi (1949), and Berti (1964).

3. See partial listings by Berti (1964), in Salmi et al. (1954) and in Volponi and Berti (1968). The tondo was also given to Masaccio by Gherardi-Dragomanni (1834), Bode (1888), Müntz (1894), Königliche Museen zu Berlin

(1904, 1912, and 1931), Magherini-Graziani (1904), Venturi (1911, p. 115), Schubring (1915), Comstock (1926), Mesnil (1927, pp. 97ff.), Lindberg (1931, pp. 62 and 189), Berenson (1932 and 1963), Toesca (1934), Gengaro (1936), Longhi (1940 and 1952), Salmi (1948: with assistant), Biehn (1953), Stiftung preussischer Kulturbesitz (1963), and Parronchi (1966).

4. See Pittaluga (1935), Clark (1946), Procacci (1951), Meiss (1964), and Watson (1969).

5. The identification by Longhi (1940) of the lost painting by Masaccio with the *Annunciation* by Masolino in the National Gallery of Art in Washington has been convincingly refuted by Salmi (1948). Pope-Hennessy (1952) has suggested that Masaccio's lost work was the source for the *Annunciation* by Fra Angelico at Cortona. However, it is specifically the Prado *Annunciation,* with its similarities to the *desco* in Berlin, which seems to show the influence of Masaccio's composition. For the importance of the lost picture, see Spencer (1955). A relationship between the *desco* and Masaccio's *Annunciation* as described by Vasari was first noted by Lindberg (1931). Berti (1964) has argued that Masaccio's lost work was also the source for the *Annunciation* in the *cimasa* of the Perugia altarpiece by Piero della Francesca, a connection first perceived by Schmarsow (1894, pp. 25ff.) and later cited by Salmi (1948). Piero's *cimasa,* whose original shape was more probably an arch (Fig. 26) rather than a rectangle as proposed by Ragghianti (see del Buono and de Vecchi, 1967, p. 102), would seem to have been designed, like the Berlin *desco,* by the reformed bifocal construction, though apparently not according to a similarly rigorous modular system. If the *cimasa* and the *desco* indeed depend from the lost *Annunciation* by Masaccio, it remains a question whether Masaccio's foreshortened stylobate cast a shadow on the floor to its right: Piero's stylobate does cast such a shadow; the stylobate in the *desco* does not.

19. *Sts. Cosmas and Damian,* ca. 1430–50 (Pl. 178).

Tempera on poplar panel, each panel 125 × 40 cm.[1]

Berlin-Dahlem, Gemäldegalerie, nos. 1141C and 1141D.

The two panels entered the Kaiser Friedrich Museum in 1911 as the gift of a Mrs. Dowdeswell of London. They have been shown at Dahlem since 1956. Both have been somewhat harshly cleaned. Losses in the paint surface and vertical cracks running the entire height of both panels have been filled in.

After being originally listed as Florentine school, ca. 1430 (Königliche Museen zu Berlin, 1912), the pair was in later catalogues of the Berlin museums given to Domenico Veneziano (Königliche Museen zu Berlin, 1931; Biehn, 1953; Stiftung preussischer Kulturbesitz, 1963). Salmi (1936 and 1938), Pudelko (1939), and Paatz (1940ff., IV) attributed it to Paolo Uccello and identified it as the remains of a dossal which, according to Vasari, Uccello painted for S. Maria del Carmine (see Vasari-Ricci, I, p. 254; Vasari-Milanesi, II, p. 208).[2] Other attributions have been to Giovanni dal Ponte (Antal, 1925) and Giovanni di Francesco (Van Marle, X). Longhi (1934, p. 17, and 1956, p. 193) correctly recognized the paintings as Emilian and convincingly ascribed them to Giovanni da Modena.

NOTES

1. In Biehn (1953, nos. 67 and 68) the dimensions of the panels are listed as 125 × 38.5 cm, and in Stiftung preussischer Kulturbesitz (1963) as 125 × 35 cm. The measurements listed here are taken from Königliche Museen zu Berlin (1912 and 1931).

2. Milanesi was of the opinion that the dossal to which Vasari referred was destroyed in the fire at the Carmine of 1771 (see Procacci, 1932).

20. *A Saint,* ca. 1440–45 (Pl. 179).

Tempera on panel, 41.6 × 26 cm.

Bern, Kunstmuseum, no. 20.

The picture is a fragment of a larger work. It has been considerably retouched, especially in the background and in the area of the saint's head. The attribution to Domenico Veneziano was proposed by Suida (1929), who identified the saint as Jerome, and was accepted by von Mandach (1936), who called the figure St. Bonaventura. The panel has also been given to Andrea di Giusto (Toesca, 1930) and to a follower of Fra Filippo Lippi (Pudelko, 1936; Pittaluga, 1949, p. 180; Örtel, 1950, no. 66).

The most secure basis for an attribution is the saint's vermilion mantle, whose shapes and pattern have much in common with the draperies in Pesellino's works of the early and mid-1440s, especially the predella panels divided between the Louvre and the Uffizi, the *Triumphs* at Fenway Court, and the small *Madonna and Child with Two Saints* in the Johnson Collection in Philadelphia. The drapery schemes in all of these derive from the paintings of Fra Filippo Lippi of the late 1430s and early 1440s. The fragment would therefore seem to have been produced between about 1440 and 1445 in the shop of Fra Filippo Lippi or Pesellino.

21. *St. John the Baptist in the Desert,* ca. 1440–50 (Pl. 180).

Tempera on panel, 36.2 × 26 cm.

Bloomington, Ind., Indiana University Art Gallery, Kress Study Collection, no. L62158.

The inscription ECCE ANGN[US DEI] is painted in Roman letters on the scroll in the saint's left hand.

The panel was formerly in the Gentner and Contini-Bonacossi Collections in Florence. It was bought by Samuel H. Kress in 1939 and was on exhibition at the National Gallery of Art in Washington from 1941 to 1952. It has been at Indiana University since 1962.

Shapley (1966) has described the picture as in "good condition except for damages in the background." There is considerable retouching, however, in the head, torso, raised arm, and halo of the saint.

When the panel was first published it was tentatively given to Domenico Veneziano with a date of ca. 1460 (National Gallery of Art, 1941). Berenson (1963) listed it as by a Florentine follower of Paolo Schiavo. Shapley (1966) reports attributions to Domenico di Michelino by Fiocco, Longhi, Perkins (tentatively), Suida, and Adolfo Venturi, and an attribution, which she endorses, to a follower of Pesellino, possibly Giusto d'Andrea, by Zeri. She also relates the panel to a *Crucifixion with Sts. Jerome and Francis* in the Kress Collection at Washington attributed to Pesellino (K 230), and to the *Resurrection* in the Frick Collection now convincingly identified as an early work of Botticini (see Fahy, 1967; Bellosi, 1967; *The Frick Collection,* 1968, pp. 216ff.). Fredericksen and Zeri (1972) tentatively give the Bloomington panel to Domenico di Michelino.

The stylized landscape derived from Ghiberti's Gates of Paradise and the predella panels of the St. Lucy Altar, and the voluminous, stiff, wedge-shaped drapery, which originates in Fra Filippo Lippi's paintings of the late 1430s and early 1440s, are characteristic of Pesellino's work of the late 1440s. But the blockiness of the forms and the crudeness of the execution suggest an artist at some distance from Pesellino himself, perhaps in the shop of Giusto d'Andrea (whose style is approximated in the saint's head and hair), yet capable of depicting the figure's foreshortened feet with remarkable skill. Indeed, the panel's curious combination of crudeness and sophistication, its internal inconsistencies (for example, the pinched left arm and shoulder as compared with the overdeveloped shoulder and arm of the right side), and its superficial similarity to a variety of quattrocento Florentine styles (Pesellino, Domenico di Michelino, Giusto d'Andrea, Domenico Veneziano, Andrea del Castagno), make it a very puzzling picture. It seems risky to propose an attribution without a prior laboratory examination.

22. *Bust of Christ,* ca. 1480–85 (Pl. 181).

Tempera on panel, 53.8 × 38 cm.

Florence, Museo Horne, no. 30.

The panel is in very poor condition, with a threadbare surface and much retouching. It has been tentatively ascribed to Domenico Veneziano by Gioseffi (1962) on the basis of a purported similarity to the *Beardless Saint* from the Carnesecchi Tabernacle. Van Marle (XI) gave the picture to the school of Piero della Francesca, and Gamba (1961) to the young Signorelli. However, Ruhmer (1954) has convincingly shown that it is by Bartolomeo Bonascia of Modena and was probably painted not long before 1485, an attribution which has been accepted by Ringbom (1965, p. 176).

CATALOGUE RAISONNÉ

23. *Three Episodes from the Legend of St. Julian,* ca. 1425 (Pl. 182).

Tempera on panel transferred to canvas, 24 × 43 cm.

Florence, Museo Horne, no. 60.

Though the panel is so severely damaged that only the most general characteristics of its style are legible, it has been identified with a story of St. Julian which, according to Vasari, was part of a predella by Masaccio in S. Maria Maggiore in Florence.[1] Longhi (1940) believed that it was painted by Masaccio for the Pisa altarpiece, but was replaced by the scenes from the lives of Sts. Nicholas and Julian by Andrea di Giusto now, with the rest of the Pisa predella, in Berlin. It has also been thought that the panel mentioned by Vasari as part of the S. Maria Maggiore predella is not the painting in the Museo Horne but a picture by Masolino in the Musée Ingres at Montauban.[2] Stechow (1930), though he accepted the view that the panel from S. Maria Maggiore is the painting in the Museo Horne, presented a carefully reasoned argument that its author was not Masaccio but Domenico Veneziano, an attribution which in Örtel's opinion (1933) "hat vieles gutes an sich." Pudelko (1934) thought Domenico's authorship extremely unlikely but felt that the state of the panel made an attribution impossible.

Enough of the painting remains to recognize that such a severe, compact composition could hardly have been planned by Domenico Veneziano, and that the attribution to Masaccio stands a good chance of being correct. In its favor are the restriction of the palette to reds, earth colors, gray, and black; the strong, directionally consistent light, and correspondingly forceful shadows by which the figures are modeled; the foreshortened dog, with its function of blocking out the segment of space occupied by the group at the left; the placement in relationship to the foreshortened wall of the figures at the right; the concentrated, dramatically powerful counterpoint of their pantomime; and the sculptural conception of forms in space throughout the composition.

NOTES

1. Vasari-Ricci (I, pp. 253 and 384) and Vasari-Milanesi (II, pp. 206f. and 293). See Gamba (1920 and 1961), Procacci (1951), Baldini (in Salmi et al., 1954), Berti (1964), Parronchi (1966), and Rossi (1967). The painting is listed as by Masaccio in Berenson (1932 and 1963).
2. See Berenson (1923). Other paintings by Masolino thought to come from the S. Maria Maggiore altarpiece are a *St. Julian* in the Museo Arcivescovile di Cestello in Florence (see Offner, 1923), a *Madonna and Child* formerly at Novoli (see Toesca, 1923), and a predella panel of *The Marriage of the Virgin* (see Pope-Hennessy, 1943). Procacci (1953) has dated the altarpiece prior to Masolino's departure for Hungary (on September 1, 1925). Gioseffi (1962) believes that it was painted between Masolino's return from Hungary (July 1427) and his departure for Rome (January 1428), a period, according to Gioseffi, during which Masolino was associated with the young Domenico Veneziano. Scholars who believe with Berenson that the Horne panel was not part of the S. Maria Maggiore Altar have assigned it to the shop of Masaccio (Salmi, 1936, 1938, and 1948), denied it to him (Giglioli, 1929, p. 63; Lindberg, 1931, p. 131), found it too damaged to permit a judgment (Mesnil, 1927, p. 136; Pittaluga, 1935, p. 176), or given it to Pesello (Schmarsow, 1930).

24. *Bust of St. Jerome,* ca. 1475 (Pl. 183).

Fresco transferred to canvas, 40 × 26 cm.

Florence, Palazzo Pitti, Galleria Palatina, no. 370.

The fragment came to the Galleria Palatina from the collection of Cardinal Leopoldo de' Medici. In an inventory of 1675 it was attributed to Piero Pollaiuolo, and in nineteenth-century guides of the Palazzo Pitti it was listed as a work of the school of Leonardo da Vinci (see Jahn-Rusconi, 1937, pp. 197ff.). The bust has been completely restored from the shoulders down, although there is repainting in the head as well. Cruttwell (1907a, p. 219), who followed the nineteenth-century ascription to the school of Leonardo, reported that the picture "has been attributed to Domenico Veneziano." This suggestion was then taken up in Hutton's edition of Cavalcaselle (1909, p. 317, n. 3).

The work has continued to be attributed to Piero Pollaiuolo (see Ortolani, 1948; Castellaneta and Camesasca, 1969) and to be associated with Leonardo (Passavant, 1959, Fig. 129). It has also been given to Bartolomeo della Gatta (Toesca, 1903), Piero di Cosimo (Knapp, 1908, p. 100; Berenson, 1932: copy of Piero di Cosimo), Antonio Pollaiuolo (Venturi, 1911, p. 558; Marangoni, 1927; Van Marle, XI), and Domenico Ghirlandaio (Ragghianti, 1935). The problem of its authorship should take into account the St. Jerome in the Verrochiesque *Crucifixion* at Argiano, whose head is so similar to that of the Pitti *St. Jerome* that Passavant (1959, p. 133) believes the latter to be a copy of it. Pudelko (1934) felt that both heads reflect Domenico Veneziano's Baptist at S. Croce. The Argiano *Crucifixion* has been given to Piero Pollaiuolo by Marangoni (1927) and Castellaneta and Camesasca (1969). Passavant (1959 and 1969) ascribes the figures of Christ and St. Jerome to Verrocchio, and St. Anthony and the landscape to a pupil. Zeri (1953) believes that Verrocchio executed only the figure of Christ and that St. Jerome, St. Anthony, and the landscape are by Perugino. Whatever the exact division of hands in the painting may be, it is clearly a collaborative work from the atelier of Verrocchio of the mid-1470s. This also would seem to be the most reasonable designation for the Pitti *St. Jerome.*

25. *The Vision of St. Jerome,* ca. 1453 (Pl. 159).

Sinopia and charcoal on plaster (*arriccio*) detached and transferred to canvas, 297 × 178 cm.

Florence, Soprintendenza alle Gallerie.

The *sinopia* was discovered under the mural (Pl. 158) of the same subject by Andrea del Castagno in the Corboli Chapel at the SS. Annunziata in 1967, when the fresco, having been

damaged by the Florentine flood of November 1966, was detached (see Meiss, 1967a). Both the *sinopia* and the fresco, painted in 1454–55 (see Fortuna, 1957), were shown at the exhibitions *The Great Age of Fresco* in New York (1968) and *Frescoes from Florence* in London (1969).

The differences in style between the *sinopia* and the fresco led Meiss (1967a) to ask whether the *sinopia* might not "have preceded the fresco by some time," and whether the male saint in the drawing, lacking attributes, is actually St. Jerome. Be that as it may, Meiss noted that the *sinopia* shows "a novel phase of Castagno's art when he was studying Domenico Veneziano." In his posture and pantomime the saint in the *sinopia* would indeed seem to be in Domenico's debt, particularly to the Baptist in the latter's mural at S. Croce. This example of an affinity between the two artists is not, however, entirely "novel." In addition to specific instances of Andrea's reliance on Domenico (see pp. 4–5), Castagno's capacity for translating "the linear rhythms of Donatello . . . into terms of painting" is not, as Murray (1963) has implied, irreconcilable with "the colour and the light effects of Domenico Veneziano;" indeed, it presupposes the latter's drawing style, beginning with Castagno's probable apprenticeship to Domenico in the mid-1430s.

Hartt (1969) has subsequently expressed the view that the *sinopia* is drawn "in an utterly different style and by a different hand" than Castagno's fresco and that its author is Domenico Veneziano. But although the *sinopia*'s contours are admittedly gentler and more elastic than, for example, the magisterial outlines of the *sinopia* at S. Apollonia, the upturned head of the saint (nearly identical in shaping and proportions with the head of St. Peter in the S. Apollonia *Last Supper*), his abrupt pose, and the heavy volumes of the figures flanking him, are wholly in the canon of Castagno. One detail proves this even more clearly: the saint in the *sinopia* has in common with the *putto* from the frieze of the Villa Pandolfini and the *David* in the National Gallery of Art in Washington the diagonally placed, frontally inclined foot, with a straight line joining the inner contour of the calf and the big toe, without a break in the plane between the top of the foot and the leg bone. Moreover, the stance of the saints in the SS. Annunziata *sinopia* and fresco is basically the same: both figures have thin, sticklike legs and narrow ankles, and in both a straight line can be drawn along the outer contour of the right leg from the waist to just above the ankle (in the *sinopia* this line has in fact been put in).[1]

Castagno may have made the *sinopia* as a monumental presentation drawing for Girolamo Corboli, who took over the patronage of the chapel containing the work in 1451. (Because of the name of the patron, the saint in the *sinopia* is surely Jerome.) The differences between the saint in the mural—with his wrenched torso, bared, bleeding chest, skeletal head, and tortuous, tubular drapery—and the springy, athletic figure in the *sinopia* are probably due to the influence of the late work of Donatello, who returned to Florence from Padua and Venice in 1453. The *sinopia* can therefore be placed in the years 1451–53.[2]

NOTES

1. Hartt (1969) also believes that the landscape backgrounds in the *Vision of St. Jerome* as well as in Castagno's other fresco of *St. Julian* in the SS. Annunziata show "the intervention of Domenico's light brush and divisionist handling of color." But this is as unlikely—neither landscape approaches the descriptive explicitness of the hillside in Domenico's fresco at S. Croce—as Fortuna's thesis (1957, n. 70) that the landscape in the *St. Julian* fresco represents Castagno's birthplace.
2. For further references to the *sinopia,* see Kuh (1967), Passavant (1969a), and Meiss (1970).

26. *The Reform of the Carmelite Rule by Pope Eugene IV, 1432–33.*

Fresco, detached and transferred to canvas.

Florence, Soprintendenza alle Gallerie.

The mural was discovered in the cloister of S. Maria del Carmine in Florence in 1860. It commemorates the ceremony on February 16, 1432 at which Pope Eugene IV granted the Carmelites at S. Maria del Carmine a modification of their rule. Much of the work has deteriorated. The parts that have survived have been detached and transferred to canvas (see *Mostra di affreschi staccati,* 1957). Vasari attributed the fresco to Fra Filippo Lippi, who is recorded as a friar at the Carmine until January 1433 (see Poggi, 1936). The great majority of scholars consequently believe that the mural was painted by Fra Filippo Lippi in 1432 (see Pittaluga, 1949). Cavalcaselle (1892 and 1911) gave it to Masaccio; Berenson (1932) ascribed it tentatively to Domenico Veneziano; and Shell (1961), following Pudelko's view (1934) that it is by a Lippesque painter of the 1440s under Domenico's influence, assigned it to the Prato Master (see catalogue no. 43) with a date close to 1440, "after the first clear statements of style by Domenico Veneziano." With Shearman (1966) and Pope-Hennessy (1968), I find it difficult to accept Shell's attribution and continue to believe that the fresco is by Fra Filippo Lippi.

27. *The Judgment of Paris,* ca. 1450–55 (Pl. 184).

Tempera on panel, 39.7 × 49.8 cm.

Glasgow, Art Gallery and Museum, Burrell Collection.

The panel became known when it was in the Benson Collection (see Cust, 1907; Borenius, 1914, no. 19), which it entered in 1902. It had previously been in the collections of H. Edmond Bonaffé in Paris and of Sir T. Gibson Carmichael in England. In the early 1930s the picture was bought by Sir Joseph Duveen, who in 1936 sold it to Jacques Seligman. In the following year it was bought by Sir William Burrell. After World War II it was on loan to the National Gallery in London. The panel has been shown at the Burlington Fine Arts Club in London in 1920, at the Exhibition *Italian Art and Britain* in London in 1960, and at Wildenstein's in London in 1965.

The work has been cleaned and lightly retouched and is in good, though slightly worn condition. Schubring (1915, no. 165) suggested that it originally belonged to the same *cassone* as the *Sleep of Paris* and the *Rape of Helen* formerly in the Lanckoronski Collection in Vienna (see catalogue no. 75). The three panels are clearly by the same hand. There is some question,

however, whether they had the same dimensions.[1] Schubring also attributed to the same painter and postulated the same origin for the *Diana and Acteon* in the Opper Collection in Kronberg, which, however, would seem not to have been executed by the same artist as the Burrell-Lanckoronski panels (see catalogue no. 29).[2]

The *Judgment of Paris* has been given to Domenico Veneziano by Venturi (1933) and Salmi (1936, 1938 and 1947a). Kennedy (1938) questioned this attribution "on the grounds of an apparent harshness of handling" (note 6). Clark (1945 and 1956), exhibition catalogues of 1960 (Royal Academy) and 1965 (*The Art of Painting*, no. 53), and Berenson (1963) ascribed it to a follower or to the workshop of Domenico. However, Zeri (1965) has rightly seen that "there is no reason to continue to place this panel in the proximity of Domenico Veneziano, since all its features are utterly Pesellinesque, and close to the early period of Domenico di Michelino." (p. 255) It had in fact been associated with Pesellino by Cust (1907) and Borenius (1914). Longhi on one occasion (1952) placed it between Pesellino and Domenico di Michelino, but on another (1960) related it only to the formative phase of Pesellino. Schubring attributed the work to the painter he called the Paris Master whom he believed to have been strongly influenced or even trained by Domenico Veneziano. This designation was accepted by Pudelko (1934) for the *Judgment of Paris* and the Opper and Lanckoronski panels, and by Clark (1945) for the *Judgment* only. Van Marle (X) gave the *Judgment* to a follower of Fra Angelico and the Opper-Lanckoronski panels to the Paris Master.

It has been correctly pointed out (in *The Art of Painting*, 1965) that the *Judgment of Paris* and the *Diana and Acteon* in the Opper Collection (see catalogue no. 29) are "among the earliest Italian paintings of classical mythology in which the nude figure predominates. The new classical approach is combined here with the Gothic tradition, and it must have been a knowledge of Northern miniatures containing nude figures that the artist partly drew on when he came to paint the picture." (pp. 304). There is a decisive difference in this respect between the Paris Master and Domenico Veneziano, whose attitude toward the classical nude was formed by Florentine quattrocento and Graeco-Roman sculpture. The hand of the Paris Master can also be detected in two *cassone* panels in the Accademia Carrara in Bergamo depicting Boccacio's story of Griselda, especially clearly in the panel with the *Marriage of Griselda* (see della Chiesa, 1955, no. 512), though the Griselda scenes are more three-dimensionally modeled and of higher quality (Pl. 187). The nude figure of Griselda in the background at the right of the *Marriage* invites comparison with the goddesses in the *Judgment;* the landscape forms in the *Marriage* have much in common with those in the *Judgment* and the Lanckoronski *Sleep;* and two specific analogies link the *Marriage* and the *Sleep* particularly closely (see catalogue no. 75).

The *Judgment of Paris* has been dated about 1450 (Borenius, 1914; Burlington Fine Arts Club, 1920), about 1460 (Clark, 1956) and, by implication (the formative phase of Pesellino), about 1440 (Longhi, 1952). It must have been painted fairly close in time to the Bergamo Griselda scenes, probably in the early 1450s.

NOTES

1. Schubring (1915, nos. 165–67), followed by Salmi (1936 and 1938), gave the measurements of all three panels as 42 × 45 cm. The Lanckoronski panels disappeared after World War II and can no longer be checked. But the actual dimensions of the Burrell panel are 39.7 × 49.8 cm.

2. Schubring's association of the Burrell, Opper,

and Lanckoronski panels has been accepted by Pudelko (1934), Salmi (1936 and 1938), and in Royal Academy (1960). To these four Schubring added a *Zeus and the Three Goddesses* formerly in the Charles Butler Collection in London and allegedly in the Johnson Collection in Philadelphia (Schubring, 1915, no. 168). However, as Barbara Sweeney kindly informed me, this work is not and never has been in the Johnson Collection. It may be the *Juno, Venus and Minerva* which Berenson (1932) listed in the Lanckoronski Collection along with the *Sleep* and the *Rape*.

28. *The Meeting of Solomon and the Queen of Sheba,* third quarter of the fifteenth century (Pl. 189).

Tempera on panel, 64 cm in diameter.

Houston, Museum of Fine Arts, Edith A. and Percy S. Strauss Collection.

The back of the panel bears a hitherto unidentified coat of arms. In the nineteenth century the tondo was in the Boutourline Collection in Florence, and later in the Foulc Collection in Paris. It entered the Strauss Collection in the early 1930s (see Siple, 1932) and has been on exhibition at the Houston Museum of Fine Arts since 1945. The work has been shown at the Brooklyn Museum in 1956 and at the Detroit Institute of Arts in 1968. It is known to me only in photographs, from which it appears to be in relatively good condition. There are indications of retouching, particularly in an area that includes the face and beard of Solomon.

The picture was first associated with Domenico Veneziano by Rankin (1907a) and has been ascribed to Domenico by Berenson (1932 and 1963), in the catalogue of the Strauss Collection (Museum of Fine Arts of Houston, 1945), and by Coletti (1953a). It has been given to Domenico or a Ferrarese painter close to Francesco Cossa (Brooklyn Museum, 1956), Alesso Baldovinetti (Leman, 1927), Matteo di Giovanni (Venturi, 1933), the school of Padua (Schubring, 1915, no. 615), and the Florentine school (Müntz, 1894; Mignon, 1902; M. von F., 1923; Berenson, 1926, p. 19). However, the majority of scholars have rightly followed Pudelko (1934) in assigning the tondo to the school of Ferrara (Salmi, 1936 and 1938; Offner, 1945; Longhi, 1952; Volpe, 1956; Detroit Institute of Arts, 1968; Chastel, 1966, p. 16; Fredericksen and Zeri, 1972).

The elaborate, precisionist quality of the architectural and figural detail in the painting remove it not only from the orbit of Domenico Veneziano but from Florence altogether, and strongly favor an attribution to a Ferrarese painter of the third quarter of the quattrocento. It is characteristic of Ferrarese taste that the two niches above the coffered canopy in the center of the composition should contain allegorical figures of Justice and Temperance. Longhi's thesis that the Houston tondo and a twelve-sided salver of the same subject in the Museum of Fine Arts in Boston belong to a tradition of *narrativa ornata* founded by Domenico Veneziano which flourished in Florence, Siena, Perugia, and Ferrara (see Longhi, 1952) is supported by too little of Domenico's own work to be more than a speculation.

29. *Diana and Acteon,* ca. 1450–60 (Pl. 188).

Tempera on panel, 43 × 52 cm.[1]

Kronberg (Frankfurt-am-Main), Collection Uwe Opper.

––––––––––

The panel was formerly in the Oskar Huldschkinsky and Richard von Kauffmann Collections in Berlin, in the Harry Fuld Collection in Frankfurt-am-Main, and subsequently in the Peter Fuld Collection in London and the Ida Maria Fuld Collection in Frankfurt-am-Main. In 1925 it was shown at an exhibition of old master paintings from private collections in Frankfurt-am-Main. The work has been lightly cleaned to remove former varnishing and is in good condition.

Schubring (1915, no. 169) gave it to the same artist, whom he called the Paris Master, as the *Judgment of Paris* in Glasgow (see catalogue no. 27), a panel formerly in London (see catalogue no. 27, n. 2), and two scenes from the legend of Paris formerly in the Lanckoronski Collection in Vienna (see catalogue no. 75). Yet the *Diana and Acteon* is clearly by a different hand than the Glasgow and Lanckoronski panels, as can be easily established by comparing the shaping and the proportions of Diana and her two companions with the much more delicate and slender forms of the three goddesses in the *Judgment of Paris.* Nevertheless, Schubring's attribution of the Opper panel to the Paris Master has been accepted by Friedlander (1917), Swarzenski (1926), Van Marle (X), and Pudelko (1934). The picture was given to Domenico Veneziano by Salmi (1936 and 1938), and the female figures were connected by him (1947a) with the torso of the *sinopia* that Domenico drew on the west wall of S. Egidio in 1445 (Pl. 58). Berenson (1932 and 1963) and Clark (1956, p. 410) ascribed the panel to Domenico's atelier.

None of these attributions seems satisfactory. Salmi has noted that the white dog in front of Acteon reproduces in reverse the dog next to St. Julian on the left side of the ruined panel with the *Story of St. Julian* in the Museo Horne (Pl. 182). But the dog in the Horne picture is modeled and foreshortened as a three-dimensional form in light and space, whereas in the Opper panel it has a more decorative, two-dimensional function. The latter bears a certain resemblance to the similarly posed dog in the *Marriage of Griselda* at Bergamo (Pl. 187), a work I have related to the Glasgow and Lanckoronski panels. In both the *Diana and Acteon* and the *Marriage of Griselda* the dog is aligned with a perspective orthogonal along the ground so as to lead the eye into the composition. While in the Bergamo panel this stratagem works unambiguously, in the picture at Kronberg the thrust into depth is to some extent deflected and contradicted by the insertion between the contour of the dog and the platform of Acteon's left leg. At the same time, the dog's placement in relation to the left leg of Acteon is remarkably similar to the position of the dog in relation to the right leg of the groom holding the stirrup of the horse the marquis is mounting in the panel at Bergamo. The foregoing observations identify the most concrete feature which leads me to give the Opper panel to a mid-fifteenth-century Florentine painter in the vicinity of the Paris Master.

Among the Glasgow, Lanckoronski, and Kronberg panels, the latter is more sophisticated in color and design, more complex and more original in composition, and closer to Domenico Veneziano than the other three in the pantomime of the figures—the postures of the legs and of

the left hand of Acteon originate in the executioner of the *Martyrdom of St. Lucy* (Pl. 118)—and in its blue, dark green, gray-violet, cream, and red tonalities.

NOTE

1. Schubring (1915, no. 169) lists the measurements as 44 × 53 cm, Swarzenski (1926) as 51.4 × 59.2 cm, and Salmi (1938) as 42 × 45 cm. In June 1978 the picture's owner kindly made it possible for me to inspect and measure it. The dimensions of the panel are 51 × 59 cm, and of the painted area 43 × 52 cm.

30. *Madonna and Child with Nine Angels,* ca. 1445–50 (Pl. 190).

Tempera on panel, 30 × 22.5 cm (painted area 29 × 21.5 cm).

London, National Gallery, no. 5581.

The panel was bought by the National Gallery from the Cook Collection in 1945. It can be traced back in England as far as 1844 (see Davies, 1961). The work is in excellent condition. It was tentatively given to Domenico Veneziano by Berenson in 1932, though subsequently (1950 and 1963) he returned to its original attribution by Jameson (1844, p. 412) and Waagen (1854, II, p. 267) to Benozzo Gozzoli. Douglas (1903), and Pudelko (1934) thought the picture by Giovanni Boccati; Borenius (1913) and Van Marle (X) gave it to the school of Fra Angelico; Longhi at one time (1940) assigned it to Fra Angelico himself but later (1952) placed it merely in his vicinity. It has also been given to a miniature painter in the circle of Fra Angelico (Schottmüller, 1911), an illuminator of the school of S. Marco (Burlington Fine Arts Club, 1920), and to a painter influenced by Fra Angelico and by Fra Filippo Lippi, "in his early, or Masacciesque phase" (Davies, 1961). Salmi has called the work Florentine (1936 and 1938), attributed it tentatively to Piero della Francesca prior to his contact with Flemish painting and with Domenico Veneziano (1947), and referred to it as one of Piero's early works (1958a). Pope-Hennessy (1974) correctly judges the panel to be by neither Fra Angelico nor Benozzo Gozzoli.

Though the author of the picture cannot be identified by name, there can be no doubt that he also painted the miniatures in a manuscript of *The Prophecies of Giovacchino da Fiore* in the British Museum attributed to Benozzo Gozzoli before Berenson (1950 and 1951) gave it to the Master of San Miniato. Neither attribution seems convincing. The identity of hands in the panel and in the manuscript is evident in a comparison of the angel holding the farther pole of the canopy to the left of the Virgin with the figure in the archway in the miniature of *Pope Clement IV* (Pl. 191). The panel, with its reminiscences of Masaccio in the Virgin, the Child, and the foreshortened head of the angel in the left background, is surely earlier than the illumination, perhaps from the time of the revival of interest in the style of Masaccio in

Florentine painting during the fifth decade of the century (see Shell, 1961) which is also reflected in the *desco da parto* in Berlin (see catalogue no. 18).

31. *Sts. Jerome and John the Baptist,* ca. 1428–31 (Pl. 192).

Tempera on poplar panel, painted area 55 × 114 cm.

London, National Gallery, no. 5962.

The panel was originally on the front of a double-faced triptych probably commissioned by Pope Martin V for his family (Colonna) chapel in S. Maria Maggiore in Rome (see Davies, 1961; Meiss, 1964b). It came to light in England and was acquired by the National Gallery in 1950. The work has suffered slight losses around the edges of the painted area but is otherwise in very good condition, with its original paint and gilt surfaces extremely well preserved. It was lightly cleaned in 1951. Meiss (1963) believed that the picture was not completely finished, on the grounds that the "tie or clasp that was intended to hold together the Baptist's tunic, as the folds imply, was never supplied", that the "upper part of St. Jerome's mantle, lacking folds, is very flat", and that its "greenish-black 'lining' distorts the perspective of the figure by extending too far toward the right." Davies (1961) has noted changes in the outline of the Baptist's foot which he "cannot interpret precisely."

The authorship and date of the panel have been the subject of much debate. In the second edition of the *Vite*—it was not mentioned in the first edition—Vasari attributed the S. Maria Maggiore triptych to Masaccio. All of its surviving panels except the *Sts. Jerome and John the Baptist,* however, are clearly by Masolino; and even the latter has been ascribed to Masolino by Davies (1961). But the majority of scholars (Clark, 1951a; Longhi, 1952a; Meiss, 1952; Pope-Hennessy, 1952a; Salmi, 1952; Hartt, 1959; Berti, 1961 and 1964; Berenson, 1963; Bologna, 1966; Parronchi, 1966) have given it to Masaccio. Procacci once (1951) thought it might have been begun by Masaccio and completed by Masolino. Later, according to Davies (1961), he came to feel that it may have been designed by Masaccio but was painted by an anonymous artist. Brandi (1957) too has seen the intervention of an unknown hand after Masaccio left the panel unfinished. Middeldorf (1962) has given the work to an artist related to Fra Angelico—he has compared the heads of the saints with those of the Linaiuoli Tabernacle—and to Domenico Veneziano—specifically in the foreshortened foot of the Baptist and the flowers on the ground. The panel has been attributed to Domenico Veneziano by Gioseffi (1962), to which Meiss (1964b) responded that "while the intervention of the young Domenico, especially in the head of St. Jerome, is an intriguing hypothesis, he certainly did not design the panel nor initiate the execution."

Parronchi (1964, p. 331, n. 1, and 1966), Hartt (1959), and Meiss (1952) argued that Masaccio painted the panel in Florence in 1422–23. Martini (1965) and Bologna (1966) have dated it 1425; Clark (1951a) and Longhi (1952a) 1425–26; and Salmi (1952) and Berti (1961 and 1964) 1428.

Procacci (1953) has the S. Maria Maggiore altarpiece could not have been painted before 1428. After a searching examination of the panels that have survived, Meiss (1964b) concluded that following a change in the program of the altarpiece Masaccio began the London *Jerome and Baptist* in 1428, that he left it unfinished at his death, and that it was continued, though not brought to final completion, by another artist, conceivably Domenico Veneziano. Gioseffi (1962) assigns the design and execution of the panel to ca. 1431–32, and Middeldorf (1962) to ca. 1435.

My own view of the picture can be stated most briefly in the form of five hypotheses: (1) The work was conceived and designed by Masaccio. Little need be said in defense of this point, on which all scholars except Davies, Gioseffi, and Middeldorf are in agreement. That the Baptist's leg and foreshortened foot, which Middeldorf has related to the left leg and foot of the Baptist in the St. Lucy altarpiece, were designed by Masaccio can be established by a comparison with the right leg and foot of the publican at the right side of the *Tribute Money*.

(2) No part of the present painted surface of the panel was executed by Masaccio. The miniaturistic facture of the execution, the meticulousness in detail, and the extreme delicacy and precision in contours are irreconcilable with Masaccio's known style. Inconsistencies such as the deficient sense of volume in the left shoulder of St. Jerome and the weakness of articulation as well as of spatial definition in the passage around the left hand of the Baptist are equally foreign to Masaccio's known habits of constructing form.

(3) No part of the picture's execution is by Domenico Veneziano. Nowhere does it show Domenico's mobile style of drawing or modeling. A comparison of the heads of St. Jerome and of St. Zenobius in the St. Lucy Altar, which Gioseffi cites in support of his attribution of the panel to Domenico, makes this quite clear. St. Jerome's head is divided into few planes and consists of regular geometric units. The head of Domenico's St. Zenobius is composed of fluctuating facets whose interplay produces an effect of animation throughout the face. No passage of the London panel shows the pictorial fabric of Domenico's works, in which form is built up by means of visibly active, crescent-shaped brushstrokes.

(4) The panel was executed by an artist of the first rank who followed Masaccio's design with remarkable empathy and a large measure of success, although, as Meiss observed, he did not entirely complete it. I would like to pursue the suggestion of Middeldorf (1962) and Davies (1961) that he may have been Fra Angelico. Davies has noted that the picture is "in some respects . . . close to Fra Angelico's *Deposition* from S. Trinita; execution of any part by Fra Angelico, nevertheless, seems most difficult to conceive." And yet much can be said in favor of this thesis. The vermilion of the mantle of St. Jerome and the pink of the Baptist's are applied in broad, luminous, evenly textured masses, as is Fra Angelico's wont. Characteristic of Fra Angelico are the blue bands and the blue edge of the book in St. Jerome's right hand. The chapel in St. Jerome's other hand, which according to Davies "may reasonably be thought suggestive of Masaccio," could, on the contrary, belong to the town in the background of Fra Angelico's S. Trinita *Deposition*. For the spire of the chapel there are two particularly close analogies in the background of the predella panel of *St. Nicholas Saving Innocent Victims from Execution* from Fra Angelico's Perugia altarpiece (Pl. 193). The setting of St. Jerome's right eye and the folds surrounding it and in the forehead are rendered as they are in the head of the Perugia Altar's St. Nicholas (Pl. 194). Moreover, the two figures have the same crisply detailed patterns of white drapery under their mantles, and similarly foreshortened hands. The undulating, sharp-edged drapery formations falling from the arms of the London Baptist have a similar

cadence as the folds falling from the left arm of the Baptist in the Perugia altarpiece; and the foreshortened right foot of the Perugia Baptist invites comparison with the remarkable foreshortened foot of the Baptist in the London panel. Finally, the main panel of the Perugia altarpiece and the two saints from S. Maria Maggiore are executed in the same detailed, gleaming, miniaturistic mode.[1]

(5) The work was painted in Florence between Masaccio's departure for Rome in 1428 and the death of Martin V in 1431. Its execution in Rome, and, consequently, the production of the altarpiece as a whole in the Eternal City is, contrary to Procacci (1953) and Davies (1961), unlikely. Stylistically the panel seems to me to be far less closely related to any of the artists to whom, following Masaccio's death, it might have been entrusted in Rome—Masolino, Pisanello, Paolo Uccello, or Domenico Veneziano—than to Fra Angelico. Fra Angelico's previously recognized most Masaccesque works are the S. Pietro Martire polyptych of 1428–29 and the altarpiece for S. Domenico at Fiesole, which I regard as slightly later. However, neither shows anything like the similarities to the London panel, or to the related Liechtenstein *Baptist* (see n. 1), as do Fra Angelico's Perugia altarpiece of 1437 and his *Deposition* from S. Trinita, which has been dated from the mid-1420s to the mid-1440s, with strong arguments for the early 1430s prior to 1434 (Orlandi, 1964). The thesis of Fra Angelico's intervention in the S. Maria Maggiore altarpiece would lend support to Orlandi's date, and would further help to account for the series of Masaccesque heads that begins in the S. Trinita *Deposition* and is continued in the St. John the Evangelist of the Linaiuoli Altar (1433–36), the St. Dominic in the *Lamentation* from S. Maria della Croce al Tempio of 1436, and the Perugia Altar's St. Nicholas. In short, my solution to the problem of the London *Sts. Jerome and John the Baptist* is that it was painted by Fra Angelico, following Masaccio's design, after the S. Pietro Martire and Fiesole altarpieces but before the S. Trinita *Deposition,* and that together with the Liechtenstein *Baptist* it marks a shift in Fra Angelico's assimilation of Masaccio from what it had been in the paintings for S. Pietro Martire and S. Domenico in Fiesole to what it was to become in works of the 1430s.

NOTE

1. The head and neck of the London Baptist have a remarkable parallel in a panel with a full-length figure of *St. John the Baptist* formerly in the Liechtenstein Collection and now in the storerooms of the Kunsthistorisches Museum at Vienna (Pl. 195). The Liechtenstein picture is less fully realized three-dimensionally and cruder in execution. But the resemblance in the heads is so compelling that either the Liechtenstein Baptist may have been copied from the London panel or both may have a common source, possibly the lost Baptist in Masaccio's Pisa altarpiece (which Davies, 1961, suggests as a source for the head of the London St. John). The Liechtenstein *Baptist* also shows a number of similarities to the St. John in Fra Angelico's Perugia altarpiece, most notably in his foreshortened feet.

32. *The Rape of Helen,* ca. 1450 (Pl. 196).

Tempera on panel, 51 × 61 cm (octagonal).

London, National Gallery, no. 591.

According to Dares Phrygius, Helen was taken by Paris from the Temple of Apollo and Artemis at Halaca in Cythera, and other women were taken with her. In the picture four women—one partly hidden behind the nearest pier with engaged pilasters—are being abducted. The maiden in the center of the composition, because of her prominence—the vanishing point of the perspective system lies just above her right eye—and the opulence of her costume, is evidently Helen. Paris would seem to be the figure in armor at the lower left.

In the early nineteenth century the picture was in the collection of the Marchese Albergotti in Arezzo. It then entered the Lombardi-Baldi Collection in Florence and was bought for the National Gallery in 1857. The panel is in good condition. It has been cleaned and retouched, especially along the edges. Davies (1961) has suggested that it may originally have been part of the painted decoration of a *cassone*.

The painting has been ascribed to Gentile da Fabriano (*Catalogue,* 1845, no. 48) and Giovanni Boccati (see Davies, 1961); but its most common attribution is to the early phase of Benozzo Gozzoli, when he was under the influence of Fra Angelico (Burckhardt, 1898, p. 312; Schubring, 1915, no. 280; Holmes, 1923; Van Marle, X; Volpe, 1956; Berenson, 1963; Keller, 1967, p. 144; Gilbert, 1971, p. 48, n. 33). It has also been given to Gentile da Fabriano the atelier of Fra Angelico (Davies, 1961; Levey, 1967, p. 213) and to his pupils Zanobi Strozzi (Collobi-Ragghianti, 1950) and Domenico di-Michelino (Berenson, 1903, I, p. 58). It was first connected with Domenico Veneziano by Berenson (1938, I, p. 88, n. 2) and was attributed to Domenico by Coletti (1953a), who thought it his first work after his arrival—according to Coletti in 1439— in Florence from Venice. This attribution has been rightly rejected without comment by Zeri (1961).

The work is clearly reminiscent of Fra Angelico—Fra Angelico "ins weltliche gegangen," as Burckhardt remarked—and Gozzoli. Yet it is difficult to assign it to a known artist of the time. Though it is stylistically related to the *Madonna and Child with Nine Angels* also in the National Gallery in London (see catalogue no. 30), it could hardly have been executed by the same hand.

33. *The Twelve Labors of the Months,* ca. 1455–60 (Pl. 197).

Glazed terra-cotta, 57 cm in diameter each.

London, Victoria and Albert Museum.

The tondi are believed to have been part of the ceiling decoration of the studio of Piero de' Medici in the Medici Palace in Florence mentioned by Filarete (1965, II, fol. 190r), who described them as "vetriamenti fatti a figure degnissime," and Vasari, who referred to them as "cose di terra colorita . . . con varie fantasie." They entered the Victoria and Albert Museum in 1861, and their reconstruction is due to Robinson (1862) and Lethaby (1906). The Medici Palace was begun in or just before 1444 and was finished by or before 1457 (see Hyman, 1968). Whether the tondi were installed before or after the completion of the building is not known.

They were not mentioned in a description of the Medici Palace on the occasion of the visit to Florence of Galeazzo Maria Sforza in April 1459 (see Hatfield, 1970).

The traditional attribution of the tondi to Luca della Robbia has been sustained by Planiscig (1948), Longhi (1952), and Pope-Hennessy (1964 and 1969a). It has been questioned by Marquand (1914); Salmi, who in 1936, 1938, and 1954 proposed a *cassone* painter working in the manner of Domenico Veneziano, and in 1973 gave the tondi to Domenico himself; and Wackernagel (1938, p. 153), who thought them by Domenico's "school." The chief difficulty in assigning the tondi to Luca della Robbia is the absence of comparative material within Luca's oeuvre. However, their attribution to Domenico Veneziano does little to solve the problem of their authorship. Salmi's contention (1973) that "their closeness to the predella of the St. Lucy altarpiece shows . . . clearly" that they were drawn by Domenico does not stand up to inspection. Furthermore, the drawings in which he has seen the influence of Domenico (Berenson, 1938, II, nos. 2773, 2774, 2776, 2777, 2778, and 2779F) and which he earlier (1936, 1938, and 1954) gave to the same hand as the tondi have, as Pope-Hennessy (1964) has pointed out, only superficial relationships to the latter and hardly any at all to Domenico Veneziano.

In the absence of firm conclusions I should like to offer four observations: (1) the tondi were in place by the time Filarete was writing his *Treatise on Architecture*, probably ca. 1461–62. (2) The drawings on the tondi are by more than one hand. (3) The poses of the figures were very likely taken from model books. (4) There is no reason why the drawings on the tondi should not have been made in the atelier of Luca della Robbia, one of the most versatile in fifteenth-century Florence, perhaps in part by Luca himself. The patterning of the folds in many of the figures is not inconsistent either in shape or in rhythm with the style of Luca's terra-cotta reliefs.

34. *A Kneeling Monk,* last quarter of the fifteenth century.

Tempera on panel, 69 × 44 cm.

Lugano, Galleria Thyssen, no. 120.

The saint has been identified as Francis or Dominic (Van Marle, 1930), Philip Benizius (Heinemann, 1937; *Sammlung Schloss Rohoncz,* 1959) and John Gualbertus (Suida, 1930a). I know the painting only in photographs. According to Pudelko (1934) and Salmi (1936), it has been extensively restored. The cross in the saint's left hand is not original.

The panel was attributed to Domenico Veneziano at the time of the exhibition of the Thyssen Collection in Munich (Neue Pinakothek, 1930; Suida, 1930a; Van Marle, 1930 and 1931) and is listed under Domenico's name in the Thyssen catalogues (Heinemann, 1937; *Sammlung Schloss Rohoncz,* 1959). This designation has been endorsed with reservations by Berenson (1932 and 1963) and Salmi (1936 and 1938). Pudelko (1934) gave the picture to a central Italian painter of the end of the quattrocento, whom Longhi (1952) identified as Cola dell' Amatrice,

and Zeri (1948) as Ludovico Urbani. Zeri has shown that the Thyssen panel was originally part of the same triptych by Urbani as a *Madonna and Child* in the museum at Nevers and a *St. Francis* in the cathedral of Recanati.

35. *St. Francis,* third quarter of the fifteenth century (Pl. 198).

Tempera on panel, 126 × 45 cm.

Milan, Brivio Collection.

The panel was acquired for the Brivio Collection after World War II from the Florentine dealer Luigi Bellini. It has been cleaned and restored and is in good condition except for an inpainted area on the upper right which includes part of the saint's head and habit. The attribution to Domenico Veneziano is by Caviggioli (1954). Fiocco (1955) has given the panel to Nicola di Antonio. Zeri (1953) recognized that it belongs to the same altarpiece as a *St. Peter* in the Brera (see Modigliani, 1950, no. 822) by the Master of the Barberini Panels, whom he later (1961) identified as Giovanni Angelo di Antonio da Camerino.

36. Franciscan Diptych, middle of the fifteenth century (Pls. 199–200).

The Marriage of St. Francis and Lady Poverty.
The Imposition on a Franciscan Friar of the Yoke of Poverty.

Tempera on panel, each panel 28 × 18 cm.

Munich, Alte Pinakothek, nos. 650 and 651.

The diptych was acquired for the Alte Pinakothek in Rome in 1808. It was shown in 1954 at the *Mostra di quattro maestri del primo rinascimento* in Florence. In spite of a number of repairs in the gilding and the figures, the panels are in good condition. Venturi (1904a) believed that the diptych was a nineteenth-century forgery. But in view of the fact that the panels entered the Alte Pinakothek in 1808 this is hardly possible.

According to Popham and Pouncey (1950), the figure imposing the yoke is "perhaps Giovanni Capistrano." Ragghianti (1940) has suggested that the diptych originally belonged together with panels of *Two Flagellants* in the Musée Bonnat at Bayonne and the Musée Condé at Chantilly, and that all four are the remains of a reliquary cupboard like the one decorated by Vecchietta for the sacristy in the Spedale della Scala in Siena.

When the diptych was first catalogued it was given to Antonio Pollaiuolo (von Dillis, 1838). Cavalcaselle (1864, II, p. 397, and 1911, p. 256) saw in it "a mixture of the styles noticeable in

the works of the school of Botticelli and Domenico Ghirlandaio.'' Morelli (1880, p. 128) thought it Umbrian, Berenson (1897 and 1932) proposed Benedetto Bonfigli, Thode (1909) a pupil of Fra Filippo Lippi, the 1904 *Katalog der älteren Pinakothek* a Florentine artist close to Niccolò da Foligno, and Schmarsow (1912) Bonfigli under the influence of Domenico Veneziano. The attribution to Domenico is Longhi's (1952). It was accepted with reservations in the subsequent Munich catalogue (*Kurzes Verzeichnis*, 1957), and seconded by Zeri (1961) and Bacci (1965). Salmi (1954) and Hartt (1959) have rightly rejected it. The panels are surely Sienese. Ragghianti (1940) and Weller (1943) have been close to the mark in assigning them to Francesco di Giorgio. Pope-Hennessy (1953), Popham and Pouncey (1950), and Degenhart and Schmitt (1969, II, p. 325) have perhaps been closer still in giving them to Vecchietta. The style of the figures and the pattern of the punchwork are certain evidence that the diptych is Sienese of the middle of the quattrocento. Its format, tacky modeling, inelegant breaking of shapes, and vivid expression and pantomime suggest Vecchietta, or at least his atelier, rather than Francesco di Giorgio.

A drawing of the figures of the *Marriage* is in the British Museum (Degenhart and Schmitt, 1969, no. 249), one of the figures of the *Imposition* is in the Kupferstichkabinett in Berlin (Degenhart and Schmitt, 1969, no. 250), and another drawing of the *Imposition* is in the Goldman Collection in New York (Degenhart and Schmitt, 1969, no. 251). The British Museum recently acquired a drawing of the *Two Flagellants* in Bayonne (Degenhart and Schmitt, 1969, no. 252). Finally, a drawing clearly belonging to the same series, of a *Franciscan Saint Blessing a Young Monk*, is in the collection of Peter W. Josten in New York (van Schaak, 1962, p. 69, Pl. I). All but the last are given by Degenhart and Schmitt to an Umbro-Sienese draftsman of the third quarter of the fifteenth century. The drawing of the *Marriage* was once given by Degenhart (1937a, p. 258) to Lorenzo Sanseverino the Younger. Popham and Pouncey have given it to Vecchietta. Ragghianti has ascribed both the British Museum and Berlin drawings to Francesco di Giorgio. The Josten drawing, which has not previously been connected with the other four in the series, currently bears an attribution to Davide Ghirlandaio.

Discussion of the drawings of the *Marriage,* the *Imposition* and the *Two Flagellants* has assumed that they are by the same hand as the corresponding panels in Munich and Bayonne. This seems very doubtful. What appears in the paintings as spontaneous, in the drawings looks studied, as if it were an attempt to improve on the more rapid execution of the brush. The proportions of the figures in the drawings are slimmer, and their expressions and pantomime are more stilted than in the paintings. The figures in the Munich diptych are shadowless, while in the drawings of both the *Marriage* and the *Imposition* they have been supplied with cast shadows. All of these points strongly suggest that the drawings were done after the paintings. When, by whom, and for what purpose are questions beyond the scope of the present inquiry.

37. *The Triumph of Fame,* 1449 (Pls. 201–202).

Tempera on panel, 61 cm in diameter.

New York, New York Historical Society, Bryan Collection, no. B–5.

The back of the panel shows the arms of the Tornabuoni (two feathers), of the Medici (eight *palle*), and of Lorenzo the Magnificent (a diamond ring, three feathers, and the motto *sempre*). From this grouping of emblems Warburg (1932, I, p. 82) concluded that the tondo was painted for the occasion of the birth of Lorenzo on January 1, 1449, and identified it with the "desco tondo da parto dipintovi il trionfo della fama" listed in the Medici Inventory (Müntz, 1888, p. 63).

The work is in excellent condition. Before it entered the Bryan Collection (which became part of the New York Historical Society in 1864) it was in the collection of Artaud de Montor in Paris with an attribution to Giotto (Artaud de Montor, 1843). The New York Historical Society *Catalogue of the Gallery of Art* (1915) described it as *Knights at a Tournament* and listed it as Italian school. Müntz (1889, p. 229) and Warburg called it Florentine. When Berenson first knew the picture he attributed it (1896a and 1897) to Piero della Francesca, but later (1932, 1932b and 1963) gave its design to Domenico Veneziano and its execution to Francesco d'Antonio Banchi. Einstein and Monod (1905) ascribed it to the "manière de Piero della Francesca." Rankin (1907 and 1907a); Hutton (in Cavalcaselle, 1909, p. 318); Schubring (1915, no. 212), Van Marle (X), who referred to the painting as a *Triumph of Love,* Venturi (1933); and Kennedy (1938) assigned it to Domenico's atelier. Mather (1920 and 1923) thought it might have been done by Alesso Baldovinetti. Degenhart (1959) has given it without reservations to Domenico Veneziano himself.

The artist responsible for the tondo, as Longhi (1927, p. 144) was the first to recognize, is the author of an altarpiece in the museum at Fucecchio (no. 42) and of the *cassone* of the *Adimari Wedding* in the Academy at Florence, whom Berenson called Francesco d'Antonio Banchi, and whose works are listed in Berenson (1932 and 1963), Pudelko (1934), and Longhi (1940). Bellosi (in *Mostra d'arte sacra della diocesi di San Miniato,* 1969) has discovered that he was the brother of Masaccio, Giovanni di Ser Giovanni, known as Scheggia (or Scheggione). Longhi's attribution has been endorsed by Salmi (1936 and 1938), Ragghianti-Collobi (1949), and Fredericksen and Zeri (1972). Pudelko (1934) accepted it with the observation that the Bryan tondo is superior in quality to this artist's average production and that it might have been painted in the atelier of Domenico Veneziano. As Offner (1920) has pointed out, however, it is no more likely that the work should be related to Domenico Veneziano than to Piero della Francesca or Paolo Uccello—or indeed to Pesellino, Fra Angelico, or Apollonio di Giovanni, to all of whom the tradition of picture making which the tondo represents was equally available. If the tondo was painted for the birth of Lorenzo the Magnificent, the importance of the commission might have elicited a particularly brilliant performance from a generally prosaic artist. (For further reference to the panel, see Comstock, 1926.)

38. *The Crucifixion,* ca. 1450.

Tempera on panel, 41 × 29.5 cm.

New York, Metropolitan Museum of Art, no. 19.87.

The work was acquired by the Metropolitan Museum from Langton Douglas in 1919. It has been extensively restored, as well as cut at the top and fitted into a larger panel. Wehle (1940) thought that it was originally "a pinnacle of an altarpiece or the central section of a small triptych." The attribution to Domenico Veneziano is Berenson's (1932 and 1963—in the latter with a question mark). Burroughs (1919) and Van Marle (X) gave the picture to Pesellino. Wehle (1940) felt that it "is possibly by Pesellino but cannot be surely assigned to any one painter," and cited attributions to Pesellino by Longhi and Mason-Perkins, and to Domenico di Michelino by Offner. Offner's designation has been endorsed by Pudelko (1934) and Salmi (1935, 1936, and 1938), who have convincingly associated the panel with a small triptych by Domenico di Michelino in the museum at Chambéry, and by Zeri (1971), who has noted that the figures and the landscape combine stylistic features derived from Fra Angelico and Pesellino, and that the work probably belongs to a relatively early period of Domenico di Michelino's career.

39. *The Coronation of the Virgin* (the predella and the foreground of the main panel), ca. 1434–35.

Tempera on panel, the main panel 213 × 211 cm, the predella 23 × 211 cm.

Paris, Musée du Louvre.

The altarpiece was painted by Fra Angelico and his atelier for S. Domenico in Fiesole. Pope-Hennessy (1951 and 1952) suggested that Domenico Veneziano was commissioned to paint the predella and the foreground of the main panel in response to his appeal for employment to Piero de' Medici in his letter of April 1, 1438 (document 1). According to the *Cronaca* of S. Domenico, however, the altarpiece seems to have been completed by the time of the consecration of the church in 1435 (see Orlandi, 1964). It was seen *in situ* and highly praised by Vasari. The main panel was taken to Paris by Napoleon in 1812, and the predella was acquired for the Louvre in 1830. The work was cleaned in 1934 and is in good condition. There is some question whether the present shape of the main panel is original.

A panel of the *Raising of Napoleon Orsini* closely resembling the composition of this subject in the third predella panel from the left was given by Örtel (1950) to the Master of the Griggs Crucifixion, but was later proven by Wolters (1953) to be a forgery. A drawing after the three figures on the left side of the *Disputation of St. Dominic* is in the Gabinetto dei Disegni at the Uffizi (no. 104-E; Berenson, 1938, no. 173-A).

Special attention was first drawn to the altarpiece by Glaser (1939) and Longhi (1940), who departed from earlier critical opinion and considered it as the major achievement of Fra Angelico's early style, a thesis which Longhi subsequently (1952) reaffirmed. Pope-Hennessy's attribution was endorsed by Coletti (1953a) and apparently also by Paccagnini (1952). It has been rejected by Robertson (1954), Volpe (1956), White (1957, p. 187, n. 3), Hartt (1959), Zeri (1961), Meiss (1963), and Baldini (in Morante and Baldini, 1970). Pope-Hennessy himself abandoned it in the second edition of his monograph on Fra Angelico (1974), arguing

instead that the main panel of the altarpiece is all by Fra Angelico, that the work was not begun until after 1450, that the low viewing point in the main panel may show the influence of the St. Lucy Altar, and that the predella is by a second hand.

40. *Madonna and Child,* third quarter of the fifteenth century.

Tempera on panel, 81 × 52 cm.

Paris, Musée du Louvre, no. 1661A.

The panel entered the Louvre in 1889 as the bequest of Baron Nathaniel de Rothschild, who had acquired it from the collection of Lord Northwick. It is in good condition. Guiffrey (1901) gave it to a pupil of Domenico Veneziano close to Baldovinetti, a designation taken up by Van Marle (X), who also saw in it the possible influence of Verrocchio. It was attributed to Domenico himself by Schmarsow (1912). De Ricci (1913) listed it as Florentine school. Berenson (1913, p. 17) correctly grouped it with a number of other works whose author he was the first to call the Master of the Castello Nativity (see also Berenson, 1932 and 1963; Siren, 1925; Pudelko, 1934; Salmi, 1936, 1938, and 1938a; Kennedy, 1938, n. 34).

41. *Madonna of Humility,* ca. 1430–35 (Pls. 203–204).

Tempera on panel, without the frame 102 × 58 cm, with the frame 175 × 72 cm, the tondo of *Christ Blessing* 17 cm in diameter.

Pisa, Museo di San Matteo.

An inscription on the back of the panel states that the work was donated in 1791 by the Alessandri family to the parish church at Cedri, near Pisa. It was discovered there after World War II by Piero Sanpaolesi. When I saw the picture in 1979 it had not been cleaned or restored. The surface was impregnated with a film of dirt, and the paint layer, especially in the mantle of the Madonna, was flaking. A number of holes had been filled with gesso plugs.

The work was published and given to Domenico Veneziano by Paccagnini (1952). Pope-Hennessy (1953) commended Paccagnini for the "great restraint and skill" with which he argued his attribution. Zeri (1961) has rejected it without comment. Longhi (1952) assigned the Cedri panel to an anonymous master of about 1433 influenced by Masolino and Fra Angelico. Later, according to Berti (1961), he proposed an artist, perhaps Portuguese, close to the

Master of the Chiostro degli Aranci to whom he also ascribed two panels, each depicting *Two Saints,* in the Musée Calvet at Avignon (nos. 556 and 557). The Avignon panels are restored to a degree, however, that makes their attribution very chancy.

Paccagnini interpreted the Cedri *Madonna* as a progressive work of about 1430. While it was probably painted in the early 1430s, it is, rather, a provincial picture of great refinement, combining a Gothic image of the Madonna of Humility with advanced Florentine influences emanating from Fra Angelico. The relationship to the latter is strongest in the Child, whose posture and hairstyle derive from the Frate's *Madonna of Humility* in the Galleria Sabauda at Turin, painted prior to 1435, the date inscribed on a copy of it by Andrea di Giusto at I Tatti (see Russoli, 1962). But the facial type of the Virgin, the shape of her features, and the Child's foreshortened crossed halo also link the Cedri panel to Fra Angelico's *Madonna and Saints* for the high altar of S. Domenico in Fiesole. It is hardly possible that the Pisa *Madonna* was indebted to Domenico Veneziano even in those respects which led Paccagnini to attribute it to him: its color, the oval stereometry of the Virgin's head, the columnar shaft of her neck, the crescent-shaped fall of her mantle, or the adjustment of spatial and decorative purposes in a compositional scheme of interlocking loops. These elements belong partly to the repertory of late Gothic painting and partly to that of Fra Angelico. The Cedri panel commands attention for the formal purity and elegance with which it brings these elements together.

42. *St. Jerome and Other Fragments,* ca. 1475–80 (Pls. 205–206).

Fresco transferred to masonite, 441 × 235 cm.

Pistoia, S. Domenico.

The work was detached and transferred to masonite during the 1950s. It was shown at the *II Mostra di affreschi staccati* in Florence (1958), and at the exhibitions *The Great Age of Fresco* in New York (1968) and *Frescoes from Florence* in London (1969).

The St. Jerome was related by Procacci (1932a) to a lost prototype by Antonio Pollaiuolo as well as to the St. Jerome by Castagno in the SS. Annunziata (Pl. 158), the Pitti *Bust of St. Jerome* (catalogue no. 24, Pl. 183), Botticelli's *St. Augustine* at Ognissanti, and to the figures of St. Jerome in the *Crucifixion* at Argiano (see catalogue no. 24) and in the altarpiece by Piero Pollaiuolo at San Gimignano. To this list should be added Domenico Veneziano's Baptist at S. Croce. Berenson (1936), Hind (1938), and Ortolani (1948) gave the Pistoia St. Jerome to Antonio Pollaiuolo. Baldini (in *II Mostra di affreschi staccati,* 1958) sees it as Verrochiesque and has reported attributions by Brandi and Martini to Bartolomeo della Gatta, an artist who, as a comparison of the heads of his *St. Roch* from S. Domenico in Cortona (Pl. 149; see *II Mostra di affreschi staccati,* 1958) and of the Baptist from S. Croce (Pl. 148) shows, was no less influenced by Domenico Veneziano than he was by Piero della Francesca and Antonio Pollaiuolo, and to whom the Pistoia *St. Jerome* was subsequently given by Martini himself (1960). In *The Great Age of Fresco* (1968) Baldini interpreted the work as "connected . . .

with the career of Domenico Veneziano" and as "characteristic" of him in "the clarity of the atmosphere, the treatment of the open sky, the monumentality of the figure which recalls Piero della Francesca, the architecture which is more like Alberti than Brunelleschi, and, most importantly, the very high quality of the fresco." In *Frescoes from Florence* (1969) Baldini wrote that the mural "could be reconciled, albeit hypothetically, with an attribution to Domenico Veneziano" (p. 154).

It is hardly possible, however, that Domenico could have had a hand in it. The head of the saint, for example, executed almost entirely *a secco*, shows the kind of harsh, complex elaboration of lighting, texture, and relief typical of the altarpieces at Argiano and San Gimignano. The position of the Pistoia fragment in the development of quattrocento painting has perhaps been plotted most accurately by Passavant (1969a), who has given it to a non-Florentine follower of Piero della Francesca coming to terms in the late 1470s with the art of Verrocchio and Pollaiuolo.

43. Murals in the Cappella dell'Assunta in the Duomo at Prato, ca. 1445–47 (Pl. 107).

The Birth of the Virgin, 302 × 361 cm.
The Presentation of the Virgin in the Temple, 335 × 402 cm.
The Disputation of St. Stephen, 300 × 360 cm.
Faith, Hope, Charity, and *Fortitude*, each 170 × 340 cm.
Sts. Paul, Jerome, Francis and Dominic, each 120 × 46 cm.
The Beato Jacopone da Todi, 181 × 59 cm.

Twelve decorative medallions with heads in the borders of the narrative compositions, each 26 cm in diameter.

With the exception of the *Jacopone da Todi*, which was transferred to canvas and taken to the Museo dell'Opera del Duomo at Prato in the late nineteenth century, the frescoes and their *sinopie* were detached and transferred to polyester between 1965 and 1968 (see Marchini, 1969). No *sinopie* were found for the figure of *Charity*, the *Presentation of the Virgin*, and the medallions. The *Birth* was shown at the exhibitions *The Great Age of Fresco* in New York (1968) and *Frescoes from Florence* in London (1969).

The mural decoration of the Cappella dell'Assunta includes in addition to the works listed here *The Marriage of the Virgin, The Stoning of St. Stephen*, and *The Finding of the Body of St. Stephen* by Andrea di Giusto (see Siren, 1904). The *Marriage* and the *Finding* occupy the lowest of the three zones on the lateral walls, and were thus the last compositions to be painted. Andrea died in 1450, and the frescoes in the chapel were probably finished in 1447. In that year the canons of the Duomo of Prato noted that two stained-glass windows which the rector (*praepositus*) had removed from the Cappella dell'Assunta in 1445 had not yet been put back (see Baldanzi, 1846, p. 47, n. 1). Kennedy (1938, n. 42) suggested that the removal of the

windows might have been a precaution against possible damage resulting from the erection of a scaffolding for the execution of the murals, and that these may therefore have been begun in 1445. Taking out the windows would also have let more light into the chapel, and for that reason too I think it likely that the rector's order to remove the windows and the beginning of the fresco decoration are connected. It seems improbable that the canons would have made a point of the windows still being missing before the murals had been concluded. The fact that they did so in 1447 suggests that the frescoes were finished by that year.[1]

During the nineteenth century the murals were attributed to a quattrocento "Giottesque painter" (Baldanzi, 1846), to Niccolò di Pietro and Lorenzo di Niccolò Gerini (Mazzei, 1880, II, p. 410), and to Starnina (Cavalcaselle, 1903, pp. 293ff.). Shortly before the turn of the century Schmarsow (1893) devoted a remarkable article to the thesis that they were by Domenico Veneziano, a view he reaffirmed in 1912. Although Schmarsow's attribution was accepted in full only by Witting (1910), it generated considerable interest in the previously neglected frescoes. Bode (1897) gave them to "einem der Richtung Domenico Venezianos nahestehenden Künstler," Escher (1922, pp. 78f.) and Wackernagel (1938, p. 121) assigned them to a follower of Domenico, and Siren (1904) to a follower of Domenico and Pesellino. During the time that the attribution of the murals was connected with Domenico Veneziano— the last scholar to do so was Wackernagel (1938)—Toesca (1908, pp. 17f.) ascribed them to "un seguace dei grandi maestri fiorentini del principio del quattrocento," Testi (1916, p. 432) called them "grossolani e debolissimi" productions of a provincial Florentine artist, and Lindberg (1931, p. 111) related them to the frescoes in the Baptistry at Castiglione d'Olona. Longhi (1928) gave them to Giovanni di Francesco but was supported in this only by Berenson (1932 and 1963) and Pope-Hennessy (1939, p. 118). A major shift in the interpretation of the frescoes occurred in the mid-1930s, when they were connected with Paolo Uccello. Giovannozzi (1934) assigned them to a "pittore vicino a Paolo Uccello," and Pudelko (1934) and Salmi (1934) gave them to a follower of Uccello whom Pudelko called the Master of the Karlsruhe *Adoration*, and Salmi the Master of the Quarata Predella. The attribution to the circle of Uccello was endorsed by Kennedy (1938, pp. 204f.) and Paatz (1940ff., II), and was reiterated in Salmi (1936 and 1938).

In his monograph on Uccello, Pope-Hennessy (1950 and 1969), no longer convinced of his earlier attribution to Giovanni di Francesco, has argued that the murals in the Cappella dell' Assunta and the works of Pudelko's Karlsruhe Master and of Salmi's Quarata Master are by a single painter, whom he has called the Prato Master. This designation was taken over by Shell (1961), though he excluded from the artist's oeuvre the pictures of the Karlsruhe Master and added to it a number of paintings attributed by the majority of modern scholars to the young Fra Filippo Lippi. From the late 1930s on the Prato frescoes have for the most part been given to Uccello himself (Ragghianti, 1938 and 1946; Longhi, 1940 and 1952; Carli, 1954; Volpe, 1956; Sindona, 1957; Gioseffi, 1958; Parronchi, 1964; Berti, 1961; del Poggetto in *The Great Age of Fresco*, 1968, and *Frescoes from Florence*, 1969; Boskovits, 1970). However, after prolonged study of the murals and the *sinopie* following their detachment and transfer I am unable to reconcile with the certain works of Uccello the style and technique of either the preparatory drawings (as Marchini, 1969, has also concluded) or the paintings. Cleaning has revealed that they were the production not of a single artist but a collaborative effort by painters connected with the atelier of Uccello, principally the Master of the Karlsruhe *Adoration* and the Master of the Quarata Predella.

CATALOGUE RAISONNÉ

Pudelko (1934) and Salmi (1938) have suggested that the Prato *Birth of the Virgin* reflects the lost composition of this subject by Domenico Veneziano at S. Egidio, and Salmi has proposed that the centralized building in the Prato *Disputation of St. Stephen* depends from the S. Egidio *Marriage of the Virgin*. The latter connection can be ruled out on the ground that the S. Egidio *Marriage* was not painted until 1461 (see catalogue no. 86). No objection stands in the way of relating the Prato and S. Egidio *Births*. But there is no evidence for what the two compositions might have had in common.

NOTE

1. They have been dated 1445–47 by Wackernagel (1938) and Longhi (1940 and 1952). Paatz (1940ff., II) has given them to 1445–46; Shell (1961) to ca. 1450; Ragghianti (1938 and 1946) to the 1430s; Carli (1954) to ca. 1438; Berti (1961a) to 1436–43; del Poggetto (in *The Great Age of Fresco*, 1968, and *Frescoes from Florence*, 1969), Boskovits (1970) and Tomasi (in Flaiano and Tomasi, 1971) to 1435–40.

44. *The Crucifixion* (the riders in the left middle ground), 1429–31 (Pls. 208–209).

Fresco transferred to canvas.

Rome, S. Clemente, Chapel of St. Catherine.

The *Crucifixion* (Pl. 52) and other frescoes in the chapel were painted by Masolino and his atelier between the end of 1429 and the beginning of 1431 on the commission of Cardinal Branda Castiglione, who until 1431 was titular cardinal of the basilica of S. Clemente (see Genthon, 1965). The work is in battered condition. Restorations of the sixteenth, eighteenth, and nineteenth centuries were partly removed by Mauro Pellicioli in 1939. In 1952 the Istituto Centrale di Restauro in Rome began a long-range effort to preserve the work and as far as possible to bring it back to its original appearance (see Urbani, 1955a). Extensive passages of a *sinopia* came to light when the fresco was detached. Both the mural and the *sinopia* were transferred to canvas and restored. Major losses were filled in with neutral tones. The fresco was then installed on its original wall.

Vasari gave the murals of the chapel to Masaccio, and this attribution has a number of adherents (Vitzthum, 1926; Örtel, 1933 and 1963; Wassermann, 1935, pp. 54f.). But since the later nineteenth century the great majority of scholars ascribed the frescoes to Masolino (see Volponi and Berti, 1968). Wickhoff (1889), who first proposed the authorship of Masolino, also recognized that the murals, especially the *Crucifixion,* show the influence of Pisanello (see also Spaventi, 1892, p. 26; Hill, 1905, p. 55). Instead of continuing to explore the promising subject of the relationship of the *Crucifixion* to Pisanello, scholars have tended to turn their attention to the less fruitful problem of its connection with Masaccio. Beenken (1932) believed that the

entire *Crucifixion* and one other mural in the chapel are by Masaccio, the rest by Masolino. Lindberg (1931, pp. 52 and 62) gave Masaccio the landscape and the figures of Christ and of the two thieves. Toesca (1934) saw Masaccio's hand in the centurion, Mary Magdalen, and several riders ("alcuni cavalieri"). An eloquent but unconvincing case for Masaccio's intervention in the landscape and the riders of the middle zone was made by Longhi (1940) and seconded by Lavagnino (1943). In the opinion of Procacci (1951) the most that Masaccio might have done is the foreshortened horseman at the right of the Magdalen. Berti (1964) has given the painting to Masolino but has ascribed the landscape and the horseman at the left in the *sinopia* to Masaccio. In Parronchi's view (1966), the landscape in the *sinopia* is by a hand other than Masolino's.

The name of Domenico Veneziano was introduced into the discussion of the chapel by Kennedy (1938, p. 9), who thought that Masolino might have employed Domenico as an assistant. Fiocco (1941, p. xxx) suggested a collaboration between the two artists. Finally, Brandi (1957) has argued that because the riders in the left middle ground of the *Crucifixion* (Pl. 208) reflect not a Tuscan but a late Gothic northern Italian tradition, they should be ascribed to Domenico Veneziano. This attribution has been rejected without comment by Zeri (1961) and has been discussed but not endorsed by Micheletti (1959) and Parronchi (1964, pp. 153ff.). Indeed, if the riders singled out by Brandi were the product of a hand other than Masolino's, it would be Pisanello's. The frontally foreshortened horsemen, the armor of the soldiers, and the multistoried hats of the riders at the left belong not to Masolino's but to Pisanello's repertory. It seems nevertheless unlikely that Pisanello actually executed these parts of the mural, and I see no reason of style why they should not have been painted by Masolino (Pl. 109).

45. *The Visitation* (upper part of the architecture), ca. 1451 (Pl. 210).

Mosaic, 450 × 320 cm.

Venice, S. Marco, Mascoli Chapel.

The *Visitation* is one of four architectural compositions of episodes from the life of the Virgin on the vault of the Mascoli Chapel commissioned, according to an inscription on the chapel's dado, by the procurators of St. Mark's in 1430. They are signed by Michele Giambono but show the intervention of artists schooled far more than Giambono in Renaissance classicism and perspective (for the organization of the workshop under the direction of Giambono, see Muraro, 1961). No documents record the names of these other artists, but since the late nineteenth century several names, principally Andrea del Castagno, Paolo Uccello, Andrea Mantegna, and Jacopo Bellini, have been suggested on the basis of stylistic arguments (see Pope-Hennessy, 1950 and 1969; Hartt, 1959). The mosaics were cleaned between 1959 and 1961.

It has never been questioned that the figures in the lower zone of the *Visitation* are by

Giambono. But it is unlikely that he also designed the upper part of the architecture, with its radically different character from the painted architecture in his mural of the *Annunciation* on the wall of the Serego Tomb in S. Anastasia at Verona, completed in 1432, a fine example of the northern Italian tradition of complex, late Gothic architectural settings with ornate pinnacles, arcades, windows, and terraces (see Arslan, 1948; da Lisca, 1944). This tradition lives on in the Mascoli *Birth* and *Presentation of the Virgin in the Temple.* For the *Visitation,* and for the *Death of the Virgin* as well, the procurators evidently wanted a more modern background— monumental in scale, classical rather than Gothic, and constructed according to linear perspective. At the same time, the woman looking down, the animals, and the household objects seen from below in the windows of the *Visitation* relate its architecture to a context of contemporary life.

In spite of all the visual evidence to the contrary, Testi (1916, pp. 50ff.), Van Marle (VII), Salmi (1936) and Hartt (1959) have not ruled out the possibility that the *Visitation* architecture was designed by Giambono. It has also been given to Michelozzo (Saccardo, 1896, pp. 33ff.), Paolo Uccello (Longhi, 1926 and 1940; Pudelko, 1934a; Volpe, 1956), Andrea del Castagno (Chastel, 1954), a follower of Squarcione (Paoletti, 1893, II, p. 198), unidentified artists working in the Florentine tradition (Pope-Hennessy, 1950 and 1969; Carli, 1954; Muraro, 1961), and to Domenico Veneziano (Coletti, 1953a). While it must be admitted that the pale, luminous tonalities of the mosaic have a certain similarity to the color of the St. Lucy altarpiece, it is inconceivable that Domenico could have had a part in its design. The cartoon for the *Visitation* architecture, as Merkel (1973) has convincingly shown, was drawn about 1451 by Jacopo Bellini (see also Thode, 1899; d'Ancona, 1899; Waldschmidt, 1900, p. 50; Venturi, 1907, p. 93; Fiocco, 1920 and 1927; Salmi, 1938). It shares a number of characteristics—the layout of the building, the cut of the perspective, luminous surfaces elaborated with sharply detailed patterns, classically inspired medallions, balconies, a window from which a figure is looking down, the patterning of vegetation—with the roughly contemporary setting of the *Martyrdom of St. Christopher* painted between 1449 and 1453 by Andrea Mantegna in the Ovetari Chapel at Padua (see Rigoni, 1927–28 and 1948; Tietze-Conrat, 1955; Camesasca, 1964). Both works stand at the beginning of a tradition of architectural settings, rooted in the drawings of Jacopo Bellini and in the influence in Padua of Donatello, which was to become one of the distinctive components of northern Italian painting, from Venice to Padua, Ferrara, and Milan, of the second half of the fifteenth century.

46. *St. John the Evangelist* (head and hands), 1442 (Pls. 12–14).

Fresco, the figure 176 cm high.

Venice, S. Zaccaria, Chapel of S. Tarasio.

CATALOGUE RAISONNÉ

The figure is part of the decoration of the vault of the apse of S. Tarasio signed by Andrea del Castagno and Francesco da Faenza in 1442. The frescoes were cleaned and restored in the 1950s. Muraro (1959 and 1960, pp. 81ff.) has distinguished seven *giornate* in the *St. John,* and separate sections of *intonaco* for the head and hands. According to Salmi (1958 and 1961, p. 61), Tintori recognized only five *giornate,* and assigned the head and hands to the same section of *intonaco.* My own observations, as well as those of Hartt (1959), agree with the reading of Muraro.

I cannot, however, concur with Muraro's attribution of the head and hands of the *St. John* to Domenico Veneziano. It has been accepted by Salmi (1958 and 1961) and Hartt (1959), commented on with approval by Bellosi (1967), and rejected by Zeri (1961) and Berti (1961 and 1963). Fiocco (1957) has given the *St. John* to Francesco da Faenza. One of the key points in Muraro's attribution is the similarity between the heads of the S. Tarasio *St. John* and the *Bearded Saint* from the Carnesecchi Tabernacle. But the resemblance is more a matter of type than of style. Castagno may well have used Domenico's figure as a source. The heads of both figures also adhere to a type in the repertory of Florentine painting of the time—as witness Masolino's heads of St. Matthew in the vault of the chapel of St. Catherine at S. Clemente and of Zacharias in the *Naming of the Baptist* in the Baptistry at Castiglione d'Olona (Pl. 16), or the head of St. Mark on one of the exterior wings of Fra Angelico's Linaiuoli altarpiece (Pl. 18).[1]

None of the heads of the seven figures on the vault of S. Tarasio, with the possible exception of St. Matthew's and God the Father's, can easily be assigned to the same hand as any of the others. The reasons for this stylistic diversity may be both the heterogeneity of the S. Tarasio workshop and the innovative nature of the program. The team that worked on the vault included, besides Andrea del Castagno and Francesco da Faenza, at least one identifiable assistant who painted most of the *sottarco* and later was responsible for the fresco from the Castello di Trebbio formerly in the Contini-Bonacossi Collection (see catalogue no. 3, n. 2). The unprecedented challenge of decorating the vault of S. Tarasio with sculpturally conceived, life-sized figures, eloquently described by Hartt (1959), demanded experimentation. The lack of uniformity among the murals may be partly the result of the adoption of solutions contributed by various members of the workshop as the program progressed.

I see no visual or other testimony that Domenico Veneziano had a role in these deliberations. The "impressionistic" touches of the brush in the head and hands of the *St. John* which Muraro interprets as evidence for Domenico's authorship are in fact alien to his style except in the landscape passages of the St. Lucy predella and the S. Croce fresco. Which member of the S. Tarasio atelier supplied these touches is difficult to say. We are on surer ground when it comes to St. John's hands (Pl. 14). In shaping, articulation, and composition, as is evident from a comparison with the hand of Castagno's *Portrait of a Man* in Washington (Pl. 15), they clearly reveal Andrea's style.

NOTE

1. The durability of the type is shown by its appearance in the figure of St. Anthony in Domenico Ghirlandaio's early fresco in the Pieve at Cercina (see Ragghianti, 1935).

47. *Crucifix with Donor,* third quarter of the fifteenth century.

Tempera on canvas, ca. 100 × ca. 60 cm.

Verona, Museo di Castelvecchio, no. 361.

The provenance of the work is not known. In an undated photograph by Villani (no. 13711) the landscape background appeared as completely repainted, the face and hands of the donor were altered by retouching, and the blood flowing from Christ's wound was partly painted out. The picture is now in its original form, and in good condition.

When Venturi (1904) first published the painting he thought that it represented "a not yet determined mode of the art of Domenico Veneziano, prior to his activity in Tuscany," and that its author was a Venetian contemporary of Domenico and imitator of Jacopo Bellini. Van Marle (X) reported that Venturi had attributed the picture to Domenico Veneziano himself. Yet it clearly has no connection with Domenico whatsoever. Fiocco (1927, pp. 159f.) related it to Fra Filippo Lippi and Ansuino da Forlì, and Avena (1937) gave it to Fra Filippo. Berenson (1932) assigned it to Francesco Bonsignori. The most reasonable attribution is Salmi's (1936 and 1938), who designated it as Veronese school of the second half—in my view more likely the third quarter—of the fifteenth century.

48. *Christ in the Tomb,* ca. 1450–60 (Pl. 211).

Tempera on panel, 21 × 35 cm.

Verona, Museo di Castelvecchio, no. 2148.

The panel entered the Verona museum with the bequest of Bartolomeo Monga. In spite of cracks, holes, flaking paint, and a brownish-yellow tonality resulting from dirt and varnish, the picture is in sound and legible condition. Van Marle (VII), who first published it, and Avena (1937 and 1947) gave it to Jacopo Bellini. The formation of both the figure and the landscape, however, is Florentine, as was recognized by Offner (1939), who correctly ascribed the panel to a follower of Fra Filippo Lippi. Longhi (1946) and Palluchini (1947) designated it as Tuscan. Coletti on one occasion (1947) assigned it to Fra Angelico, and on another (1953a) was inclined merely to place it near him ("accostarlo all'Angelico"). Both Semenzato (1954) and Volpe (1956) have attempted to reconcile what they feel as its mixture of Venetian and Florentine characteristics, the former by giving it to Domenico Veneziano prior to his arrival in Florence from Venice, and the latter by arguing that it belongs to the northern Italian phase of Fra Filippo Lippi. Berti (1961) has reaffirmed the thesis that the painting is Venetian, calling it "school of Jacopo Bellini and Antonio Vivarini, early 1440s." Semenzato's attribution to Domenico Veneziano has been rejected without comment by Zeri (1961). Marchini (1975)

[176]

agrees with Volpe that the panel is the "unico resto dell'attività del Lippi nel Veneto."

The work is related to three pictures from the atelier of Fra Filippo Lippi which have been associated with Lippi's pupil Fra Diamante: in its landscape with the *Obsequies of St. Jerome* at Prato and the *Three Saints* in the Fogg Art Museum; and in the pinched, timid relief of the figure with the Christ of the *Pietà with Sts. Francis and Jerome* in the Arcivescovado at Florence.

49. *Crucifixion with Two Saints,* ca. 1440–50.

Tempera on panel, 43 × 25.4 cm.[1]

Present location unknown.

The saints have been identified by Chiapelli (1924) as Louis of Toulouse and Benedict, and by Swarzenski (1926, no. 55) as Bernard and Peter of Castelnuovo. The panel was formerly in the Formilli Collection in Florence. In the 1920s it was in the collection of Ludwig von Gans at Oberursel, near Frankfurt-am-Main. I have found no record of it subsequent to the sale of the Gans Collection at Frankfurt-am-Main on May 7, 1929.

It was given to Domenico Veneziano by Chiapelli (1924), who proposed that it was originally the central compartment of the predella of the St. Lucy altarpiece. The attribution to Domenico was endorsed by Swarzenski (1926). Longhi (1925) placed it between Pesellino and Fra Filippo Lippi, Van Marle (X) ascribed it to the school of Pesellino, and Salmi (1936 and 1938) assigned it to a follower of Lippi. The picture is known to me only in a reproduction, from which its condition is not clearly legible. The work as a whole is curiously inconsistent. The figure of Christ, for example, is much more sculptural and realistic than the saints. An attribution seems hardly possible.

NOTE

1. These are the measurements given by Chiapelli (1924). Swarzenski (1926) listed the dimensions of the panel as 40.5 × 23.6 cm.

APOCRYPHAL WORKS: PORTRAITS

50. *Portrait of a Lady,* ca. 1465 (Pl. 212).

Tempera on poplar panel, 51 × 35 cm.

Berlin-Dahlem, Gemäldegalerie, no. 1614.

In the early nineteenth century the panel was in the Galerie Massias in Paris. It was then acquired by the Earl of Ashburnham, and entered the Kaiser Friedrich Museum in 1897. It has been cleaned and lightly restored, and is in good condition.

The picture was at one time thought to be by Cimabue (*Annales du musée,* 1815, p. 147). Shortly before the turn of the century it was given to Piero della Francesca (New Gallery, 1894, no. 116), an attribution endorsed by Cruttwell (1907, p. 178) and, with Baldovinetti as an alternative, by Cust (1928). Berenson (1896) and Clark (1930) ascribed it to Baldovinetti. Other attributions have for the most part been fairly evenly divided between Domenico Veneziano and Antonio Pollaiuolo.[1] Richter (1910, II, p. 432) assigned the panel to an anonymous Florentine painter and medalist. Constable (1930a), Fry (1930), Berenson (1932 and 1963) and Schottmüller (1932) have given it to Piero Pollaiuolo.

In spite of the insistence of German scholars that the painting is by Domenico Veneziano, it is not difficult to demonstrate the authorship of Antonio Pollaiuolo. Compared with Domenico's St. Lucy (Pl. 62), the contour of the Berlin *Lady*'s profile is brisker, more salient, and more independent in relation to the modeling of the head. It provides more information about the specific appearance of the chin, mouth, nose and ear, and about the setting of the eye. The relief of the head in the Berlin panel is shallower. In contrast to the modeling habits of Domenico Veneziano, the extremely light modeling in the portrait does not follow the rhythm and the shapes of the contours. The bust stands out sharply against Antonio's characteristic thinly painted, luminous sky, touched with streaks and puffs of clouds. His love for visually rich and complex textures is given play in the brocade dress and the balustrade (which recalls the railing in Antonio and Piero Pollaiuolo's altarpiece in the Chapel of the Cardinal of Portugal at S. Miniato al Monte), as it also is in the coiffure and hair ornament of the *Lady* in the Poldi-Pezzoli Museum at Milan (catalogue no. 58), whose style is congruent in every particular with that of the *Lady* in Berlin. That the two portraits are by the same hand is shown by their ears, whose identical formations have little in common with the regular oval shapes and loops of the ears of Domenico. In comparing the two paintings it should be kept in mind that the panel in Berlin has been restored. Nevertheless, the *Lady* in Milan seems more evolved, and is probably later. If the Berlin *Lady* can be assigned to ca. 1465, the picture in Milan could well have been painted ca. 1470–75.

NOTE

1. In favor of Domenico Veneziano are Bode (1897 and 1923, p. 41), Königliche Museen zu Berlin (1904, 1912, and 1931), Schmarsow (1912), Händke (1916), Longhi (1917), Escher (1922, p. 78), Van Marle (X), Royal Academy (1931), Holmes (1930), Böck (1934b), Biehn (1953), Stiftung preussischer Kulturbestiz (1963), Wundram (1970, p. 138), and Klessmann (1971). The work is given to Antonio Pollaiuolo by Venturi (1911, pp. 574ff., 1929, and 1930), Suida (1929 and 1930), Gamba (1930), Toesca (1935), Lipman (1936), Salmi (1936 and 1938), Kennedy (1938), Sabatini (1944), Ortolani (1948), Pope-Hennessy (1966), and Busignani (1970).

51. *Portrait of a Lady,* ca. 1460 (Pl. 213).

Tempera on panel, 45 × 32 cm.

Boston, Isabella Stewart Gardner Museum, no. B-945.

The panel was acquired by the Gardner Museum in 1914 from an Italian dealer by way of Böhler of Munich and Steinmeyer of Paris. Cleaning in 1972 revealed a loss between the eye and eyebrow that was repaired (see Hendy, 1974), and suggests that the present black background was originally blue. The work has been given to Domenico Veneziano by Berenson (1932 and 1963, and in letters to Steinmeyer of January 22, 1914, and to Sir Philip Hendy of February 4, 1930), Salmi (1936, 1938, and 1938a), Carli (1954, with reservations), and Mallé (1965), but denied him by Suida (1929). Van Marle (X), Venturi (1930, 1931, and 1933), Hendy (1931 and 1974), and Berti (1961a) have assigned it to Paolo Uccello. Cust (1928) ascribed it to Baldovinetti or Piero della Francesca; Pudelko (1935) to the Master of the Karlsruhe *Adoration*. Offner (1933), Lipman (1936 and 1936a), Kennedy (1938, p. 131), Pope-Hennessy (1950), and Zeri (1971) have attributed it to the Master of the Castello Nativity. On another occasion Pope-Hennessy (1966) expressed doubts about this attribution and more recently (1969) designated both the Gardner and the Bache *Ladies* (see catalogue no. 60) as simply Florentine school.

The authorship of the Gardner portrait cannot be separated from that of the *Ladies* in the Bache and Lehmann Collections (catalogue nos. 60 and 61). The Bache and Gardner panels are clearly variations of the same formula, both iconographically (in costume, hairstyle, and hair ornaments) and stylistically (the slope of the forehead; the setting and the shape of the eye; the relative proportions of neck, face, hair, and hair ornament; the continuous plane, modulated in extremely delicate relief, formed by the neck and face, with slightly more emphatic modeling around the wings of the nose and the eye). Among these stylistic characteristics there are sufficient reminiscences of the profile of Domenico Veneziano's St. Lucy (Pl. 62) to suggest that the prototype of the two pictures may have been the *Portrait of a Lady* listed as by Domenico Veneziano in the Medici Inventory (see catalogue no. 83). The connection of the Bache and Gardner *Ladies* with the profile of the princess in Paolo Uccello's *St. George and the Dragon* in the National Gallery in London, which has been cited by several scholars, appears to me more iconographic than stylistic. The refinement of the two portraits, their decorativeness and attenuated shapes, would be consistent with a date about 1460, slightly later than has been proposed by Pope-Hennessy.

The *Lady* in the Lehmann Collection (catalogue no. 61), waist-length, with covered hair, and different in shape as well as in proportions from the Bache and Gardner portraits (with a basically straight rather than curved or sloping profile, wide face, and small features in relation to the size of the head), bears a certain relationship to the atelier of Fra Filippo Lippi (see Lippi's *Portrait of a Man and Woman in Profile* in the Marquand Collection of the Metropolitan Museum of Art). Insofar as it is legible, the severely damaged panel is entirely characteristic of the predominantly Lippesque style of the Master of the Castello Nativity.

52. *Portrait of a Lady,* third quarter of the fifteenth century.

Tempera on panel, 50 × 34 cm.

Florence, Galleria degli Uffizi, no. 1491.

The provenance of the picture is not known. It has recently been cleaned and is in good condition. A virtually identical panel, also cleaned some years ago but much less well preserved, is in the Harkness Collection at the Metropolitan Museum of Art. The attribution of the Uffizi portrait to Domenico Veneziano was proposed by Bode (1897 and in Burckhardt, 1910, p. 629) and was endorsed by Douglas (in Cavalcaselle, 1911, p. 233) and with reservations by Van Marle (X). Cust (1928) gave the picture to Baldovinetti or Piero della Francesca, Berenson (1909) ascribed it tentatively to Verrocchio, and Suida (1929a, pp. 26f.) tentatively to Leonardo da Vinci. All other attributions have been to the Pollaiuoli. According to Cruttwell (1907, p. 180), Venturi (1911, pp. 574ff., and 1929), Lipman (1936, with reservations), Ragghianti-Collobi (1949), and Busignani (1970), the portrait is by Antonio Pollaiuolo. Berenson (1932 and 1963), Schottmüller (1932), and Ortolani (1948) have given it to Piero Pollaiuolo. For Pudelko (1934) it belonged "in den Kreis des Piero Pollaiuolo," Toesca (1935) considered it a collaborative work by both brothers, and Salmi (1936 and 1938) called it simply "opera pollaiolesca."

The Pollaiuolo workship seems to have been the last quattrocento atelier in Florence where female profile portraits, which had come into fashion shortly after the middle of the century, were produced in any quantity. If offered its customers at least two types: one with an elaborate coiffure, represented by Uffizi 1491, the *Lady* in the Harkness Collection, and Antonio Pollaiuolo's autograph portrait in the Poldi-Pezzoli Museum (see catalogue no. 58); and another in which the sitter's hair is covered by a cap, as in the portrait in Detroit and in no. 585 in the National Gallery in London (see catalogue no. 57). For the latter type no autograph example by Antonio or Piero Pollaiuolo is known.

53. *Portrait of a Man*, last quarter of the fifteenth century.

Fresco on tile, 47 × 38 cm.

Florence, Galleria degli Uffizi, no. 1485.

The work is said to have been in the possession of the Corboli family of San Giovanni Valdarno. Later it was in the collection of Cardinal Leopoldo de' Medici. In 1675 it was acquired for the *guardaroba* of Grand Duke Ferdinand de' Medici, and in 1772 it entered the Uffizi. It was attributed to Domenico Veneziano by Schmarsow (1893 and 1912). Cavalcaselle (1864, p. 547; 1892, p. 327; 1911, p. 61) connected it with Botticelli. Delaborde (1876), Knudtzon (1900, pp. 88ff.), and Magherini-Graziani (1904, p. 113) gave it to Masaccio; Van Marle (X) tentatively to Castagno; and Scharf (1935, p. 38) to Domenico Ghirlandaio. Venturi (1911, p. 674) noted an ascription to Filippino Lippi, but himself felt that the picture was earlier. Berenson (1932 and 1963), Petit Palais (1935), Salmi (1936, 1938, and 1948), and Salvini (1952) have assigned it to Filippino Lippi. The repainted and redrawn state of the work, already noted by Cavalcaselle (1892), makes an attribution extremely difficult. The head would seem to be related to the atelier of Domenico Ghirlandaio at least as much as to that of Filippino Lippi.

54. *Portrait of a Man,* second half of the fifteenth century.

Tempera on panel.

Florence, Private collection.

The work is known to me only from a reproduction in the article in which Suida (1929) attributed it to Domenico Veneziano. Van Marle (X) and Pudelko (1934) gave it to Alesso Baldovinetti. On the basis of the reproduction I would judge the picture probably but not necessarily Florentine.

55. *Portrait of a Man,* third quarter of the fifteenth century (Pl. 214).

Tempera on panel, 42.4 × 31.4 cm.

Hampton Court Palace, no. 50.

The work has been at Hampton Court since the time of Charles II. I have not seen the original. A photograph shows a fair amount of restoration. It was tentatively given to Domenico Veneziano by Van Marle (X). Venturi (1922) and Pudelko (1934) assigned it to Baldovinetti, Cust (1928) to Baldovinetti or Piero della Francesca, Berenson (1932 and 1957) tentatively to the young Giovanni Bellini, and Kennedy (1938) with reservations to Gentile Bellini. Baker (1929) called it Florentine, Salmi (1938) Venetian. The descriptive inflections of the contour of the profile and the subtle attention to the characterization of the textures of skin, hair, and cloth suggest a north Italian rather than a Florentine painter.

56. *Portrait of a Lady,* ca. 1460–70 (Pl. 215).

Tempera on panel, 63 × 40.5 cm.

London, National Gallery, no. 758.

The sitter is probably Francesca Stati, sister of Piero Soderini, wife of the poet Angelo Galli of Urbino, and Countess Palma of Urbino (see Davies, 1961). The panel was acquired by the National Gallery in 1866 as a work of Piero della Francesca through the Florentine dealer Egidi. It is said to have come from the collection of Count Pancrazio in Ascoli Piceno. In spite of repairs, mainly around the eye and in the background, the picture is in good condition.

It has been given to Domenico Veneziano by Bode (1897), Schmarsow (1912), Lionello

Venturi (1930a), and Salmi (1936 and 1938); but a far greater number of scholars have ascribed it to either Paolo Uccello or Alesso Baldovinetti.[1] Suida (1929) thought it might be by one or the other, Burckhardt (1898, p. 182) attributed it to Piero della Francesca, and Adolfo Venturi (1929) to Antonio Pollaiuolo. However, as Roger Fry (1911) most convincingly showed, the painting is clearly by Baldovinetti.

NOTE

1. In favor of Uccello have been Richter (1883, p. 17), Loeser (1898), Berenson (1903 and 1909), Van Marle (X), Böck (1933 and 1939), Longhi (1952), and Busignani (1970). The portrait has been assigned to Baldovinetti by Fry (1911), Holmes (1923), Cust (1928), Berenson (1932 and 1963), Pudelko (1935), Lipman (1936), Kennedy (1938), Pope-Hennessy (1950 and 1969), Carli (1954), and Davies (1961).

57. *Portrait of a Lady,* third quarter of the fifteenth century.

Tempera on panel, 42 × 29 cm.

London, National Gallery, no. 585.

The sitter has been identified as Isotta da Rimini; but there is no convincing reason why this should be so (see Davies, 1961). The panel was once in the possession of the Guicciardini family in Florence and was acquired for the National Gallery by Sir Charles Eastlake in 1857. It is in good condition. There are some repairs around the wing of the nose and above the eye, and a fairly large pentimento along the upper part of the neck. The background has been considerably repainted. The panel was given to Domenico Veneziano by Bode (1897) and Berenson (1932 and 1963). Cavalcaselle (1864, p. 543) ascribed it to a follower of Uccello, and Soupault (1929, p. 21) to Uccello himself. Schottmüller (1932) and Toesca (1935) believed it to be by Piero Pollaiuolo. It was assigned to Antonio Pollaiuolo by Schmarsow (1912), Van Marle (XI), Venturi (1929), and Pudelko (1934). Lipman (1936), Salmi (1936 and 1938), Sabatini (1944), and Ortolani (1948) called it school of Antonio Pollaiuolo, and Davies (1961) Florentine school. A virtually identical picture is in a private collection in Detroit (see Sabatini, 1944, p. 101). The two are examples of one of the types of female profile portraits produced in the Pollaiuolo workshop (for another type, see catalogue no. 52).

58. *Portrait of a Lady,* ca. 1470–75 (Pl. 216).

Tempera on panel, 46 × 34 cm.

Milan, Museo Poldi-Pezzoli.

The provenance of the picture is not known. It was shown at the Exhibition of Italian Art in London in 1930. During the nineteenth century the inscription UXOR JOHANNIS DE BARDI was removed from the back of the panel in the belief that it was not authentic. The work was cleaned and cradled in 1951, and is in good condition.

Bertini (1881), Molinier (1889), Müntz (1889, p. 16), and Burckhardt (1898, p. 182) attributed the portrait to Piero della Francesca. Berenson (1896) gave it tentatively to Verrocchio, Richter (1910, II, p. 432) to an anonymous Florentine painter and medalist, and Cust (1928) to Piero della Francesca or Baldovinetti. Bode's (1897) ascription to Domenico Veneziano found support until as late as 1930 (see Burckhardt, 1910, p. 692; Cavalcaselle, 1911, p. 233; Schmarsow, 1912; Semrau, 1920, p. 165; Escher, 1922, p. 78; Van Marle, X; and Holmes, 1930). Beginning in that year a number of scholars assigned the portrait to Piero Pollaiuolo (Clark, 1930; Constable, 1930a; Fry, 1930; Berenson, 1932 and 1963; Schottmüller, 1932; and Morassi, 1936). But the great majority, from the early years of this century until the present, have given it to Antonio Pollaiuolo (Cruttwell, 1907, p. 178; Venturi, 1911, pp. 574f., 1929, and 1930; Frizzoni, 1912; Longhi, 1917; Suida, 1929 and 1930; Royal Academy, 1931; Mauro-Castro, 1931; Toesca, 1935; Lipman, 1936; Salmi, 1936 and 1938; Wittgens, 1937; Kennedy, 1938, p. 131; Sabatini, 1944; Ortolani, 1948; Ragghianti-Collobi, 1949; Russoli, 1955; Lopez-Rey, 1935; Baroni and dell'Acqua, 1952; Pope-Hennessy, 1966; and Busignani, 1970). The panel is clearly an autograph work of Antonio Pollaiuolo, probably of the early 1470s (see my further comments in catalogue no. 50).

59. *Portrait of a Man,* ca. 1460 (Pl. 217).

Tempera on poplar panel, the panel 59.4 × 44.4 cm, the painted area 52 × 37.3 cm.

Munich, Alte Pinakothek, no. 658.

The picture was at one time in the possession of the Torrigiani family in Florence. It has been in the Alte Pinakothek since before 1838. Salmi (1932) described it as much repainted. It was cleaned by Christian Wolters in 1953 and is now in reasonably good condition. Von Dillis (1838) and Schmarsow (1895, pp. 79f.) gave it to Masaccio. Cavalcaselle (1864, p. 549) thought its author was "one who had studied the works of Ghirlandaio." Douglas (in Cavalcaselle, 1911, p. 63), called him Pollaiuolesque, Salmi (1932 and 1948) felt he belonged to the circle of Botticelli, and Mason-Perkins (1913) identified him as Benvenuto di Giovanni. In the *Katalog der älteren Pinakothek* of 1904 the panel was listed as Florentine school, ca. 1440. It was given to Domenico Veneziano by Hutton (in Cavalcaselle, 1909, p. 373, n. 3) and Ragghianti (1935). Longhi (1952) judged it the only quattrocento portrait that might be linked to Domenico, and Zeri (1957) considers it entirely worthy of Domenico's name. Deusch (1928, pp. 41f.) related it to Castagno, and following its cleaning it was in fact exhibited over Castagno's name (*Kurzes Verziechnis,* 1957). Horster (1960) and Salmi (1961) have assigned it to a painter working in the style of Castagno.

The portrait's harshness in lighting and relief, as well as its hardness of drawing, preclude the possibility of a stylistic connection with Domenico Veneziano. The connection with Castagno is closer but not sufficiently close for the work to have been produced in his atelier. It seems to me to represent an adaptation or revival of Castagno's style by an artist who only partly understood it, applying it more literally than imaginatively to the sitter's head, and hardly at all to the rest of the composition. A plausible date would be about 1460.

60. *Portrait of a Lady,* ca. 1460 (Pl. 218).

Tempera on panel transferred to canvas, 39 × 26 cm.

New York, Metropolitan Museum of Art, Jules S. Bache Collection, no. 49.7.6.

Fischel (1920) and Valentiner (1938) argued but failed to prove to the satisfaction of later scholars that the sitter is Elisabetta da Montefeltro, the wife of Roberto Malatesta of Rimini.

Before entering the Bache Collection in 1924 the panel was in the Holford Collection. It has been at the Metropolitan Museum since 1949. It is in fair condition, with some losses in modeling throughout the composition. Benson's (1924) attribution to Domenico Veneziano was endorsed in the catalogue of the Bache Collection (*A Catalogue of Paintings,* 1929), as well as by Mayer (1930), Wortham (1930), and Berenson (1932 and 1963). When it was first exhibited it was placed between the Florentine and the Umbrian schools (Burlington Fine Arts Club, 1910; Fry, 1910). Since 1930 the majority of scholars have given it to Paolo Uccello (Venturi, 1930a; Salmi, 1936, 1938, and 1938a; Böck, 1939; Pittaluga, 1946, p. 14; Carli, 1954; Micheletti in Salmi et al., 1954; Sindona, 1957; Berti, 1961a; and Mallé, 1965). Offner (1933), Lipman (1936 and 1936a), Kennedy (1938, p. 131), Valentiner (1938), Pope-Hennessy (1950), and Zeri (1971) have assigned it to the Master of the Castello Nativity. Pudelko (1934) thought it by the Master of the Karlsruhe *Adoration.* Cust (1928) ascribed it to Baldovinetti or Piero della Francesca. Pope-Hennessy has recently (1966 and 1969) changed his attribution of both the Bache and the Gardner *Ladies* (see catalogue no. 51) from the Castello Master to Florentine school. My own view is that both pictures may be Florentine adaptations of about 1460 of a lost portrait by Domenico Veneziano, possibly the one listed as by him in the Medici Inventory (catalogue no. 83).

61. *Portrait of a Lady,* ca. 1460 (Pl. 219).

Tempera on panel, 58 × 38 cm.

New York, Metropolitan Museum of Art, Lehmann Collection.

The back of the panel bears the following inscription in eighteenth-century script: RITRATTO DI BATTISTA SFORZA, MOGLIE DI FEDERIGO, DUCA D'URBINO, MORI 1473. DALLA MANO DI PIERO DELLA FRANCESCA. Prior to 1883 the work was in the Toscanelli Collection in Florence. It then entered the Aynard Collection in Paris and was acquired for the Lehmann Collection sometime between 1913 and 1917. Although it is in very damaged condition, it is the only quattrocento profile portrait that has not been at least to some extent restored.

It was given to Piero della Francesca in the *Catalogue de la collection Toscanelli* (1883, no. 140), the Aynard Collection catalogue (Petit Palais, 1913, no. 62), by Reinach (1905ff., I, p. 553), and tentatively by Berenson (1932). All other attributions except Hutton's (in Cavalcaselle, 1909, III, p. 199) and Berenson's (1909a) to Antoniazzo Romano have been fairly evenly divided among Domenico Veneziano (Siren and Brockwell, 1917, no. 20; Weyr, 1918; Salmi, 1936, 1938, and, with reservations, 1938a; Kennedy, 1938, tentatively; Berti in Salmi et al., 1954), Paolo Uccello (Lehmann, 1928, tentatively; Mayer, 1930; Venturi, 1930a, 1931 and 1933; Böck, 1933; Pudelko, 1934 and 1935; Sindona, 1957; Berti, 1961a), and the Master of the Castello Nativity (Offner, 1933; Lipman, 1936 and 1936a; Valentiner, 1938; Pope-Hennessy, 1950, 1966, and 1969; Carli, 1954; Berenson, 1963). The last of these designations seems to me the most plausible (see catalogue no. 51).

62. *Portrait of a Lady,* ca. 1460.

Tempera on panel transferred to canvas, 48.8 × 36.3 cm.

Philadelphia, John G. Johnson Collection, no. 34.

The provenance of the painting is not known. It entered the Johnson Collection in 1905 and has been rather extensively restored. Mason-Perkins (1905) gave it to Uccello, and Van Marle (X) to Uccello's school. Berenson (1913) called it school of Domenico Veneziano and was reminded by its color of Neri di Bicci. It was then ascribed to Neri by Kennedy (1938, p. 131) and Pope-Hennessy (1950, 1966, and 1969). On another occasion Berenson (1932) listed the picture as by an unknown Florentine painter but as possibly designed by Domenico Veneziano. Rankin (1909) assigned it to Francesco di Giorgio, Cust (1928) to Baldovinetti or Piero della Francesca, and Lipman (1936) to a follower of Piero. It has also been designated simply as Florentine school (John G. Johnson Collection, 1941; Berenson, 1963). Sweeney (1966, p. 52) has convincingly recognized the author of the portrait as the Master of Fucecchio, recently identified as Giovanni di Ser Giovanni (see catalogue no. 37). The work is a provincial variant of the portraits in the Gardner and Bache Collections (see catalogue nos. 51 and 60).

63. *Portrait of a Man,* last quarter of the fifteenth century.

Tempera on panel, 32 × 24.5 cm.

Rome, Pinacoteca Capitolina.

In the early nineteenth century the sitter was identified as Petrarch (Tofanelli, 1818, no. 78). The panel is said to have been in the collection of Cardinal Pio di Savoia and to have been bought from him by Pope Benedict XIV (1740–58). It later became the property of the commune of Rome, and had entered the Pinacoteca Capitolina by the early nineteenth century. It is known to me only from a photograph, which shows it to be in poor condition. According to Venturi (1890), it has been "much retouched."

The portrait was given to Domenico Veneziano by Ulmann (1894a, p. 271). Venturi (1889 and 1890) called it Florentine of the second half of the fifteenth century, but later (1918) attributed it to Pisanello, a designation endorsed by Coletti (1953). An early inventory of the Pinacoteca Capitolina (Tofanelli, 1818) listed the panel as by Giovanni Bellini, while Cavalcaselle (1871, p. 212), Van Marle (XVII) and Bocconi (1930 and 1950) connected it with the atelier of Gentile Bellini. Male profile portraits in central Italy tended to be replaced toward the end of the fifteenth century by portraits in three-quarters view. In Venice, however, the male profile portrait remained in fashion until the end of the quattrocento. For this reason, and because of the realistic description of the sitter's features, the Capitoline picture is very likely Venetian.

64. *Portrait of a Lady,* second half of the fifteenth century.

Tempera on panel (?).

Switzerland, Private collection.

The work is known to me only from a reproduction in Coletti (1953a, Pl. 48), according to whom it is considerably restored, and who ascribed it to Domenico Veneziano, an attribution rejected without comment by Zeri (1961). Volpe (1956) called the portrait Venetian of about 1460, possibly Antonio Vivarini. This is indeed the direction in Venetian painting suggested by Coletti's reproduction.

ATTRIBUTIONS TO DOMENICO VENEZIANO'S WORKSHOP OR FOLLOWERS

65. *Madonna and Child,* ca. 1440.

Tempera on panel, the panel 58 × 37 cm, the painted area 57 × 33 cm.

Dublin, National Gallery of Ireland, no. 603.

The panel was formerly in the collection of Stefano Bardini in Florence. In 1899 it entered the Butler Collection in London, was then acquired by Langton Douglas, and came to the National Gallery of Ireland in 1910. Overpainting of the seventeenth or eighteenth centuries, principally a veil surrounding the Virgin's head, was removed in the late 1960s (see *Restored Paintings*, 1971). Notwithstanding losses in the paint surface of the Virgin's head, the panel is in good condition. Among the singular features revealed by cleaning are the asymmetry of the Virgin's face and in the curves of the shell behind her head; the disconnectedness of her arms from her torso, and of her hands (especially of her right hand) from her arms; and the fact that, like Piero della Francesca's *Madonna del parto,* she wears a simple tunic without either a mantle or a veil.

At the Bardini Sale in 1899 and on three other occasions the work was attributed to Lorentino d'Andrea, an Umbrian follower of Piero della Francesca (Christie, Manson, and Woods, 1899, no. 357; Burlington Fine Arts Club, 1910, no. 30; National Gallery of Ireland, 1920; and in Thieme-Becker, XXIII, p. 381). It was connected with Domenico Veneziano by Fry (1910), who gave it to a follower of Domenico and Piero della Francesca. Pudelko (1936d), followed by the majority of scholars in the last four decades, ascribed the picture to Paolo Uccello (see Salmi, 1936, and, with reservations, 1938; Ragghianti, 1938; Carli, 1954; Micheletti in Salmi et al., 1954; Sindona, 1957 and 1970; *Centenary Exhibition,* 1964, no. 4; Berti, 1961a; and Zeri, 1974). Pope-Hennessy (1950 and 1969) and Shell (1961) have given it to the Prato Master, and Coletti (1953a) to "un modesto collaboratore veneto" of Fra Filippo Lippi.

In spite of eloquent arguments by Pudelko before the work was cleaned and by Sindona (1970) after cleaning in favor of Uccello's authorship, I cannot reconcile the self-consciousness and capriciousness of the painting with Uccello's certain works. Pope-Hennessy's and Shell's attribution to the Prato Master—a name which should be understood as designating a direction in the Uccello atelier represented by the murals in the Cappella dell' Assunta in the cathedral at Prato and by works associated with the Karlsruhe *Adoration* and the Quarata predella (see catalogue no. 43)—seems to me closer to the mark. The Dublin *Madonna,* to a greater extent than the other works of this group, shows the influence of Fra Filippo Lippi's style of the late 1430s, especially in the indebtedness of the Child to the Infant of the *Corneto Tarquinia Madonna* of 1437 (Pl. 76).

66. Fragments from the Pazzi Chapel, third quarter of the fifteenth century.

Head of a Saint in Frontal View.
Head of a Saint in Three-Quarters View.

Sinopia transferred to canvas.

Florence, Soprintendenza alle Gallerie.

The two *sinopie* were found at eye level under the *intonaco* of one of the interior walls of the Pazzi Chapel in the course of restorations following the flood of 1966, and were exhibited at Or San Michele in 1968 (*Il restauro dei monumenti*, 1968). Kiel (1969) has reported that the frontal head has been given to Donatello and the head in three-quarters view to Desiderio da Settignano, but has herself related them to the heads of Domenico Veneziano's fresco from S. Croce, and to a number of heads designed or painted by Baldovinetti which show Domenico's influence, with a date of about 1450. Though this may be on the early side, Kiel's reproductions of the *sinopie* appear to bear out her observations on their stylistic direction.

67. *Madonna and Child with Sts. John the Baptist and Anthony Abbot,* second quarter of the fifteenth century (Pl. 220).

Tempera on panel, 76 × 37 cm.

London, Italian Embassy.

The panel was formerly in the Gualino Collection in Turin. It is known to me only in a photograph, from which the condition of the picture is difficult to judge. Venturi (1926) and de Benedetti (1934) assigned it to a follower of Pesellino, and Berenson (1932 and 1936) to a follower of Domenico Veneziano. The round, frontal head of the Virgin appears related to a type which Pudelko (1934) recognized in Domenico di Bartolo's *Madonna* in the Rifugio at Siena, the tabernacle by Paolo Schiavo at S. Piero a Sieve, Francesco d'Antonio's tabernacle in the Piazza S. Maria Novella in Florence, and his *Madonna* at Montemarciano. To this list should be added the *Madonna of Humility* in the Osservanza Master's altarpiece of the *Birth of the Virgin* at Asciano. The Gualino picture too would seem to be Sienese rather than Florentine. It shows no stylistic connection whatever with Domenico Veneziano.

68. *St. John the Baptist,* c. 1455 (Pl. 221).

Tempera on panel, 79 × 44 cm.

Loreto, Museo della Santa Casa, no. 19.

The provenance of the work is unknown. I have not seen the original. From a photograph its condition seems to be good. It has been assigned by Salmi (1938) to a Marchigian, Squarcioniesque imitator of Domenico Veneziano, by Berenson (1932) to Marco Zoppo, and by Serra (1934, II, p. 420, n. 100) to the *maniera* of Zoppo. Longhi (1940a) recognized that it is by the same painter as a *Crucifixion* formerly in the Simonetti and now in the Cini Collection, whom he identified as Ludovico Urbani, and whom Zeri at one time (1948) referred to as the

Master of the Simonetti *Crucifixion*. On another occasion Zeri (1953) perceived that this master is the same painter whom Offner (1939) designated as the Master of the Barberini Panels, and later still Zeri (1961) was able to identify him as Giovanni Angelo di Antonio da Camerino. Both Offner and Zeri have stressed the influence on Giovanni Angelo of Domenico Veneziano, first transmitted when the former was in Perugia in the mid-1440s, and reinforced during his Florentine sojourn of ca. 1447–51. Zeri has convincingly dated the Loreto *Baptist* after Giovanni Angelo's departure from Florence in 1451. Proof of Giovanni Angelo's dependence on Domenico is the panel's floral background, whose roses and pattern of five-leaf clusters are identical with those in Domenico's *Madonna* in Washington (Pl. 132).

69. *Madonna and Child with Sts. Mary Magdalen, Verdiana, Anthony Abbot and Francis,* 1471.

Tempera on panel, 141 × 138 cm.

Lungotuono (Castelfiorentino), S. Maria.

The upper step leading to the Virgin's throne bears the inscription Q TAVOLA AFATTO FARE NERI DI DOMENICO DI NERI DI DANARI DI LIMOSINE MCCCCLXXI A DI XXVII DOTTOBRE. The work is in ruinous condition. It was cleaned and restored, with very large losses filled in with a neutral tone, prior to the exhibition *Arte in Valdelsa* in Certaldo in 1963. When first published the work was given to the school of Domenico Veneziano (Vavasour-Elder, 1909). Berenson (1932 and 1963) and subsequent scholars have recognized its author as Cosimo Rosselli (Gronau, 1935; Musatti, 1950; *Arte in Valdelsa*, 1963, no. 50), while continuing to stress its indebtedness to Domenico. The condition of the altarpiece makes it difficult to estimate the extent of this influence.

70. *The Cross, the Mystic Lamb and the Book of the Seven Seals, and the Madonna della Misericordia,* second quarter of the fifteenth century (Pl. 222).

Tempera on poplar panel, 144 × 184 cm.

Perugia, Galleria Nazionale dell' Umbria, no. 135.

The panel has three sets of inscriptions:

NASCITUR / ABLUITUR / MORITUR /DESCENDIT AD YMA /SURGIT / ASCENDIT / VENIET DIES EIUS next to the seven seals.

IHU CRUCIFIXE AGNUS DEI QUI TOLLIS PECCATA MUNDI PER SANTAM TUAM MISERERE MEI SANTE DEUS SANTE FORTIS SANTE ET IMMORTALIS MISERERE NOBIS AMEN around the mandorla of the apocalyptic images.

MISERICORDIA VIRGO PIA / A MALA MORTE ET PESTE IN VIA / PREGA IHU CHE NON SIA / DAL FLAGELLO SUA IRA / DEFENDE NOS SANTA MARIA AMEN around the mandorla of the Madonna.

The work is said to come from the *congregazione della carità* in Perugia, and has been identified with a *gonfalone* (banner) commissioned by the Confraternity of Borgo Sant' Angelo in Perugia at the time of the plague of 1476 (see Ricci, 1936). However, the painting is not in fact a banner, being on wood rather than on cloth, and is stylistically earlier than 1476. It has suffered considerable damage. Cleaned and restored after World War II, it was exhibited at the first *Mostra di dipinti restaurati* (1953) in Perugia, where it was characterized as the "unico documento della eredità lasciata in Perugia da Domenico Veneziano." It was first given to an Umbrian follower of Domenico by Salmi (1921, 1936, 1938, and 1954), a designation endorsed by Carli (1954) but emphatically rejected by Longhi (1952) and Zeri (1961). The latter has correctly diagnosed its style as related to followers of Masaccio and Fra Angelico such as Andrea di Giusto and "Antonio da Firenze" (presumably Francesco d'Antonio). For an analysis of the iconography and a description of the cleaning and restoration of the panel, see *Mostra di dipinti restaurati* (1953).

71. *The Judgment of Solomon,* ca. 1460 (Pl. 223).

Tempera on panel, diameter of dodecagon 74 cm.

Richmond, The Virginia Museum of Fine Arts, no. 46.18.1.

The back of the panel contains a seated figure of Hope flanked by two winged *putti* holding coats of arms. I know the picture only from photographs, in which it appears to have been cleaned and restored, and to be in good condition. It was formerly in the Chabrières-Arles and Secrétan Collections in Paris, the Achillito Chiesa Collection in Milan, and the collection of William Randolph Hearst. It entered the Virginia Museum of Fine Arts in 1946 as the bequest of Mrs. Alfred I. Du Pont.

The salver has been called Florentine of the middle of the quattrocento (Müntz, 1894; American Art Galleries, 1926, no. 44), Florentine or Ferrarese (Hammer Galleries, 1941, no. 162.22), and Paduan of about 1470 (Schubring, 1915, no. 614). Berenson (1932) listed it as a copy of a work by Domenico Veneziano, and Salmi (1936 and 1938) gave it to a Florentine imitator of Domenico of about 1460. Comstock (1926) assigned it to Giovanni Boccati, Pudelko (1934) to the Paris Master, Longhi (1952) to the Master of San Miniato, and Fredericksen and Zeri (1972) to Apollonio di Giovanni.

In spite of the hard drawing style and the fanciful architecture at the center of the panel, which could point to a Paduan or Ferrarese origin, the salver is probably a Florentine work of about 1460. The composition is given over so predominantly to the ceremonious staging of architecture and onlookers that the focus of the *istoria* is easy to overlook. In the architectural regularity and perspective alignment of the figures, the design of the outer pedimental segments of the central structure and of the buildings on either side of the *piazza,* the Oriental hats of the two men to the right of center, and the formation of the landscape, the painter of the dodecagon reflects characteristics of Piero della Francesca's murals at S. Francesco in Arezzo. I see nothing in the Richmond panel that concretely relates it to Domenico Veneziano.

72. Two Predella Panels, second quarter of the fifteenth century.

The Banquet of Herod, 28 × 34.5 cm.
Salome Receiving the Head of St. John the Baptist, 38.5 × 37 cm.

Tempera on panel.

Rome, Pinacoteca Vaticana, nos. 287 and 289.

The provenance of the panels is not known. They have been extensively redrawn and repainted. Siren (1906) gave them to a Florentine *cassone* painter of about 1450. The *Guide to the Vatican Picture Gallery* (1914, p. 57) called them Florentine, fifteenth century. Van Marle (IX) thought them "of Sienese origin executed under Sassetta's immediate influence." Pope-Hennessy (1939, p. 185) assigned them to a "crude Florentine copyist of Domenico Veneziano," reiterating the earlier view of Mason-Perkins (1906), who believed them influenced by Domenico and by Alesso Baldovinetti. The works have been so altered by hasty-looking restoration that they may seem more provincial and awkward than they in fact are, and this makes it extremely difficult to designate them more specifically then as central Italian of the second quarter of the fifteenth century.

73. *Madonna and Child with Sts. Mary Magdalen, John the Baptist, Anthony Abbot and Francis,* ca. 1470 (Pl. 224).

Tempera on panel.

Romena (Pratovecchio), S. Pietro.

The panel has been cut down at the sides. It was once in badly damaged condition but has been cleaned and restored since the end of World War II. The *Guida d'Italia* (1935) listed it as in the *maniera* of Domenico Veneziano, and a census of works of art made following World War II (The British Committee, 1945, p. 60) as of his "school." In the third edition of the *Guida d'Italia* (1959) it was called "scuola fiorentina del '400." Berenson (1963) thought it close to Botticini, and Bellosi (1967), who noted the influence on the altarpiece of the Lippesque *sacra conversazione* in the Louvre (no. 1661), attributed it to Botticini himself. Its four saints, like three of the saints in the Louvre altarpiece, are derived from the St. Lucy Altar. Whether the painting is by Botticini or not, it is the work of a Florentine painter of about 1470 with connections to the atelier of Verrocchio.

74. *Madonna and Child,* ca. 1435.

Tempera on panel, 63 × 45.5 cm.

Location unknown.

I know the work only from a color reproduction published by Longhi (1965), who reported that the picture was on the Florentine art market in 1941–42, and believed it by a Florentine artist of the 1430s close to Domenico Veneziano. It would be fairer to say that it belongs to the dominant stylistic trend in Florentine painting of the mid-1430s (see p. 13).

75. Two Scenes from the Legend of Paris, ca. 1450–55 (Pls. 185–186).

The Rape of Helen, 42 × 45 cm.
The Sleep of Paris, 42 × 45 cm.

Tempera on panel.

Location unknown.

Prior to World War II the panels were in the Lanckoronski Collection in Vienna. Nothing is known of their provenance. From photographs it appears that they have been considerably restored. The *Sleep* seems to be in somewhat better condition than the *Rape*. Schubring (1915, nos. 166 and 167) gave them to the Paris Master, together with the *Judgment of Paris* in Glasgow (catalogue no. 27), the *Diana and Acteon* in the Opper Collection (catalogue no. 29), and a panel of *Zeus and the Three Goddesses* formerly in the Butler Collection in London (see catalogue no. 27, n. 2). Schubring's attribution was endorsed by Van Marle (X) and Pudelko

(1934). Berenson (1932 and 1963) and Salmi (1936 and 1938) assigned the Vienna panels to the atelier of Domenico Veneziano. Kennedy (1938) considered them further from Domenico's style than the Opper *Diana and Acteon.*

In spite of their repainted state, the Lanckoronski panels can confidently be given to the same artist as the Glasgow *Judgment of Paris.* The *Sleep* and the *Judgment* have in common the placement and formation of trees and foliage, the costume of Paris, and the shaping of the profile heads of the goddesses looking to the left (the last goddess on the right in the *Sleep,* and Venus in the *Judgment*). Like the *Judgment,* the *Sleep* can be profitably compared with the *Marriage of Griselda* at Bergamo (Pl. 187). The goddesses in the former and the figure of Griselda leaving the well in the Bergamo panel wear identically arranged dresses, and the well in both pictures is composed of similarly cut, jagged stones. Furthermore, the gesture of the extended left hand by which the walking figure of Griselda balances her forward movement is also the gesture of Helen as she is being carried off by Paris in the *Rape.* (A similar gesture, but with the thumb pointing in the opposite direction from the fingers, is assumed by the left hand of Acteon in the Opper panel. For its use by Domenico Veneziano and others, see chap. II, n.43).

76. *The Triumph of Chastity,* third quarter of the fifteenth century.

Tempera on panel, 63 cm in diameter.

Location unknown.

In the late nineteenth century the panel was in the Staatliche Kunstakademie at Düsseldorf (no. 109). After the turn of the century it was in the storerooms of the Königliche Museen at Berlin, and in 1912 was transferred on loan to the Landesmuseum in Münster, where it was until World War II. Schubring (1915, no. 643) thought the tondo north Italian of about 1480, but later (1929) gave it to Sassetta, and on a third occasion (1930) to the Sienese school. However, the panel is unquestionably Florentine (see Koch, n.d.; Pope-Hennessy, 1939, p. 185). Berenson (1932 and 1963) assigned it to the studio of Domenico Veneziano, and Salmi (1936 and 1938) judged its style derivative of Domenico's. Pudelko (1934) considered it closely related to the Bryan *Triumph of Fame* (catalogue no. 37), while Longhi (1952) attributed it to the shop of the Master of Fucecchio (Giovanni di Ser Giovanni), the author of the Bryan tondo. The stylistic repertory of the two works is so congruent that they are very likely products of the same atelier, though the Triumph of Chastity, judging from photographs, lacks the Bryan tondo's pictorial charm and lightness of touch.

ERRONEOUSLY IDENTIFIED ATTRIBUTION

77. *The Last Judgment,* ca. 1380–90.

Fresco.

Novoli, Torre degli Agli.

Carocci (1893) erroneously referred to this tabernacle as a work of Domenico Veneziano. It was in fact painted on the commission of Giovanni degli Agli by Antonio Veneziano (see Offner, 1927a).

UNIDENTIFIABLE ATTRIBUTIONS

78. Subject unknown.

Empoli, Galleria della Collegiata.

According to Carocci (1899), the work is a panel from S. Giovanni a Monterrapoli and "in certain details is reminiscent of Domenico Veneziano."

79. *Madonna and Child.*

Marseilles, Musée des Beaux Arts.

The painting was attributed to Domenico by Witting (1910).

COPIES

80. *Madonna and Child,* third quarter of the fifteenth century (Pl. 225).

Tempera on panel, 47 × 30 cm.

Bergamo, Accademia Carrara, Collezione Lochis, no. 317.

According to Shell (1968), the panel is a copy by the pseudo-Piero Francesco Fiorentino of a lost work by Domenico Veneziano. Ricci (1912) gave the painting to the school of Fra Filippo Lippi, and reported attributions by Count Lochis to Lippi himself, and by A. Venturi to Domenico di Bartolo. Berenson (1932) tentatively thought it a copy by Giovanni Boccati of an original by Lippi. The attribution to Domenico di Bartolo was accepted with reservations by della Chiesa (1955). The picture is so firmly rooted in the stylistic tradition of Fra Filippo Lippi that a connection with Domenico Veneziano is very unlikely. The placement and the drapery of the Virgin recall Lippesque derivations by Pesellino (see the *Madonna and Child* in the Kress Collection at the Denver Art Museum), while the body and the face of the Child have close parallels in the Lippesque *Madonnas* by the Master of the Castello Nativity in the Walters Art Gallery in Baltimore and the Niedersächsisches Landesmuseum in Hannover. The author of the Bergamo panel is surely not the pseudo-Piero Francesco Fiorentino, whose style

is characterized by hard, glossy contours and finishes, but rather a painter related to Longhi's Pratovecchio Master (see Longhi, 1952).

81. Diptych with Portraits of Two Members of the Medici Family, second half of the fifteenth century (Pls. 226–227).

Oil on panel, 50 × 20 cm each.

Zurich, Landolthaus, Gottfried Keller Stiftung.

The backs of the portraits display the Medici arms in the form of a circular design with one *palla* in the center and five along the circumference, framed by a garland, and set into a field of simulated marble decorated with looped cords ending in tassels. Pudelko (1936c), Pope-Hennessy (1966) tentatively, and Berti (1963, and in Volponi and Berti, 1968) have identified the sitters as Piero and Giovanni de' Medici. Ragghianti-Collobi (1949) has endorsed the identification of the former but has proposed that the portrait facing left may be either Pierfrancesco or Bernardetto de' Medici.

The diptych was acquired by the Gottfried Keller Stiftung in 1893 and may at one time have been in the possession of the painter Raphael Mengs. Both panels have been overcleaned and restored—the right-hand wing more extensively than its companion, as well as cut at the top and bottom (as is evident from the patterns of the cords on the backs). With the exception of Pudelko (1936c) and Berti (in Salmi et al., 1954; 1963; and in Volponi and Berti, 1968), who have given the diptych to Andrea del Castagno, scholars have regarded the portraits as copies: Berenson (1932 and 1963) of Masaccio; Salmi (1936, 1938, and 1948) of Paolo Uccello, painted in the nineteenth century; Longhi (1940) and Bottari (1953, p. 16) of Petrus Christus; Lanyi (1944) of "pre-existing originals" which he did not attempt to define more specifically; Pope-Hennessy (1966) "possibly" of the lost frescoes of Domenico Veneziano or Baldovinetti at S. Egidio; and Ragghianti-Collobi (1949) of the S. Egidio *Death of the Virgin* by Castagno (the portrait facing right) and *Marriage of the Virgin* by Domenico Veneziano (the portrait facing left). Gamba (as reported in Salmi et al., 1954) has attributed the copies to the circle of Ghirlandaio.

Although no solution to the problem of the date and authorship of the diptych seems possible without examining the panels in the laboratory, it is unlikely that they have any relationship to Domenico Veneziano. If one or the other were derived from the *Marriage of the Virgin* at S. Egidio, the copyist would have been following the work not of Domenico but of Alesso Baldovinetti. The costumes suggest that the originals dated from the middle or the third quarter of the quattrocento. But the copies may be later. The precisionist quality of their glossy surfaces and textures suggests that rather than being Florentine copies of Flemish originals, as Longhi and Bottari supposed, they may well be copies of the end of the quattrocento of Florentine originals by a painter from or trained in the Netherlands.

82. *The Judgment of Paris.*

Tempera on panel, dodecagonal.

Location unknown.

The work was formerly in the Landau-Finaly Collection in Florence. It was sold at auction in Florence on July 15, 1948. The back of the panel is said to contain a *putto* in the same pose, though reversed, as the *putto* on the back of the Masaccesque *desco da parto* in Berlin (catalogue no. 18). Salmi (1948, p. 232) attributed the *Judgment* salver to the Paris Master (see catalogue no. 27). According to Berti (1964, n. 200), it is a nineteenth-century copy of an original conceivably painted by Domenico Veneziano as a pendant to the Berlin *desco* at a time—about 1427—when, in Berti's view, Domenico was in contact with Masaccio. I have not succeeded in finding a photograph of the dodecagon.

LOST WORKS

83. *Portrait of a Lady.*

Florence, Medici Palace.

The work is listed in the Medici Inventory (see source 5B) as a "*colmetto* with two doors, inside of which is painted the head of a lady by the hand of *maestro* Domenico da Vinegia," and is valued at 8 florins. What the shape of a *colmetto* was is not clear (see Chambers, 1970, p. 109). Presumably a portrait, the painting may have been the prototype for the female profile portraits in the Isabella Stewart Gardner Museum (catalogue no. 51) and the Bache Collection at the Metropolitan Museum of Art (catalogue no. 60).

84. *Allegorical Figure.*

Florence, Medici Palace.

The work is described in the Medici Inventory (see source 5A) as "a canvas painted with a seated figure in a tabernacle, half nude and holding a skull, by the hand of *maestro* Domenico da Vinegia, colored in oil, simulating marble," and is valued at 10 florins. The figure has been identified by Gilbert (1959) as a *Vanitas,* in which the skull would have symbolized death. This is entirely possible. Janson (1937) has shown that the skull was used in Italian art—in a medal by Giovanni Boldu, a follower of Pisanello—as a symbol of death by 1458.[1] Pictures on canvas too were not uncommon by the middle of the quattrocento. Baldovinetti painted his *Madonna*

and Child in the Musée Jacquemart-André on canvas approximately a decade before Domenico's death; and in 1454 Alesso wrote in his day book that he was painting a large canvas for Andrea del Castagno.[2] However, it would have been unusual for a Florentine picture prior to 1461 to have been "colored in oil" and to have "simulated marble."

The words in the Medici Inventory for "colored" and "simulating" have feminine endings—*cholorita* and *contrafatta,* thereby making it clear that it was specifically the *fighura* which was painted so as to simulate marble, in other words, that she was a sculpted rather than a real figure. Common as such images were in Netherlandish painting from the early fifteenth century on, in Italy until the end of the quattrocento they are confined to the representation of reliefs in the context of architecture, as in the Barberini Panels in Boston and New York (ca. 1475) or Mantegna's *Presentation of Christ in the Temple* in the Uffizi (ca. 1465). Easel pictures in which the principal figures are painted in grisaille do not generally appear in Italian art until the last decade of the century. The earliest would seem to be Mantegna's *Triumph of Scipio,* his small paintings of Old Testament subjects, and works like Signorelli's *Allegory of Abundance.*[3]

The work ascribed in the Medici Inventory to Domenico Veneziano consequently belonged to what was in Domenico's lifetime a Flemish, not yet an Italian genre. By the second quarter of the quattrocento, however, Netherlandish painting had come to be greatly admired in Italy, and had influenced not only Domenico Veneziano but also Fra Filippo Lippi, Fra Angelico, and Piero della Francesca.[4] If Domenico Veneziano was the author of the Medici *Vanitas,* this would not have been the only example of his precocious use of a Flemish motif, though, to be sure, a more astonishing one than the simulated engraved inscription in the St. Lucy altarpiece (see Covi, 1963). Derived from Netherlandish practice too would have been the execution in oil. In the Medici Inventory, as in Vasari, the phrase *colorita a olio* specifically means the Netherlandish oil technique, a subject about whose invention, probably by Jan van Eyck, and later adoption in Italy we still know relatively little.[5] Be that as it may, the description of the allegorical painting allegedly by Domenico Veneziano is of interest insofar as it tells us that the claim that Domenico painted in oil was not invented by Vasari but had been made more than half a century before the first edition of the *Vite.*[6]

NOTES

1. Another early example, not mentioned by Janson, is on the reverse of a medal by Fra Antonio da Brescia, accompanied by the inscription NULA EST REDENCIO (see Habich, n.d., Pl. XXX-2). The significance of the skull in these medals, and presumably in the painting listed in the Medici Inventory, should be distinguished from the meaning it has when held by personifications of the Synagogue, as in the tondo in the upper right corner of Masolino's *Man of Sorrows* at Empoli, where it denotes the skull of Adam.

2. See Kennedy (1938, p. 236). Other works on canvas or linen of the third quarter of the quattrocento are the Uccellesque *Tebaide* in the

Accademia in Florence and Uccello's *St. George and the Dragon* in the National Gallery in London. According to Vasari, there were large canvases by Uccello and three *Labors of Hercules* on canvas by Antonio Pollaiuolo in the Medici Palace.

3. The six Old Testament pictures by Mantegna and his atelier—*Esther and Mordecai* in the Cincinnati Museum of Art, the *Judgment of Solomon* in the Louvre, *Judith* in Dublin, *David and Goliath* and the *Sacrifice of Isaac* in Vienna, and *Samson and Delilah* in the National Gallery in London—are on canvas or silk. In contrast to easel paintings, frescoes in grisaille were common in Italy, from Giotto's

Allegories in the Arena Chapel, to Gentile da Fabriano's five *Prophets* at S. Giovanni in Laterano which Bartolomeo Fazio described as being "so presented as to appear not painted, but wrought from marble," and Andrea del Castagno's *Niccolò da Tolentino*. Monochrome coloring with a greenish tonality in fresco painting was mentioned by Cennino Cennini (1933, pp. 121f.) and adopted by Paolo Uccello for his *Sir John Hawkwood*. The only surviving Italian grisaille works prior to the late quattrocento other than murals are on paper or vellum, such as Lorenzo Monaco's *Visitation* and *Journey of the Magi* in the Kupferstichkabinett in Berlin.

4. See Panofsky (1953, p. 361, nn. 2–3), Pudelko (1934 and 1936a), Middeldorf (1955), Zeri (1961), and Meiss (1941, 1956 and 1961).

5. For an exchange regarding the wholly fanciful notion that Vasari used the word *olio* to mean *occhio*, in the manner of the poets of the thirteenth century, see Van Regteren Altena (1954) and Middeldorf (1956). Emmanuel (1965) has argued that a close reading of Vasari's account of the invention of the oil technique discloses the "secret" process used by Jan van Eyck that has hitherto eluded scholars. Assuming that it is inconceivable that Vasari was not fully informed about so crucial a matter, Emmanuel believes the key to Vasari's account to be the phrase *vernice liquida,* which he translates as "emulsion." The secret of Jan van Eyck, Emmanuel suggests, was an emulsion of oil, resin, and water, which could be used without a binder of egg yolk. He attributes the luminous effect of van Eyck's colors to a structural change which occurs in this emulsion when "washed" with water while it is still tacky. According to Emmanuel, the invention of Jan van Eyck was a method of painting *on* oil—of applying successive layers of watercolor washes to adhesive coats of a resin-and-oil emulsion. Van Eyck's use of oil, Emmanuel argues, was restricted to underpainting—to the emulsive base which was then made to glow through the application over it of watercolor. For the difficulty in identifying the binding media, often involving a number of different components, in Italian later quattrocento painting, see Johnson and Packard (1971).

6. We can be fairly certain that Vasari did consult the Medici Inventory. In the course of the *Vita* of Antonio and Piero Pollaiuolo he described three pictures of *The Labors of Hercules* which, he wrote, Antonio Pollaiuolo painted for the Medici Palace. Yet Vasari could hardly have seen them there, for after the sack of the palace by the troops of Charles VIII in 1494 the three canvases were moved to the Palazzo della Signoria, where they were seen and erroneously attributed to Verrocchio by Albertini (1510), and also admired by Vasari (see Ortolani, 1948, p. 187). The most likely source of Vasari's information that they were by Antonio Pollaiuolo and that they were from the Medici Palace was the Medici Inventory, where they are in fact listed. (The inventory was not available to Albertini at the time he published his *Memoriale* in 1510 because it is not the original manuscript of 1494, but a copy made upon the return of the Medici to power in 1512.)

85. Two Marriage Chests, 1447–48.

Florence, Parenti Palace.

The two *cassoni* were commissioned for the wedding on January 13, 1448 of Caterina di Matteo Strozzi and Marco di Parenti di Giovanni Parenti. The progress of their manufacture and decoration can be followed in an account preserved among the Strozzi family papers in the Florentine Archivio di Stato (see document 3). The account lists eighteen payments, from September 11, 1447, to July 19, 1448. Six entries record payments for the wooden chests

themselves and for various materials and accessories, coming to a total of about 16 florins (13 florins, 14 lire, 7 soldi and 8 denari. The other twelve entries list payments of about 33.5 florins (29 florins, 18 lire, 11 soldi and 4 denari) to Domenico Veneziano. The total of these two sums, 50 florins, is the amount for which, according to the conditions set forth in the account, Domenico agreed to deliver the *cassoni* to Marco Parenti. This was his budget. It was evidently understood that his fee would be whatever remained after expenditures for the construction and embellishment of the chests. Indeed, on July 19, 1448, when all these and also a number of advances to himself had been paid, Domenico's assistant Antonio di Giovanni received for his master 4 florins, 13 soldi and 5 denari, the balance of the 50 florins stipulated in the contract.[1]

The entries of the payments to craftsmen are of interest becuase they are the only surviving description of the process of assembling *cassoni* in quattrocento Florence. On September 11, 1447, Domenico's budget was charged 7 florins and 12 *soldi di pìccioli* for the plain wooden chests (*forzieri*), which had been delivered to him by the carpenter Giovanni d'Andrea from the Chianti village of Albola. The delivery by an unidentified safemaker of small coffers or safes (*forzerini*) to be placed inside the chests ("che sse mettono ne' forzieri") was recorded on January 22, 1448, at a cost of 1 florin, 2 lire, and 15 soldi. The contract specified that these, like the chests themselves, were to be painted and gilded. The *cassoni* were ready for gilding by April 22. On that day the account lists the charge of 3 florins, 3 lire, and 8 denari for gold and silver leaf ("oro e ariento battuto") brought by the vestmaker Antonio di Domenicho from the goldbeater firm of Piero di Francesco and Company.[2] On June 5 the sum of 1 florin and 7 *soldi di pìccioli* was disbursed for black lining supplied by the linen manufacturing firm of Giovanni d'Ambrogio del Verzino and Company.[3] Later in June the hosiers Zanobi di Nicholò and Company received 1 florin, 3 lire and 15 soldi, and on July 2 the linenmaker Antonio d'Antonio was paid 3 lire and 18 soldi for furnishings which the account does not identify.

It is clear from the twelve payments to Domenico Veneziano that he did more than just decorate the *cassoni* with paintings. The account suggests that he was also responsible for their design and assembly. Only two payments to him—of December 23, 1447 and January 12, 1448, coming to 11 florins, 5 lire, 8 soldi, and 11 denari—are specifically designated as being for painting ("per parte di dipintura de' sopra detti forzieri"). Six others—of February 23 and 29, April 12, an unspecified date in April, and June 14 and 18, for a total of 9 florins, 7 lire, and 15 soldi—are not identified. The next-to-last entry states that the *cassoni* were to be ready on January 13, 1448, the day of Marco's and Caterina's wedding, but that they were not properly finished ("non sono bene finiti"). Domenico finally completed them by June 20. Two days earlier he had received the largest of his unspecified payments, a sum of 5 florins, 2 lire, and 11 soldi. Among Domenico's other four payments, one, recorded on July 19, 1448, a month after the *cassoni* had been delivered, represented the balance of his budget of 50 florins. Another, of July 2, was for half a barrel of wine. The two remaining ones were for the settlement of debts to Marco Parenti for the repayment of a loan and to Domenico's landlord Baldassare di Falcho for six months' back rent (see p. 22).

One of the Parenti *cassoni* was identified by Frimmel (1896) with a circular painted box formerly in the Figdor Collection in Vienna, decorated on the sides with painted medallions and on the lid with a pair of lovers, a work by Domenico di Bartolo that has no connection with the lost wedding chests designed, assembled, and decorated by Domenico Veneziano.[4]

NOTES

1. The total of all previous payments is 38 florins, 24 lire, 162 soldi, and 43 denari. Together with the payment of July 19, the expenditures in the Parenti account come to 42 florins, 24 lire, 175 soldi, and 48 denari (or 42 florins, 32 lire, and 19 soldi, which in 1448 would have been the equivalent of 50 florins).

2. In 1441, before he had been incorporated, Piero di Francesco himself had delivered gold leaf to Bicci di Lorenzo at S. Egidio (see document 2C).

3. This firm was assessed 4 florins at the time of the special Florentine tax of 1451 (see Molho, 1970, p. 114).

4. The Figdor box has been given to Domenico di Bartolo by Hartlaub (1910), Toesca (1920), Van Marle (X), Berenson (1932), Pope-Hennessy (1944), and Brandi (1949). Scharf (1930) attributed it to the style of Pisanello. For the iconography of the box, see Warburg (1932, I, p. 83, n. 1).

86. Frescoes on the West Wall of the Choir of S. Egidio in Florence, 1439, 1441–42, and 1445.

The Meeting at the Golden Gate.
The Birth of the Virgin.
The Marriage of the Virgin.

Fragments of the fifteenth-century mural decoration of the choir of S. Egidio by Domenico Veneziano, Andrea del Castagno, and Alesso Baldovinetti were recovered in 1938 (see Paatz, 1940ff., II; Salmi, 1947a). In 1955 they were detached and transferred to canvas, and two years later were shown at the Fortezza del Belvedere (see *Mostra di affreschi staccati,* 1957). Some of the fragments have been installed in the Palazzo dei Congressi. Others were for some time, and may still be, in storage at the Villa Corsini in Castello.

The fragments consist of sections of simulated marble paneling and strips with feet, the ends of draperies, pebbly or grassy terrain and ornamental borders from the west, north, and east walls of the choir (Pls. 161–166); a *sinopia* from the west wall with the upper part of a figure and construction lines for an architectural setting (Pl. 58; Figs. 10–11); and ornamental borders from the vault (Pls. 167–168).

The chapel of S. Egidio was founded in 1286 by Folco Portinari, the father of Dante's Beatrice, and was under the patronage of the Portinari family. It was rebuilt between 1418 and 1420 by Bicci di Lorenzo. The new structure was dedicated in 1420 by Pope Martin V, an event commemorated by the same Bicci di Lorenzo in a fresco on the façade (see *II Mostra di affreschi staccati,* 1958; Beck, 1971). The present choir, with a round entrance arch and round lunettes surmounted by a cupola on pendentives, dates from 1594, the year inscribed on the inner face of the arch (Pl. 170). Originally, as the recovered fresco fragments from the vaulting zone show, the choir had a pointed entrance arch and pointed lunettes, and was surmounted by a four-partite vault, its four triangular fields framed by ornamental borders. According to Salmi (1947a), the fields of the vault may have been filled with mandorlas containing personifications of Virtues, as in the Cappella dell' Assunta at the cathedral of Prato (see catalogue no. 43). The fifteenth-century frescoes in the choir were partially destroyed and whitewashed at the time of the late-sixteenth-century modernization, and were painted over when the choir was redeco-

rated about 1650. During the eighteenth century the vaulting zone was embellished with illusionistic architectural frescoes by Matteo Bonechi and Giovanni Tonnelli.

Payments to Domenico Veneziano for his work at S. Egidio are recorded in four ledgers in the Florentine Archivio di Stato (see document 2). In the six-year period from 1439 to 1445 Domenico received a total of just over 116 florins, including expenses for materials. The ledgers reveal two campaigns of relatively sustained activity, one from May to September 1439, and another from June 1441 to May 1442, corresponding to the execution of two murals. A single payment for a third, unfinished fresco, which was later completed by Alesso Baldovinetti, was recorded in June 1445.

In the opening payment of the first campaign on May 11, 1439, Domenico was reimbursed 2 lire and 8 soldi for five and one-half ounces of lac (*lacca*), an artificial color of red (see Cennini, 1933, pp. 26f.), which he had bought at 9 soldi the ounce. On June 13 a courier from the Venetian branch of the Medici Bank, Cosimo de' Medici and Company, was paid 11 soldi for delivering to the chapel sixteen ounces of blue (*azuro*). The dispatch of such a courier from Venice to S. Egidio was probably not as extraordinary as it might seem. Pigello Portinari, a member of the family who were the patrons of the chapel, was at that time employed in the Venetian office of the Medici Bank, and his father Giovanni had until 1435 been its director (see de Roover, 1966, pp. 247f.). The 11 soldi the courier received must have been his fee or tip. It is impossible that they could have represented the price of sixteen ounces of either of the two kinds of *azuro*–azurite or lapis lazuli—then in use, both of which were much more expensive, lapis lazuli vastly more.[1] Which kind of blue was delivered to Domenico Veneziano cannot be determined, since the ledgers of Cosimo de' Medici and Company in Venice no longer exist.

On August 22 Domenico received the large sum of 44 florins, a payment which was entered again in a second ledger on September 7, with the notation that it had been paid to "Master Domenico di Bartolommeo da Vinegia who is painting in the choir of S. Egidio." The last entry for the year 1439, and the final one for the first campaign, recorded that on September 12 Domenico's account was charged 2 florins and 3 lire which were remitted to his assistant Piero della Francesca ("portò Pietro di Benedetto dal Borgho a San Sipolchro sta cho'llui").

The first campaign was no doubt devoted to the execution of the *Meeting at the Golden Gate*—chronologically the first of the six subjects from the life of the Virgin which Vasari identified at S. Egidio—in the lunette register. It probably was substantially finished by August 22, when Domenico received what appears to have been his fee of 44 florins. The sum consigned to Piero della Francesca three weeks later may well have been for the final *a secco* touches. As in the entries recording the consignment of payments to Domenico's assistant Antonio in the Parenti account, the term *portò* indicates that the money delivered to Piero was for his master. In both commissions Domenico appears to have paid his assistants himself. The period of four months which elapsed between the first and last listed payments for the *Meeting at the Golden Gate* is surprisingly short compared with the duration of the second campaign, for which there are payments for a span of twelve months. The discrepancy is especially striking because the first mural, being the highest on the wall, would have required the building of a scaffold, whereas for the second fresco the scaffold would already have been in place. It is likely, therefore, that the first campaign had begun before May 1439. This is also suggested by the entries on May 11 for lac and on June 13 for blue. According to Cennino Cennini, neither lac nor blue could be used in *buon fresco,* and during the fourteenth and fifteenth centuries they were usually applied *a secco.*[2] Thus the entries of May 11 and June 13, though they are

the first we know recording Domenico's work at S. Egidio, could hardly document its beginning. By the time they were made the *Meeting at the Golden Gate* had progressed beyond the *sinopia* and as far as the application of colors.[3] The erection of a scaffold and the preparation of the wall—and very likely the painting of the vault, which would logically have been done while the scaffold was at its full height, even before beginning on the lunette zone of the wall—would have taken at least several months. We may therefore suppose that Domenico started working at S. Egidio as soon as the weather permitted—during the winter months the cold made fresco painting impossible—in the early spring of 1439.

The second campaign opened more than twenty months after the first mural was finished with an entry on June 1, 1441 of 8 florins and 70 lire charged to the account of the chapel, that is to say, Domenico's expense account for materials. Then on June 11 the account of the painter Bicci di Lorenzo was charged 10 florins, 1 lira, and 10 soldi for an unspecified quantity of gold leaf which had been delivered to him by the goldbeater Piero di Francesco. The gold leaf consigned to Bicci di Lorenzo was no doubt destined for Domenico's second mural, which according to Vasari represented the *Birth of the Virgin* and contained "a very sumptuous room" ("una camera molto ornata"). Slightly more than 10 florins would have bought about 1,100 pieces of gold leaf,[4] surely enough for gilding the bedroom of St. Anne in Domenico's fresco. Bicci di Lorenzo was during the second quarter of the fifteenth century one of the major representatives in Florence of the tradition of trecento craftsmanship, and had already been employed by the hospital of S. Maria Nuova as a gilding expert (see Kennedy, 1938, n. 41), a capacity in which he also seems to have assisted Domenico Veneziano.

After an interval of three and one-half months Domenico's account was charged for three purchases of linseed oil: 5 soldi and 4 denari on October 1 for one pound, 12 soldi on October 5 for two pounds, and 18 soldi on October 10 for three pounds. It is very unlikely, however, that there could be any connection between these purchases and Vasari's claim that Domenico painted his murals at S. Egidio in oil. By the phrase *a olio* Vasari invariably meant the Netherlandish oil technique (see p. 2), the medium he preferred on any kind of support, including dry walls. "The experience of many years has taught me how to work in oil on walls," he wrote in the Introduction to the second edition of the *Vite,* without, however, specifying the ingredients or the composition of his oil medium. Linseed oil, according to Vasari, is to be used only for the *arricciato*—for smoothing out the wall prior to priming it in preparation for oil painting.[5] This is clearly not the way Domenico Veneziano employed the linseed oil he bought in October 1441, when the mural on which he was working was obviously well under way, and had already received gilt. He probably used it in one or both of two ways: for *a secco* varnishes or glazes such as those with which his pupil Baldovinetti experimented in the Gianfigliazzi Chapel in S. Trinita and in the atrium of the SS. Annunziata, or as a binder in *a secco* fresco painting according to a method described by Cennino Cennini.[6] Under the heading "How You Should Work Up the Colors with Oil and Employ Them on the Wall," Cennino specifies that the requisite oil medium is to be made of linseed oil reduced to half its volume by boiling or exposure to the sun, and that the resultant pigment is appropriate for modeling draperies, "flesh painting, and for doing any sort of work which you may care to carry out; and mountains, trees, and every other subject in the same way."[7] Though Cennino is not as informative on this point as we might wish, the practice to which he refers appears to go back at least as far as Giotto, who, according to Ghiberti (Schlosser, 1912, I, p. 36), "already worked in oil." Be that as it may, *a secco* painting and glazing were standard

practices in Domenico's time, as he himself demonstrated in the *Madonna* of the Carnesecchi Tabernacle, and, it would seem, in the dresses of the attendant ladies in the *camera molto ornato* of the *Birth of the Virgin*.

Although the freezing weather of winter, especially in January and February, would have precluded work on the fresco, on January 13, 1442, Domenico received 2 lire and 4 soldi "for his needs." On February 22 he received 30 florins. This seems to have been half of his fee, since another payment to him of 30 florins is listed in the last recorded payment of the second campaign on May 28. With that the mural appears to have been finished. Almost a year had passed since it had been gilded, and almost eight months since Domenico's purchases of linseed oil. The period between the first recorded payment on June 1, 1441, and the second on June 11 for the delivery of gold leaf would not have allowed much time for the preparation of the wall and the *sinopia*, and we may assume that like the *Meeting at the Golden Gate*, the *Birth of the Virgin* was begun before the ledgers first refer to it.

Domenico's fees for his first two murals at S. Egidio—44 florins for one and 60 florins for the other—were distinctly high for their time. In 1451 Andrea del Castagno agreed to paint the three frescoes on the east wall of S. Egidio for 100 florins (see Fortuna, 1957), and in 1462 Alesso Baldovinetti received only 20 florins for his *Nativity* in the courtyard of the SS. Annunziata (see Kennedy, 1938). One wonders, however, why the fee for the *Birth of the Virgin* was more than 25 percent higher than that for the *Meeting at the Golden Gate*. Possibly because the *Meeting*, occupying the lunette zone, was smaller. Or perhaps because in the *Birth* Domenico used oil, whereas he may not have done so in the *Meeting*. The latter explanation would find confirmation in the fact that on February 12, 1454 Paolo Uccello and Antonio di Papi received 10 florins more for a mural at S. Miniato al Monte than their contract called for because they had painted it "in oil, which they were not obliged [to do]" (see Fortuna, 1957).

More than a year after the completion of the *Birth of the Virgin*, on June 6, 1443, the total of all payments to Domenico Veneziano up to that time was carried over to a new ledger, including the 2 florins and 3 lire consigned to Piero della Francesca, but not the expenditures for lac, blue, and linseed oil. The latter, though charged to Domenico's expense account for materials, were paid directly to messengers or craftsmen. The total sum that Domenico had received—106 florins, 5 lire, and 7 soldi—was also entered in yet another account book, accompanied once more by the notation that he "is the painter who is painting the choir of S. Egidio."[8] Then on June 1, 1445 Domenico was issued one last payment of 10 florins. On the margin of the page facing the one on which the entry was made an accountant wrote after Domenico's death that if these 10 florins "were to remain debited, they are lost, because he left nothing" ("se restassi a ddare, sono perduti che non lasciò nulla"). The marginal note tells us that Domenico died bankrupt and that at the time of his death the hospital still considered the 10 florins he had received sixteen years earlier an outstanding debt. They must have been an advance for work on the *Marriage of the Virgin*, according to Vasari, the third of his murals, which Domenico had not done. Sometime after June 1, 1445 he evidently left his employment at S. Egidio and never returned.

Sixteen years later—on April 17, 1461, four weeks before Domenico's burial—the governor of the hospital of S. Maria Nuova made an agreement with Alesso Baldovinetti by which the latter bound himself to complete Domenico's unfinished fresco (document 7). Presumably, he did so. Nevertheless, the *Libro di Antonio Billi* and the *Codex Magliabecchiano*, and following them Vasari, wrote that Domenico's wall at S. Egidio remained unfinished because he was

murdered by Andrea del Castagno (see p. 4). How, we may ask, did they know that Domenico did not bring his frescoes to completion? The church of S. Egidio was the chapel not only of the hospital of S. Maria Nuova but also, until 1450, of the Florentine Company of St. Luke. Thus, for five years after Domenico Veneziano had abandoned his work in the chapel the painters of Florence were constantly visibly reminded that he had not finished his third fresco on the west wall. Later, probably in order to provide an explanation for this, the legend sprang up that Andrea del Castagno had murdered him, and it was in the context of this legend that the fact that Domenico failed to complete his murals was transmitted to the chroniclers of the sixteenth century (see p. 4).

In his agreement with the governor of the hospital Baldovinetti promised to conclude the *storia di Nostra Donna* left incomplete by Domenico Veneziano within a year and to donate his services to the hospital "for the love of God," perhaps in order to make good Domenico's debt of 10 florins and to offer some compensation for the fact that his master had left the composition unfinished for sixteen years—"by way of a sort of filial piety," as Kennedy (1938, n. 220) put it. Baldovinetti's assistants too were to receive from the hospital only their living expenses, and the hospital would, as was customary, bear all costs for colors, gilt, and whatever else might be required. The accountant who made the marginal note to the effect that the 10 florins of June 1, 1445 were still a debt seems to have known of Baldovinetti's agreement, for he used the subjunctive form ("restassi"), thereby saying that Domenico's advance of 10 florins are lost ("sono perduti") only if they *were to* remain a debt—in other words, that if Baldovinetti kept his promise to finish Domenico's mural the debt would be canceled.[9]

Baldovinetti's estimate that it would take him and his assistants a year to complete the *Marriage of the Virgin* suggests that Domenico had not progressed very far with it and that the painted execution of the work was due not to him but to Alesso.[10] The wording of the agreement confirms this. Baldovinetti promised to "conpiere et finire di dipignere una storia di Nostra Donna, cominciata per maestro Domenico da Vinegia." However, following *conpiere* the notary had at first written *uno*, and then crossed it out. Perhaps he was going to say "conpiere uno affresco," but then decided or was asked to be more specific and to add "et finire di dipignere." The use of both "conpiere" and "finire di dipignere" suggests that Domenico had not only failed to paint the mural but that he may not even have completed the design. The *sinopia* (Pl. 58) would seem to be all that he did.

With the painting of the *Marriage of the Virgin* the mural decoration of the choir of S. Egidio was finally concluded, almost a quarter of a century after it had been begun. After Domenico left the *Marriage* unfinished no activity on the walls of the chapel is recorded for more than five and one-half years. Then between January 1451 and September 1453 Andrea del Castagno painted the *Annunciation*, the *Presentation of the Virgin in the Temple*, and the *Death of the Virgin* on the east wall (see Giglioli, 1905). The north wall and the walls on either side of the entrance to the choir facing the nave and flanking the altar were decorated at an unknown date by Alesso Baldovinetti.[11]

Because we have so few works by Domenico Veneziano, the remnants of the S. Egidio murals deserve our close attention. The decorative band recovered in the vault of the choir consists of a garland of oak leaves tied with a ribbon, and above it a border with a simulated open-worked pattern, which is repeated in the decorative borders at the sides of the murals on the three walls (Pls. 167–168). Both the garland and the open-worked border are carefully

rendered so as to produce the effect of relief. The garland is a precursor of the wreath of palm leaves framing the arch of Domenico's *Baptist and Francis* at S. Croce (Pl. 146) and is an early example of a classicizing motif—it has its origin in Roman ceiling decoration (Pl. 169, see Horster, 1973)—frequently found in mid-quattrocento architectural decoration (as in the arches of the tomb of Leonardo Bruni and of the tabernacle in S. Miniato al Monte, and in the vault of the porch of the Pazzi Chapel) and occasionally, derived therefrom, in mural painting (Neri di Bicci's *St. John Gualberto and Other Saints* from the cloister of S. Pancrazio, and Giovanni di Francesco's lunette fresco over the entrance to the Spedale degli Innocenti).

The simulated marble paneling of the lowest zone of the west, north and east walls is about 1.70 m high and is identical with the imitation marble panels behind Baldovinetti's *Annunciation* in the Chapel of the Cardinal of Portugal at S. Miniato al Monte. Salmi (1947a) has given the design of the S. Egidio paneling to Domenico Veneziano. But since it would have been the last thing to be painted, one may assume, as Paatz (1940ff., II) has suggested, that it was carried out by the atelier of Baldovinetti. On the west and east walls there were originally six painted panels, each approximately 65 cm wide (Fig. 11).

The strips with feet, draperies, and bits of terrain from the west, north, and east walls were in very damaged, barely legible condition when they were first recovered (Pls. 161–166). It is no criticism of the careful and conscientious restoration of these fragments to admit that their present appearance provides scant evidence for their attribution to the masters employed at S. Egidio. Of the two pairs of feet from the north wall Salmi (1947a) has given that from the left side (Pl. 163) to Piero della Francesca, and that from the right (Pl. 164) to Baldovinetti. Aside from the visual difficulties, however, it is extremely unlikely that Piero could have been in Florence to participate in the decoration of the north wall. As far as we know, his presence at S. Egidio was confined to assisting Domenico Veneziano on the *Meeting at the Golden Gate* in 1439. We are on safer and visually not inconsistent ground if we follow the *Libro di Antonio Billi* and the *Codex Magliabecchiano,* and ascribe both fragments from the north wall to Baldovinetti.

The most important and most legible among the recovered fragments is the *sinopia* from the west wall (Pl. 58). It covers an area roughly 80 × 200 cm and depicts the profile outline of a female torso, with the left arm extended and the right held against the breast. To the left is a design composed of several straight lines that flare upward in a series of curves from a stem or holder. Behind and to the right of the figure are single and paired horizontal and diagonal lines. Salmi (1947a) has connected the style of the figure with the Glasgow *Judgment of Paris* (catalogue no. 27) and the Opper *Diana and Acteon* (catalogue no. 29), both of which he gives to Domenico Veneziano. The figure in the *sinopia* can be more profitably compared, however, with the Virgin in the *Annunciation* from the St. Lucy altarpiece (Pl. 127); and it is characteristic of Domenico that one of the orthogonals of the perspective construction of the *sinopia* (*TM* in Fig. 10) should define the front contour of the figure's neck.

As Berti (in Salmi et al., 1954) and Gioseffi (1962) have rightly concluded, the *sinopia* is probably Domenico Veneziano's preliminary drawing for the *Marriage of the Virgin,* and the strips below it (Pls. 161–162) the remnants of the fresco Baldovinetti agreed to paint in 1461. Confirmation for this is furnished by the fact that the agreement describes the work as being "on the side [of the choir] next to the cloister" ("dal lato di verso el chiostro"). There are structures in the form of cloisters on both sides of S. Egidio. However, that to the east, built by

Bicci di Lorenzo in 1422, is in fact a forecourt. The *chiostro* to which the agreement refers is undoubtedly the late-thirteenth or early-fourteenth-century cloister of the women's hospital of S. Maria Nuova known as the *chiostro delle ossa* to the west of the chapel (Fig. 24).[12] Gioseffi has identified the figure in the *sinopia* as the Virgin holding out her hand to receive the ring, and the design in front of her as either a bouquet of flowers or as a floral pattern on the brocade garment of the priest or on the front of the altar behind which he might have stood. Gioseffi has also drawn out a number of the diagonal lines of the *sinopia* in order to show that the floral motif was on the central axis of the composition. Finally, he has completed the central figure and, on the basis of the fresco strip below the *sinopia,* three other figures of attendant ladies, one of them after a drawing in the Fogg Art Museum attributed by Berenson to Pesellino. Although it is usual for the Virgin in depictions of the *sposalizio* to extend her right hand, in Domenico's *sinopia* she holds out her left, as she also does in predella panels of Fra Angelico's *Annunciations* at Cortona, Montecarlo, and in the Prado, and in the predella panel in the Museo di S. Marco (Pl. 59) from the Frate's Uffizi *Coronation of the Virgin,* which was originally installed on the choir screen of S. Egidio.[13] The figures of Mary in the *sinopia* and in the panel in the Museo di S. Marco also have in common the placement of the right arm *under* the left one (while in the *Marriage* panels of the Cortona, Montecarlo, and Prado *Annunciations* her right arm is placed *above* her left). It would be consistent with the similarities between the two figures that Domenico should have envisioned for his composition a scheme not unlike that of the Museo di S. Marco panel by Fra Angelico.

A good deal more can be done with the horizontal and diagonal lines of the *sinopia* than in Gioseffi's reconstruction. Four belong to the perspective scheme of the composition (Fig. 10): the orthogonals *JT* and *MT,* and the transversals *NO* and *PQ.* The rest are part of the architectural design of the background. However, the two orthogonals and two transversals yield sufficient data for completing the perspective system of the planned composition (Fig. 11). In all essentials it is identical with the perspective construction in the *sinopia* of Paolo Uccello's *Nativity* from S. Martino della Scala (Pl. 87). Its original width was approximately 450 cm, accommodating six simulated marble panels in the lowest zone of the wall. The perspective schemes in both *sinopie* are examples of the reformed bifocal system, a method of perspective projection used by painters throughout the fifteenth century (see p. 39).

Three pairs of diagonal lines on the right side of Domenico's *sinopia* suggest a sequence of steps (see Gioseffi, 1962), and this has prompted Meiss (1964) and Battisti (1971, I, p. 461, n. 35) to refer to the architectural setting sketched out in the *sinopia* as an "arena composition," such as that in the background of Donatello's bronze relief of the *Miracle of the Irascible Son*.[14] A more likely indication of Domenico's intentions may be provided by the *Marriage of the Virgin* from Fra Angelico's S. Egidio *Coronation of the Virgin* (Pl. 59). Its perspective staircase behind the Virgin would not be inconsistent, as Battisti has also suggested, with the diagonal lines at the right of Domenico's *sinopia.*

When Alesso Baldovinetti began working on the mural in 1461 he may well have continued to follow the arrangement of Fra Angelico's predella panel as his model. The portraits in the mural identified by Vasari—Bernadetto de' Medici,[15] Bernardo Guadagni,[16] and Folco Portinari[17]—are likely to have been among the suitors behind Joseph.[18] The extravagantly elegant ladies ("alcune femine con habiti in dosso vaghi, e graziosi fuor di modo, che si usavano in que' tempi") were probably the bridesmaids behind the Virgin. The bits of drapery

in the strips below the *sinopia* (Pl. 161) may be the remnants of their dresses. The ground in the fresco strip seems to be a meadow, as it is in the panel by Fra Angelico.

Of the two frescoes painted at S. Egidio by Domenico Veneziano, the *Meeting at the Golden Gate* seems to have had a landscape background like that of Domenico's Berlin *Adoration of the Magi* (see p. 19). Pudelko (1934) and Salmi (1938) have argued that the composition of the S. Egidio *Birth of the Virgin* is reflected in the mural of this subject in the Cappella dell' Assunta at the cathedral of Prato (see catalogue no. 43). But the evidence on which this suggestion is based—the relationship between the Prato *Birth* and the *Birth* painted shortly after 1433 by Leonardo da Besozzo at S. Giovanni a Carbonara in Naples (see Urbani, 1955), and the inference by Pudelko that Domenico, whose artistic origin he believed to be north Italian, would for that reason have depicted the *Birth* as Leonardo da Besozzo did—fails to establish a link between the two works.

Derivations from the murals by Domenico Veneziano and Alesso Baldovinetti have been recognized or proposed in a variety of works. Salmi (1936) thought that the drawing of a *Kneeling Woman* in the Uffizi (91F), who occurs again in the engraving of *Sardanopolis* in the *Cronaca* of Maso Finiguerra (see Colvin, 1898, Pl. 94; Giglioli, 1933), was taken from a figure in Domenico's *Birth of the Virgin*. Giovannozzi (1934) argued that the *Birth* may have contained a seated figure which was repeated at the left side of the *Birth* at Prato, in Benozzo Gozzoli's *Birth of Esau and Jacob* in the Campo Santo at Pisa, and in his *Miracle of St. Dominic* in the Brera. According to Pope-Hennessy (1939) Domenico's *Birth* influenced not only the composition of the same subject at Prato but also the *Birth of the Virgin* by the atelier of Sassetta in the Rothermere Collection. In his description of the S. Egidio *Birth* Vasari mentions a *putto* striking the door of the Virgin's chamber with a hammer ("un putto, che batte col martello l'uscio di detta camera con molto buona grazia"), and Meiss (1964) has recognized him as the source for the nude figure hammering shut the door of the tower in the Count Ugolino illustration of the Yates-Thompson Dante manuscript, a picture he has ascribed to Priamo della Quercia.

Salmi's thesis (1938) that the centralized buildings in the Prato *Disputation of St. Stephen* and in Lorenzo di Viterbo's *Marriage of the Virgin* in S. Maria della Verità at Viterbo depend from the mural of the *Marriage* at S. Egidio is invalidated for the former because the Prato *Disputation* was painted a decade and a half earlier than the S. Egidio *Marriage,* and for the latter because it is very unlikely, judging by the indications in Domenico's *sinopia,* that the mural which was painted over it by Baldovinetti contained a centralized building.[19] The suggestions of Gioseffi (1962) and Meiss (1964) that figural and spatial schemes in the frescoes at the Spedale della Scala in Siena presuppose the design of the *Marriage of the Virgin* at S. Egidio also encounter the problem of chronology: the Sienese murals were completed in 1444, seventeen years before Baldovinetti began painting the S. Egidio *Marriage.* In the latter, according to Vasari, there was the figure of a dwarf breaking a staff ("un Nano, che rompe una mazza, molto vivace"). Meiss (1959 and 1961a) was surely right in recognizing a derivation of this figure in the *Marriage of the Virgin* at I Tatti, though this work is not, as Meiss argued, by the Master of the Chiostro degli Aranci, but by the young Botticini.[20] Ragghianti (1935) believes that Domenico's S. Egidio murals influenced the architectural setting of the *Presentation of the Virgin in the Temple* in S. Francesco at Lucca, which he attributes to the young Domenico Ghirlandaio.

NOTES

1. Cennini (1933, pp. 35ff.) calls azurite *azzurro della Magna*, because "it occurs extensively in Germany," and lapis lazuli *azurro oltramarino*. On May 10, 1451 the account of Andrea del Castagno at S. Egidio was charged nearly 3½ florins for one ounce of lapis lazuli, and on June 5 of that year it was charged just under 16½ lire for fourteen ounces of azurite (see Fortuna, 1957, p. 65). According to an entry of May 10, 1463 in a ledger of the SS. Annunziata, the price at that time of a cheap variety of blue ("azzurro basso di Magna") was 11 soldi the ounce (see Kennedy, 1938, p. 242). The lowest price I have encountered for blue in quattrocento Florence—5 soldi an ounce—was paid by Baldovinetti on April 12, 1472, for five pounds of azurite for use as a base under a finer grade of blue ("per fare el letto sotto l'azzurro fine") in his murals in the choir of S. Trinita. The account books for these murals show that the average price per ounce of *azurro sottile* between 1471 and 1473 was 27 soldi (see Kennedy, 1938, pp. 246f.).

2. Blue was used in *buon fresco* by Sodoma, so Eve Borsook has kindly informed me, in the murals of the Life of St. Benedict which he began in 1505 at Monte Oliveto Maggiore.

3. It is difficult to be more specific about how far the work had advanced because we cannot be sure whether *a secco* passages were added during or only after the completion of *buon fresco* work (see Procacci, 1958 and 1961, and *The Great Age of Fresco,* 1968, pp. 22ff.).

4. This estimate is based on the figures of three shipments of gold leaf delivered to Baldovinetti at S. Trinita in June 1472: 1,700 pieces (*pezzi*) of *oro fine* on June 13 for 61 lire, 500 pieces on June 15 for 18 lire, and 4,000 pieces on June 23 for 128 lire, at the rate of 3 lire and 4 soldi per hundred (see Kennedy, 1938, pp. 246f.).

5. See Vasari-Frey, p. 127. The *affresco* technique had by Vasari's time largely been replaced by the *mezzo fresco* and *a secco* methods. As a historian rather than a practitioner, however, Vasari extolled the virtues of the true fresco tradition of the Early Renaissance.

6. See Kennedy (1938, pp. 101ff.). For a useful discussion of the differences among oil media used in the fifteenth century, see Constable (1963, pp. 84ff.).

7. There is no evidence for the opinion of Horne (1903) that "Domenico, no doubt, possessed the secret of some improvement upon the old method of painting in oil on walls." Kennedy (1938) noted that Domenico's purchase of six pounds of linseed oil would have been "hardly enough to paint the whole wall if it were used as a vehicle, [though] it may, of course, have been only one element in the composition of the medium, or it may have been used in the preparation of the *intonaco*" (n. 40). According to Cennini, however, oil played no part in the preparation of walls. A medium in which oil was "only one element" is also unlikely, since Cennini makes a clear distinction between colors mixed with water and with linseed oil. In regard to the latter he writes that "where you worked them up with water, you now work them up with this oil."

8. Hartt (1959, p. 177, n. 41) seems to be referring to this entry in listing a "large payment" to Domenico Veneziano "in 1443, month not specified." However, this entry does not record the making of a payment but is simply a bookkeeping operation. The same is true of the "payments" which, according to Hartt, Domenico received on September 7, 1439 (when a sum paid to the master on August 22 was transferred to another ledger), and on December 1, 1440 (when an entry was made for the total of the payments to Domenico up to that time, with the addition of an unaccounted for 3 soldi).

9. A comparable note was appended to a document in the *Libro di ricordi A* of S. Maria Nuova after the death of Andrea del Castagno. The document records that at the end of two years Andrea owed the hospital nearly 82 florins' worth of work. However, the marginal note states that the frescoes are finished and that the debt can be canceled ("e so finiti cppuossi chancellare"). Fortuna (1957) has interpreted this to mean that like Domenico, Andrea had left his wall unfinished, but later decided to go back and complete it.

10. At the time Baldovinetti agreed to finish Domenico's work he was engaged on the *Nativity* at the SS. Annunziata, which he began in May 1460 and completed in September 1462. He may have taken so long over it because following the death of Domenico he may have devoted his main efforts to the S.

Egidio *Marriage of the Virgin.*

11. The north wall is certified for Baldovinetti by the *Libro di Antonio Billi* and the *Codex Magliabecchiano* (see sources 9A and 10A). For his work on the outside walls of the entrance to the choir, on either side of the altar, we have a document of December 18, 1460 recording a payment of 8 florins to him for "cierte dipinture . . . intorno alla tavola dello altare maggiore;" Alesso's reference to "una storietta la quale io fo in san Gilio alato a l'altare maggiore" in his *Libro di ricordi A* (see Kennedy, 1938); Vasari's testimony that Baldovinetti painted the "facciata dinanzi; la quale fu in quel tempo molto lodata, perchè, fra le altre cose, vi era un Sant'Egidio, tenuto bellissima figura;" and the statement of Albertini (source 6A) that "alcune figure dinanzi sieno per mano de Alxo. Bal." Salmi's (1947a) claim that the figures mentioned by Albertini were in the foreground of the *Marriage of the Virgin* and that the St. Egidio to whom Vasari referred was one of the figures on the north wall is difficult to understand in view of the fact that *dinanzi* generally and unambiguously means "in front."

12. On the grounds that the cloister referred to in the phrase "dal lato di verso el chiostro" is Bicci di Lorenzo's forecourt, Kennedy (1938), Paatz (1940ff., II), Salmi (1947a and 1961), and Beccherucci (1950) concluded that Domenico decorated the east wall (Pls. 165–166), opposite his *sinopia*, and Castagno the west wall. Domenico's *sinopia*, according to Salmi, is a sketch for the *Birth of the Virgin*, which, Salmi contends, he painted in the middle register of the opposite wall.

13. The painting has been dated on stylistic grounds between ca. 1425 and after 1440. Orlandi (1964) has published a number of documents which would support the latter dating.

14. For a formal and iconographic analysis of Donatello's composition, see Seymour (1968).

15. For Bernardetto de' Medici, see Horne (1905). Vasari's reference to Bernardetto as *conestabile de' Fiorentini* is strictly speaking not correct. The term *conestabile* designates a military commander, which Bernardetto never was. However, in 1438 Cosimo de' Medici sent him to Lombardy as a *commissario* (civil commissioner) attached to Francesco Sforza, who was at that time the commander of the Venetian forces aiding Florence in the second war against Filippo Maria Visconti. Later, Bernardetto de' Medici and Neri Capponi were the *commissarii* for the Florentine troops in the victory over the Milanese at Anghiari on June 29, 1440.

16. Bernardo di Vieri Guadagni had a distinguished record as a public servant for the Florentine republic during the last decade of the fourteenth and the first quarter of the fifteenth centuries, serving as *gonfaloniere di giustizia* during the first two months of 1411 (see Passerini, 1873, pp. 42ff.).

17. Folco Portinari could be either the father of Dante's Beatrice and the founder (in 1286) of the hospital of S. Maria Nuova, or Folco d'Adoardo Portinari, who was manager of the home office of the Medici Bank from 1420 until his death in 1431 (see de Roover, 1966, pp. 232f.).

18. Kallab (1908, pp. 194ff.) has connected Vasari's interest in the portraits of quattrocento fresco cycles with his murals of the history of Florence on the ceiling of the Salone dei Cinquecento in the Palazzo della Signoria, which required him to depict members of noble Florentine families of the past. Battisti (1971, I) has suggested that the S. Egidio *Marriage* may have contained a portrait of Piero della Francesca which Vasari used as a model for the portrait of Piero in the second edition of the *Vite.* Ragghianti-Collobi (1949) and Pope-Hennessy (1966) have proposed that one or both of the portraits in the diptych in the Landolthaus at Zurich (catalogue no. 81) may be copies from this mural.

19. If there were a connection between the Viterbo *Marriage,* which was completed in 1469, and S. Egidio, it would be with Andrea del Castagno's *Presentation of the Virgin in the Temple,* in which Vasari described "drawn in perspective, an eight-sided free-standing temple in the middle of a square" (source 11D).

20. The I Tatti panel has been connected with Botticini by Longhi (1952) and Bellosi (1967). Berenson (1932) and Russoli (1962) gave it to Giovanni Boccati, Zeri (1961) to a Pollaiuolesque master, and Busignani (1970) to the shop of Verrocchio. For the implausibility of Meiss' attribution, see Chiarini (1961).

87. Frescoes on the Vault of the Sacristy of S. Maria at Loreto, ca. 1447.

In both editions of the *Vite* Vasari reported that Domenico Veneziano and Piero della Francesca collaborated on these lost murals (sources 11B and 11D). In the second edition Vasari wrote that the two artists worked at Loreto before Domenico came to Florence, that they left the frescoes unfinished because they feared the plague, and that the decoration of the vault was later completed by Signorelli.

It is not very likely that Vasari had seen the frescoes, since as far as we know he passed through Loreto only once, on his way from Rome to Ancona, on April 22, 1566 (see Kallab, 1908, p. 386). The sacristy in which Domenico and Piero would have worked was torn down in 1468 as part of a rebuilding program of the church ordered by Pope Paul II. The new, enlarged structure has two sacristies. The vaults of both have frescoes—one by Signorelli, the other by Melozzo da Forlì.

The plague struck in the Marches between 1447 and 1452 (see Calcagni, 1711, pp. 69ff.). If Vasari is right in saying that this was the reason why Domenico and Piero left their frescoes unfinished, the work that they did should probably be placed in 1447,[1] rather than prior to 1439, as has been suggested by Mancini (1917, p. 14, n. 5), Longhi (1927, p. 117) and Pudelko (1934).

NOTE

1. See Milanesi (in Vasari-Milanesi, II, p. 674, n. 1), Cavalcaselle (1892, pp. 131ff.), Colnaghi (1928), and Clark (1951 and 1969).

88. Frescoes in the Baglioni Palace in Perugia, 1437–38.

The lost murals were mentioned by Vasari in both the first and second editions of the *Vite* (see source 11D). According to the second edition, Domenico Veneziano, "before he came to Florence . . . had done . . . a room in the Baglioni Palace, which today is ruined. . . ." An analysis of the letter Domenico wrote to Piero de' Medici from Perugia on April 1, 1438 suggests that he had been in Perugia since March 1437 and that by the time he wrote the letter the Baglioni frescoes may have been completed (see p. 14).

The Baglioni Palace was destroyed in 1540 in order to make room for the fortification known as the Rocca Paolina. The former palace is depicted in the background of the late-fifteenth-century fresco of the *Siege of Perugia by Totilla* in the former Cappella de' Priori in the Galleria Nazionale dell'Umbria. Milanesi (in Vasari-Milanesi, II) identified the lost frescoes with a cycle of twenty-five *uomini illustri* in the courtyard (*atrio*) of the palace for which epitaphs were composed by the Perugian chronicler and humanist Francesco Maturanzio (see Fabretti, 1842, pp. 43ff.). But this is very unlikely, first because Vasari specifically says that the frescoes were in a room (*camera*) rather than in the courtyard, and secondly because it seems impossible that the formal repertory of a series of monumental figures could have had the influence

that Domenico Veneziano's murals did on the painters of Perugia and Siena (see pp. 16–17). A more plausible proposal for Domenico's frescoes is that they were the decoration of a *camera degli sposi* commissioned for the wedding of Braccio Baglioni in April 1437 (Kennedy, 1938, n. 26).

Exception has also been taken to Milanesi's identification of the lost murals by Bombe (1909) on the grounds that Francesco Maturanzio, the author of the epitaphs for the *uomini illustri* series, was not born until 1443, and that one of the notables portrayed, Carlo Fortebraccio, did not die until 1479. These objections have been met by Santi (1970), who has argued that the epitaphs could have been composed after the figures had been painted, and that unlike other Umbrian quattrocento cycles of *uomini illustri*—for example, at the Palazzo Trinci in Foligno or the Palazzo Ducale in Urbino—the series in the Baglioni Palace included only living or historically real persons. Yet Santi's attempt to revive Milanesi's thesis cannot, for the reasons I have stated, be sustained.

Specifically, Santi has identified as a remnant of the cycle of *uomini illustri,* and as a work by Domenico Veneziano, a monumental fresco fragment of a *Man in Armor,* measuring 324 × 131 cm, recently installed in the Galleria Nazionale dell'Umbria (Pl. 228). Below the figure are the remains of an inscription, of which the following is legible:

	O DISIOI OE
AMARE	ESTRATO
EL SIONO P	EN RE
LIO V	SSOI

The figure was identified by Bombe (1909 and 1917, p. 81), Gnoli (1923, p. 97), Van Marle (X) and Gamba (1949, p. VII) as Ruggero Cane Ranieri, but Santi has shown that this cannot be correct. The fresco was found in the Rocca Paolina and was first recorded in 1872. It is severely damaged. An inventory of 1878 describes it as "in cattivo stato." At an unknown date it was detached and transferred to canvas. In 1969 it was cleaned, repaired and transferred to a new canvas by Giovanni Macini.

Santi has argued in support of his ascription that "the monumental stance [*impianto*] and the high quality of the geometric conception of the figure can only be attributed to a master whose Uccellesque experience could be explained by the association which Domenico had at about that time begun with Paolo di Dono, confirming the stylistic and chronological course of the painter already proposed by Salmi, who places in the early career of Domenico the Carnesecchi Tabernacle." Clearly, Santi is reaching for straws, both in his interpretation of the style of the remains of the mural and in his characterization of the early work of Domenico Veneziano. The visual evidence of the fresco is simply not sufficient to warrant an attribution, and Santi's reference to an alleged relationship between Domenico and Uccello does not provide a workable criterion for assessing Domenico's capabilities in a large-scale figural composition of 1437–38.

PLATES

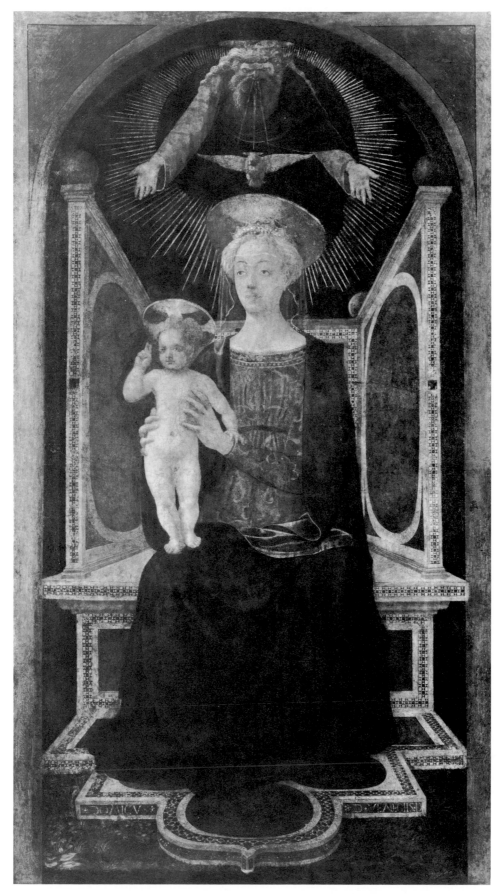

Pl. 1. Domenico Veneziano, Carnesecchi Tabernacle, London, National Gallery, *Madonna and Child Enthroned*.

Pl. 2. Domenico Veneziano, Carnesecchi Tabernacle, *Head of a Bearded Saint.*

Pl. 4. Domenico Veneziano, Carnesecchi Tabernacle, signature.

Pl. 3. Domenico Veneziano, Carnesecchi Tabernacle, *Head of a Beardless Saint.*

Pl. 5. Domenico Veneziano, Carnesecchi Tabernacle, signature.

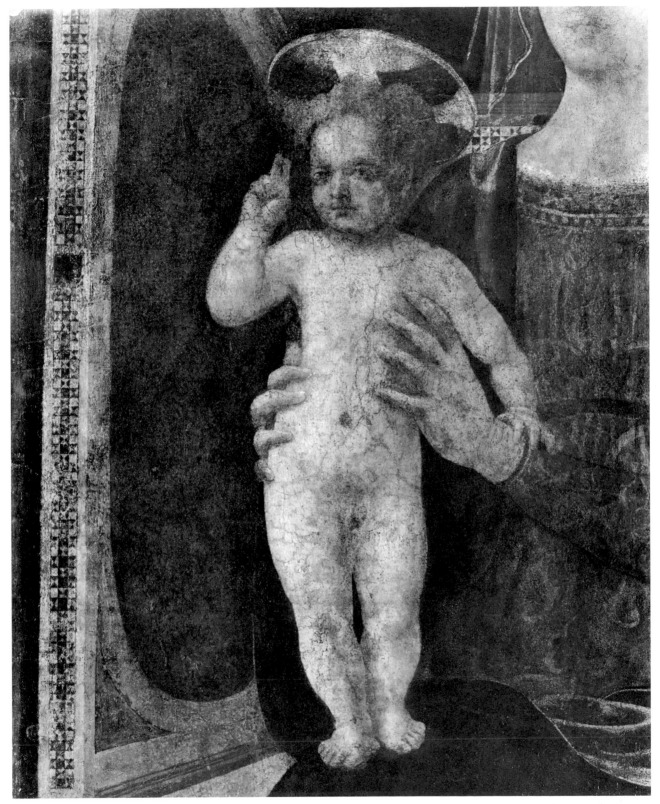

Pl. 6. Domenico Veneziano, Carnesecchi Tabernacle, Christ child.

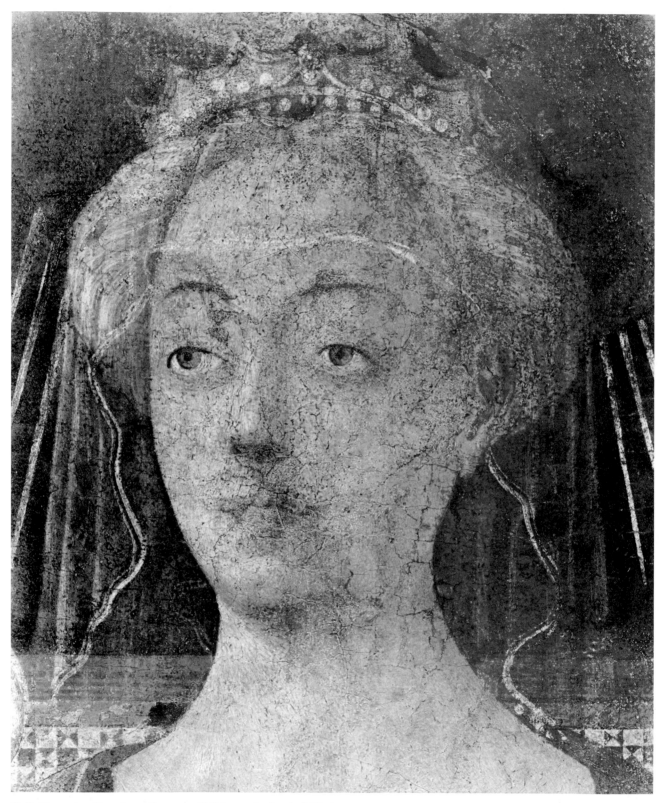

Pl. 7. Domenico Veneziano, Carnesecchi Tabernacle, head of Virgin.

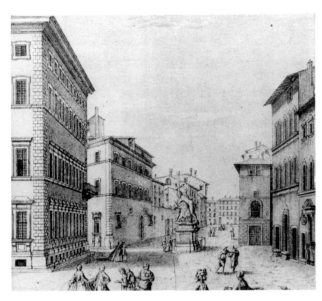

Pl. 8. Giuseppe Zocchi, the Canto de' Carnesecchi in 1754.

Pl. 9. Masaccio, *Trinity,* Florence, S. Maria Novella.

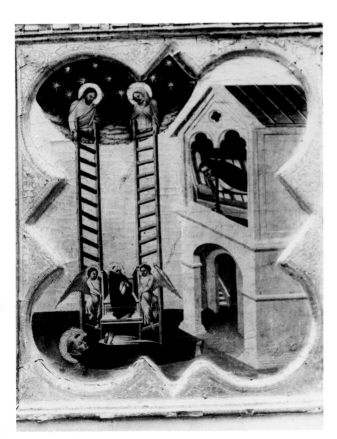

Pl. 10. Francesco Traini, *St. Dominic Carried to Heaven by Angels,* Pisa, Museo di San Matteo.

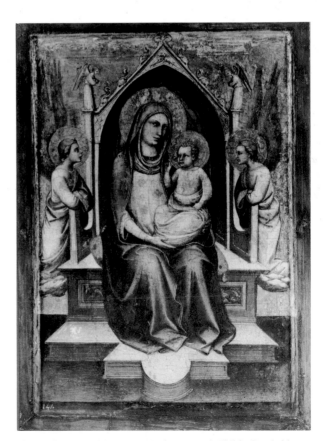

Pl. 11. Lorenzo Monaco, *Madonna and Child,* Cambridge, Fitzwilliam Museum.

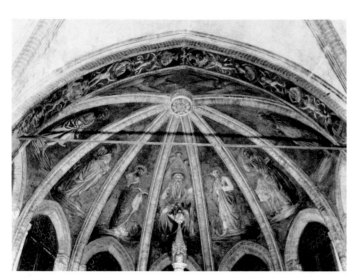

Pl. 12. Andrea del Castagno and Francesco da Faenza, vault frescoes, Venice, S. Tarasio.

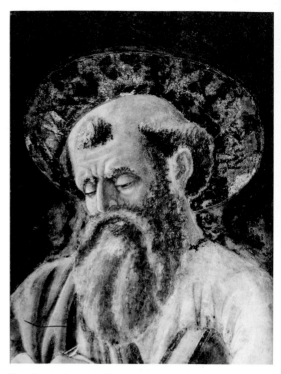

Pl. 13. Andrea del Castagno, *St. John the Evangelist*, Venice, S. Tarasio, head.

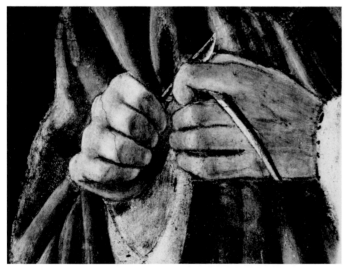

Pl. 14. Andrea del Castagno, *St. John the Evangelist*, hands.

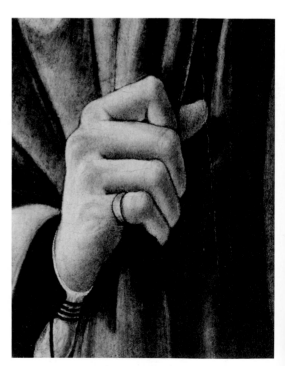

Pl. 15. Andrea del Castagno, *Portrait of a Man*, Washington, National Gallery of Art, Mellon Collection, right hand.

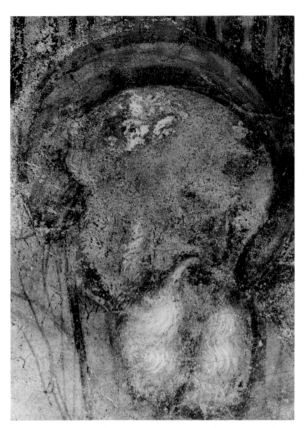

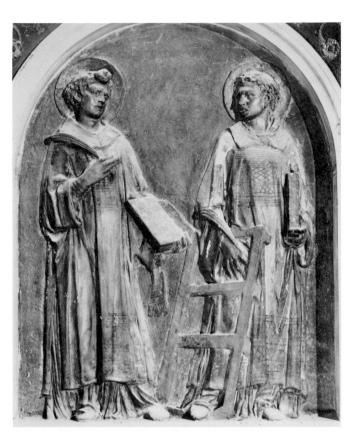

Pl. 16. Masolino, *The Naming of St. John the Baptist*, Castiglione d'Olona, Baptistry, head of Zacharias.

Pl. 17. Donatello, *Sts. Stephen and Lawrence,* Florence, S. Lorenzo, *sagrestia vecchia.*

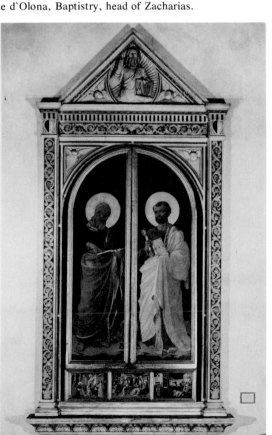

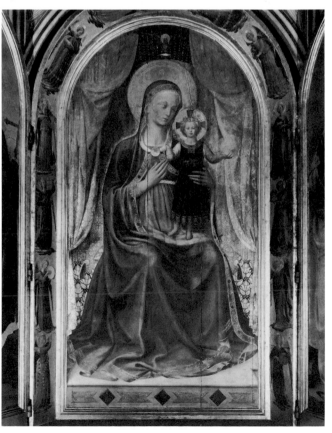

Pl. 18. Fra Angelico, Linaiuoli Tabernacle, Florence, Museo di S. Marco, *Sts. Paul and Peter.*

Pl. 19. Fra Angelico, Linaiuoli Tabernacle, *Madonna and Child*.

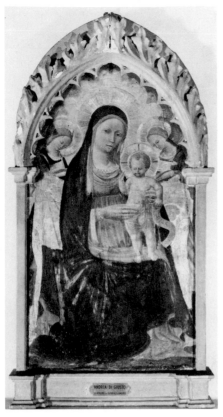

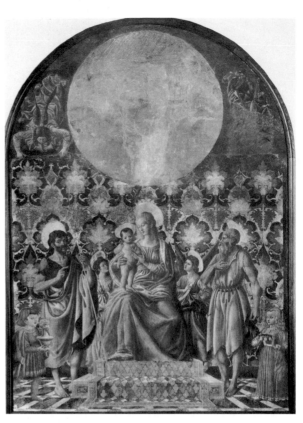

Pl. 20. Andrea di Giusto, *Madonna and Child with Two Angels*, Florence, Accademia.

Pl. 21. Master of the Trebbio fresco, *sacra conversazione*, Florence, Palazzo della Signoria.

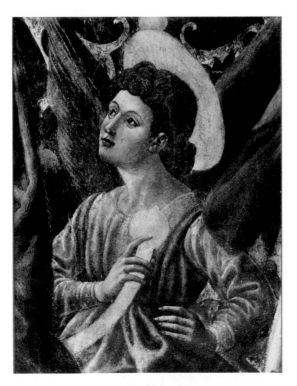

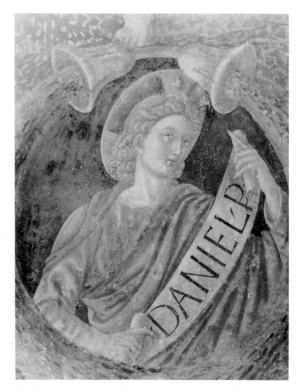

Pl. 22. Master of the Trebbio fresco, *sacra conversazione*, Angel.

Pl. 23. Master of the Trebbio fresco, *Daniel*, Venice, S. Tarasio.

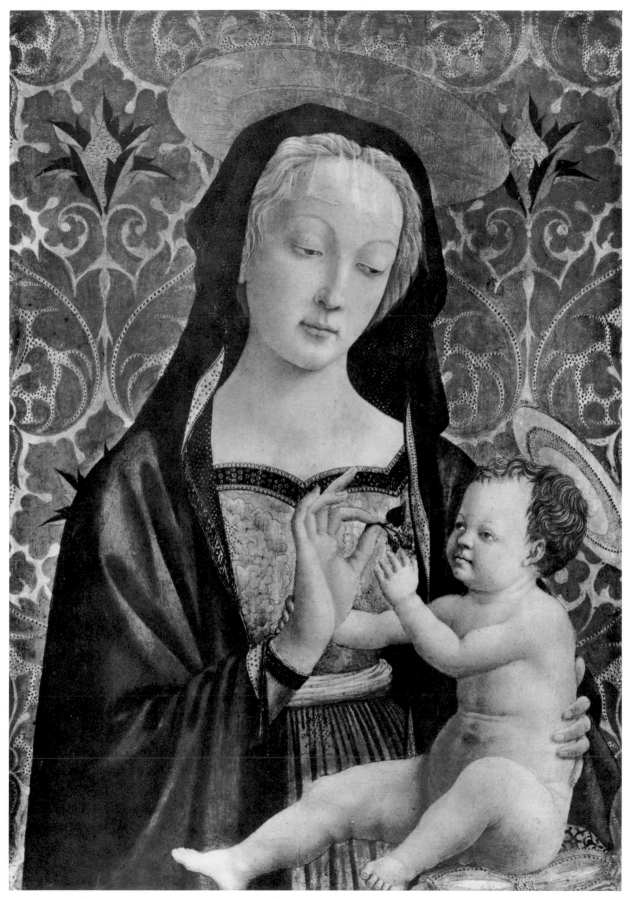

Pl. 24. Domenico Veneziano, *Madonna and Child,* Settignano, Villa I Tatti.

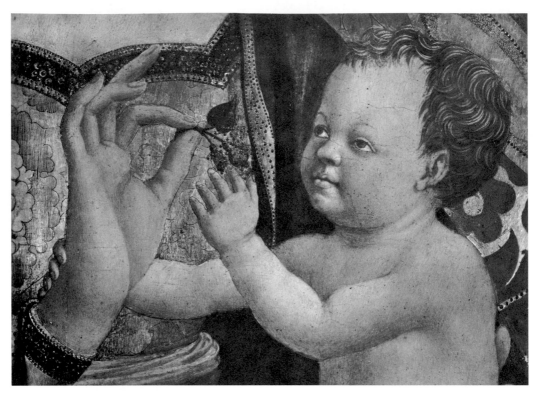

Pl. 25. Domenico Veneziano, *Madonna and Child,* head of Christ child.

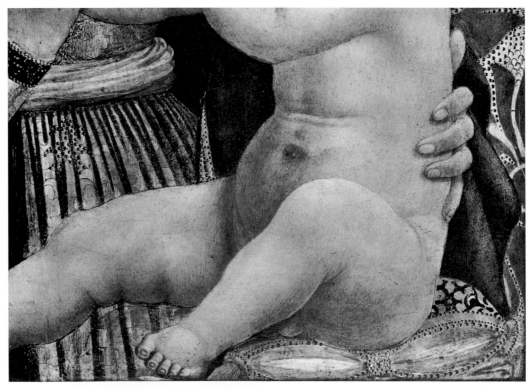

Pl. 26. Domenico Veneziano, *Madonna and Child,* body of Christ child.

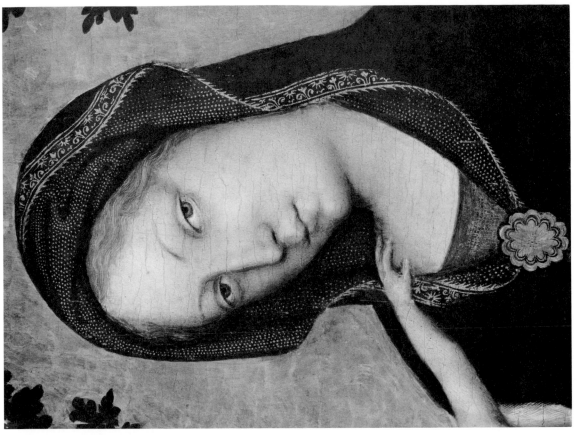

Pl. 28. Gentile da Fabriano, *Madonna and Child with Saints and Donor*, Berlin-Dahlem, Gemäldegalerie, head of Virgin.

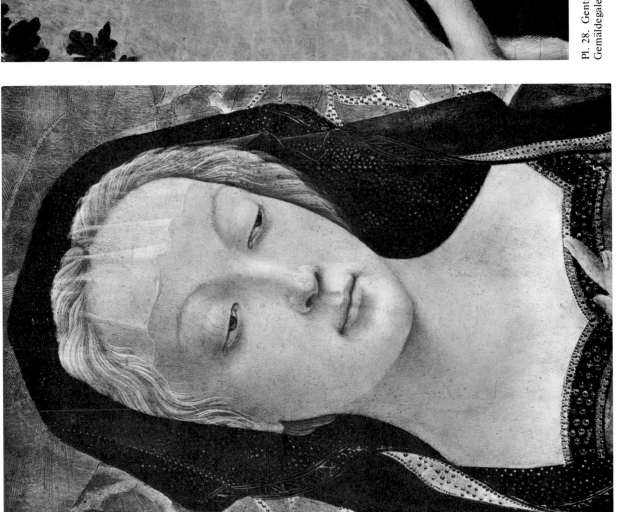

Pl. 27. Domenico Veneziano, *Madonna and Child*, head of Virgin.

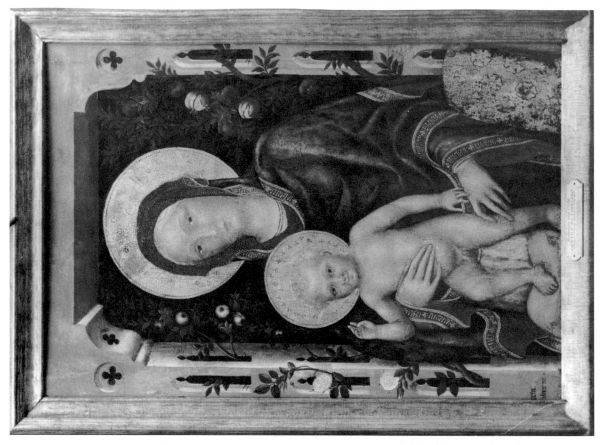

Pl. 30. Gentile da Fabriano, *Madonna and Child*, New Haven, Yale University Art Gallery.

Pl. 29. Luca della Robbia, *Cantoria*, Florence, Museo dell'Opera del Duomo, Players on Psaltery, *putto*.

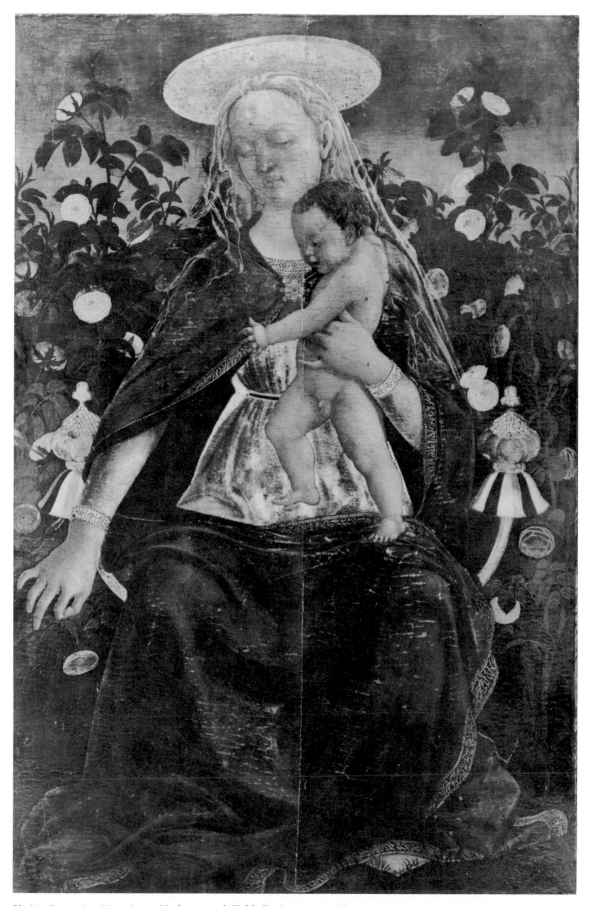

Pl. 31. Domenico Veneziano, *Madonna and Child,* Bucharest, Art Museum of the Romanian People's Republic.

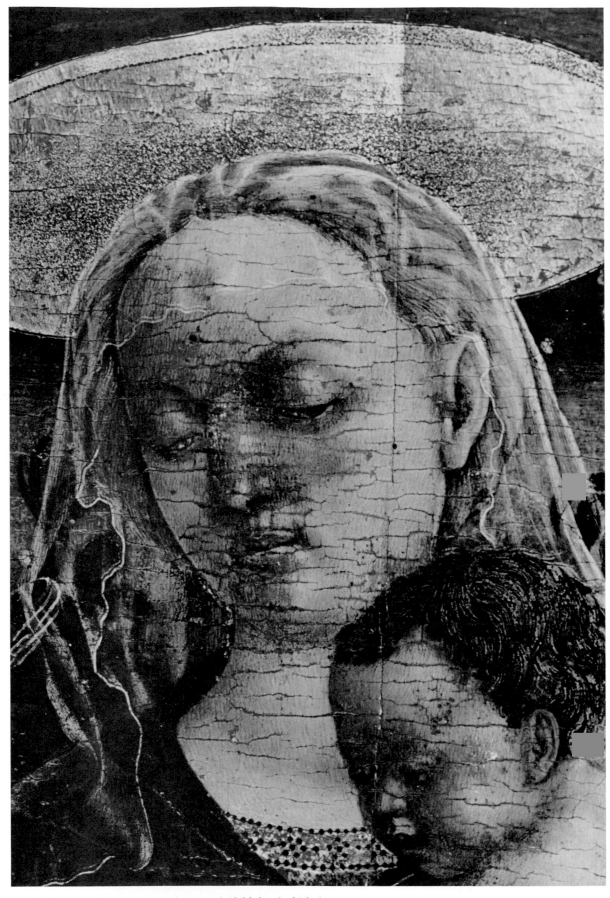

Pl. 32. Domenico Veneziano, *Madonna and Child*, head of Virgin.

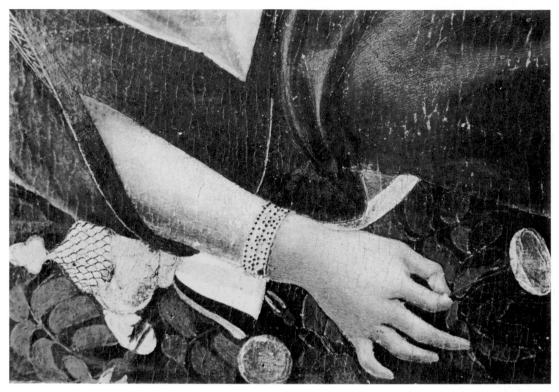

Pl. 34. Domenico Veneziano, *Madonna and Child*, hand of Virgin.

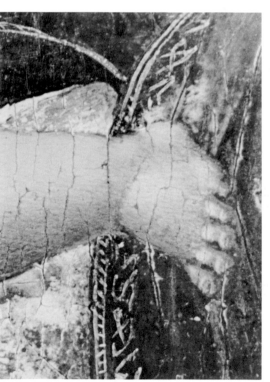

Pl. 33. Domenico Veneziano, *Madonna and Child*, foot of Christ child.

Pl. 37. Master of the Trebbio fresco, *putto*, Venice, S. Tarasio.

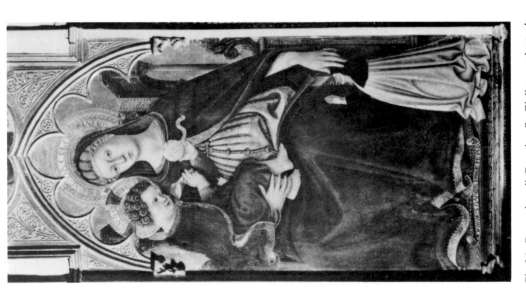

Pl. 36. Domenico di Bartolo, S. Giuliana polyptych, Perugia, Galleria Nazionale dell'Umbria, Madonna and Child.

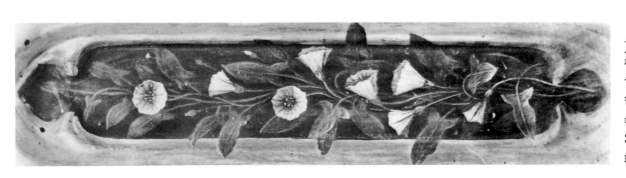

Pl. 35. Gentile da Fabriano, *The Adoration of the Magi*, Florence, Uffizi, convolvulus.

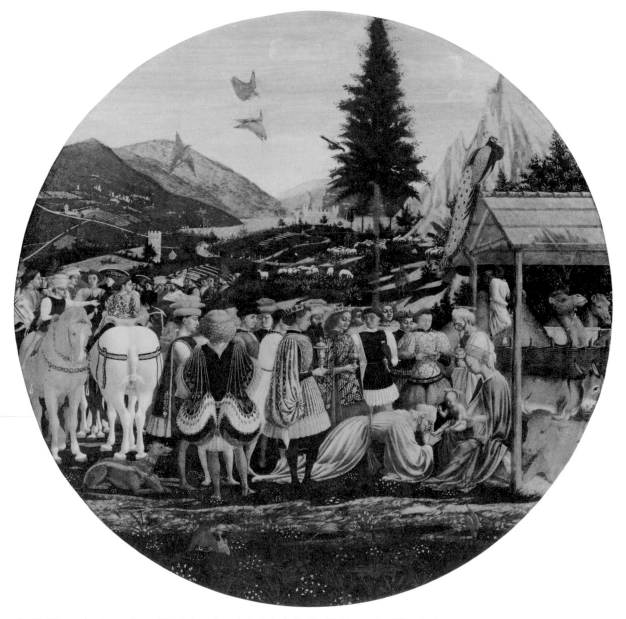

Pl. 38. Domenico Veneziano, *The Adoration of the Magi,* Berlin-Dahlem, Gemäldegalerie.

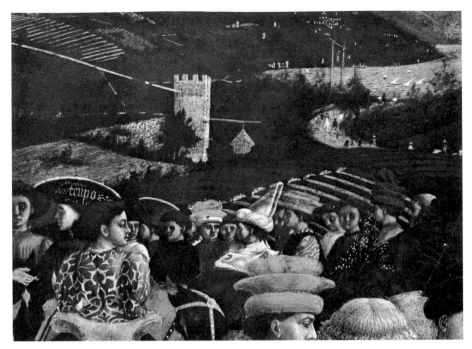

Pl. 39. Domenico Veneziano, *The Adoration of the Magi,* rear of cortège.

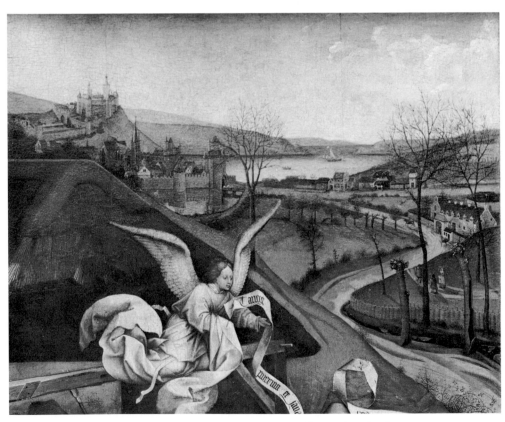

Pl. 39A. Master of Flémalle, *The Nativity,* Dijon, Musée des Beaux Arts, landscape.

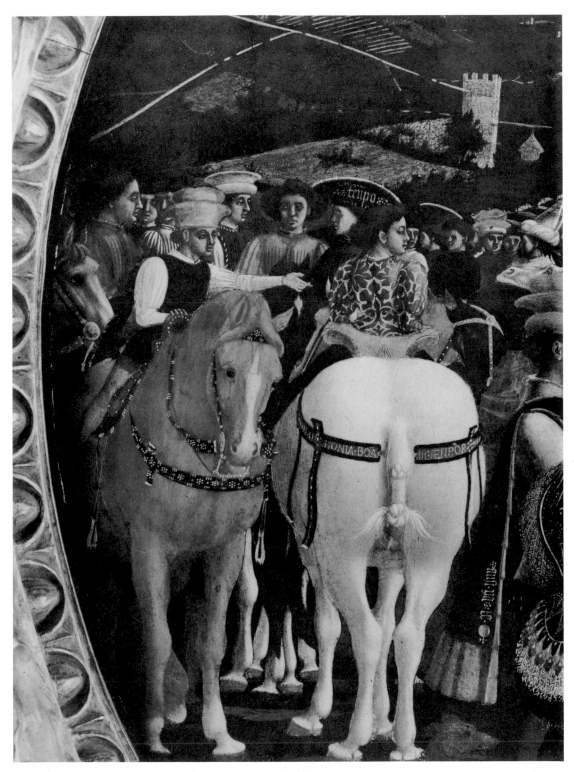

Pl. 40. Domenico Veneziano, *The Adoration of the Magi*, riders.

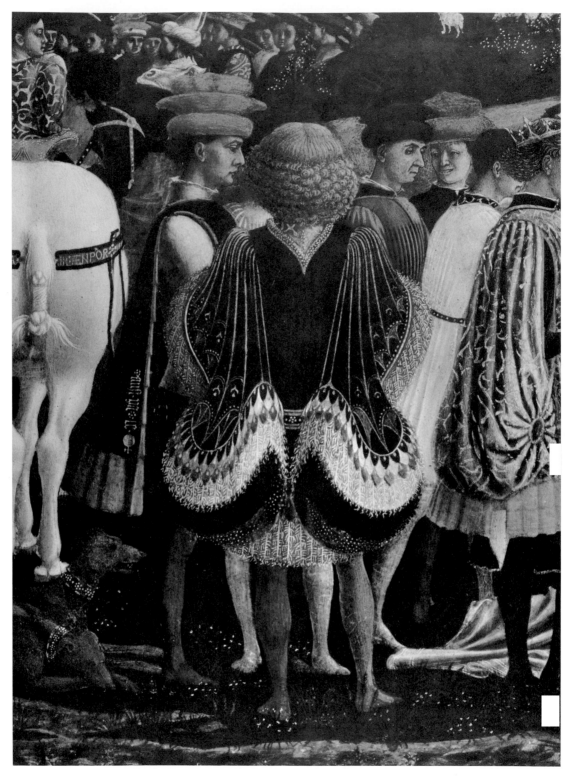

Pl. 41. Domenico Veneziano, *The Adoration of the Magi,* standing figures.

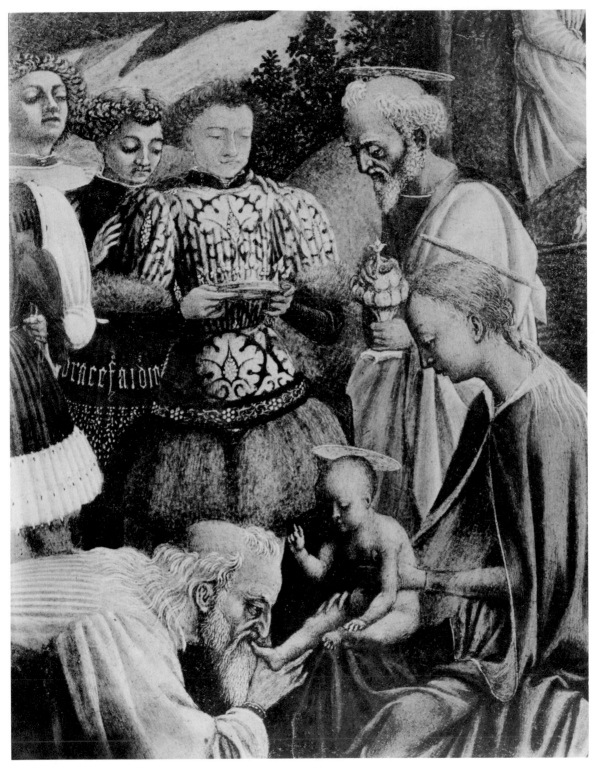

Pl. 42. Domenico Veneziano, *The Adoration of the Magi,* Virgin and Child.

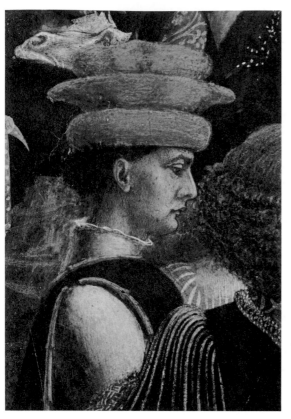

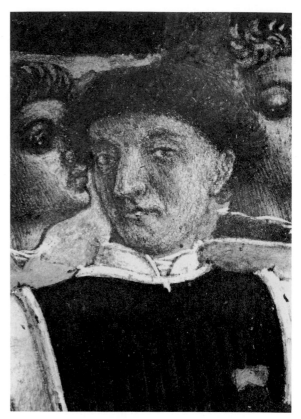

Pl. 45. Domenico Veneziano, *The Adoration of the Magi,* profile head.

Pl. 44. Domenico Veneziano, *The Adoration of the Magi,* portrait of Piero de' Medici.

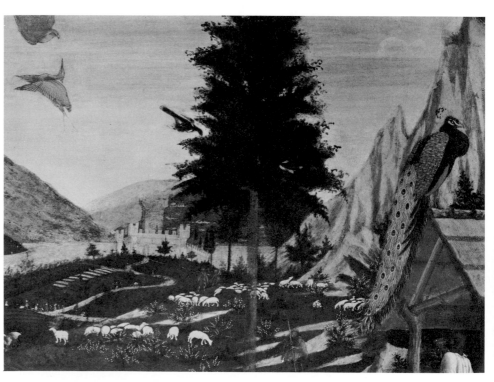

Pl. 43. Domenico Veneziano, *The Adoration of the Magi,* landscape with tree.

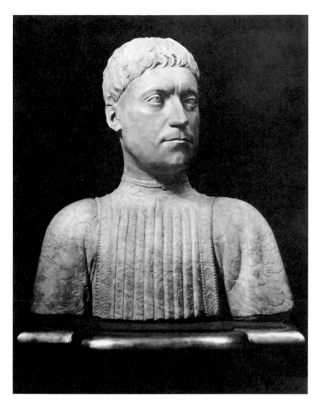

Pl. 46. Mino da Fiesole, *Piero de' Medici,* Florence, Bargello.

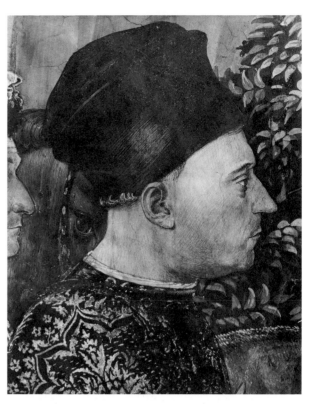

Pl. 47. Benozzo Gozzoli, *The Journey of the Magi,* Florence, Medici Palace, portrait of Piero de' Medici.

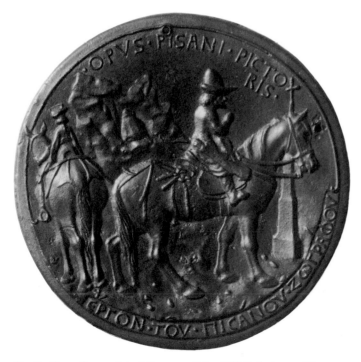

Pl. 49. Pisanello, medal of Emperor John VIII Paleologus, Florence, Bargello.

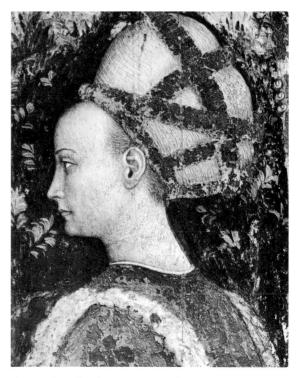

Pl. 48. Pisanello, *St. George and the Princess,* Verona, S. Anastasia, head of princess.

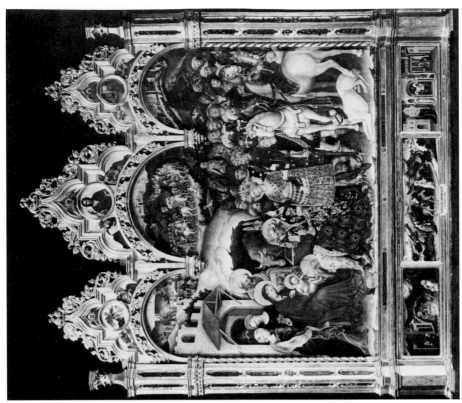

Pl. 51. Gentile da Fabriano, *The Adoration of the Magi*, Florence, Uffizi.

Pl. 50. Donatello, *St. John on Patmos*, Florence, S. Lorenzo, *sagrestia vecchia*.

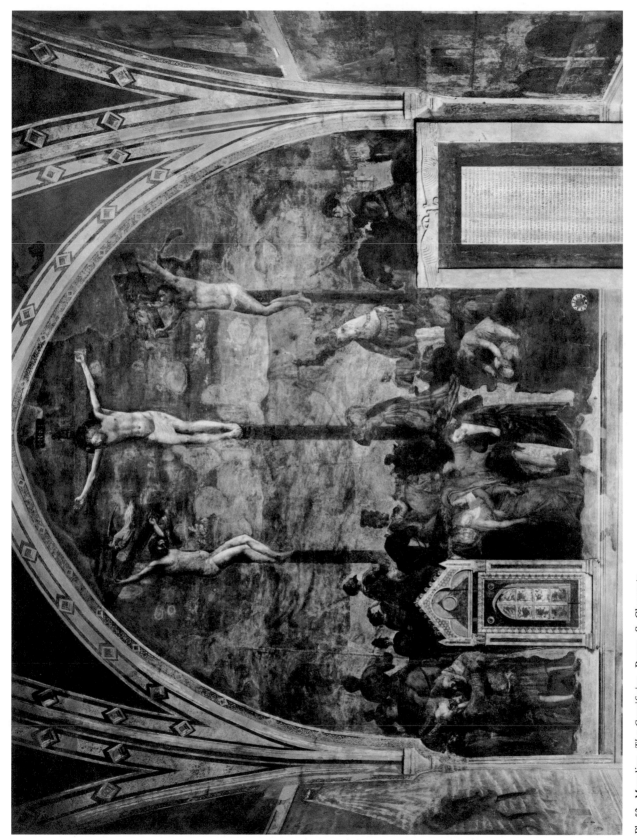

Pl. 52. Masolino, *The Crucifxion*, Rome, S. Clemente.

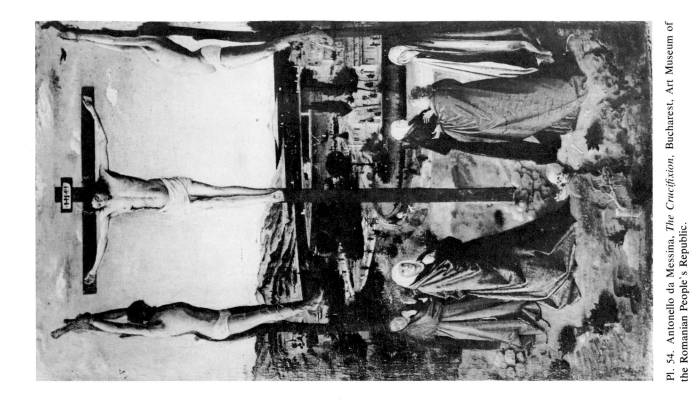

Pl. 54. Antonello da Messina, *The Crucifixion*, Bucharest, Art Museum of the Romanian People's Republic.

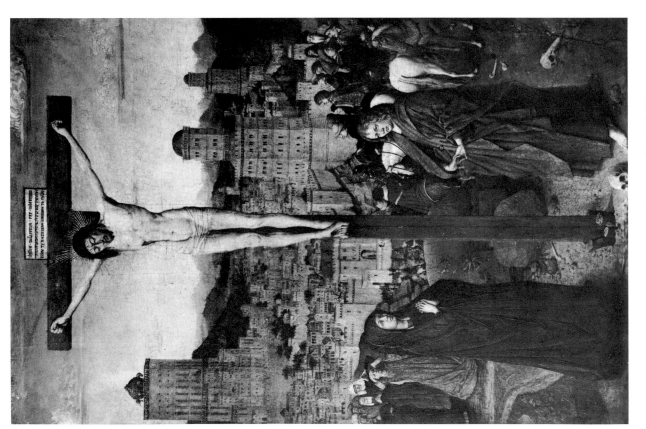

Pl. 53. Follower of Jan van Eyck. *The Crucifixion*, Venice, Ca' d'Oro.

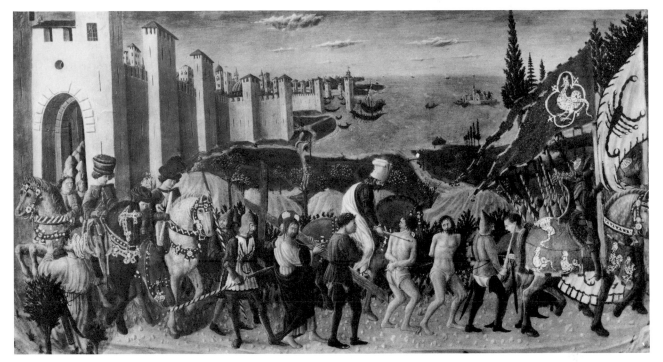

Pl. 55. Giovanni Boccati, *The Way to Calvary,* Perugia, Galleria Nazionale dell'Umbria.

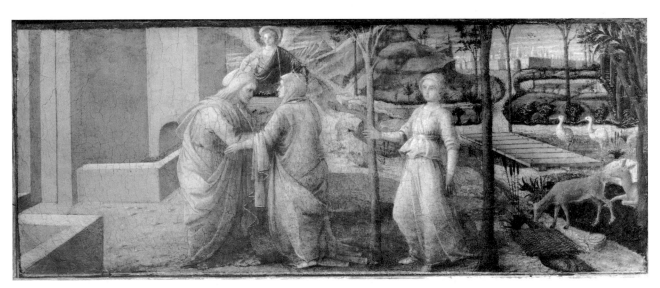

Pl. 57. Fra Filippo Lippi, *The Meeting at the Golden Gate,* Oxford, Ashmolean Museum.

Pl. 56. Domenico di Bartolo, *Pope Celestine III Granting the Hospital Its Charter*, Siena, Spedale della Scala.

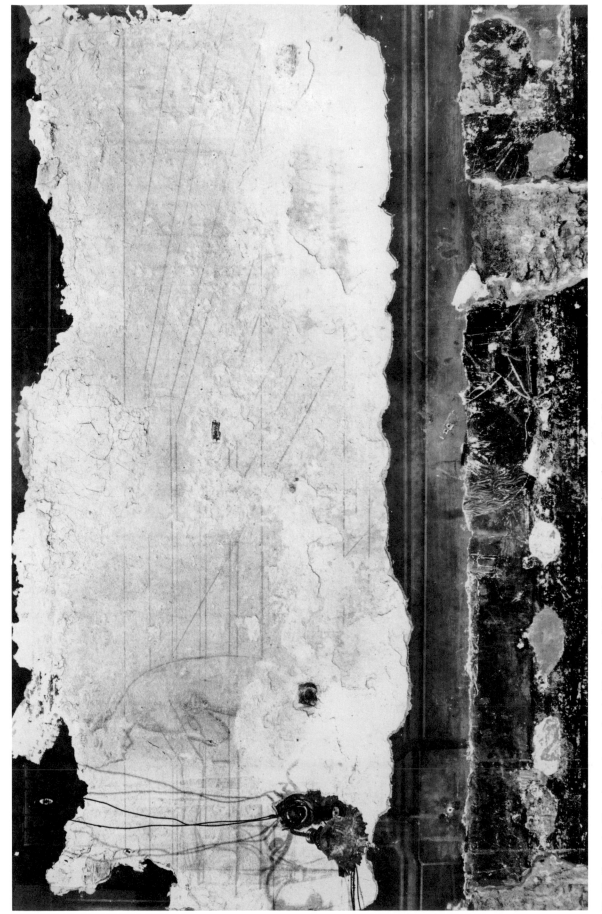

Pl. 58. Domenico Veneziano, *sinopia* for the *Marriage of the Virgin*, Florence, Soprintendenza alle Gallerie.

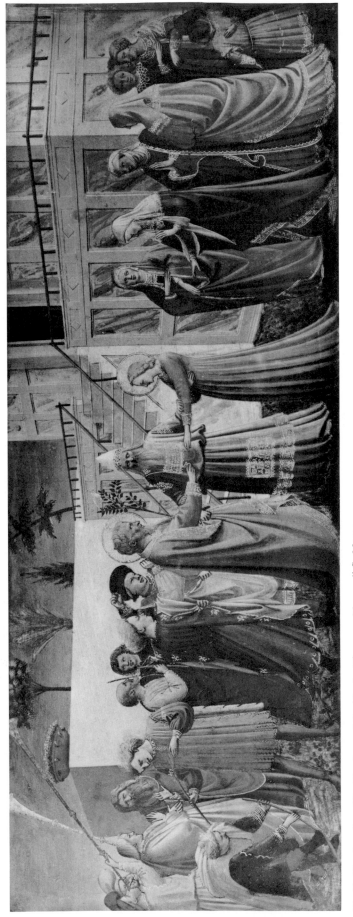

Pl. 59. Fra Angelico, *The Marriage of the Virgin*, Florence, Museo di S. Marco.

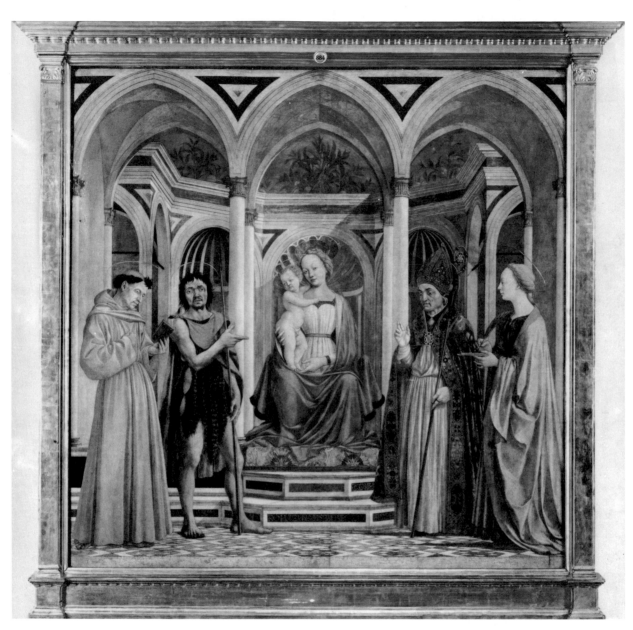

Pl. 60. Domenico Veneziano, St. Lucy Altar, Florence, Uffizi.

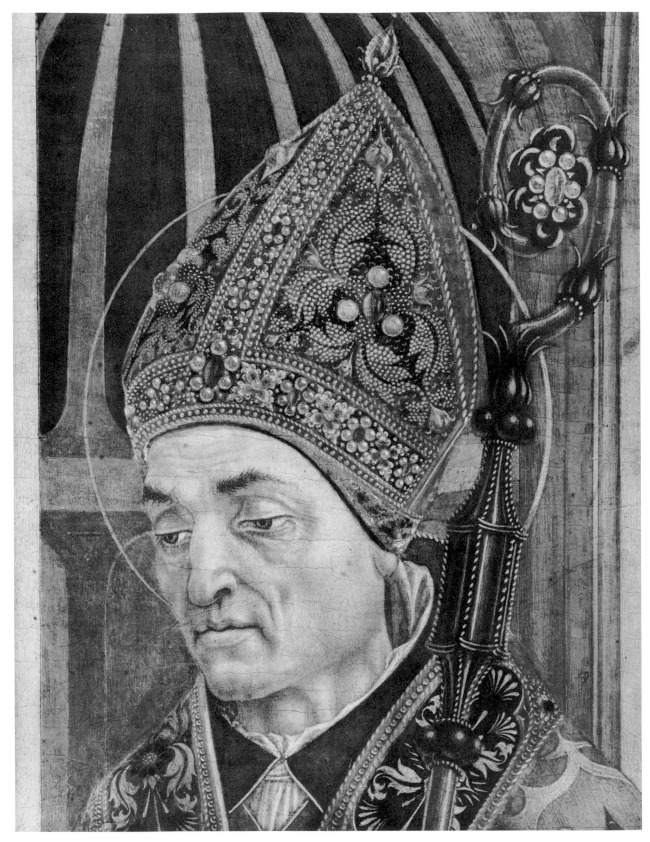

Pl. 61. Domenico Veneziano, St. Lucy Altar, head of St. Zenobius.

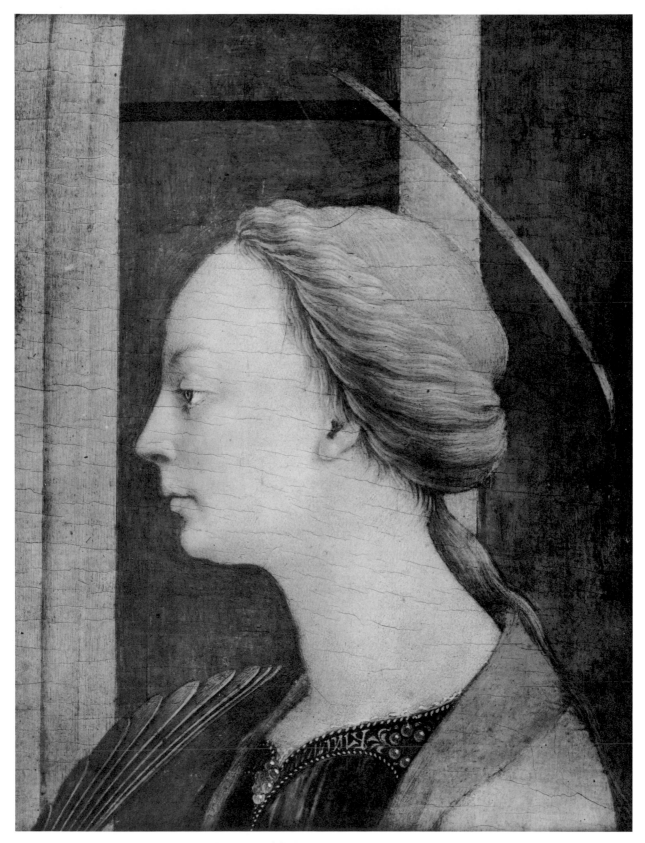

Pl. 62. Domenico Veneziano, St. Lucy Altar, head of St. Lucy.

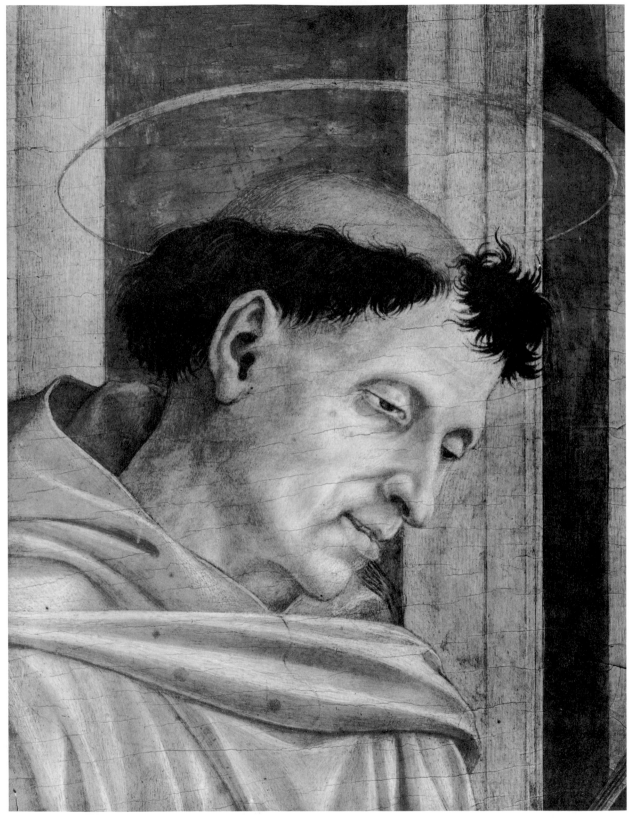

Pl. 63. Domenico Veneziano, St. Lucy Altar, head of St. Francis.

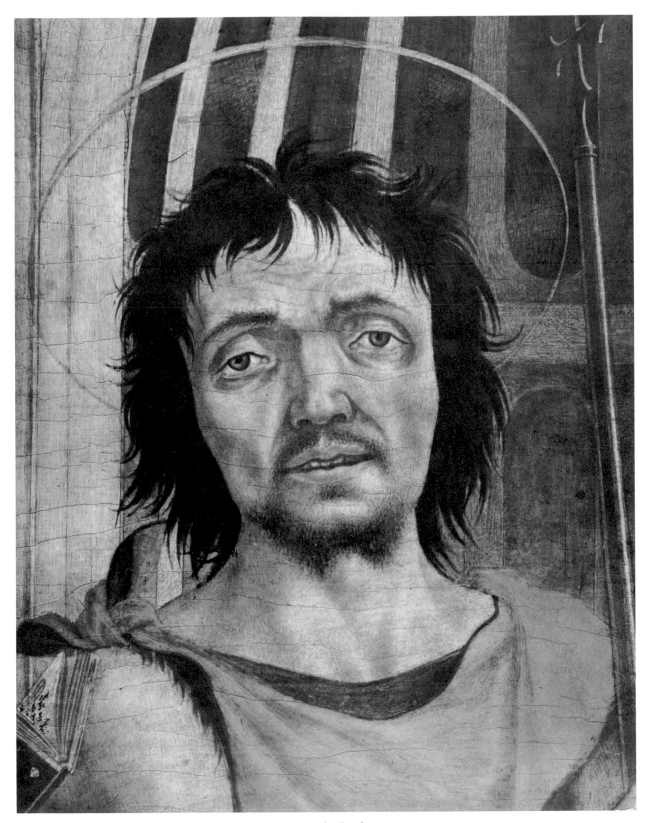

Pl. 64. Domenico Veneziano, St. Lucy Altar, head of St. John the Baptist.

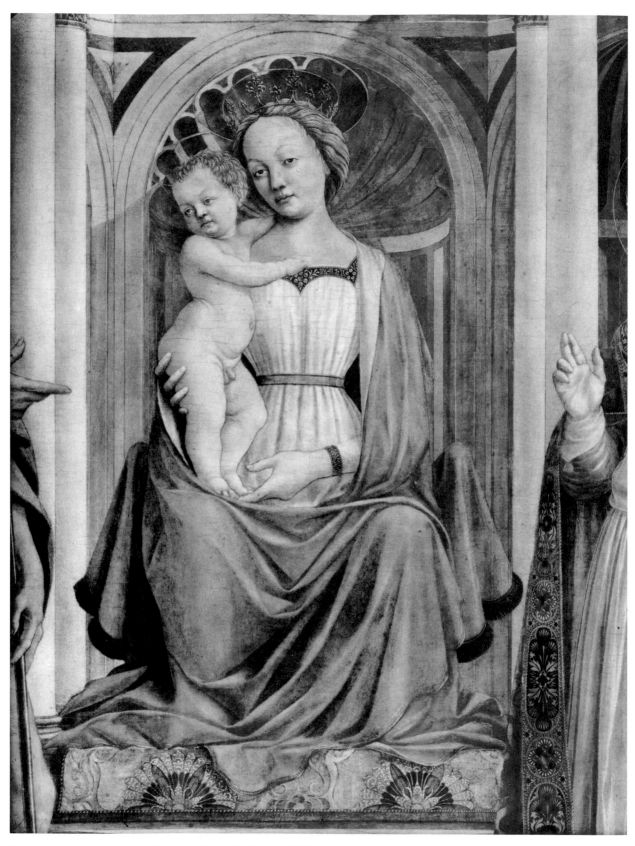

Pl. 65. Domenico Veneziano, St. Lucy Altar, Virgin and Child.

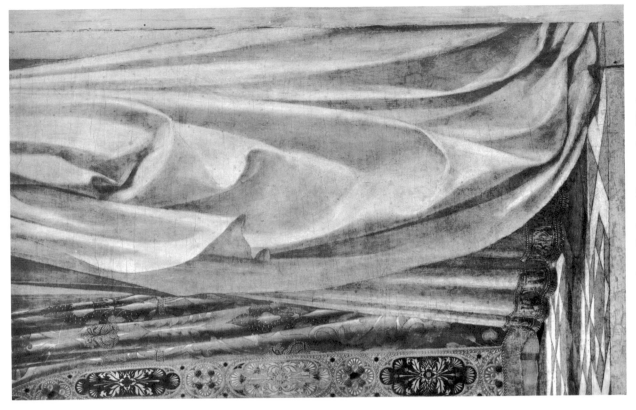

Pl. 67. Domenico Veneziano, St. Lucy Altar, mantle of St. Lucy.

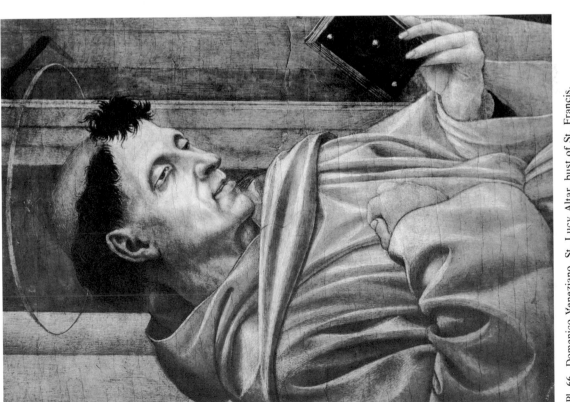

Pl. 66. Domenico Veneziano, St. Lucy Altar, bust of St. Francis.

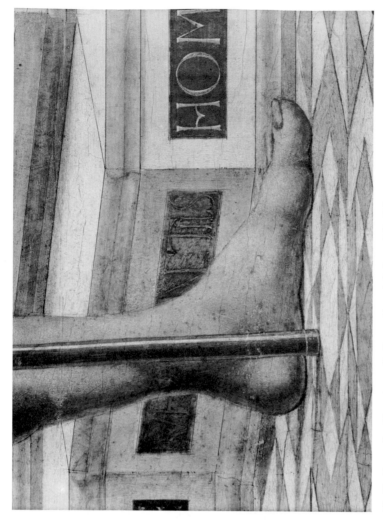

Pl. 69. Domenico Veneziano, St. Lucy Altar, left foot of St. John.

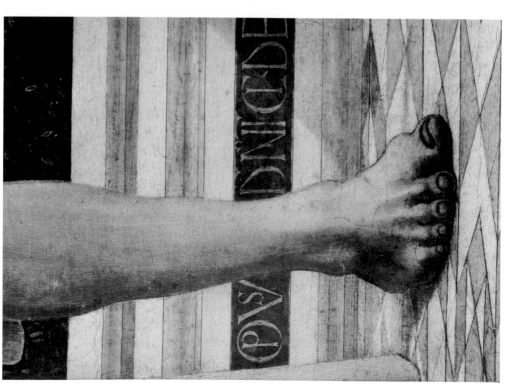

Pl. 68. Domenico Veneziano, St. Lucy Altar, right foot of St. John.

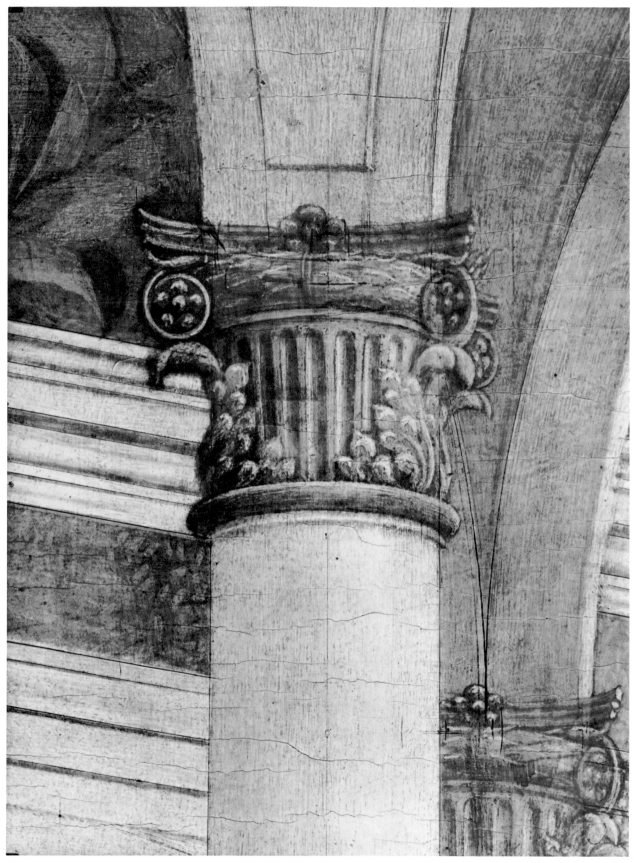

Pl. 70. Domenico Veneziano, St. Lucy Altar, capital of loggia.

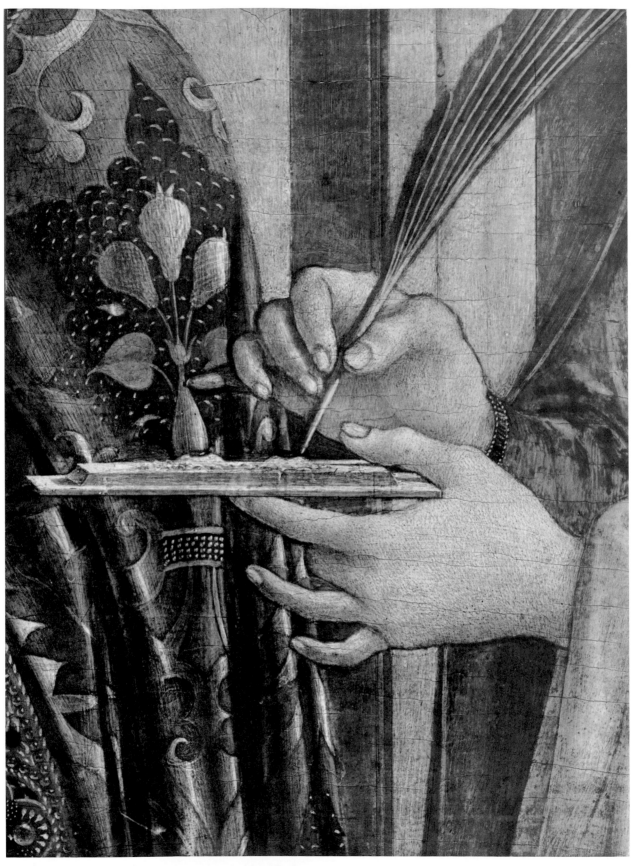

Pl. 71. Domenico Veneziano, St. Lucy Altar, hands of St. Lucy.

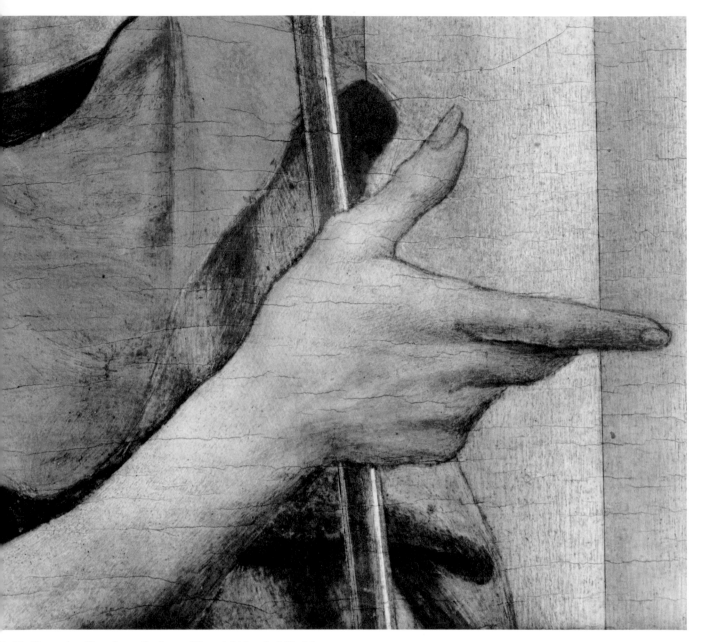

l. 72. Domenico Veneziano, St. Lucy Altar, right hand of St. John.

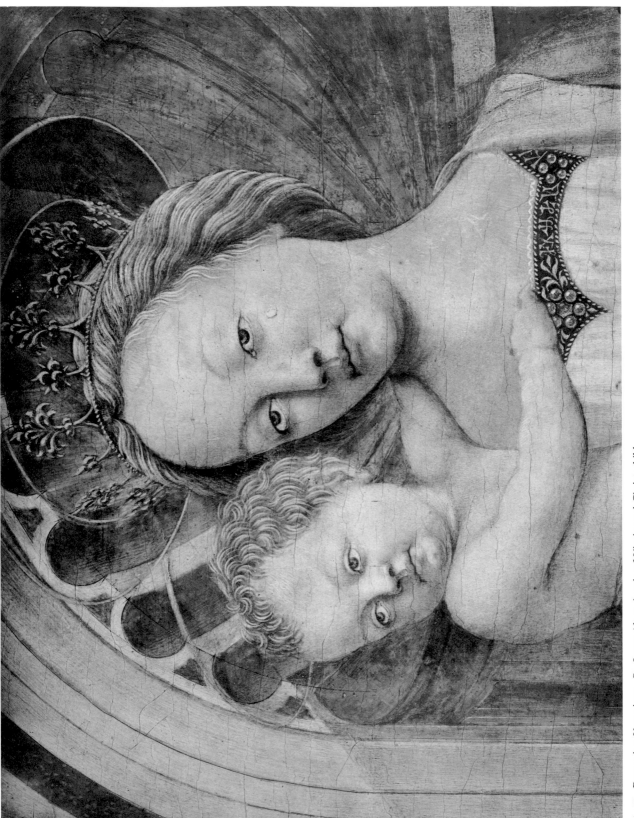

Pl. 73. Domenico Veneziano, St. Lucy Altar, heads of Virgin and Christ child.

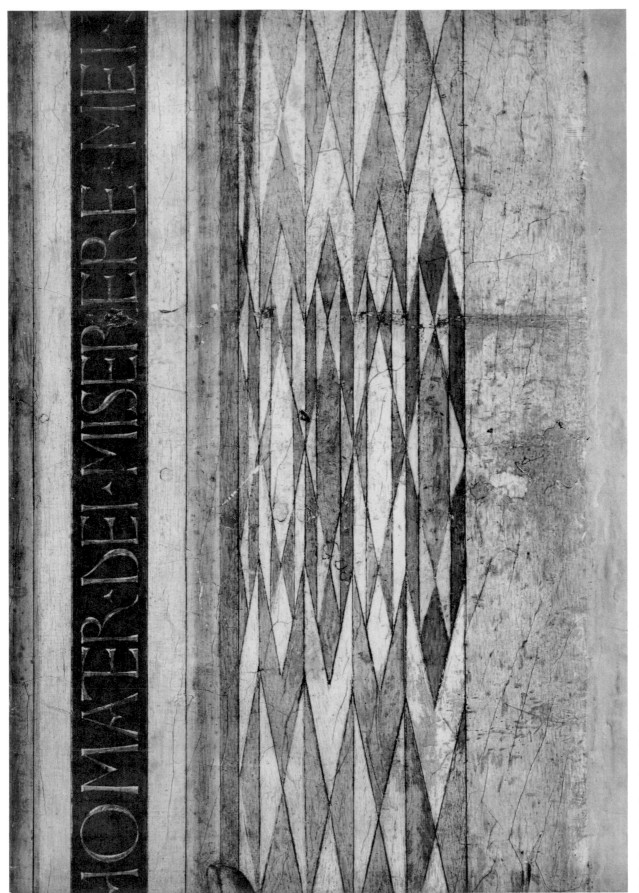

Pl. 74. Domenico Veneziano, St. Lucy Altar, pavement.

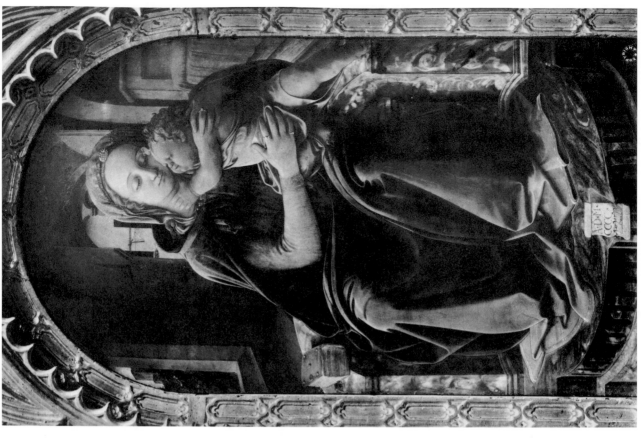

Pl. 76. Fra Filippo Lippi, *Madonna and Child*, Rome, Galleria Nazionale d' Arte Antica.

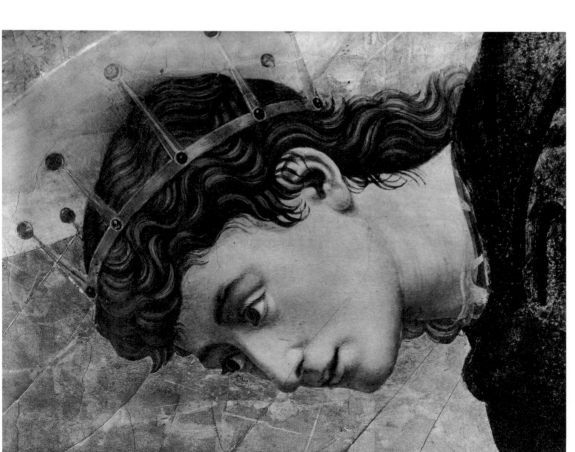

Pl. 75. Andrea del Castagno, *The Assumption of the Virgin*, Berlin-Dahlem, Gemäldegalerie, head of S. Miniato.

Pl. 78. Lorenzo Ghiberti, tomb of Leonardo Dati, Florence, S. Maria Novella.

Pl. 77. Donatello, *putto*, Siena, Baptistry, Baptismal Font.

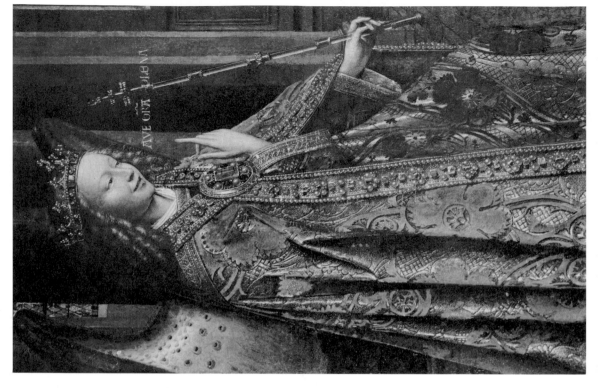

Pl. 80. Jan van Eyck, *The Annunciation*, Washington, D.C., National Gallery of Art, Mellon Collection, Gabriel.

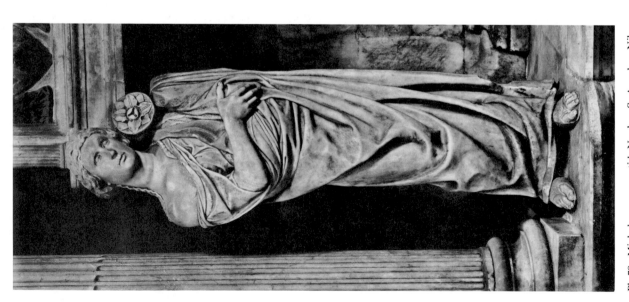

Pl. 79. Michelozzo, caryatid, Naples, S. Angelo a Nilo, Brancacci Tomb.

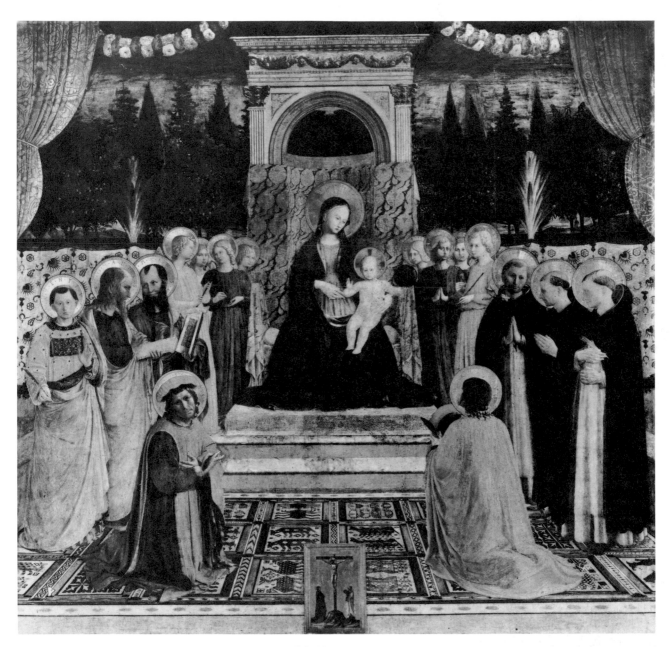

Pl. 81. Fra Angelico, S. Marco Altar, Florence, Museo di S. Marco.

Pl. 84. Taddeo di Bartolo, *St. John the Baptist*, Siena, Palazzo Pubblico.

Pl. 82. Michelozzo, capital, Florence, S. Miniato al Monte, tabernacle.

Pl. 83. Pagno di Lapo Portigiani, capital, Florence, Medici Palace, window.

Pl. 85. Baptistry, Florence, detail.

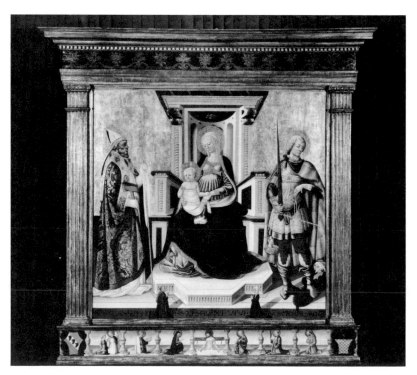

Pl. 86. Neri di Bicci, *sacra conversazione,* Montreal, Museum of Fine Arts.

Pl. 87. Paolo Uccello, *sinopia* for the *Nativity*, Florence, Soprintendenza alle Gallerie.

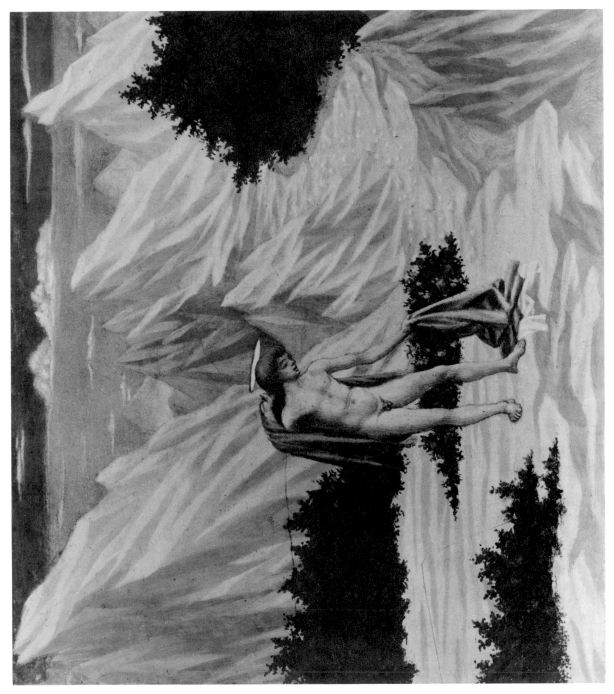

Pl. 88. Domenico Veneziano, *The Vocation of St. John the Baptist*, Washington, National Gallery of Art, Samuel H. Kress Collection.

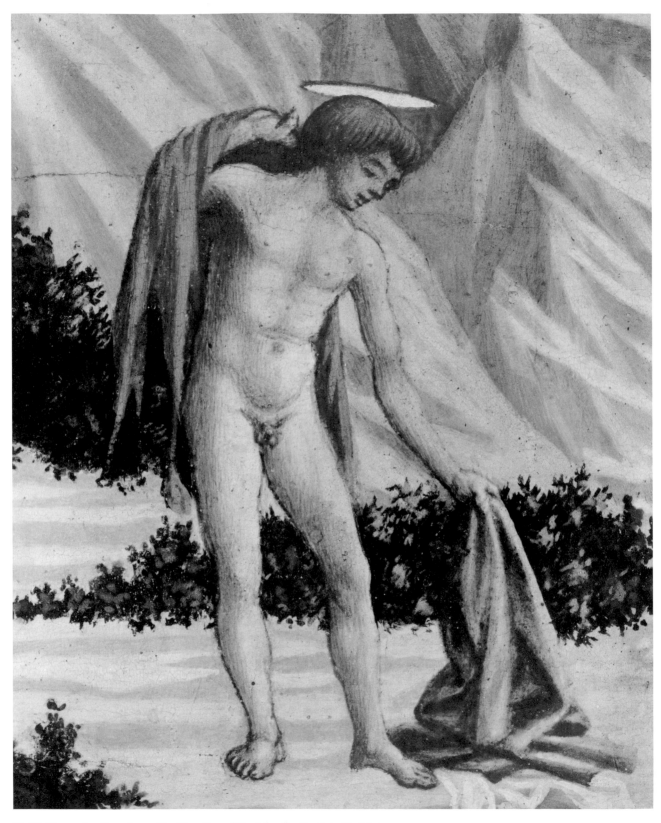

Pl. 89. Domenico Veneziano, *The Vocation of St. John the Baptist*, St. John.

Pl. 90. Masolino, *The Vocation of St. John the Baptist,* Castiglione d'Olona, Baptistry.

Pl. 91. Masolino, apse frescoes, Castiglione d'Olona, Baptistry.

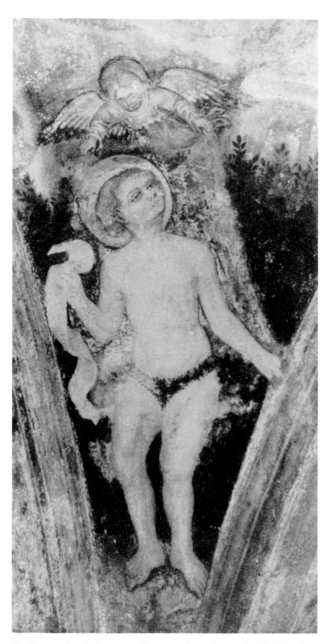

Pl. 92. Circle of Pisanello, *The Vocation of St. John the Baptist,*
Pordenone, cathedral.

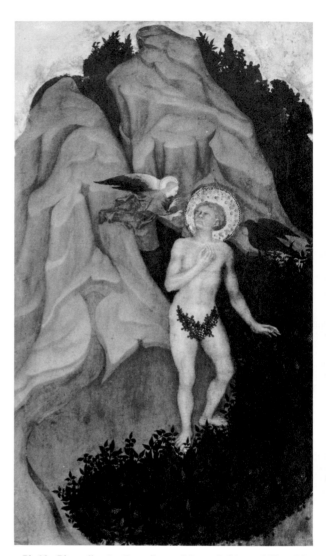

Pl. 93. Pisanello, *St. Benedict on Mount Subiaco,* Milan, Museo
Poldi-Pezzoli.

Pl. 97. Circle of Gentile da Fabriano, drawing from the antique, Milan, Biblioteca Ambrosiana.

Pl. 96. Circle of Gentile da Fabriano, drawing from the antique, Paris, Louvre.

Pl. 95. Graeco-Roman, Orestes sarcophagus, *Codex Pighianus*, Berlin, Staatsbibliothek.

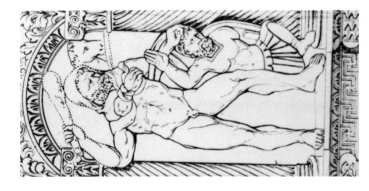

Pl. 94. Graeco-Roman, *Hercules and Diomedes*, Hercules sarcophagus. Rome, Museo Torlonia.

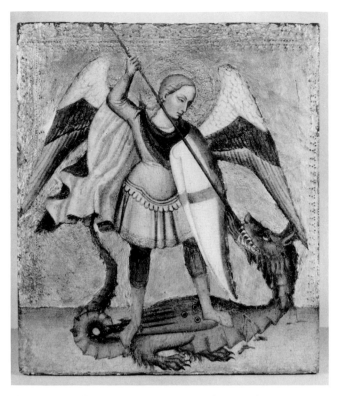

Pl. 98. Italian, fourteenth century, *St. Michael,* Baltimore, Walters Art Gallery.

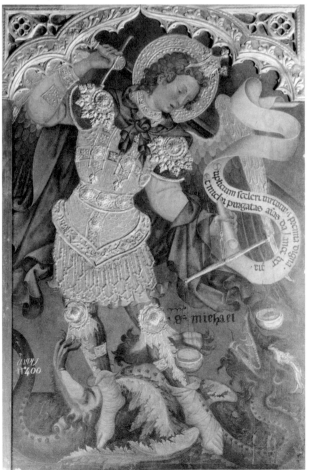

Pl. 99. Jacobello del Fiore, *Justice with Sts. Michael and Gabriel,* Venice, Accademia.

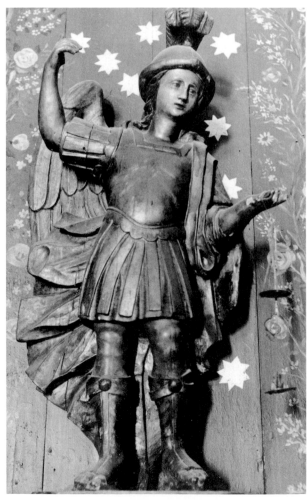

Pl. 100. Portuguese, eighteenth century, *St. Michael,* Colares, parish church.

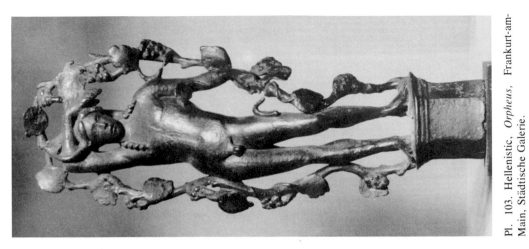

Pl. 103. Hellenistic, *Orpheus*, Frankurt-am-Main, Städtische Galerie.

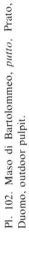

Pl. 102. Maso di Bartolommeo, *putto*, Prato, Duomo, outdoor pulpit.

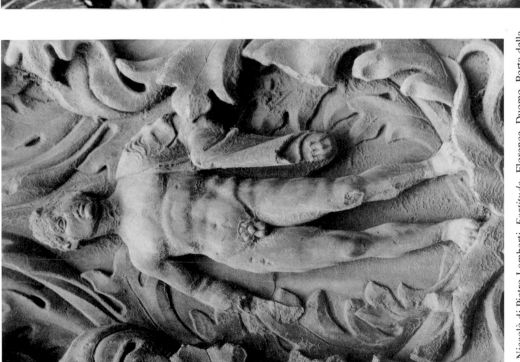

Pl. 101. Niccolò di Pietro Lamberti, *Fortitude*, Florence, Duomo, Porta della Mandorla.

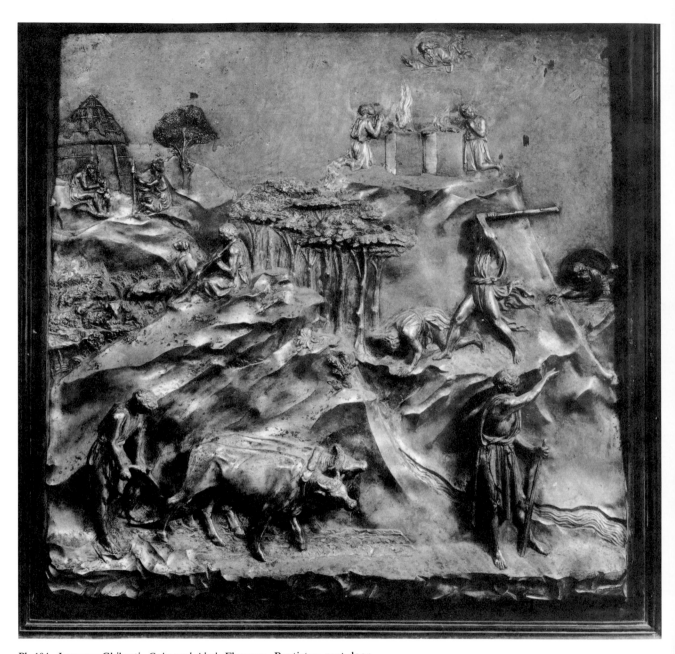

Pl. 104. Lorenzo Ghiberti, *Cain and Abel,* Florence, Baptistry, east door.

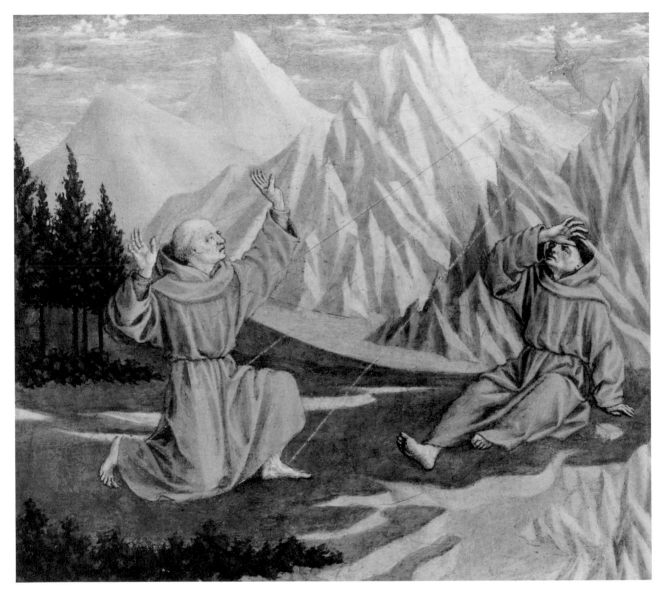

Pl. 105. Domenico Veneziano, *St. Francis Receiving the Stigmata*, Washington, National Gallery of Art, Samuel H. Kress Collection.

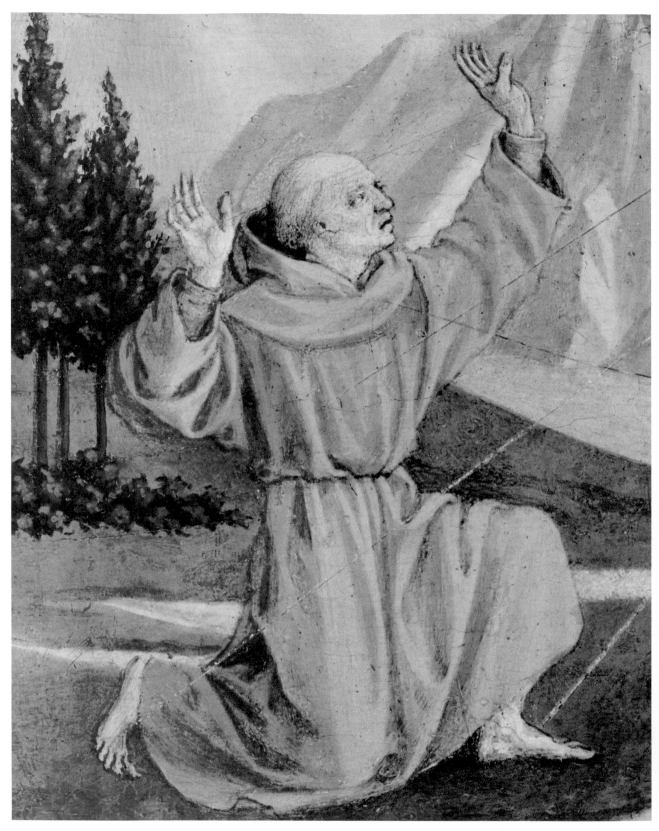

Pl. 106. Domenico Veneziano, *St. Francis Receiving the Stigmata,* St. Francis.

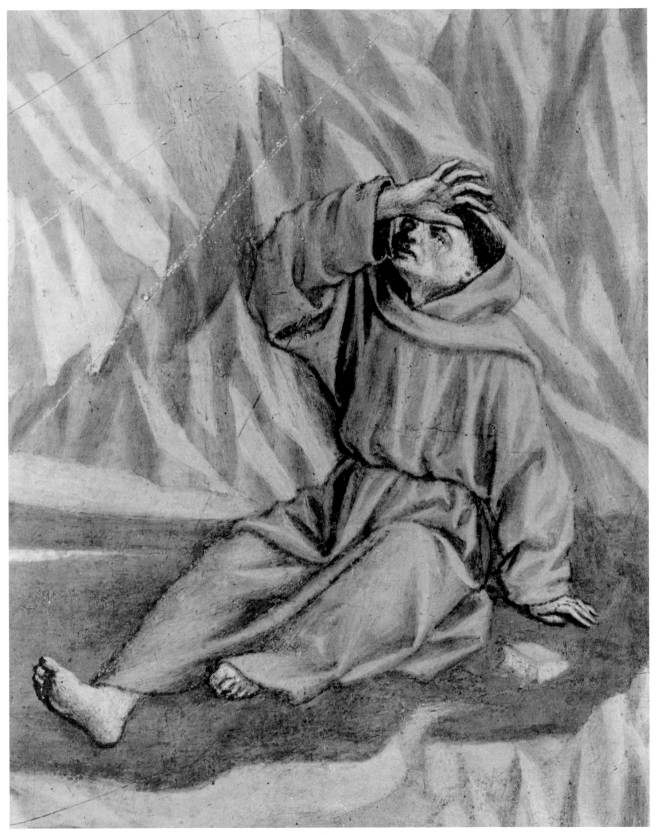

Pl. 107. Domenico Veneziano, *St. Francis Receiving the Stigmata*, Friar Leo.

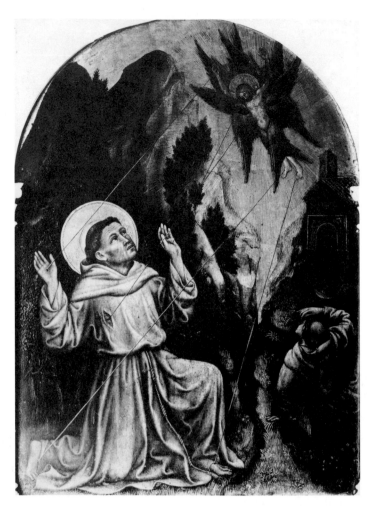

Pl. 108. Gentile da Fabriano, *St. Francis Receiving the Stigmata,* Crenna di Gallarete, Carminati Collection.

Pl. 109. Florentine, mid-fifteenth century, *St. Francis Receiving the Stigmata,* Florence, S. Margherita de' Ricci.

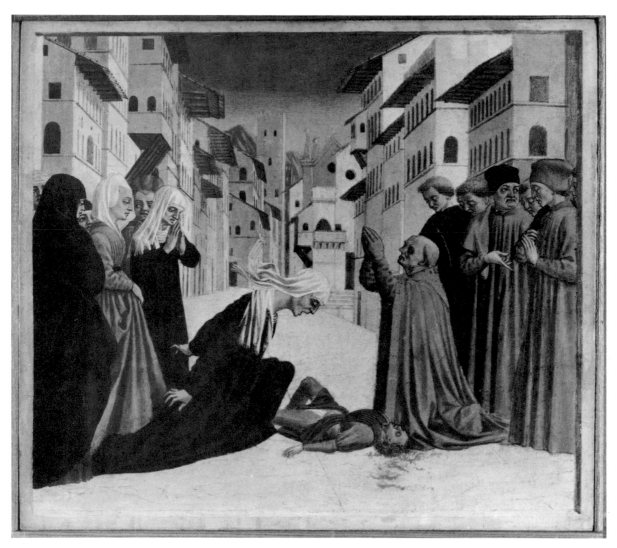

Pl. 110. Domenico Veneziano, *A Miracle of St. Zenobius*, Cambridge, Fitzwilliam Museum.

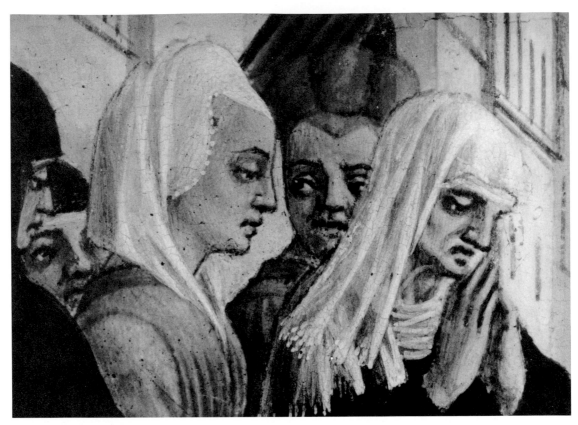

Pl. 111. Domenico Veneziano, *A Miracle of St. Zenobius,* onlookers at left.

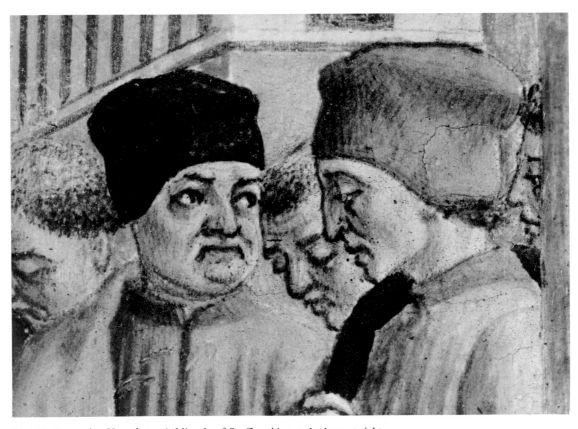

Pl. 112. Domenico Veneziano, *A Miracle of St. Zenobius,* onlookers at right.

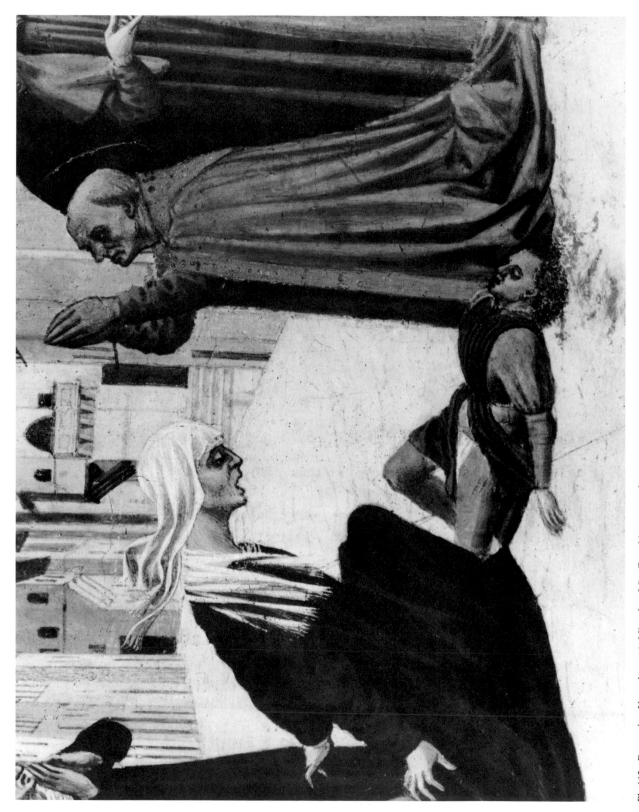

Pl. 113. Domenico Veneziano, *A Miracle of St. Zenobius*, central group.

Pl. 114. Graeco-Roman, *Death Scene*, Meleager sarcophagus, Paris, Louvre.

Pl. 115. Lorenzo Ghiberti, *A Miracle of St. Zenobius*, Florence, Duomo, St. Zenobius shrine.

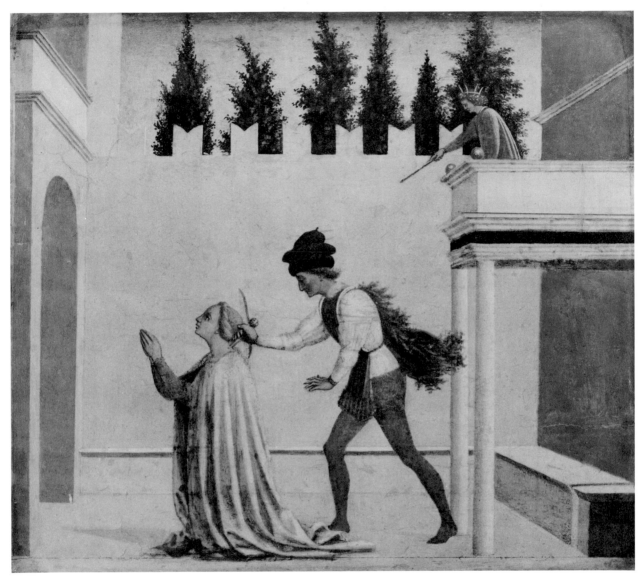

Pl. 116. Domenico Veneziano, *The Martyrdom of St. Lucy,* Berlin-Dahlem, Gemäldegalerie.

Pl. 117. Domenico Veneziano, *The Martyrdom of St. Lucy,* the governor Pascasius.

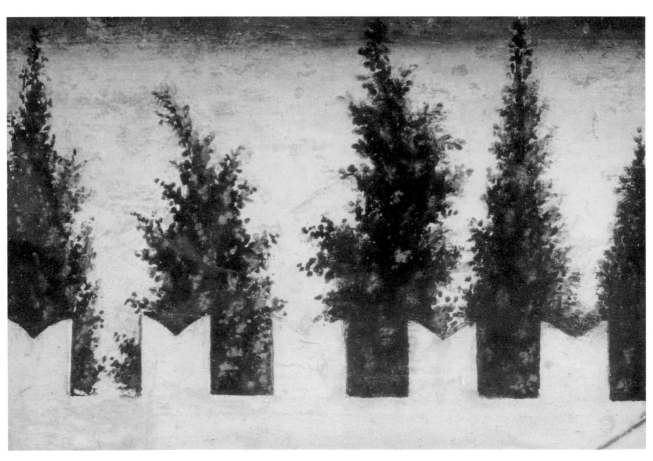

Pl. 119. Domenico Veneziano, *The Martyrdom of St. Lucy,* trees.

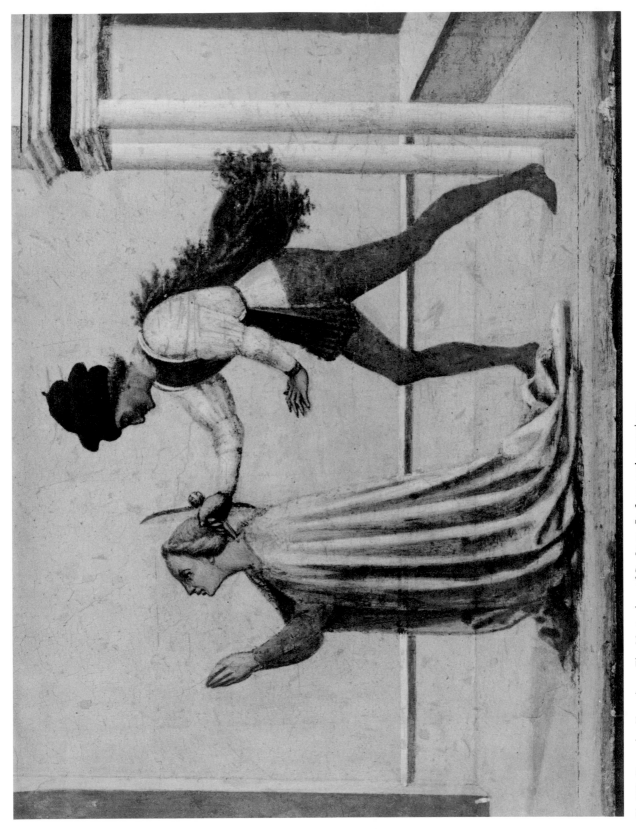

Pl. 118. Domenico Veneziano, *The Martyrdom of St. Lucy*, St. Lucy and executioner.

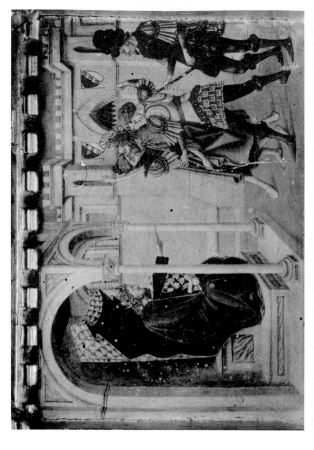

Pl. 121. Domenico di Bartolo, *St. John the Baptist Before Herod*, Perugia, Galleria Nazionale dell'Umbria.

Pl. 122. Andrea di Giusto, *The Attempted Martyrdom of St. Catherine*, Florence, Accademia.

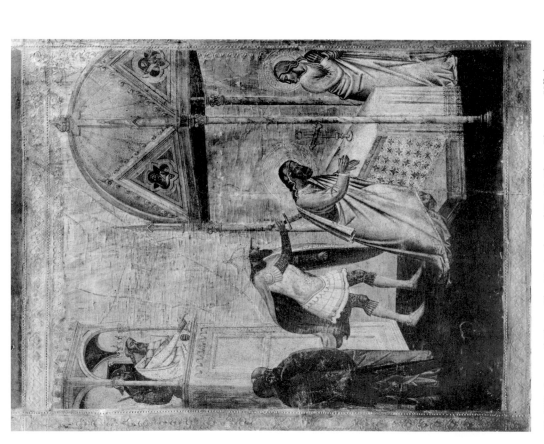

Pl. 120. Jacopo di Cione, *The Martyrdom of St. Matthew*, Florence, Uffizi.

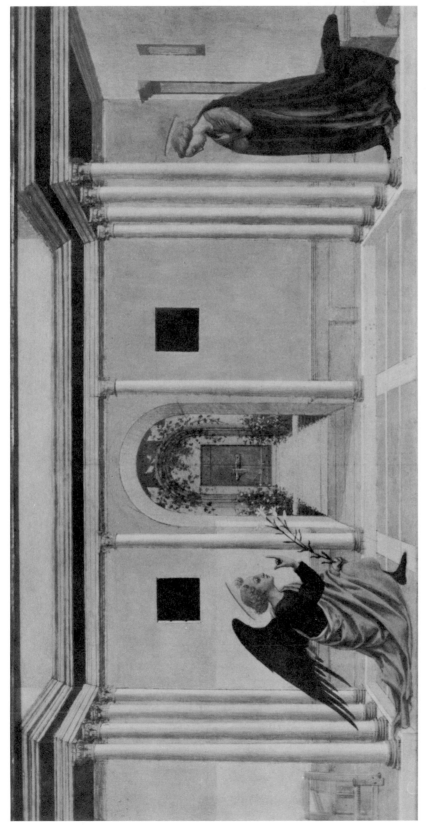

Pl. 123. Domenico Veneziano, *The Annunciation*, Cambridge, Fitzwilliam Museum.

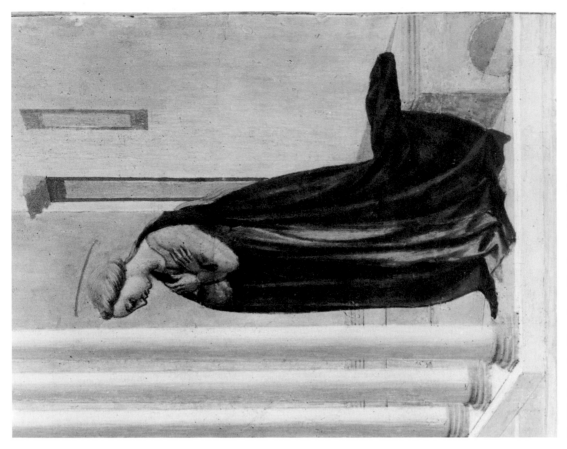

Pl. 125. Domenico Veneziano, *The Annunciation*, Mary.

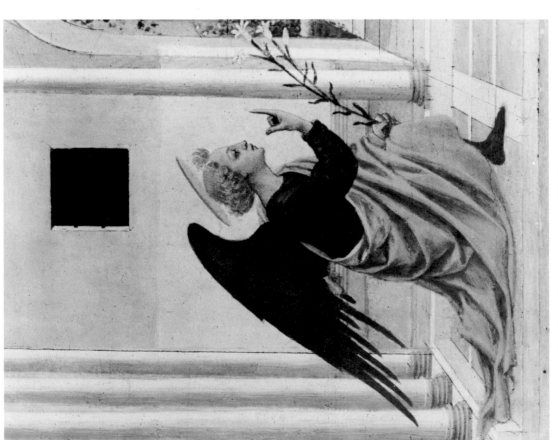

Pl. 124. Domenico Veneziano, *The Annunciation*, Gabriel.

Pl. 127. Domenico Veneziano, *The Annunciation*, head of Mary.

Pl. 126. Domenico Veneziano, *The Annunciation*, head of Gabriel.

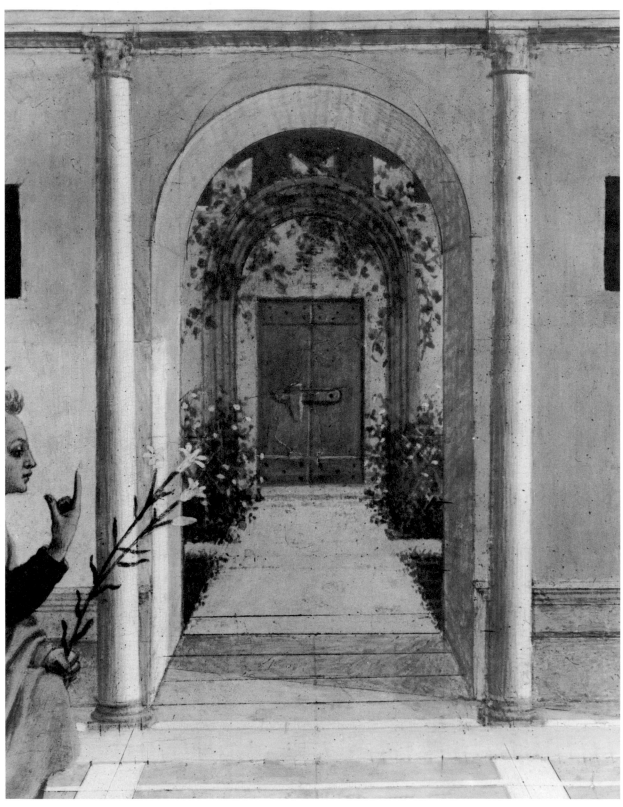

Pl. 128. Domenico Veneziano, *The Annunciation*, garden.

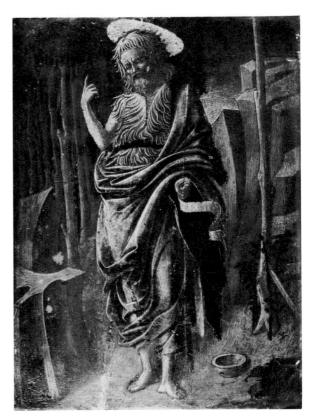

Pl. 130. Master of the Chantilly Baptist, *St. John the Baptist,* Chantilly, Musée Condé.

Pl. 129. Gentile da Fabriano, *St. Nicholas and the Poor Man's Daughters,* Rome, Pinacoteca Vaticana, detail.

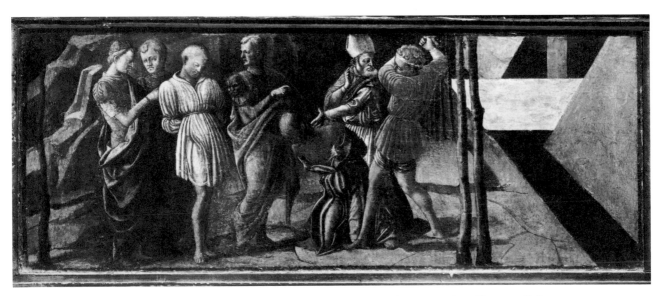

Pl. 131. Master of the Chantilly Baptist, *St. Nicholas Saving Innocent Victims from Execution,* Florence, S. Lorenzo.

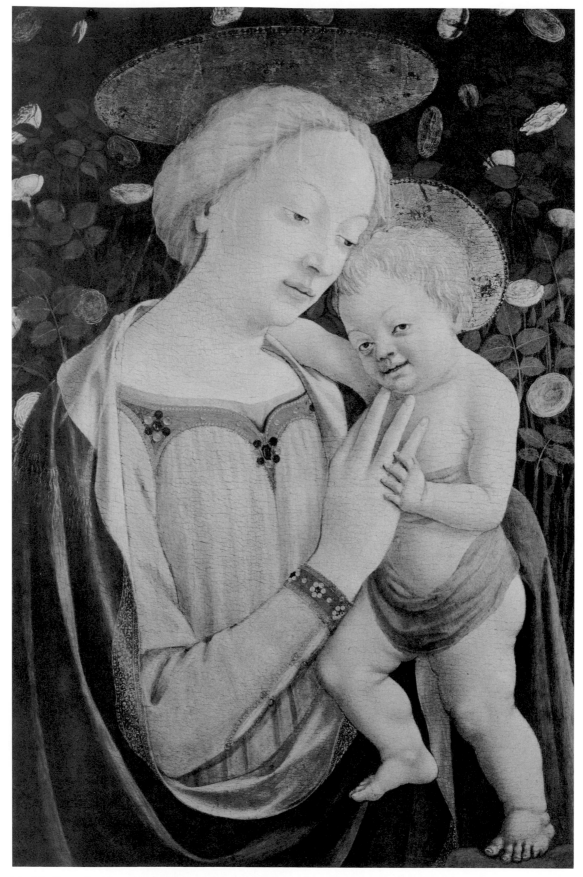

Pl. 132. Domenico Veneziano, *Madonna and Child,* Washington, National Gallery of Art, Samuel H. Kress Collection.

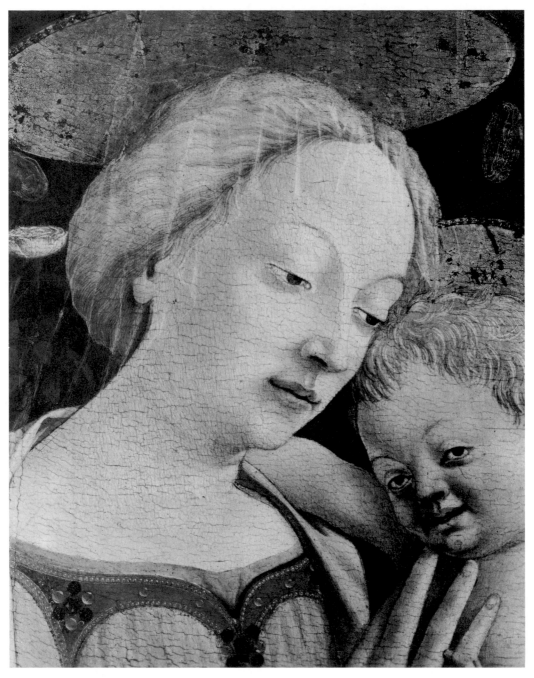

Pl. 133. Domenico Veneziano, *Madonna and Child,* head of Virgin.

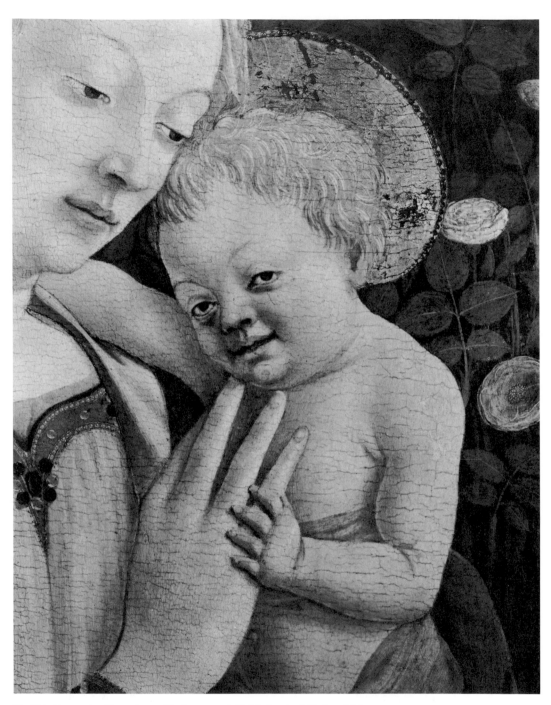

Pl. 134. Domenico Veneziano, *Madonna and Child,* head of Christ child.

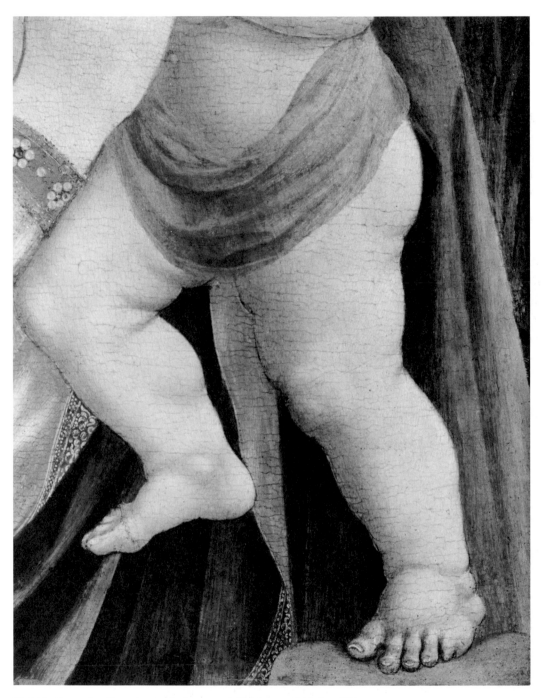

Pl. 135. Domenico Veneziano, *Madonna and Child,* legs of Christ child.

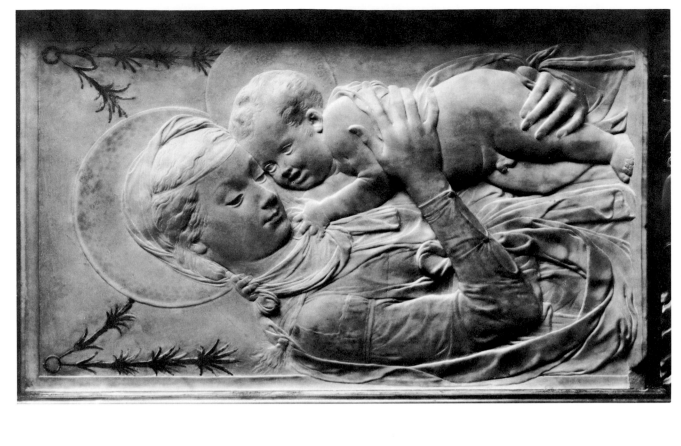

Pl. 137. Desiderio da Settignano, *Madonna and Child*, Turin, Galleria Sabauda.

Pl. 136. Domenico Veneziano, *Madonna and Child*, right arm of Virgin.

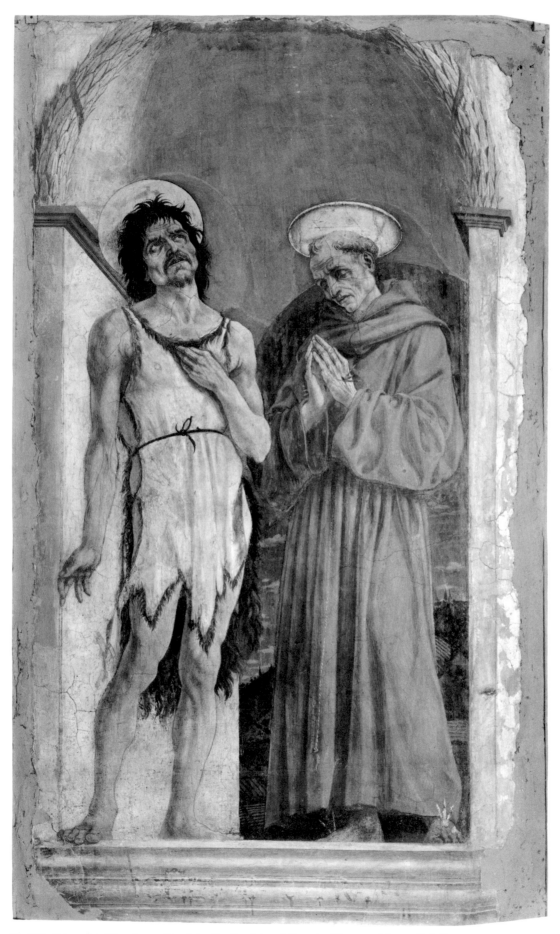

Pl. 138. Domenico Veneziano, *Sts. John the Baptist and Francis*, Florence, Museo di S.Croce.

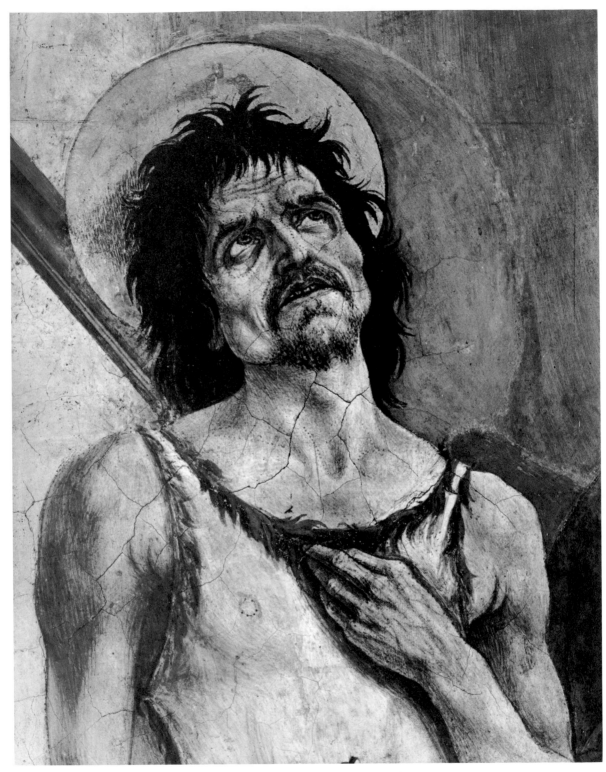

Pl. 139. Domenico Veneziano, *Sts. John the Baptist and Francis,* bust of St. John.

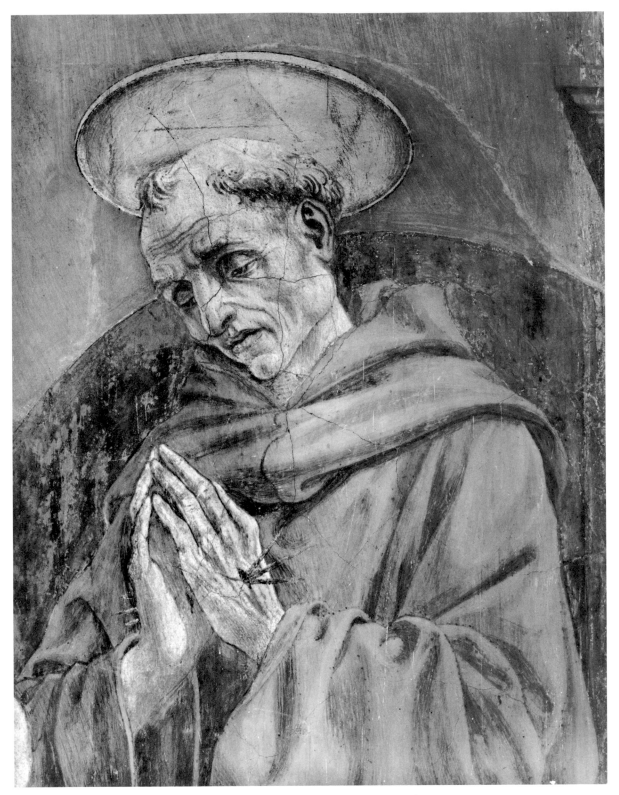

Pl. 140. Domenico Veneziano, *Sts. John the Baptist and Francis*, bust of St. Francis.

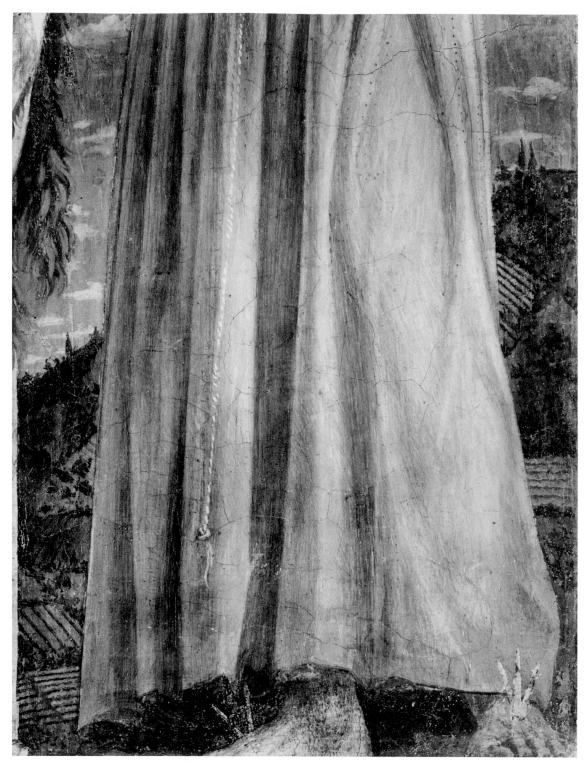

Pl. 141. Domenico Veneziano, *Sts. John the Baptist and Francis,* landscape.

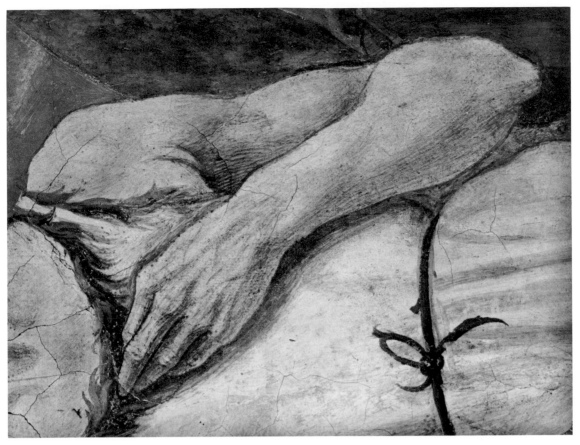

Pl. 143. Domenico Veneziano, *Sts. John the Baptist and Francis*, left arm of St. John.

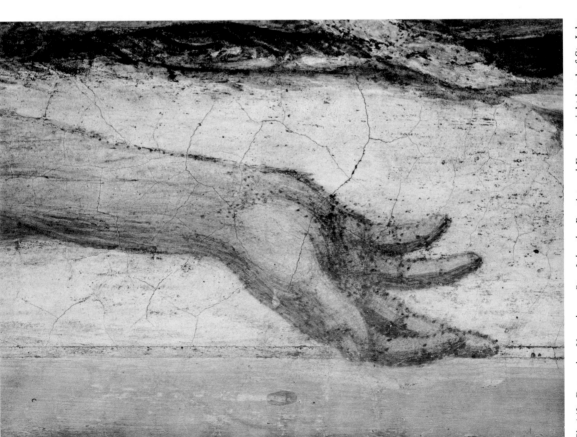

Pl. 142. Domenico Veneziano, *Sts. John the Baptist and Francis*, right hand of St. John.

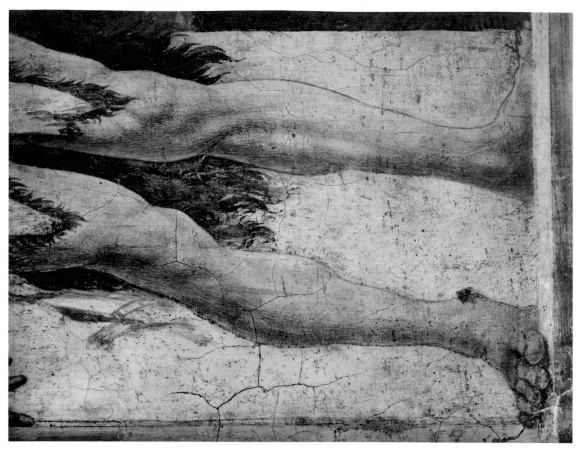

Pl. 145. Domenico Veneziano, *Sts. John the Baptist and Francis*, legs of St. John.

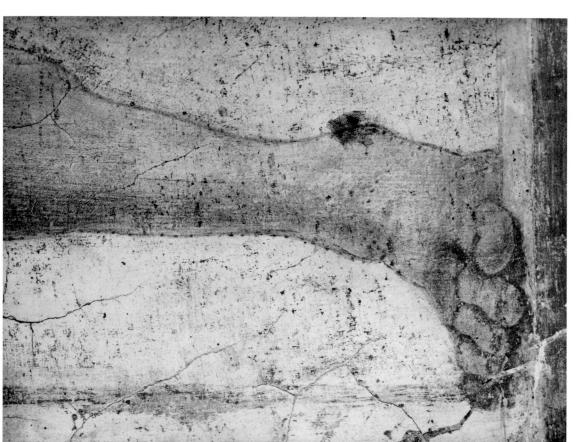

Pl. 144. Domenico Veneziano, *Sts. John the Baptist and Francis*, right foot of St. John.

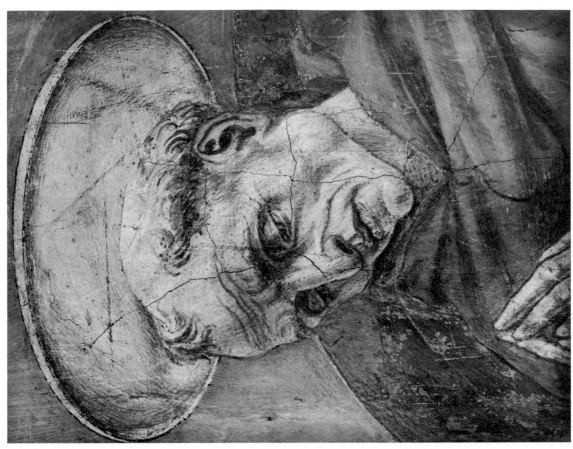

Pl. 147. Domenico Veneziano, *Sts. John the Baptist and Francis*, head of St. Francis.

Pl. 146. Domenico Veneziano, *Sts. John the Baptist and Francis*, palm wreath.

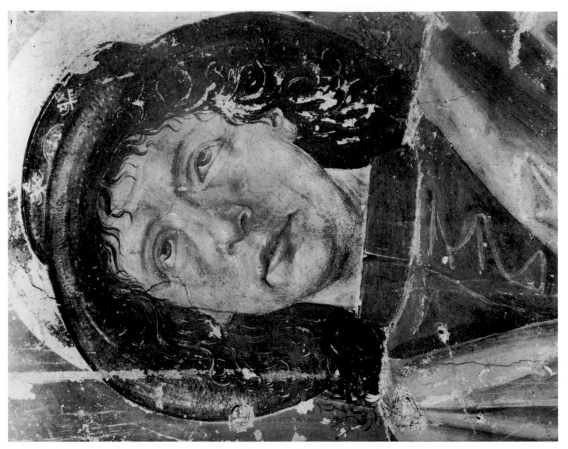

Pl. 149. Bartolomeo della Gatta, *St. Roch*, Arezzo, Pinacoteca Communale, head.

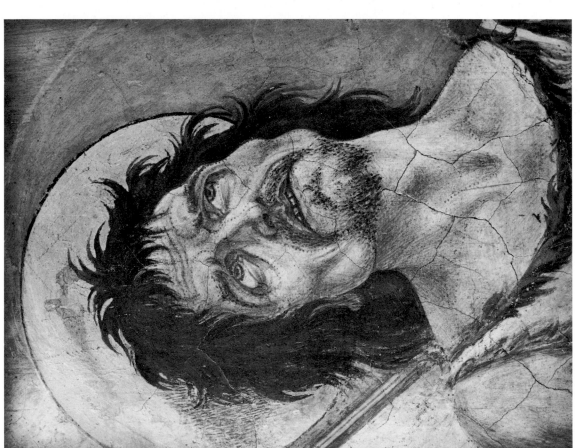

Pl. 148. Domenico Veneziano, *Sts. John the Baptist and Francis*, head of St. John.

Pl. 150. Donatello, *Annunciation*, Florence, S. Croce.

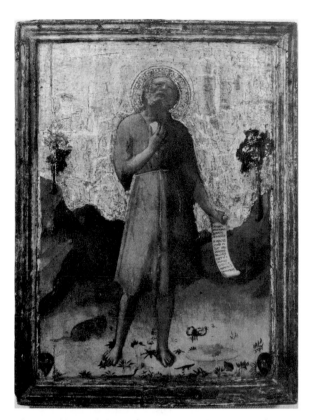

Pl. 151. Giovanni Toscani, *St. Jerome*, Princeton, The Art Museum, Princeton University.

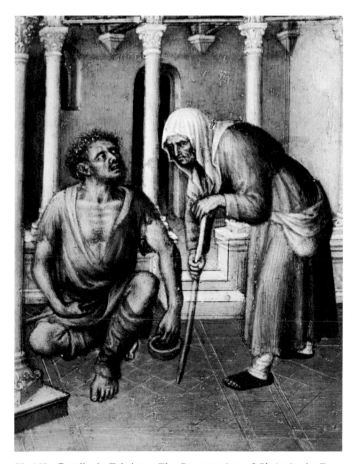

Pl. 152. Gentile da Fabriano, *The Presentation of Christ in the Temple*, Paris, Louvre, beggars.

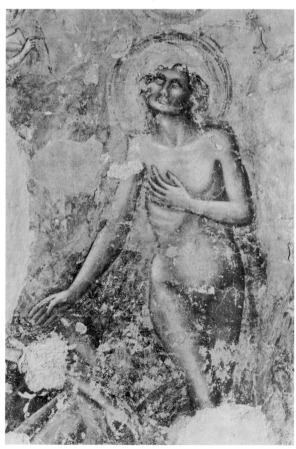

Pl. 153. Vitale di Bologna, *The Baptism of Christ*, Bologna, Pinacoteca.

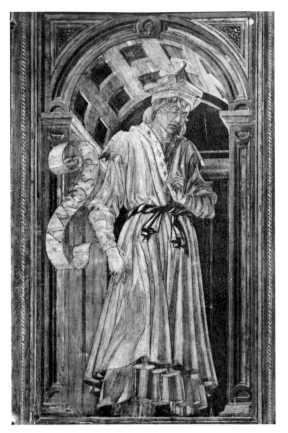

Pl. 154. Giuliano da Maiano, *Amos*, Florence, Duomo, *sagrestia delle messe*.

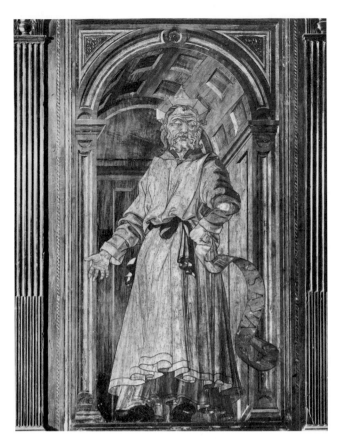

Pl. 155. Giuliano da Maiano, *Isaiah*, Florence, Duomo, *sagrestia delle messe*.

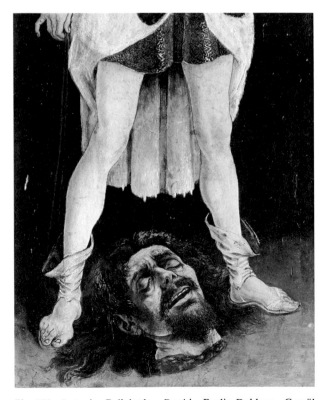

Pl. 156. Antonio Pollaiuolo, *David*, Berlin-Dahlem, Gemäldegalerie, legs.

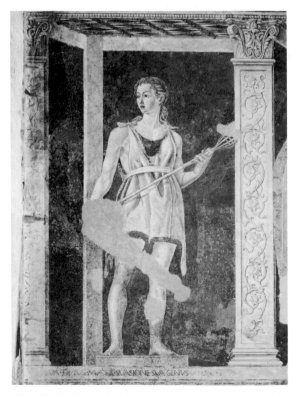

Pl. 157. Andrea del Castagno, *Eve*, Florence, S. Apollonia.

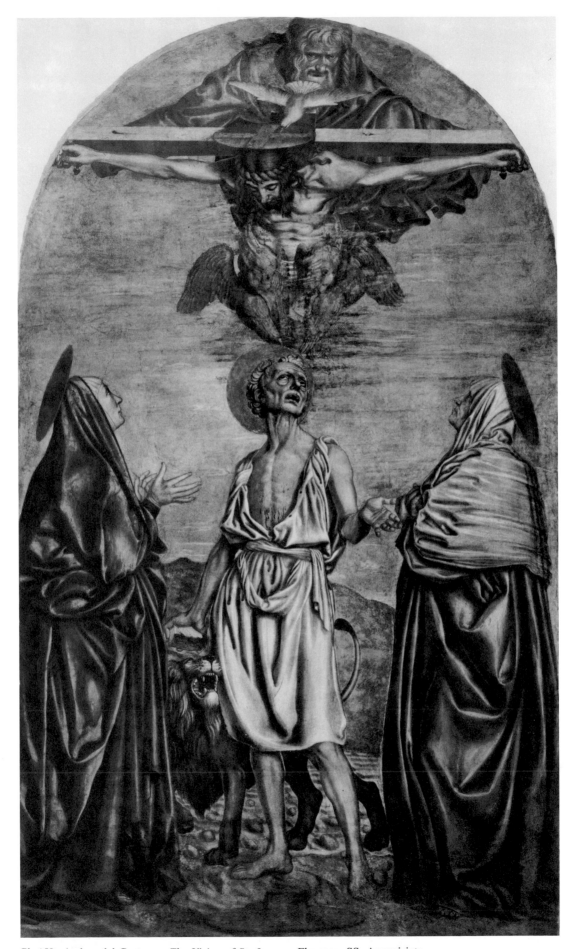

Pl. 158. Andrea del Castagno, *The Vision of St. Jerome*, Florence, SS. Annuniziata.

Pl. 159. Andrea del Castagno, *sinopia* for the *Vision of St. Jerome*, Florence, Soprintendenza alle Gallerie.

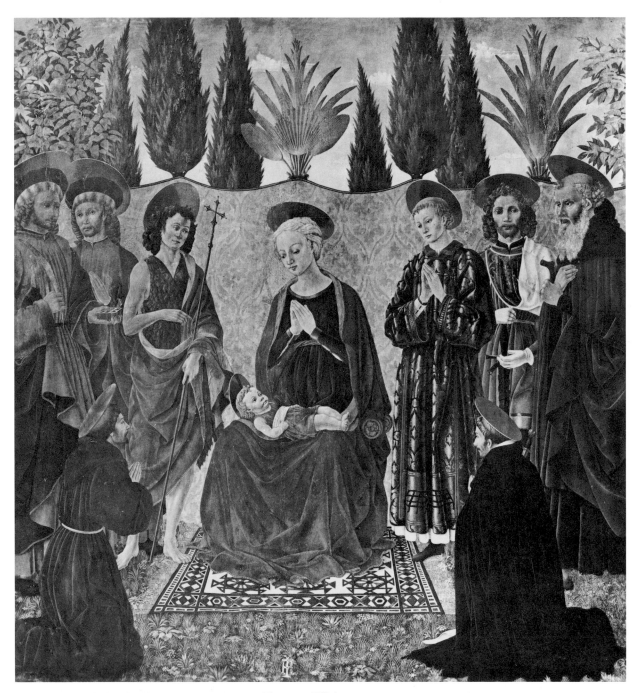

Pl. 160. Alesso Baldovinetti, *sacra conversazione*, Florence, Uffizi.

Pl. 161. Alesso Baldovinetti, fragments from west wall of S. Egidio, Florence, Soprintendenza alle Gallerie.

Pl. 162. Alesso Baldovinetti, fragments from west wall of S. Egidio, Florence, Soprintendenza alle Gallerie.

Pl. 163. Alesso Baldovinetti, fragments from north wall of S. Egidio, Florence, Soprintendenza alle Gallerie.

Pl. 164. Alesso Baldovinetti, fragments from north wall of S. Egidio, Florence, Soprintendenza alle Gallerie.

Pl. 165. Andrea del Castagno, fragments from east wall of S. Egidio, Florence, Soprintendenza alle Gallerie.

Pl. 166. Andrea del Castagno, fragments from east wall of S. Egidio, Florence Soprintendenza alle Gallerie.

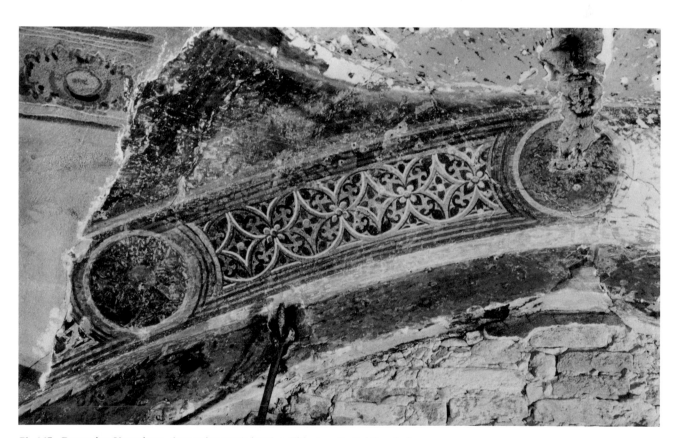

Pl. 167. Domenico Veneziano, decorative vault border, Florence, S. Egidio, choir.

Pl. 170. S. Egidio, Florence, interior of choir.

Pl. 168. Domenico Veneziano, decorative vault border, Florence, S. Egidio, choir.

Pl. 169. Roman imperial, oak wreath from soffit border.

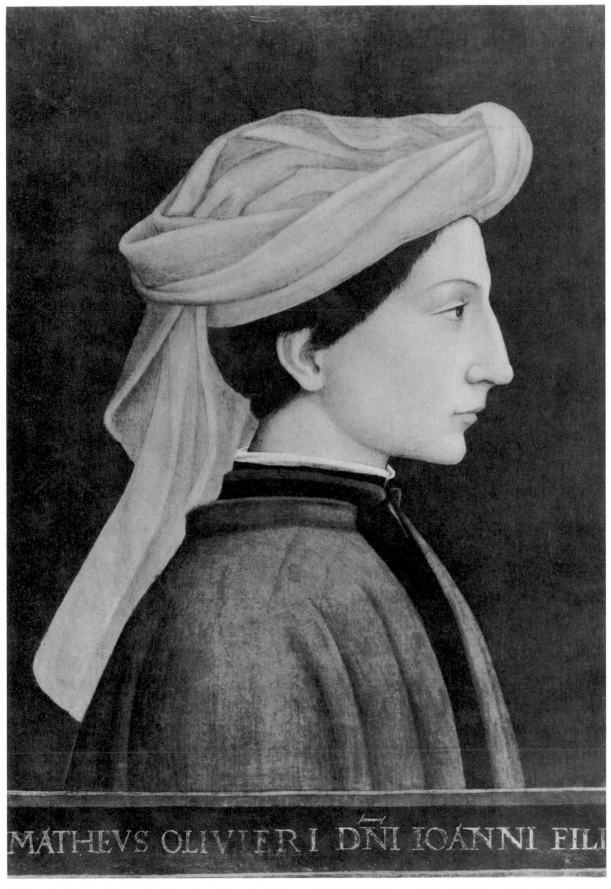

Pl. 171. Workshop of Domenico Veneziano, *Portrait of Matteo Olivieri,* Washington, National Gallery of Art, Mellon Collection.

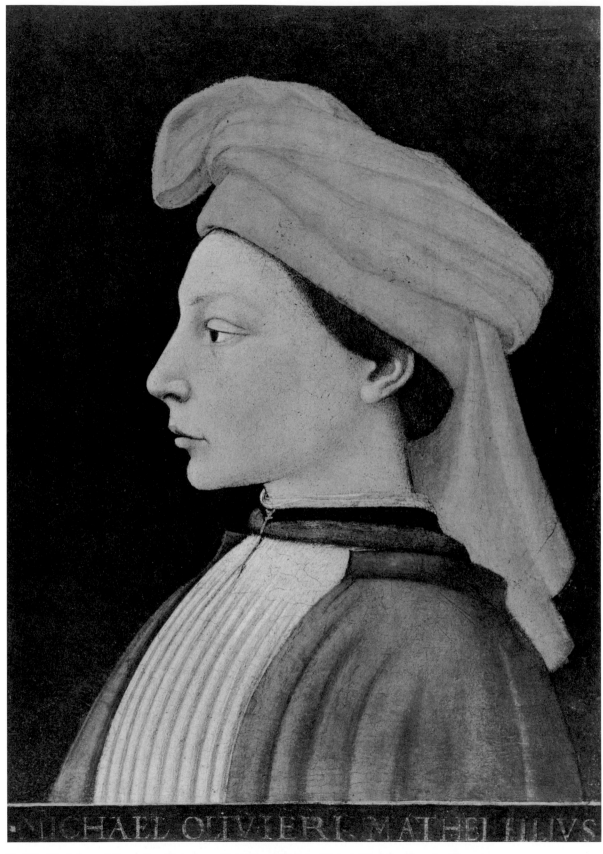

MICHAEL OLIVIERI MATHEI FILIVS

Pl. 172. Workshop of Domenico Veneziano, *Portrait of Michele Olivieri*, Norfolk, Chrysler Museum.

Pl. 173. Circle of Antonio Vivarini, *Head of a Saint,*
Asolo, S. Gottardo.

Pl. 174. Workshop of Antonio Vivarini, *The Martyrdom
of a Female Saint,* Bassano del Grappa, Museo Civico.

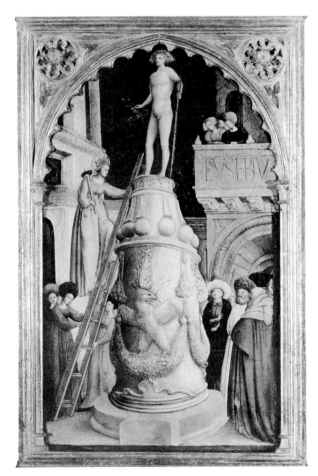

Pl. 175. Workshop of Antonio Vivarini, *St. Catherine
Casting Down a Pagan Idol,* Washington, National Gal-
lery of Art, Samuel H. Kress Collection.

Pl. 176. Florentine, mid-fifteenth century, *desco da parto*, Berlin-Dahlem, Gemäldegalerie.

Pl. 178. Giovanni da Modena, *Sts. Cosmas and Damian*, Berlin-Dahlem, Gemäldegalerie.

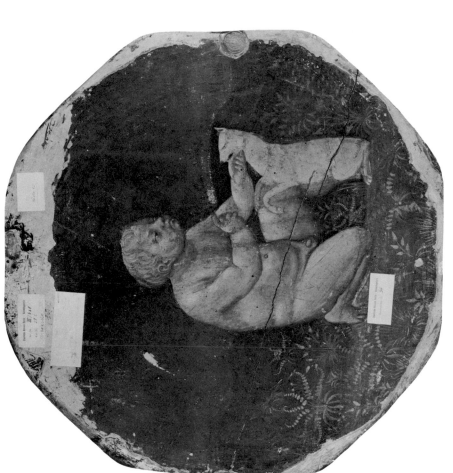

Pl. 177. Florentine, mid-fifteenth century, *putto*, Berlin-Dahlem, Gemäldegalerie.

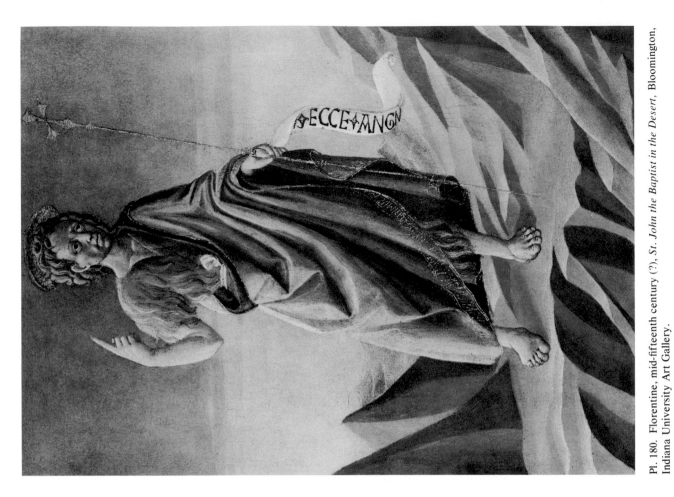

Pl. 180. Florentine, mid-fifteenth century (?), *St. John the Baptist in the Desert*, Bloomington, Indiana University Art Gallery.

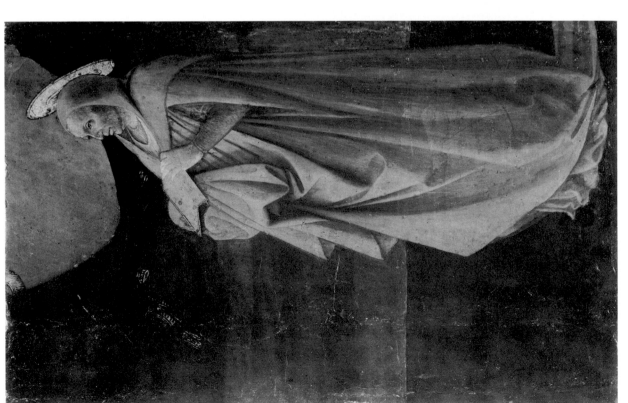

Pl. 179. Circle of Fra Filippo Lippi, *A Saint*, Bern, Kunstmuseum.

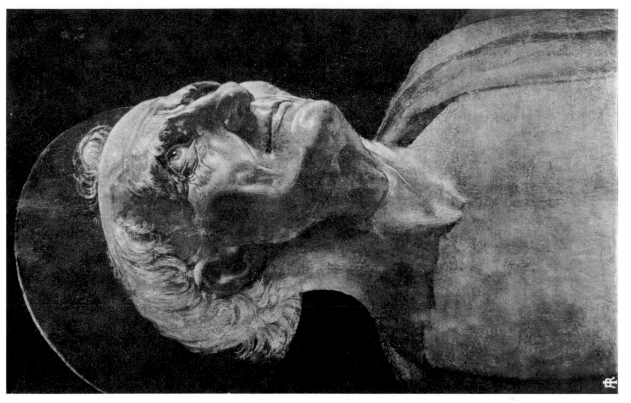

Pl. 183. Workshop of Verrocchio, *Bust of St. Jerome*, Florence, Palazzo Pitti.

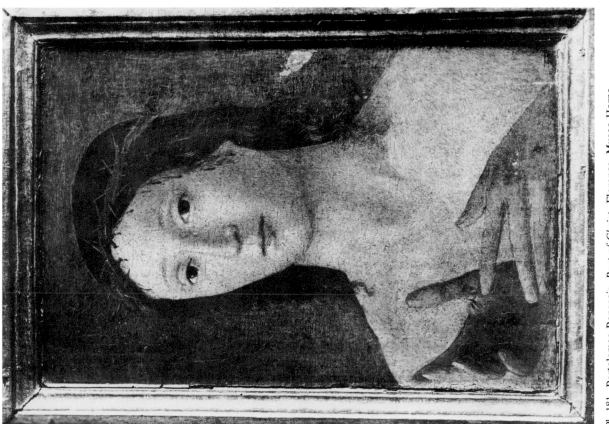

Pl. 181. Bartolomeo Bonascia, *Bust of Christ*, Florence, Museo Horne.

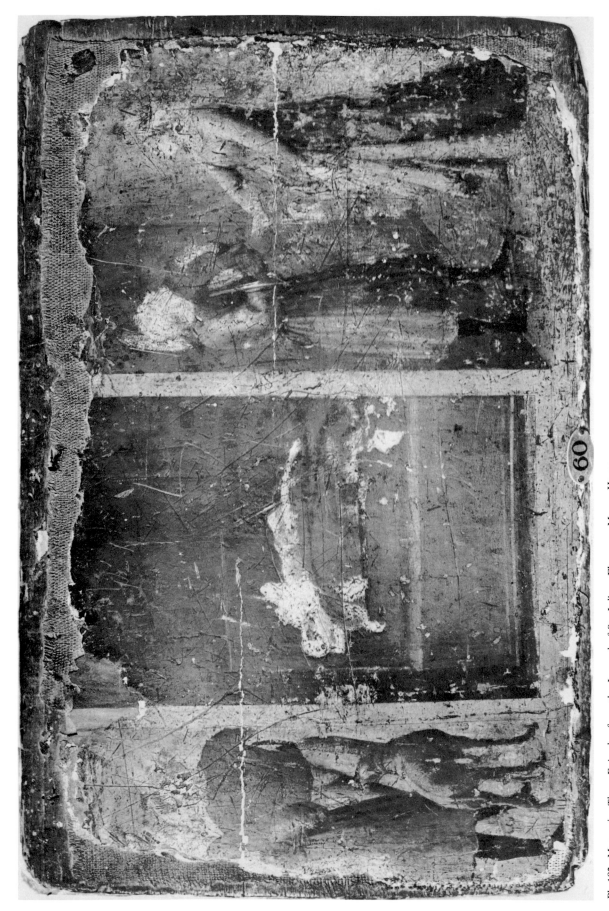

Pl. 182. Masaccio, *Three Episodes from the Legend of St. Julian*, Florence, Museo Horne.

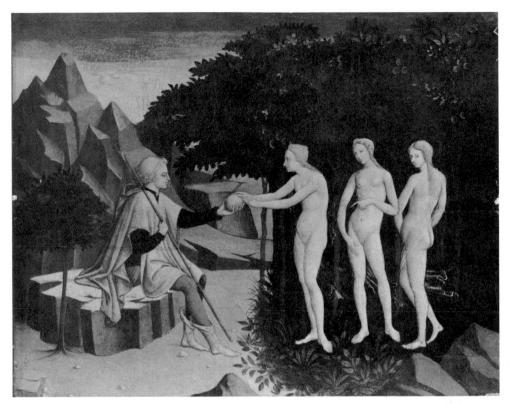

Pl. 184. Paris Master, *The Judgment of Paris,* Glasgow, Art Gallery and Museum, Burrell Collection.

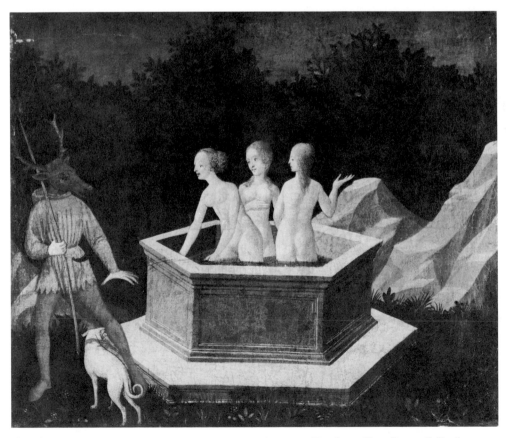

Pl. 188. Florentine, mid-fifteenth century, *Diana and Acteon,* Kronberg, Uwe Opper Collection.

Pl. 185. Paris Master, *The Rape of Helen*, formerly Vienna, Lanckoronski Collection.

Pl. 186. Paris Master, *The Sleep of Paris*, formerly Vienna, Lanckoronski Collection.

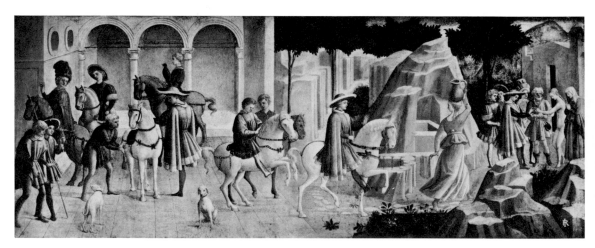

Pl. 187. Paris Master, *Episodes from the Story of Griselda*, Bergamo, Accademia Carrara.

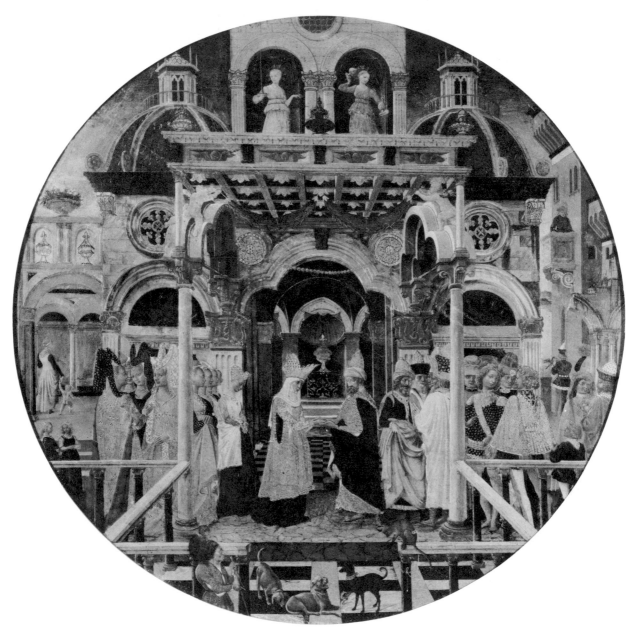

Pl. 189. Ferrarese, third quarter of the fifteenth century, *The Meeting of Solomon and the Queen of Sheba,* Houston, Museum of Fine Arts, Edith A. and Percy S. Strauss Collection.

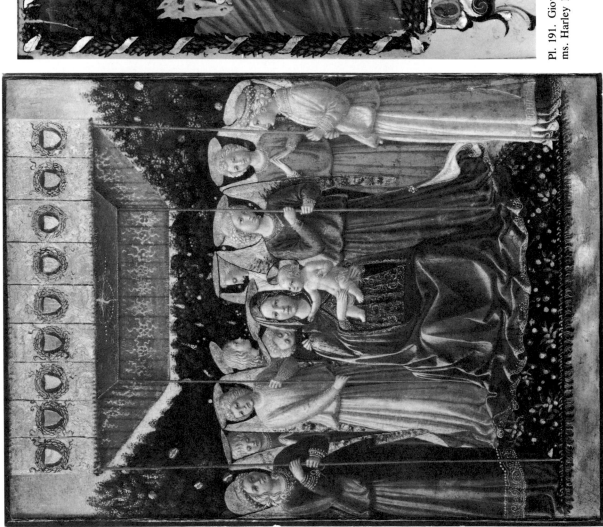

Pl. 191. Giovacchino da Fiore Master, *Pope Clement IV*, London, British Museum, ms. Harley 1340.

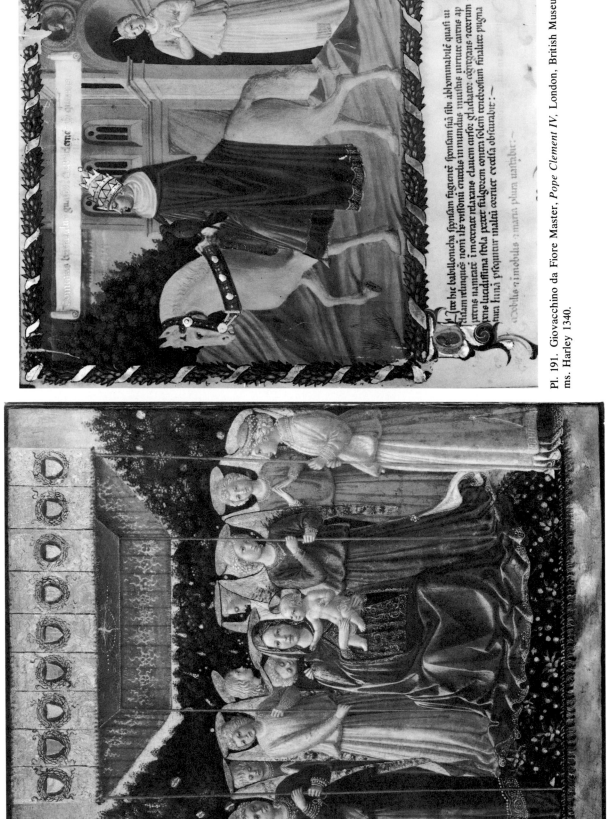

Pl. 190. Giovacchino da Fiore Master, *Madonna and Child with Nine Angels*, London, National Gallery.

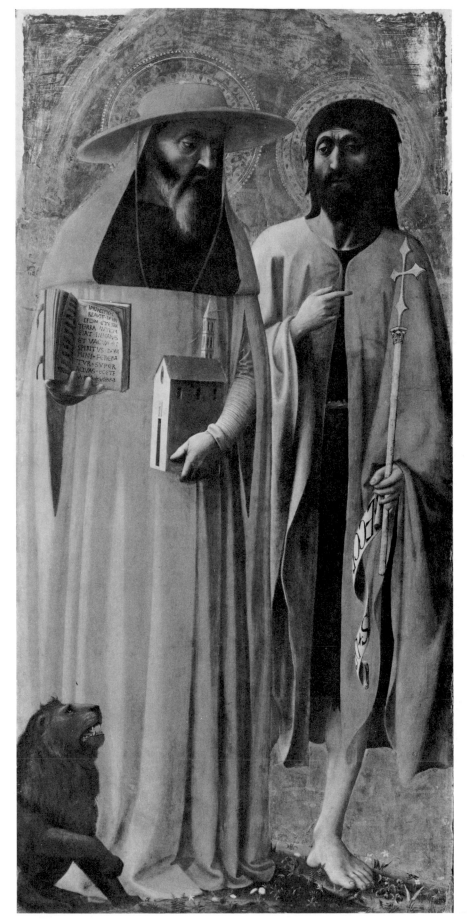

Pl. 192. Masaccio and Fra Angelico, *Sts. Jerome and John the Baptist,* London, National
Gallery.

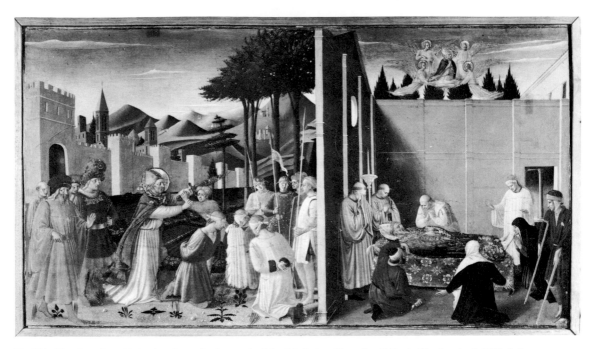

Pl. 193. Fra Angelico, *Episodes from the Legend of St. Nicholas*, Perugia, Galleria Nazionale dell'Umbria.

Pl. 194. Fra Angelico, *Madonna and Child with Saints*, Perugia, Galleria Nazionale dell'Umbria, St. Nicholas.

Pl. 195. Assistant of Fra Angelico, *St. John the Baptist*, Vienna, Kunsthistorisches Museum.

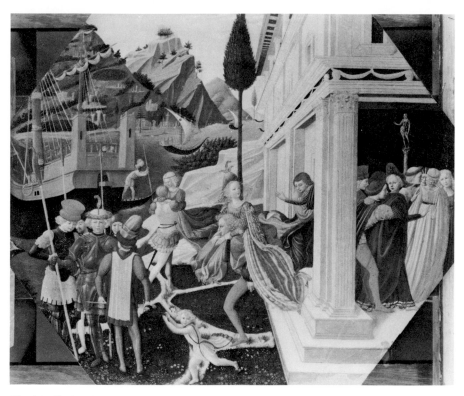

Pl. 196. Circle of Fra Angelico, *The Rape of Helen,* London, National Gallery.

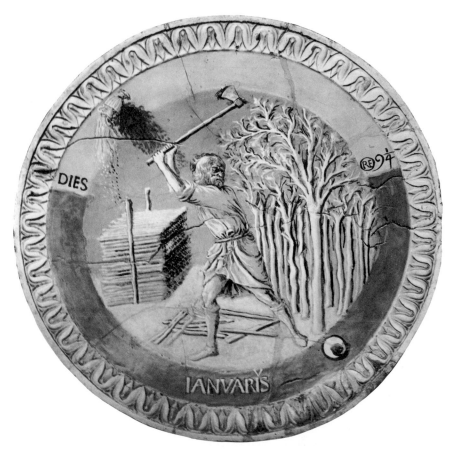

Pl. 197. Luca della Robbia, *January,* London, Victoria and Albert Museum.

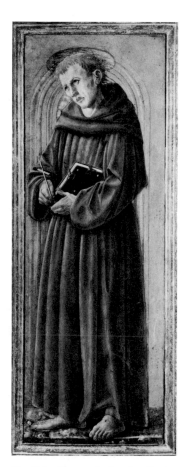

Pl. 198. Giovanni Angelo di Antonio da Camerino, *St. Francis,* Milan, Brivio Collection.

Pl. 199. Circle of Vecchietta, *The Marriage of St. Francis and Lady Poverty*, Munich, Alte Pinakothek.

Pl. 200. Circle of Vecchietta, *The Imposition on a Franciscan Friar of the Yoke of Poverty*, Munich, Alte Pinakothek.

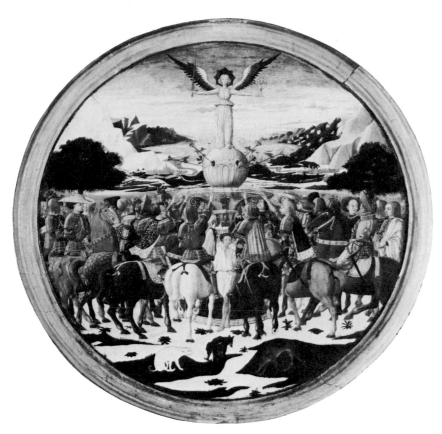

Pl. 201. Giovanni di Ser Giovanni, *The Triumph of Fame,* New York, New York Historical Society, Bryan Collection.

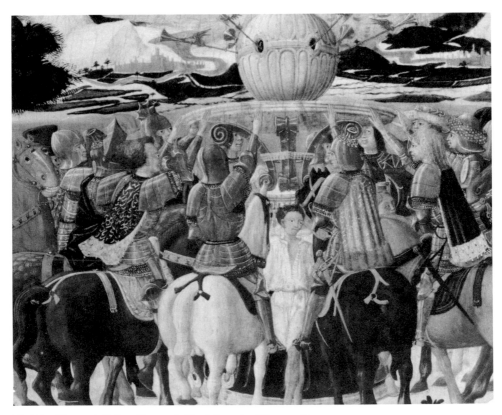

Pl. 202. Giovanni di Ser Giovanni, *The Triumph of Fame,* riders.

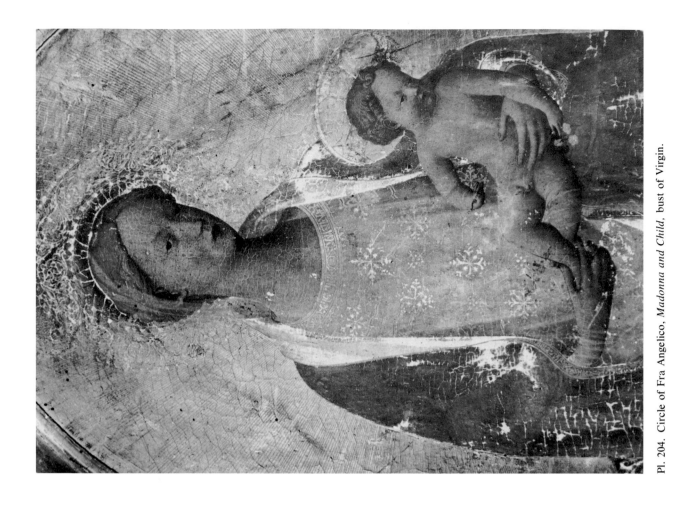

Pl. 204. Circle of Fra Angelico, *Madonna and Child*, bust of Virgin.

Pl. 203. Circle of Fra Angelico, *Madonna and Child*, Pisa, Museo di San Matteo.

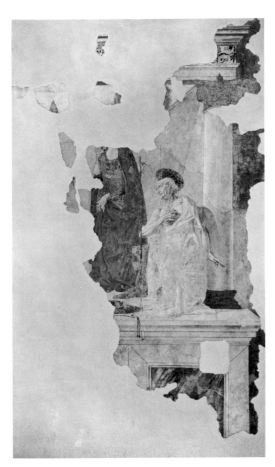

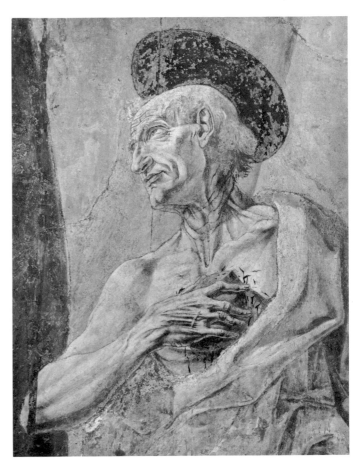

Pl. 205. Tuscan, late fifteenth century, *St. Jerome and Other Fragments,* Pistoia, S. Domenico.

Pl. 206. Tuscan, late fifteenth century, *St. Jerome and Other Fragments,* bust of St. Jerome.

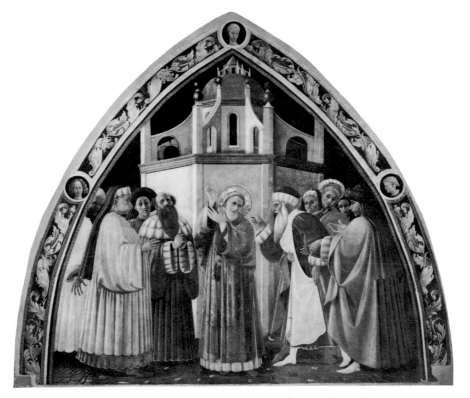

Pl. 207. Circle of Paolo Uccello, *The Disputation of St. Stephen,* Prato, Duomo.

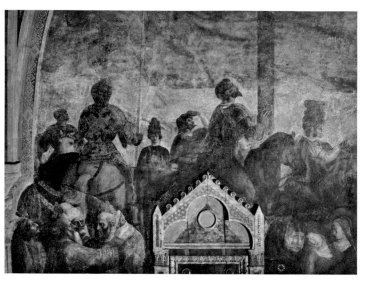

Pl. 208. Masolino, *The Crucifixion,* Rome, S. Clemente, riders.

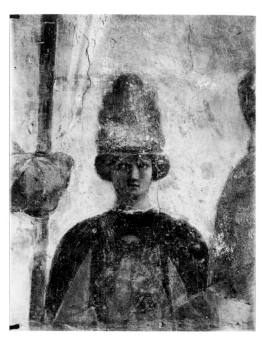

Pl. 209. Masolino, *The Crucifixion,* bust of rider.

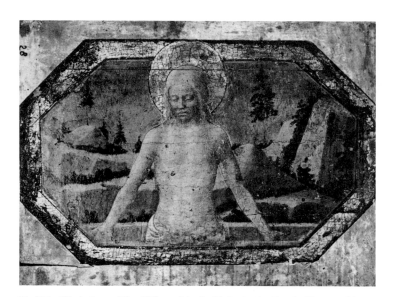

Pl. 211. Workshop of Fra Filippo Lippi, *Christ in the Tomb,* Verona, Museo di Castelvecchio.

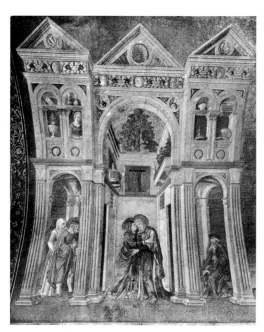

Pl. 210. Michele Giambono and Jacopo Bellini, *The Visitation,* Venice, S. Marco, Mascoli Chapel.

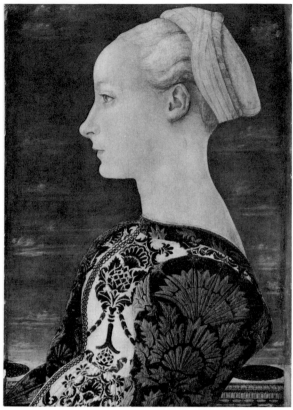

Pl. 212. Antonio Pollaiuolo, *Portrait of a Lady*, Berlin-Dahlem, Gemäldegalerie.

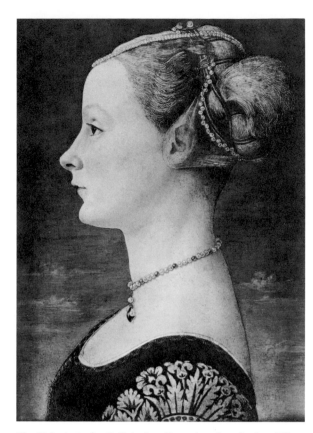

Pl. 216. Antonio Pollaiuolo, *Portrait of a Lady,* Milan, Museo Poldi-Pezzoli.

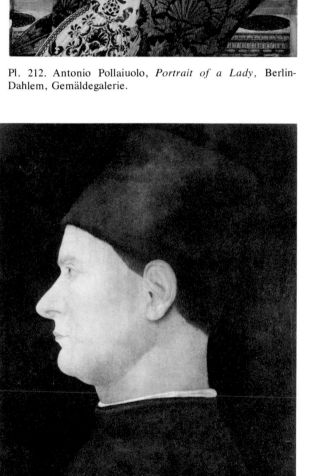

Pl. 214. North Italian, late fifteenth century, *Portrait of a Man,* Hampton Court.

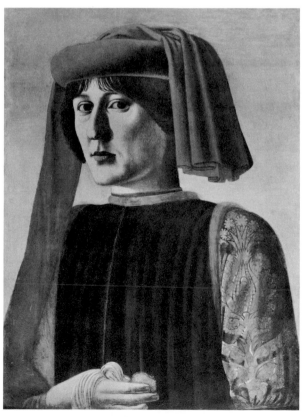

Pl. 217. Florentine, mid-fifteenth century, *Portrait of a Man,* Munich, Alte Pinakothek.

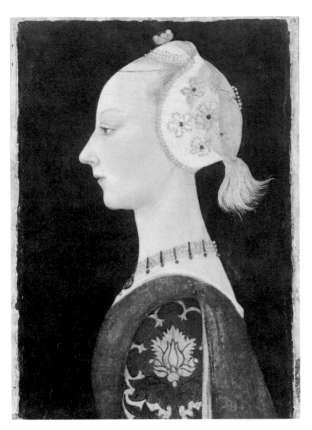

Pl. 213. Florentine, mid-fifteenth century, *Portrait of a Lady,* Boston, Isabella Stewart Gardner Museum.

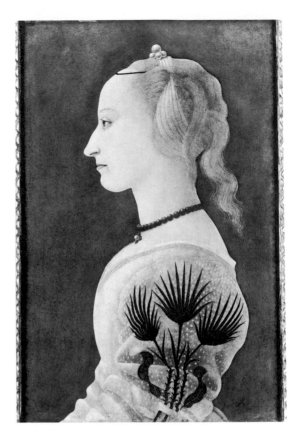

Pl. 215. Alesso Baldovinetti, *Portrait of a Lady,* London, National Gallery.

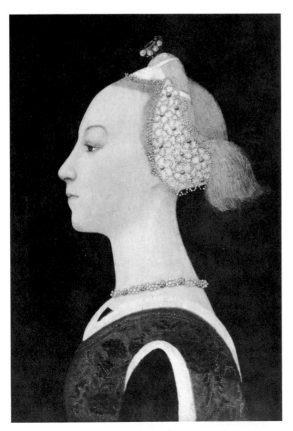

Pl. 218. Florentine, mid-fifteenth century, *Portrait of a Lady,* New York, Metropolitan Museum of Art, Bache Collection.

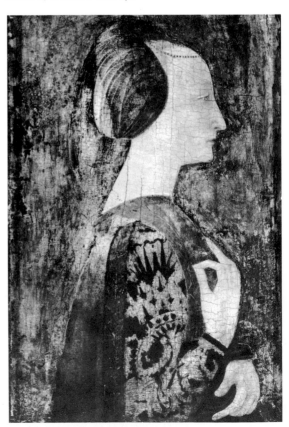

Pl. 219. Master of the Castello Nativity, *Portrait of a Lady,* New York, Metropolitan Museum of Art, Lehmann Collection.

Pl. 220. Sienese, mid-fifteenth century, *Madonna and Child with Sts. John the Baptist and Anthony Abbot,* London, Italian Embassy.

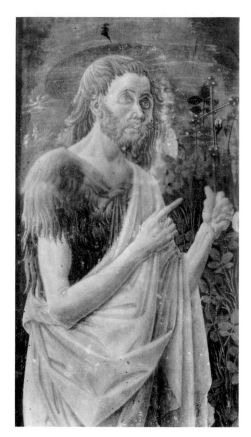

Pl. 221. Giovanni Angelo di Antonio da Camerino, *St. John the Baptist,* Loreto, Museo della Santa Casa.

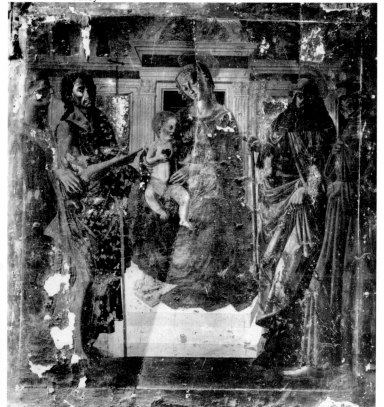

Pl. 224. Circle of Verrocchio. *sacra conversazione*, Romena, S. Pietro.

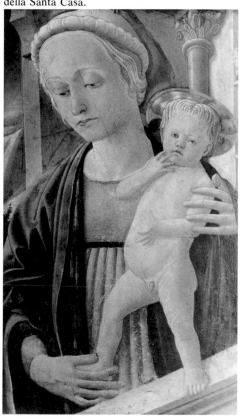

Pl. 225. Florentine, third quarter of the fifteenth century, *Madonna and Child,* Bergamo, Accademia Carrara.

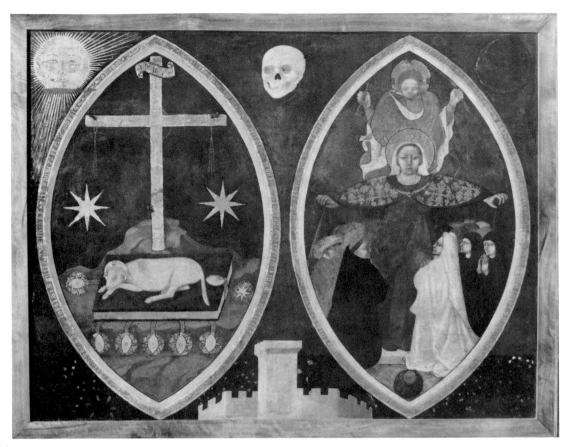

Pl. 222. Umbrian, mid-fifteenth century, *The Cross and the Mystic Lamb and the Book of the Seven Seals, and the Madonna della Misericordia,* Perugia, Galleria Nazionale dell'Umbria.

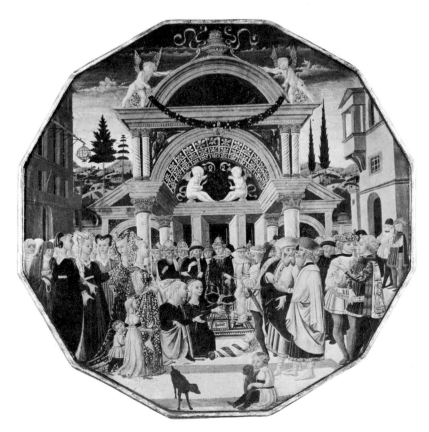

Pl. 223. Florentine, mid-fifteenth century, *The Judgment of Solomon,* Richmond, The Virginia Museum of Fine Arts.

Pl. 228. Umbrian, mid-fifteenth century, *Man in Armor*, Perugia, Galleria Nazionale dell'Umbria.

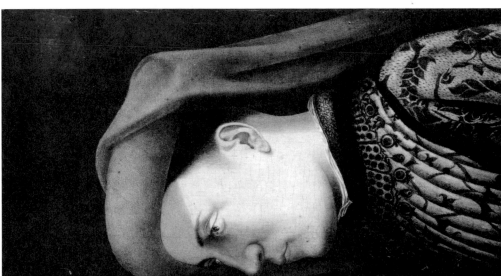

Pl. 227. Netherlandish, late fifteenth century, *Portrait of a Member of the Medici Family*, Zurich, Landolthaus.

Pl. 226. Netherlandish, late fifteenth century, *Portrait of a Member of the Medici Family*, Zurich, Landolthaus, Gottfried Keller Stiftung.

DOCUMENTS AND SOURCES

INTRODUCTORY NOTE TO TRANSCRIPTION OF DOCUMENTS

In the S. Egidio and Parenti accounts (documents 2 and 3) the phrase *de' dare* means "is debited," and *de' avere* means "is credited." Sums in the accounts are entered in gold as well as in silver, since the Florentine monetary system operated according to both a gold and a silver standard. The relationship of silver currency (*moneta di pìccioli*) to gold florins (*fiorini* or *fiorini a oro*) was expressed in terms of pounds (*lire di pìccioli*). The Parenti account also lists *fiorini larghi* (*fiorini larghi d'oro*), a coinage which first appeared in the middle of the fifteenth century and was not yet mentioned in the S. Maria Nuova ledgers. The units of the two currencies are as follows: 1 *fiorino* = 20 *soldi a oro* = 240 *denari a oro*, and 1 *lira di pìccioli* = 20 *soldi di pìccioli* = 240 *denari di pìccioli*. Craftsmen's wages and retail prices are recorded in denominations of silver, and wholesale prices and artists' fees are entered in terms of gold.

The entries on the left side of the page in the Parenti account, which specify the cost of materials or services, are phrased in units of silver or gold, or both. However, the figures here are usually accompanied by the identifying words *a oro* or *pìccioli*. (There are two exceptions to this. The entry of 1 florin on March 6, 1448, obviously did not require the addition of *a oro;* and *pìccioli* may have been omitted after the listing of 52 soldi in the tenth entry because the same sum was recorded in terms of silver (2 lire and 12 soldi) in the right-hand column of the page). In the right-hand column of the Parenti account all figures are entered in the standardized form of gold florins, *lire di pìccioli*, *soldi di pìccioli*, and *denari di pìccioli*. The only other currency unit employed in this account is the *grosso,* a small silver coin worth 5½ *soldi di pìccioli*, which figures in the entries of June 14 and 18, and of July 2.

Since the sum of the eighteen payments of the Parenti account (42 florins, 32 lire, and 19 soldi) must be the equivalent of 50 florins, the price for which the *cassoni* were to be delivered, it follows that in 1447–48 the ratio of florins to *lire di pìccioli* was about 1:4.2. Indeed, the first entry of the account states that the florin is rated at 84 *soldi di pìccioli* (4 lire and 4 soldi, or 4.2 lire). When the florin was first issued in 1252 the ratio to lire had been 1:1. In 1400 it was about 1:3.75, and in 1420 it was 1:4. By 1500 it had become 1:7.

DOCUMENTS

1. Letter written by Domenico Veneziano from Perugia on April 1, 1438, to Piero de' Medici in Ferrara (Frontispiece).

Spectabilis et generose vir, dopo le debite rechomendacione etc. Avisovi che per la Dio gracia io essere sanno, desideroso vedervi sanno e lieto. Più e più vólte ho dimandato de vui, e mai nonn ò saputo nula, salvo ch'i'ò dimandato Manno Donati, el quale me dise vui essere in Ferara e sanisimo. Hone riceuta gran chonsolazione; et avendo saputo prima dove fossi stato, v'averei schrito per mia chonsolacione e debito, avenga Dio la mia bassa chondizione non merita schrivere ala vostra gientileza, ma solamente el perfecto e buono amore ch'io porto a vui e a tuti i vostri me dà soma audazia de potervi schrivere, chonsiderando quanto io ve sono tenuto et hubligchato.

Hora al presente ho sentito che Chosimo à deliberato far fare, ziò dipingchiere, una tavola d'altare, et vole um magnificho lavorio, la quale chosa molto me piazie e più mi piacerebe se posibele fuse per vostra megianità ch'io ch'io la dipingiese. Et si ziò aviene, ho speraza in Dio farvi vedere chose meravigliose, avengna che ze sia di bon maestri chome fra' Felipo et fra' Giovane, i quali ànno di molto lavorio a fare, et spicialmente fra' Felipo à una tavola che va in Santo Spirito, la quale lavorando lui dì e note, non la farà in cinqu'ani, sì è gran lavoro. Ma che se sia, el grande e buono animo ch'i'ò de sservirvi, me fa prusuntuoso, hoferendome che si io facese mancho bene che niuno che ze sia, voglio essere hoblichato ad ogni meritoria choricione, a farne che ogni pruova farne ogni pruova che bisognia, honorando hogniuno. E se pure el lavorio fuse sì grando che Chossimo deliberase darlo a più maestri, ho veramente più a uno che a un altro, priegchovi quanto è posibele a servo pregare signiore, che'l vi piazia adoperare le vertù vostre inn esserne favorevole et aghutoro in fare ch'io n'abia qualche particela. Chè se vui sapesi el disiderio ch'io ho de fare qualche famoso lavorio et spicialmente a vui, me saristi in ziò favorevole. Son certo che per vui non remarà; prieghove, fatene el posibele, ch'io vi prometo ne receverete honore de' fatti miei.

Altro per hora non me achade, salvo che si di qua poso per vui alchuna chossa, chomandate chome a vostro servitore. Priegovi non vi rechrescha farme dela sopraschrita tavola risposta, e sopra tuto avisatime di vostra sanità, da me sopra hogni altra chosa desiderosa. Christo vi prosperi et adenpia tuti li vostri disideri.

> Per lo vostro fedelisimo servitore
> Domenicho da Vinesia dipintore, a vui
> se richomanda, in Perusia 143VIII
> adì primo d'aprile.

On the back:

Spectabili et generoso viro Petro Chossime de Medicis de Florencia, maiori suo honorando, in Ferara.

Florence, Archivio di Stato, *Mediceo avanti il principato*, VII, fol. 290.

Published in Gaye (1839, pp. 136f), Pini (1876, I, p. 34), in German translation in Guhl (1880, pp. 19f.), and in English translation in Chambers (1970, pp. 92f.).

DOCUMENTS AND SOURCES

2. Payments to Domenico Veneziano and others for murals in the choir of S. Egidio.

 A. Florence, Archivio di Stato, *S. Maria Nuova, 5059, Quaderno di cassa DD, 1438–1439,* c. 134 (left side):

+MCCCCXXXVIIII

La chappella dell'altare magiore di Sancto Gidio de' dare adì 11 di magio L. due s. otto, portò maestro Domenicho da Vinegia, disse per oncie 5½ di lacca conperò a s. 9 l'onciaf. — L. 2 s. 8—

E adì 13 di giugno s. undici paghamo a uno fante che arechò oncie 16 d'azuro da Coximo de' Medici & Ci. di Vinegia; al quaderno creditori G, c. 67f. — l.—s. 11—

 c. 134 (right side):

+MCCCCXXXVIIII

La chappella de'avere, posto de' dare al quaderno segnato EE, c. 56f. — l. 2 c. 19—

 c. 185 (left side):

+MCCCCXXXVIIII

Maestro Domenicho di Bartolomeo da Vinegia che dipigne la cappella magiore di Sancto Gidio de' dare adì XXII d'aghosto f. quarantaquattro, portò lu 'detto in fiorini nuovi di cameraf. 44—

 c. 185 (right side):

+MCCCCXXXVIIII

Maestro Domenicho di Bartolomeo posto de'avere al quaderno segnato EE, c. 95f. 44—

 B. *S. Maria Nuova, 5060, Quaderno di cassa EE, 1439–1440,* c. 94v:

+MCCCCXXXVIIII. Maestro Domenicho di Bartolomeo da Vinegia che dipignie la chappella maggiore di Santo Gidio, de'dare adì XII di settembre f. quarantaquattro, posto de'avere al quaderno segnato DD, c. 185, e posto lo spedale de' avere, c. 93f. 44—

E de' dare adì XII di settembre f. due s. XV a oro, portò Pietro di Benedetto dal Borgho a San Sipolchro sta cho'illui, in grossif. 2 l. 3—

c. 95r:

Maestro Domenicho da Vinegia de'avere adì primo di dicenbre 1440 f. quarantasei L. III s. III, posto de'avere al quaderno segnato FF, c. 19f. 46 L. 3.3—

C. *S. Maria Nuova, 5817, Libro di debitori e creditori C, 1441–1446*, c. 35v:

1441 La chappella dell'altare maggiore di Santo Egidio de'dare adì primo di gugnio 1441 f. otto l. settanta . . .

E de'dare adì XI di gungnio f. dieci L. una s. X, posto Bicci di Lorenzo dipintore de'avere in questo, c. 154, sono per oro che ss'ebbe da Piero di Francesco Battiloro, ed eransi posti a chonto di detto Bicci e volevon essere a questa ragionef. 10 l. 1 s. 10—

E de'dare adì primo d'ottobre s. V d.IIII, posto maestro Domenicho dipintore per lib. 1 d'olio di linseme; a uscita segnata PP, c. 130f.— l. — s. 12 d. 4—

E de'dare adì V d'ottobre s. XII, posto maestro Domenicho dipintore per lib. 2 di dett'olio; a uscita, c. 130f. — l. — s. 12—

E adì X d'ottobre s. XVIII, posto maestro Domenicho sopradetto per lib, 3 d'olio di linseme; a uscita, c. 131f. — l. — s. 18—

c. 58v:

+MCCCCXLI

m⁰ Domenicho di Bartolomeo da Vinegia che cci dipignie la chappella maggiore, de'dare adì V di luglio f. quarantasei L. tre s. III, posto de'avere al quaderno segnato FF, c. 19, a uscita, c. 62f. 46 l. 3 s. 3—

E adì XIII di gienaio L. due s. IIII, portò contanti per suo' bisogni; a uscita segnata PP, c. 94f. — l. 2 s. 4—

E de'dare adì XXII di febraio f. trenta d'oro, portò contanti; a uscita segnata PP, c. 101f. 30—

E adì XXVIII di maggio 1442 f. trenta, portò contanti; a uscita, c. 115f. 30—

c. 59r:

m⁰ Domenicho di Bartolomeo da Vinegia dipintore de'avere adì VI di giugno 1443 f. cientosei L. V s. VII, posto de'dare al libro de' debitori segnato B, c. 255f. 106 l. 5 s. 7—

D. *S. Maria Nuova, 5818, Libro di debitori e creditori C, 1443–1490*, c. 53v:

Maestro Domenicho di Bartolomeo da Vinegia de'dare f. cientosei L. V s. VII pìccioli, levati dal libro vecchio de' debitori segnato B, a c. 255.........f. CVI l. 5 s. 7

Costui è il dipintore che dipingnie la chappella grande di San Gilio.

E de' dare adì primo di gungnio 1445 f. dieci d'oro, posto de' avere al quaderno di chassa segnato G, a c. 190.........f. X l.—

In the margin:

✠ M° Domenicho/se restassi a ddare, sono perduti chè non lasciò nulla.

Published in Wohl (1971); partly published in Harzen (1856, p. 232), Andreucci (1871, pp. 79f.), and Mather (1948).

3. Payments to Domenico Veneziano and others for two *cassoni* for Marco di Parente Parenti.

+MCCCCXLVII

Maestro Domenico di Bartolommeo da Vinegia dipintore de'dare adì XI di settembre L. trenta pìccioli, per lui a Giovanni d'Andrea da Albola legnaiuolo, i quali furono per un paio di forzieri di legname comperò da llui, i quali m'à a dipignere; e debbogl[i]ene dare in tutto, quando saranno chompiuti, d'achordo cho'lui, fiorini cinquanta. Vagliono L. 30, a s. 84 el fiorino.........f. VII l. — s. XII d.— pìccioli

E de'dare adì XXII di dicembre f. sei s. XIIII a oro, portò Antonio sta cho'llui in f. VI larghi, per parte di dipintura de' sopradetti forzieri m'à a fare.........f. VI l. II s. XVIIII d. VI

E de'dare adì XII di gennaio f. cinque s. XI d. VIII a oro, portò e' detto a f. V larghi, per parte di pagamento chome di sopra.........f. V l. II s. VIIII d. V

E de'dare adì XXII detto L. sette pìccioli, per lui a uno forzerinaio, pe' forzerini chomperò, che ssi mettono ne' forzieri.........f. I l. II s. XV d.—

E de'dare adì XXIII di febraio f. due s. II d. III a oro, portò Antonio sta cho'lui in f. 2 larghi.........f. II l. — s. VIIII d. VI

E de'dare adì XXVIIII di marzo 1448 f. uno, portò e'detto chontanti.........f. I l.—

E de'dare adì XII d'aprile 1448 f. uno s. II d. III a oro, portò e'detto in f.1 largho.........f. 1 l. — s. VIIII d. VI

E de'dare adì XXII d'aprile 1448 L. sedici s. III pìccioli alle rede di Piero di Francescho battiloro a chompagni, portò Antonio di Domenicho farsettaio, i quali furono per oro e ariento battuto tolse da loro pe' sopradetti forzieri.........f. III l. III s. VIII d.—

E de'dare adì primo di giugno f. due s. X. a oro per lui a Baldassare di Falcho, portò Daniello sui figliuolo, i quali disse erano per pigione di VI mesi passati d' una chasa tiene da llui a pigione.........f. II l. II s. II d. VI

E de'dare adì d'aprile, cioè insino a detto dì. s. cinquantadue, portò e'detto chontanti.........f. — l. II s. XII d.—

E de'dare adì V di giugno 1448 s. XII pìccioli, promissi per lui a Giovanni d'Ambruogio del Verzino e chompagni linaiuoli, per uno fornimento d'uno farsetto di guarnello nero levò da loro, posto debbino avere in questo a c. 4.........f. I l. — s. VII d.—

E de'dare adi XIIII detto grossi VI, portò e'detto chontanti.........f. — l. I s. XIII d.—

E de'dare adì XVIII detto f. cinque s. XII a oro, portò Antonio sta con lui, in grossi.........f. V l. II s. XI d.—

E de'dare adì detto L. otto pìccioli, promissi per lui a Zanobi di Nicholò e chompagni chalzaiuoli, posto che debbino avere in questo a c. 16.........f. I l. III s. XV d.—

E de'dare adì II di luglio 1448 L. tre s. XVIII pìccioli, per lui a Antonio d'Antonio linaiuolo, portò Antonio di Giovanni in grossi.........f. — l. III s. XVIII d.—

E de'dare adì detto, per barili ½ di vino, per tutto, s. XXV pìccioli.........f. — l. I s. V d.—

E de'dare L. quattordici s. I d. VI pìccioli, i quali gli prestai più tempo fa in V partite, inchominciati insino nel 1444, per più suoi bisogni.........f. III l. I s. VI d. VI

E de'dare adì XVIIII di luglio 1448 f. quattro s. III d. II a oro, portò Antonio sta cho'llui, per resto di f. 50 gli debbo dare de' detti forzieri.........f. IIII l. — s. XIII d. V pìccioli

Anne dato adì XIII di gennaio per uno paio di forzieri dipinti e adorni d'oro; e chon forzerini e chassette dorate e dipinte, e uno spechio chome è di chostume, f. cinquanta; i quali forzieri, perchè non sono bene finiti, passate questi dì delle noze, me gli debbe finire a perfezione.

Di poi, adì XX di guigno 1448, me gli rimandò chompiuti di dipignere e forniti a perfezione.........f. L.

Florence, Archivio di Stato, *Carte strozziane, II serie, 17 bis* (*Ricordi di Marco e Piero Parenti, 1447–1520*), c. 8r.

Published in Wohl (1971); partly published in Strozzi (1877, pp. 21f.) and in German translation in Strozzi (1927).

4. Contract between Benedetto Bonfigli and the chaplain of the Palazzo de' Priori in Perugia for the mural decoration of half of the Cappella de' Priori.

Magister Benedictus Buonfigli de Perusio, porte Sancti Petri, pictor, pro se et suos heredes obligavit se et omnia sua bona presentia et fuctura pro observatione infrascriptorum, promisit et convenit religioso viro dopno Bartolomeo de Senis capellano capelle palatii Magnificorum dominorum Priorum, stipulanti et recipienti pro commune Perusii et omnibus quorum interest, intererit seu interesse possit, pingere seu pingi facere partem seu ratam capelle palatii predicti modis, pactis et condictionibus in infrascripta cedula continetur, videlicet.

Benedicti Buonfigli infrascriptorum copiam cedule (in the margin).

+ Al nome di Dio adì ultimo di novembre 1454

Questa é una cedula dela mità dela capella del palazzo dey Signiore, la quale se vuole pigniere con queste mode, pacte et conditione che qui de socto scriveremo.

E'm prima, che el maiestro che toglierà a fare el dicto lavorìo, che degg[i]a fare sopr'esso l'altar uno Crocifisso, e da piede la Nostra Donna e Sancto Giovagnie e Sancto Arcolano e Sancto Lodovicho.

E più volemo che el maicstro che farà el dicto lavorìo, che sia tenuto e degg[i]a Ludovicho, con quello modo e forma che ala dicta storia se convene.

E più volemo che el maiestro che farà el dicto lavorìo, che sia tenuto e degg[i]a lavorare continuamente in la decta capella quando se può lavorare.

E più volemo che durante el sopradicto lavorìo non possa nè degg[i]a togli[e]re altro lavorìo a fare, per fine che non à fornito el dicto lavorìo.

E più volemo che, fornito el sopradicto lavorìo, se degg[i]a stimare per uno de queste tre maiestre, cioè el frate del Carmino, mastro Domenico da Vinegia e el frate da Fiesole; e non podendo avere l'uno de queste maiestre, che se degg[i]a pigliare uno o doy maiestre a volontà e piacimento de' Signiore Priore che seranno ay tempi, a una co'lo capellano. E quello che per queste maiestre se stimasse, degg[i]a essere el pagamento suo; e si e' dicte maiestre che ànno stimato el dicto lavorìo dicano essere lavorìo recipiente, che se intenda sequire l'altro resto dela capella per lo dicto modo.

E promètese dare a chi toglierà la sopradicta capella f. vintecinque, a bolognini XL per fiorino, per arra e parte de pagamento, in questo modo cioè: f. dieci dal dì del contracto

per fine a uno mese, e da lì a doy mese f. dieci, e da lì a doy altre mese el resto. E al dicto maiestro non degg[i]a avere più denaio per fine al fine del suo lavorìo.

E si el sopradicto lavorìo stimato che fosse non essere recipiente, se degg[i]a el dicto maiestro che l'à facto, perdere omne sua fatiga e spese avesse in lo dicto lavorìo, e la capella ci atenga ay dicte XXV fiorini, cioè la capella.

E promètese al dicto maiestro che toglierà el dicto lavorìo, darglie calcina, aqua, legniame e fune da fare ponte apartenente al dicto lavorìo.

E più volemo che omne spesa che intrerà a stimare el dicto lavorìo, cioè a conducciere ey dicte maiestre, che se intenda che el maiestro che toglierà el dicto lavorìo ci atenga ala mità, el al' altra mità la capella.

Io Benedecto de Buonofiglio pentore ò tolto a fare el sopradicto lavorìo cole sopradicte mode e pacte che de sopra se conti[e]ne, e a fede di ciò me so' soscripto de mia propia mano questo dì doy de dicenbre MCCCCLIIII.

Et io dopno Bartolomeio da Siena, capellano dey Magnifici Signiore Priore, me so' soscripto de mia propia mano questo dì dicto de dicenbre MCCCCLIIII.

Perugia, Archivio di Stato, *Consigli e riformanze, 90,* cc. 127v–128v.

Published in Mariotti (1788, p. 132, n. 2) and Orlandi (1964, p. 128), who erroneously refer to the register containing the document as the *Annali de' Signori Priori di Perugia.*

5. Domenico Veneziano's lease for a house in the S. Paolo parish in Florence.

1455 Item postea, dictis anno, indictione et die quattuordecima mensis maii. Actum Florentie, in populo Sancti Stefani abbatie, presentibus testibus etc. ser Antonio Adami Gratie et ser Iuliano Francisci Bandini, notariis et civibus Florentinis, et aliis.

Ser Finus olim Francisci, rector ecclesie Sancti Petri a Colognole vallis Sevis comitatus Florentie, omni meliori modo etc. locavit etc. Dominico Bartholomei pictore populi Sancti Pauli de Florentia, ibidem presenti et pro se et suis heredibus recipienti, domum cum palcis, cameris et aliis hedifitiis, positam in dicto populo Sancti Pauli de Florentia, cui a primo via, a II bona ecclesie Sancti Pauli, a III ser Soletti Filippi notarii, infra predictos confines vel alios veriores, pro tempore et termino unius anni proxime futuri, incipiendis hodie hac presenti suprascripta die. Que bona dictus locator promixit dicto conductori alteri non locare etc., sed ea defendere etc. Et e contra dictus locator promixit dicto locatori dicta bona pro dicto locatori tenere et possidere etc., et in fine locationis restituere et relapsare etc., et dare pro dicto tempore unius anni, nomine pensionis, florenos

sex auri, faciendum solutionem de sex mensibus in sex menses. Que omnia etc. prom-
iserunt etc., sub pena florenorum centum auri etc., que pena etc. Pro quibus etc. obligav-
erunt etc., renumptiaverunt etc. Rogantes etc., per guarentigiam etc.

Florence, Archivio di Stato, *Notarile antecosimaniano,* v. 217 (ser Piero del Viva, atti dal 1450
al 1456), c. 241r.

Published in Milanesi (1885, p. 144).

6. Payment for recording Domenico Veneziano's and Fra Filippo Lippi's estimate of Pesel-
lino's *Trinity*.

A uno notaio, a dì decto (10 di loglio 1457), che fu roghatore dello lodo fu per frate
Filippo e di Domenicho da Vinegia e per portatura della taula dello legniame, in tut-
to lib. — sol. XV den.—

Pistoia, Archivio di Stato, *Patrimonio ecclesiastico* (*Compagnia della SS. Trinita, G, 495*), c.
12r.

Published in Bacci (1904 and 1942, p. 121).

7. Baldovinetti agrees to complete Domenico Veneziano's *Marriage of the Virgin* at S. Egidio.

1461 Ricordanza chome oggi questo dì xvii d'aprile 1461 Alesso di Baldovinetto dipin-
tore promette a messere Iacopo di Piero, moderno spedalingo dello spedale di Santa Maria
Nuova di Firenze, presente e ricevente per detto spedale, per di qui a uno anno proximo
advenire, conpiere (cancelled in the text: uno) et finire di dipignere una storia di Nostra
Donna, cominciata per maestro Domenicho da Vinegia nella chappella maggiore della
chiesa di San Gilio dal lato di verso el chiostro, a tutte spese di cholori et oro e d'ogni altra
cosa bisognasse per detto lavoro di decto spedale. Con questo che detto messere Iacopo
sia tenuto a dare a detto Alesso e a qualunche stesse seco a dipignere detta storia, le spese
del vivere solo. Et la faticha sua detto Alesso rimette a detto spedale per l'amore di Dio.
Et per chiareza di ciò, di volontà de'sopradetti, io Giovanni di Zanobi di ser Giovanni
Dini, notaio fiorentino, ò facta la presente ricordanza.
Io Alesso sopradetto sono chontento a quanto di sopra si chontiene, e però mi sono
soscritto di mia propia mano, anno e ddì detto di sopra.
Io ser Iacopo di Piero, spedalingo di sopra decto, sono contento a quanto è scripto di
sopra, anno e mese e dì decto.

DOCUMENTS AND SOURCES

Florence, Archivio di Stato, S. Maria Nuova, *Libro di ricordanze B, 1455–1555*, c. 57.

Published in Giglioli (1905), Poggi, (1909, Appendix B), Kennedy (1938, p. 240) and in English translation in Chambers (1970, p. 196).

8. Notices of Domenico Veneziano's burial.

A. Florence, Archivio di Stato, *Arti, Medici e Speziali,* 245 (*Libro dei morti, 1459–1475*), c. 23v:

Adì XV di maggio 1461 . . . Dominicho Vineziano, riposto in S. Piero Gattolino.

Published in Mather (1948).

B. Florence, Archivio di Stato, *Grascia, Libri de morti,* 5 (*Libro nero P, 1457–1506*), c. 26v:

Domenicho Veniziano, riposto in San Piero Gattolino . . . adì XV di maggio 1461.

Unpublished.

9. Entry of Domenico Veneziano's name in an undated register of the Florentine Company of St. Luke.

Domenico di Bartolommeo

Published in Mather (1948).

SOURCES

1. Giovanni Rucellai, *Lo Zibaldone* (ca. 1460–70).

Memoria che noi abiamo in chasa nostra più chose di scholtura e di pitura, di tarsie e comessi, di mano de' migl[i]ori maestri che siano stati da buono tenpo in qua, non tanto in Firenze ma in Italia: e nomi de' quali sono questi, cioè:

maestro Domenicho da Vinegia, pittore;
frate Filippo de l'ordine . . . , pittore;

Giuliano da Maiano legnaiuolo, maestro di tarsie e comessi;
Antonio d'Iacopo del Polaiuolo, maestro di disegno;
Maso Finighuerra orafo, maestro di disegno;
Andrea del Verochio, scultore e pittore;
Bettorio di Lorenzo Bartolucci, intagl[i]atore;
Andreino dal Chastagno, detto degl'Inpichati, pittore;
Paolo Ucello, pittore;
Disidero da Settignano}
Giovanni di Bertino } maestri di scharpello.

Published in Marcotti (1881, pp. 67f.) and Perosa (1960, pp. 23f.).

2. Antonio Averlino Filarete, *Trattato dell'architettura* (ca. 1461–62).

. . . Ma a me parrebbe si dovesse figurare le cose appartenenti acquesta virtù & anche al vitio. Et cosi quegli che anno acquistata questa virtù & anche quegli che sono stati vitiosi acagione che chi se videsssi fussino cagione dinatare gli uomini a seguire virtù & cosi a fuggire & ischifare il vitio & ancora: a me pare che così si debba fare sichè a noi sta. Truova il maestro & che si dia hordine a fare fare queste cose. Lo dubito Signiore abisognerà aspettare perchè cè carestia di maestri che sien buoni perchè queste cose vogliono stare bene. A ogni modo voglio stieno bene, ma non si troveranno maestri buoni. Non so, perchè n'è morti una sorte che erano a Firenze che sarebbero venuti qua erano buoni maestri tutti cioè uno chiamato Masaccio un'altro chiamato Masolino uno ch'era frate chiamato fra Giovanni poi ancora nuovamente ne sono morti tre altri buoni uno chiamato Domenico da Vinegia un'altro chiamato Francesco di Pesello il quale Pesello ancora fu grande maestro d'animali un altro si chiamava Berto il quale morì a Lione sopra a Rodano. Un'altro ancora il quale era nella pintura molto dotto & perito il quale si chiamava Andreino degl'Impicchati sichè dubito sarà dificulta averne . . .

Published in Eastlake (1869, II) and Filarete (1896, p. 307, and 1965 fol. 69r, pp. 119f.).

3. Alamanno Rinuccini, Dedicatory Epistle to the Translation into Latin of Philostratus' *Life of Apollonius* (1473).

Nostrae autem aetati proximus Masaccius naturalium quarumque rerum similitudines ita pingendo expressit, ut non rerum imagines, sed res ipsas oculis cernere videamur. Quid vero Dominici Veneti picturis artificiosius? Quid Philippi monachi tabulis admirabilius? Quid Iohannis ex Praedicatorum ordine imaginibus ornatius? Quid omnes, varietate quadam inter se dissimiles, certis tamen excellentia et bonitate simillimi putantur.

[349]

DOCUMENTS AND SOURCES

Published in Fossius (1791, p. 43), Rinuccini (1953, p. 106) and, in English translation in Gombrich (1966, p. 2).

4. Giovanni Santi, *Cronaca* (ca. 1482–91).

> Ma nell'Italia in questa età presente
> Vi fu el degno Gentil da Fabriano,
> Giovan da Fiesol frate el ben ardente,
> Et in medaglie et in pictura el Pisano,
> Fra Philippo et Francesco Pesselli,
> Domenico chiamato el Venetiano,
> Massaccio e Andrein Paulo Ocelli,
> Antonio e Pier si gran desegnatori
> Piero dal Borgo, antico più di quelli.

Published in Santi (1893, p. 189).

5. The Medici Inventory.

A. Uno panno dipintovi una fighura a sedere in uno tabernacholo, mezza nuda, con uno teschio in mano, di mano di maestro Domenico da Vinegia, cholorita a olio, contrafatta a marmo.........f. 10.

B. Uno colmetto con dua sportelli, dipintovi dentro una testa di una dama, di mano di maestro Domenico da Vinegia..........f. 8.

Florence, Archivio di Stato, *Mediceo avante il principato,* 165 (Inventario dei beni di Lorenzo il Magnifico, copiato nel 1512 da uno fatto nel 1494 al tempo della sua morte), fols. 38r–v.

Published in Müntz (1888, pp. 84f.).

6. Francesco Albertini, *Memoriale,* Florence, 1510; 2d ed., Florence, 1863, p. 15; 3d ed., Florence, 1932.

A. La Chiesa de Sancta Maria Nuova, fu consecrata da papa Eugenio IIII. l'anno che se fece il synodo in Flo. presente lo Imperatore greco è devotissimo. La cappella maiore è mezza di Andreino, et mezzo di Dominico Veneto, benchè alcune figure dinanzi sieno per mano de Alxo. Bal.

B. El Crucefixo di legno di Donato, il quale fece la Nuntiata di pietra: appresso la tavola di Pietro P[ollaiuolo].

7. Luca Landucci, *Diario fiorentino dal 1450 al 1516.*

E di marzo 1458, si pose una gravezza che si chiamo catasto, e posola nella Sala del Papa.

E in questi tempi si cominciò la lanterna della cupola di Santa Maria del Fiore, e'l palagio di Cosimo de' Medici, e San Lorenzo e Santo Spirito e la Badia d'andare a Fiesole, e molte case in verso le mura di verso San Bernaba e di verso Santo Ambruogio e in più lati. E in questi tempi vivevano questi nobili e valenti uomini: l'arcivescovo Antonino ch'uscì di San Marco, frate, e andò sempre vestito come frate di quell' Ordine di San Domenico, al quale si può dire beato; messer Bartolomeo de' Lapacci, vescovo e predicatore eccellentissimo sopra tutti gli altri ne' nostri dì; maestro Pagolo medico, filosofo e astrologo e di santa vita; Cosimo di Giovanni de' Medici, el quale si chiamava da tutto 'l mondo el gran mercante, ch' aveva la ragioni per tutto l' abitato; non si poteva fare maggiore comparazione che dire: e' ti par essere Cosimo de' Medici: quasi dicendo: che non si poteva trovare el maggiore ricco e più famoso; Donatello scultore, che fece la sepoltura di messer Lionardo d'Arezzo in Santa Croce; e Disidero iscultore che fece la sepoltura di messer Carlo d'Arezzo pure in Santa Croce. Poi venne su el Rossellino, un uomo molto piccolino, ma grande in iscoltura; fece quella sepoltura del Cardinale che è a San Miniato, in quella cappella a mano manca; maestro Antonio, sonatore d'organi, che passò ne' sua dì ognuno; maestro Antonio di Guido, cantatore improviso, che ha passato ognuno in quell' arte; maestro Andreino degl'Impiccati, pittore; maestro Domenico da Vinegia, pittore, veniva su; maestro Antonio e Piero suo fratello che si chiamava del Pollaiuolo, orafi, scultori e pittori; maestro Mariano che 'nsegnava l'abaco; Calandro maestro d'insegnare l'abaco e uomo molto buono e costumato, che fu mio maestro.

Published in Landucci (1883, pp. 2f.) and in English translation in Landucci (1927 and 1969, pp. 2f.).

8. Francesco Baldovinetti, *Memoriale* (1513)

Dipinse [Alesso Baldovinetti] una Vergine Maria in sul chantto de' Carnesecchi.

Published in Poggi (1909, p. 50).

9. *Il Libro di Antonio Billi* (1481–1530).

A. [Andrea del Castagno] Dipinse in più luoghi: come fu na facciata in Santo Gilio in Firenze; et drieto allo altare maggiore dipinse Alesso Baldovinetti, et uno Domenicho da Vinegia, el quale fu morto da detto Andreino con una maza ferrata in sulla testa per invidia et però non potette finire detta facciata; et alla morte confessò omicidio.

B. . . . Dipinse Castagno . . . in decta chiese [S. Croce] nella capella de' Cavalcanti uno Santo Girolamo et uno Santo Francesco.

Published in Frey (1892a, pp. 22, 23).

10. *Il Codice Magliabecchiano* (ca. 1537–42).

A. [Andrea del Castagno] Dipinse in Firenze nella chiesa di San Gilio una facciata, che la 2.a dreto all'altare dipinse Alesso Baldovinettj, et la 3.a verso . . . maestro Domenicho da Vinetia, il quale da detto Andreino fu morto per invidia d'un colpo di una maza ferrata in sulla testa, che gli dette, aciò finire non potessi la detta facciata; laquale cosa esso Andreino alla sua morte confessò detto omicidio.

B. Et ancora nella chiesa di dettj fratj [S. Croce] nel cantone a canto alla cappella de Cavalcantj overo della Nuntiata di Donato sono di suo mano [Andrea del Castagno] un San Girolamo et un San Francesco.

C. Maestro Domenicho da Vinetia pittore dipinse in Firenze nella chiesa di San Gilio la facciata verso . . . della cappella maggiore. Et fu morto, mentre lavorava in detta facciata da Andreino dellj Impicchatj per invidia, che a concorrentia dipignevano in detto luogho.

Published in Frey (1892, pp. 98, 101).

11. Vasari, *Le Vite* (1550 and 1568).

A. Introduction to the second edition of the *Vite* (Vasari-Frey, 1911, pp. 120ff.).

Fu una bellissima invenzione e una gran commodità all' arte della pittura il trovare il colorito a olio, di che fu primo inventore in Fiandra Giovanni da Bruggia. Il quale mandò la tavola a Napoli al re Alfonso et al duca d' Urbino Federico II la stufa sua; et fece un San Gironimo, che Lorenzo de' Medici haveva, et molte altre cose lodate. Lo seguitò poi Rugieri da Bruggia, suo discepolo, et Ausse, creato di Rugieri, che fece a Portinari in

Santa Maria Nuova di Firenze un quadro picciolo, il qual' è hoggi apresso al Duca Cosimo; et è di sua mano la tavola di Careggi, villa fuora di Firenze della Illustrissima Casa de Medici. Furono similmente de primi Lodovico da Luano et Pietro Christa et maestro Martino et Giusto da Guanto, che fece la tavola della comunione del duca d'Urbino et altre pitture, et Ugo d'Anversa, che fe la tavola di Santa Nuova di Firenze. Questa arte condusse poi in Italia Antonello da Messina, che molti anni consumò in Fiandra; et nel tornarsi di qua dai monti fermatosi ad habitare in Venezia, la insegnò ad alcuni amici. Uno de' quali fu Domenico Veniziano, che la condusse poi in Firenze, quando dipinse a olio la capella de' Portinari in Santa Maria Nuova, dove la imparò Andrea dal Castagno, che la insegnò agli altri maestri; con i quali si andò ampliando l'arte et acquistando sino a Pietro Perugino, a Lionardo da Vinci et a Rafaello da Urbino, talmente che ella s'è ridotta a quella bellezza che gli artifici nostri, mercè loro, l'hanno acquistata.

B. *Vita* of Piero della Francesca (Vasari-Ricci, II, p. 72; Vasari, 1568, II, p. 355).

1550	1568
[Piero della Francesca] Dipinse a S. Maria di Loreto in compagnia di Domenico da Vinegia.	[Piero della Francesca] Dipinse a Santa Maria di Loreto in compagnia di Domenico da Vinegia il principio d'un opera nella volta della sagrestia; ma perchè temendo di peste la lasciarono imperfetta, ella fu finita da Luca da Cortona, discepolo di Piero, come si dirà al suo luogo.

C. *Vita* of Antonello da Messina (Vasari-Ricci, II, p. 94; Vasari, 1568, II, p. 377).

1550	1568
Era in quella città allora de più eccellenti pittori uno, chiamato M. Domenico da Venezia, il quale fece ad Antonello in nella sua giunta quelle carezze, et cortesie, che maggiori si posson fare ad amico che si ami: per il che Antonello che non si volse lassar vincere dalle cortesie da M. Domenico dopo non molti mesi, gli insegniò il secreto del colorire a olio: del quale egli fu molto contento et in Venezia per quello onorato.	Fra i pittori, che allora erano in credito in Vinezia era tenuto molto Ecc. un Maestro Domenico. Costui arivato Antonello in Venezia, gli fece tutte quelle carezze, e cortesie, che maggiori si possono fare a un carissimo, e dolce amico. Per lo che Antonello, che non volle essere vinto di cortesia da M. Domenico, dopo non molti mesi gl'insegnò il secreto, e modo di colorire a olio. Della qual cortesia, & amorevolezza straordinaria, niun'altra gli sarebbe potuta esser più cara: & certo ragione, poi che, per quella, si come imaginato si era, fu poi sempre nella patria molto onorato. E certo coloro sono inganati in di grosso, che pensano, essendo avarissimi, anco di quelle cose, che loro non cos-

1550

Ne vi andò troppo tempo che egli fu condotto a Fiorenza da quegli che facevano in Venezia le faccende mercantili de' Portinari, per lavorare la cappella di Santa Maria Nuova, edificata da loro, come si dirà nella vita di Andrea del Castagnio, perchè poi M. Domenico la insegniò ad Andrea predetto, et egli a tutti i discepoli suoi, tanto che ella si sparse per tutta Italia.

1568

tano, dovere essere da ognuno, per i loro begliocchi, come si dice, serviti. Le cortesie di Maestro Domenico Viniziano cavarono di mano d'Antonello quello, che haveva con sue tante fatiche, e sudori procacciatosi; e quello, che forse per grossa somma di danari non haverebbe a niuno altro conceduto. Ma perche di M. Domenico si dirà quando sia tempo quello, che lavorasse in Firenze, & a cui fusse liberale di quello, che haveva da altri cortesemente ricevuto; . . .

D. *Vita* of Andrea del Castagno (Vasari-Ricci, II, pp. 122ff.), and of Andrea del Castagno and Domenico Veneziano (Vasari, 1568, II, pp. 397ff.).

1550

[Andrea del Castagno] Fece ancora in Santa Maria Nova nel cimiterio infra l'ossa un santo Andrea, che fu cagione, che et il Refettorio, dove i servigiali mangiano et gli altri dello Spedale, la cena di CHRISTO con gli Apostoli vi dipignesse. Per il che acquistato grazia con la casa de Portinari fu messo alla cappella dello altar maggiore di San Gilio in detta chiesa; nella quale laborò una parete, et dell' altre una ne fu data ad Alesso Baldovinetti, et l'altra al molto allora celebrato pittore DOMENICO DA VINEGIA. Perchè i Portinari l'aveano fatto venire da Vinegia, perciòchè di quel luogo il colorire a olio portato aveva, onde di tal cosa grandissima incidia gli ebbe Andrea; et benchè si conoscesse esse più eccellenté di lui, per questo non restò che lo invidiasse; perchè vedendolo Andrea come foristiero da' suoi cittadini con molte carezze tratenuto; fu cagione che invelenito pensò di torselo dinanzi col perseguitarlo con fraude. Era Andrea persona al-

1568

[Andrea del Castagno] Fece ancora nel cimiterio di s. Maria nuova in fra le ossa un santo Andrea, che piacque tanto, che gli fu fatto poi dipignere nel Reffettorio, dove i servigiali, & altri ministri mangiano, la cena di Christo con gl'Apostoli. Per lo che, acquistato grazia con la casa de' Portinari, & con lo spedalingo, fu datogli a dipignere una parte della cappella maggiore, essendo stata allogata l'altra ad Alesso Baldovinetti, e la terza al molto allora celebrato pittore Domenico da Vinezia, il quale era stato condotto à Firenze per lo nuovo modo, che egli haveva di colorire a olio. Attendendo dunque ciascuno di costoro all'opera sua, haveva Andrea grandissima invidia à Domenico, perchè se bene si conosceva più eccellente di lui nel disegno, haveva non di meno per male, che essendo forestiero, egli fusse da' Cittadini carezzato, et trattenuto: e tanta hebbe forza in lui, perciò la colera, e lo sdegno, che cominciò andar pensando, o per

legrissima, et simulatore non manco valente che pittore, se bene nessuno nol conosceva, et molto nella lingua spedito et d'animo fiero, et in ogni azzione del corpo come della mente risoluto. Usò ad alcuni artefici, nell'opre che fecero, segnare col graffio dell'ugna gli errori, che in quelle conosceva; et ancora a quegli, che nella sua giovanezza lo avevano morso nelle prime opre, che fuora aveva messo, per istizia dar delle pugna loro, et a buona occasione di altrui, che l'offendeva, vendicarsi.

Avenne, che di quei primi di, che DOMENICO DA VINEGIA il quale nella sagrestia di Santa Maria dell'Oretto aveve dipinto in compagnia di Piero della Francesca, giunse in Fiorenza fece sul canto de' Carnesecchi nell'angolo delle due vie, che vanno a Santa Maria novella un tabernacolo a fresco con una Nostradonna e alcuni Santi da lato, onde molto da cittadini ed artefici in quel tempo fu lodato. Per il che crebbe ad Andrea la invidia et lo sdegno contra di lui assai maggiore che prima non aveva. La onde fatto pratica più si domesticò con Maestro Domenico: il quale perchè buona persona et amorevole era, assai alla musica attendeva: et dilettandosi sonare il liuto, andava la notte cantando, et alcune serenate faccendo a sue innamorate: et Andrea spesso in compagnia di lui andava, monstrando avere più grato ne più domestico amico, onde gli fu insegnato da Domenico l'ordine e'l modo del colorire a

una, o per altra via di levarselo dinanzi: E perchè era Andrea non meno sagace simulatore, che egregio pittore, allegro quando voleva, nel volto, della lingua spedito, e d'animo fiero, & in ogni azzione del corpo, cosi come era della mēte, risoluto; hebbe cosi fatto animo con altri, come con Domenico, usando nell'opere degl'artefici di segnare nascosamente col graffiare dell'ugna, se errori vi conosceva. Et quando nella sua giovanezza furono in qualche cosa biasimate l'opere sue, fece a cotali biasimatori con percosse, & altre ingiurie conoscere, che sapeva, e voleva sempre, in qualunche modo, vendicarsi delle ingiurie. Ma per dire alcuna cosa di Domenico prima, che venghiamo all'opera della cappella; avanti, che venisse a Firenze, egli haveva nella sagristia di S. Maria di Loreto, in compagnia di Piero della Francesca dipinto alcune cose con molta grazia, che l'havevano fatto per fama, oltre quello, che haveva fatto in altri luoghi, come in Perugia una camera in casa de' Baglioni, che hoggi è rovinata conoscere in Fiorenza: Dove essendo poi chiamato, prima, che altro facesse, dipinse in sul canto de' Carnesecchi, nell'Angolo delle due vie, che vanno l'una alla nuova, l'altra alla vecchia piazza di S. Maria Novella, in un Tabernacolo a fresco una N. Donna in mezzo d'alcuni santi: Laqual cosa, perchè piacque, e molto fu lodata da i Cittadini, e dagl'Artefici di que' tempi, fu cagione, che s'accendesse maggiore sdegno, & invidia nel maladetto animo d'Andrea, contra il povero Domenico: perchè, deliberato di far con inganno, e tradimento quello, che senza suo manifesto pericolo non poteva far alla scoperta, si finse amicissimo d'esso Domenico; il quale perchè buona persona era, & amorevole, cantava di musica, e si dilettava di sonare il Liuto, lo ricevete volontieri in amicizia, parendogli Andrea persona d'ingegno, e sollazevole. E così con-

olio, il quale in Toscana non era ancora in uso. Aveva Andrea finito a fresco nella cappella una storia della Nostra donna, quando è dallo angelo annunziata chè tenuta cosa bellissima per avervi egli dipinto lo angelo in aria, cosa non usata fino a quel tempo. Ma molto più bella ancora fu tenuta una altra istoria d'una Nostra donna pure quando ella sale i gradi del Tempio: in sù i quali figurò molti poveri, et fra gli altri uno che con un boccale da in su la testa ad un'altro, cosa molto bene finita da lui per lo sprone della concorrenzia di maestro Domenico, con industria, arte, et amore. Dall'altra parte aveva maestro Domenico fatto ad olio nell'altra parete di detta cappella la Natività, et lo sposalizio di detta Vergine:

tinuando questa da un lato vera, a dall'altro finta amicizia, ogni notte si trovavano insieme a far buon tempo, & serenate a loro inamorate; di che molto si dilettava Domenico; Il qual amando Andrea da dovero, gli insegnò il modo di colorire a olio, che ancora in Toscana non si sapeva. Fece dunque Andrea, per procedere ordinatamente, nella sua facciata della cappella di S. Maria Nuova, una Nunziata, che è tenuta bellissima, per havere egli in quell'opera dipinto l'Angelo in aria, il che non si era insino allora usato. Ma molto più bell'opera è tenuta dove fece la N. Donna, che sale i gradi del tempio, sopra i quali figurò molti poveri, e fra gl'altri uno, che con un boccale da in su la testa ad un'altro; e non solo questa figura ma tutte l'altre sono belle affatto, havendolo egli lavorate cõ molto studio, & amore, per la concorrenza di Domenico. Vi si vede anco tirato in prospettiva, in mezzo d'una piazza un tempio a otto faccie isolato, e pieno di pilastri, e nicchie: a nella facciata dinanzi benissimo adornato di figure finte di marmo. E intorno alla piazza è una varietà di bellissimi casamenti; i quali da un lato ribatte l'ombra del tempio, mediante il lume del Sole con molto bella, difficile, & artifiziosa considerazione. Dall'altra parte fece maestro Domenico a olio Gioachino, che visita S. Anna sua consorte, e di sotto il nascere di N. Donna, fingendovi una camera molto ornata, & un putto, che batte col martello l'uscio di detta camera con molto buona grazia. Di sotto fece lo sposalizio d'essa Vergine, con buon numero di ritratti di naturale, fra i quali è M. Bernadetto de' Medici conestabile de' Fiorentini, con un berettone rosso; Bernardo Guadagni, che era Gonfaloniere, Folco Fortinari, & altri di quella famiglia. Vi fece anco un Nano, che rompe una mazza, molto vivace; & alcune femine con habiti in dosso vaghi, e graziosi fuor di modo, secondo, che si usavano in que' tempi. Ma questa opera

1550

et Andrea aveva cominciato a olio l'ultima storia della morte di Nostradonna: Nella quale per la concorrenzia di M. Domenico spronato dal desiderio di esser' tenuto quello che egli era veramente, fece in iscorto un' Cataletto dentrovi la morta, la quale non è un' braccio et mezo di lunghezza, et pare lunga tre. Intorno a questa figurò gli Apostoli in una maniera, che se bene si conosce ne' visi loro la allegrezza del vederne portare quella anima in Cielo da IESU CHRISTO; e' vi si conosce ancora il dolore et l'amaritudine del rimanere in terra senza essa. Tra gli Apostoli mescolò molti Angeli che tengono lumi accesi, con belle arie di teste, et si bene condotte, che e' mostrò certamente di saper maneggiare i colori a olio si bene, quanto M. Domenico suo concorrente.

Tuttavolta, avendo già condotto questa opera a bonissimo termine, accecato dall'invidia per le lodi che alla virtù di Domenico udiva dare volendo al tutto levarselo dattorno, imaginossi varie vie da farlo morire, et fra l'altre una ne mise in essecuzione in questa guisa. Una sera di state, come altre volte era solito, maestro Domenico tolse il liuto, et di Santa Maria Nuova partitosi, lasciò Andrea, il quale nella camera sua disegnava, et l'invito, che Domenico gli aveva fatto di menarlo a spasso per la terra accettar non volse, mostrando che allora avesse fretta di disegnare alcune cose importanti;

1568

rimase imperfetta, per le cagioni, che di sotto si diranno. Intanto haveva Andrea nella sua facciata fatta a olio la morte di nostra Donna: Nellaquale per la detta concorrenza di Domenico, e per essere tenuto quello, che egli era veramente si vede fatto con incredibile diligenza in iscorto un cataletto dentrovi la Vergine morta, il quale, ancora, che non sia più, che un braccio, & mezzo di lunghezza pare tre. Intorno le sono gl'Apostoli fatti in una maniera, che se bene si conosce ne' visi loro l'allegrezza di veder esser portata la loro Madonna in Cielo da Giesu Christo, vi si conosce ancora l'amaritudine del rimanere in terra senz'essa. Tra essi Apostoli sono alcuni Angeli, che tengono lumi accesi con bell'aria di teste, e si ben condotti, che si conosce, che egli così bene seppe maneggiare i colori a olio; come Domenico suo concorrente. Ritrasse Andrea in queste pitture di naturale M. Rinaldo degl'Albizi; Puccio Pucci; Il Falgavaccio, che fu cagione della liberazione di Cosimo de' Medici, insieme con Federigo Malevolti, che teneva le chiavi dell'Alberghetto. Parimente vi ritrasse M. Bernardo di Domenico della Volta Spedalingo di quel luogo inginocchioni, che par vivo: e in un tondo nel principio dell'opera se stesso, con viso di Giuda Scariotto, come egl'era nella presenza e ne' fatti. Havēdo dunque Andrea cōdotta questa opera a bonissimo termine, accecato dall'invidia per le lodi, che alla virtù di Domenico udiva dare, si deliberò levarselo dattorno: E dopo haver pēsato molte vie una ne mise in essecuzione in questo modo. Una sera di state, si come era solito, tolto Domenico il liuto uscì di s. Maria Nuova, lasciando Andrea nella sua camera a disegnare, non havendo egli voluto accettar l'invito d'andar seco a spasso, con mostrare d'havere a fare certi disegni d'importanza. Andato dunque Domenico da se solo a suoi piaceri, Andrea sconociuto si

1550

Per il che Domenico subito partito, et a suoi piaceri usati per la città caminando; Andrea sconosciuto nel suo ritorno si mise ad aspettarlo dietro a un canto, et con certi piombi il liuto et lo stomaco a un tempo gli sfondò, et con essi anco di mala maniera su la testa il percosse, et non finito di morire, fuggendosi in terra lo lasciò; et a Santa Maria Nuova alla sua stanza tornato si rimise con l'uscio socchiuso, intorno al disegno, che aveva lasciato. Perchè sentito in poco spazio di tempo il romore del morto portatosi, gli fu da alcuni servigiali di quel luogo percossa la porta della camera, et datogli la nuova del quasi morto amico. La onde corso a'l romore con spavento terribile gridando tuttavia fratel mio, et piantolo assai, poco andò che Domenico gli spirò nelle braccia. Ne mai per alcun tempo si seppe ancora.

Finì l'opera sua, et quella del morto amico rimase imperfetta, la quale da gli artefici comunemente, et da tutti i cittadini fu lodato. . . . Et Domenico in Perugia fece altresì una camera per li Baglioni, tenuta vaghissima; et ancora in molti altri luoghi alcune opera bellissime. Egli era ottimo prospettivo, et in molte cose dell'arte moto valse. Gli diedero sepoltura in Santa Maria Nuova nell'eta degli anni suoi LVI. . . . Visse [Andrea] nel suo tempo molto onoratamente, et perche era persona splendida et dilettavasi molto di vestire et di stare in casa pulitamente; Lasciò poche facultà alla morte sua la quale gli tronco la vita nella età d'anni LXXII. Et risendosi dopo la morte sua l'empietà che egli aveva usata a maestro Domenico, con odiose esequie fu sepolto in Santa Maria Nuova e fu gli fatto questo epitaffio.

1568

mise ad aspettarlo dopo un canto, & arivando a lui Domenico, nel tornarsene a casa; gli sfondò con certi piombi il liuto, lo stomaco in un medesimo tempo: Ma non parendogli d'haverlo anco acconcio a suo modo, cõ i medesimi lo percosse in sula testa malemente: poi lasciatolo in terra si tornò in s. Maria Nuova alla sua stanza, e socchiuso l'uscio, si rimase a disegnare in quel modo che da Domenico era stato lasciato. In tanto essendo stato sentito il rumore; erano corsi i servigiali, intesa la cosa, a chiamare, e dar la mala nuova allo stesso Andrea micidiale, e traditore: Il qual corso dove erano gl'altri intorno a Domenico non si poteva consolare, ne restar di dir: hoimè fratel mio, hoimè fratel mio. Finalmente Domenico gli spirò nelle braccia; ne si seppe, per diligenza, che fusse fatta, chi morto l'havesse. E se Andrea, venendo a morte, nõ l'havesse nell confessione manifestato non si saprebbe anco.

Visse Andrea honoratamente, e perchè spendeva assai, e particularmente in vestire, & in stare honorevolmente in casa, lasciò poche facultà, quando d'anni 71 passò ad altra vita. Ma perchè si riseppe, poco dopo la morte sua, l'impietà adoperata verso Domenico, che tanto l'amava fu con odiose essequie sepolto in S. Maria Nuova, dove similmente era stato sotterrato l'infelice Domenico d'anni cinquantasei. E l'opera sua cominciata in S. Maria Nuova rimase imperfetta; e non finita del tutto; come haveva fatto la tavola dell'altar maggiore di S. Lucia de' Bardi, nella quale è condotta con molta diligenza una N. Donna col figliuolo in braccio, S. Giovanni Battista, S. Nicolò, S. Francesco, e S. Lucia. Laqual tavola haveva poco inãzi, che fusse morto all' ultimo fine perfettamente cõdotta & c. . . .

Castaneo Andreae mensura incognita nulla
Atque color nullus, linea nulla fuit.
Invidia exarsit, fuitque proclivis ad iram:
Domitium hinc Venetum substulit insidijs,
Domitium illustrem pictura. Turpat acutum
Sic saepe ingenium vis inimica mali.

E. *Vita* of Jacopo, Giovanni and Gentile Bellini (Vasari-Ricci, II, p. 157; Vasari, 1568, II, pp. 429f.).

1550

Conciosia che Iacopo Bellini Pittore Veneziano: concorrente di quel Domenico che insegnò il colorire ad olio ad Andrea del Castagno: ancor che molto si effiticasse per venir eccellente nell' Arte; non acquistò però nome in quella, se non dopo la partita di esso Domenico.

1568

Adunque Jacopo Bellini pittore Viniziano, essendo stato discepolo di Gentile da Fabriano, nella concorrenza, che egli hebbe con quel Domenico, che insegnò il colorire a olio ad Andrea del Castagno; ancor che molto si effiticasse per venir eccellente nell' Arte; non acquistò però nome in quella, se non dopo la partita da Vinezia di esso Domenico.

12. Raffaele Borghini, *Il Riposo,* Florence, 1584, p. 334.

A. In Santa Croce nella cappella de' Cavalcanti dipinse [Andrea del Castagno] un San Giovan batista e un san Francesco . . .

B. Essendogli [Andrea del Castagno] stata data a dipignere una parte della Cappella maggiore di Santa Maria Nuova; perciochè un'altra parte fu data ad Alesso Baldovinetti, e l'altra a Domenico da Vinegia, che havea portato pur all'hora il segreto del dipignere a olio in Firenze; fece Andrea con detto Domenico simulata amicitia, portandogli grande invidia, perchè le cose sue erano per lo nuovo modo del dipignere commendate assai: e poichè hebbe tanto finto seco, che Domenico gli insegnò dipignere a olio, mosso dalla maladetta rabbia dell'Invidia una sera a tradimento l'uccise, e perchè egli fintamente molto lo pianse, non si seppe tal fatto se non dopo la morte d'Andrea, che egli stesso in confessione all'ultimo della sua vita il manifestò. Dipinse a olio nella facciata, che a lui toccò Andrea, la morte della Nostra donna, dove si vede un cataletto entrovi la Vergine morta, il quale, come che non sia più lungo d'un braccio e mezo, apparisce di tre braccia, e intorno vi sono gli Apostoli, Agnoli, et altre figure lavorate con gran diligenza, dove si conosce che egli seppe non meno maneggiare i colori a olio, che si facesse

Domenico suo concorrente. Morì d'anni 71, e fu sepellito in Santa Maria Nuova, dove ancora fu sotterrato l'infelice Domenico d'anni 56.

13. Francesco Bocchi, *Le bellezze della città di Firenze,* Florence, 1591, p. 154.

S. Giovanbatista, e un S. Francesco, sono di mano di Andrea del Castagno, fatte con bella maniera di colorito, come si vede: perchè quanto siano di pregio, da questo si dee far ragione, che nel MDLXVI, quando ogni muraglia fu tolta via, la quale nel mezzo impediva la magnificenza di questo tempio [S. Croce] fu conservato il muro intiero de queste figure, e nel luogo dove e al presente con fatica, e con ispesa collocato.

BIBLIOGRAPHY

ABBREVIATIONS

AA	*Art in America*
AB	*The Art Bulletin*
AL	*Arte lombarda*
AQ	*The Art Quarterly*
AV	*Arte veneta*
BA	*Bollettino d'arte*
BM	*The Burlington Magazine*
CA	*La critica d'arte*
GBA	*Gazette des beaux-arts*
JK	*Jahrbuch für Kunstwissenschaft*
RPK	*Jahrbuch der preussischen Kunstsammlungen*
JWCI	*Journal of the Warburg and Courtauld Institutes*
MKIF	*Mitteilungen des kunsthistorischen Instituts Florenz*
RA	*Rivista d'arte*
RJK	*Römisches Jahrbuch für Kunstgeschichte*
RK	*Repertorium für Kunstwissenschaft*
ZKG	*Zeitschrift für Kunstgeschichte*
ZKW	*Zeitschrift für Kunstwissenschaft*

dell' Acqua, G. A. and R. Chiarelli. *L'opera completa del Pisanello*. Milan, 1972.

Alberti, L. B. *On Painting*. Ed. and trans., J. R. Spencer. London, 1956.

_____. *On Painting and on Sculpture*. Ed. and trans., C. Grayson. London, 1972.

Albertini, F. *Memoriale di molte statue e pitture della città di Firenze*, Florence, 1510. Ed. G. Milanesi, C. Guasti and C. Milanesi, Florence, 1863; ed., O. Campa, Florence, 1932.

_____. *Opusculum de mirabilibus novae et veteris urbis Romae*, Rome, 1510 (1510a).

Alpers, S. L. "Ekphrasis and Aesthetic Attitudes in Vasari's Lives." *JWCI*, XXIII (1960), pp. 190ff.

American Art Galleries. *Catalogue of the Achillito Chiesa Collection*, II. New York, 1926.

Ames-Lewis, F. "Did Filippo Lippi Visit Flanders?" *Bulletin of the Association of Art Historians*, 5 (October 1977), unpaginated.

d'Ancona, P. Review of H. Thode, "Andrea del Castagno in Venedig." In *L'arte*, II (1899), p. 105.

BIBLIOGRAPHY

Andreucci, O. *Della biblioteca e pinacoteca dell'arcispedale di Santa Maria Nuova.* Florence, 1871.

Annales du musée. 2e collection. Paris, 1815.

Antal, F. "Studien zur Gotik im Quattrocento." *JPK,* XLVI (1925), pp. 3ff.

————. *Florentine Painting and Its Social Background.* London, 1947.

Argan, G. C. "The Architecture of Brunelleschi and the Origins of Perspective Theory in Italy." *JWCI,* IX (1946), pp. 96ff.

————. *Fra Angelico.* New York, 1955.

Arslan, W. "Intorno a Giambono e a Francesco dei Franceschi." *Emporium,* CVIII (1948), pp. 785ff.

The Art of Painting in Florence and Siena from 1250 to 1500. London, 1965.

Art News. "The Mellon Gift, a First Official List," XXXV (March 20, 1937), pp. 15f.

The Art Quarterly. "Two of the National Gallery's New Acquisitions," VII (1944), pp. 299f.

Artaud de Montor. *Peintres primitifs.* Paris, 1843.

Arte in Valdelsa del secolo XII al secolo XVIII. Certaldo, 1963.

Ash, C. C. "Domenico di Bartolo." M. A. thesis, Institute of Fine Arts, New York University, 1968.

Avena, A. *Il museo di Castelvecchio.* Rome, 1937.

————. *Capolavori della pittura veronese.* Verona, 1947.

Bacci, M. *Domenico Veneziano.* Milan, 1965.

Bacci, P. "La Trinità del Pesellino della National Gallery di Londra." *RA,* II (1904), pp. 78ff.

————. *Documenti e commenti per la storia dell'arte.* Florence, 1942.

Bachelin, L. *Tableaux anciens de la galerie Charles Ier roi de Roumanie, catalogue raisonné,* Paris, 1898.

de Baglion, L. *Pérouse et les Baglioni.* Paris, 1909.

Baker, C. *Catalogue of Pictures at Hampton Court.* London, 1929.

Baldanzi, G. *Descrizione della chiesa cattedrale di Prato.* Prato, 1846.

Baldinucci, F. *Notizie de' professori del disegno da Cimabue in qua.* Florence, 1681ff. Ed., G. Piacenza, Turin, 1768ff.; ed. F. Rannalli, Florence, 1845ff.

Barocchi, P., ed. *Trattati d' arte del cinquecento.* Bari, 1960.

Baroni, G., and G. A. dell' Acqua. *Tesori d'arte di Lombardia.* Milan, 1952.

Battisti, E. *Rinascimento e barocco.* Turin, 1960.

————. *Piero della Francesca.* Milan, 1971.

————. "Mantegna come prospettico." *AL,* XVI (1971), pp. 98ff. (1971a).

————. "Note sulla prospettiva rinascimentale." *AL,* XVI (1971), pp. 87ff. (1971b).

BIBLIOGRAPHY

Baxandall, M. *Giotto and the Orators*. Oxford, 1971.

_____. *Painting and Experience in Fifteenth Century Italy*. Oxford, 1972.

Bean, J. *Les dessins italiens de la collection Bonnat, Bayonne, Musée Bonnat*. Paris, 1960.

Beccherucci, L. Review of Salmi (1947a). In *RA*, XXVI (1950), pp. 222ff.

Beck, J. "Masaccio's Early Career as a Sculptor." *AB*, LIII (1971), pp. 181ff.

Beenken, H. "Masaccios und Masolinos Fresken von S. Clemente in Rom." *Belvedere*, IX (1932), pp. 7ff.

Bellosi, L. "Intorno ad Andrea del Castagno." *Paragone*, 211 (September 1967), pp. 3ff.

de Benedetti, M. "Notes on Italian Paintings at the Italian Embassy in London." *Apollo*, XX (1934), pp. 301ff.

Benson, R. H. *Catalogue of the Holford Collection*, Westonbirt, 1924.

Berenson, B. *The Florentine Painters of the Renaissance*. New York, 1896; 3d ed., New York, 1909.

_____. "Les peintures italiennes de New York et de Boston." *GBA*, XV (1896), pp. 195ff. (1896a).

_____. *The Central Italian Painters of the Renaissance*. New York, 1897; 2d ed., New York, 1909 (1909a).

_____. "Alesso Baldovinetti et la nouvelle Madonne du Louvre." *GBA*, XX (1898), pp. 39ff.

_____. "Une exposition de maîtres anciens à Florence." *GBA*, XXIV (1900), pp. 79ff.

_____. *The Study and Criticism of Italian Art*. London, 1901.

_____. *The Study and Criticism of Italian Art*. Second Series. London, 1902.

_____. *The Drawings of the Florentine Painters*. London, 1903; 2d ed., Chicago, 1938.

_____. *Catalogue of a Collection of Paintings and Some Art Objects, I: Italian Paintings*. Philadelphia, 1913.

_____. "Una predella di Masolino nel museo Ingres a Montauban." *Dedalo*, III (1923), pp. 633ff.

_____. "Nove pitture in cerca di un' attribuzione." *Dedalo*, V (1925), pp. 601ff.

_____. *Three Essays in Method*. Oxford, 1926.

_____. "Quadri senza casa." *Dedalo*, X (1930), pp. 133ff.

_____. *Italian Pictures of the Renaissance*. Oxford, 1932.

_____. "Fra Angelico, Fra Filippo e la cronologia." *BA*, XXVI (1932), pp. 49ff. (1932a).

_____. "Quadri senza casa." *Dedalo*, XII (1932), pp. 512ff. (1932b).

_____. *Pitture italiane del rinascimento*. Milan, 1936.

_____. "Un codice illustrato del maestro di San Miniato." *RA*, XXXVI (1950), pp. 93ff.

_____. "Miniatures Probably by the Master of the San Miniato Altarpiece," *Essays in Honor of Georg Swarzenski*, Chicago, 1951.

_____. *Italian Pictures of the Renaissance, Florentine School*. London, 1963.

BIBLIOGRAPHY

Berti, L. "Il museo di S. Croce." *BA*, XLIV (1959), pp. 182ff.

_____. "Domenico Veneziano." *Encyclopedia of World Art*. New York, 1961, IV, cols. 422ff.

_____. "Una nuova Madonna e degli appunti su un grande maestro." *Pantheon*, XIX (1961), pp. 298ff. (1961a).

_____. "Appunto su Andrea del Castagno a S. Zaccaria." *Acropoli*, III (1963), pp. 261ff.

_____. *Masaccio*. Milan, 1964.

_____. *Andrea del Castagno*. Florence, 1966.

_____. *Fra Angelico*. New York, 1968.

Bertini, G. *Catalogo generale della fondazione artistica Poldi-Pezzoli*. Milan 1881.

Bettarini, R. and P. Barocchi, eds. Giorgio Vasari, *Le vite de' più eccelenti pittori, scultori e architetti*. Florence, 1966, III.

Biehn, H. *Meisterwerke italienischer Kunst*. Wiesbaden, 1953.

di Bisticci, Vespasiano. *Vite di uomini illustri del secolo XV*. Florence, 1938.

Blunt, A. *Artistic Theory in Italy, 1450–1600*. Oxford, 1940.

Bocchi, F. *Le bellezze della città di Firenze*. Florence, 1591. Ed. G. Cinelli, Florence, 1677.

Bocconi, S. *The Capitoline Collections*. Rome, 1930; 2d ed., 1950.

Bode, W. "Zusätze und Berichtigungen zu Burckhardt's *Cicerone*." *Jahrbücher für Kunstwissenschaft*, V (1873), pp. 1ff.

_____. "Eine Predellentafel von Domenico Veneziano." *JPK*, IV (1883), pp. 89ff.

_____. "La renaissance au musée de Berlin." *GBA*, XXXII (1888), pp. 476ff., and XXXIII (1889), pp. 487ff.

_____. "Domenico Venezianos Profilbildniss eines jungen Mädchens in der Berliner Galerie." *JPK*, XVIII (1897), pp. 187ff.

_____. *Florentiner Bildhauer der Renaissance*. Berlin, 1902.

_____. *Die Kunst der Frührenaissance in Italien*. Berlin, 1923.

_____. "Die Predella der Altartafel des Domenico Veneziano mit der Madonna zwischen den vier Heiligen in den Uffizien." *Berliner Museen, Berichte aus den preussischen Kunstsammlungen*, XLVI (1925), p. 23.

Bode, W., and H. von Tschudi. "Die Anbetung der Könige von Vittor Pisano und die Madonna mit Heiligen aus dem Besitz des C. Pozzo." *JPK*, VIII (1885), pp. 18ff.

Bodkin, T. *Dismembered Masterpieces*. London, 1945.

Böck, W. "Das Anbetungstondo von Domenico Veneziano im Kaiser Friedrich Museum." *Sitzungsberichte der kunstgeschichtlichen Gesellschaft* (1931–32), pp. 12ff.

_____. "Uccello Studien." *ZKW*, II (1933), pp. 249ff.

_____. "Domenico Veneziano." *Pantheon*, XIII (1934), pp. 79ff.

BIBLIOGRAPHY

_____. "Notizien und Nachrichten: Malerei, Italien, 15. Jahrhundert." *ZKG*, III (1934), pp. 388ff. (1934a).

_____. "Quattrocento Paintings in the Kaiser Friedrich Museum." *BM*, LXIV (1934), pp. 29ff. (1934b).

_____. *Paolo Uccello*. Berlin, 1939.

Bologna, F. *Gli affreschi della Cappella Brancacci*. Milan, 1966.

Bombe, W. "Der Palast des Braccio Baglioni in Perugia und Domenico Veneziano." *RK*, XXXII (1909), pp. 295ff.

_____. *Geschichte der Peruginer Malerei*. Berlin, 1917.

Borenius, T. *A Catalog of the Paintings at Doughty House, Richmond and Elsewhere in the Collection of Sir Frederick Cook, Bart*. London, 1913.

_____. *Catalog of Italian Paintings Collected by Robert and Evelyn Benson*. London, 1914.

_____. "Pictures from British Collections at the Italian Exhibition." *Apollo*, XI (1930), pp. 41ff.

_____. "The New Kress Gift to the National Gallery, Washington." *BM*, LXXXVI (1945), pp. 55f.

Borghini, R. *Il riposo*. Florence, 1584; 2d ed., Florence, 1730.

Borsook, E. *The Mural Painters of Tuscany*. London, 1960.

Boskovits, M. "Giotto Born Again: Beiträge zu den Quellen Masaccios." *ZKG*, XXIX (1966), pp. 51ff.

_____. "Due secoli di pittura murale a Prato: aggiunte e precisazioni." *Arte illustrata*, III (January–February 1970), pp. 32ff.

Bottari, S. *Antonello*. Milan and Messina, 1953.

Brandi, C. *La regia pinacoteca di Siena*. Rome, 1933.

_____. "Ein 'desco da parto' und seine Stellung innerhalb der toskanischen Malerei nach dem Tode Masaccios." *JPK*, LV (1934), pp. 154ff.

_____. *Quattrocentisti senesi*. Milan, 1949.

_____. "I cinque anni cruciali per la pittura fiorentina del quattrocento." *Studi in onore di Matteo Marangoni*. Florence, 1957, pp. 167ff.

Braunfels, W. "Nimbus und Goldgrund." *Das Münster*, III (1950), pp. 321ff.

The British Committee on the Preservation and Restitution of Works of Art. *Archives and Other Material in Enemy Hands, Works of Art in Italy, Losses and Survivals in the War, Part I*. London, 1945.

Brooklyn Museum. *Religious Paintings 15th–19th Century*. New York, 1956.

Brown A., and W. Rankin. *A Short History of Italian Painting*. New York, 1914.

Brucker, G. *Renaissance Florence*. New York, 1969.

del Buono, O. and P. de Vecchi. *L'opera completa di Piero della Francesca*. Milan, 1967.

Burckhardt, J. *Der Cicerone*. Basel, 1860. Ed., W. Bode and C. von Fabriczy, Leipzig, 1910.

_____. *Beiträge zur Kunstgeschichte von Italien*. Basel, 1898.

BIBLIOGRAPHY

Burlington Fine Arts Club. *Catalogue of an Exhibition of Pictures of the Umbrian School.* London, 1910.

_____. *Catalogue of an Exhibition of Florentine Painting Before 1500.* London, 1920.

Burroughs, B. "A Crucifixion by Pesellino." *Bulletin of the Metropolitan Museum of Art,* XIV (1919), pp. 155ff.

Bush-Brown, A. "Giotto: Two Problems in the Origins of His Style." *AB,* XXXIV (1952), pp. 42ff.

Busignani, A. *Pollaiuolo.* Florence, 1970.

Busuioceanu, A. "Une oeuvre inédite de Domenico Veneziano." *Actes du XIVe congrès international d'histoire de l'art.* Basel, 1936, pp. 99f.

_____. "Una nuova Madonna di Domenico Veneziano." *L'arte,* VIII (1937), pp. 1ff.

_____. *La galerie de peintures de sa majesté le roi Carol II de Roumanie.* Paris, 1939.

Calcagni, D. *Memorie istoriche della città di Recanati nella marca d'Ancona.* Messina, 1711.

Cambiagi, G. *L'antiquario fiorentino ossia guida per osservare con metodo le rarità e bellezze della città di Firenze.* Florence, 1765.

Cameron, E. "The Depictional Semiotic of Alberti's *On Painting.*" *Art Journal,* XXXV (1975), pp. 25ff.

Camesasca, E. *Mantegna.* Milan, 1964.

Canova, G. M. "Riflessioni su Jacopo Bellini e sul libro di disegni del Louvre. *AV,* XXVI (1972), pp. 9ff.

Cardellini, I. *Desiderio da Settignano.* Milan, 1962.

Carli, E. *Tutta la pittura di Paolo Uccello.* Milan, 1954.

Carocci, G. "Notizie: tabernacoli abbandonati." *Arte e storia,* XII (1893), pp. 134f.

_____. "La galleria della Collegiata d'Empoli." *Le gallerie nazionali italiane,* IV (1899), pp. 335ff.

Casalini, F. "Corrispondenza fra teoria e pratica nell'opera di Piero della Francesca." *L'arte,* LXXI (1968), no. 2, pp. 62ff.

Cassirer, E. *Individual and Cosmos in the Renaissance.* New York, 1963.

Castellanata, C. and E. Camesasca. *L'opera completa del Perugino.* Milan, 1969.

Catalogo della mostra del tesoro di Firenze sacra. Florence, 1933.

Catalogue de la collection des tableaux de M. le consul-général Bamberg exposé au profit de la société Nérlandaise de bienfaisance à Bruxelles. Brussels, 1877.

Catalogue de la collection Toscanelli. Florence, 1883.

Catalogue of the Lombardi-Baldi Collection. Florence, 1845.

A Catalogue of Paintings in the Collection of Jules S. Bache in New York. New York, 1929.

Catalogue of the Pictures and Other Works of Art, National Gallery of Ireland and National Portrait Gallery. Dublin, 1920.

Cavalcaselle, G. B. and J. A. Crowe. *Storia della pittura in Italia.* Florence, 1892, V.

BIBLIOGRAPHY

Caviggioli, A. "Due capolavori del XV secolo." *Arte figurativa antica e moderna*, 10 (July–August 1954), pp. 19ff.

Cazzani, E. *Castiglione d'Olona nella storia e nell'arte*. Milan, 1967.

Cecchini, G. *La galleria nazionale dell'Umbria*. Rome, 1932.

Cennini, C. *The Craftsman's Handbook*. Trans., D. V. Thompson, Jr., New Haven, 1933.

Centenary Exhibition of the National Gallery of Ireland. Dublin, 1964.

Centi, T. M. "Sulla nuova cronologia dell'Angelico." *Bollettino dell'Istituto Storico Artistico Orvietano*, XIX–XX (1963–64), pp. 91ff.

The Century Association. *Catalogue of the Exhibition of Italian Paintings of the Renaissance*. New York, 1935.

Chambers, D. S. *Patrons and Artists in the Italian Renaissance*. London, 1970.

Chastel, A. "La mosaique à Venise et à Florence au XVe siècle." *AV*, VIII (1954), pp. 119ff.

_____. *Studios and Styles of the Italian Renaissance*. New York, 1966.

Cherici, V. *Guida storico—artistica del R. Spedale degli Innocenti di Firenze*. Florence, 1926.

Chiapelli, A. "Una nuova opera di Domenico Veneziano." *L'arte*, XXVII (1924), pp. 93ff.

Chiarini, M. "Di un maestro 'elusivo' e di un contributo." *Arte antica e moderna*. 13–16 (1961), pp. 134ff.

della Chiesa, A. O., *Accademia Carrara*, Bergamo, 1955.

Manson, Christie and Woods. *Sales Catalogue of the Alexander Barker Collection*. London, 1874.

_____. *Sales Catalogue of the Collection of Alexander Barker*. London, 1879.

_____. *Sales Catalogue of Notable Works of Art in the Collection of Stefano Bardini*. London, 1899.

City of Birmingham Museum and Art Gallery. *Exhibition of Italian Art from the 13th to the 17th Century*. Birmingham, 1955.

Clark, K. "Notes on the Italian Exhibition." *Life and Letters*, IV (1930), pp. 95ff.

_____. "L. B. Alberti on Painting." *Proceedings of the British Academy*, XXX (1944), pp. 283ff.

_____. *Florentine Painting of the Fifteenth Century*. London, 1945.

_____. "Architectural Backgrounds in XVth Century Italian Painting." *The Arts*, I (1946), pp. 13ff.; II (1947), pp. 33ff.

_____. *Piero della Francesca*. London, 1951, 2d ed., London, 1969.

_____. "An Early Quattrocento Triptych from Santa Maria Maggiore." *BM*, XCII (1951), pp. 339ff. (1951a).

_____. *The Nude*. New York, 1956.

Colasanti, A. "Un polittico di Giovanni Boccati a Belforte del Chianti." *L'arte*," VII (1904), pp. 477f.

_____. *Gentile da Fabriano*. Bergamo, 1909.

BIBLIOGRAPHY

Coletti, L. "Pittura veneta del tre al quattrocento, II." *AV,* I (1947), pp. 251ff.

_____. *Pisanello.* Milan, 1953.

_____. *Pittura veneta del quattrocento.* Novara, 1953 (1953a).

Collobi, L. "Lazzaro Bastiani." *CA,* IV (1939), pp. 39ff.

Collobi-Ragghianti, L. "Zanobi Strozzi, pittore." *CA,* VIII (1950), pp. 454ff.; (1950), pp. 17ff.

Colnaghi, D. E. *A Dictionary of Florentine Painters from the 13th to the 17th Centuries.* London, 1928.

Colvin, S. *A Florentine Picture Chronicle.* London, 1898.

Comstock, H. "Italian Birth and Marriage Salvers." *International Studio,* LXXXV (September 1926), pp. 50ff.

Constable, W. G. "Dipinti di raccolte inglesi alla mostra d'arte italiana a Londra." *Dedalo,* X (1930), pp. 723ff.

_____. "Quelques aperçus suggérés par l'exposition italienne de Londres." *GBA,* LXXII (1930), pp. 277ff. (1930a).

_____. *The Painter's Workshop,* Boston, 1963.

Covi, D. A. *The Inscription in Fifteenth Century Florentine Painting."* Ph.D. dissert., Institute of Fine Arts, New York University, 1958.

_____. "Lettering in Fifteenth Century Florentine Painting," *AB* XLV (1963), pp. 1ff.

Cowardin, S. "Some Aspects of Color in Fifteenth Century Florentine Painting." Ph.D. diss., Harvard University, 1963.

Crowe, J. A. and G. B. Cavalcaselle. *A New History of Painting in Italy.* London, 1864, II. Ed., E. Hutton, London, 1909, II.

_____. *Geschichte der italienischen Malerei.* Ed. and trans., M. Jordan, Leipzig, 1870, III.

_____. *A History of Painting in North Italy.* London, 1871, I.

_____. *A History of Painting in Italy.* Ed., L. Douglas, London, 1903, II; 1911, IV.

Cruttwell, M. *Antonio Pollaiuolo.* London, 1907.

_____. *The Florentine Galleries.* London, 1907 (1907a).

Cust, L. "La collection de M. R.-H. Benson." *Les arts* (October 1907), pp. 1ff.

_____. "A Portrait of Baldovinetti at Hampton Court Palace." *Apollo,* VII (1928), pp. 26f.

Dalai, M. E. "La questione della prospettiva 1960–1968." *L'arte,* I (1968), no. 2, pp. 96ff.

Davies, M. *National Gallery Catalogues: The Earlier Italian Schools.* London, 1950, 2d ed., London, 1961.

Davisson, D. D. "The Iconology of the S. Trinita Sacristy, 1418–1435: A Study of the Private and Public Functions of Religious Art in the Early Quattrocento." *AB,* LVII (1975), pp. 315ff.

Degenhart, B. "Stefano da Verona." Thieme-Becker, XXXI (1937), p. 529.

BIBLIOGRAPHY

_____. "Zur Graphologie der Handzeichnungen." *Kunstgeschichtliches Jahrbuch der Bibliothek Hertziana*, I (1937), pp. 223ff. (1937a).

_____. *Pisanello*. Turin, 1945.

_____. *Italienische Zeichnungen des frühen 15. Jahrhunderts*. Basel, 1949.

_____. "Stefano's 'Paradiesgarten' in ursprünglicher Form." *Die Kunst und das schöne Heim*. L (1952), pp. 369ff.

_____. "Domenico Veneziano als Zeichner," *Festschrift Friedrich Winkler*. Berlin, 1959, pp. 100ff.

Degenhart, B. and A. Schmitt. "Gentile da Fabriano in Rom und die Anfänge des Antikenstudiums." *Müncher Jahrbuch der Bildenden Kunst*, XI (1960), pp. 59ff.

_____. *Corpus der frühen italienischen Zeichnungen 1300–1450, I: Süd- und Mittelitalien*. Berlin, 1969.

Delaborde, H. "Des oeuvres et de la manière de Masaccio." *GBA*, XIV (1876), pp. 369ff.

Detroit Institute of Arts. *Decorative Arts of the Italian Renaissance, 1400–1600*. Detroit, 1968.

Deusch, W. R. *Andrea del Castagno*. Königsberg, 1928.

von Dillis, G. *Verzeichniss der Gemälde in der königlichen Pinakothek zu München*. Munich, 1838.

Douglas, L. "Esposizioni londinesi." *L'arte*. VI (1903), pp. 107ff.

Duveen Pictures in Public Collections of America. New York, 1941.

Dvorak, M. *Geschichte der italienischen Kunst im Zeitalter der Renaissance*. Munich, 1927.

Eastlake, C. H. *Materials for a History of Oil Painting*. London, 1869.

Edgerton, S. Y., Jr. "Alberti's Perspective: A New Discovery and a New Evaluation." *AB*, LXIII (1966), pp. 371ff.

_____. "Alberti's Colour Theory: A Medieval Bottle Without Renaissance Wine. *JWCI*, XXXII (1969), pp. 109ff.

_____. *The Renaissance Rediscovery of Linear Perspective, 1425–1436*. New York, 1975.

_____. "*Mensura temporalia facit geometria spiritualis:* Some Fifteenth Century Italian Notions About When and Where the Annunciation Happened." *Studies in Late Medieval and Renaissance Painting in Honor of Millard Meiss*. New York, 1978, pp. 115ff.

von Einem, H. "Castagno ein Mörder?" *Der Mensch und die Künste, Festschrift für Heinrich Lützeler zum 60. Geburstag*. Düsseldorf, 1962, pp. 433ff.

Einstein, L. and F. Monod. "Le musée de la société historique de New-York," *GBA*, XXXIII (1905), pp. 414ff.

Eisenberg, M. " 'The Penitent St. Jerome' by Giovanni Toscani." *BM*, CXVIII (1976), pp. 275ff.

Eisler, C. "The Athlete of Virtue, the Iconography of Asceticism." *De Artibus Opuscula XL*. New York, 1961, pp. 82ff.

_____. "The Madonna of the Steps, Problems of Date and Style." *Stil und Überlieferung in der Kunst des Abendlandes*. Berlin, 1967, II, pp. 115ff.

BIBLIOGRAPHY

Emmanuel, E. *Van Eyck und Vasari im Licht neuer Tatsachen.* Tel-Aviv, 1965.

Escher, K. *Malerei der Renaissance in Italien.* Berlin, 1922, I.

Ettlinger, L. D. "Hercules Florentinus." *MKIF,* XVI (1972), pp. 119ff.

Exposition de l'art italien de Cimabue a Tiepolo. Paris, 1935.

von F., M. "Die Sammlung Foulc." *Pantheon,* II (1923), pp. 499ff.

Fabretti, A. *Note e documenti . . . alle biografie di capitani e venturieri dell'Umbria.* Montepulciano, 1842.

von Fabriczy, C. "London, National Gallery, Neuerwerbungen im Jahre 1886." *RK,* X (1887), p. 306.

———. "Giuliano da Maiano." *JPK,* XXIV (1903), *Beiheft,* pp. 137ff.

Fahy, E. P., "Some Early Italian Pictures in the Gambier-Parry Collection." *BM,* CIX (1967), pp. 128ff.

von Falke, O. "Gotische Samtstoffe der Sammlung Figdor." *Pantheon,* VII (1929), pp. 209ff.

———. *Decorative Silks.* New York, 1936.

Fantozzi, F. *Nuova guida ovvero descrizione storica-artistica-critica della città e contorni di Firenze.* Florence, 1842.

Fasanelli, J. A. "Some Notes on Pisanello and the Council of Florence." *Master Drawings.* III (1965), pp. 36ff.

Fasolo, V. "Reflessi Brunelleschiani nelle architetture di pittori." *Atti del primo congresso nazionale di storia dell'architettura.* Florence, 1938, pp. 197ff.

Filarete, Antonio Averlino. *Trattato dell'architettura.* Ed., W. von Öttinger, Vienna, 1896; ed. and trans., J. R. Spencer, New Haven, 1965.

Fiocco, G. "Michele Giambono," *Venezia, studi d'arte e storia.* Milan and Rome (1920), I, pp. 217ff.

———. "Un affresco di Paolo Uccello nel Veneto." *BA,* III (1923), pp. 193ff.

———. *L'arte di Andrea Mantegna.* Bologna, 1927; 2d ed., Venice, 1959.

———. *Andrea Mantegna.* Milan, 1937.

———. *Pittura toscana del quattrocento.* Novara, 1941.

———. "Le pitture venete del castello di Konopiste." *AV,* II (1948), pp. 7ff.

———. "Un'opera di Nicola di Maestro Antonio d'Ancona." *AV,* IX (1955), p. 211.

———. "Voci di Andrea del Castagno in Russia." *Atti dell' Accademia Nazionale dei Lincei,* XII (1957), pp. 378ff.

———. "Il mito di Dello Delli." *Arte in Europa.* Milan, 1966, I, pp. 341ff.

Fischel, O. *Amtliche Berichte aus den königlichen preussischen Kunstsammlungen,* XLI (1920), p. 116.

Fitzwilliam Museum. *Annual Report for 1923.* Cambridge (England), 1924.

Flaccavento, G. "Sulla data del *De statua* di L. B. Alberti." *Commentari,* XVI (1965), pp. 216ff.

Flaiano, E. and L. T. Tomasi. *L' opera completa di Paolo Uccello.* Milan, 1971.

BIBLIOGRAPHY

Formigli, G. *Guida per la città di Firenze e suoi contorni.* Florence, 1852.

Fortuna, A. *Andrea del Castagno.* Florence, 1957.

———. "Alcune note su Andrea del Castagno." *L'arte,* LVII (1958), pp. 345ff.

Fossi-Todorow, M. "Un taccuino di viaggi del Pisanello e della sua bottega." *Studi di storia dell'arte in onore di Mario Salmi.* Rome, 1962, II, pp. 133ff.

———. *I disegni del Pisanello e della sua cerchia.* Florence, 1966.

Fossius, F. *Monumenta ad Alamanni Rinuccini vitam contextendam.* Florence, 1791.

Francastel, P. *La figure et le lieu.* Paris, 1967.

Frankfurter, A. "Italian Paintings on Loan Display at Century Club." *Art News,* XXXIII (March 9, 1935), pp. 3ff.

———. "Interpreting Masterpieces." *Art News Annual,* XXI (1952), pp. 5ff.

Fredericksen, B. B. and F. Zeri. *Census of Pre-Nineteenth-Century Italian Paintings in North American Public Collections.* Cambridge (Mass.), 1972.

Freemantle, R. *Florentine Gothic Painters from Giotto to Masaccio,* London, 1975.

Frescoes from Florence. London, 1969.

Frew, J. "Antonello, Naples and the North." *Bulletin of the Association of Art Historians,* 5 (October 1977), unpaginated.

Frey, C., ed. *Il codice Magliabecchiano.* Berlin, 1892.

———. *Il libro di Antonio Billi.* Berlin, 1892 (1892a).

Frey, K. *Der literarische Nachlass Giorgio Vasaris.* Munich, 1930.

The Frick Collection: an Illustrated Catalogue, II, Paintings: French, Italian, Spanish. New York, 1968.

Friedländer, M. *Die Sammlung von Richard von Kaufmann, I: die Italienischen Gemälde.* Berlin, 1917.

Friedmann, H. "The Symbolism of Crivelli's *Madonna and Child Enthroned with Donor* in the National Gallery." *GBA,* XXXII (1947), pp. 59ff.

Frimmel, T. "Gemälde in der Sammlung Albert Figdor in Wien." *Kleine Galerie Studien,* IV (1896), pp. 1ff.

Frizzoni, G. "Una nuova perla nel gabinetto dei Veneti del museo Poldi—Pezzoli a Milano." *Rassegna d'arte,* XII (1912), pp. 117ff.

Fry, R. "The Umbrian Exhibition at the Burlington Fine Arts Club." *BM,* XVI (1910), pp. 267ff.

———. "On a Profile Portrait by Baldovinetti." *BM,* XVIII (1911), pp. 311ff.

———. "Notes on the Italian Exhibition." *BM,* LVI (1930), pp. 83ff.

von der Gabelentz, H. C., *Italienische Malerei der Vor- und Frührenaissance im staatlichen Lindenau Museum Altenburg.* Altenburg, 1956.

BIBLIOGRAPHY

Galantic, I. "The Sources of Leon Battista Alberti's Theory of Painting," Ph.D. diss., Harvard University, 1969.

Gamba, C. "La Ca' d'Oro e la collezione Franchetti." *BA*, X (1916), pp. 321ff.

_____. "Il palazzo e la raccolta Horne." *Dedalo*, I (1920), pp. 162ff.

_____. "Problemi artistici all'esposizione di Londra." *Marzocco*, April 27, 1930, p. 2.

_____. "Dipinti fiorentini di raccolte americane all'esposizione di Londra." *Dedalo*, XI (1931), pp. 570ff.

_____. *Pittura umbra del rinascimento.* Novara, 1949.

_____. *Il Museo Horne a Firenze.* Florence, 1961.

von Teuffel, C. Gardner. "Masaccio and the Pisa Altarpiece." *Jahrbuch der Berliner Museen*, XIX (1977), pp. 23ff.

Gaye, G. *Carteggio inedito d'artisti dei secoli XIV, XV, XVI.* Florence, 1839.

Geiger, B. *Handzeichnungen alter Meister.* Vienna and Zurich, 1948.

Gengaro, M. L. "A proposito di Domenico di Bartolo." *L'arte*, XXXIX (1936), pp. 104ff.

Genthon, I. "Note sul volume di Lajos Vayer dedicato a Masolino." *Acta historiae artium*, XI (1965), pp. 209ff.

Gherardi-Dragomanni, F. *Memorie della terra di S. Giovanni nel Valdarno superiore.* Florence, 1834.

Giambullari, B. *La storia di S. Zanobi, vescovo fiorentino.* Florence, 1863.

Giglioli, O. H. "Le pitture di Andrea del Castagno e di Alesso Baldovinetti per la chiesa di S. Egidio." *RA*, III (1905), pp. 206ff.

_____. "Masaccio: studio di bibliografia ragionata." *Bollettino del Istituto di Archeologia e Storia dell'Arte*, III (1929), pp. 55ff.

_____. "Maso Finiguerra." *Miscellanea di storia dell'arte in onore di I. B. Supino.* Florence, 1933, pp. 375ff.

Gilbert, C. "The Archbishop on the Painters of Florence, 1450." *AB*, XLI (1959), pp. 75ff.

_____. "Florentine Painters and the Origin of Modern Science." *Arte in Europa.* Milan, 1966, I, pp. 333ff.

_____. "The Renaissance Portrait." *BM*, CX (1968), pp. 280ff.

_____. "The Drawings Now Associated with Masaccio's Sagra." *Storia dell'arte*, 1969, pp. 260ff.

_____. "Piero della Francesca's *Flagellation:* The Figures in the Foreground." *AB*, LIII (1971), pp. 41ff.

_____. "Fra Angelico's Fresco Cycles in Rome: Their Number and Dates." *ZKG*, XXXVIII (1975), pp. 245ff.

_____. Review of S. Orlandi, O. P., *Beato Angelico.* In *AB*, XLVII (1965), pp. 273f.

Gill, J. *The Council of Florence.* Cambridge (England), 1959.

Gioseffi, D. "Complementi di prospettiva." *CA*, IV (1957), pp. 468ff.; V (1958), pp. 102ff.

BIBLIOGRAPHY

_____. "Domenico Veneziano, l'esordio masaccesco e la tavola con i SS. Girolamo e Giovanni Battista della National Gallery di Londra." *Emporium,* CXXXV (1962), pp. 51ff.

De Giotto à Bellini. Paris, 1956.

Giovannozzi, V. "Note su Giovanni di Francesco." *RA,* XVI (1934), pp. 337ff.

Glaser, K. "The Louvre Coronation and the Early Phase of Fra Angelico's Art." *GBA,* XXI (1939), pp. 149ff.

Glasser, H. "Artists' Contracts of the Early Renaissance." Ph.D. diss., Columbia University, 1965.

Gnoli, U. *Pittori e miniatori nell'Umbria.* Spoleto, 1923.

Goffen, R. "Icon and Vision: Giovanni Bellini's Half-length Madonnas." *AB,* LVII (1975), pp. 487ff.

Gollob, H. *Gentiles da Fabriano und Pisanellos Fresken am Hospital von St. Giovanni in Laterano zu Rom.* Strasbourg, 1927.

_____. "Pisanellos Fresken im Lateran und der Codex Vallardi." *Studi in onore di Nicco Fasola.* AL, X (1965), pp. 51ff.

Golzio, V. and G. Zander. *L'arte in Roma nel secolo 15.* Bologna, 1968.

Gombrich, E. H. *Norm and Form.* London, 1966.

_____. "The Leaven of Criticism in Renaissance Art." *Art, Science and History in the Renaissance.* Baltimore, 1967, pp. 3ff.

Goodison, J. W. and G. H. Robertson. *Fitzwilliam Museum, Cambridge, Catalogue of Paintings, I: Italian Schools.* Cambridge (England), 1967.

Grassi, L. "Considerazioni intorno al 'Polittico Quaratesi.'" *Paragone.* 15 (March 1951), pp. 23ff.

_____. *Tutta la pittura di Gentile da Fabriano.* Milan, 1953.

_____. *I disegni italiani del trecento e quattrocento.* Venice, 1961.

Grayson, C. "L. B. Alberti's 'costruzione legittima.'" *Italian Studies,* XIX (1964), pp. 14ff.

The Great Age of Fresco, Giotto to Pontormo. New York, 1968.

Gronau, G. "Domenico Veneziano." Thieme-Becker, IX (1913), pp. 408ff.

_____. "Cosimo Rosselli." Thieme-Becker, XXIX (1935), p. 35.

Gruyer, G. "La collection Bonnat au musée de Bayonne." *GBA,* XXXIX (1903), pp. 193ff.

_____. *Musée de Bayonne, Collection Bonnat.* Paris, 1908.

Guhl, E. *Künstlerbriefe.* Ed., A. Rosenberg, Berlin, 1880.

Guida d'Italia del Touring Club Italiano: Toscana. Milan, 1935, 3d ed., Milan, 1959.

Guide to the Vatican Picture Gallery. Rome, 1914.

Guiffrey, G. "Le legs de la Baronne Nathaniel de Rothschild au musée du Louvre." *La revue de l'art ancien et moderne,* IX (1901), pp. 357ff.

Habich, G. *Die Medaillen der italienischen Renaissance.* Berlin, n.d.

BIBLIOGRAPHY

Händke, B. "Der französisch-niederländische Einfluss auf die italienische Kunst von ca. 1250 bis ca. 1500 und der Italiens auf die französisch-deutsche Malerei von ca. 1350 bis ca. 1400." *RK*, XXXVIII (1916), pp. 28ff.

Hall, M. "The 'Tramezzo' in S. Croce, Florence and Domenico Veneziano's Fresco." *BM*, CXXII (1970), pp. 797ff.

———. "The Operation of Vasari's Workshop: The Design of S. Maria Novella and S. Croce." *BM*, CXV (1973, pp. 204ff.

———. "The *Ponte* in S. Maria Novella: The Problem of the Rood Screen in Italy." *JWCI*, XXXVII (1974), pp. 157ff.

———. "The *Tramezzo* in Santa Croce, Florence, Reconstructed." *AB*, LVI (1974), pp. 325ff. (1974a).

Hamilton, N. *Die Darstellung der Anbetung der heiligen drei Könige in der toskanischen Malerei von Giotto bis Leonardo*. Strasbourg, 1901.

Hammer Galleries. *Art Objects and Furnishings from the William Randolph Hearst Collection*. New York, 1941.

Harrsen, M., and G. K. Boyce. *Italian Manuscripts in the Pierpont Morgan Library*. New York, 1953.

Hartlaub, G. F. *Matteo da Siena und seine Zeit*. Strasbourg, 1910.

Hartt, F. "The Earliest Works of Andrea del Castagno." *AB*, XLI (1959), pp. 159ff. and 225ff.

———. *History of Italian Renaissance Art*. New York, 1969.

Hartt, F. and G. Corti. "Andrea del Castagno: Three Disputed Dates." *AB*, XLVIII (1966), pp. 228ff.

Harzen, E. "Über den Maler Pietro degli Franceschi und seinen vermeintlichen Plagiarius, den Franz-is-kermönch Luca Pacioli." *Archiv für die zeichnenden Künste*, II (1856), pp. 231ff.

Hatfield, R. "Five Early Renaissance Portraits." *AB*, XLVII (1965), pp. 315ff.

———. "Three Kings and the Medici, a Study in Florentine Art and Culture During the Quattrocento." Ph.D. diss., Harvard University, 1966.

———. "Some Unknown Descriptions of the Medici Palace in 1459." *AB*, LII (1970), pp. 232ff.

———. "The Compagnia de' Medici." *JWCI*, XXXIII (1970), pp. 107ff. (1970a).

Hauptmann, M. *Der Tondo*. Frankfurt, 1936.

Hefele, K. *Der hl. Bernardino von Siena und die franziskanische Wanderpredigt in Italien während des XV. Jahrhunderts*. Freiburg, 1912.

Heinemann, R. *Sammlung Schloss Rohoncz*. Munich, 1937.

Hendy, P. *Catalogue of the Exhibited Paintings and Drawings in the Isabella Stewart Gardner Museum*. Boston, 1931.

———. *Piero della Francesca and the Early Renaissance*. London, 1968.

———. *European and American Paintings in the Isabella Stewart Gardner Museum*. Boston, 1974.

BIBLIOGRAPHY

Herzner, V. "Donatellos 'pala over ancona' für den Hochaltar des Santo in Padua." *ZKG*, XXXIII (1970), pp. 89ff.

Hetzer, T. *Titian, Geschichte seiner Farbe*. Frankfurt, 1948.

Heydenreich, L. H. "Spätwerke Brunelleschis." *JPK*, LII (1931), pp. 1ff.

———. "Gedanken über Michelozzo di Bartolommeo." *Festschrift Wilhelm Pinder*. Leipzig, 1938, pp. 264ff.

———. "Strukturprinzipien der florentiner Frührenaissance Architektur: Prospectiva aedificandi." *Studies in Western Art*. Princeton, 1963, II, pp. 123ff.

———. *Italienische Renaissance, Anfänge und Entfaltung in der Zeit von 1400 bis 1460*. Munich, 1972.

Hill, G. F. *Pisanello*. London, 1905.

———. *A Corpus of Italian Medals Before Cellini*. London, 1930.

Hind, A. M. *Early Italian Engravings, Part I: Florentine Engravings and Anonymous Prints of Other Schools*. London, 1938.

Holmes, C. *Old Masters and Modern Art, National Gallery, Italian Schools*. London, 1923.

———. "The Italian Exhibition." *BM*, LVI (1930), pp. 55ff.

Holmes, G. *The Florentine Enlightenment 1400–1450*. London, 1969.

Horne, H. "A Newly Discovered 'Libro di ricordi' of Alesso Baldovinetti." *BM*, II (1903), pp. 22ff.

———. "Andrea del Castagno." *BM*, VII (1905), pp. 66ff.

———. "Il Graffione." *BM*, VIII (1905), pp. 189ff. (1905a).

Horster, M. "Castagnos Fresken in Venedig und seine Werke der vierziger Jahre in Florenz." *Wallraf-Richartz Jahrbuch*, XV (1953), pp. 103ff.

———. "Das florentiner Jünglingsporträt in München, Alte Pinakothek, Inv. 658." *Pantheon*, XVIII (1960), pp. 209ff.

———. "Brunelleschi und Alberti in ihrer Stellung zur römischen Antike." *MKIF*, VVII (1973), pp. 29ff.

Huter, C. "Gentile da Fabriano and the Madonna of Humility." *AV*, XXIV (1970), pp. 26ff.

Hyman, I. "Fifteenth Century Florentine Studies: The Palazzo Medici and a Ledger for the Church of San Lorenzo." Ph.D. diss., New York University, 1968.

Isermeyer, C. A. "Die Cappella Vasari und der Hochaltar in der Pieve von Arezzo." *Festschrift für Karl Georg Heise*. Berlin, 1950, pp. 137ff.

Jahn, O. "Uber die Zeichnungen antiker Monumente im Codex Pighianus." *Berichte der sächsischen Gesellschaft der Wissenschaften*, XX (1868), pp. 161ff.

Jahn-Rusconi, A. *La reale galleria Pitti in Firenze*. Rome, 1937.

Jameson, A. B. *Companion to the Private Galleries of Art*. London, 1844.

Janson, H. W. "The Putto with the Death's Head." *AB*, XIX (1937), pp. 423ff.

BIBLIOGRAPHY

_____. "The Sculptured Works of Michelozzo di Bartolommeo," Ph.D. diss., Harvard University, 1941.

_____. "Two Problems in Renaissance Sculpture." *AB*, XXIV (1942), pp. 326ff.

_____. *The Sculpture of Donatello*. Princeton, 1957.

_____. "The Image Made by Chance in Renaissance Thought." *De Artibus Opuscula, Essays in Honor of Erwin Panofsky*. New York, 1961, pp. 254ff.

_____. "Ground Plan and Elevation in Masaccio's *Trinity* Fresco." *Essays in the History of Art Presented to Rudolf Wittkower*. London, 1967, pp. 83ff.

Jaspers, K. *Anselm and Nicholas of Cusa*. New York, 1974.

John G. Johnson Collection. *Catalogue of Italian Paintings*. Philadelphia, 1941.

Johnson, M., and E. Packard. "Methods Used for the Identification of Binding Media in Italian Paintings of the Fifteenth and Sixteenth Centuries." *Studies in Conservation,* XVI (1971), pp. 145ff.

Joost-Gaugier, C. L. "Considerations Regarding Jacopo Bellini's Place in the Venetian Renaissance." *AV,* XXVIII (1974), pp. 21ff.

Kaftal, G. *Saints in Italian Art, Iconography of the Saints in Tuscan Painting*. Florence, 1952.

Kallab, W. *Vasaristudien*. Ed., J. von Schlosser, Vienna and Leipzig, 1908.

Katalog der älteren Pinakothek zu München. Munich, 1904.

Kauffmann, H. *Donatello, eine Einführung in sein Bilden und Denken*. Berlin, 1935.

_____. "Über 'rinascere,' 'rinascità' und einige Stilmerkmale der Quattrocento Baukunst." *Concordia Decennalis*. Cologne, 1941, pp. 123ff.

Kehrer, H. C. *Die heiligen drei Könige in Literatur und Kunst*. Leipzig, 1908f.

Keller, H. "Gedanken zu einer grossen Ausstellung." *Kunstchronik,* VII (1954), pp. 233ff.

_____. *Italien und die Welt der höfischen Gotik*. Wiesbaden, 1967.

Kennedy, R. W. *Alesso Baldovinetti, a Critical and Historical Study*. New Haven, 1938.

Kiel, H. "Aus der Arbeit der Museen: Italien." *Pantheon,* XXVII (1969), pp. 63ff.

Klein, R. "Pomponius Gauricus on Perspective." *AB,* XLIII (1961), pp. 211ff.

Klessmann, R. *The Berlin Museum*. New York, 1971.

Knapp, F. *Piero di Cosimo*. Berlin, 1908.

Knudtzon, F. *En Brochure om Masaccio*. Copenhagen, 1900.

Koch, F. *Verzeichniss der Gemäldesammlung des westphälischen Kunstvereins im Landesmuseum zu Münster*. Münster, n.d.

Königliche Museen zu Berlin. *Beschreibendes Verzeichniss der Gemälde im Kaiser-Friedrich-Museum*. Berlin, 1883, 2d ed., 1904; 3d ed., 1912; 4th ed., 1931.

Krautheimer, R. and T. Krautheimer-Hess. *Lorenzo Ghiberti*. Princeton, 1956.

BIBLIOGRAPHY

Kris, E. and O. Kurz. *Die Legende vom Künstler*. Vienna, 1934.

Kugler, F. *Handbuch der Geschichte der Malerei seit Constantin dem Grossen*. Ed., J. Burckhardt, Berlin, 1847.

————. *The Italian Schools of Painting*. Ed., A. H. Layard, London, 1902.

Kuh, K. "Florence: Mending Damaged Treasures." *Saturday Review of Literature*, July 22, 1967, p. 17.

Kurth, W. *Die Darstellung des nackten Menschen in dem Quattrocento von Florenz*. Berlin, 1912.

Kurzes Verzeichnis der Bilder, Alte Pinakothek. Munich, 1957.

Landucci, L. *Diario fiorentino dal 1450 al 1516 continuato da un anonimo fino al 1542, pubblicato sui codici della Communale di Siena e della Marucelliana*, Ed., I. del Badia, Florence, 1883.

————. *A Florentine Diary from 1450 to 1516*. London and New York, 1927; reprint, New York, 1969.

Lanyi, J. "The Louvre Portrait of Five Florentines." *BM*, LXXXIV (1944), pp. 87ff.

Lanzi, L. *Storia pittorica dell'Italia*. Bassano, 1789, 2d ed., Bassano, 1795f.; 3d ed., Bassano, 1809.

Lassaigne, J. and G. C. Argan. *The Fifteenth Century, from Van Eyck to Botticelli*. Trans., G. Stuart, Geneva, 1955.

Lavagnino, E. "Masaccio: dicesi è morto a Roma." *Emporium*, XCVII (1943), pp. 100ff.

Lavin, I. "On the Sources and Meaning of the Renaissance Portrait Bust." *AQ*, XXXIII (1970), pp. 207ff.

Lavin, M. A. "Giovannino Battista: A Study in Renaissance Religious Symbolism." *AB*, XXXVII (1955), pp. 85ff.

————. "Giovannino Battista: A Supplement." *AB*, KLIII (1961), pp. 319ff.

Lehmann, R. *Catalogue of the Philip Lehmann Collection*. New York, 1928.

Leman, H. *La collection Foulc*. Paris, 1927.

Lerner-Lehmkühl, H. *Zur Struktur und Geschichte des florentiner Kunstmarkts im 15. Jahrhundert*. Wattenscheid, 1936.

Lethaby, W. R. "Maiolica Roundels of the Months of the Year at the Victoria and Albert Museum." *BM*, IX (1906), pp. 406ff.

Levey, M. *Early Renaissance*. Harmondsworth, 1967.

Lindberg, A. *To the Problem of Masolino and Masaccio*. Stockholm, 1931.

Lipman, J. "The Florentine Profile Portrait in the Quattrocento." *AB*, XVIII (1936), pp. 54ff.

————. "Three Profile Portraits by the Master of the Castello Nativity." *AA*, XXIV (1936), pp. 110ff. (1936a).

da Lisca, A. "Verona, Sant'Anastasia, la cappella maggiore e le sue decorazioni." *Atti e memorie dell' Accademia di Agricoltura, Scienze e Lettere di Verona*. XXI (1944), pp. 8ff.

Lloyd, C. *A Catalogue of the Earlier Italian Paintings in the Ashmolean Museum*. Oxford, 1977.

BIBLIOGRAPHY

Loeser, C. "Paolo Uccello." *RK*, XXI (1898), pp. 83ff.

Lomazzo, O. *Idea del tempio della pittura*. Milan, 1590.

Longhi, R. "Piero dei Franceschi e lo sviluppo della pittura veneziana." *L'arte*, XVII (1914), pp. 198ff.

_____. "Bollettino bibliografico." *L'arte*, XX (1917), p. 356.

_____. "Un frammento della pala di Domenico Veneziano per Santa Lucia de' Magnoli." *L'arte*, XXVIII (1925), pp. 31ff.

_____. "Lettera pittorica a Giuseppe Fiocco su l'arte del Mantegna." *Vita artistica*, I (1926), pp. 127ff.

_____. *Piero della Francesca*. Rome, 1927, 2d ed., Milan, 1946.

_____. "Saggi in Francia." *Vita artistica*, II (1927), pp. 45ff. (1927a).

_____. "Ricerche su Giovanni di Francesco." *Pinacoteca*. I (1928), pp. 34ff.

_____. *Officina ferrarese*. Rome, 1934.

_____. *Catalogo della mostra di Melozzo*. Forli, 1938.

_____. "Fatti di Masolino e di Masaccio." *CA*, V (1940), pp. 145ff.

_____. " 'Genio degli anonimi.' " *CA*, V (1940), pp. 97ff. (1940a).

_____. *Viatico per cinque secoli di pittura veneziana*. Florence, 1946.

_____. "Il 'Maestro di Pratovecchio.' " *Paragone*, 35 (November 1952), pp. 10ff.

_____. "Presenza di Masaccio nel trittico delle neve." *Paragone*, 25 (January 1952), pp. 8ff. (1952a).

_____. *Officina ferrarese 1934, seguita degli ampliamenti 1940 e di nuovi ampliamenti 1940–55*. Florence, 1956.

_____. "Appunti su 'uno sguardo alle fotografie della mostra 'Italian Art and Britain' alla Royal Academy di Londra.' " *Paragone*, 125 (January–March 1960), pp. 59ff.

_____. "Una 'Madonna' fiorentina del decennio di crisi 1430–40" *Paragone*, 187 (September 1965), pp. 56f.

Lopez-Rey, J. *Antonio del Pollajuolo y el fin del quattrocento*. Madrid, 1935.

Luporini, E. *Brunelleschi, forma e ragione*. Milan, 1964.

Mackowski, H. "Ausstellung italienischer Kunst in London." *Der Cicerone*, XXIII (1930), pp. 93ff.

_____. "The Masters of the Pesellino Trinity." *BM*, LVII (1930), pp. 212ff. (1930a).

Magherini-Graziani, G. *Masaccio, ricordo delle onoranze rese in San Giovanni di Valdarno nel di XXV Ottobre MCMIII in occasione del V centenario della sua nascita*. Florence, 1904.

Mallé L. "Appunti albertiani in margine al 'Della pittura.' " *AL*, X (1965), pp. 211ff.

Mancini, G. *Giorgio Vasari, cinque annotate*. Florence, 1917.

von Mandach, C. *Berner Kunstmuseum, Führer durch die Sammlungsausstellung, Gemälde und Plastik*. Bern, 1936.

BIBLIOGRAPHY

Marangoni, M. "Un ecclettico fiorentino." *L'arte,* XXX (1927), pp. 256ff.

Marchini, G. "Di Maso di Bartolommeo e d'altri." *Commentari,* III (1952), pp. 108ff.

———. *Due secoli di pittura murale a Prato, mostra di affreschi, sinopie e graffiti dei secoli XIV e XV.* Prato, 1969.

———. *Filippo Lippi.* Milan, 1975.

Marcotti, G. *Un mercante fiorentino e la sua famiglia.* Florence, 1881.

Mariotti, G. *Lettere pittoriche perugine.* Perugia, 1788.

van Marle, R. *The Development of the Italian Schools of Painting.* The Hague, 1923ff.

———. "Ein Domenico Veneziano in der Sammlung Rohoncz." *Der Cicerone,* XXII (1930), pp. 369ff.

———. "I quadri italiani della raccolta del castello Rohoncz." *Dedalo,* XI (1931), pp. 1365ff.

Marquand, A. *Luca della Robbia.* Princeton, 1914.

Martines, L. *The Social World of the Florentine Humanists, 1390–1460.* London, 1963.

Martini, A. "Spigolature venete." *AV,* XI (1957), pp. 53ff.

———. "The Early Work of Bartolomeo della Gatta." *AB,* XLII (1960), pp. 133ff.

———. *Masolino a Castiglione d'Olona.* Milan, 1965.

Mason-Perkins, F. "Pitture italiane nella raccolta Johnson a Filadelfia." *Rassegna d'arte,* V (1905), pp. 115ff.

———. "Note su alcuni quadri del museo cristiano del Vaticano." *Rassegna d'arte.* VI (1906), pp. 21ff.

———. "Alcuni dipinti senesi sconosciuti o inediti." *Rassegna d'arte,* XIII (1913), pp. 195ff.

Mather, F. J. "Three Florentine Furniture Panels." *AA,* VIII (1920), pp. 148ff.

———. *A History of Italian Painting.* New York, 1923.

———. "The Problem of the Brancacci Chapel Historically Considered." *AB,* XXVI (1944), pp. 175ff.

Mather, R. G. "Documents Mostly New Relating to Florentine Painters and Sculptors of the Fifteenth Century." *AB,* XXX (1948), pp. 20ff.

Matz, F. "Über eine dem Herzog von Coburg-Gotha gehörige Sammlung alter Handzeichnungen nach Antiken." *Monatsberichte der Berliner Akademie der Wissenschaften.* Phil.-Hist. Klasse, 1871, pp. 445ff.

Mauro-Castro, G. *Antonio e Piero del Pollaiuolo.* Rome, 1931.

Mayer, A. L. "Die Sammlung Jules Bache in New York." *Pantheon,* VI (1930), pp. 537ff.

Mazzei, Ser Lapo. *Lettere di un notaio a un mercante del sec. XIV.* Ed., C. Guasti, Florence, 1880.

Meinhof, W. "Leonardos Hieronymus." *RK,* LII (1931), pp. 101ff

Meiss, M. "Italian Style in Catalonia and a Fourteenth Century Catalan Workshop." *Journal of the Walters Art Gallery,* IV (1941), pp. 45ff.

BIBLIOGRAPHY

————. "A Documented Altarpiece by Piero della Francesca." *AB*, XXIII (1941), pp. 53ff.

————. "Light as Form and Symbol in Some Fifteenth Century Paintings." *AB*, XXVII (1945), pp. 175ff.

————. *Painting in Florence and Siena After the Black Death*. Princeton, 1951.

————. "London's New Masaccio." *Art News*, LI (February 1952), pp. 24ff.

————. "Jan van Eyck and the Italian Renaissance." *Atti del XVIII congresso internazionale di storia dell'arte*. Venice, 1956, pp. 58ff.

————. "Mortality Among Florentine Immortals." *Art News*, LVIII (May 1959), pp. 26ff.

————. *Giotto and Assisi*. New York, 1960.

————. " 'Highlands' in the Lowlands." *GBA*, XXXVIII (1961), pp. 273ff.

————. "Contributions to Two Elusive Masters." *BM*, CIII (1961), pp. 57ff. (1961a).

————. "Masaccio and the Early Renaissance, the Circular Plan." *Studies in Western Art*. Princeton, 1963, II, pp. 123ff.

————. "French and Italian Variations on an Early Fifteenth Century Theme: St. Jerome in his Study." *GBA*, XLII (1963), pp. 147ff. (1963a).

————. "The Yates Thompson Dante and Priamo della Quercia." *BM*, CVI (1964), pp. 403ff.

————. *Giovanni Bellini's St. Francis in the Frick Collection*. Princeton, 1964 (1964a).

————. "The Altered Program of the Santa Maria Maggiore Altarpiece." *Studien zur toskanischen Kunst*. Munich, 1964, pp. 169ff. (1964b).

————. *French Painting in the Time of Jean de Berry*. London and New York, 1967.

————. "Important Rediscoveries in Renaissance Art in Florence." *Art News*, LXVI (Summer 1967), pp. 26ff. (1967a).

————. *The Great Age of Fresco, Discoveries, Recoveries and Survivals*. London, 1970.

————. "The Original Position of Uccello's John Hawkwood." *AB*, LII (1970), p. 231 (1970a).

Mencherini, P. *Santa Croce di Firenze*. Florence, 1929.

Mendelsohn, H. *Fra Filippo Lippi*. Berlin, 1909.

Merkel, E. "Un problema di metodo: la 'Dormitio Virginis' dei Mascoli." *AV*, XXVIII (1973), pp. 65ff.

Mesnil, J. "Die Kunstlehre der Frührenaissance im Werke Masaccios." *Vorträge der Bibliothek Warburg*, 1926, pp. 122ff.

————. *Masaccio et les débuts de la renaissance*. The Hague, 1927.

Micheletti, E. *Masolino da Panicale*. Milan, 1959.

————. *L'opera completa di Gentile da Fabriano*. Milan, 1976.

Middeldorf, U. "L'Angelico e la scultura." *Rinascimento*, VI (1955), pp. 179ff.

————. " 'Olio'-'Oglio.' " *BM*, XCVIII (1956), p. 169.

BIBLIOGRAPHY

————. "Un rame inciso del quattrocento." *Scritti di storia dell'arte in onore di Mario Salmi.* Rome, 1962, II, pp. 273ff.

Mignon, G. "La collection de M. Edmund Foulc." *Les Arts,* I (June 1902), pp. 11ff.

Milanesi, G. "Le vite di alcuni artefici fiorentini scritte da Giorgio Vasari corrette ed accresciute coll'aiuto de' documenti." *Giornale storico degli archivi toscani,* VI (1862), pp. 1ff.

————. *Documenti per la storia dell'arte senese.* Siena, 1877.

————. "Documenti inediti dell'arte toscana dal XII al XVI secolo." *Il Buonarroti,* II (1885), pp. 141ff.

Miller, P. P. "Recent Discoveries in Italian Painting." *Art News,* XXIV (June 1926), pp. 14ff.

Mittig, H. E. "Uccellos Hawkwood-Fresko: Platz und Wirkung." *MKIF,* XL (1969), pp. 35ff.

Mode, R. L. "Masolino, Uccello and the Orsini 'Uomini Famosi.' " *BM,* CXIV (1972), pp. 369ff.

Modigliani, E. *Catalogo della pinacoteca di Brera.* Milan, 1950.

Moisé, F. *Santa Croce di Firenze.* Florence, 1845.

Molho, A. "The Florentine 'tassa dei traffichi' of 1451." *Studies in the Renaissance.* XVII (1970), pp. 73ff.

Molinier, E. "Le musée Poldi-Pezzoli à Milan." *GBA,* XXXI (1889), pp. 42ff.

Molsdorf, W. *Christliche Symbolik der mittelalterlichen Kunst.* Leipzig, 1926.

Montclair Art Museum. *Loan Exhibition of Paintings, Furniture and Art Objects from the Collection of Carl W. Hamilton.* Montclair, 1925.

Morante, E. and U. Baldini. *L'opera complete dell'Angelico.* Milan, 1970.

Morassi, A. *Il museo Poldi-Pezzoli in Milano.* Rome, 1936.

Morelli, G. *Die Werke italienischer Meister in den Galerien von München, Dresden und Berlin.* Leipzig, 1880.

————. *Kunstkritische Studien über italienische Malerei, die Galerie zu Berlin.* Leipzig, 1893.

Morisani, O. *Michelozzo architetto.* Florence, 1951.

————. "Art Historians and Art Critics, III: Cristoforo Landino." *BM,* XCV (1953), pp. 267ff.

Mostra di affreschi staccati. Florence, 1957.

II mostra di affreschi staccati. Florence, 1958.

Mostra d'arte sacra della diocesi di San Miniato. San Miniato, 1969.

Mostra di dipinti restaurati. Perugia, 1953.

Müntz, E. *Les collections des Medicis au XVe siècle.* Paris, 1888.

————. *Histoire de l'art pendant la renaissance.* Paris, 1889, I.

————. "Les plateaux d'accouchement." *Monuments et mémoires, Académie des Inscriptions et Belles Lettres,* I (1894), pp. 203ff.

Muraro, M. "Domenico Veneziano at San Tarasio." *AB,* XXXIX (1959), pp. 151ff.

[381]

BIBLIOGRAPHY

_____. *Pitture murali nel Veneto e tecnica dell'affresco.* Venice, 1960.

_____. "The Statutes of the Venetian *Arti* and the Mosaics of the Mascoli Chapel." *AB,* XLIII (1961), pp. 263ff.

_____. "Mantegna e Alberti." *Arte, pensiero e cultura a Mantova nel primo rinascimento in rapporto con la Toscana.* Florence, 1965, pp. 103ff.

Murray, P. and L. *The Art of the Renaissance.* New York, 1963.

Musatti, R. "Catalogo giovanile di Cosimo Rosselli." *RA,* XXVI (1950), pp. 103ff.

Musée Bonnat. *Catalogue sommaire.* Paris, 1930; 2d ed., Paris, 1952.

Museum of Fine Arts of Houston. *Catalogue of the Edith A. and Percy S. Strauss Collection.* Houston, 1945.

National Gallery of Art. *Preliminary Catalog of Paintings and Sculpture.* Washington, D.C., 1941.

National Gallery of Ireland and National Portrait Gallery. *Catalogue of Pictures and Other Works of Art.* Dublin, 1920.

Neue Pinakothek. *Ausstellung der Sammlung Schloss Rohoncz, Gemälde.* Munich, 1930.

The New Gallery. *Catalogue of an Exhibition of Early Italian Art from 1300–1500.* London, 1894.

New York Historical Society. *Catalogue of the Gallery of Art.* New York, 1915.

Nicholson, A. "Donatello: Six Portrait Statues." *AA,* XXX (1942), pp. 77ff.

Offner, R. "Italian Pictures at the New York Historical Society and Elsewhere, III." *AA,* VIII (1920), pp. 7ff.

_____. "A St. Jerome by Masolino." *AA,* VIII (1920), pp. 68ff. (1920a).

_____. "Un pannello di Masolino a San Giuliano a Settimo." *Dedalo,* III (1923), pp. 636ff.

_____. "A Remarkable Exhibition of Italian Paintings." *The Arts,* V (1924), pp. 241ff.

_____. *Italian Primitives at Yale University.* New Haven, 1927.

_____. *Studies in Florentine Painting.* New York, 1927 (1927a).

_____. *A Critical and Historical Corpus of Florentine Painting.* New York, 1930ff.

_____. "The mostra del tesoro di Firenze sacra, II." *BM,* LXIII (1933), pp. 166ff.

_____. "The Barberini Panels and Their Painter." *Medieval Studies in Memory of A. Kingsley Porter.* Cambridge (Mass.), 1939, I, pp. 205ff.

_____. "The Strauss Collection Goes to Texas." *Art News,* XLIV, May 15, 1945, pp. 16ff.

_____. "Light on Masaccio's Classicism." *Studies in the History of Art Dedicated to William Suida.* London, 1959, pp. 66ff.

Oprescu, G. *Masters of World Painting in Rumanian Museums.* Bucharest, 1960.

_____. *Great Masters of Painting in the Museums of Rumania.* Bucharest, 1961.

Orlandi, S., O.P. "Il Beato Angelico—note cronologiche." *RA,* XXIX (1954), pp. 161ff.

<div align="center">BIBLIOGRAPHY</div>

————. *Beato Angelico*. Florence, 1964.

Örtel, R. "Masaccios Frühwerke." *Marburger Jahrbuch für Kunstwissenschaft*, VII (1933), pp. 1ff.

————. "Wandmalerei und Zeichnung in Italien." *MKIF*, V (1940), pp. 217ff.

————. *Fra Filippo Lippi*. Vienna, 1942.

————. *Frühe italienische Tafelmalerei*. Stuttgart, 1950.

————. "Perspective and Imagination." *Studies in Western Art*. Princeton, 1963, II, pp. 152ff.

Ortolani, S. *Il Pollaiuolo*. Milan, 1948.

Paatz, W. "Una Natività di Paolo Uccello e alcuni consideratizioni sull'arte del maestro." *RA*, XVI (1934), pp. 111ff.

————. "Ein antikischer Stadthaustypus im mittelalterlichen Italien." *RJK*, III (1939), pp. 127ff.

————. "Italien und die künstlerischen Bewegungen der Gotik und Renaissance." *RJK*, V (1941), pp. 165ff.

Paatz, W. and E. *Die Kirchen von Florenz*. Frankfurt-am-Main, 1940ff.

Paccagnini, G. "Una proposta per Domenico Veneziano." *BA*, XXXVII (1952), pp. 115ff.

————. *Pisanello*. London, 1973.

Pächt, O. "Early Italian Nature Studies and the Early Calendar Landscape." *JWCI*, XIII (1950), pp. 13ff.

Paintings from the Berlin Museum. New York, 1948.

Palluchini, R. *Catalogo della mostra di capolavori dei musei veneti*. Venice, 1946.

————. "Capolavori della pittura veronese dal tre al quattrocento." *AV*, I (1947), pp. 235ff.

————. *I Vivarini*. Venice, 1962.

————. *Pittura veneta del trecento*. Novara, 1964.

Panofsky, E. "The Friedsam Annunciation." *AB*, XVII (1935), pp. 433ff.

————. *Early Netherlandish Painting*. Cambridge (Mass.), 1953.

————. *Renaissance and Renascences in Western Art*. Copenhagen, 1960.

————. *Studies in Iconology*. New York, 1962.

Paoletti, P. *L'architettura e la scultura del rinascimento in Venezia*. Venice, 1893.

Parronchi, A. *Studi sulla 'dolce prospettiva.'* Milan, 1964.

————. "La 'costruzione legittima' è uguale alla 'costruzione con punti di distanza.' " *Rinascimento*, XV (1964), pp. 35ff. (1964a).

————. *Masaccio*. Florence, 1966.

————. "Il dossale dei Santi Cosma e Damiano." *Arte antica e moderna*, 33 (January–March 1966), pp. 45ff. (1966a).

BIBLIOGRAPHY

Passavant, G. *Verrocchio.* Düsseldorf, 1959.

———. *Andrea del Verrocchio.* London, 1969.

———. "Fresken aus Florenz." *Kunstchronik,* XXII (1969), pp. 341ff. (1969a).

Passerini, L. "Il sigilo fiorentino con l'Ercole." *Periodico di numismatica e sfragistica.* I (1868), pp. 276ff.

———. *Genealogia e storia della famiglia Guadagni.* Florence, 1873.

Pastor, L. *Geschichte der Päpste.* Freiburg, 1901, I.

Perosa, A., ed., *Giovanni Rucellai ed il suo Zibaldone, I, 'Il Zibaldone Quaresimale.'* London, 1960.

Petit Palais. *Catalogue de la collection Aynard.* Paris, 1913.

———. *Exposition de l'art italien de Cimabue à Tiepolo.* Paris, 1935.

Phillips, C. "Correspondance d'Angleterre." *GBA,* XXXIV (1886), pp. 487ff.

Pietri, A. B. "Di due tavole del Ghirlandaio nel museo civico di Pisa." *BA,* III (1909), pp. 326ff.

Pini, G. *La Scrittura di artisti italiani.* Ed. G. Milanesi, Florence, 1876.

Pittaluga, M. *Masaccio.* Florence, 1935.

———. *Paolo Uccello.* Florence, 1946.

———. *Fra Filippo Lippi.* Florence, 1949.

Planiscig, L. *Luca della Robbia.* Florence, 1948.

Podreider, F. *Storia dei tessuti d'arte in Italia.* Bergamo, 1928.

Poggi, G. *I ricordi di Alesso Baldovinetti.* Florence, 1909.

———. "Le ricordance di Neri di Bicci." *Il Vasari,* III (1930), pp. 133ff., 222ff.

———. "Sulla data dell'affresco di Fra Filippo Lippi nel chiostro del Carmine." *RA,* XVIII (1936), pp. 95ff.

Polzer, J. "The Anatomy of Masaccio's Holy Trinity." *Jahrbuch der Berliner Museen.* XIII (1971), pp. 18ff.

Pope-Hennessy, J. *Sassetta.* London, 1939.

———. "A Predella Panel by Masolino.' *BM,* LXXXII (1943), pp. 30f.

———. "The Development of Realistic Painting in Siena." *BM,* LXXXIV (1944), pp. 110ff.

———. *Sienese Quattrocento Painting.* London, 1947.

———. *The Complete Work of Paolo Uccello.* London, 1950, 2d ed., London, 1969.

———. "The Early Style of Domenico Veneziano." *BM,* XCIII (1951), pp. 216ff.

———. *Fra Angelico.* London, 1952; 2d ed., Ithaca, 1974.

———. "The Sta. Maria Maggiore Altarpiece." *BM,* XCIV (1952), pp. 31f. (1952a).

———. "Recent Research." *BM,* XVC (1953), pp. 277ff.

BIBLIOGRAPHY

_____. *Italian Renaissance Sculpture.* London, 1958.

_____. *Catalogue of Italian Sculpture in the Victoria and Albert Museum.* London, 1964.

_____. *The Portrait in the Renaissance.* New York, 1966.

_____. "The Interaction of Painting and Sculpture in Florence in the Fifteenth Century." *Journal of the Royal Society of the Arts,* CXVII (1969), pp. 406ff. (1969a).

_____. "The Forging of Italian Renaissance Sculpture." *Apollo,* XCIX (1974), pp. 242ff. (1974a).

_____. "Shots of Donatello." *New York Review of Books,* XX (January 24, 1974), pp. 7ff. (1974b).

_____. "The Medici Crucifixion of Donatello." *Apollo,* CI (1975), pp. 82ff.

_____. Review of H. W. van Os, *Vecchietta and the Sacristy of the Siena Hospital Church.* In *Apollo,* CI (1975), pp. 495f. (1975a).

Popham, A. E. and P. Pouncey. *Italian Drawings in the Department of Prints and Drawings in the British Museum, the Fourteenth and Fifteenth Centuries.* London, 1950.

Porcher, J. *Les Belles Heures de Jean de France, Duc de Berry.* Paris, 1953.

Post, C. R. *A History of Spanish Painting.* Cambridge (Mass.), 1930, III.

Primo Rinascimento in Santa Croce. Florence, 1968.

Principal Pictures in the Fitzwilliam Museum. Cambridge (England), 1929.

Procacci, U. "L'incendio della chiesa del Carmine nel 1771." *RA,* XIV (1932), pp. 141ff.

_____. "Opere sconosciute d'arte toscana." *RA,* XIV (1932), pp. 463ff. (1932a).

_____. "Gherardo Starnina." *RA,* XVII (1935), pp. 381ff.

_____. *Tutta la pittura di Masaccio.* Milan, 1951.

_____. "Sulla cronologia delle opere di Masolino e di Masaccio tra il 1425 e il 1428." *RA,* XXVIII (1953), pp. 3ff.

_____. *La tecnica degli antichi affreschi.* Florence, 1958.

_____. *Sinopie e affreschi.* Florence, 1961.

Pudelko, G. "Studien über Domenico Veneziano." *MKIF,* IV (1934), pp. 145ff.

_____. "The Early Works of Paolo Uccello." *AB,* XVI (1934), pp. 231ff. (1934a).

_____. "Florentiner Porträts der Renaissance." *Pantheon,* XV (1935), pp. 92ff.

_____. "The Minor Masters of the Chiostro Verde." *AB,* XVII (1935), pp. 71ff. (1935a).

_____. "Per la datazione delle opere di Fra Filippo Lippi." *RA,* XVIII (1936), pp. 45ff.

_____. "The Early Work of Fra Filippo Lippi." *AB,* XVIII (1936), pp. 104ff. (1936a).

_____. "Paolo Schiavo." Thieme-Becker, XXX (1936), p. 46 (1936b).

_____. "Two Portraits Ascribed to Andrea del Castagno." *BM,* LXVIII (1936), pp. 235ff. (1936c).

_____. "An Unknown Holy Virgin by Paolo Uccello." *AA,* XXIV (1936), pp. 127ff. (1936d).

[385]

BIBLIOGRAPHY

————. "The 'Maestro del Bambino Vispo.' " *AA*, XXVI (1938), pp. 47ff.

————. "Paolo Uccello." Thieme-Becker, XXXIII (1939), pp. 524ff.

Ragghianti, C. L. "La giovinezza e lo svolgimento artistico di Domenico Ghirlandaio," *L'arte*. VI (1935), pp. 167ff.

————. "Intorno a Filippo Lippi." *CA*, III (1938), pp. xxiiff.

————. "Sul metodo nello studio dei disegni." *Le arti*, III (1940), pp. 9ff.

————. "Argomenti lippeschi e uccelleschi." *Miscellanea minori di critica d'arte*. Bari, 1946, pp. 69ff.

————. Review of U. Procacci, *Tutta la pittura di Masaccio*. In *Sele arte*, I (September–October 1952), p. 65.

Ragghianti-Collobi, L. *Catalogo della mostra d'arte antica: Lorenzo il magnifico e le arti*. Florence, 1949.

Rankin, W. "Intorno ad alcuni dipinti italiani a Nuova York." *Rassegna d'arte*, VII (1907), pp. 42ff.

————. "Cassone panels in American Collections." *BM*, XII (1907), pp. 63ff. (1907a).

————. "The Collection of Mr. John G. Johnson, the Early Italian Pictures." *International Studio*. XXXVII (May 1909), pp. lxxixff.

Razzi, S. *Vite de' santi e beati toscani*. Florence, 1627.

Redslob, E. *The Berlin-Dahlem Gallery*. New York and London, 1967.

van Regteren Altena, J. Q. " 'Olio'—'Oglio.' " *BM*, XCV (1954), p. 387.

Reinach, S. *Répertoire des peintures du moyen âge et de la renaissance, 1280–1580*. Paris, 1905ff.

Il restauro dei monumenti dal 1944 al 1968. Florence, 1968.

Restored Paintings, National Gallery of Ireland. Dublin, 1971.

Ricci, C. *Elenco dei quadri dell'Accademia Carrara in Bergamo*. Bergamo, 1912.

Ricci, E. *Il gonfalone degli eremitani di S. Agostino a Perugia*. Perugia, 1936.

Ricci, G. *Nuova guida della città e contorni di Firenze*. Florence, 1848.

de Ricci, S. *Description raisonnée des peintures du Louvre, écoles étrangères: Italie et Espagne*. Paris, 1913.

Richa, G. *Notizie istoriche delle chiese fiorentine*. Florence, 1754ff.

Richter, G. M. "Pisanello Studies, II." *BM*, LV (1929), pp. 128ff.

Richter, J. P. *Italian Art in the National Gallery*. London, 1883.

————. *The Mond Collection*. London, 1910.

Rigoni, E. "Nuovi documenti sul Mantegna." *Atti del Reale Istituto Veneto*, LXXXVII (1927–28), pp. 1165ff. (supplement in AV, II [1948], pp. 141ff.).

————. "Jacopo Bellini a Padova nel 1430." *RA*, XI (1929), pp. 261ff.

Ringbom, S. *Icon to Narrative, the Rise of the Dramatic Close-up in Fifteenth-Century Devotional Painting*. Abö, 1965.

BIBLIOGRAPHY

Rinuccini, A. *Lettere ed orazioni*. Florence, 1953.

Robert, C. *Die antiken Sarkophag-reliefs*. Berlin, 1890ff.

Robertson, G. "A Recent Book on Fra Angelico." *BM*, XCVI (1954), p. 186.

Robinson, J. C. *Italian Sculpture of the Middle Ages and of the Period of the Revival of the Arts in the South Kensington Museum*. London, 1862.

de Roover, R. *The Rise and Decline of the Medici Bank*. New York, 1966.

Rosini, G. *Storia della pittura italiana, esposta coi monumenti*. Pisa, 1839ff.

Rossi, F. *Il Museo Horne a Firenze*. Milan, 1967.

Rossi, V. "Due dipinti di Piero Pollaiuolo." *Archivio storico dell'arte*, III (1890), pp. 160ff.

Röthlisberger, M. "Notes on the Drawing Books of Jacopo Bellini." *BM*, XCVIII (1956), pp. 358ff.

Royal Academy of Arts. *Exhibition of Italian Art, 1200–1900*. London, 1930.

————. *A Commemorative Catalogue of the Exhibition of Italian Art*. London, 1931.

————. *Italian Art and Britain*. London, 1960.

Rubinstein, N. *The Government of Florence Under the Medici (1434 to 1494)*. London, 1966.

Ruhmer, E. "Bartolomeo Bonascia; ein Nachfolger Piero della Francescas in Modena." *Münchner Jahrbuch der bildenden Kunst*. V (1954), pp. 89ff.

von Rumohr, C. F. *Italienische Forschungen*. Ed., J. von Schlosser, Frankfurt-am-Main, 1920.

Russoli, F. *La pinacoteca Poldi-Pezzoli*. Milan, 1955.

————. *La raccolta Berenson*. Milan, 1962.

Sabatini, A. *Antonio e Piero del Pollaiuolo*. Florence, 1944.

Saccardo, P. *Les mosaiques de Saint-Marc*. Venice, 1896.

Salmi, M. "Gli affreschi del Palazzo Trinci a Foligno." *BA*, XIII (1919), pp. 139ff.

————. "Note sulla galleria di Perugia." *L'arte*, XXIV (1921), pp. 168ff.

————. "Paolo Uccello, Domenico Veneziano, Piero della Francesca e gli affreschi del duomo a Prato." *BA*, XXVIII (1934), pp. 1ff.

————. "Aggiunte al tre e al quattrocento fiorentino." *RA*, XVIII (1935), pp. 411ff.

————. *Paolo Uccello, Andrea del Castagno, Domenico Veneziano*. Rome, 1936; 2d ed., Milan, 1938.

————. "La giovinezza di Fra Filippo Lippi." *RA*, XVIII (1936), pp. 1ff. (1936a).

————. "La Madonna 'Dantesca' nel museo di Livorno e il 'maestro della Natività Castello.'" *Liburni civitas*. XI (1938), pp. 5ff. (1938a).

————. "La bibbia di Borso d'Este e Piero della Francesca." *La Rinascità*, VI (1943), pp. 365ff.

————. "Un ipotesi su Piero della Francesca." *Arti figurative*, III (1947), pp. 78ff.

————. "Contributi fiorentini alla storia dell'arte: ricerche intorno a un perduto ciclo pittorico del

rinascimento.'' *Atti e memorie dell'Accademia Fiorentina di Scienze Morali, la Colombaria.* I, 1943–46, Florence, 1947, pp. 421ff. (1947a).

————. *Masaccio.* Milan, 1948; 1st ed., Rome, 1932.

————. ''Gli scomparti della pala di S. Maria Maggiore acquistati dalla National Gallery.'' *Commentari,* III (1952), pp. 14ff.

————. ''La miniatura fiorentina mediovale.'' *Accademie e biblioteche d'Italia,* XX (1952), pp. 8ff. (1952a).

————. ''Fuochi d'artificio o della pseudo-critica.'' *Commentari,* V (1954), pp. 65ff.

————. *Italian Miniatures.* New York, 1954 (1954a).

————. ''L'ouvraige de Lombardie e il primo rinascimento.'' *Actes du XVII congrès international d'histoire de l'art.* Amsterdam, 1955, pp. 269ff.

————. ''Ancora di Andrea del Castagno dopo il restauro degli affreschi di San Zaccaria a Venezia.'' *BA,* XLIII (1958), pp. 117ff.

————. *Il Beato Angelico.* Rome, 1958 (1958a).

————. *Andrea del Castagno.* Novara, 1961.

————. Review of Degenhart and Schmitt (1969). In *AB,* LV (1973), pp. 625ff.

Salmi, M., et al. *Catalogo della mostra storica nazionale della miniatura.* Florence, 1953.

————. *Catalogo della mostra di quattro maestri del primo rinascimento.* Florence, 1954.

————. *Catalogo della mostra di opere del Beato Angelico.* Florence, 1955.

Salvini, R. *La galleria degli Uffizi.* Florence, 1952.

Salvini, R. and L. Traverso. *Predelle dal '200 al '500.* Florence, 1959.

Sammlung Schloss Rohoncz. Castagnola, 1959.

Sandberg Vavalà, E. *Uffizi Studies.* Florence, 1948.

Sanpaolesi, P. ''I dipinti di Leonardo agli Uffizi.'' *Leonardo, saggi e ricerche.* Rome, 1954, pp. 29ff.

————. *Brunelleschi.* Milan, 1962.

Santi, F. ''L'affresco baglionesco della galleria nazionale dell'Umbria.'' *Commentari,* XXI (1970), pp. 51ff.

Santi, G. *Federigo di Montefeltro, Duca di Urbino, cronaca.* Ed., H. Holtzinger, Stuttgart, 1893.

Saxl, F. *Last Lectures.* London, 1957.

Scaglia, G. ''An Allegorical Portrait of Emperor Sigismond by Mariano Taccola of Siena.'' *JWCI,* XXXI (1968), pp. 428ff.

van Schaak, E. *Master Drawings in Private Collections.* New York, 1962.

Scharf, A. ''Die Brautschachtel der Sammlung Figdor.'' *Der Cicerone,* XXII (1930), pp. 5ff.

————. *Filippino Lippi.* Vienna, 1935.

Scheller, R. W. *A Survey of Medieval Model Books.* Haarlem, 1963.

BIBLIOGRAPHY

von Schlosser, J. *Ghibertis Denkwürdigkeiten*. Berlin, 1912.

Schmarsow, A. "Die Cappella dell'Assunta im Dom zu Prato." *RK*, XVI (1893), pp. 159ff.

———. *Masaccio Studien*. Kassel, 1895.

———. "Maîtres italiens à la galerie d'Altenburg e dans la collection de A. de Montor." *GBA*, XX (1898), pp. 492ff.

———. "Domenico Veneziano." *L'arte*, XV (1912), pp. 9ff.

———. "Zur Masolino-Masaccio Forschung." *Kunstchronik und Kunstliteratur* [supplement], *Zeitschrift für bildende Kunst*. LXIV (1930), pp. 2ff.

Schöne, W. *Über das Licht in der Malerei*. Berlin, 1954.

Schottmüller, F. *Fra Angelico*. Stuttgart, 1911.

———. "Antonio Pollaiuolo." Thieme-Becker, XVII (1932), p. 210.

Schröteler, H. *Zur Rekonstruktion des Donatello Altars im Santo zu Padua*. Bochum, 1969.

Schubring, P. *Cassoni*. Leipzig, 1915.

———. "Neue Cassoni." *Belvedere*, VIII (1929), pp. 176ff.

———. "New Cassoni Paintings." *AA*, XVIII (1930), pp. 228ff.

Schulz, A. M. *The Sculpture of Bernardo Rossellino and His Workshop*. Princeton, 1977.

Schuyler, J. "Studies of Florentine Quattrocento Busts." Ph.D. diss., Columbia University, 1972.

Semenzato, C. "Un'opera giovanile di Domenico Veneziano?" *RA*, XXIX (1954), pp. 133ff.

Semrau, M. *Die Kunst der Renaissance in Italien und im Norden*. Esslingen, 1920.

Serra, L. *L'arte nelle Marche*. Rome, 1934.

———. "La mostra dell'arte antica italiana a Parigi." *BA*, XXIX (1936), pp. 30ff.

Seymour, C., Jr. *Art Treasures for America*. London, 1961.

———. "The Young Luca della Robbia." *Allen Memorial Art Museum Bulletin*, XX (1963), pp. 92ff.

———. *Sculpture in Italy 1400–1500*. Baltimore, 1966.

———. "Some Aspects of Donatello's Methods of Figure and Space Construction: Relationships with Alberti's *De statua* and *Della pittura*." *Donatello e il suo tempo*, Florence, 1968, pp. 195ff.

Shapley, F. R. *Paintings from the Samuel H. Kress Collection, Italian Schools, XIII–XV Century*. London, 1966.

Shearman, J. "Masaccio's Pisa Altarpiece: An Alternative Reconstruction." *BM*, CVIII (1966), pp. 449ff.

Shell, C. H. "Giovanni dal Ponte and the Problem of the Other Lesser Contemporaries of Masaccio," Ph.D. diss., Harvard University, 1958.

———. "The Early Style of Fra Filippo Lippi and the Prato Master." *AB*, XLIII (1961), pp. 201ff.

———. "Francesco d'Antonio and Masaccio." *AB*, XLVII (1965), pp. 465ff.

_____. "Domenico Veneziano, Two Clues." *Festschrift Ulrich Middeldorf*. Berlin, 1968, pp. 150ff.

Shorr, D. C. *The Christ Child in Devotional Images in Italy During the XIV Century*. New York, 1954.

Siebenhüner, H. *Über den Kolorismus der Frührenaissance*. Schramberg, 1935.

Sill, G. G. *A Handbook of Symbols in Christian Art*. New York, 1975.

Sindona, E. *Paolo Uccello*. Milan, 1957.

_____. "Gotico e rinascimento: Pisanello, Paolo Uccello e il pittore dell' Adorazione." *Fede e arte*, VII (1960), pp. 172ff.

_____. *Pisanello*. Paris, 1962.

_____. "Una conferma uccellescha." *L'arte*, III (1970), pp. 67ff.

Sinibaldi, G. "Note su Lorenzo di Bicci," *RA*, XXVI (1950), pp. 199ff.

Siple, E. S. "Recent Acquisitions in America." *BM*, LX (1932), pp. 109ff.

Siren, O. "Di alcuni pittori fiorentini che subirono l'influenza di Lorenzo Monaco." *L'arte*, VII (1904), pp. 342ff.

_____. "Notizie critiche sui quadri sconosciuti del museo cristiano vaticano." *L'arte*, IX (1906), pp. 321ff.

_____. "Two Early Quattrocento Pictures." *BM*, XLVI (1925), pp. 281ff.

Siren, O. and M. Brockwell. *Catalogue of a Loan Exhibition of Italian Primitives at the Kleinberger Galleries*. New York, 1917.

Smith, M. Q. "Carpaccio's Hunt in the Lagoon." *Apollo*, XCIX (1974), pp. 240f.

Smyth, C. H. *Mannerism and Maniera*. New York, 1963.

Somaré, E. *Masaccio*, Milan, 1924.

Soupoult, F. *Paolo Uccello*. Paris, 1929.

Spaventi, S. M. *Vittor Pisano, detto il Pisanello*. Verona, 1892.

Spencer, J. R. "Spatial Imagery of the Annunciation in Fifteenth Century Florence." *AB*, XXXVII (1955), pp. 273ff.

Stechow, W. "Zum Masolino-Masaccio Problem." *Kunstchronik und Kunstliteratur* [supplement], *Zeitschrift für bildende Kunst*, LXIX (1930), pp. 125ff.

Sterling, C. "Un tableau inédit de Gentile da Fabriano." *Paragone*, 101 (May 1958), pp. 26ff.

_____. "Observations on Petrus Christus." *AB*, LIII (1971), pp. 1ff.

_____. "Jan van Eyck avant 1432." *Revue de l'art*. 33 (1976), pp. 7ff.

Stiftung preussischer Kulturbesitz. *Staatliche Museen, Gemäldegalerie, Verzeichnis der ausgestellten Gemälde des 13. bis 18. Jahrhunderts im Museum Dahlem*. Berlin, 1963.

Stix, A. and L. Fröhlich-Blum. *Die Zeichnungen der toskanischen, umbrischen und römischen Schulen, Beschreibender Katalog der Handzeichnungen in der graphischen Sammlung Albertina*. Vienna, 1932, III.

BIBLIOGRAPHY

Strozzi, Alessandra Macinghi negli. *Lettere di una gentildonna fiorentina del secolo XV ai figlioli in esuli.* Ed., C. Guasti, Florence, 1877.

———. *Briefe.* Trans., A. Doren, Jena, 1927.

Suida, W. "Ein Bildnis von Domenico Veneziano." *Belvedere,* VIII (1929), pp. 433f.

———. *Leonardo und sein Kreis.* Leipzig, 1929 (1929a).

———. "Die Ausstellung italienischer Kunst in London." *Belvedere,* IX (1930), pp. 35ff.

———. "Die italienischen Bilder der Sammlung Rohoncz." *Belvedere,* IX (1930), pp. 175ff. (1930a).

———. "Die Sammlung Kress in New York." *Pantheon,* XXVI (1940), pp. 274ff.

———. *Paintings and Sculpture from the Kress Collection, National Gallery of Art.* Washington, D.C., 1945.

———. *Twenty-five Paintings from the Collection of the Samuel H. Kress Collection, University of Arizona.* Tucson, 1955.

Supino, I. "Notizie di Toscana: esposizione di alcune opera d'arte antica." *L'arte,* III (1900), pp. 312ff.

Swarzenski, G. *Ausstellung von Meisterwerken alter Malerei aus Privatbesitz.* Frankfurt-am-Main, 1926.

Sweeney, B. *Catalogue of the Johnson Collection, Philadelphia Museum of Art,* Philadelphia, 1966.

Testi, L. *Storia della pittura veneziana.* Bergamo, 1916, II.

Thieme, U. and F. Becker, eds. *Allgemeines Lexikon der bildenden Künstler.* Leipzig, 1907ff.

Thode, H. "Andrea Castagno in Venedig." *Festschrift für Otto Benndorf.* Vienna, 1899, pp. 307ff.

———. *Saint François d'Assise et les origines de l'art de la renaissance en Italie.* Paris, 1909, I.

Tietze-Conrat, E. *Andrea Mantegna.* London, 1955.

Tikkanen, J. J. "Zwei Gebärden mit dem Zeigefinger." *Acta Societatis Scientificarum Fennicae,* XLIII (1913), pp. 82ff.

The Times Literary Supplement. Review of Goodison and Robertson (1967), February 22, 1968, p. 172.

———. Review of Degenhart and Schmitt (1969), July 10, 1969, p. 756.

Tintori, L. and M. Meiss. *The Painting of the Life of St. Francis in Assisi.* New York, 1967.

Toesca, P. "Ricordi di un viaggio in Italia." *L'arte,* VI (1903), pp. 225ff.

———. *Masolino da Panicale.* Bergamo, 1908.

———. *La pittura e la miniatura nella Lombardia.* Milan, 1912.

———. "Una scatola dipinta di Domenico di Bartolo." *Rassegna d'arte senese.* XIII (1920), pp. 107f.

———. "Frammento di un trittico di Masolino." *BA,* XVII (1923), pp. 3ff.

———. "Trecentisti toscani nel museo di Berna." *L'arte,* XXXIII (1930), pp. 5ff.

———. "Domenico Veneziano." *Enciclopedia italiana,* X (1932), pp. 117ff.

BIBLIOGRAPHY

————. "Masaccio." *Enciclopedia italiana,* XXII (1934), pp. 472ff.

————. "Pollaiuolo." *Enciclopedia italiana,* XXVII (1935), pp. 694ff.

————. *Il trecento.* Turin, 1951.

Tofanelli, A. *Description des objets de sculpture et de peinture qui se trouvent au Capitole.* Rome, 1818.

Treasures of Cambridge, London, 1959.

The Twentieth Century Anniversary Exhibition, the Official Art Exhibit of the Great Lakes Exposition. Cleveland, 1936.

Ulmann, A. "Bilder und Zeichnungen der Brüder Pollaiuoli." *JPK,* XV (1894), pp. 230ff.

Ulmann, H. "Führer durch die römischen Gemäldesammlungen." *Zeitschrift für bildende Kunst.* V (1894), pp. 270ff. (1894a).

Urbani, G. "Leonardo da Besozzo e Perinetto da Benevento dopo il restauro degli affreschi di S. Giovanni a Carbonara." *BA,* XXXVIII (1955), pp. 297ff.

————. "Restauri di affreschi nella cappella di S. Clemente a Roma." *Bollettino dell'istituto centrale di restauro,* 21/22 (1955), pp. 13ff. (1955a).

Valentiner, W. "Andrea dell'Acquila in Urbino." *AQ,* I (1938), pp. 275ff.

Vasari, G. *Le vite de' più eccellenti architetti, pittori e scultori italiani.* Florence, 1550. Reprint ed., C. Ricci, Milan and Rome, 1927.

————. *Le vite de' più eccellenti pittori, scultori ed architettori.* Florence, 1568. Ed., G. Milanesi, Florence, 1878ff.; ed., K. Frey, Munich, 1922, I, 1.

Vaughan, M. "Masterpieces in the Hamilton Collection." *Art News,* XXVII (June 1929), pp. 75ff.

Vavasour-Elder, I. "Spigolatura di Val d'Elsa." *Rassegna d'arte,* X (1909), pp. 159ff.

Vayer, L. "Analecta iconographica Masoliniana." *Acta historiae artium,* XI (1965), pp. 217ff.

Venturi, A. *The Capitol Picture Gallery.* Rome, 1890.

————. "La galleria del Campidoglio." *Archivio storico dell'arte,* II (1889), pp. 441ff.

————. *Gentile da Fabriano e il Pisanello.* Florence, 1896.

————. "Un quadro del museo di Verona." *L'arte,* VII (1904), pp. 300ff.

————. "Quadri falsi nella galleria di Monaco." *L'arte,* VII (1904), p. 391 (1904a).

————. Review of Hill (1905). In *L'arte,* IX (1906), pp. 154ff.

————. *Le origini della pittura veneziana, 1300–1500,* Venice, 1907.

————. *Storia dell'arte italiana.* Milan, 1911, VII, 1.

————. "Un ritratto del Pisanello." *L'arte,* XXI (1918), pp. 277ff.

————. "Ritratti del Baldovinetti a Hampton Court." *L'arte,* XXV (1922), pp. 10ff.

————. "Tavoletta di Domenico Veneziano." *L'arte,* XXVIII (1925), pp. 28ff.

————. *Studi dal vero.* Milan, 1927.

BIBLIOGRAPHY

————. "Frauenbildnisse von Antonio Pollaiuolo." *Pantheon,* III (1929), pp. 12f.

————. "Notes on the Exhibition of Italian Art." *Apollo,* XI (1930), pp. 233ff.

Venturi, L. *La collezione Gualino,* Turin, 1926.

————. "Paolo Uccello." *L'arte,* XXXIII (1930), pp. 63ff. (1930a).

————. *Pitture italiane in America.* Milan, 1931.

————. *Italian Paintings in America.* New York, 1933.

————. "Lo sviluppo artistico di Filippo Lippi." *L'arte,* XXXVI (1936), pp. 39ff.

Verga, C. "L'architettura nella *Flagellazione* di Urbino." *CA,* XLI, 150 (1977), pp. 25ff.

————. "Un pavimento di Piero?" *CA,* XLII, 151–53 (1977), pp. 100ff. (1977a).

del Vita, A. "Opere d'arte distrutte e salvate da Giorgio Vasari." *Il Vasari,* II (1929), pp. 155ff.

Vitzthum von Eckstädt, G. "Ein Stadtbild im Baptisterium von Castiglione d'Olona." *Festschrift zum sechzigsten Geburtstag von Paul Clemen.* Bonn, 1926, pp. 401ff.

Volpe, C. "In margine a un Filippo Lippi." *Paragone,* 83 (November 1956), pp. 38ff.

Volponi, P. and L. Berti. *L'opera completa di Masaccio.* Milan, 1968.

A. W. "Correspondance de Londres." *GBA,* XXIV (1868), pp. 196ff.

Waagen, G. F. *Treasures of Art in Great Britain.* London, 1854.

Wackernagel, M. *Der Lebensraum des Künstlers in the florentinischen Renaissance.* Leipzig, 1938.

Waldschmidt, W. *Andrea del Castagno.* Berlin, 1900.

Walker, J. *Self-Portrait with Donors.* Boston, 1974.

Wallraf-Richartz Museum. *Kölnische und westphälische Malerei vor Stefan Lochner.* Cologne, 1955.

Warburg, A. *Gesammelte Schriften.* Leipzig, 1932.

Wassermann, G. *Masaccio und Masolino.* Strasbourg, 1935.

Watson, P. F. "Virtù and Voluptas in Cassone Painting." Ph.D. diss., Yale University, 1969.

Wätzold, S. *Die Kopien des 17. Jahrhunderts nach Mosaiken und Wandmalereien in Rom.* Vienna and Munich, 1964.

Wehle, H. *The Metropolitan Museum of Art, a Catalog of Italian, Spanish, and Byzantine Paintings.* New York, 1940.

Weinberger, M. "Silk Weaves of Lucca and Venice in Contemporary Painting and Sculpture." *Bulletin of the Needle and Bobbin Club* (1941), pp. 3ff.

Weisbach, W. *Francesco Pesellino und die Romantik der Frührenaissance.* Berlin, 1901.

————. "Der Meister des Carrandschen Triptychons." *JPK,* XXII (1901), pp. 35ff. (1901a).

Weise, G. *Die geistige Welt der Gotik und ihre Bedeutung für Italien.* Berlin, 1939.

Weiss, R. "Jan van Eyck and the Italians." *Italian Studies,* XI (1956), pp. 1ff.; XII (1957), pp. 7ff.

BIBLIOGRAPHY

————. *Pisanello's Medallion of the Emperor John VIII Palaeologus.* London, 1966.

————. *The Renaissance Discovery of Classical Antiquity.* Oxford, 1969.

Weizsäcker, R. "Das Pferd in der Kunst des Quattrocento." *JPK,* VII (1886), pp. 40ff.

Weller, A. S. *Francesco di Giorgio.* Chicago, 1943.

Welliver, W. "The Symbolic Architecture of Domenico Veneziano and Piero della Francesca." *AQ,* XXXVI (1975), pp. 1ff.

Weyr, R. "Primitives and Others." *International Studio,* LXIII (January 1918).

White, J. *The Birth and Rebirth of Pictorial Space.* London, 1957.

————. "Paragone: Aspects of the Relationship Between Painting and Sculpture." *Art, Science and History in the Renaissance.* Baltimore, 1967, pp. 43ff.

————. "Donatello's High Altar in the Santo at Padua, Part Two: The Reconstruction." *AB,* LI (1969), pp. 119ff.

Wickhoff, F. "Die Fresken der Katherinen Kapelle in S. Clemente." *Zeitschrift für bildende Kunst,* XXIV (1889), pp. 301ff.

————. "Über einige italienische Zeichnungen im British Museum." *JPK,* XX (1899), pp. 202ff.

Wilde, J. "Die 'Pala di San Cassiano' von Antonello da Messina, ein Rekonstruktionsversuch." *Jahrbuch der kunsthistorischen Sammlungen in Wien,* III (1929), pp. 57ff.

Wittgens, F. "The Contributions of Italian Private Collections to the Exhibition at Burlington House." *Apollo,* XI (1930), pp. 73ff.

————. *Il museo Poldi-Pezzoli a Milano.* Milan, 1937.

Witting, F. "Forschungen." *Kunstchronik,* XXI (1910), p. 495.

Wittkower, R. "Brunelleschi and 'Proportions in Perspective.' " *JWCI,* XVI (1953), pp. 292ff.

Wittkower, R. and B. A. R. Carter. "The Perspective of Piero della Francesca's 'Flagellation.' " *JWCI,* XVI (1953), pp. 292ff.

Wittkower, R. and M. *Born Under Saturn.* London, 1963.

Wohl, H. "Domenico Veneziano Studies." Ph.D. diss., New York University, 1958.

————. "Domenico Veneziano Studies: the Sant'Egidio and Parenti Documents." *BM,* CXIII (1971), pp. 635ff.

————. "Letter to the Editor." *AB,* LVIII (1976), pp. 473f.

Wolters, C. "Eine Fälschung nach Fra Angelico." *Kunstchronik,* VI (1953), p. 36.

Wortham, H. E. "The Bache Collection." *Apollo,* XI (1930), pp. 350ff.

Wundram, M. *Frührenaissance.* Baden-Baden, 1970.

Yashiro, Y. "An Artistic Discovery." *The Times* (London), February 23, 1925, p. 15.

Zahle, E. *Italiensk Kunst og Kunstindustrie.* Copenhagen, 1934.

Zampetti, P. *A Dictionary of Venetian Painters.* Leigh-on-Sea, 1969.

BIBLIOGRAPHY

————. *Giovanni Boccati*. Milan, 1972.

Zeri, F. "A proposito di Ludovico Urbani." *Proporzioni*, II (1948), pp. 167ff.

————. "Il maestro dell'Annunciazione Gardner." *BA*, XXXVIII (1953), pp. 125ff.

————. "La riapertura della Alte Pinakothek di Monaco." *Paragone*, 95 (November 1957), pp. 64ff.

————. *Due dipinti, la filologia e un nome*. Turin, 1961.

————. "La mostra 'L'Arte in Valdelsa' a Certaldo." *BA*, XLVIII (1963), pp, 245ff.

————. "Italian Primitives at Messrs. Wildenstein." *BM*, CVII (1965), pp. 252ff.

————. *Italian Paintings, Florentine School, a Catalogue of the Collection of the Metropolitan Museum of Art*. New York, 1971.

————. "Major and Minor Italian Artists at Dublin." *Apollo*, XCIX (1974), pp. 88ff.

Zocchi, G. *Scelta di XXIV vedute delle principali contrade, piazze, chiese, e palazzi della città di Firenze*. Florence 1754; reprint, New York, 1967.

Zöge von Manteuffel, K. *Die Gemälde und Zeichnungen des Antonio Pisano aus Verona*. Halle, 1909.

INDEX

INDEX

Nelli, Ottaviano, 81

Neri di Bicci, 185. Works: Cameto, Pieve, *sacra conversazione*, 124; Florence, Accademia, *The Annunciation*, 62, 124, *Madonna and Child with Saints*, 81; Rucellai Palace, architectural fresco, 31; S. Pancrazio, *St. John Gualberto and Other Saints*, 124, 205; Spedale degli Innocenti, *The Coronation of the Virgin*, 124; Grenoble, Musée de peinture et de sculpture, *Sts. Catherine, Anthony and John the Baptist*, 124; Montreal, Museum of Fine Arts, *sacra conversazione*, 124, Pl. 86; Settignano, S. Martino a Mensola, *sacra conversazione*, 124

Neroccio dei Landi, *Madonna and Child*, Cracow, National Museum, 82

New York, Century Club, *Exhibition of Italian Paintings of the Renaissance*, 128, 129; Metropolitan Museum of Art, 132, *The Great Age of Fresco*, 153, 169, 170, *Portrait of a Lady*, 24, 179, 184, 185, 196, Pl. 218; Morgan Library, ms. 498, *The Visions of St. Bridget of Sweden*, 80

Niccolò dell'Arca, 49

Niccolò da Foligno, 165

Niccolò da Foligno (attributed to), *Madonna and Child with Saints*, Cambridge, Fogg Art Museum, 82

Nicholas V, pope, 12

Nicholas of Cusa, 54

Nicola di Antonio, 164

Nicolò di Pietro, 141

Nicolò di Pietro, *Madonna and Child*, Venice, Accademia, 7

Northwick, Lord, 168

Offner, Richard, 129, 167

Olivieri, Ser Giovanni, 139

Olivieri, Matteo, 139, Pl. 171

Olivieri, Michele, 139, Pl. 172

Olympia, Temple of Zeus, sculptures, 68

Opper, Uwe, collection, Kronberg, *Diana and Acteon*, 61, 113, 155, 157, 158, 192, 193, 205, Pl. 188

Orvieto, cathedral, facade sculptures, 57

Osservanza Master, *Madonna of Humility*, Asciano, Museum, 62, 188

Palaeologus, John VIII, 17, 72, 73, 350

Palazzuolo, 30

Panciatichi Collection, Florence, 117

Pancrazio, Count, collection, Ascoli Piceno, 181

Paolo Veneziano, 81

Parenti, Marco, xxiv, 19, 20, 21, 22, 23, 30, 198, 199

Paris, Louvre, Codex Vallardi, 11, Meleager sarcophagus, 49, Pl. 114; Musée Jacquemart-André, *desco da parto*, 144; Petit Palais, *Exposition de l'art italien de Cimabue à Tiepolo*, 133

Paris Master, 157, 190, 196. Works: Bergamo, Accademia Carrara, *Episodes from the Story of Griselda*, 155, 157, 193, Pl. 187; Glasgow, Art Gallery and Museum, *The Judgment of Paris*, 113, 154, 155, 156, 157, 192, 205, Pl. 184; London, Charles Butler Collection, *Zeus and the Three Goddesses*, 156, 192; Vienna, Lanckoronski Collection, *Juno, Venus and Minerva*, 156, *The Rape of Helen*, 154, 155, 157, 192, 193, Pl. 185, *The Sleep of Paris*, 154, 155, 157, 192, 193, Pl. 186

Pascasius, governor of Sicily, 49, 132

Passamani, Bruno, 143

Paul II, pope, 210

Peleş Castle, Romania, collection of King Carol I, 118

Pellicioli, Mauro, 172

Perugia, 69; Baglioni Palace, 14, 210; Confraternity of Borgo Sant' Angelo, 190; *congregazione della carità*, 190; Galleria Nazionale dell'Umbria, Capella de' Priori, 23, 30, 31, *The Siege of Perugia by Totila*, 210, *The Cross, the Mystic Lamb and the Book of Seven Seals, and the Madonna della Misericordia*, 189, 190, Pl. 222, *Man in Armor*, 17, 211, Pl. 228; *Mostra di dipinti restaurati*, 190; Rocca Paolina, 14, 210, 211

Perugino, Pietro, 31, 69, 152, 353

Pesellino, Francesco, 2, 3, 24, 58, 84, 120, 121, 123, 129, 132, 149, 150, 155, 166, 167, 171, 177, 188; predella of S. Croce altarpiece (see Lippi, Fra Filippo), 4, 149, *St. Francis Receiving the Stigmata*, Paris, Louvre, 58; *The Story of David*, Birmingham, City Museum and Art Gallery, 24; *The Triumphs of Petrarch*, Boston, Isabella Stewart Gardner Museum, 149; *Female Figure*, Cambridge, Fogg Art Museum, 206; *Madonna and Child*, Denver, Art Museum, 194; Trinity altarpiece, London, National Gallery, 24, 25, 347; *sacra conversazione*, New York, Metropolitan Museum of Art, 80; *Madonna and Child with Two Saints*, Philadelphia, John G. Johnson Collection, 149

Pesellino, Francesco (attributed to), *Crucifixion with Sts. Jerome and Francis*, Washington, National Gallery of Art, 136, 150

Pesello, 151; *The Adoration of the Magi*, Florence, Palazzo della Signoria, 82, 120, 126

Pesello, Francesco di, 123, 349, 350

Pesello, Giuliano, 121

[408]

INDEX

INDEX